PHOTOGRAPHY

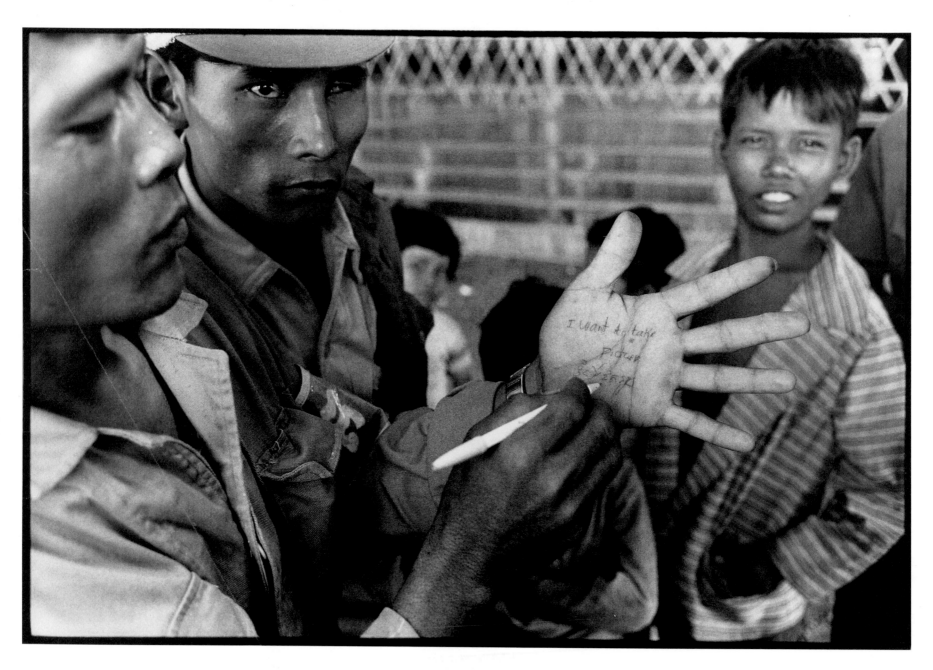

BILL BURKE
Knyum Sum Taut Roop
I Want to Take Picture
Courtesy of Bill Burke

PHOTOGRAPHY

Henry Horenstein
Rhode Island School of Design

Russell Hart
American Photo Magazine

Contributors:

Thomas Gearty, Massachusetts College of Art

Vicki Goldberg, The *New York Times*

Prentice
Hall

UPPER SADDLE RIVER, NEW JERSEY 07458

Library of Congress Cataloging-in-Publication Data
Horenstein, Henry
 Photography / Henry Horenstein, Russell Hart.
 p. cm.
 Includes index.
 ISBN 0-13-617580-5
 I. Photography. I. Hart, Russell, 1953-II. Title.

TR145 .H6223 2001
7871—dc21 00-037354

Editorial director: Charlyce Jones Owen
Publisher: Bud Therien
AVP, Director of Production and Manufacturing: Barbara Kittle
Senior Production Editor: Barbara DeVries
Prepress and Manufacturing Manager: Nick Sklitsis
Prepress and Manufacturing Buyer: Lynn Pearlman
Marketing Manager: Sheryl Adams
Creative Design Director: Leslie Osher
Art Director, Interior and Cover Design: Carole Anson

Cover Art: Wayne Calabrese/Amana America Inc./Photonica
Supervisor of Production Services: Guy Ruggiero
Electronic Page Layout: Rosemary Ross
Art Studio: Douglas and Gayle
Copy Editor: Sylvia Moore
Editorial Assistant: Wendy Yurash
Photo Research: Francelle Carapetyan
Photo Permission Manager: Kay Dellosa
Photo Permission Specialist: Michelina Viscusi

This book was set in 10/12 Cantoria MT by the HSS in-house formatting and production services group and was printed and bound by RR Donnelley.
The cover was printed by Phoenix Color Corporation.

© 2001 by Henry Horenstein
Published by Prentice-Hall, Inc.
A Unit of Pearson Education
Upper Saddle River, NJ 07458

Printed in the United States of America

10 9 8 7 6 5 4 3 2 1

ISBN 0-13-617580-5

Prentice Hall International (UK) Limited, *London*
Prentice-Hall of Australia Pty. Limited, *Sydney*
Prentice-Hall Canada Inc., *Toronto*
Prentice-Hall Hispanoamericana, S.A., *Mexico*
Prentice-Hall of India Private Limited, *New Delhi*
Prentice-Hall of Japan, Inc., *Tokyo*
Pearson Education Pte. Ltd., *Singapore*
Editora Prentice-Hall do Brasil, Ltda., *Rio de Janeiro*

To Lorie Novak, again.

HH

To my father, Francis, the best teacher I know,
and my mother, Lorena, the best artist I know.

RH

CONTENTS

CHAPTER 9
FILM EXPOSURE

CHAPTER 10
CAMERA FILTERS

CHAPTER 11
LIGHTING TOOLS
AND TECHNIQUES

CHAPTER 12
FILM PROCESSING

PREFACE

Photography is now a mainstream art course taught at virtually every level from grade school to college—the latter in art schools, professional schools, and liberal-arts settings. It is taught in continuing education programs, at camera clubs, and in an ever-growing number of year-round workshops. Yet the medium's academic success is a fairly recent phenomenon. If you wanted to study photography just 30 years ago, your options were far more limited. Most art schools didn't have separate photography programs and many major universities didn't even offer an accredited course. And only a few institutions gave graduate degrees in photography.

The growth in photographic education reflects a huge change in photography's social and cultural status. In the art world, photography has finally been accepted as a legitimate medium, worthy of the same attention as painting or sculpture. Museums large and small have permanent collections of photography; hundreds if not thousands of galleries and private dealers exhibit and sell fine-art photography. In the advertising and design communities, photography is used more than ever as a means of persuasion. And where art directors, editors, and clients once told photographers how to work, they now look to photographers for ideas and style.

And there have been many technical changes, too. Photography has always been to a large degree driven by technology, but that has been especially true of the last few years. Commercially available photographic materials and processes have improved in quality, flexibility, and permanence. Photographic equipment—especially cameras—has become highly electronic, allowing precise automation of exposure, focus, and other aspects of picture making. And perhaps most significant, the computer has become photography's handmaiden, in terms of image capture, editing, and output.

Whether digital photography will eventually replace traditional film-based photography—and when—is still a matter of speculation. For the time being, many photographers have adopted a hybrid approach. They make photographs with film and process them conventionally, but then scan them to create digital image files that can be manipulated in the computer and output as digital prints that may or may not look like conventional photographic prints. The level of post-exposure control offered by digital technology generally exceeds that of the conventional darkroom, hence the term digital darkroom. But while filmless photography is making serious inroads, it usually can't match the quality of film, except with expensive and large studio-bound systems.

The purpose of this book is to address the vast changes of photography's past few years, and to help bring photographic education into the twenty-first century. It presents traditional photographic technique in great detail, explaining such basic matters as film exposure, camera controls, film processing, and printing for both black-and-white and color. Rather than treating black-and-white and color photography as separate disciplines, *Photography* integrates the subjects. And it also provides a thorough exploration of the role of modern technology—camera automation and digital imaging—and how traditional and new technologies can be used together for the best results.

The book's art program plays a critical role in its educational goals. Its many portfolio images come from all areas of photography—technical and commercial to fine-art. The intent was to provide an overview of some of the best creative photographers working today, in whatever field they've chosen to work, and also to help explain in captions something about their working methods and techniques. To a large degree, these portfolio images pick up visually where Vicki Goldberg's photo history (Chapter 1) leaves off, with that chapter providing a visual reference to the past and the portfolios providing a visual reference to today.

A how-to text can take the reader only so far. In eight special profiles, the book details the working methods, thoughts, and visual styles of some of the most visible professionals in a variety of areas of photography. Our goal is to give the reader an understanding of how successful photographers work and also to create a sense of the choices available to future generations of photographers.

The next few years will bring new challenges and opportunities at what promises to be a very rapid pace. Succeeding editions of *Photography* will doubtless lean more and more towards automation and digital image capture and processing. The authors are uniquely qualified to interpret and explain these changes. Both are active photographers, working in both the fine-art and commercial areas. Henry Horenstein has been a photography teacher since 1970, currently at the Rhode Island School of Design, and has written several of the most enduring photographic textbooks. Russell Hart had taught photography at the Boston Museum School and Tufts University, and has been a photography writer and editor since 1980, mainly at *American Photo* and *Popular Photography* magazines.

ACCOMPANYING SUPPLEMENTS

- Laboratory Manual / Workbook (0-13-975509-8); (97550-8)

- Instructor's Manual (0-13-975491-1); (97549-0)

- Website
 www.prenhall.com/horenstein

ACKNOWLEDGMENTS

The authors want to thank the many, many people who helped make *Photography* happen. Thomas Gearty of the Massachusetts College of Art and the Art Institute of Boston was the glue that held us together; he contributed to all aspects of the book, including writing, picture research, editing, and photography. Huge thanks also to Vicki Goldberg of the *New York Times*; she produced a compact, lively, and authoritative history of photography for our first chapter.

Dan Richards of *Popular Photography* magazine wrote an admirable draft of Chapter 11. Many photographers contributed important illustrations, both for the portfolio examples and for specific illustrations. They include Bob Hower, Andrea Raynor, Jim Dow, Thomas Gearty, and Shellburne Thurber. Stacey Greig and Rob Rinaldi did studio photography. Eva Sutton and Hadley Stern contributed much of the information and illustrations for Chapter 17. Evan Scheele printed many of the photographs.

Readers included Neal Rantoul, Larry Volk, and Andrea Raynor, all of Northeastern University; Jim Dow of the School of the Museum of Fine Arts, Boston; Rowena Otremba of Boston's Zona photo lab; M.K. Simqu of Ringling School of Art and Design; and Andrea Hoelscher of the Massachusetts College of Art.

We appreciate the helpful suggestions and insights of the Prentice Hall reviewers:

- Jill M. Cason, Central Piedmont Community College

- Neil Chapman, Mount San Antonio College

- Glenn Hansen, College of DuPage

- Charles Luce, County College of Morris

- Kim Mosely, St. Louis Community College

- Curtis Stahr, Des Moines Area Community College

- David Sutherland, Newhouse School of Public Communications, Syracuse University

Thanks also to Elaine O'Neil of the Rochester Institute of Technology for advice on non-silver photography, Karl Baden of Boston College, Soon-Mi Yoo and Joanne Lukitsch of the Massachusetts College of Art, and Michelle Kloehn, Amy Townsend-Small, and Rena Berger for a wide variety of tasks. We appreciate the expertise of Elizabeth Thomsen Greenberg, who prepared the online study guide for the Website, and Are Flågan who created the simulations.

Last but decidedly not least, we thank the book's team at Pearson/Prentice Hall: our forbearing, sympathetic editor and publisher, Bud Therien; our patient and impeccably organized production editor, Barbara DeVries; our very creative art director, Carole Anson; and our talented formatter, Rosemary Ross.

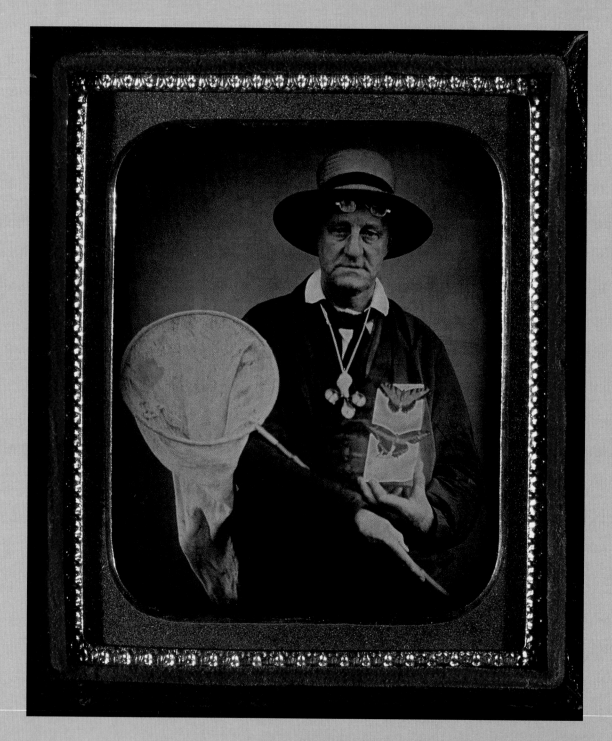

ANONYMOUS
The Lepidopterist

Photography's first widely-used process, the daguerreotype was a one-of-a-kind image. Created on a polished metal plate coated with a light-sensitive emulsion, it was exposed in the camera and developed directly to a positive. The finished image was often presented in an elaborate ornamental case, and had to be viewed at an angle so that the under-lying metal—which showed through in the subject's "shadows"—reflected something dark in the environment. Though it wasn't repro-ducible, the daguerreotype offered much finer detail, with greater sharpness, than its reproducible competitor, the calotype. Its small size made it well-suited to portraits, in which the profession or passions of the sitter (here, a butterfly collector) were often indicated with props.

Photographic History Collection/National Museum of American History/Smithsonian Institution

The year 1839 was auspicious. The first baseball player stepped to the plate; the first bicycle wheeled down the road; and Louis Jacques Mandé Daguerre (in France) and William Henry Fox Talbot (in England) independently announced the invention of photography. Of these changes, only photography would go on to change the world, and our perceptions of it, so dramatically.

Daguerreotype and calotype (as Talbot called his method) were entirely different processes. The finished daguerreotype was the very same polished metal plate the photographer had exposed in the camera, its emulsion developed directly to a positive. It was thus a one-of-a-kind image, reversed from left to right. The calotype was a positive print made from a separate paper negative, and could be reproduced time and again.

The daguerreotype prevailed for photography's first dozen years, sidelining the reproducibility that would later be considered intrinsic to the medium. It helped that France's parliament purchased the process from its inventor and bestowed it on the world free of charge, while Talbot restricted his creation by making prospective users take out a license. More important, a society hungry for exacting realism preferred the daguerreotype's feast of minute detail to the calotype's heavy shadows and soft definition. Still, the painterly qualities of Talbot's invention attracted photographers of pictorial inclination, such as the Scottish portraitists David Octavius Hill and Robert Adamson.

The daguerreotype had its own problems. Its low sensitivity to light, along with the small apertures of available lenses, forced portrait subjects to hold still as long as several minutes for a proper exposure, even in the open-air illumination of common rooftop studios.

That made it a challenge to get an image unblurred by motion, let alone a natural-looking pose. (Head braces were required, perhaps explaining the dour look of early portraiture!) But technical improvements soon shortened exposure times to seconds, and the camera became the greatest aid to vanity since the invention of the compliment. Between June of 1854 and June of 1855, for example, over 400,000 daguerreotypes alone were taken in Massachusetts, a state having a population of just a million at that time.

Though portraiture was on its way to an abiding commercial success, some photographers were more high-minded than others in their approach. Boston's Southworth and Hawes and New York's Mathew Brady (whose studio would later produce the most famous images of the Civil War) resolved to use the fledgling medium to define America's character through the look of its countrymen. This was a fitting purpose in an era when physical appearance was thought to reveal the inner self. Brady published his *Gallery of Illustrious Americans,* a visual testament to its subjects' exemplary public service. The superb French portraitist Nadar trained his camera on the great and famous of his day, helping to make popular heroes of the country's creative community.

This explosion of portraiture, which before photography was the luxury of the rich and aristocratic, changed the character of memory. Photographs allowed people to remember how they looked as children, or how dead relatives had appeared in life, and to know the faces of people they would never meet. And when photography finally became easy enough for anyone to do it, a new and obligatory form of portraiture

William Henry Fox Talbot
The Breakfast Table, 1840
The reproducibility of Talbot's calotype process made it the basis for modern photographic technique. The positive image was created from a paper negative that could be used to make as many prints as desired. Negatives could be sensitized in advance, then developed and printed long after they were exposed. This freed the photographer to travel with his or her camera, unlike the studio-bound daguerreotype practitioner. National Museum of Photography, Film & Television/Science & Society Picture Library

evolved to mark important events in life: baptisms, birthdays, weddings.

PICTURE POSTCARDS

Despite the proliferation of photographic prints, it would be decades before text and photographs could be reproduced together by efficient mechanical means. In 1844 Talbot had published one of the first photographically illustrated books, *The Pencil of Nature,* but with real photographic prints tipped-in, it was limited to an edition of 150. In the 1850s, the Frenchman Louis Désiré Blanquart-Evrard devised techniques for producing actual prints in numbers large enough to make publishing practical, if still expensive. But the nineteenth century, an age of industry, kept looking for a cheaper, better way to put words and photographs together—one that would allow their mass distribution. The information era had begun.

Meanwhile, photographers such as Maxime Du Camp, Francis Frith, and Auguste Salzmann made long forays to faraway places—the Middle East, with its biblical sites, was an especially popular destination—and printed their pictures in travel books that helped shrink the globe. Karnak and Jerusalem could now be viewed from the vantage point of an armchair in London. The resulting public fascination with such places may well have fueled popular support for the era's rapacious colonial conquests. Indeed, photographs were used as propaganda for territorial acquisition and settlement; advertisements for free land in the American West were sometimes illustrated with engravings from photographs. Handsomely printed landscapes by western expeditionary photographers such as William Henry Jackson, Timothy O'Sullivan, and Carleton

Nadar (Gaspard Félix Tournachon)
George Eastman, 1890
Nadar ran a thriving commercial portrait studio in late 19th-century Paris, photographing the artists and celebrities of the day—here, photographic inventor George Eastman, founder of Kodak. Like Eastman, he never lost his willingness to experiment. Nadar pioneered photography by artificial light, using battery-powered lamps to illuminate the Paris catacombs, its famous underground tombs. And he became the first aerial photographer when he photographed the city from a hot-air balloon. Photographic History Collection/ National Museum of American History/Smithsonian Institution

Francis Frith
The pyramids of El-Geezah, from the Southwest, 1858
Frith's mid-century photographic expeditions to Egypt and the Holy Land brought him great commercial success. His publishing company sold hundreds of thousands of prints to Victorian-era "armchair travelers" anxious to visit exotic places from the comfort of home. Full of rich detail made possible by wet-plate negatives and albumen paper, the photographs also may have promoted public sentiment favoring an English presence in the Middle East. Photographic History Collection/National Museum of American History/Smithsonian Institution

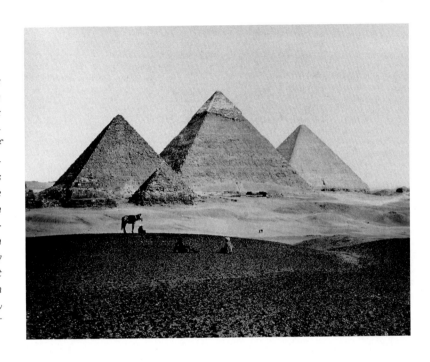

Henry Peach Robinson
Sleep, 1867
As an established painter, Robinson was well-prepared to fight for the acceptance of photography as an art, a battle that heated up in the 1860s. Robinson used combination printing—single images created by compositing multiple negatives of carefully-planned scenes—to overcome many of the technical limitations of photography and to imitate the conventions of painting. His work's reception was mixed: Some critics refused to believe that photography could achieve the artistic level of painting, while others felt that Robinson's compositions denied the medium's true nature. The Royal Photographic Society Collection, Bath, England. Web site http://www.rps.org

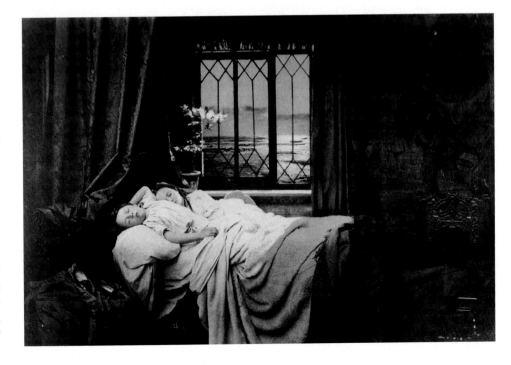

Watkins surely reinforced the popular notion of manifest destiny, encouraging Americans to "Go west, young man."

Whatever its less wholesome effects, the camera was an unusually democratic and democratizing instrument. It made some kinds of knowledge—visual knowledge at least—accessible to people who could not have attained it otherwise. Nineteenth-century butchers, bakers, and candlestick makers began to have a better idea of the places their wealthy patrons actually visited. Photographs communicate exactly the same visual facts to everyone who looks at them.

But photographers wanted to do more than merely convey information. In 1839, the French painter Paul Delaroche had supposedly exclaimed on seeing a daguerreotype, "From this day, painting is dead!" As we all know, he was wrong. In fact, photography had trouble winning the status of art because of its mechanical nature; many doubted that its practitioners had styles or could manipulate their images as artists did. So some photographers felt compelled to prove themselves to be as good as painters.

Beginning in the late 1850s in England, Oscar G. Rejlander and Henry Peach Robinson exhibited compositions assembled from as many as 30 negatives, their purpose being to achieve a dramatic realism that came easily to painting but not to photography. Dubbed "combination printing," the technique was used more simply by photographers like Gustave Le Gray and William Henry Jackson, who shot separate negatives for a scene's land and sky, then printed them in register on a single sheet of photographic paper to maintain detail in both areas. This compensated for their primitive emulsions' excessive sensitivity to blue, which caused the sky to be overexposed when exposure

was correct for the land. Combination printing was one of many ways early photographers struggled to overcome the limits of their materials.

PHOTOGRAPHY EXPLODES

The short reign of the daguerreotype ended in 1851 when the Englishman Frederick Scott Archer devised the wet collodion plate—a sheet of glass coated with a sticky solution of explosive nitrocellulose dissolved in alcohol and ether, sensitized by dipping it in silver nitrate. Made on lustrous new albumen paper, prints from collodion negatives were nearly as sharp as daguerreotypes. Collodion's advan-

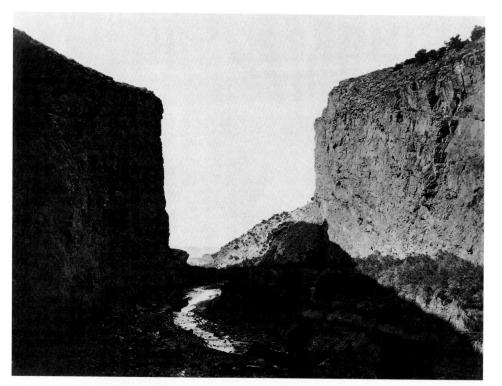

Timothy O'Sullivan
Vermillion Creek
Canyon, 1872
O'Sullivan made his name as a Civil War photographer, but his work after the war was even more arduous: He traveled across the unexplored American West as a photographer on government survey parties. O'Sullivan was gone for months at a time, hauling heavy darkroom gear and huge glass plates for his negatives by boat, wagon, or even pack mule. In spite of the difficulties, he made a visually powerful record of the unspoiled frontier, ahead of the waves of settlers who followed soon after.
Courtesy of the Library of Congress

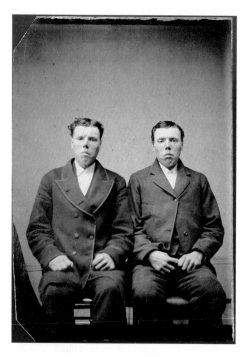

Anonymous
Tintype of Brothers, c. 1870s
The tintype was a working-class daguerreotype—a one-of-a-kind positive made by coating a wet collodion emulsion on a sheet of blackened metal, then exposing and processing it so that the emulsion washed clear in the dark areas. Its inexpensive materials made tintype a popular medium for mass-market portraiture through the end of the 19th century and well into the 20th in some areas. Courtesy of Thomas Gearty

André A. E. Disdéri
Uncut Cartes-de-Visite
The first mass-market use of the negative-positive process—and the death blow to the daguerreotype—was Frenchman Disdéri's multiple-lens camera, patented in 1854. It made up to eight separate portraits of a subject on a single negative, which was then processed and printed by an assembly line of technicians. The carte-de-visite, as the mounted 2½ x 3½-inch prints were known, was used both for celebrity and personal portraiture. The middle class collected celebrity portraits like baseball cards and exchanged their own likenesses with family and acquaintances. Courtesy George Eastman House

John K. Hillers
Inquiring for the Water
Pocket, c. 1875

A special prism viewer made stereographic images—shot with twin-lensed cameras to simulate human binocular vision—appear three-dimensional. They were an increasingly popular form of entertainment and education well past the end of the 19th century, providing a vivid sense of far-off places and events. This is why 19th-century expeditionary photographers such as Hillers used stereo cameras when they wanted to document their parties' encounters—here, explorer John Wesley Powell consulting a Native American for directions. Stereographs' smaller format also kept cameras compact and lenses fairly "fast," making it possible to capture active, spontaneous subjects more easily than with the customary larger-format cameras. Photographic History Collection/National Museum of American History/Smithsonian Institution

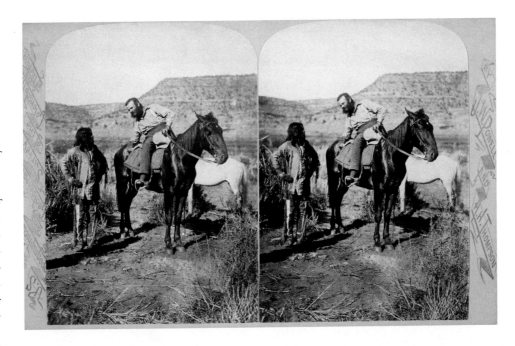

tage: No longer did high photographic sharpness require a one-of-a-kind image; it could be reproduced over and over again. Its disadvantage: The plate had to be exposed while wet and developed almost immediately.

This meant that outdoor photographers had to lug portable darkrooms up mountains and across the burning sands. Those documenting the American West now had an especially arduous task, though the wet plate's combination of quality and duplicability perfectly suited their mission. In photographic studios, wet collodion's problems were solved with a kind of primitive darkroom assembly line in which semiskilled workers each performed a specific task such as coating, sensitizing, processing, or retouching.

In the mid-1850s, the tintype appeared. Essentially a wet collodion negative reversed to positive by coating it on a sheet of black-varnished tin and deliberately underexposing it, its one-of-a-kind image made it a bit of a throwback; cheap, durable, and easy to mail, it was a poor man's daguerreotype. The working classes now had their portraits too; American tintype photographers took countless pic-

tures of Civil War recruits for mailing home to mothers. In 1860, tintypes of Lincoln turned up on Republican lapels—the first photographic campaign buttons.

In 1854 the Parisian André A. E. Disdéri brought about a similar popularization of miniature paper prints, devising a multiple-lens camera to take four or eight images on a single film plate. After processing, the print from this plate was cut up into so-called cartes-de-visite that were approximately 2½ x 3½ inches in size. Cartes began as calling cards exchanged by aristocrats, but soon became a middle-class mania; in 1860, Disderi produced an average of 1,600 plates a month. Capitalism marched on in tandem with new photographic technologies and refinements of old ones: cartes were efficiently manufactured, inexpensively produced and priced, and they appeared just as the market for celebrity portraits was burgeoning.

Changing social conditions had combined with the new medium to promote the first real celebrity craze. People were eager for heroes and a sense of intimacy with them, even if that only meant having their pictures to stare at. When photo

albums came to market around 1860, middle-class fans stuffed them with pictures of royalty, statesmen, military men, actors, writers, composers, and artists. For almost two months after Fort Sumter surrendered to the Confederacy in the American Civil War, 1,000 portraits of the stalwart Yankee commander were sold each day.

DOUBLE THE IMPACT

If cartes-de-visite were the early forerunners of movie star fan photos and baseball cards, the stereograph prefigured television. Its powerful illusion of depth and reality was created by shooting the same scene from two slightly different horizontal positions (the shift about equal to the distance between our eyes' pupils), then allowing each image to be seen only by the corresponding eye. Though early on the effect was produced by making sequential side-by-side exposures with a single-lensed camera, twin-lensed stereoscopic models were manufactured as early as 1856. Their simultaneous exposures meant that active subjects could be photographed, and the shorter focal lengths needed for the stereograph's small images allowed relatively large lens apertures, which in turn permitted faster, motion-stopping shutter speeds. For this reason, stereo models became, in effect, the "snapshot" cameras of western expeditionary photographers.

The binocular viewers needed for the stereoscopic effect found a place in millions of middle-class parlors in Britain, Europe, and America, making photographs a seemingly necessary adjunct of a comfortable life. Families would gather to look at new pictures of Yosemite by Carleton Watkins or of China by John Thomson, sharing them with friends and visitors. Information, entertainment, and news from far-off places came into the home this way.

THE PHOTOGRAPHIC DOCUMENT

By the third quarter of the century, photographs were enlisted to advertise manufactured goods, incorporated into sales

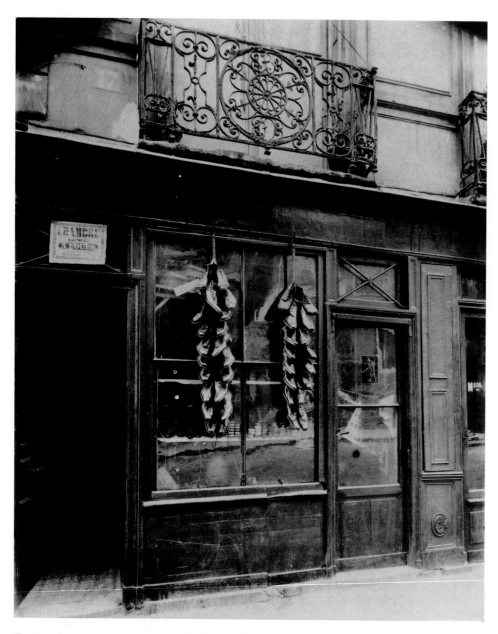

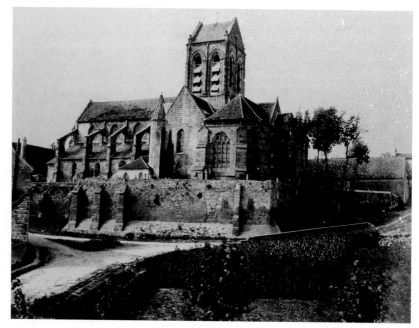

Edouard-Denis Baldus Church at Auvers, 1855
In the 1850s Baldus was commissioned by the French government to photograph historic buildings, many of them slated for destruction or restoration. His carefully composed images did justice to their subjects' scale and grandeur and proved that photography could provide a vividly descriptive and poignant historical record. Church at Auvers
by Baldus, Edouard (1813–1889); French, born Prussia. Salted paper print from paper negative. 32.4x43.2 cm. (12⅞ x 17 in.). 19th
C., 1855. The Metropolitan Museum of Art, Purchase Rogers Fund, and Joyce and Robert Menschel Gift and Harriette and Noel
Levine Gift, 1990 (1990.012)

Eugène Atget Balcon, 17 rue du Petit-Pont, 1913
Virtually unknown in his lifetime (1856-1927), Atget spent the first years of the 20th century photographing Parisian life and scenery, images that he sold to artists, architects, publishers, and government archives. His technique and equipment were outdated even then, including an old large-format camera that produced glass negatives. Atget often shot storefronts, fountains, gardens, and parks early in the morning to get a clear, crowd-free view; his long exposures sometimes rendered moving figures with a ghostly blur, the sort of effect that brought him to the attention of the Surrealist artists working in Paris during this time. His work, saved from oblivion by photographer Berenice Abbott, is a highly atmospheric record of Paris as it was being consumed by the 20th century. AP:6014. Albumen-silver
print from a glass negative, 8⅝" x 7" (22 x 17.19cm.). The Museum of Modern Art, New York. Abbott-Levy Collection. Partial gift of Shirley C. Burden.
Copy Print © 2000 The Museum of Modern Art, New York

cards and trade catalogues. But the medium's extraordinary cataloguing capabilities were also called into the service of government, science, and medicine. In 1851, the French government commissioned photographers Edouard-Denis Baldus, Hippolyte Bayard, Henri Le Secq, and Gustave Le Gray to photograph the monuments of Gallic culture that needed restoration. When city planner Baron Haussmann remade Paris in its modern image a few years later, destroying dozens of neighborhoods in the process, Charles Marville meticulously recorded those medieval enclaves that were slated to disappear. In Glasgow in 1868 and 1877, authorities hired Thomas Annan to photograph charming old buildings and landmarks (actually hopeless slums) that were soon to be torn down.

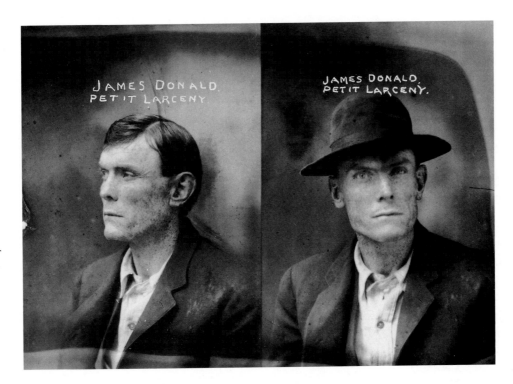

But perhaps the most remarkable example of such photographic preservationism came at the turn of the century, in the largely self-assigned work of Eugène Atget. Using techniques and equipment that were outmoded even then, he made a living by selling views of Paris to artists and publishers—in the process creating a uniquely lovely record of a city in transition. In its depiction of what Atget sensed would soon be swallowed by the modern world (and though much of it was made after 1900), his work was arguably the culmination of photography's natural alliance with the nineteenth century's search for its own past and for a sense of historic continuity.

Photography not only stabilized the image of the vanishing past but also helped put the present in order. The usefulness of photographic identification and classifying systems was recognized as early as 1839 by police, who took the first mug shots in Europe that year. In Paris in the 1880s, photographs of criminals were catalogued by types of noses, mouths, and other features, so that thieves from other cities or murderers who might have shaved their beards could still be identified.

The exactitude and replicability of photographs created new archives that began to replace scientific drawings; during the American Civil War, for example, images of wounds were compiled for medical study. But in some cases, photography actually changed the course of science. The most famous example of this was Eadweard Muybridge's extended series of photographs of human and animal locomotion, inspired by his own landmark photographic proof, in 1878, that a galloping horse briefly has all four legs off the ground.

PUSHBUTTON PROGRESS

Photography took a huge step in the 1870s with the invention of dry plates. These new emulsions maintained light sensitivity in a dry state, which allowed them to be commercially mass produced.

And they could be stored for days, weeks, or even months after exposure—basically, until an established darkroom could be found. This immeasurably lightened the burden of travel photography.

There was, however, a tradeoff: The first dry plates' collodion emulsions were considerably less sensitive than those of wet plates. This led to the substitution of gelatin as the emulsion's binder, as proposed by the Englishman Richard Leach Maddox in 1871. The gelatin dry plate was found to have unprecedented light sensitivity and suddenly it was possible to use much shorter exposure times, which made it easier to freeze motion and afforded dependably sharper results with a hand-held camera.

Then, in 1888, George Eastman had the stroke of genius that would change photography forever: He introduced the Kodak. A simple box camera, it came pre-loaded with a roll of film that provided 100 exposures. At the end of the roll, the owner sent the camera itself to Eastman's Rochester, New York, facility, where the film was developed and printed, the camera reloaded, and everything mailed back. The Kodak's legendary sales slogan, "You press the button, we do the rest," referred not so much to the camera's point-and-shoot operation (focus, lens aperture, and shutter speed were all fixed), but to Eastman's processing service. In making photographers of the millions who couldn't do their own darkroom work, Eastman single-handedly created the photofinishing industry.

From Eastman's nonadjustable Kodak to plate-film models offering more control, cameras that could be hand-held combined with "faster" films and lenses to facilitate the kind of shooting required in photojournalism, street photography (candid photographing of everyday life), social documentation, and of course snapshots. Photographs of news events had been taken as early as the 1840s, but they were rare and depended on weather,

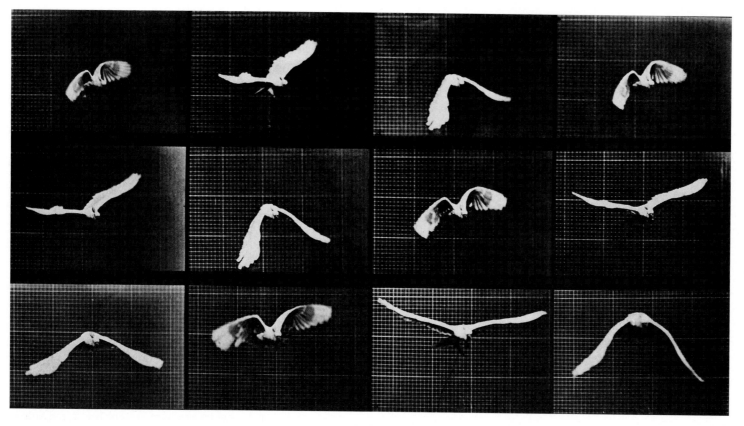

Eadweard Muybridge
Cockatoo Flying, c. 1887
In the 1870s, Leland Stanford, governor of California and future founder of Stanford University, commissioned Muybridge to photograph his prize racehorse in motion, a technical challenge Muybridge met with tripwires and custom-built high-speed shutters. The pictures proved that when a galloping horse raises all four feet off the ground, its legs are clustered beneath its body—rather than stretched out, as painters had long depicted them. Muybridge's effort was the beginning of his landmark study of movement, for which he employed as many as three dozen cameras recording the action from two or three points of view. Published in 1887, his 11-volume Animal Locomotion contained nearly 800 plates showing everything from birds flying to men boxing to a woman hopping on one foot.
Hulton-Deutsch Collection/Corbis

light, and how long the news was willing to hold still. When the British photographer Roger Fenton photographed the Crimean War in 1855 with equipment that could not stop action, his pictures were chiefly of soldiers in camp; his image of a bare field strewn with cannon balls is nonetheless a chilling memento of the Battle of the Valley of Death. Alexander Gardner and Timothy O'Sullivan were more explicit—but no more capable of stopping motion—in their coverage of the American Civil War. They could only photograph the dead after battle, though these were the most graphic images of war Americans had ever seen.

But as the turn of the century approached, the new photographic technologies began to give street photography and photojournalism that sense of momentariness we associate with them today. In the 1890s the nobleman Giuseppe Primoli snapped the hustle of Italian street life, while Paul Martin captured the fleeting patterns of everyday existence among the English working classes.

PHOTOGRAPHIC MEANS AND ENDS

Several good, semi-mechanical processes made it possible to print photographs with text in the second half of the nineteenth century, but their high cost limited quantities and distribution. The great mass of people had to wait for the halftone, which recreated the photograph with a grid of variably sized dots of ink. Invented in more than one place and form between 1878 and 1890, this process opened up the era of mechanical reproduction that still has us in its thrall. (Today's newspapers, magazines, and books still use halftones for black-and-white reproduction.) Yet the press didn't exactly leap at the opportunity; the world's first daily paper illustrated solely with photographs, London's *Daily Mirror*, didn't appear until 1904. And America didn't have a newspaper illustrated with photos until 1919, though by then papers everywhere used at least some photographs.

The first book containing halftone reproductions, *How the Other Half Lives*, by journalist Jacob Riis, was published in 1890. An exposé of New York City's slums, it was a huge success. Riis, who took most of the pictures himself, felt that only photographs could bring home the rotten conditions he was fighting. His work, which depended in part on the use of newly invented magnesium flash powder to allow exposures in dark, squalid hovels, was the first effective use of photography for social reform.

Yet such documentary photographs are seldom as objective as claimed. Riis's images are exceptionally raw and gritty, for his crusade required evidence that would shock people into action. By contrast, sociologist Lewis Hine's pictures of

Alexander Gardner
President Lincoln at the
Battlefield, Antietam, 1862
*Using political connections from his
portrait studio business in New York
City and Washington, D.C., Mathew
Brady sought and received official
permission to photograph at Civil
War battlefields. He was soon send-
ing staff photographers such as Gard-
ner with the Union Army to create a
record of the conflict, images that
demonstrated the power of photogra-
phy as a documentary tool. But given
the low sensitivity of wet-plate nega-
tives and the need for a darkroom-on-
wheels to coat and process the plates,
photographs could only be made
behind the lines and after battles.*
Photographic History Collection/National Museum of
American History/Smithsonian Institution

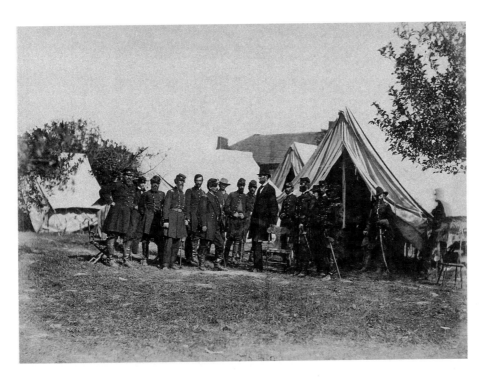

Lewis W. Hine
Boy at Loom, Cotton Mill,
Indiana, 1908
*Hine studied sociology at the Univer-
sity of Chicago, then combined his
progressive education with photogra-
phy to investigate the problems asso-
ciated with immigration and indus-
trialization. One of his first projects
was an extended series of portraits of
new arrivals at New York City's
immigration center, Ellis Island.
From 1908 to 1917 Hine documented
the plight of underprivileged children
for the National Child Labor Com-
mittee. These empathetic images—
made in garment sweatshops, coal
mines, woolen mills, and agricultural
tracts—were widely published.
Hine's photographic campaign
altered public perceptions about such
exploitation and ultimately helped
change child labor laws.* Photographic
History Collection/National Museum of American His-
tory/Smithsonian Institution

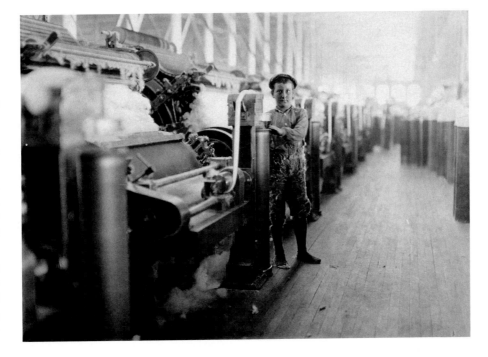

American immigrants and child laborers
(taken a decade after Riis's work) have a
certain nobility and poignancy, since
Hine was seeking respect and sympathy
for his subjects. (Hine's style laid the
foundation for the socially committed
documentary photography of the 1930s.)
The camera may be unbiased, but pho-
tographers are not, and the look of their
documents sometimes owes a good deal
to their intentions.

THE ART PART

Shortly after the new century began, a
seven-year-old French boy named
Jacques-Henri Lartigue began to turn
the isolated moments of still photography
into what amounted to an artistic style.
He snapped the seemingly perpetual
motion of the era's experiments with
transportation: biplanes and gliders sail-
ing overhead, automobiles and motorcy-
cles racing through the countryside. His
wealthy, eccentric family's obsession
with such machines gave him ready
access to them. The ability to capture an
image of the world as it sped by encour-
aged a new appreciation of life's unher-
alded moments. In the century's second
decade, the Hungarian photographer
André Kertész found poetry in neglected
corners of daily existence: a blind fiddler
being led across the street, a child admir-
ing ducklings.

While a few adept and prescient souls
like Kertész anticipated the straight
approach of what would eventually be
called street photography, Pictorialist pho-
tographers in Europe and America tried to
prove they were neither Sunday snap-
shooters nor mere craftsmen, but true
artists. Members of Pictorialist photo-
graphic societies—such as England's
Linked Ring, America's Photo-Secession,
and comparable groups in Vienna and
Paris—generally favored soft focus and
hand-manipulated prints that achieved
effects more like the traditional graphic
arts than photography. Indeed, some of
their techniques—gum bichromate and
bromoil, for example—involved the use of

sensitized pigments and brushed-on inks. Much of the best work of the Photo-Secessionists, whose ranks included Edward Steichen, Alvin Langdon Coburn, Frederick Evans, and Clarence White, was published in Alfred Stieglitz's *Camera Work*, perhaps the most beautiful photographic magazine ever produced.

Pictorialism also captured the imagination of American photographers like Gertrude Käsebier (whose elegant studies set a standard in portraiture) and Anne W. Brigman (whose idealized nudes intrigued a newly sophisticated viewing public), just as women were edging into the workplace. Other women, including Frances Benjamin Johnston (whose social studies were handsomely orchestrated) and Jesse Tarbox Beals (whose tenement scenes took a less manipulated approach) proved themselves adept at photojournalism. But by then women had already made important, if unsung, contributions to photography. In England, Anna Atkins's privately published part-book on algae predated Talbot's commercially printed volume by a couple of months. Julia Margaret Cameron's portraits of English achievers and beauties were as poetically compelling as any in the nineteenth century. But photography, a messy business, was assumed to be a man's game until it became simpler—and declared itself an art.

MODERN PHOTOGRAPHY

By the second decade of the century, photographic modernism had begun to edge soft-focus Pictorialism aside. Stieglitz was its chief proponent and Paul Strand its most able practitioner; together they defined a "straight" aesthetic characterized by sharp focus and unmanipulated printing. They extolled the mechanical nature of the camera, an idea in line with the modernist insistence on truth to materials. By mid-decade Strand was experimenting with both formal abstraction and unsparing close-ups of street people; in the early 1920s he expressed his staunch commitment to photography's mechanical origins by making clean, cool photographs of the interior of a movie camera.

Straight photography's opposition to the fuzzy prettifications of Pictorialism found its ultimate expression in the hard, clear, exquisitely printed work of Edward Weston, Ansel Adams, Imogen Cunningham, and the loose-knit association of Weston-inspired photographers known as Group *f*/64. These photographers worked mainly with view cameras, to exploit the greater definition of large-format negatives; in fact, the name Group *f*/64 refers to a very small lens aperture used in large-format photography to maximize foreground-to-background sharpness. Their ideals, which in Weston's terms meant a search for some essential truth (the essence of a pepper, the soul of woman) dominated photographic practice in America from the 1930s until the 1960s. Europe in the 1920s and 1930s also had its advocates of a straight photographic style—the "New Objectivity" of Albert Renger-Patzsch and the stunning dispassion of August Sander's self-assigned photographic catalogue of German social and physical types, the immense variety of which earned him the rancor of purity-minded Nazis. But most European photographers were up to other tricks.

Alexander Rodchencko in the U.S.S.R. and Laszlo Moholy-Nagy, a Hungarian who had emigrated to Germany, were among the chief spokesmen of a utopian dream of photography. They

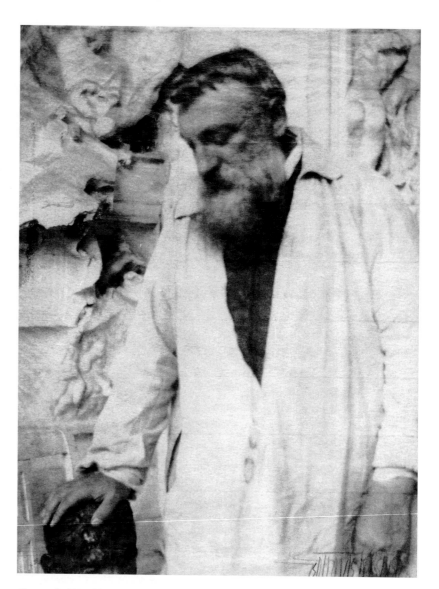

Gertrude Käsebier Auguste Rodin, 1905
The ambition of Pictorialist photographers, such as Käsebier, was to raise photography to the artistic level of painting. To do this they often made pictures with soft-focus lenses; used nonsilver processes such as gum, bromoil, and platinum printing; and applied inks, paints, and other artists' materials directly to their negatives and prints. One of the most prominent portraitists of her day, Käsebier was a founding member of the Pictorialist Photo-Secession group and was featured in the first issue of Alfred Stieglitz's landmark magazine, Camera Work. *Hallmark Photographic Collection, Hallmark Cards, Inc., Kansas City, Missouri*

Anna Atkins
Asplenium Braziliense,
South America, 1854
Starting in 1843 and continuing in installments over 10 years, Atkins published the first-ever book with photographic illustrations. Each page was an original cyanotype photogram, created by placing plants in direct contact with sensitized paper that was then exposed to sunlight. The cyanotype process uses inexpensive iron salts as the light-sensitive agent, which accounts for both its blue color and popularity with turn-of-the-century amateur photographers. A similar process would later be used to reproduce engineering and architectural drawings (blueprints), and has since been revived by contemporary photographers exploring nonsilver options for making photographic prints.
Anna Atkins, British, 1799–1871. Cyanotype print from the unique album "Cyanotypes of British and Foreign Flowering Plants and Ferns" 1854. 34.6 x24.5 cm. The Art Museum, Princeton University. Museum purchase, anonymous gift. © 1991 Photo: Trustees of Princeton University. Photo: Clem Fiori

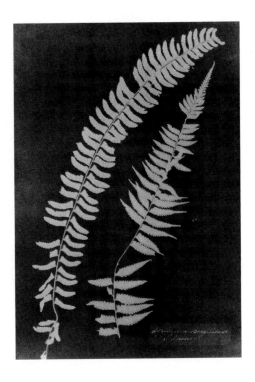

believed that photographs could inaugurate a "new vision" and bring on social change; they imbued their work with this spirit through the use of unorthodox perspectives and tilted frames of reference. Indeed, the modern aesthetic of European photography in the 1920s and 1930s was a far cry from its straight American counterpart: part cubism, part rigorous design, and part revolutionary idealism. Ignited by the Russian Revolution's notion that artists should lend their skills to everyday uses, its flames fanned by the industrial ethic of Germany's Bauhaus school of art and architecture, this potent mix soon spread into the area of mass commerce.

Thus, a high-art aesthetic—one that in the Soviet Union had been intended to speed the liberation of humankind from capitalism—was co-opted as a selling strategy by capitalist countries and rapidly became the visual language of millions. Rodchenko harnessed modernism to book jackets and movie posters; the American Paul Outerbridge put it to work selling men's shirt collars; Man Ray injected elements of it into fashion photographs. The power of photographs to glorify material goods was discovered anew, and this time mass reproduction could be its handmaiden. Drawings declined as many commercial applications were taken over by the camera. One of the most lasting marriages of the century had been consummated: that of photography and advertising.

CUT, PASTE, AND DREAM
The visual languages of both commercial and revolutionary propaganda relied heavily on collage (the pasting together of separate images to create a single work, sometimes rephotographed) and montage (creating a similar effect by exposing multiple images on film or paper). Both were a kind of response to the world's saturation with media, and photographs in particular. The Dadaists seized these techniques to advance their stated cause, the overthrow of rules governing what was permitted in art. Artists like Max Ernst and Hannah Höch in Germany used the most ordinary images and bits of text from the popular press to make statements about the absurdity of modern life. Russian artists put the technique to more political use, but most political of all was the German John Heartfield, who made scathing anti-Nazi collages for the Communist magazine *AIZ*. The chief method in this assault was the absorption of popular culture into high art, a tactic that just about necessitated putting a premium on photographs and photographic images.

To that end, experiment was the order of the day; all things new and unfamiliar were highly desirable. Around 1920, Man Ray, Lazlo Moholy-Nagy, and Christian Schad in Germany had separately rediscovered the photogram, a form of cameraless photography that made familiar objects enigmatic: placed on sensitized paper and exposed to light, such objects left glowing imprints in an indeterminate space. Man Ray's assistant accidentally discovered, and the photographer happily claimed, "solarization," an effect of tone reversals and emphatic outlines caused by a light turned on during the development of photographic film or paper.

The Surrealists were particularly enchanted with these abrogations of the standard approaches to art. Some of them even believed photography to be the quintessential surrealist medium, for in reproducing reality it could reveal the world's intrinsic strangeness. (Parisian Surrealists had a special fondness for Eugène Atget's atmospheric realism.) Even Brassaï, better known for his pictures of Parisian lowlife, photographed ordinary objects in ways that made them mysterious or sinister. And the German artist Hans Bellmer made and photographed papier mâché dolls, naked female figures that sported legs where arms should be, or multiple breasts, or eyes in their stomachs. (As with many other such artists, Bellmer's photographs were his work's final form.) Surrealism remained a strong force in photography much longer than it did in painting or sculpture—witness the work of the Englishman Bill Brandt or the Mexican

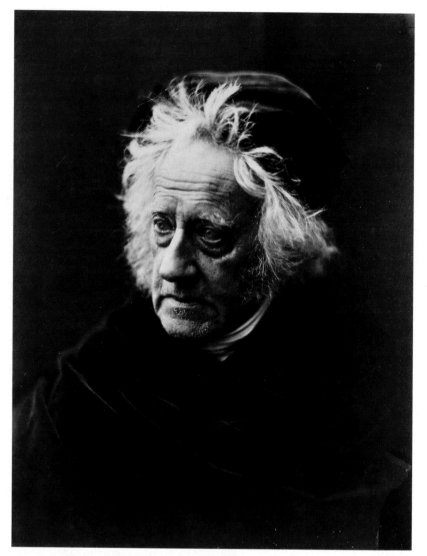

Alvin Langdon Coburn The Flatiron Building, New York, 1912

Shaped like the prow of a ship, New York City's Flatiron Building, completed in 1902, was the first to be made with steel girders. Its parkside location and daring shape made it a popular subject for Pictorialist photographers anxious to create images of thriving city life. Members of Alfred Stieglitz's Pictorialist Photo-Secession group—which Coburn joined in 1904, when he was just 22—hand-manipulated their negatives and used labor-intensive processes such as carbon and gum-bichromate printing to control the look and color of the final image. Alvin Langdon Coburn, British, born in the United States, 1882–1966. Gelatin silver print, 28.7 x 21.0 cm. The Art Museum, Princeton University. Clarence H. White Collection, assembled and organized by Professor Clarence H. White, Jr. and given in memory of Lewis F. White, Sr. and Jane Felix White. © 1993 Photo: Trustees of Princeton University. Photo Credit: Bruce M. White

Julia Margaret Cameron Sir John Frederick William Herschel (1792–1867)
Cameron was a member of England's 19th-century intellectual elite, which included illustrious artists and scientists such as Alfred Lord Tennyson and Charles Darwin. From the moment she got her first camera in 1863, her images were unique for their time. While other photographers exploited the crisp detail and subtle tones made possible by wet-plate negatives and albumen prints, Cameron favored soft focus and strong, even melodramatic lighting. Drafted from both family and scholarly circles, her subjects—here, scientist John Herschel, who himself made important contributions to photographic chemistry and terminology—were highly idealized. Stapleton Collection, UK

Imogen Cunningham

Fageol Ventilators, 1934

Early in her career, Cunningham worked in the impressionistic style of the Pictorialists. But in the 1920s she made an aesthetic about-face, forming the Group f/64 with Ansel Adams, Edward Weston, and other West-Coast photographers. Members advocated "straight," unmanipulated photography; preferred the precise rendering of the large-format view camera; and maximized image sharpness by photographing at small lens apertures, hence the group's name. Cunningham's cool, clean photographs of industrial structures, as well as plant forms and the human figure, were a dramatic shift from her Pictorialist beginnings. Photograph by Imogen Cunningham. © 1970, 1998. The Imogen Cunningham Trust

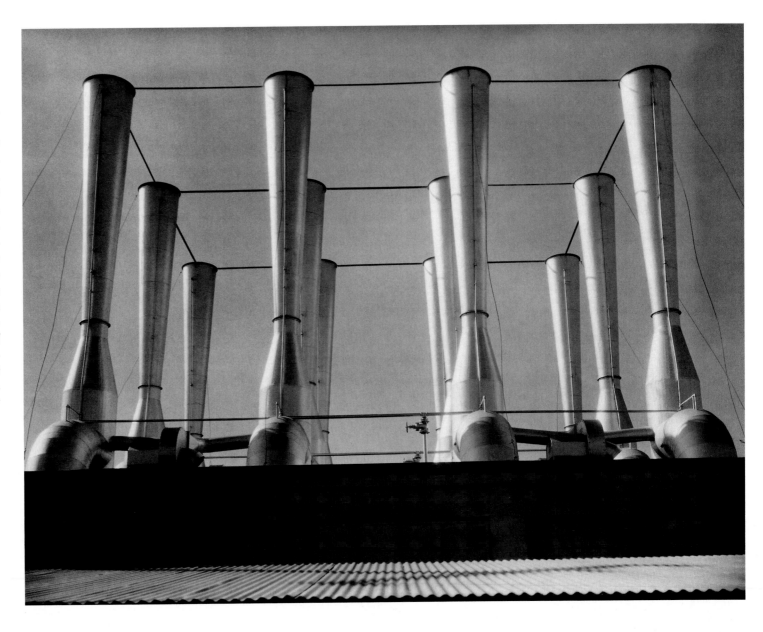

Manuel Alvarez Bravo—and it still lingers today.

EUROPE COMES TO AMERICA

The exodus from Europe under the pressure of Nazism in the 1930s brought talented photographers to this country, and many had a strong impact on American photography. Moholy-Nagy founded the New Bauhaus and, somewhat later, the Chicago Institute of Design, introducing Bauhaus educational and design philosophies. Within a few years he had gathered highly influential photographers and educators like Harry Callahan and Aaron Siskind, who would train several generations of younger Americans. Moholy-Nagy bequeathed to America less his modernist style than his spirit of experimentation, which Callahan and Siskind carried on.

Europeans also imported the photojournalistic aesthetic they had pioneered. Some were applying it with the new German-made Leica 35mm rangefinder, a small, quiet camera that made stopping motion and catching people unawares easier. (Originally designed to use the discarded tail-ends of 35mm movie film, it came to market in 1925.) One such photographer was the great Alfred Eisenstaedt (also German), who appeared on the first masthead of *Life* magazine in 1936. Another was Robert Capa, whose front-line reports from the Spanish Civil War kept Europeans and Americans abreast of that conflict. Martin Munkacsi even brought a photojournalist's eye to fashion photography, then dominated by the classic and static elegance of men like Edward Steichen, Horst P. Horst, and George Platt Lynes.

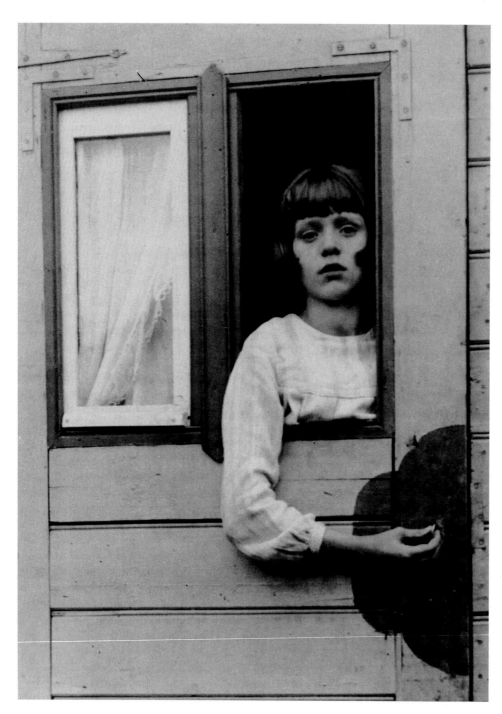

August Sander Young Girl in Circus Caravan, 1932

Before World War I, Sander assigned himself the ambitious task of systematically photographing Germans in all walks of life—from farmers and tradesmen to artists and statesmen. He did this in a style that was strikingly direct and modern in feeling, allowing the physical and cultural variety of the German people to speak for itself. In 1929 Sander published some of these portraits in what was to be the first volume of a 20-volume series called Face of Our Time. *But he was forced to abandon the project when the Nazi Party—which disliked Sander's broad definition of who was German—destroyed many of his negatives and harassed his family and friends.* (Machen im Kirmeswagen). Duren, Germany. (1932). Gelatin-silver print, 11 x 8" (27.9 x 20.3 cm). The Museum of Modern Art, New York. Gift of the photographer. Copy Print © 2000 The Museum of Modern Art, New York

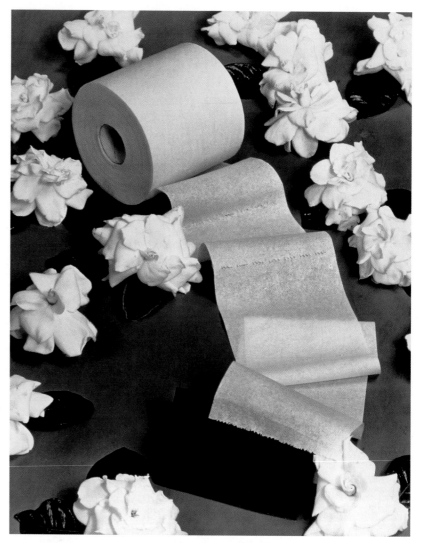

Paul Outerbridge Jr. Toilet Paper Advertisement

The advertising business began to recognize the commercial possibilities of photography in the 1920s, establishing an enduring bond between the medium and anyone with something to sell. Outerbridge was one of many photographers who applied art-school training to the making of images for magazine and newspaper ads. His still lifes brought a modernist aesthetic to subjects from shirt collars to toilet paper. In the 1930s, the growing sophistication and practicality of color photography added another seductive element to this new form of commercial art. Paul Outerbridge Jr., " Toilet Paper Advertisement" (plate number 448). Courtesy of G. Ray Hawkins Gallery, Santa Monica, California

Munkacsi's use of motion activated the still world of *Vogue* and *Harper's* magazines and directly influenced the next generation of fashion photographers, including Richard Avedon.

But it was the Frenchman Henri Cartier-Bresson who gave the 35mm phenomenon its own aesthetic; echoes of his style still sound today. Cartier-Bresson was far more interested in formal considerations than most photojournalists. What he called "the decisive moment," a phrase still very much in the photographic lexicon, was that split second when the visual arrangement of the action most fully corresponded to the content of the event.

The influence from the continent persisted after the war, and beyond photojournalism. The Austrian-born photographer Lisette Model, for example, taught many up-and-coming photographers in New York; her somewhat cynical style found a follower in Diane Arbus, whose hyperintense scrutiny of dwarves, transvestites, and even ordinary people brought a taste for the grotesque into the mainstream. In its varied forms and experimental bent, the European aesthetic laid the groundwork for American photography's post-World War II turn away from the Stieglitz-Weston ideal of technical purity and transcendent images.

NEWS IN A FLASH

General-interest picture magazines also got their start in Europe in the late 1920s. They were spawned not only by smaller cameras and faster film but by improved presses, wire services, and an increasing public fascination with the news and with photographs. A poll in Iowa in 1925 had shown that newspaper readers had high levels of interest in pictures and even higher levels in groups of related pictures—a phenomenon surely not confined to that state. Late in the decade, such papers as the *Berliner Illustrierte Zeitung* and the *Münchener Illustrierte Presse,* employing photographers like Munkacsi and André Kertész, effectively

Man Ray Untitled, 1923

His name synonymous with photographic experimentation, Man Ray used photography's oldest technique—that of placing objects of varying translucence on a sheet of light-sensitive paper and exposing it to white light, no camera involved—to create strikingly modern abstractions. The photographer called these images Rayographs, and their often unanticipated effects satisfied his belief that art should exploit accident. Man Ray. (Untitled) (Shoetree? and abstract shapes). Paris, France, Europe. 1923. Gelatin-silver print, 11⅝" x 9⅜" (29.5 x 23.7cm) Museum of Modern Art, New York. Gift of Mr. and Mrs Alfrd H. Barr, Jr. Copy Print © 2000 The Museum of Modern Art, New York

invented the photo-essay. French and other European magazines soon followed, while *Life* was founded in 1936 and *Look* a few months later.

In an era devoted to speed in travel and timesaving devices like washing machines, the public got more and more of its information through the rapid-communications

medium of photographs. That process was itself accelerated through further technical advances such as 1929's flashbulb, which allowed photographers to catch politicians and entertainers in mid speech or mid action—and sometimes at awkward moments. The camera could now undermine most of the myths attached to fame, and tabloid newspapers took full advantage of its knack for making anyone look bad long before the more respectable press joined in.

THE ANNALS OF HISTORY

The First World War and the Russian Revolution had fostered a heightened political consciousness, and when the

Great Depression struck in the 1930s, professional photographers in many countries made records of poor and marginal populations. Arguably, they did so not for the sake of their subjects, but to spark the conscience of the middle class.

The decade's writers, artists, and photographers were all devoted to this documentary enterprise. The two greatest photographic forces in America were *Life* magazine—dedicated to illuminating America for Americans—and the Farm Security Administration (founded as the Resettlement Administration in 1935). Directed by Roy Stryker, the agency's Historic Section was charged with photographing America's rural life, its mis-

sion to convince city dwellers and Congress that the Depression had left farmers in need of help from the federal government's New Deal programs. Among its outstanding photographers were Walker Evans, Dorothea Lange, Ben Shahn, Marion Post Wolcott, Russell Lee, and Arthur Rothstein; they helped compile the most comprehensive portrait ever made of this nation.

The work of Walker Evans in particular became a touchstone for American photographers after the 1960 republication of *Let Us Now Praise Famous Men*, a collaboration with writer James Agee that had received little notice when it first appeared in 1941. Made with a view camera, Evans's

Dorothea Lange
Migratory Cotton Picker,
Eloy, Arizona, 1940

Lange worked as a portrait photographer until she was 32, when she moved from the studio to the streets. After working on a report about migrant labor, she was hired by the Farm Security Administration (FSA) to help document the social consequences of the Great Depression of the 1930s. Through the beginning of World War II the FSA amassed a unique public archive of almost 300,000 images— including Lange's powerful photographs of uprooted American families. Lange, Dorothea. Migratory Cotton Picker, Eloy, Arizona. USA, North America (1940). Gelatin-silver print, 10½ x 13½" (26.8 x 34.3 cm.) The Museum of Modern Art, New York. Gift of the photographer. Copy Print © 2000 The Museum of Modern Art, New York

pictures offered a cool, middle-distance look at sharecroppers and small town life and architecture. Though on the surface they seem neutral and objective, they celebrated the individuality and inherent worth of all people and things, in keeping with the times.

Photographers explored the urban effects of the Depression as well. Lacking a government sponsor, members of New York's Photo League—among them Berenice Abbott, Aaron Siskind, and W. Eugene Smith—turned their cameras on their own city's poor. Social concern drove documentary photography until World War II co-opted the public's attention and the Farm Security Administration's mandate changed to serve the purposes of war.

War photography was both the ultimate news and the ultimate document. The portability of cameras and the public's enthusiasm for photographs made World War II the most thoroughly covered conflict until then. Photojournalist Robert Capa continued his work, addressing the civilian effects of war and also landing with American troops on the beaches on D-Day. W. Eugene Smith,

Louise Dahl-Wolfe Suzy Parker in Dior Hat, Tuileries, Paris, 1950

Dahl-Wolfe got her break with a documentary project shot in a rural Tennessee community, published in Vanity Fair magazine in 1933. This led to over two decades of work as a fashion photographer for Harper's Bazaar. As one of many women who had a significant impact on fashion imagery—including Toni Frissell and Lillian Bassman—Dahl-Wolfe was known for her special sensitivity to styling. Louise Dahl-Wolfe/Courtesy Staley-Wise Gallery, New York

whose later photo-essays for *Life* magazine ("Country Doctor" and "Spanish Village," among dozens) would make him one of the most revered and influential of photojournalists, focussed his passionate sense of drama and suffering on a subject that had those qualities to spare.

Not until Vietnam would a war receive more coverage. But that horrific conflict produced a major change in war reportage when in 1962 *Time* and *Life*

magazines published correspondent Larry Burrows's color photographs. Some thought color photographs of combat were too realistic and unnecessarily shocking. Others argued that the intrinsic seductiveness of color ought not to be coupled with so painful a subject.

In fact, a practical method of making color photographs was not invented until the mid-1930s, when Kodak introduced Kodachrome and German-owned Agfa

introduced Agfacolor. Before that time, almost all photographs were monochromatic—mostly shades of black and white but sometimes brown (or some other color) and white. Credit for the invention of Kodachrome—and practical color photography—goes to childhood friends and classical musicians Leopold Mannes and Leopold Godowsky, known to Kodak as "Man and God."

THE 1960s AND BEYOND

After World War II, art photography in America and Europe turned introspective; in the wake of contemporary art movements and the search for psychological and spiritual significance, it also often tended toward abstraction. Minor White is the leading American example of this approach. His influence was tremendous, spread not only through his work but through extensive teaching, his editorship of *Aperture* magazine, and his part in the founding of the Society for Photographic Education, whose members taught future generations of photographers.

Yet a more content-oriented approach to photography (one that rejected both the photographic purity of Stieglitz and the semi-abstraction of Moholy-Nagy) persisted in the work of Robert Frank. Born in Switzerland, Frank came to America in 1947 with a European disregard for the perfectly focussed and classically composed document—though he took this to an extreme. His off-kilter style gave perfect form to his outsider's eye for the social isolation and racial problems in this country.

Frank's *The Americans*, published here in 1959, was poorly received by most critics. But it exerted enormous influence on subsequent black-and-white street photography and on photojournalism in later decades. It injected alienation into photographic discourse, which was edging from the assurance of innate human nobility that motivated Walker Evans and the Farm Security Adminis-

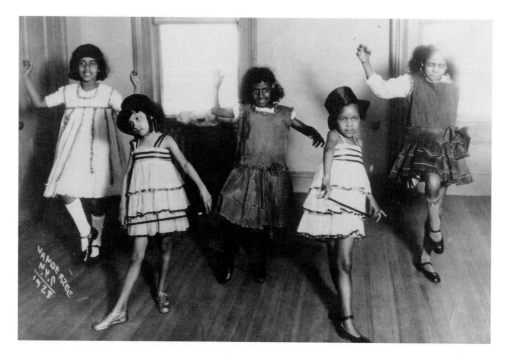

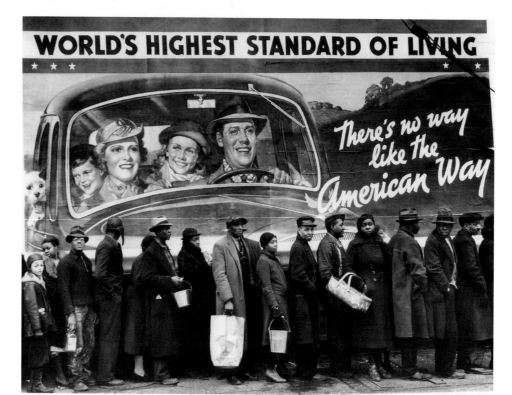

WORLD'S HIGHEST STANDARD OF LIVING
There's no way like the American Way

James Van der Zee
Dance Class, 1928
From his studio on New York City's 135th Street, Van der Zee produced a comprehensive record of the faces of the 1920s' Harlem Renaissance, the burst of African-American artistic and intellectual expression between the end of World War I and the Depression. As the community's most prominent photographer, he was deeply involved in local life. He made portraits of celebrities such as champion boxer Joe Louis and black activist Marcus Garvey, but also photographed special occasions in the lives of ordinary people—weddings, church socials, and school events.

Margaret Bourke-White
World's Highest Standard of Living. "There's No Way Like the American Way"
Bourke-White started off as an industrial photographer but achieved international success as a roving photojournalist, maintaining offices in Manhattan's Chrysler Building, the very emblem of art deco modernism. Her prominence led to an invitation from the Soviet Union to photograph new industry after its first five-year plan, making her the first foreigner permitted to do so. Bourke-White's strongly graphic style helped define the photo-essay and shape Life magazine, which used her image of Montana's massive Fort Peck Dam on the cover of its first issue, in 1936. This image of Kentucky flood victims has an unusually strong irony for Bourke-White's work. LIFE Magazine © TIME Inc.

Robert Frank
Candy Store,
New York City, 1955–57

As a Swiss immigrant, Frank brought a special detachment to his photographs of 1950s America, made on extensive travels across the country. The best of these pictures were collected in his 1959 book, The Americans, *which challenged both the prevailing photographic style and the country's sunny self-image. In its introduction, beat guru Jack Kerouac wrote that Frank had "sucked a sad poem right out of America onto film." Frank cultivated a calculated anti-art style—off-kilter framing, grainy textures, and dark, brooding prints—that had a profound influence on succeeding generations of photographers.* Robert Frank, American b. 1924. Gelatin silver photograph 11 x 13⁹⁄₁₆ in. 8⁵⁄₁₆ x 12⁹⁄₁₆ in. Copyright Robert Frank, Courtesy Pace/MacGill Gallery, New York. The Target Collection of American Photography museum purchase with funds provided by Target Stores

tration photographers toward Diane Arbus's assumption of oddness and awkwardness. Its cultivation of what seemed to be photographic "mistakes" and inadequacies—blur, graininess, apparently haphazard composition, abrupt cropping, dark prints—was ultimately judged by photographers to be a purer form of modernism: true to the medium, to a photographic vision that only the camera could produce. Frank's work paved the way for the social critique of Garry Winogrand, which dominated American street photography in the 1960s; for the cranky humor and unconventional angles in photographs by

Lee Friedlander; and for the next generation of straight photographers such as William Eggleston, Nicholas Nixon, and Robert Adams.

ART SWALLOWS PHOTOGRAPHY

But a funny thing had happened to fine-art photography on its way to the 1960s: it was taken over by painters. In the mid-1950s Robert Rauschenberg began transferring newspaper and magazine photographs onto his paintings. A few years later, Andy Warhol was silkscreening repetitive images of news and disasters onto canvas, and painting over photographic images of stars like Marilyn Monroe.

In fairness, many nineteenth-century painters—Delacroix, Ingres, Degas—had employed photography in one way or another. But usually they did not admit it. By this century the secret was out, and a work like Marcel Duchamp's 1912 painting *Nude Descending a Staircase* could be freely and admittedly derived from Etienne Jules Marey's photographic motion studies (though its abstraction of such imagery was still controversial). But in the 1960s, art latched onto photography with a new vigor.

The 1960s were the heyday of picture magazines such as *Life, Picture Post* in Britain, and *Paris Match* in France. Big

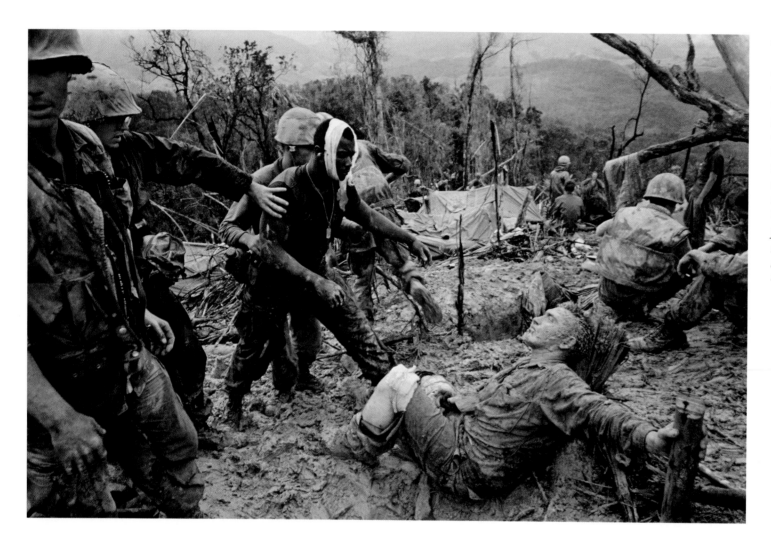

Larry Burrows
Reaching Out, 1969
Burrows defied the conventional wisdom that gritty black and white was best suited for combat photography, using color film to document the Vietnam War. Color was thought by many to be too aestheticizing, but it actually added a shocking realism to Burrows's front-line pictures. With continued improvements in film quality and reproduction methods, color has since become a norm in photojournalism. Larry Burrows Collection

American cities each had several profusely illustrated newspapers. Billboards used photographs to hawk the desirability of products. And artists began to incorporate photography into their work (or actually took pictures) partly because it was not Art. In a series of books on subjects such as *Nine Swimming Pools,* Ed Ruscha made deadpan documents with no pretense to careful composition or printing, rebelling against both expressionism and the criteria for

high art. Conceptual artists like John Baldessari, Bruce Nauman, and Sol LeWitt exhibited photographs (sometimes on canvas and sometimes not) of events as minor as tossing a ball but meant to illustrate ideas. Site art, performance art, and happenings depended on photographs as the only lasting and visible evidence of their appearance and existence. Some performances, like Lucas Samaras's, were solitary and staged solely for the camera.

While artists were heating up the interaction between art and photography in the 1960s, photographers were also experimenting with nontraditional techniques and materials. Robert Heinecken's "Are You Rea" portfolio (1964-68) was contact-printed directly from magazine pages, revealing both sides of the page at once. Naomi Savage experimented with photo-etching and other printmaking techniques. Ray K. Metzker made large composite images rather than single per-

fect prints. Some even tried out copying machines. These artists were also rebelling against the rules of the game, though they were more likely to be seeking a new kind of photography than trying to make anti-art. Either way, the art establishment did not yet show much interest in people who called themselves photographers. But photographs began to sneak into art galleries, and the public gradually began to think of them as art.

One area of great experimentation in the 1970s was color. Though a small number of photographers—among them Harry Callahan and Ernst Haas—had done extensive color work in the preceding decades, color had generally been considered inauthentic or unartistic. But the Museum of Modern Art's 1976 William Eggleston show finally put color on the map. (Curator John Szarkowski argued that Eggleston had "invented" color photography by making images in which color was as important as content—a reflection of the images' calculatedly prosaic subject matter.) In 1978 Polaroid began to invite selected artists to work in Polacolor with its 20" x 24" camera; indeed, ever-larger photographic prints helped convince art collectors that some photographs could hold their own on the wall with paintings. By the 1980s art and photography were not merely intertwined but practically indistinguishable, often joining hands in mixed-media work and installations.

PHOTOJOURNALISM MOVES UP IN SOCIETY

The first exclusively photographic museum in a major city, the International Center of Photography in New York, was devoted to photojournalism, at least initially. Founded in 1974 by Cornell Capa, brother of Robert and a respected photojournalist in his own right, the ICP opened as the field's prospects were dimming. *Life* and *Look* had just closed up shop; newspapers were dying off. Television news held sway.

Spurred by the new interest in photography and the breakdown of old barriers in the art world, museums and galleries reevaluated reportage. The dearth of suitable magazines made photojournalists turn to books and exhibitions as outlets for their work; true to those venues, the imagery of Mary Ellen Mark, Gilles Peress, Eugene Richards, Sebastiao Salgado, and others injected strong doses of aesthetics and a pinch of Arbus, Winogrand, and Friedlander into documentation. Although magazines and newspapers have increasingly emphasized color in recent years, the black-and-white social reporting of photographers such as these has proved remarkably resilient.

THE TROUBLE WITH REALITY

And then there's postmodernism, which germinated in the late 1970s as a critique of modernism's stranglehold on culture. The term originally applied to architecture, which as a movement embraced playful references to other eras and objects as an alternative to the neutral, boxy style of architectural modernism. But postmodernism has come to refer to any art playing on the idea that originality can no longer exist in an age so deluged with imagery and visual styles. In this view, both art and life have in effect become pastiches of the media—shaped if not created by them—and might as well admit it.

Feminism had a large role in this movement. Many of postmodern photography's most important practitioners have been women, who seem to be particularly comfortable working with mixed media, received imagery, and photography. The

movement's downgrading of originality has been welcomed by feminists as a critique of the value of master and masterpiece, distinctly male-gender words.

Appropriation—"borrowing" imagery from elsewhere, often pop culture—has been one of postmodernism's signatures. Richard Prince rephotographed the Marlboro man in the 1970s, removing the advertising captions to take the images' cowboy hokum out of context. Cindy Sherman shot what appeared to be stills from B-movies, but the pictures were pure inventions that starred Sherman herself in every role. Barbara Kruger excerpted magazine illustrations and advertisements and captioned them with ad-like slogans charged with feminist and political content. Sherrie Levine exhibited copy prints from reproductions of photographs by Evans and Weston.

The message of these photographers, and of appropriation, is that far from being firsthand, our acquaintance with art—indeed, much of our experience—is mediated through reproductions on the page and screen. If Robert Frank's *The Americans* signaled the end of a kind of glorification of "the common man," postmodernism at this level suggests the end of the work of art: the reduction of aesthetic objects to commodities and texts to be deciphered for their significance. Fortunately, art keeps refusing to believe it's dead.

Nevertheless, photographers now openly cast doubts on their own medium. As the public grew suspicious of the media, art photographers used various strategies to undercut the vaunted realism and documentary value of photography. Staged and directed photographs, and sets constructed solely to be photographed (notions that go back at least to H. P. Robinson in the mid-nineteenth century,

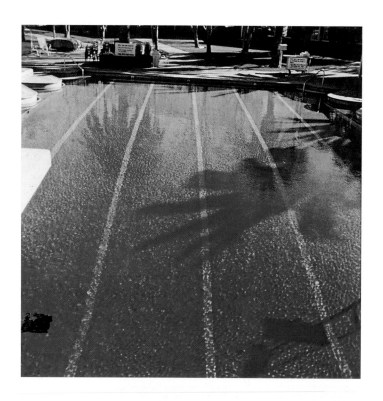

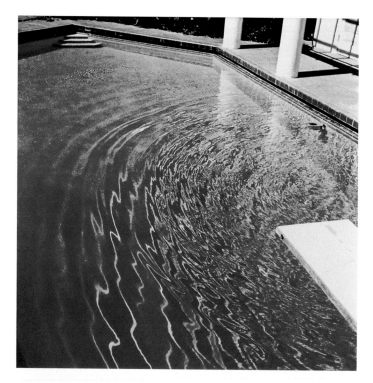

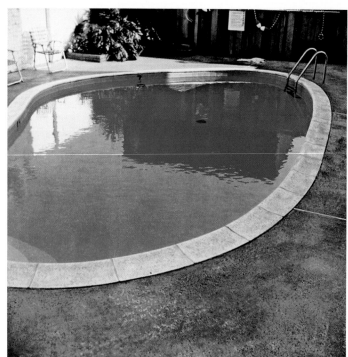

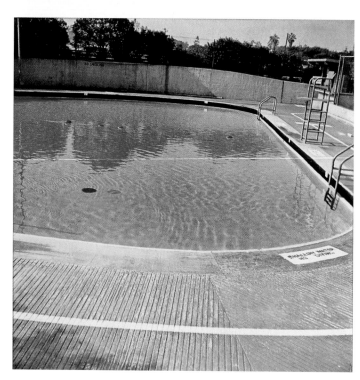

Edward Ruscha
From Nine Swimming
Pools, 1968
*Starting in the 1950s the lines
between visual arts began to blur,
with painters such as Ruscha
viewing photography as just
another creative tool in their
arsenal. Ruscha brought 1960s
irony to the tradition of the visual
catalogue associated with pho-
tographers like Atget and Sander,
presenting his work in artists'
books such as* Twenty-Six
Gasoline Stations *(1962),* Nine
Swimming Pools *(1968), and* A
Few Palm Trees *(1971). While
Ruscha's deadpan images seem
to reject the idea that pho-
tographs can provide a worth-
while emotional or visual experi-
ence for the viewer, they often
contain interesting information.*
Edward Ruscha/Patrick Painter Editions.
Painter Editions Canada

Cindy Sherman

Untitled #96, 1981

Sherman plays two parts in her pictures: She's the photographer and, usually, the model, too. In her most well-known work, a series called "Untitled Film Stills," she recreated the feeling of B-movie vignettes—the images owing much of their effectiveness to ingenious styling and costuming, one of the hallmarks of "postmodern" photography. Sherman's other work has ranged from reenactments of famous paintings to grotesque images of medical prostheses, but has a common thread in its exploration of female stereotypes and women's social roles.
Courtesy Cindy Sherman and Metro Pictures

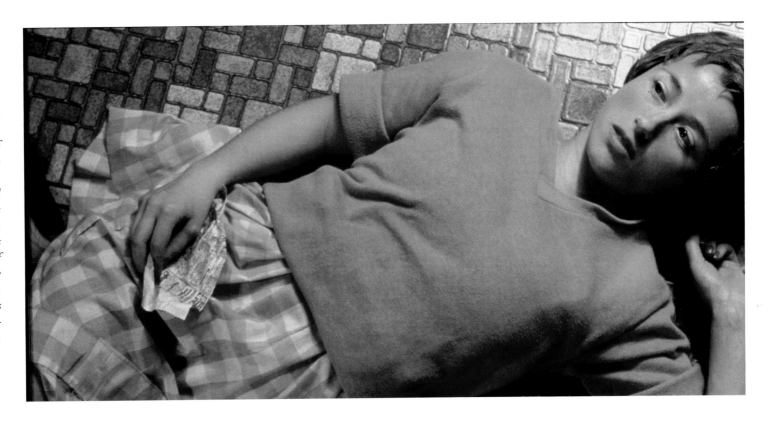

though utterly different in intent) made a vigorous comeback in the work of Ellen Brooks, Robert Cumming, Laurie Simmons, and Joel-Peter Witkin. Photographers like Tina Barney and Philip-Lorca DiCorcia create events that at first or even second glance look as if they'd been caught in passing but actually have been elaborately planned and set up to appear that way. Is reality now so elusive that it must be stage-managed to look real?

THE OTHER SIDE OF POSTMODERNISM

Yet many young photographers, led by artists such as the American Nan Goldin, the German Wolfgang Tillmans, and the Englishman Nick Waplington, have turned their cameras inward. Just as Goldin has long photographed her own

subculture (over the years, a riveting mix of themes involving sexuality and substance abuse) these young photographers make pictures mainly of their own lives and friends. They shoot what they *know*, and make no pretense of interpreting or even representing objective reality—the prime directive of old-fashioned modernist photography.

This aesthetic inclination parallels an exigency in our culture as a whole: a new need to establish individual identity when, despite our mass communications and freedoms, people are more anonymous than ever (or at least feeling that way). Work along these lines seems at once narcissistic (certainly another reflection of our time) and a powerful cry against that anonymity. It is perhaps just another form of advocacy in a capitalist

society rampant with advocacy, whether by individuals of themselves or by corporations of their products and services. The proliferation of Internet Websites—a phenomenon that has been fully embraced by photographers anxious to promote their work—is just one measure of this. Indeed, the Web has begun to usurp the actual space of galleries, with photography shows curated and exhibited in cyberspace.

THE ELECTRONIC FUTURE

Indeed, while photographers wonder about the nature of photography, experience, and reality, new digital technologies have threatened to change the terms of photography's existence altogether. It's even easier to question the truthfulness of images when they can be reduced

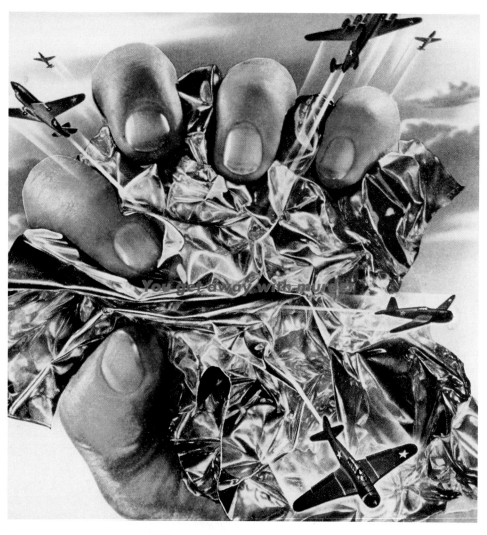

to pixels and rearranged at will. Yet photojournalists, still perhaps the most honest of photographers, are making pictures with filmless electronic cameras and transmitting them to the office over the telephone. And photographers of all stripes are scanning and digitizing their images so that they can use computers to retouch, rearrange, and collage them.

Such new forms leave some wondering if traditional photography is on its way out, or destined to become a relatively elitist enterprise for a limited group of aficionados. At the very least, electronic communication seems destined to change photography's parameters, if not to alter its very nature. If it also takes over distribution, photography may find the ultimate fulfillment of its destiny as a mass democratic medium.

It seems safe to say that photography is no more likely to disappear than art. It is, however, inextricably bound to culture and communication. As they change, the medium will change with them, as it has throughout its history.

Barbara Kruger Untitled, 1987
A former graphic designer for magazines, Kruger creates montages that combine unsettling high-contrast imagery with potent slogans and proclamations seemingly derived from modern consumer culture. Reminiscent of Constructivist posters and imbued with the feeling of print propaganda, her work is intended to challenge social, political, and sexual stereotypes. Barbara Kruger, "Untitled" (You get away with murder). 30½"by 30" photograph, 1987. Collection: The Hallmark Photographic Collection, Kansas City. Courtesy: Mary Boone Gallery, New York

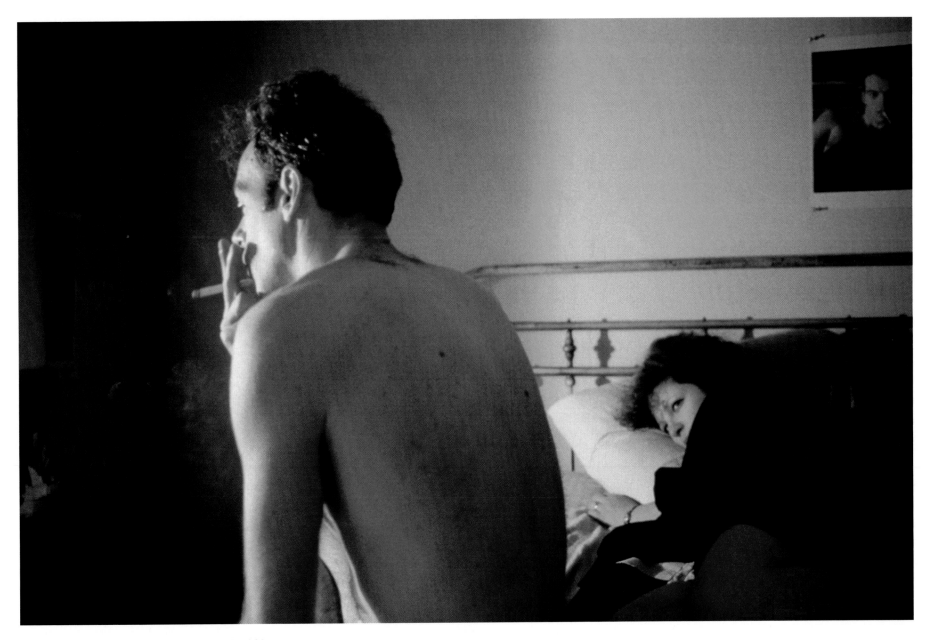

Nan Goldin Nan and Brian in Bed, NYC, 1983

Goldin has made her own life her primary subject, constantly photographing friends and lovers. Her extended family has included many who live far from the social mainstream—drag queens, lesbians, drug addicts. But Goldin's work has influenced young photographers with more ordinary lives to turn their cameras inward, finding subject matter, and meaning, in their everyday circumstances. Nan Goldin Studio

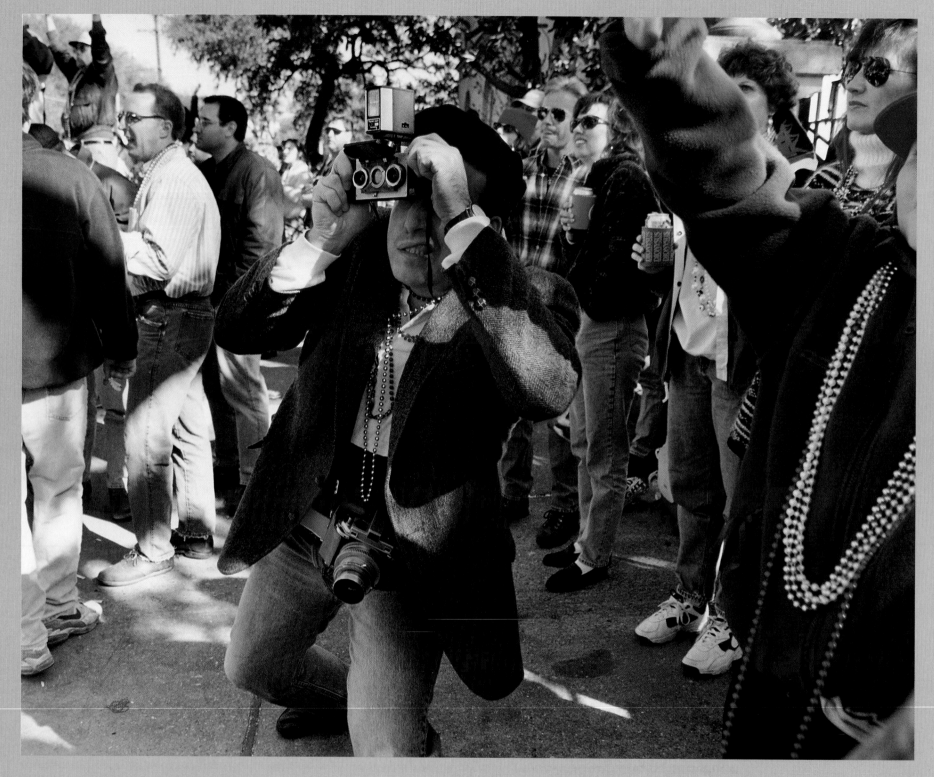

ANDREA RAYNOR
The Photographer, New Orleans, LA, 1996

Raynor makes many of her photographs in crowds. This lets her shoot without calling as much attention to herself, which in turn gives her pictures more candor. For the same reason, Raynor uses a medium-format rangefinder, which is quieter and less conspicuous in operation than a medium-format SLR. The camera's 6 x 7cm negatives yield sharp, fine-grained results even at Raynor's large print sizes—typically 20" x 24". © Andrea Raynor

GETTING STARTED

If you've never used a camera before, or if you still lack confidence about using yours, modern photographic technology can help—letting you take pictures without the need to understand everything about your particular camera. You are probably using a 35mm SLR (single lens reflex, see page 43–47). Most modern cameras automate some or many of the various decisions and choices that go into taking a photograph. In fact, once you load a **35mm film cassette** (see page 32) into it, your camera may take over altogether. It may automatically advance the roll to the first frame of film, then to the next one each time you take a shot. It may calculate how much light the film must receive to reproduce the subject's true shades and/or colors, and even gather that quantity of light automatically by adjusting its own settings. Your camera may even be able to focus the lens on its own, to create the sharpest possible image of the subject on film.

If your camera can do any or all of this, you just might want to let it—for the first roll or two of film you shoot—so you'll get a feel for the camera. After that, you'll want to step back and make such decisions on your own, to learn what's really involved in the process of making a photograph. Even totally automatic cameras can usually be controlled manually or will allow you to override their automation somehow. Of course, if you have a camera that offers manual control only, you'll have to focus it and adjust its settings yourself. Either way—automatic or manual—the following step-by-step guide should help you get started shooting. For now, refer to the diagrams for typical locations of camera parts and controls, remember-

ing that your own model of camera may be different. (Keep your instruction manual handy.) You'll learn in detail what these features actually do as you read chapters of this book.

Note that photographic high technology now includes the ability to make photographs without film, using digital cameras, that capture images using a special light sensor, then store them as digital files that can be retrieved and manipulated with a computer. For more about shooting with digital cameras, see Chapter 17.

LOADING FILM

To start shooting, you'll need a roll of film. If you're in a photography class, your teacher may ask you to shoot black-and-white film, which renders the subject in shades of gray rather than in colors, and can also be easily developed by you in the darkroom. If you're not doing your own darkroom work, then you may be shooting color film. See Chapter 8 for more on different types of film.

Whatever film you shoot, the camera's light meter—its built-in light measuring device—needs to know the film's speed. Indicated with an ISO number (sometimes referred to by its old name, ASA), a film's speed is simply a measure of its sensitivity to light, such as ISO 400 and ISO 100. Different-speed films must receive different amounts of exposure to a subject's light (transmitted through the camera's lens) to create a picture that is neither too dark nor too light. See Chapter 9 for more on film speed and exposure.

Many current cameras are able to set the film speed automatically by reading a **DX code** printed on the side of the 35mm film cassette. With manual mod-

els you may need to set the speed yourself, with a dial or other type of control. The film speed is indicated on the side of the film cassette and on the box that it comes in.

Most cameras can't do a thing without power, though. So before you start photographing, you should check your battery. If your camera has an LCD panel (see illustration on next page), it may tell you when the battery is low, possibly by blinking a half-filled, battery-shaped icon or some other indicator. Check your camera manual to find out what type of battery the camera takes, and if none is installed, proceed as follows:

- **Open the battery compartment and install the battery (or batteries).** Often, on the camera bottom, the battery compartment contains marks or diagrams that show you how to orient the batteries when you insert them, and the battery itself is marked with plus and minus symbols. Because of their heavy power demands, more automated cameras usually take either special lithium cells or AA batteries. Manual, mechanical models may take one or more small button cells.

- **Turn on the camera.** With automated models, this is usually done with a pushbutton or a sliding or rotating switch.

- **Open the camera back.** Before you do this, check to see if there's any film in the camera. Many 35mm models have a small window in the camera back (see page 32) that lets you see the printing on the outside of the film cassette. If you see a film cassette through the window, be sure to rewind the film before opening the

35mm film cassette Light-tight cylindrical housing containing a roll of 35mm film.

DX code Black and silver bar pattern on outside of film cassette that tells an automatic camera what film speed to set.

camera back and removing it. With cameras lacking a film-check window you may need to look at the frame counter, which is either on the LCD panel or in a small, separate window on the camera body. If anything other than "0" or "E" (for empty) is displayed, there may be film inside, and you should rewind it before opening the camera back.

To open the back of a camera that has automatic film advance, you ordinarily slide a switch or flat lever on the camera's left side, as seen from the back. (Sometimes you have to hold down a locking button as you do this.) If you have a camera that requires manual film loading and advance, you usually have to pull up on the film rewind knob to open the

back. (This may also require pressing a release of some sort.)
- **Insert the film cassette.** When you open the camera back, you see two open chambers to either side of a rectangular cutout. (The rectangle is where each frame of film rests when you take a picture.) The larger, hollow chamber—almost always on the left—is where you place the film cassette.

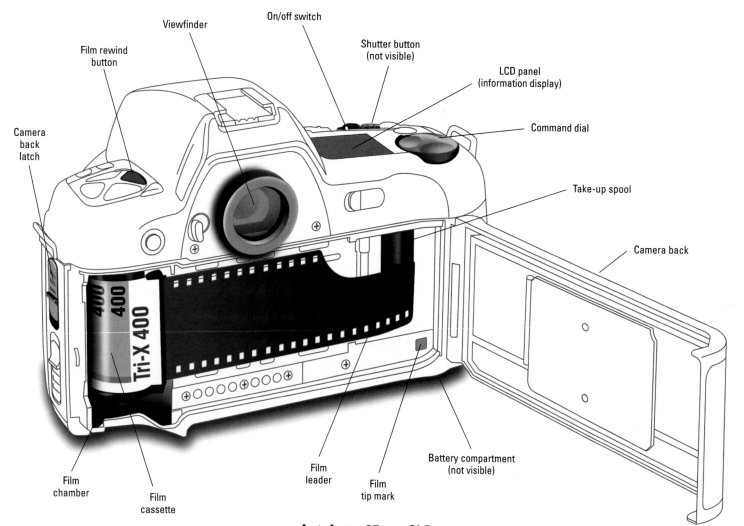

On/off switch

Viewfinder

Shutter button
(not visible)

Film rewind
button

LCD panel
(information display)

Camera
back
latch

Command dial

Take-up spool

Camera back

A typical autofocus 35mm SLR, with the back open and film in position.

Tri-X 400
400
400

Film
chamber

Film
cassette

Film
leader

Film
tip mark

Battery compartment
(not visible)

Autofocus 35mm SLR

A typical manual-focus 35mm SLR, with the back open and film in position.

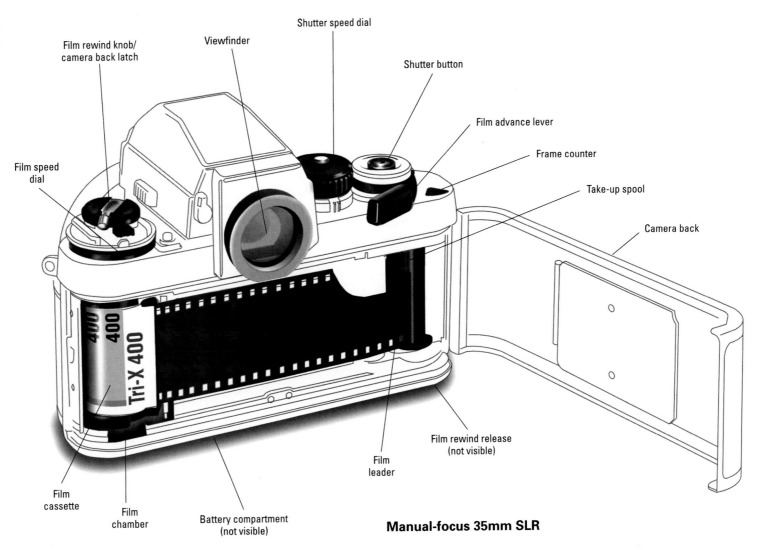

Film rewind knob/camera back latch

Viewfinder

Shutter speed dial

Shutter button

Film advance lever

Film speed dial

Frame counter

Take-up spool

Camera back

Film cassette

Film chamber

Battery compartment (not visible)

Film leader

Film rewind release (not visible)

400 400

Tri-X 400

Manual-focus 35mm SLR

spool hub End of the plastic film spool that protrudes from the film cassette.

film leader Short, tapered end of a roll of 35mm film, used to help load film into the camera.

take-up spool Spool opposite the film cassette that holds exposed film and pulls new film into place for each exposure.

sprocket holes Perforations on both sides of a 35mm film roll, used by the camera to grasp and advance the film.

The **spool hub** that protrudes from one end of the film cassette (see illustrations page 32) should be pointing toward the bottom of the camera, as you insert the cassette, and the film should point to the right. With some models, the spool hub slips over a small protrusion at the bottom of the film chamber; with others, you slip the flat end of the cassette over a spindle that protrudes from the top of the chamber. In either case, the cassette may take a little nudging and wiggling to fit in. With manual cameras, you may also have to pull up on the rewind crank to lift the top spindle before the cassette will slip in.

■ **Extend and/or engage the film leader.** Once you position the cassette in the camera, what you do next depends on whether your particular camera loads and advances film manually or automatically. Either way, you must pull a small amount of film out of the cassette, which you do by grasping the **film leader**—the tapered tongue of film that extends from the cassette's light-tight lip. If your camera loads film automatically, pull out just enough film (usually an inch or less) to make the leader's front edge reach the film tip mark (usually orange or red) near the film **take-up spool.**

If you have a camera that requires manual loading, you must slip the film leader into a groove or under a catch on the take-up spool, then rotate the film advance lever (located on the top of the camera). Make sure the small teeth in the spindle next to the take-up spool fit into the perforations along the edges of the film, which are called **sprocket holes.** Rotate the film advance lever until the perforations on both sides of the film are engaged.

Any time you pull on the film leader, keep your thumb or finger on the cassette to prevent it from lifting out of the film chamber. And make sure the

film is lying flat against the rectangular cutout before closing the back.

- **Close the camera back, pushing firmly until it clicks.** When you do this, most automatic cameras immediately advance the film to the first frame, displaying the number "1" on their frame counters. (With some models, you may need to touch the shutter button to initiate automatic loading after you close the back.) With a manual-advance camera, you must usually alternately press the shutter button and rotate the film advance lever one full stroke until the frame counter reaches "1."

If an automatic-loading camera's LCD panel flashes a "0" or "E" (for empty) and/or a stylized symbol of a film cassette, you either pulled out too much film or didn't pull out enough. If you see this display, reopen the camera back and double-check that the film leader extends all the way to the film tip mark. If it falls short, pull out more film, then close the back again. If the film leader extends beyond the film tip mark, you may have to rewind the slack back into the cassette, as described below.

If you have a manual-loading camera and the frame counter did not reach "1" when you rotated the film advance lever, the film may not have loaded correctly. Watch the rewind crank on the top of the camera as you advance the film; if it does not turn each time you rotate the film advance lever, the film leader is not properly engaged. Reopen the camera back, reengage the film leader, close the back, and attempt to advance the film to the first frame again. (You may also need to rewind some slack into the cassette before doing this.)

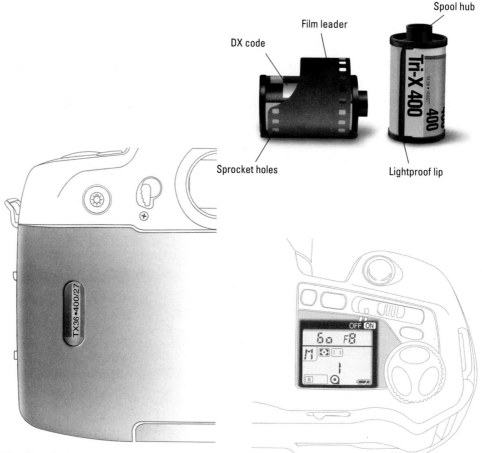

The film-check window lets you see if a 35mm film cassette is loaded in the camera.

The 35mm film cassette provides a light-tight housing for the roll of film. For film-loading purposes, its most important part is the leader, the short, tapered strip that protrudes from the cassette's light-tight lip (left). When the film is rewound, most cameras retract the leader all the way inside the cassette—the best way to tell if a roll of 35mm film has been exposed (right).

If the LCD display on an autoloading camera displays the number "1" after you load a film cassette, you have loaded the film correctly. If it displays "E" or "0" and/or flashes a symbol of the film cassette, you must reload the film.

If you've pulled too much film from the 35mm cassette while loading it, do the following before reloading. (See illustration on page 34.)

- Take the cassette out of the camera and hold it between the thumb and fingers of one hand, pointing the spool hub toward you.
- Grasp the spool hub with the thumb and forefinger of your other hand and rotate it counterclockwise to draw film back into the cassette. This rotation may not appear to have an effect until the coil of film inside the cassette begins to tighten up.

- Continue to rotate the spool hub until the half-width portion of the leader is a few perforations away from the cassette's lip. Turn it slowly so that you don't accidentally pull the whole leader back into the cassette. Now repeat the loading process.

TAKING PICTURES AND REWINDING FILM

Modern 35mm SLRs often allow you to take pictures automatically, in a "point-and-shoot" fashion, as described earlier. But even if your camera doesn't offer full automation, chances are it offers

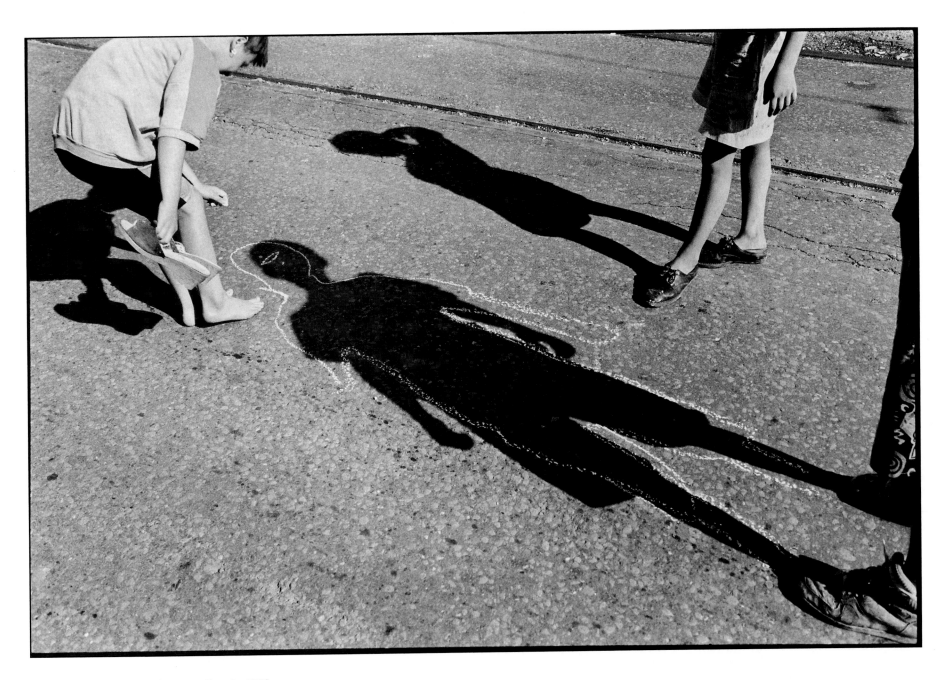

Gilles Peress Untitled, Sarajevo, Bosnia, 1993

Peress brings a rare graphic sophistication to photojournalism. Shooting with a 35mm SLR, he uses energetic and sometimes jarring composition both to give seemingly documentary images a visual signature and to comment (often in a biting way) on the important events of our time. In this image from war-ravaged Bosnia, a chalk outline drawn by children around a playmate's shadow suggests the way forensic experts analyze crime and accident scenes—evoking the death and destruction surrounding them. Courtesy Magnum Photos, Inc.

autoexposure (AE). This means it calculates how much light the film needs for correct exposure and automatically adjusts its settings to gather that amount of light from the subject. If your camera has a **program autoexposure (P)** mode, it can make all the necessary exposure settings. This mode may be a good place to start, when taking your first roll or two. (See Chapter 9 for details about how to set the camera to other modes for more critical exposure control.)

■ **Choose your subject and turn on the camera.** Even if your camera has no autofocus or autoexposure capability, you may need to turn it on for operation of the light meter and/or shutter. Some models are always ready to use and don't need to be turned on.

■ **Focus the lens.** Look at your subject through the viewfinder, the small window on the upper back of the camera. If you have a manual-focus lens, rotate its focusing ring back and forth until the most important part of the subject appears sharp in the viewfinder. (See Chapter 4 for more on manual focusing.) If you have an autofocus lens and camera, follow the steps in the box on page 35.

■ **Compose your subject.** When you look through your camera's viewfinder, you see a rectangular frame. You use this frame to compose—to arrange the scene's elements the way you want them to appear in your photograph. When you compose, keep your eye on the relationship between things in the scene and the edges of

the viewfinder; be aware of whether those things are inside the frame, touching it, or cut off by it.

■ **Set the exposure.** If you're not using your camera in a program autoexposure mode, you will have to set the lens aperture, the shutter speed, or both. You do this with the guidance of

If you've pulled too much film from the 35mm cassette while loading it, you must take up the slack before reloading (see page 32).

WHAT IF YOUR CAMERA WON'T LET YOU SHOOT?

If your camera won't let you take a picture—or won't even turn on—there are several possible causes. After all, if all of an autofocus camera's systems are go (if it can get a good exposure and correct focus, for instance) it will allow you to fire even when there's no film in the camera. To avoid shooting blanks, always check to make sure there's film in the camera. If there is, and your camera still won't shoot, try the following:

■ Reload the film. If an automatic camera can't engage the film leader, it won't let you take pictures.

■ Replace the battery. All but totally mechanical cameras depend on battery power.

■ Check to see if the battery is correctly installed. If it's not, an automatic camera just won't start (nor will it provide any LCD or viewfinder displays). If your model takes more than one battery, all must be correctly installed. Also, don't mix different types or brands of battery, or old and new batteries.

■ Clean the battery contacts. If a battery has been in your camera for a long time, leakage of its acidic contents may

have corroded the battery compartment's metallic contacts. To clean the contacts, get a pencil with a rubber eraser on the end, open the battery compartment, remove the battery, and vigorously rub the eraser against both the top and bottom contacts.

■ With autofocus models, switch to manual focus—or focus on something else. Sometimes an autofocus camera simply can't focus; typical causes are dim light or a lack of subject contrast or detail. The solution: either find something else on which to place the viewfinder's focus point, or simply take the camera out of autofocus mode and focus manually.

■ On some manual models, the film advance lever must be engaged partway in order to make the exposure. Be sure the lever is pulled out a bit from the camera and try again.

■ Rewind the film and insert a new roll. It doesn't happen very often, but sometimes film snags on the cassette or the camera. This may be caused by physical damage to the cassette.

autoexposure (AE)
System that automatically controls camera settings to produce correct film exposure.

program autoexposure (P) Type of autoexposure in which both lens aperture and shutter speed are chosen automatically by the camera.

LOCKING THE FOCUS WITH AN AUTOFOCUS CAMERA

Most autofocus SLRs give you the option of focusing manually, using the viewfinder to evaluate and maximize the sharpness of the subject as you would with a manual-focus model. But these cameras are just as reliable, and often faster, in their autofocus operation—provided you help them focus in the right place.

In autofocus models, you have to indicate to the camera where to focus. You do this with the viewfinder's **focus point**—the small brackets, lines, circles, or boxes in the middle of the viewfinder frame. For the camera to focus where you want it to—the most important part of the scene—you must position the focus point there. Unfortunately, doing this doesn't always give you the composition you want. So to have it both ways—to get correct focus

and the composition you want—you must take the following steps each time you shoot a picture. (See Chapter 4 for more on autofocus.) Called locking the focus, this technique takes practice but soon becomes reflexive.

1. Looking through the viewfinder, place the focus point on the part of the subject you want most sharp— your main subject. Doing this centers the subject.

2. Press the shutter button half-way down to activate and lock the focus.

3. Holding the shutter button halfway down, reorient the camera so that your desired composition appears in the viewfinder.

4. Press the shutter button all the way to take the picture.

Some SLR models have three, five, or more individual focus points across the center of the viewfinder. Each point is usually indicated with a small box shape. The points to either side of the central point allow you to focus on off-center subjects without having to lock the focus and recompose. You can set the camera so that it will choose the correct focus point on its own, which it usually does quite well, though not infallibly. Or you can choose the focus point manually, by rotating a dial control until the point you want glows or darkens. A few camera models even let you choose the focus point with "eye control"—simply by looking at the desired point as you press the shutter button. All that said, if a subject is significantly off-center, it's still a good idea to lock the focus and recompose.

If you don't lock the focus on an off-center subject, it may end up out of focus in your photograph (left). To lock the focus, you center the viewfinder's focus point on the main subject (middle), press the shutter button halfway, reestablish your final composition, and shoot (right).

focus point Brackets, lines, circles, or boxes in the center of the viewfinder that indicate where the camera will autofocus.

displays in the viewfinder—usually numbers and/or scales with moving pointers. (There is little standardization among 35mm SLRs of how shutter speed and aperture are set and displayed, so check your own camera's

instruction manual for details.) The settings you choose affect both how well your camera can freeze the subject's movement and how much of the scene will be in sharp focus from front to back.

■ **Hold the camera steady and take the picture.** If your camera isn't setting the shutter speed automatically, make sure the speed is high enough to counteract your own involuntary hand vibrations—at least 1/60, higher for

HOW TO HOLD YOUR CAMERA STEADY

Holding the camera steady and pressing the shutter button smoothly are both crucial to making your pictures sharp—just as crucial, often, as the quality of your equipment or the care with which you focus. Hand tremors or sudden jabbing of the shutter button can jiggle or jerk the camera undetectably—causing anything from a lack of sharpness to a streaky blur in your photograph.

Find a comfortable way to grip the camera—one that allows easy operation of camera controls—and stick with it. Note that many 35mm cameras have grip surfaces and ergonomic contours designed for you to curl your fingers around for a more secure hold.

For horizontal photographs:

- Whatever the design of your camera, your right hand should be positioned pretty much the same: forefinger resting, not arched, against

the shutter button; other fingers pressed against the front of the camera; and thumb almost vertical against the camera back. If your camera has a manual film advance lever, place the end of your thumb underneath its tip, in a position that allows you to quickly rotate it after every shot. And hold the lens from below, not from the side or top.

- Your left hand should cradle the lens, with fingers wrapped around its barrel so that you can operate all the controls. The bottom of the camera then rests against the palm of your hand or the base of your thumb, depending on the camera's size.

For vertical photographs:

- Your left-hand grip becomes more important when you orient the camera vertically. In holding the lens, the left hand actually does most of the work of supporting the camera.

Where you place your right hand depends partly on whether your camera has automatic or manual film advance. If it's manual, you'll probably need to orient the camera so that the shutter button is at the top, allowing you to freely rotate the film advance lever. If your camera has automatic film advance, the shutter button (and your right hand) can be placed at the top or the bottom.

As for the shutter button, your finger should remain resting on it whenever you're shooting. When you take a picture, press it in one smooth motion, releasing pressure only after you hear the shutter click. This minimizes the chance that vibration transmitted to the camera will blur the photograph. It's an especially important technique if you're using an autofocus camera, because the shutter button has a two-step operation that also allows you to activate and lock the focus.

lenses in the telephoto range. (See the box and diagram above.)

- **Rewind the film and remove the cassette.** When you've finished shooting the roll, the film must be fully rewound into its light-tight cassette before you can safely open the back and remove it. Automatic cameras rewind on their own at the end of the roll, but you can usually push a separate rewind button if you want to rewind film before the end of a roll. The rewind button is typically very small and recessed, and may be marked with a double-arrow/film cassette symbol.

With manual-advance cameras, you know you're at the end of a roll after you've exposed the last frame (number 36 on a 36-exposure roll, for example), and/or the film advance lever won't fully turn, or turn at all. Don't force the lever if you feel resistance; if you do, you can damage the camera or tear the film. To rewind film, you first have to push a button that unlocks the film-advance mechanism; the button is usually on the camera's bottom beneath the take-up spool. Then you flip out the crank on the rewind knob and slowly rotate it in

the direction indicated by its arrow. Don't pull up on the rewind knob or you may open the camera back, causing the entire roll to be exposed.

After you feel the film leader pull off the film take-up spool (it usually makes a clicking sound), the pressure needed to turn the knob will lessen. Turn the crank several more complete rotations before opening the camera back and removing the cassette. Note that as with an automatic camera, you can usually rewind film back into its cassette any time you choose.

Virginia Beahan and Laura McPhee
The Blue Lagoon, Svartsengi Geothermal Hot Water Pumping Station, Iceland, 1988
Almost everyone uses a camera that takes 35mm film, but to make their photographs of geologic turmoil and wonder, Virginia Beahan and Laura McPhee haul a bulky camera that takes 8" x 10" film across some of earth's most inhospitable terrain. The combination of their visual detachment and the large-format negative's extraordinary rendering power gives a surreal quality to scenes of steaming volcanoes, bubbling mudpots, and, here, geothermal harmony. Courtesy Virginia Beahan and Laura McPhee

MARY ELLEN MARK
BLACK-AND-WHITE DOCUMENTARY PHOTOGRAPHY

Documentary photography is grounded in the medium's unique ability to create a realistic representation of the world around us—to capture its shapes, tones, textures, and physical interrelationships. Indeed, since its beginnings, photography has been used to make simple, unadorned records of everything from acts of nature to the human face. But the ability to render facts has also allowed photography to become a powerful tool for educating human beings, and even changing their opinions. This is the job of a good documentary photographer, and it is more than a technical exercise.

Given the importance of subject matter to documentary photography, though, it's not always easy to distinguish the work of one documentary photographer from another. Mary Ellen Mark is a different story: a documentary photographer with a powerful style. For anyone schooled in the vocabulary of black-and-white, Mark's images are instantly recognizable. What's remarkable is that she is able to combine her signature style with the same compassion for the down-and-out that motivated such legendary social documentary photographers as W. Eugene Smith, Dorothea Lange, and Lewis Hine. Whether Mark is photographing Irish gypsies, Indian prostitutes, or circus performers around the world, her subjects never seem freakish or inaccessible. She always manages "to find something basic about being human in the lives of those on the fringes of the society," wrote curator Marianne Fulton in the 1991 *Mary Ellen Mark: 25 Years,* a classic volume of Mark's work.

Such books are an important vehicle for Mark's work, as they have been for many documentary photographers. Starting with her 1974 *Passport,* Mark's books have included *Ward 81,* a disturbing essay on an Oregon state women's mental hospital; *Streetwise,* a penetrating look at the subsistence of teenage pimps, prostitutes, and small-time drug dealers in Seattle; *Falkland Road,* an intimate study in color of Indian prostitutes in Bombay's notorious red light district; and *Indian Circus,* a powerful, continuing project on the hard life of circus performers. Books have helped Mark reach a much wider audience and have furnished her work with more staying power than exhibitions or magazine stories alone could have achieved.

Mark's photographs rely on a unique visual vocabulary. It often includes off-kilter tilts and unusually low or high points of view. It always sets up a knowing relationship between foreground and background. And it involves constant experimentation with the edges of the frame, cropping the subject in ways that are sometimes abrupt but always calculated. How can a documentary photographer take such chances, visually speaking? "There's always the risk that you'll make the wrong decision, and that the picture won't work," says Mark, who has won three National Endowment for the Arts grants and a coveted Guggenheim fellowship. "My contact sheets are filled with pictures I don't consider strong, but they're like sketchbooks: You're just working out different ideas as you shoot. Sometimes you don't realize until the very end what you want to do."

Take Mark's seemingly quiet image of an Indian circus clown waiting outside a tent to start his performance. "He was lying across the back of his donkey, and suddenly the donkey yawned," says Mark. "The picture wouldn't have been anything without that yawn." But what's surprising about the image is its eccentric composition—with the main subject in the bottom half of the frame, the animal's legs cropped off, a fragment of circus tent behind, and the whole scene cocked at an angle. It says much about Mark's artistic impulses that she would risk such daring framing with a perfect moment.

Of course, composition has much to do with the shape of the frame. Unlike most documentary photographers, who shoot in one format only, Mark works in formats up to 4" x 5", with many of her most memorable pictures in the medium-format square. "The square is a beautiful shape," says Mark, who herself started out shoot-

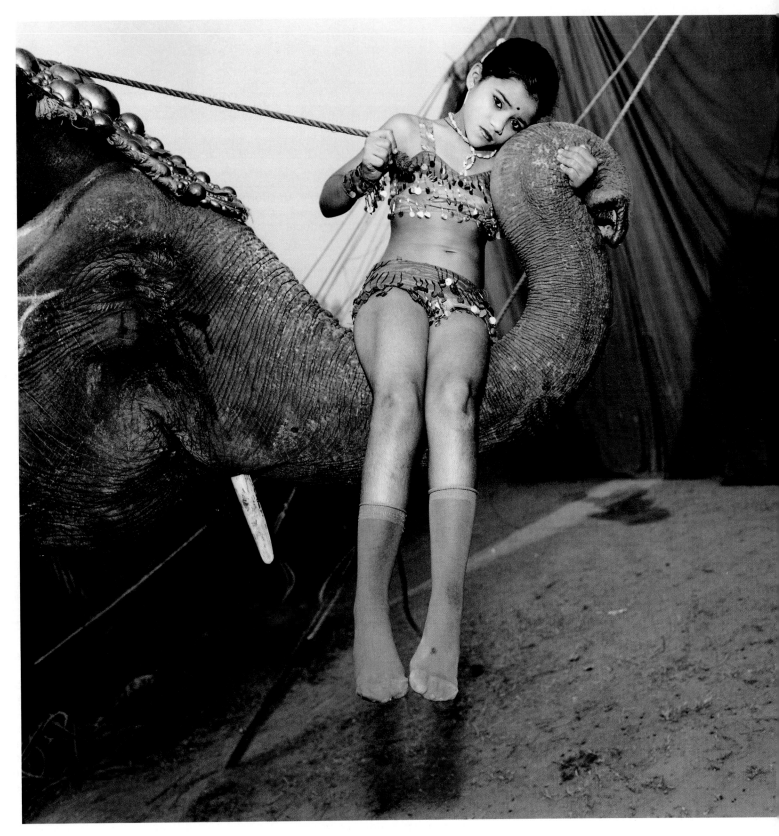

Jyotsana Riding on
Vahini the Elephant
Amar Circus, Delhi, India
1989

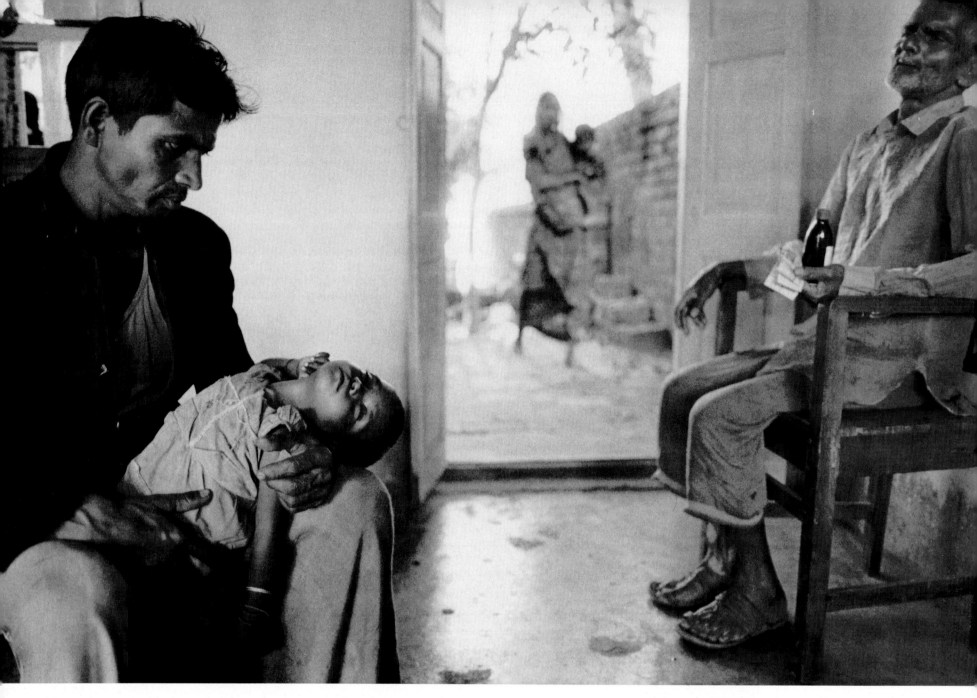

*Dispensary just outside
Calcutta
Mother Teresa's Missions
of Charity, Calcutta, India
1981*

ing in 35mm by available light. "But coming from 35mm's long rectangle, it's kind of a shock to work with. You have to be careful not to make things too symmetrical." Mark's choice of format is dictated, she says, both by the importance of subject detail (larger formats providing more information) and the need for spontaneity (smaller formats providing more freedom). But she tries to bring a degree of spontaneity even to large-format pictures, and feels that there's a lesson to be learned from each format. "When I started working in medium format, it made me a better 35mm photographer," she says. "And when I started working in 4" x 5", it made me a better medium-format photographer."

Mark also takes important lessons from the commercial work that she must do to support personal projects such as her circus pictures, which have involved repeated trips to Mexico and Southeast Asia in addition to India. Early

on in her career, this included doing still photography on movie sets, where she learned (by observation) a great deal about lighting technique. It now ranges from fashion stories for the venerable *New York Times Magazine* to celebrity portraits for gossipy *US* magazine. "I believe that doing different kinds of work makes me a more astute documentary photographer," she says. "When I started out, most of my assignments were to photograph the kinds of subjects I wanted to shoot anyway, for myself. But circumstances change. The world has become more commercial, and this is as true of photography as anything else. When I shoot fashion, I work with people who are excellent stylists and designers, and I learn a lot from them. I think you have to learn from change, rather than lament it."

That philosophical attitude carries over into Mark's ability to make suspicious subjects open up to her. "I don't

have any formula," she says. "It's just a matter of who you are and how you talk to people—of being yourself. Whether they're celebrities or just ordinary people, your subjects will trust you only if you're confident about what you're doing. They can sense that immediately. It really bothers me when photographers first approach a subject without a camera, try to establish a personal relationship, and only then get out their cameras. It's deceptive. I think you should just show up with a camera, to make your intentions clear. People will either accept you or they won't."

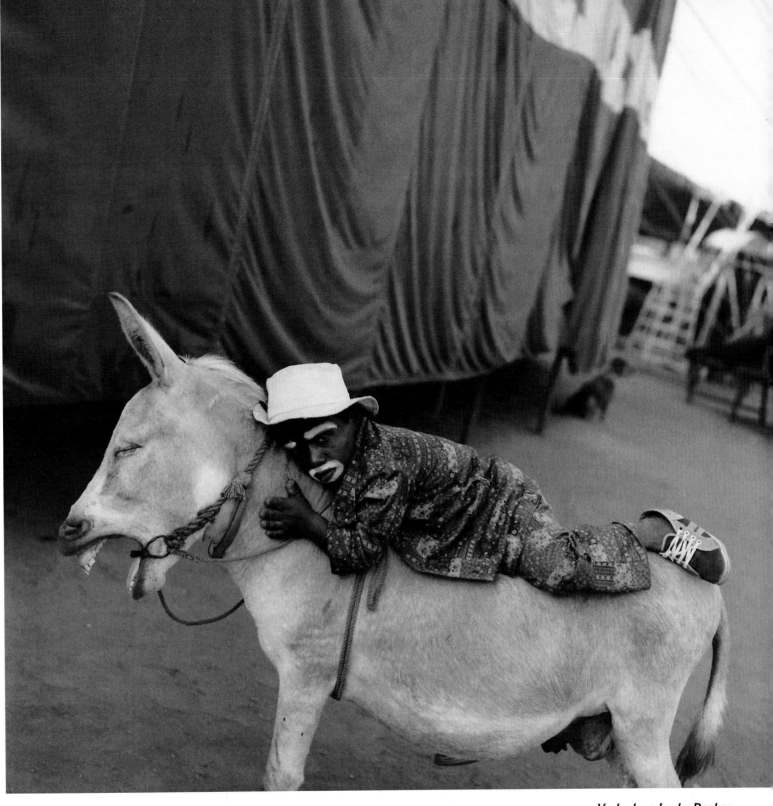

Venkesh on Lucky Donkey
Great Jumbo Circus,
Mangalore, India
1989

ABELARDO MORELL
Light Bulb, 1991

Morell uses ordinary and familiar objects—and sometimes photographic paraphernalia—to make visual statements about light and shadow. His pictures often describe the behavior of light with diagram-like setups such as this, which demonstrates that virtually any dark chamber (here, a cardboard box) can be turned into a camera with the addition of a lens. The faint projection of the lightbulb created by the lens shows how the image strikes the film in a working camera—upside-down and backward. The subject is restored to its correct orientation when the processed film is printed. © Abelardo Morell. Courtesy of Bonni Benrubi Gallery, New York

CHAPTER 3
INSIDE YOUR CAMERA

camera Lightproof box containing a lens, shutter, and other means for making a photographic image.

lens Cylinder of shaped pieces of glass or plastic at the front of a camera that bends rays of light from the subject to create a sharp image on film.

shutter Device inside a camera or lens that opens and closes to regulate how long light is permitted to enter the camera.

exposure Amount of light that reaches the film (or paper, when making a photographic print).

viewfinder Window on the back of a camera used for composing and focusing the subject.

film formats Refers to both the physical dimensions of the image the camera creates and the size of the film used.

35mm film Roll of perforated film, 35mm wide in a light-tight cassette.

large-format film Single sheets of film, usually measuring 4" x 5" or larger.

medium-format film Spooled rolls of film measuring 2¼" across.

Stripped of all its mechanical and electronic components, a **camera** is basically a lightproof box. It does admit a bit of light, but only through a **lens** on one side. Using a cylindrical stack of precisely shaped pieces of glass, the lens gathers light from your photographic subject—projecting a miniature image of it on the opposite inside wall of the box. Place a piece of film against that inside wall and you can capture the image.

You don't really even need a lens to form an image; a very small hole will do. (See pages 92–94.) But a lens produces a higher-quality photograph. And just as important, it increases control by allowing you to use a bigger hole, to get light into the camera faster while still producing a sharp image of the subject. In fact, almost all photographic lenses contain an adjustable diaphragm—a cluster of overlapping metal blades that form a circular opening—so that the size of the hole through which the light enters can be precisely set. This opening is called the lens aperture.

Some lenses also contain a **shutter** that opens and closes when you take a photograph to regulate the amount of time light is allowed to pass through the lens to the film. This interval is called the shutter speed. With most modern cameras the shutter is a metal or cloth curtain inside the camera itself, positioned just in front of the film.

Shutter speed and lens aperture are the two main ways a photographer controls the amount of light entering the camera. (You will learn more about lens aperture in Chapter 6, and more about shutter speeds in Chapter 7.) You need this dual control for two main reasons. One is simply to get the right amount of light to the film—the correct **exposure**—in order to produce the optimum picture quality. The other,

even more important in a creative sense, is to determine the way the subject is represented in your photograph. The combination of lens aperture and shutter speed you choose lets you do such visually useful things as soften a portrait's background, freeze a moving athlete in midstride, or make a landscape sharp from its foreground to its background. That creative control, combined with the ability to adjust the lens's focus—the distance at which it will render the image most sharply—makes the camera a supple instrument for capturing your subject.

Because different subjects require different photographic techniques to reproduce them in the best or clearest possible way, many different kinds of cameras have evolved. But most cameras for serious photography can be divided into three basic types, according to the way you focus and compose, the way you view the subject through the camera, and the way you adjust the camera to make the subject sharp. These types, described on the following pages, are the single-lens reflex, the rangefinder, and the view camera.

With most types of cameras, composing and focusing are accomplished by looking through a small window on the back of the camera. This window is called the **viewfinder.** The viewfinder is the eye of the camera—literally, a window on the photographic possibilities of your world.

Each of the three types of cameras described on the following pages is available in different **film formats.** (For a detailed description and illustration of film formats, see page 142.) Format is a reference both to the physical dimensions of the photographic image a camera creates and to the size of the film that it's designed to shoot. Your 35mm SLR, if that's the camera you're using, makes its images on **35mm film**—a long roll of

perforated film that is 35mm wide. (In almost all cases, each image actually measures 24mm x 36mm.) A view camera, by contrast, is designed for **large-format film**—single sheets of film most often measuring 4" x 5" and sometimes larger. In between 35mm and large format is **medium-format film,** which encompasses a range of different image sizes, all of which fit on spooled rolls of film measuring about 2¼" across.

For every combination of camera type and format, a great range of individual models is available, from those that are strictly mechanical and manually controlled to those with advanced electronics and powerful automation. This range of choice is greatest with the 35mm SLR. Camera designers have devoted much attention to the 35mm SLR because it's an extremely versatile instrument—one that allows you to shoot a wide variety of subjects with great success. But as your photographic skills and style advance, you may want to experiment with the other types of cameras described here.

THE SINGLE-LENS REFLEX CAMERA

There is only one way to see precisely what portion of a scene your camera will put on film when you press the shutter button: to look directly through the camera's lens. But viewing a subject this way is complicated by the fact that the film obstructs the view. In order to capture the image, you need to put the film right behind the lens, where the lens projects its image of the subject. You could get around this problem by composing and focusing the subject first, then placing film in the camera to take the picture. In fact, this is what users of view cameras usually do (see page 50). But working that way slows down the process of taking photographs.

The **single-lens reflex (SLR)** solves this problem with a through-the-lens (TTL) viewing system. This system gives users a unique combination of precise compositional control and fast operation, and has helped make the SLR the camera of choice for most photographers. With an SLR, you see what the lens sees—and what will end up on the film. This allows SLRs to accept a greater variety of lenses than any other type of camera, a range that includes high-magnification telephotos. But SLRs are also available in models that accept film sizes larger than 35mm, mostly medium-format.

An SLR's through-the-lens viewing system begins with a **reflex mirror.** Positioned between the back of the camera's lens and the film, and tilted up at 45 degrees, it reflects the image of the subject formed by the lens so that it's facing the top of the camera. The image then strikes a translucent horizontal focusing screen, allowing it to be easily seen. (For more about what the focusing screen does and how it works, see Chapter 4.) The mirror also inverts the image so that it appears right side up.

The SLR mirror does even more than that, though. When you push the shutter button to take your picture, the mirror flips up on hinges to get out of the light's path, allowing the subject's image to reach the film. Then, after the film is exposed, the mirror drops back down to its viewing position so that you can see the subject once again—and keep shooting if you want to. This accounts for most of the clicking noise you hear when you take a picture.

Some SLR models—notably those that take medium-format rather than 35mm film—allow the subject to be composed and focused right on the camera's horizontal focusing screen. But to do so you have to look down at the screen, holding the camera at chest or waist height. (The same is true of the twin-lens reflex camera; see page 46.) This can be an awkward arrangement because you have to look up to study the actual subject, then down again to check

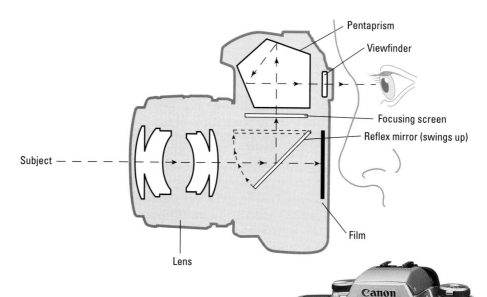

its image on the screen. Another problem is that the image is backward—reversed from left to right. When you swing the camera sideways to make a horizontal adjustment in composition, you tend to move it the wrong way. You have to learn to make such adjustments in a counterintuitive direction.

To overcome such difficulties, most SLRs (and all 35mm SLRs) add a **pentaprism** to the viewing system. Basically a five-sided mirror, the pentaprism bounces the image back and forth until it's in its correct right-to-left orientation—that is, it matches the actual subject. The pentaprism also bends the image at a right angle, aiming it at the back of the camera. This bending and bouncing of light has an important purpose: to let you view your subject, and take pictures, by holding the SLR to your eye rather than at your chest or waist.

For most photographers, eye-level shooting is a more comfortable and natural-feeling way to take pictures. It means you can quickly look back and forth between the camera and the subject to keep track of what's going on around the subject and be ready for changes that might make your photograph more interesting. Eye-level shooting also means that photographs made with a hand-held camera (a camera you use in your hands rather than on a tripod)

have a more familiar point of view. Shooting from the chest or waist, by contrast, can make subjects appear to be looming over the photograph's viewer.

Because eye-level viewing is so much easier, the pentaprism is an integral part of 35mm SLRs. With most it's permanently built in; with some professional models it can be removed and interchanged with other special-purpose versions (such as for sports subjects). With medium-format SLRs, the pentaprism is usually an optional accessory, though most photographers prefer to use one. Whatever its form, the pentaprism and the small, secondary optics that relay the image to the viewfinder (and your eye) form a unit that is often referred to as the finder, though some manufacturers may also call it a prism.

The SLR's viewing system is often integrated with its metering and exposure-control systems. In addition to seeing the subject through an SLR's viewfinder, you

The single-lens reflex (SLR) camera lets you compose and focus your subject through the same lens used to take the picture. To make this possible, the image of the subject formed by the lens—which is upside-down and backward—is first reflected upward by an angled mirror to a horizontal focusing screen. The mirror turns the image rightside up, while the screen makes it visible. Mirrored surfaces in the pentaprism then reflect the focusing screen image into the viewfinder eyepiece, reversing it from right to left in the process. All this bouncing of light not only makes the image match the subject, but allows the camera to be used at eye level. When you press the shutter button to take a picture, the mirror swings up out of the way so that light can strike the film.

single-lens reflex (SLR) Camera in which the subject is viewed, focused, and composed through the lens used to take the picture.

reflex mirror Mirror inside an SLR camera that reflects the image from the lens to the viewfinder, allowing composing and focusing through the lens.

pentaprism Five-sided mirror inside an SLR's viewfinder that allows eye-level viewing of the subject.

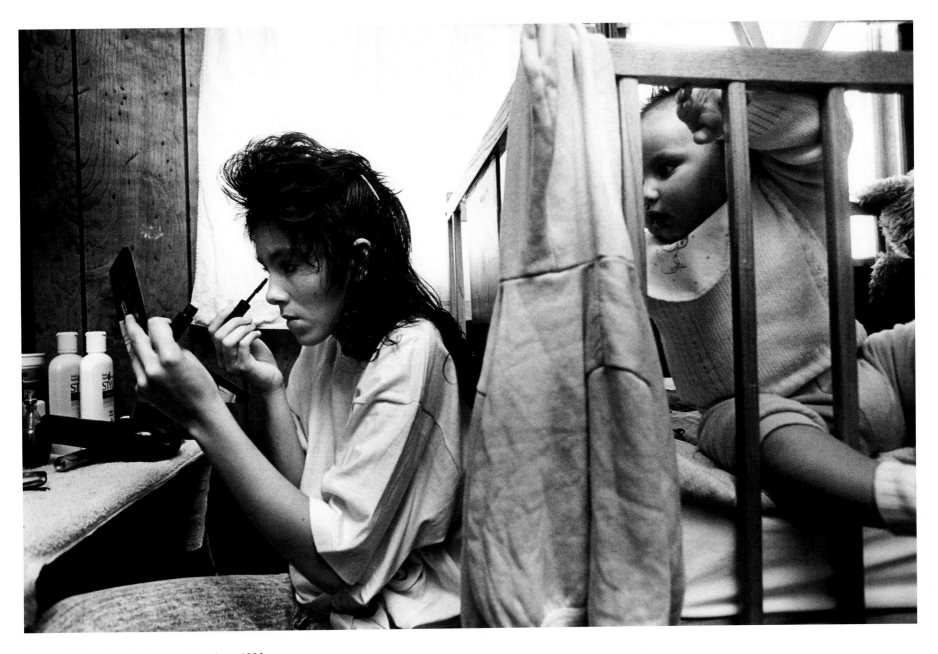

Eugene Richards Mother and Daughter, 1990
Richards' seemingly casual composition is in fact very calculated, giving visual energy and a stylistic signature to an image that's essentially documentary. Richards has focused on poor and disenfranchised people; to work unobtrusively in their personal spaces, he shoots with a small 35mm single-lens reflex (SLR). The SLR lets him view the subject through the same lens that takes the picture, giving him the precise control of composition he requires. Eugene Richards, Inc.

THE TWIN-LENS REFLEX CAMERA

The **twin-lens reflex (TLR),** makes square images on medium-format roll-film. It lets you focus and compose your photographic subject in a way similar to that of an SLR. The main difference between the two systems is in how the camera actually creates an image on its focusing screen. Like an SLR, the TLR uses a mirror set at a 45-degree angle to bounce the image from the lens upward to the screen. But rather than flip the mirror up to let light from the lens reach the film, it keeps the mirror in a fixed position—and uses a second lens to send the subject's image to the mirror.

This second viewing lens sits directly above the taking lens—the lens that actually takes the photograph. The two are mechanically linked so that when you focus the top lens, the bottom one is adjusted at the same time. (You must look down at the focusing screen in order to compose and focus.) A TLR's viewing lens is identical to its taking lens in terms of how much of the subject it takes in, so composition is reasonably accurate. But the viewing lens's higher position creates a slight discrepancy between what you see and what you get: You actually get a little less than you see at the top of your composition, and a little more at the bottom. This discrepancy is called parallax error (see box, page 48). Costlier TLR models adjust the viewfinder image to compensate for this. But since this discrepancy is greatest when you're closest to the subject, to minimize it, most models limit how close you can focus.

Though many photographers continue to shoot with them, high-quality twin-lens reflexes are manufactured in very small numbers. Used models are widely available; some even have interchangeable lenses. And you can still buy new, inexpensive models with nonremovable lenses, often made in China or Russia. While these aren't optically as good as most older models, they can still make excellent photographs.

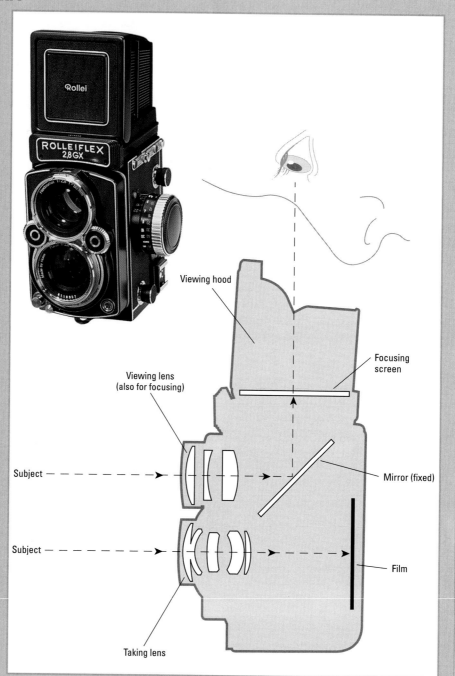

Unlike other types of cameras, the twin-lens reflex incorporates two lenses: one for taking the picture, the other for viewing the subject. The upside-down image from the viewing lens strikes a nonmoving mirror that turns it rightside up and reflects it to a focusing screen that makes the image visible. You have to look down at it to compose and focus the subject, so the camera must be held at chest level or below when you're shooting. One drawback of this design is that the focusing screen image is reversed from right to left, so making adjustments in composition takes some practice.

twin-lens reflex (TLR)
Camera type with two lenses, one used to view, focus, and compose the subject and the other used to take the picture.

often see displays of f-stop and shutter speed, as well as indications that guide you to the correct exposure settings. These usually appear along the dark edges of the "frame" you use to compose the subject. Depending on what kind of SLR you have—manual-focus or auto-focus—you also see markings in the middle of the viewfinder. As parts of the focusing screen, these help you to focus manually and/or to control and monitor the camera's autofocus system. For more about these important markings, see box, page 66.

THE RANGEFINDER CAMERA

Many of the classic photographs of the twentieth century were made with the 35mm **rangefinder** camera. Some fine-art and documentary photographers continue to use this camera type for its compact design, fast handling, and quiet operation, even though it has been surpassed in popularity by SLRs. Because a rangefinder's viewing and focusing system does not require a bulky reflex mirror or pentaprism (as does an SLR), the camera body can be kept relatively small. This advantage is one reason there are more medium-format rangefinders than 35mm rangefinders.

When you look through an SLR's viewfinder, you're seeing the subject through the lens. When you look through a rangefinder, though, you're seeing the subject through a separate viewfinder window, usually above and to the side of the lens. In the center of the viewfinder frame, you see a small, bright patch. If the lens isn't correctly focused, a double image of that small piece of the subject appears in the patch. (One image is fainter than the other.) To focus the camera, you turn a ring on the lens until the two images are superimposed.

The second (fainter) image enters the camera through a second window, on the other side of the lens, and is reflected by a rotating prism to a translucent mirror inside the viewfinder. The focusing ring on the lens of the rangefinder is mechanically linked to the prism. As you turn the

To compose and focus with a rangefinder camera, you look through a viewfinder window that is independent from the lens—usually above and to the side. A small, bright rectangular patch appears in the middle of the viewfinder; when the subject is out of focus, the patch contains a double image of it. You turn a ring on the lens until the two images are superimposed and the subject is then in focus. Rangefinder advantages include quiet operation and being able to see the viewfinder image during the actual exposure (both due to the absence of a moving reflex mirror); these make the rangefinder camera a good choice for unobtrusive shooting.

ring, the prism rotates, shifting the position of the reflected image from side to side. Though it's prone to misalignment, when working correctly, this system of focusing is highly accurate.

With a rangefinder, you see the subject all the time as you're shooting, because there's no need to move a mirror out of the path of the lens's light to make an exposure. (With an SLR, the viewfinder image briefly blacks out with each shot, because the mirror can't reflect an image to the viewfinder when it's raised.) The lack of a moving mirror also means that rangefinders are quieter in their operation than SLRs. This can make

them more suited to off-the-cuff shooting—and indeed, rangefinder users often do the kind of candid photography that depends on keeping a low profile. Finally, since rangefinder lenses don't have to be designed around a mirror, they can be optically simpler, and some photographers believe that this makes them sharper too.

However you focus them, rangefinders have a common disadvantage: **parallax error,** the discrepancy between what you see through the viewfinder and what the lens actually puts on the film (see box on page 48). Another problem affects models with interchangeable

rangefinder Camera type in which you view, focus, and compose the subject through a window separate from the lens.

parallax error Difference between what you see through the camera's viewfinder and what the lens will actually record on the film.

PARALLAX ERROR

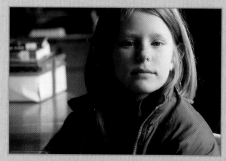 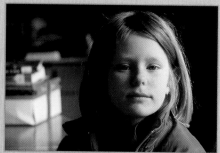

Rangefinder, twin-lens, and other cameras that don't allow you to view the subject through the same lens used to take the picture are prone to parallax error, in which the composition you see in the viewfinder doesn't correspond exactly to what you get on film. This can cause the final image to be unexpectedly cropped (left). Some models automatically adjust the viewfinder to compensate for parallax error, which is greatest when you're shooting close to the subject. Other models require you to use lines or other parallax marks in the viewfinder to compensate for the problem manually. To use the marks, simply take the picture while keeping the part of the scene you want within the marks (center). The results should show the desired framing (right).

One advantage of the single-lens reflex camera is that when you look through the viewfinder, you're seeing a pretty close representation of what the lens will record on film. It's a different story with rangefinder cameras, twin-lens reflex cameras, and point-and-shoot cameras. Because these models require that you compose and focus your subject through a separate window (or a second lens) to the side of and above the main lens, there's a discrepancy between what you see and what you get on film. That difference—which usually causes the final image to be shifted to the right and/or down—is called parallax error. The closer you are to your subject, the more significant parallax error becomes. It must be taken into account, either manually or

automatically, if you want your picture to match what you saw in the view-finder.

Fortunately, most cameras that suffer from parallax error have viewfinders that let you minimize it, an approach called parallax compensation. In its simplest form, the needed compensation is indicated with a set of lines inside the edges of the viewfinder or within the viewfinder's main frame lines. You use these lines to compose when your subject is close: that is, you make sure to keep the subject within them so that it won't be cut off in the final image. (See example above.)

Many rangefinder cameras, both 35mm and medium-format, take a more sophisticated approach to parallax compensation. As you adjust the

focus, the frame lines or black edges of the viewfinder move in and out continuously to subtly change the framing. Some even adjust for the fact that the subject gets ever so slightly bigger in the frame when you focus closer—something you see readily with an SLR.

When you use parallax compensation lines or systems, try to make your composition take those areas into account. And keep in mind that many rangefinder manufacturers limit the ability of their lenses to focus close, which lessens the needed parallax compensation. You may not be able to focus a rangefinder lens much closer than about three feet, for example, whereas you may be able to focus an SLR as close as a foot from your subject, or even closer.

lenses: Because rangefinders don't show you the subject through the lens, like an SLR, mounting a different lens doesn't actually change the portion of the scene you see in the viewfinder. Instead, a different set of viewfinder **frame lines** lights up for each lens. Frame lines indicate how to compose simply by boxing off the part of the scene the lens will actually record.

Because the boxes formed by frame lines can only be so small, there's a practical limit to how much a rangefinder lens can magnify a subject. When you need higher magnification—the extreme telephotos that are a must for sports and wildlife photography, for example—an SLR is the only choice. For similar reasons, rangefinders can't offer the special-purpose lenses that help make the SLR

such a versatile tool for special effects (see Chapter 5).

THE VIEW CAMERA

The **view camera** has changed little since photography's beginnings, either in its mechanics or the slow, deliberative way that it must be operated. Essentially an adjustable box, it consists of front and rear **standards** joined by an accordion-

frame lines Markings in a rangefinder's viewfinder indicating the portion of a scene that a lens will take in.

view camera Camera consisting of front and rear standards joined by a flexible light-tight bellows. View cameras are typically used on a tripod and use large-format film.

standards Adjustable vertical supports of a view camera that hold the lens at the front and the ground glass (and film) at the rear.

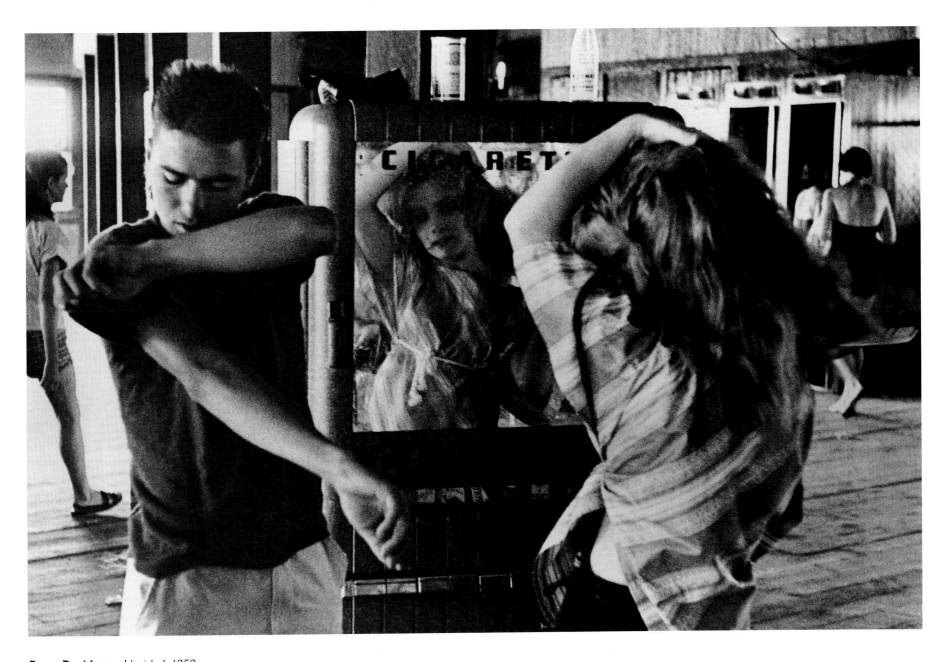

Bruce Davidson Untitled, 1959

The rangefinder was the first serious 35mm-format camera. Even after the introduction of the 35mm single-lens-reflex camera, photographers such as Davidson continued to use rangefinders for their quick, quiet operation and small, inconspicuous size. Those qualities helped give Davidson's slice-of-life images of 1950s New York City—here, of Brooklyn gang members—a remarkable candor. Magnum Photos, Inc.

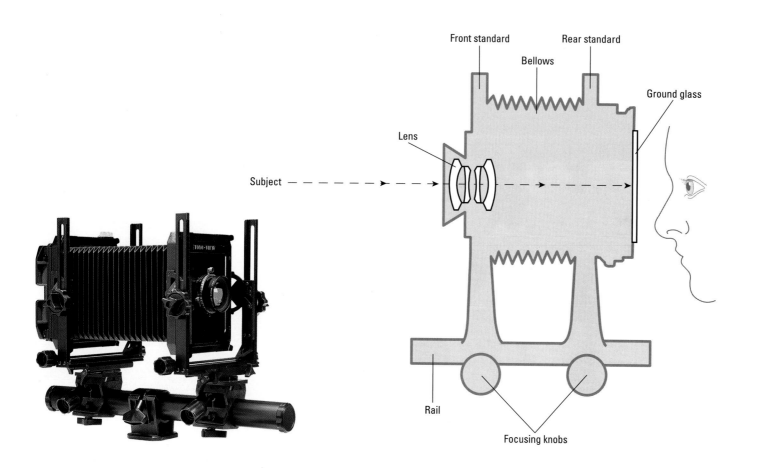

Front standard · Rear standard · Bellows · Ground glass · Lens · Subject · Rail · Focusing knobs

A view camera offers the most direct composing and focusing of any type of camera. To focus a monorail view camera, you turn a knob to move its front (lens) and/or rear (film) standards along a rail, adjusting the distance between them until the image formed by the lens on the camera's ground glass is sharp. The ground glass image is hard to see, so to compose and focus you usually place a dark cloth over your head and the camera back to cut out extraneous light. To take the picture, you slide a holder loaded with film under the ground glass after you have established the composition and focus. All this makes view cameras relatively slow and cumbersome to operate, limiting their use mostly to static subjects.

like light-tight **bellows.** Thanks to the bellows' ability to expand and contract, the standards can be moved back and forth independently along a rail or geared bed. In fact, this is how you focus a view camera: by changing the physical distance between the front standard (which holds the lens) and the rear standard (which holds the film).

For guidance in this adjustment, you study the sharpness of the image formed by a view camera's lens on its rear standard's translucent **ground glass.** The ground glass is also where you compose the subject; it's the view camera's viewfinder. Unlike an SLR, which uses mirrors and extra optics to relay the lens's image to your eye, or a rangefinder, which doesn't show you the image through the lens at all, the view camera offers pure through-the-lens viewing. The image you see on the ground glass is the very same image that will end up on the film during an exposure. In fact, it's the same size as the image

formed on the film; the ground glass and image area are virtually the same.

To compose and focus with a view camera, you have to place a dark cloth over the back of the camera and over your head. Otherwise, light falling on the outside surface of the ground glass would make it difficult or impossible to see the image clearly. Composition is a bit trickier: The image on the ground glass is both upside-down and backward. (This is actually the way all cameras form images on film, regardless of type; when the image is printed, projected, or reproduced, it's restored to its correct orientation.) Composing with the view camera's upside-down and backward image takes some getting used to.

Once you've set up your shot, a view camera must remain in a fixed position while you insert and expose the film, in order to maintain your composition. This is one of several reasons a view camera must ordinarily be used on a tripod—a three-legged adjustable camera support

(see Chapter 7). A tripod is also needed because the view camera usually requires the use of slower shutter speeds (the duration of the time the film is exposed to light), and also because its image-control adjustments require a fixed camera position. Besides, there's no practical way to support a view camera in your hands!

What's more, with a view camera, unlike a hand-held camera, each exposure requires a high level of individual attention. View cameras are mainly designed to accept single sheets of large-format (4" x 5" or larger) film. Sheets of film are generally placed in holders, one sheet on each side of the holder with a light-tight dark slide covering it. After you've composed and focused your shot, you slide a film holder into the camera back, remove the dark slide, and expose the sheet. A view camera is described by the sheet size of the film it accepts: a 4" x 5" view camera shoots 4" x 5" film; an 8" x 10" view camera shoots 8" x 10" film.

bellows Accordian- or bag-like tube that connects a view camera's front and rear standards.

ground glass Translucent glass sheet in a view camera's rear standard, used for composing and focusing the image.

TYPES OF VIEW CAMERA

There are basically two types of view camera, both available in a full range of sizes including models that accept 4" x 5", 5" x 7", 8" x 10", and 11" x 14" sheet film—though 4" x 5" and 8" x 10" are most common. One type is the **monorail view camera.** The other is the **field camera.**

A monorail model is what it sounds like: The camera's front (lens) and rear (film) standards move forward and backward along a single, rigid rail for focusing purposes. Because the monorail view camera tends to be bulky, rigid, and heavy (often made of metal), it's generally reserved for studio work such as product photography, still life, portraiture, and sometimes fashion. But because the camera allows a free range of motion—in particular, the ability to slide, tilt, and swing its standards—it provides remarkable creative image control.

The field camera is somewhat more limited in its range of motion than a monorail camera. But unlike most monorail models, it's designed to be collapsed into a small shape, forming its own protective case. (The front standard folds down against the camera bed, and then the hinged back is lowered on top of it.) This, along with its typically lightweight wooden construction, makes the field camera much more portable than most monorail models. (Some field cameras are made of metal or high-impact plastic.) This is why it's favored by photographers who like to shoot large-format film on location (away from a studio).

The field camera forms its own carrying case, folding into a compact box when not in use. Because it is portable, it's often used by photographers who must shoot "on location." Many field cameras are made of nicely-finished wood rather than metal alloy or plastic composites.

Working with single sheets of film means you can easily change the type of film you're using from one shot to the next, instead of feeling obliged to shoot an entire roll before switching film. You can shoot one subject with color film and the next with black-and-white, or shoot a single subject with two or more different films. (Many professional photographers using view cameras shoot tests on Polaroid films before exposing the final film; see page 231.) Sheet film also allows you to process each exposure in the way that best suits a specific subject—extending or reducing the development time to control image contrast, for example (see Chapter 12). With 35mm, on the other hand, you usually have to process the entire roll of film the same way.

Perhaps the single greatest advantage to using a view camera is that its individual sheets of film are larger in area than frames on a roll of film. This produces superior print or reproduction quality, simply because the larger the film area, the finer the grain (in a given size print) and the sharper the image detail (all other things being equal). The view camera's descriptive power makes it ideal for photographic styles and subjects that depend on the rendering of fine detail. On the commercial side, photographers use view cameras to shoot everything from perfume bottles to cars. On the fine-art side, landscape and architectural photographers use them to increase the sense of texture and substance in their subjects. Whether the subject is a product, landscape, or building, a view camera lets you control the image in ways that are simply impossible with other kinds of cameras.

What's interesting is that much of this control depends not on high technology but on simple mechanics—mainly, the camera's adjustable front and back, which slide up and down and from side to side and can be pivoted both horizontally and vertically. The extent of these "movements," as they're called, depends on the design of the individual camera. But when used correctly, they allow you to portray a subject with less distortion than smaller, less flexible cameras may cause, and they give you nearly total control of image sharpness.

In terms of pure image control, such abilities make the view camera the ultimate photographic instrument. But like any type of camera, it has its disadvantages. Because it's bulky and slow to set up, it's unsuited to the spontaneous, unrehearsed photography for which many smaller-format cameras are ideal. It can't be used for subjects that require a fast reaction, such as sports and wildlife. Nor do its lenses have enough magnifying power, generally speaking, to fill the frame with a very distant subject. And for technical reasons that you will learn about later, view cameras often require the use of slow shutter speeds—the length of the time the film is exposed to light. This in turn requires the use of a tripod, as mentioned, and limits the ability to "stop" action.

OTHER CAMERA TYPES

Students and professional photographers do their work mainly with SLRs, rangefinders, or view cameras of various descriptions. But you needn't limit your

monorail view camera Type of view camera using a single rail to support the front and rear standards.

field camera Type of view camera that collapses for portability.

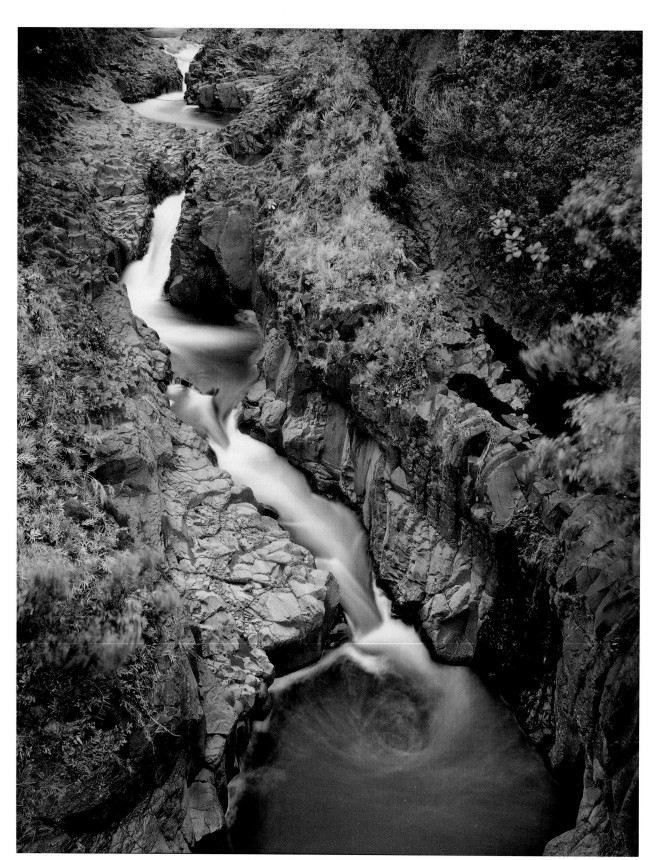

Linda Connor

Seven Sacred Pools,
Maui, Hawaii, 1978

Connor uses a large-format view camera. Her camera's sizable 8" x 10" negatives allow her to obtain great image detail and clarity, as well as a tonal smoothness that complements the mystical feeling of her landscape work. Even though using view cameras in remote places can be time consuming and awkward, this subtlety and precision make them the choice of photographers like Connor. Linda Connor Photographer

picture-making to these familiar models, especially if you're looking for new ways to approach a subject or solve specific photographic problems. Point-and-shoot models, for example, long the exclusive tool of amateurs, are capable of producing very high-quality photographs, and professionals often keep one in their pocket or camera bag. And "toy" cameras can yield surprising and interesting results, as many creative photographers have discovered.

Point-and-Shoot Cameras Even if you've never used a 35mm SLR before, there's a good chance you've taken pictures with a **point-and-shoot camera**. The complete automation and compactness offered by these popular cameras can give photography a spontaneity that is sometimes impossible with more "serious" models.

Even professional photographers have been known to use point-and-shoot cameras for specific shots—pictures they might otherwise have taken with an SLR. That trend has contributed to a new category of point-and-shoot cameras: expensive, well-built models with high-quality lenses and manual overrides of their automation. But point-and-shoot cameras come in a great variety, from panoramic models to reloadable underwater models that allow you to choose from a variety of print formats.

Point-and-shoots range from models with fixed focus and limited exposure capability to autofocus models with a full complement of modes—pushbutton settings that allow you to control the camera to deal with specific shooting situations. Whatever their level, most such cameras have motorized film advance and rewind and built-in flash units that fire automatically when light is too dim for a good exposure.

Point-and-shoots come in several different forms. Most use 35mm film; many new models use the smaller Advanced Photo System format (see Chapter 8). There are also so-called "single-use" models, essentially disposable cameras, which come in both 35mm and Advanced

point-and-shoot camera Mainly an amateur camera, characterized by small size and high degree of automation.

POINT-AND-SHOOT POINTERS

To ensure good results with a point-and-shoot camera, follow these suggestions. Note that many refer to concepts presented in detail later in this book.

- **Use fast film.** Fast color-print films—those with ISO numbers of 400 or higher—are best for point-and-shoot cameras. If the lens quality is good, negatives can be enlarged to create good-sized prints. But just as important, fast film produces more background detail in low-light flash shots, and in nonflash photography makes the camera set higher shutter speeds, which lessens the chance of blur.

- **Use flash outdoors.** Set a point-and-shoot to its "fill flash" mode to make the flash fire even in bright light or direct sun. (In its standard autoflash mode, the camera fires the flash only when light is low.) Fill flash lightens dark shadows in a subject, as long as the subject is reasonably close, making tones less harsh.

- **Lock the focus and recompose.** The central focus point in a point-and-shoot's viewfinder can sometimes fall on the background when you take a picture, causing the main subject to be out of focus. This is most likely when the subject is off-center. To prevent it, use the technique described on page 35 for autofocus SLRs.

- **Move in, don't zoom in.** The zoom lenses on point-and-shoot cameras encourage users to compose by zooming in—adjusting the lens to make the subject bigger in the frame—rather than physically moving in. This not only increases practical problems but usually makes composition less interesting. Instead of always zooming, move closer to your subject when possible to make things bigger or smaller in the frame.

Intended mainly for snapshot use, point-and-shoot cameras also have found a following among some professional photographers, who use them to achieve a spontaneous "look." Point-and-shoot cameras usually feature automatic exposure, automatic focus, and automatic film advance and rewind. Their built-in flash units even turn on automatically when needed. Various models use 35mm (right) and Advanced Photo System (left) film, while digital point-and-shoots (center) don't use film at all.

Photo System versions. And there are models that capture and store their images digitally (that is, without film) for computer use. These are known as digital point-and-shoots (see Chapter 17).

Reloadable point-and-shoots come with a variety of lenses, virtually all of which are non-removable. Most of the well-appointed ones usually have zoom lenses—lenses with adjustable magnification that allow you to change the size of the subject in the frame without physically moving (see Chapter 5). The most useful of these are the few models that start zooming at true wide-angle focal lengths (for example, 28mm in a 35mm point-and-shoot). While they are very popular, models that zoom to long focal lengths (115mm to 160mm, for example) can present technical problems when "zoomed in" all the way on a subject.

For best quality, stick with good single-focal-length (non-zooming) models, which also tend to be less expensive than zoom models and may also have better optics. Most such models have moderately wide-angle lenses, typically 35mm (in the 35mm format) but often wider. These lenses also usually have a larger lens aperture—that is, they let more light in so that you can often photograph in low light without using a flash.

Point-and-shoot cameras are really designed for color negative film—film from which you make a color print. Models with reasonable exposure sophistication can usually do a decent job with transparency film, though if you use films faster than ISO 200, you may get overexposure. You also can shoot black-and-white film successfully in point-and-shoots.

Toy Cameras To play down the technique and technology of photography, fine-art photographers sometimes turn to toy cameras. These inexpensive models produce poor results by any technical standard. But their flaws can actually give your photographs an unrefined, impressionistic, and artful quality.

Crudely constructed, toy cameras usually produce square images on medium-format rollfilm (120 size). Their cheap plastic lenses offer little or no focusing control and soften or distort the subject. But the image is usually somewhat sharper in the center than at its edges—one of the hallmarks of these models. That effect is usually compounded by the lens's inability to project the subject's image evenly over the entire film area, which causes vignetting at the photograph's edges and corners (darkening in the print). Using color film with toy cameras introduces still more distortion, since the lens isn't designed for accurate color rendition. The resulting colors are generally muted and often inaccurate.

Some toy cameras have crude focusing control, but this takes some guesswork on the photographer's part. There may be two or three settings, for close, midrange, and far camera-to-subject distances. The relatively small lens aperture (the size of the opening in the lens) helps maintain some degree of sharpness from foreground to background of a subject, but it also contributes to frequent underexposure and low-contrast negatives. (Like single-use cameras, toy cameras also usually have only one shutter speed.)

For these reasons, it's best to use toy cameras in bright, sunny conditions; even open shade on such days may be too dim. You can compensate for the risk of underexposure by always using fast film (ISO 400 or higher) and/or overdeveloping the negatives to heighten their contrast (see Chapter 12). Always use negative film (black-and-white or color), which allows you to make adjustments in printing. Don't use transparency films, as toy cameras lack the needed exposure control.

The very unpredictability of a toy camera's results is a large part of its appeal. Indeed, each particular camera has its own characteristics; you may have to shoot a few rolls to figure out the quirks of yours. Here are some things to keep in mind:

- **Light leaks** are common, causing the film to be fogged—struck by unwanted stray light. This results in streaks of random exposure. To prevent this, seal

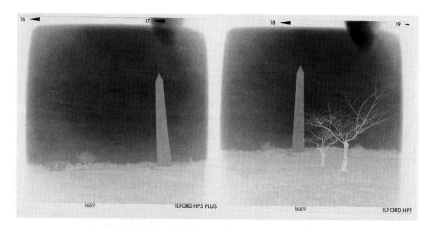

the camera's outer seams and joints (especially along the edges of the camera back) with opaque black tape after you load the film.

- Remove exposed film only in low light, and immediately wrap it in aluminum foil or other opaque material. This helps prevent fogging along the edges of the film due to a loose fit on the spool.

- Some models have internal inserts that you remove to change from a square to a rectangular format; taking them out may leave holes that you'll have to tape up to prevent light leaks. Also tape over the red-filtered window (used for viewing the exposure number) on the camera back.

- Toy camera lenses have inaccurate viewfinders; they record more of the subject on film than they actually show in the viewfinder. To compensate for this, get closer to your subject than you normally would when you compose. If you're close to a subject, also aim a little higher to correct for parallax error (see box, page 48).

Toy cameras like the Holga (left) have long been a favorite tool of fine-art photographers, in part because their cheap plastic lenses introduce visually interesting optical defects. These include variations in softness (in which some parts of the image look sharper than others), vignetting (in which less light reaches the corners of the image, causing them to be dark in the print), and muted colors (since the cheap plastic lenses are not designed for optimal color performance). Light leaks are common in toy cameras, as seen in the flare in the upper right-hand corner in this example. To avoid them you must carefully seal the camera with opaque black tape.

light leaks Unwanted light that causes patches or streaks of density on film.

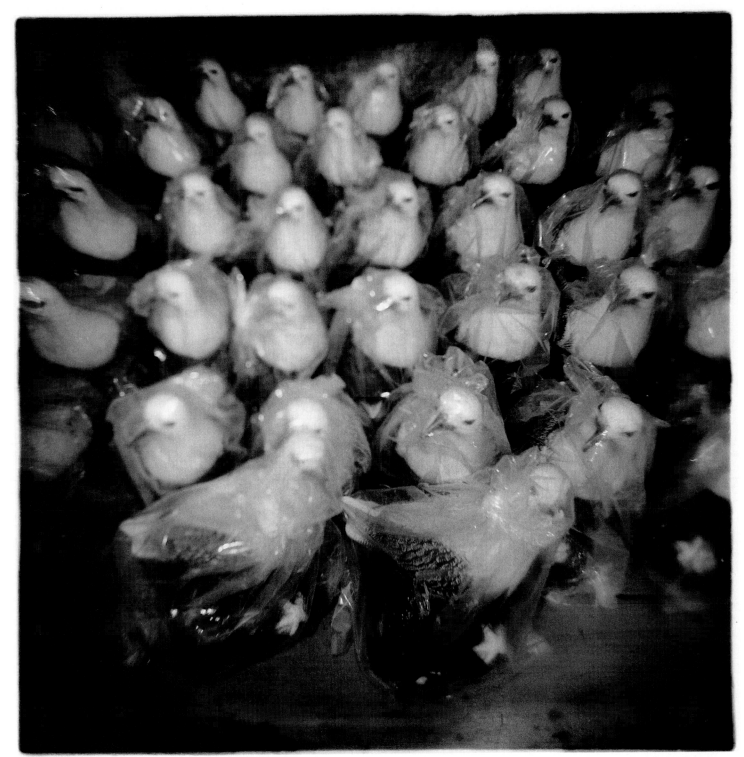

Thomas Gearty
Waldoboro, Maine, 1995
Gearty uses a toy camera to make photographs that seem more like depictions of dreams or memories than physical reality. The camera's plastic lens makes the center of the image relatively sharp, but progressively softer toward its edges. The lens's inability to properly "cover" the camera's 2¼"-square image area with an even amount of light also accounts for the photograph's vignetting, a gradual darkening toward the corners.
© Thomas Gearty

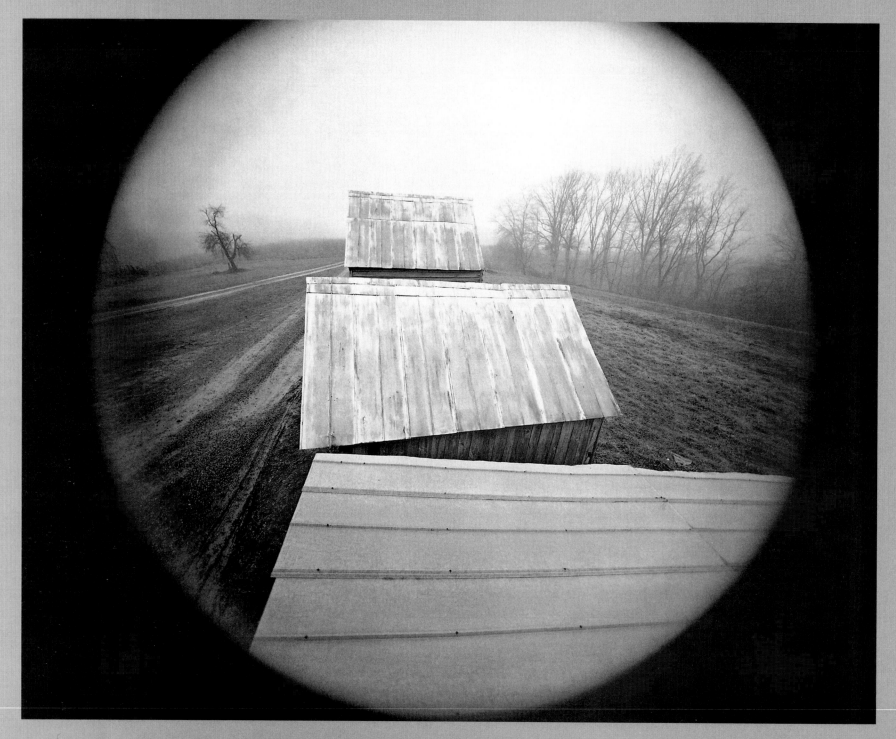

EMMET GOWIN
Buckingham County, Virginia, 1973

All photographic lenses form a circular image, but the cameras for which they're designed use only the circle's central area. The film just takes a rectangle out of the middle of the image circle. Here, Emmet Gowin used a camera that accepts 8" x 10" film, but with a lens designed for a smaller format, probably 4" x 5". The larger film recorded the entire circular image projected by the lens and left the surrounding areas unexposed—an effect that dramatically reinforces the receding space of this unconventional landscape photograph. Courtesy of the artist and PaceWildensteinMacGill Gallery, New York

THE LENS:
AN INTRODUCTION

lens Cylinder of shaped pieces of glass (or plastic) that bend rays of light from the subject to create a sharp image on film.

lens elements Individual pieces of shaped glass (or plastic) within the lens.

aberrations Distortions in color, shape, or sharpness caused by a lens, partly or largely correctable with good lens design.

focusing Process of moving the lens forward or backward (manually or automatically) until it produces the sharpest possible image of the subject.

Any object we see—or photograph—reflects light in many directions at once. As elementary as it seems, this is why we can move around the object and still view it. In fact, each point in that object (even something smaller than an eyelash or a freckle) reflects countless rays of light. This disorganized scattering of light is why film alone can't form an image of a subject, even in the light-tight box called a camera (see below). To create a photographic image you need a way to collect and control the rays of light entering the camera. This is the job of the **lens,** a cylinder of shaped pieces of glass or plastic at the front of the camera.

A lens accomplishes two main things. First, it creates a sharp image of your subject on the film. And second, it makes it possible to use a relatively large opening to admit light from the subject into the camera and still produce a sharp image. This means that you can get quite a lot of light from the subject into the camera—and onto the film—in a relatively short amount of time. Getting a lot of light to the film in a brief interval means, in turn, (1) that moving subjects may be photographed without producing a blurred image; (2) that pictures can be taken in lower light levels; and (3) that a camera may be held by hand for a photograph, rather than supported in a fixed position.

A photographic lens has a variety of glass **lens elements** to control the way light rays are bent. Many of these extra elements correct for **aberrations**—distortions of color, shape, and sharpness—associated with simple lenses like magnifying glasses. Good photographic lenses

contain anywhere from five or six to a dozen or more elements.

When you take a photograph, you have to make three basic decisions concerning the lens. One is where to focus it. **Focusing** is the process of moving the lens forward and backward until it produces the sharpest possible image of your main subject, or of the most important part of the scene, on the film in your camera.

The second decision you must make about the lens is what focal length to use. Focal length is a measurement, expressed in millimeters, of the distance between the lens and the film when the lens is focused as far away as possible. In practical terms, focal length describes the lens's ability to magnify a subject (to make it bigger in the frame and on the film) and, a related effect, how much of a scene (how wide or narrow a section) the lens will actually "see." (See Chapter 5.)

The third decision you must make concerning the lens is what lens aperture

to use. The lens aperture is the size of the circular opening in the lens; along with the shutter speed, it controls the exposure, how much light can reach the film. The lens aperture is also one of several ways to control depth of field, the depth of the zone of sharpness in the scene you're photographing (see Chapter 6).

You will learn more about these concepts in the following three chapters. This chapter is about focusing, though, since it is in some ways the simplest of the three decisions you must make. As with other lens functions, focusing may be either manually controlled or fully automated by your camera—though most models that offer automatic focusing (mainly 35mm SLRs) also let you focus manually if you choose. Even when you allow these cameras to do the focusing for you, you must still usually tell the camera where to focus, as described later in this chapter. Read the following section on manual focusing for an understanding of how focusing happens and

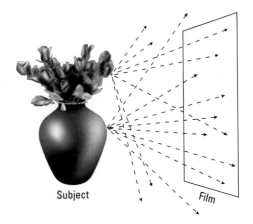

Subject Film

Every point in a visible object reflects light in many directions at once. Without a lens to collect and bend these rays, they can't form a recognizable image of the object on photographic film.

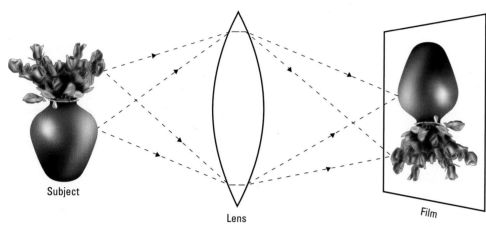

Subject Lens Film

The lens creates a recognizable image of the subject by gathering a cone of light from each point in the subject and bending it inward so that it forms a matching point on the film.

how best to focus if your camera's autofocus system isn't up to the task.

MANUAL FOCUS

You focus the subject to make it sharp, because for every subject at a different distance from your camera, the lens must be at a different distance from the film. Focusing is the process of moving the lens in and out to find that distance. With most cameras, this movement happens inside the **lens barrel,** the cylindrical exterior of the lens. (With a view camera, you must move the entire lens.) If your camera is an autofocus model, it can move the lens for you (see page 60). But virtually all autofocus models also let you focus manually—by physically adjusting the lens yourself—which can be especially valuable because some subjects often confuse autofocus systems, causing them to focus inaccurately. If you have a camera that requires **manual focus,** you have to do the focusing yourself.

Whether you're focusing manually with an autofocus or a manual-focus camera, you usually do it by adjusting the lens's **focusing ring,** a rotating collar, until the most important part of your picture—your main subject—appears sharp in the viewfinder. (With view cameras and some medium-format models, you have to rotate knobs to move the lens back and forth along a rail.)

However it's done, focusing is an important creative tool. In allowing you to control what will be most sharp in your photograph, or to maximize overall sharpness, it gives you the ability to influence the way a viewer will experience the image—specifically, where he or she will look first. Yet focusing isn't quite as straightforward a process as you might think, even though an SLR (the camera you're probably using) lets you view the subject directly through the lens. In fact, most inexperienced photographers actually overfocus when they're focusing manually. They spend too much time on the process, turning the focusing ring back and forth endlessly, never convinced the subject is sharp enough. Not only does this risk losing the shot if the

subject is moving or momentary, it actually increases the chance of focusing error.

The best advice for manual focusing is to do it fairly fast and to stop as soon as the image appears sharp. Don't turn the focusing ring back and forth repeatedly; studying the viewfinder image too long may actually impair the eye's ability to determine sharpness. If you're having trouble judging focus, look away at a distant object and then try again to focus your subject.

This approach to focusing pertains mainly to focusing by judging the sharpness of the subject visually. You must focus this way with a view camera. The advice does not apply to focusing with a rangefinder (see page 62). If you're using a manual-focus SLR, however, its viewfinder probably contains one or more devices to help you focus more quickly and/or precisely. These devices are actually built into the camera's internal **focusing screen,** the glass or plastic diffusing sheet in a camera onto which the lens projects the image for viewing and focusing (see page 66).

Manual-focus SLR focusing screens often contain two different focusing devices, which you see in the center of the viewfinder. One is the **split-image circle,** a small round area with a line dividing it in half. It tells you that a subject is out of focus by interrupting the alignment of subject details that intersect the line; to focus, you rotate the lens's focusing ring until the details are properly aligned.

Because most split-image circles divide the circle with a horizontal line, you're best off focusing on a vertical line in the subject, or on any area in which the boundary between tones is vertical—the edge of a face, the side of a tree,

lens barrel Cylindrical exterior housing of a lens.

manual focus Focus controlled by physically adjusting the lens on the camera.

focusing ring Rotating collar on a lens barrel used for manual focusing.

focusing screen Glass or plastic diffusing sheet inside a camera onto which a lens projects the image for viewing and focusing.

split-image circle In some SLR cameras, a small central circle in the viewfinder that helps you focus by aligning subject details.

or the corner of a building, for example. If you're holding the camera vertically (for a vertical composition, that is), the split-image line will be vertical, too. In this case you'll need to focus on a horizontal edge, which is generally easier to find.

Split-image focusing is very precise. Its flaw is that you may not be able to find the needed vertical detail in your main subject area, or wherever it is you want to focus. In this event you'll have to find something else to focus on. If you do, though, make sure that it's at the same distance from the camera as the main subject. One suggestion: If you can only find a horizontal line in the subject, tilt the camera or even hold it vertically to focus on it. Then reorient the camera to its horizontal position for the shot.

For times when split-image focusing is difficult or impossible, many focusing screens also incorporate a **microprism collar,** a doughnut-shaped area surrounding the split-image circle. (Some screens dispense with the split-image circle, making the microprism area a full circle.) The microprism area contains hundreds of tiny prisms that break up subject detail. When a subject is out of focus, the microprism collar's coarse texture shimmers. You turn the camera's focusing ring until the shimmering stops and the subject appears smooth and clear.

Sometimes a subject won't allow the use of a microprism collar or split-image circle because it's too dim, too unpredictable, or too fast-moving. Focusing on the clear portion of an SLR's focusing screen may also be difficult. In these instances, you may need to rely on special focusing strategies, described as follows.

Estimation Focusing You can focus many cameras manually without even

looking through the lens. Most lenses have a numerical scale printed on the barrel, denoting the relationship between distance and focus. You make an educated guess about the distance, in feet or meters, to the main subject, then simply set that distance on the lens. You set the distance by lining up a mark or line on the lens barrel with the numbers on the focusing ring. (Just be sure you're reading off the foot scale, not the meter scale, unless you'd rather work with the metric system.)

Because you don't have to look through the camera for focusing, **estimation focusing** can be useful when you don't want to distract your subject or you don't want your subject to know you're about to take his or her picture. You simply raise the camera to your eye and immediately shoot without lingering to focus. Estimation focusing also lets you take pictures without putting the camera to your eye at all—for example, when shooting "from the hip."

Estimation focusing is by definition inexact. There are a couple of ways to

decrease the chance that an incorrect guess will cause your subject to be out of focus. One is to limit the technique to wide-angle or normal lenses, avoiding it with telephotos. Wide-angle lenses in particular have a lot of depth of field, large areas of sharpness in front of and behind your focused distance (see Chapter 5), so that even if you're off a bit, the subject may fall into this area and be acceptably sharp in the picture. The second way to guarantee good results is by setting a relatively small lens aperture—perhaps f/8 or smaller to increase depth of field (see Chapter 6).

Surrogate Focusing A variation of estimation focusing, the technique of **surrogate focusing** is useful both when your main subject is hard to focus (for example, when it lacks texture or detail) or when you don't want a subject to be aware that you're photographing him or her. Choose an object well to the side of your main subject, but approximately the same distance away. Focus on the object. Then, as soon as you see the picture you

The standard viewfinder in manual-focus SLRs often incorporates two central focusing aids—a split-image circle and a microprism collar. The split-image circle interrupts subject details that are out of focus (left); to use it, you rotate the lens's focusing ring until these details are aligned (right). The microprism collar (which surrounds the split-image circle) has a texture that shimmers when the subject is out of focus (left); to use it, you rotate the lens's focusing ring until the texture disappears (right).

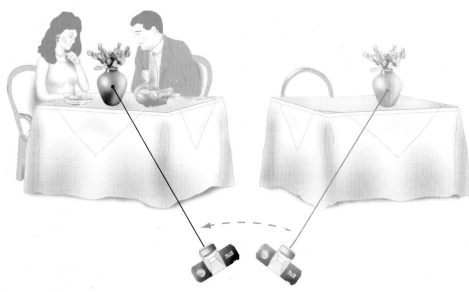

Surrogate focusing is useful when you don't want people to notice you're taking their picture. Simply focus on something to the side of your intended subject, but at about the same distance, then turn to the subject and shoot—without stopping to refocus. This technique shortens the time spent aiming the camera at the subject and is as effective with autofocus as it is with manual focus. However, when focusing automatically, you must remember to press down the shutter button halfway to lock the focus before you re-aim the camera at the subject.

want (which may take some looking out of the corner of your eye), quickly turn to your actual subject, compose, and shoot.

Surrogate focusing allows you to reduce the time between when you aim the camera at the subject and when you shoot. It also gives the subject—who may assume you're shooting something else—less time to become self-conscious or awkward. Even if the result isn't critically sharp, you may be better off having captured a spontaneous image than a sharp but studied one. Note that surrogate focusing also can be done with auto-focusing systems; you just "lock" focus on the surrogate object (see page 63).

You can also use surrogate focusing to photograph subjects that are moving too fast to be focused accurately through the viewfinder. When used with action subjects, this technique is sometimes called **prefocusing.** To do it, you must anticipate the position of your subject in the scene at the moment of exposure. First, focus the lens on something at that distance—the ground or a tree, perhaps. Maintain your composition until the subject reaches that spot. Then shoot.

AUTOFOCUS
Often abbreviated AF, **autofocus** is now standard in 35mm SLRs, from beginners' models to top-of-the-line pro-

fessional cameras, as well as a number of rangefinder-style models. This reflects its acceptance by both amateur and working photographers, most of whom will tell you that it substantially increases their percentage of sharp pictures.

But autofocus is far from perfect. There are many subjects that can trip it up, which is why nearly all AF cameras and lenses also can be focused manually. To choose between autofocus and manual focus, you usually just throw a switch on the camera body or lens. (With some 35mm SLR systems you can fine-tune or second-guess the focus manually immediately after the camera has autofocused, without having to throw a separate switch.) Even when you let an autofocus camera do the focusing for you, you often have to help it along in ways described below.

An autofocus system uses a small motor to move the lens (or the glass elements inside the lens barrel) back and forth in order to adjust its distance from the film. With some camera systems, the motor is in the camera body itself. With others, it's in the lens. But what you see in the viewfinder is the same: Your subject snaps into focus as you lightly touch the shutter button. In order to set the lens to the correct focus, an autofocus camera analyzes light from your subject with sensors (similar to those used in video cameras) and sophisticated software (see box on page 64).

When you look through an autofocus camera's viewfinder, you also see marks in its center—usually a pair of brackets. These marks are called the **focus point.** An AF camera will focus on whatever part of the scene the focus point covers.

The main problem with this system occurs when your composition doesn't

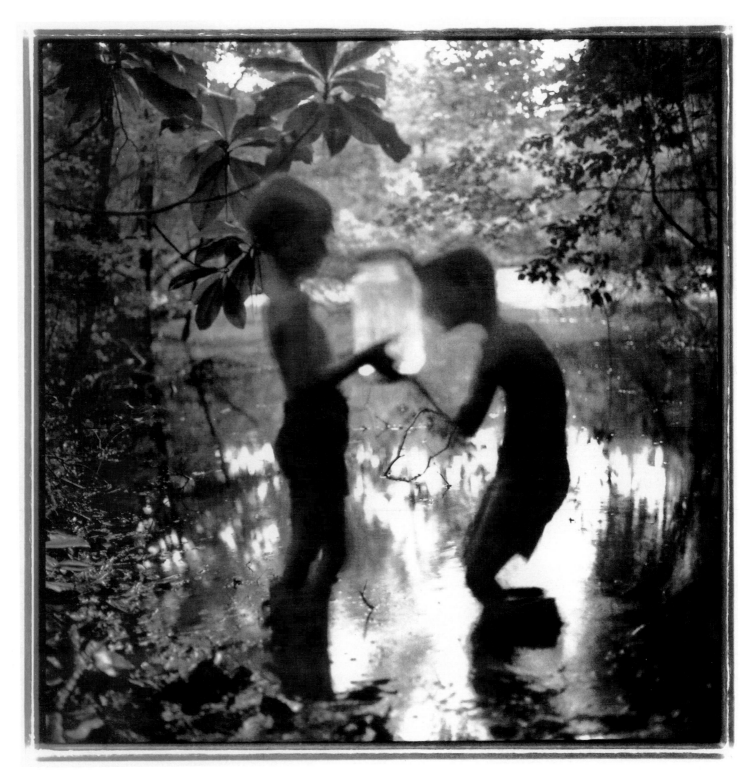

Keith Carter

Fireflies, 1992

There's no rule that says your main subject must be in focus. By focusing beyond the figures rather than on them, and exposing for the light behind them to turn them into virtual silhouettes, Carter gives a dreamlike quality to what would otherwise have been a literal representation. This makes the photograph seem more like a memory of childhood than a faithful rendering of children at play. © Keith Carter/Photographer, Inc.

THE AUTOFOCUS SHUTTER BUTTON

On an autofocus camera, the shutter button is more than just the button you push to take a picture. It's also your main autofocus control. Press it halfway, and the camera autofocuses—locking the focus on whatever part of the scene the viewfinder's focus point is covering. Press the shutter button all the way and the camera takes the picture.

Getting a feel for the shutter button's two-step operation takes a little patience. The key is to keep your finger on the shutter button at all times—before, during, and after the exposure. If a subject moves in or out, if you move back and forth to change your composition, or if you decide to focus on a different part of the scene, all you have to do is lighten your touch on the shutter button, reposition the focus point, and press the shutter button halfway again. You're ready for the next shot.

Training yourself to use an autofocus camera's shutter button in this smooth way, instead of poking or jabbing it, has an added benefit: It lessens the chance that you will shake the camera when you take the picture. And this makes it all the more likely that the picture will be sharp.

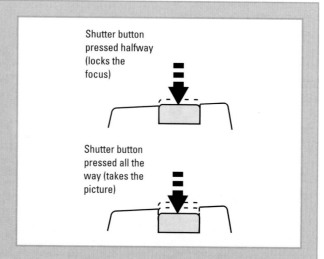

The shutter button on an autofocus camera is actually a two-position control. Pressing it halfway down activates the autofocus (AF), and locks the focus as well. Pressing the button all the way down takes the picture.

FOCUSING A RANGEFINDER

Unlike an SLR, a TLR, or a view camera, a rangefinder has no screen for focusing. Instead, you focus by aligning a double image of the scene that appears in a small, bright rectangle in the center of the rangefinder's viewfinder. One of those images is simply a brightened section of the whole scene visible through the viewfinder. The other is of the same section, only fainter; it comes through a second window on the far side of the camera body's front, then is bounced by a prism to a half-silvered mirror inside the eyepiece.

A rangefinder lens's focusing ring is mechanically linked to the prism. As you turn the ring, the prism rotates, shifting the position of the image on the mirror (the fainter image) from side to side. You adjust the focus until that fainter image is superimposed on the brighter image.

Rangefinder focusing can be very accurate. And there are even several autofocus rangefinder models available. The combination of rangefinder focusing and autofocus technology makes the process even more precise.

The main problem with rangefinder focusing occurs when there is not enough subject detail to focus on at the center of your composition, where the focusing patch is. In particular, there may be no strong vertical lines—and superimposing the two images is much easier with vertical elements. Even if there's something to focus on in the exact middle of your composition, you may not want to focus there because the most important part of the scene—the part you want sharp—is off to the side.

So to focus a rangefinder, you often need to first identify an area of good detail that's at about the same distance as the main subject. Position the rangefinder patch over the area, focus, then reorient the camera to establish your final composition before taking the shot. This approach is very similar to focusing with an SLR's split-image circle.

In the middle of a rangefinder camera's viewfinder is a rectangular patch that is brighter than the surrounding area. When the subject is out of focus, a double image of that area appears in the patch (left). To focus the camera, you rotate the lens's focusing ring until the two images appear superimposed (right).

land the focus point on the part of the scene you want most sharp—ordinarily the main subject. When this happens, the camera will focus on some other part, causing the main subject to be rendered unsharp. The most common instance of this is when you place a subject off-center in the frame. Off-center composition usually causes the viewfinder's focus point to fall on the background, which will throw the main subject out of focus, if it's in the foreground.

Focus Lock Fortunately, there's a simple technique that sidesteps this problem. It's called **locking the focus.** Locking the focus is fundamental to using an autofocus camera. In most cases you lock the focus with the shutter button—the very same button you use to take the picture. In fact, autofocus cameras' shutter buttons are specifically designed for a two-step operation (see box, opposite).

You use this shutter-button two-step, together with the viewfinder's focus point, to control where the autofocus system focuses. Here's what you'd do if your main subject were off-center to the right. First, "aim" the focus point at the subject; doing this will temporarily center it in the frame. Next, press the shutter button halfway down to make the camera autofocus. Then, maintaining that halfway pressure to lock the focus, reestablish your final composition (that is, pivot the camera to the left to place the subject off-center to the right). Finally, press the shutter button all the way to take the picture. Locking the focus quickly becomes reflexive. (See page 35 for a step-by-step description of the procedure.)

If the subject is dead-center in the frame you don't have to lock the focus;

locking the focus
With an autofocus system, the technique of pressing the shutter button halfway down and holding it there to prevent the camera from refocusing when you finalize your composition and shoot.

wide-area autofocus Autofocus system that features several focus points across the middle of the viewfinder for better focusing control with off-center subjects; also called multipoint autofocus.

WIDE-AREA AUTOFOCUS

Many autofocus SLRs make focusing on off-center subjects easier by incorporating **wide-area autofocus** or multipoint autofocus systems. These models have several focus points (usually three or more) arrayed across the central quarter or third of the viewfinder, indicated by various markings, such as simple brackets or boxes. Because multiple focus points cover a larger area in the middle of the viewfinder, they're more likely to overlap a subject to one side. For this reason, wide-area AF can focus on subjects that are slightly off-center. But if a subject is substantially off-center, you usually need to lock the focus before shooting.

With wide-area autofocus models, the camera can choose which focus point it uses for focusing, usually picking the one that falls on the closest part of the scene (such as an off-center main subject). But with most models you can also choose the focus point yourself, with a thumbwheel or dial. (Certain models even let you choose simply by glancing at the point!) When focus is achieved, the point glows or darkens to indicate that it has been selected.

This enhanced control is useful when you're shooting a lot of pictures of an off-center subject, eliminating the need to lock the focus after each exposure. Instead, you just select one of the outermost focus points, making sure it covers the subject, and maintain your composition while shooting.

you can just press the shutter button in one continuous motion. But even some centered subjects can trip up autofocus. Two people standing side by side, for example, may have a gap between them—and if the viewfinder's focus point falls within that space it may focus on whatever is behind the figures.

An AF camera usually tells you that it has focused successfully by lighting up its autofocus confirmation lamp, usually found along the edge of the viewfinder frame where other displays appear. Some models also can be set to emit an audible beep once autofocus is complete. Just

keep in mind that the camera will light up the lamp, or beep, even if it has focused in the wrong place, as long as it has focused somewhere. So even with an autofocus camera, you need to check in the viewfinder to make sure the subject you want is sharp.

Despite such advantages and refinements autofocus has its problems, and it can be thrown off by certain kinds of subjects. Some AF models have difficulty focusing on horizontal lines—Venetian blinds, for example. If yours does, focus on something else at the same distance, or tilt the camera a little sideways so that

HOW AUTOFOCUS WORKS

The autofocus systems in today's electronic SLRs borrow from both video and digital technologies. To determine the subject's distance from the camera, they actually split its image in half right down the center of the lens. Light rays from these partial images are focused through secondary lenses onto two separate rows of tiny light-sensing cells. The pattern of light on each row of cells is converted to a digital signal, and the two signals are compared by a microcomputer. If the patterns match, the subject is in focus. If they don't, the computer determines how far apart they are, and how much of a correction in focus is required to make them match. That information is then relayed to the focusing motor, which moves the lens in or out as needed. All of that happens in a split-second.

Because it analyzes light reflected by the subject, this approach is called **passive autofocus.** But dim or flat (low-contrast) light can trip it up, so some models use a backup system, called **active autofocus,** when light drops below a certain level. With active AF, a beam of red light is projected onto the subject, and the camera uses its reflection to measure the subject's distance. (The lamp that creates the beam is built into the camera body or accessory flash unit.)

Though active AF isn't dependent on subject contrast the way passive AF is, unlike passive AF it's limited in its distance range. It also tends to be less accurate. But it's cheaper to manufacture, which is one reason it's the autofocus technology ordinarily used in most point-and-shoot cameras.

the horizontal lines are at an angle. Also, autofocus systems can't operate below a certain light level without the help of an AF-assist beam built into the camera body or an accessory flash unit (see box above). What's more, if an AF SLR's focus point lands on a part of the subject that is either lacking in detail or texture (a featureless white wall) or that is highly reflective (the sun shining on water), the camera will have difficulty focusing. Whatever the cause, you'll know the camera is having a problem because the lens will zip back and forth, trying but failing to make the subject sharp. When that happens, there's a simple solution: Focus manually.

AF Modes Autofocus cameras usually have two AF modes: **one-shot autofocus** and **continuous autofocus** (also known as servo autofocus). In one-shot AF, the camera won't let you take a picture until it has achieved focus, then it locks in the focused distance until you let up on the shutter button. (This is why one-shot AF is sometimes known as "focus-priority" AF.) One-shot AF is an autofocus camera's basic focusing mode, and it's the mode in which the focus-locking technique is crucial. If a subject moves forward or backward after you've locked the focus, to prevent it from being out of focus in your picture you have to let

up on the shutter button and press it again to refocus.

This isn't a very practical approach to subjects that are moving, which is why manufacturers usually add continuous autofocus mode. In continuous AF, the camera keeps refocusing continuously for as long as you press the shutter button, immediately adjusting for changes in composition or subject distance. This mode is also known as "release-priority" AF because it lets you take the picture (release the shutter) regardless of whether the subject is in focus.

Continuous autofocus usually comes with a further refinement: **predictive autofocus,** sometimes also known as "focus tracking." Cameras with this capability can actually anticipate the position of a moving subject at the exact moment of exposure, compensating for the slight delay between when you press the shutter button and when the shutter opens. Predictive autofocus is an effective alternative to traditional "follow focusing," in which a photographer actually adjusts the focus manually to keep a moving subject sharp. It's especially effective with continuous film advance, in which the camera shoots rapid-fire frames for as long as you hold down the shutter button.

As sophisticated as they've become, autofocus systems are still much more literal in their photographic "thinking" than a human operator. An experienced photographer knows when focus is adequate to produce an acceptably sharp result, taking the picture even if it's not exact. A one-shot autofocus system has to get the focus perfect or it just won't take the picture at all. An experienced photographer knows something the camera doesn't: that the most important thing is to get the picture.

passive autofocus
Autofocus system that works by analyzing light reflected from the subject.

active autofocus
Autofocus system that works by projecting a beam of red light onto the subject; activated when light is too dim for passive autofocus.

one-shot autofocus
Autofocus system in which the camera won't let you take a picture until it has achieved focus.

continuous autofocus
Autofocus system in which the camera readjusts focus continuously as the distance between the camera and subject changes.

predictive autofocus
Autofocus system that anticipates the position of a moving subject, adjusting focus to compensate for the delay between when you press the shutter button and when the shutter actually opens.

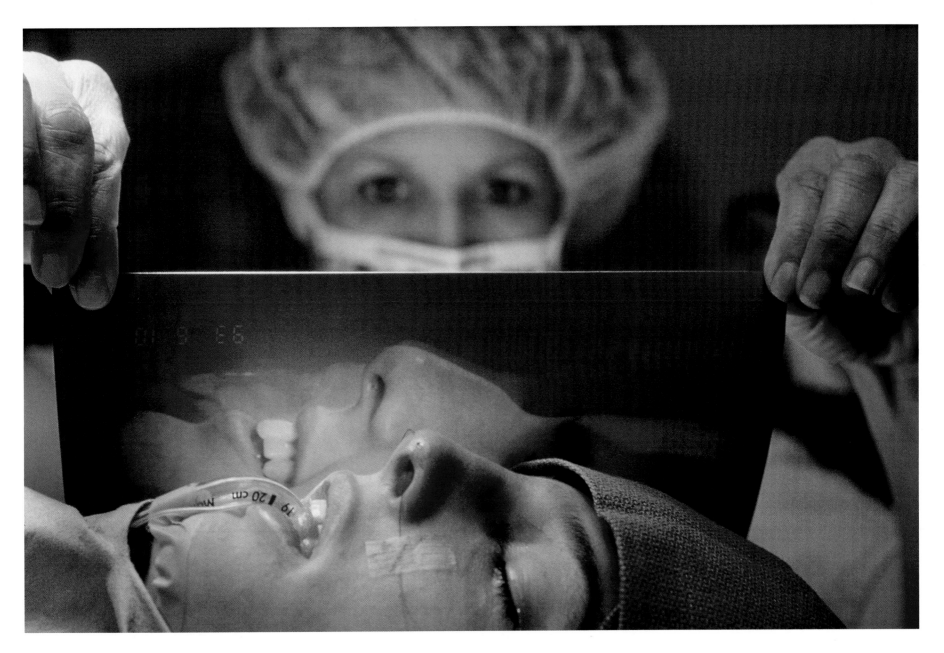

Lauren Greenfield Lindsey, 18, after her nose-job surgery. A nurse holds a photograph of Lindsey's preoperation nose.
When you're photographing a close subject, as here, there is less margin for focusing error than with subjects that are farther away.
For this reason, you have to focus more carefully. But once a close subject is correctly focused, things behind it or in front of it fall
out of focus dramatically—causing it to stand out sharply. The effect in Greenfield's photograph is to give especially strong empha-
sis to the subject of the photograph—and the results of surgery © *Lauren Greenfield*

CLEANING THE LENS

Even the best photographic lens can't create a sharp image with good contrast if it's dirty. Lenses are vulnerable to fingerprints and also to regular exposure to an outdoor environment, which can cause a buildup of dust and grime on the front element of the lens. To ward off smudges and dust, many photographers keep a clear (UV or skylight) filter screwed onto the front of the lens (see Chapter 10). The filter eliminates the need to repeatedly clean a lens, though you'll have to clean the filter itself. But if you must clean the lens, do it carefully; otherwise, you may abrade the thin coatings on lenses that control reflections.

To properly clean a lens or a filter, you'll need special lens cleaning fluid and tissue, both available at photo retailers. Before cleaning, remove loose grit and dirt from the lens surface with compressed air or, in a pinch, by blowing on it. (If there's grit on the lens when you rub it with a tissue, you will scratch it.) Apply several drops of cleaning fluid to a tissue folded over on itself, then use it to gently wipe the lens surface in a spiral pattern, starting at the center of the lens and continuing to the edges. Do this several times if necessary, then take a dry tissue and apply it gently in the same way to polish out streaks.

Special microfiber cleaning cloths are often sold for lens cleaning. These can be used in conjunction with fluid following the procedures above. Some photographers use them dry, but even if you're careful to dust off the lens surface first, doing so increases the risk that grit will scratch the lens as you wipe it.

One final note: Remove your lens and inspect its back, too, cleaning it if necessary. Though it's more protected when on the camera than the front, it can get smudged when you change lenses.

Always clean a photographic lens with tissues, cloths, and fluids specially designed for the purpose. These materials are available at all photography stores. To prevent scratches, be sure to blow or brush off the lens surface before applying pressure with the tissue or cloth you use.

FOCUSING SCREENS AND DIOPTERS

Advanced SLRs often feature interchangeable focusing screens, allowing you to switch from one screen to another for particular types of subjects. (Depending on the camera used, screens are exchanged either through the lens mount or by removing the camera's pentaprism.) Standard screens for manual-focus SLRs often incorporate both a split-image circle and a microprism collar (see pages 58–59). But you can get everything from plain screens (to focus simply by judging the subject's visible sharpness) to screens with grids of lines for precise composition (especially useful for maintaining straight lines with architectural subjects). Note that focusing screens for autofocus SLRs have altogether different markings (see page 63).

Standard focusing screens vary in their brightness, and a screen's brightness can affect your ability to focus manually. Some independent companies sell replacement focusing screens that produce a brighter image than standard-issue screens; others offer proprietary treatments that brighten off-the-shelf screens. (You send your existing screen to the company for this treatment.) These options can help if you do a lot of shooting in dim light, but they all require that your screen be interchangeable.

Problems with manual focusing can also be due to the optical system that relays the image from an SLR's pentaprism to your eye. In fact, some cameras have a small dial or sliding control adjacent to the viewfinder eyepiece called a **diopter adjustment,** which allows you to fine-tune the viewfinder optics to suit your individual vision.

You may also be able to get accessory diopter lenses that screw directly into the viewfinder eyepiece of some camera models. Matched to your specific prescription, these allow you to use the camera without your glasses. But if your correction is high, when you take the camera from your eye you won't see the subject clearly—and you may not even be able to check camera settings unless you put your glasses back on. Some find this more awkward than having to shoot with glasses.

Some SLR cameras offer interchangeable focusing screens, allowing you to substitute special-purpose screens for the one that comes in the camera, which with manual focus models is most often a combination of split-image circle and microprism collar (top). One popular alternative is the gridded screen (center), which helps you keep lines straight with architectural subjects. Another type fills the whole central circle with a microprism texture (bottom). Focusing screens are switched either through the camera's open lens mount or by removing the camera's viewfinder prism.

diopter adjustment
Camera control that allows manual adjustment of viewfinder sharpness to suit your particular eyesight.

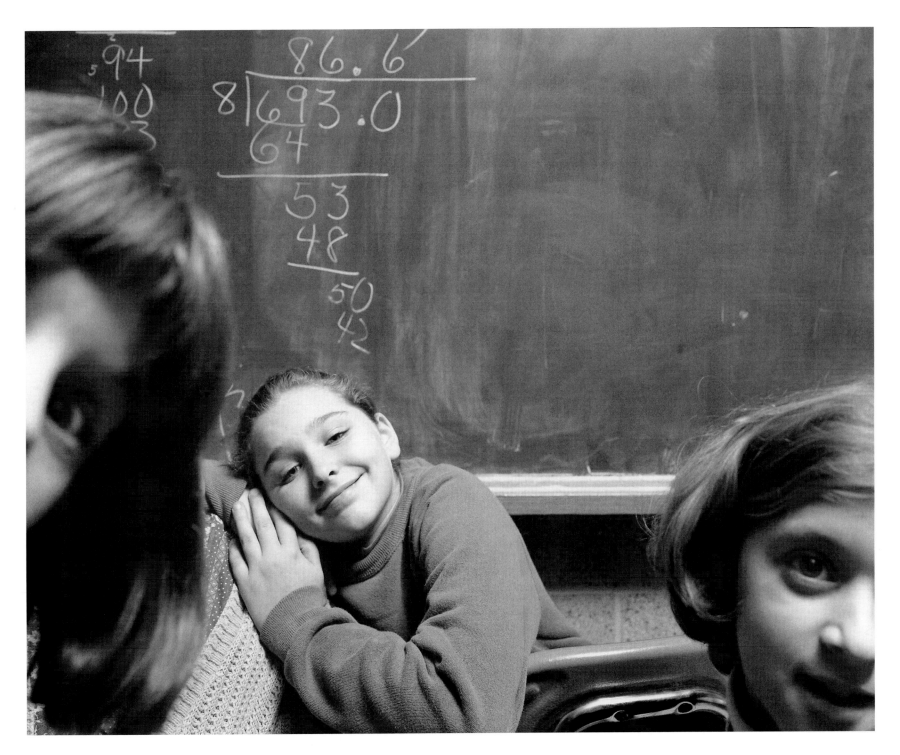

Nicholas Nixon Math. Rebecca, Sylvie, and Claudia. Room 306, Tobin School, Cambridge, 1994
Because an 8" x 10" view camera is bulky and slow to operate, it's normally reserved for static subjects—those that will hold still for composing and focusing. Nicholas Nixon defies this conventional wisdom by using the camera to create unstudied pictures of people in groups. This means he must compose and focus very quickly. Note that focus is especially critical with medium- and large-format cameras because they require longer focal lengths than 35mm cameras for the same visual effect, and longer focal lengths make depth of field, the zone of focus from front to back, especially shallow. © Nicholas Nixon

ALEX WEBB
COLOR DOCUMENTARY PHOTOGRAPHY

WEBB'S TOOLS

Two 35mm rangefinder bodies

28mm, 35mm and 50mm rangefinder lenses

35mm SLR body

24mm, 50mm and 85mm SLR lenses

Hand-held incident light meter

On-camera flash (with diffusing dome and tan gel for warming effect)

Homemade boxes to hold 8 rolls of film

A documentary photographer records and interprets the people, activities, and environments of various cultures and societies. This is somewhat similar to what photojournalists do, but documentary photography is generally more in-depth than photojournalism. It almost always involves a greater time commitment—and many more rolls of film.

But in many ways the line between documentary photography and photojournalism is blurred. Some photojournalists, particularly those working for magazines, do in-depth work. And at times documentary photographers do shorter assignments for newspapers and magazines as a way to make a living.

Unfortunately there are relatively few paying jobs for pure documentary photographers. It's a freelance business, and even the most successful ones struggle. Perhaps that's the reason documentary photographers are so passionately committed to their work; the ones that aren't don't survive for long. That commitment is often driven by the documentary photographer's passion for the subject, often a particular place, culture, or political issue that holds special meaning for him or her.

Alex Webb is one of the most successful documentary photographers working today. Making a living for Webb and other documentary photographers usually means a hodgepodge of projects that vary widely from year to year and that alternately generate and siphon off income. While working on one or more personal projects, Webb will also do a few editorial (magazine) and corporate assignments, teach a class or two, and possibly lecture. Sales of original prints and an occasional grant help. Income from syndication—reuse of photographs in magazines, books, and other media—is also important. Webb's syndication and assignment work are handled by his well-regarded agency Magnum, home at various times to Henri Cartier-Bresson, W. Eugene Smith, Mary Ellen Mark, Bruce Davidson, Elliot Erwitt, and many other legendary photographers.

Webb's work is often exhibited in museum and gallery settings and is owned by many institutional and private collectors. However, books are his preferred vehicle for presenting photographs. In fact, he starts most of his personal projects with a book in mind, though not all end up being published that way. "Magazines need to sell ads and magazines," he explains, "and once your photographs go to a magazine it's out of your control." Books have their limitations, of course—production costs must be carefully controlled—but relatively speaking, Webb gets to exercise "considerable freedom in structuring and sequencing a book."

There are other reasons books work so well for Webb. Because they typically use fifty or more photographs on a single subject, he gets to show the subject in great depth. This is what every documentary photographer lives and works for. Also, books have a relatively long life. Unlike magazine stories or exhibitions, they stay intact and available for a much longer period of time. But for Webb there are personal reasons for his strong attraction to bookmaking. From his student days in New England, he always felt a strong "kinship to writers and poets." He majored in history and literature at Harvard, finding inspiration in novelists as varied as Graham Greene, Gabriel Garcia Marquez, Elmore Leonard, and Russell Banks.

While he worked in black-and-white as a young photographer, a trip to the Caribbean, "where color is such an important part of the culture," turned Webb around. Stylistically, his work is uniquely intense—what he calls "punchy and emotional"—with bursts of color vying with deep dark shadows. Another common thread to Webb's work is his curiosity and his willingness to accept ambiguity and the "enigma of the world." Unlike many photojournalists and other documentary photographers, he doesn't try to create a final statement about his subjects. Instead, he sees his work as an ongoing investigation rather than a neat conclusion.

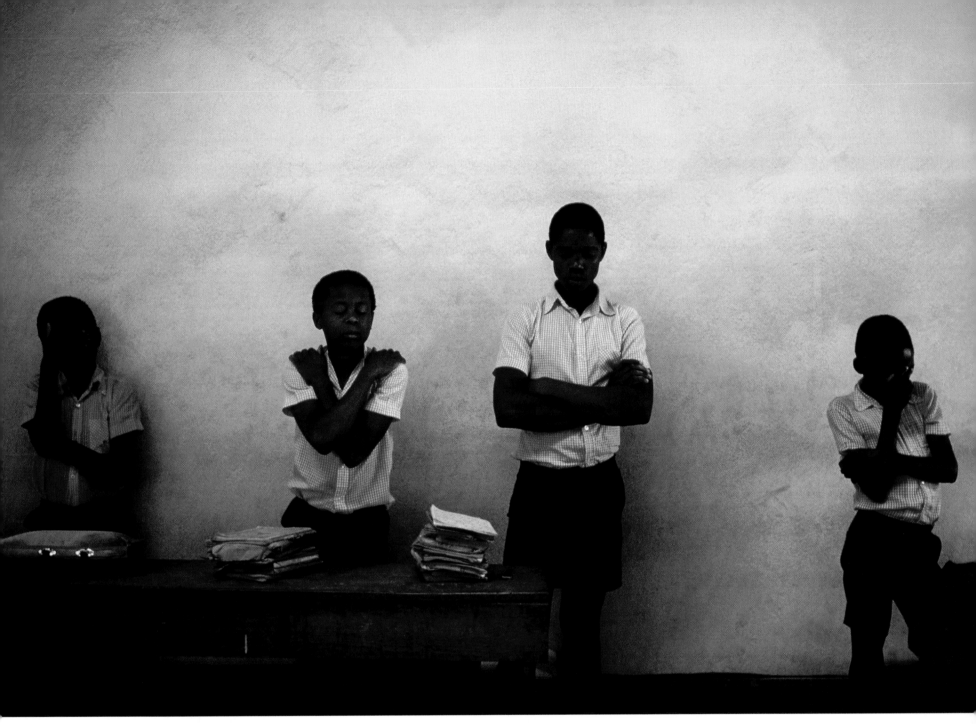

Bombardopolis, Haiti
1986

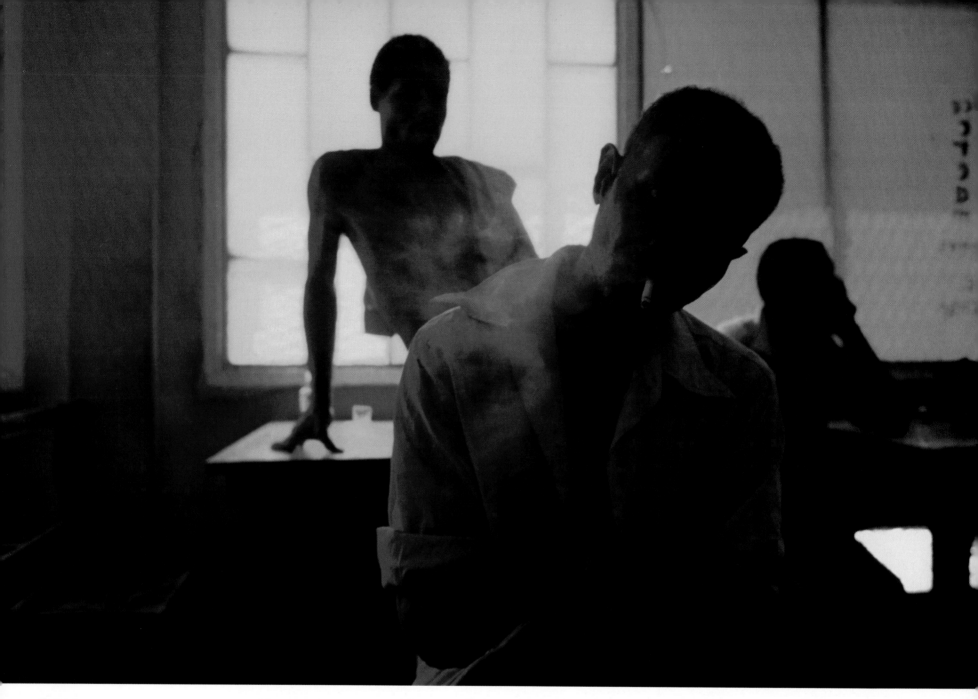

Grenada
1979

His work from Haiti, published in 1989 as *Under a Grudging Sun*, is a good example of this. He started going to Haiti on his own to photograph the people, and within two years he had been back and forth nine times on various magazine assignments, and for himself. The climate changed dramatically during the time he was there, as the political situation became more and more violent. Though his photographs were used to describe that situation, for Webb his book was structured more as a spiral, much as he saw the history of Haiti—violent periods interlaced with more peaceful times. He saw the final work as "a continuing document of the street, with a specific socio/political point of view," not a neutral record of the two years he spent there.

Webb uses 35mm transparency film, mainly Kodachrome 64 and Kodachrome 200. The transparencies are sent directly to the printer when the image is used for

publication. For exhibitions, Webb makes Ilfochrome prints directly from the transparencies (see pages 344-346).

When photographing in bright light, Webb prefers to use a 35mm rangefinder. It's small and unobtrusive, and unlike single-lense reflex (SLR) cameras, everything appears sharp when seen through the rangefinder—a quality Webb likes, except in low light when he prefers an SLR. Low light means wide open apertures and shallow depth of field. As you look through an SLR, you see the depth of field provided by the largest aperture, so you see color and shapes out of focus—as they will appear in the final image.

Among Webb's many other projects are books on the Caribbean, Florida, and the Texas-Mexico border. Though he has generally been successful getting his projects published, each one is a new challenge. The problem is economic; photography books are expensive to produce

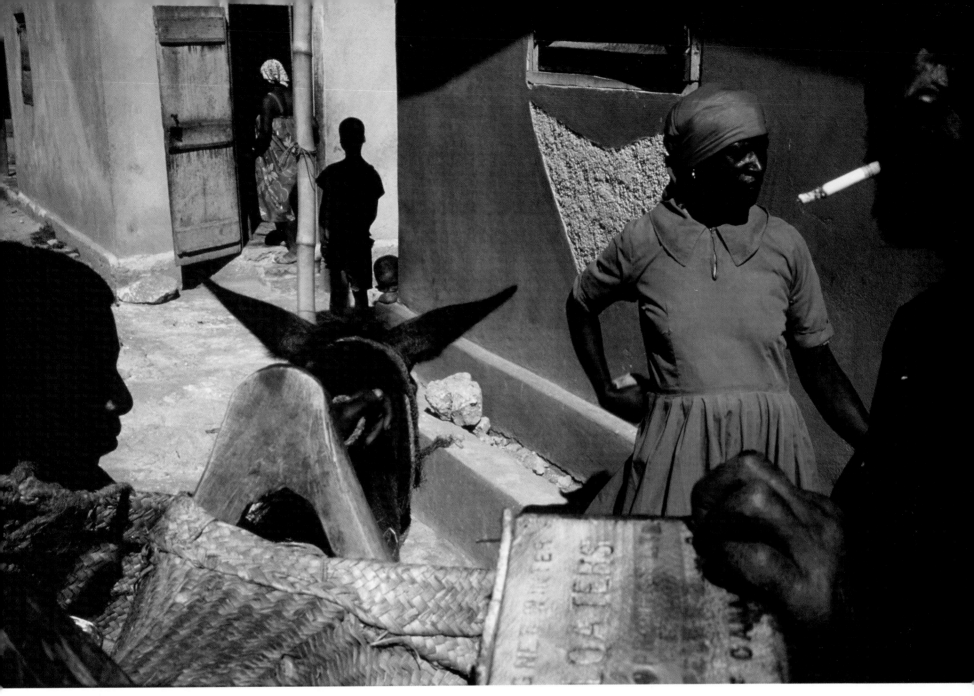

Bombardopolis, Haiti
1986

and rarely sell well enough to make a profit. Understandably, it's difficult to convince publishers that they should invest in a book that may lose money.

Still, Webb will continue on his projects—and with the help of an assignment from a magazine, maybe a university lecture, and possibly a publishing grant, he'll get another book in print. Documentary photographers are rarely wealthy, but they are resourceful—and determined. For the good ones, their work is their life, and they somehow manage to find a way to live it.

DORIS ULMANN

Baptism, South Carolina, c. 1930

*Ulmann combined a Pictorialist style with social content, pho-
tographing American rural traditions with a large-format camera
and a soft-focus lens. Here, she used a lens of moderately long
focal length to magnify her subject enough so she didn't have to
venture into the water.* University of Oregon Library System

THE LENS:
FOCAL LENGTH

The main way photographers describe a lens and what it does is by its **focal length.** Technically, focal length is the distance between the lens and the image it forms when it's focused at infinity—as far away as possible. A lens's focal length is often called its "size" (as in, What size lens are you using?), and determines two things. The first is how big your main subject will be in a photograph, a variable called **magnification.** The second is how much of a scene you can fit in a frame, a variable called **angle of view.**

Some lenses are of fixed focal length, referred to as **single-focal-length lenses.** The only way you can change the image a single-focal-length lens puts on film is by changing your physical position and/or moving the camera; you cannot adjust the lens's magnification or angle of view. Other lenses allow their focal length—and thus their magnification and angle of view—to be adjusted over a specified range. These are called **zoom lenses.** Zooms are commonly available for 35mm SLRs (and point-and-shoot) cameras, but they are rare with other types of cameras.

Focal length is expressed in millimeters, abbreviated mm, and is usually indicated on the front of the lens barrel. A single-focal-length lens's focal length is denoted by a single number, such as 50mm (referred to as a fifty-millimeter lens). A zoom lens's focal length range is denoted by a pair of numbers, such as 35–70mm (referred to as thirty-five-to-seventy millimeters). Keep in mind that the terms "35mm camera" or "35mm format" have nothing to do with focal length; in these cases, 35mm simply refers to the width of the film. Confusion often arises because 35mm is

focal length Distance between the lens and its image (on the film) when lens is focused at infinity.

magnification How big your subject will be represented on film.

angle of view How much a lens "sees"—what portion of a scene it records on film.

single-focal-length lenses Lenses that offer just one specific focal length, such as 50mm or 135mm.

zoom lenses Adjustable lenses that can be set within a range of focal lengths, such as anywhere from 28mm to 70mm.

FORMAT, LENS, FOCAL LENGTH, AND ANGLE OF VIEW

A lens's angle of view depends upon what format you are using. For instance, a 135mm lens on a 35mm SLR camera is considered telephoto. But the same 135mm focal length on a large-format view camera is considered wide angle. The following chart shows the relationship between typical focal length lenses and their angles of view for different size cameras:

Focal Length	Angle of View/Film Format 35mm		6x7cm		4"x5"	
14mm	114°	Wide				
20mm	94°	Wide				
28mm	75°	Wide				
35mm	63°					
40mm			98°			
50mm	46°	Normal	85°			
55mm	43°	Normal		Wide	112°	
65mm			71°	Wide	102°	
75mm			63°		95°	
85mm	28°				Wide	
90mm			54°	Normal	84°	
105mm	23°		47°	Normal		
135mm	18°				62°	
150mm			34°		57°	Normal
165mm					52°	Normal
200mm	13°		26°		44°	
210mm		Telephoto	25°		42°	
250mm		Telephoto	21°			
300mm	8°	Telephoto		Telephoto	30°	Telephoto
350mm			15°		26°	
400mm	6°					
480mm					19°	
500mm	5°		10°			
1000mm	3°					

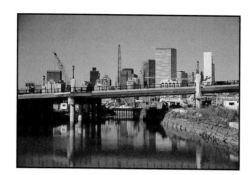

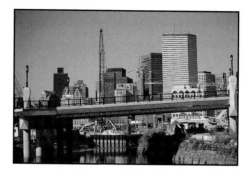

20mm lens
(94º angle of view)

35mm lens
(63º angle of view)

50mm lens
(46º angle of view)

The longer a lens's focal length—expressed in millimeters—the more it magnifies your subject, as shown in this series of pictures shot with a 35mm camera from the same position with different lenses. As magnifying power increases, the amount of the scene taken in by a lens—called the angle of view—is reduced. A 20mm ultrawide-angle lens, for example, has an angle of view of 94°, so it reproduces subject details at a smaller size since it includes such a large area. A 500mm supertelephoto lens has a narrow 5° angle of view, so it greatly enlarges distant details.

135mm lens
(18º angle of view)

300mm lens
(8º angle of view)

500mm lens
(5º angle of view)

coincidentally a popular focal length for a 35mm camera.

You can change your focal length—and thereby change the size of your subject or the portion of a scene you capture—in two ways. If your camera is an interchangeable-lens model (one that allows you to remove and reattach its lenses), you must switch to a different lens. And if you're shooting with an SLR and a zoom lens, you can adjust the lens's focal length, usually by rotating a ring on its barrel. Either way, you can see the full effect of changing the focal length through a viewfinder, one big advantage of using an SLR. That's important, because the ability to change focal length is one of photography's great creative tools.

To help describe what they do, lens focal lengths are generally grouped into three categories: normal, short, and long. The **normal focal length** for a 35mm SLR is 50mm. **Long focal lengths** for 35mm SLRs are those significantly beyond 50mm, usually around 70mm and up, and **short focal lengths** for 35mm SLRs are those well under 50mm, usually 35mm and below. A normal focal length makes things look roughly the same size in the viewfinder as they do to your eye. A long lens magnifies things, making them appear larger in the camera's viewfinder than they do in life—sort of like looking through a telescope, which is one reason long lenses are often called **telephoto lenses** (see page 79). And a short lens actually makes things look smaller than they do to your naked eye, but in the process captures a bigger (wider) section of the scene you're shooting. This is the reason short lenses are usually called **wide-angle lenses** (see pages 75, 77, 79).

Different focal lengths have different photographic applications. And every kind of subject tends to have a different focal length, or group of focal lengths, that best suits it—though there's plenty of room for interpretation. In providing different magnification and angles of view, different focal lengths also lend themselves to a variety of photographic perspective effects (see page 80), as well as a range of depth of field (see Chapter 6).

NORMAL LENS

Before zooms became commonplace, nearly all 35mm SLRs were sold with "normal" lenses—single-focal-length

50mm f/1.4

A normal focal length is the best choice when you want your lens to create an image in which the scene's size relationships seem most natural.

50mm lenses. But the main reason was that a 50mm focal length reproduces the subject in the viewfinder (and on film) in much the same way as we see it. Even the standard zooms sold with most current 35mm cameras have ranges that encompass the 50mm focal length, such as 35–70mm or 28–80mm.

In reality, human vision spans more than the fairly narrow angle of view of a 50mm lens, which measures about 46° (see chart on page 73). A better way to think about the normal lens is that, of all focal lengths, it helps you create the

most natural photographic representation of the size relationships between elements of a scene. In a sense, then, 50mm is the most "transparent" of all the focal lengths available for 35mm cameras; it has the fewest optical effects and distortions.

Normal lenses offer several advantages. They are almost always lighter and more compact than lenses of any other focal length. And they usually have a relatively wide maximum aperture (the size of the largest f-stop), which makes them able to gather light more quickly from the subject. This allows you to shoot hand-held (without a tripod) in lower light levels—indoors and out. By contrast, zooms have smaller maximum apertures, which limits your ability to shoot in lower light. Longer and shorter single-focal-length lenses also tend to have smaller maximum apertures than normal lenses.

But the 50mm focal length can be limiting: too narrow in its angle of view for general-purpose shooting, yet not long enough for distortion-free portraiture. Portraits are usually best made with slightly longer lenses (see page 80). This is one reason zooms, ranging from moderately short to moderately long, have replaced 50mm lenses as standard on most current cameras; they expand the range of subject matter you can shoot, from landscapes to portraits.

WIDE-ANGLE LENS

A wide-angle focal length does just what it sounds like it does: it takes in a larger section of the scene you're photographing than you'd get with a normal focal length. In fitting more of a scene on the film, a wide angle makes objects look smaller

normal focal length
Lens focal length that reproduces a subject approximately as it appears to the human eye. For 35mm format, 50mm is considered "normal."

long focal lengths
Lenses that magnify the subject to appear larger than it does to the human eye. For 35mm format, 70mm and up.

short focal lengths
Lenses that reproduce a broad view, or wide angle, of a scene. For 35mm format, usually 35mm or less.

telephoto lenses
Long focal lengths.

wide-angle lenses
Short focal lengths.

14mm f/2.8

Fish-eye 15mm f/2.8

24mm f/2.8

17-35mm f/2.8

50mm f/1.4

28-70mm f/2.8

35-80mm f/4.0-5.6

85mm f/1.8

85mm f/1.2

100mm f/2.8 Macro

28-135mm f/3.5-5.6

200mm f/2.8

70-200mm f/2.8

80-200mm f/4.5-5.6

75-300mm f/4.0-5.6

35-350mm f/3.5-5.6

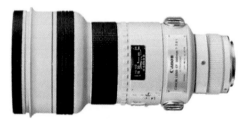

300mm f/2.8

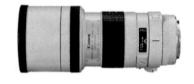

300mm f/4.0

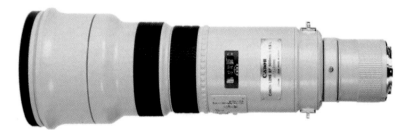

500mm f/4.5

Lenses for 35mm photography come in a range of shapes and sizes that reflect their many different purposes. Physically smaller lenses are generally of shorter focal length and/or have smaller maximum apertures. Larger lenses are generally of longer focal length and/or have wide maximum apertures. Many lenses have special optical and/or mechanical designs and features that allow everything from close-up photography (macro lenses) to control of perspective (PC lenses).

28mm f/2.8

A wide-angle lens is useful when you want to photograph a large area from a fairly close position. Doing this "stretches" the picture space, so wide-angle lenses are also valuable for setting up relationships between foreground and background elements.

than they would be rendered by a normal focal length. Typical single-focal-length wide-angle lenses come in 20mm, 24mm, 28mm, and 35mm focal lengths, and wide-angle zooms have a variety of ranges, including 20–35mm.

The most obvious time to use a wide-angle lens, or a wide-angle setting on a zoom, is when you otherwise wouldn't be able to get far enough away from a subject to include it all. A wide-angle lets you show more of an interior, for example. It makes it easier to include the top of a tall building when other buildings or nearby structures prevent you from getting farther away or when they block your view. A wide-angle focal length also lets you include a larger span of landscape in the frame when your ability to move backward is limited or logistically difficult. More subtly, it can create a sense of being inside the subject or action, rather than at a distance from it, which is most interesting when you're photographing groups of people. You get this effect because you have to be closer to the subject in order to make it fill the frame.

A wide-angle focal length also has great value as a compositional tool.

While it lets you get closer to an object to make it fill a big part of the frame, it still shows a lot of the background. Doing this also makes close objects seem larger relative to background details, which in turn allows you to set up dramatic near-far relationships. Landscape photographers are especially fond of this tactic, composing with prominent foreground elements (plants, structures, and so on) and also showing a wide expanse of background (fields, mountains, and so on). The resulting sense of depth and dimensionality just isn't possible with longer focal lengths.

Wide-angle focal lengths are well suited to this type of composition for two more reasons. All other things being equal, they offer greater depth of field—a deeper zone of sharpness—than lenses of longer focal length (see Chapter 6). This means that near and far parts of a scene usually can both be made sharp. Also, wide-angle focal lengths usually allow you to focus at much closer distances than longer focal lengths; this is especially true of single-focal-length wide-angles. While a long lens for the 35mm format might not let you focus any closer than five or even ten feet, depending on its particular focal length and design, a wide-angle may let you focus as close as one foot. And if you combine middle-distance focus with a relatively small lens aperture, a wide-angle can make everything in the picture sharp from a few feet away to infinity. No other type of lens can do that.

The generous depth of field associated with wide-angle focal lengths makes them as popular among photojournalists as they are with landscapists. If a photog-

rapher is fairly sure in advance that a subject will fall within a certain distance range, rather than refocusing each shot individually he or she can preset the lens's focus to a specific distance, choose a relatively small lens aperture, and fire away. (See Chapter 4 for more about such techniques.)

Moderately wide, the 35mm focal length has a 63° angle of view that's broader than a normal lens's subject coverage, yet produces a minimum of distortion. This balance makes it a good choice for environmental portraiture—pictures of people that include meaningful surroundings, rather than simply concentrating on the person. But it's at the 28mm focal length that true wide-angle effects and benefits such as those described above start to come into play. The 28mm focal length's 75° angle of view lets you shoot tight interiors or tall buildings. A 20mm focal length offers an even wider 94° angle of view, and though it's prone to distort the subject, careful composition can minimize the effect. Focal lengths of 20mm and shorter (18mm, 14mm, and so forth) are often called ultrawide-angle.

In the wide-angle focal length range, a change of just a few millimeters in focal length has a significant effect on angle of view. This is one reason wide-angle zoom lenses, which can be set to incremental focal lengths—23mm or 29mm, for example—are so popular. Perhaps the most popular range is 20–35mm, but such zooms come in 17–35mm, 20–40mm, and 24–50mm ranges, among others. And many zooms start with wide-angle focal lengths and zoom to long focal lengths, such as 28–70mm, 28–80mm, 35–105mm, 28–200mm, or 28–300mm.

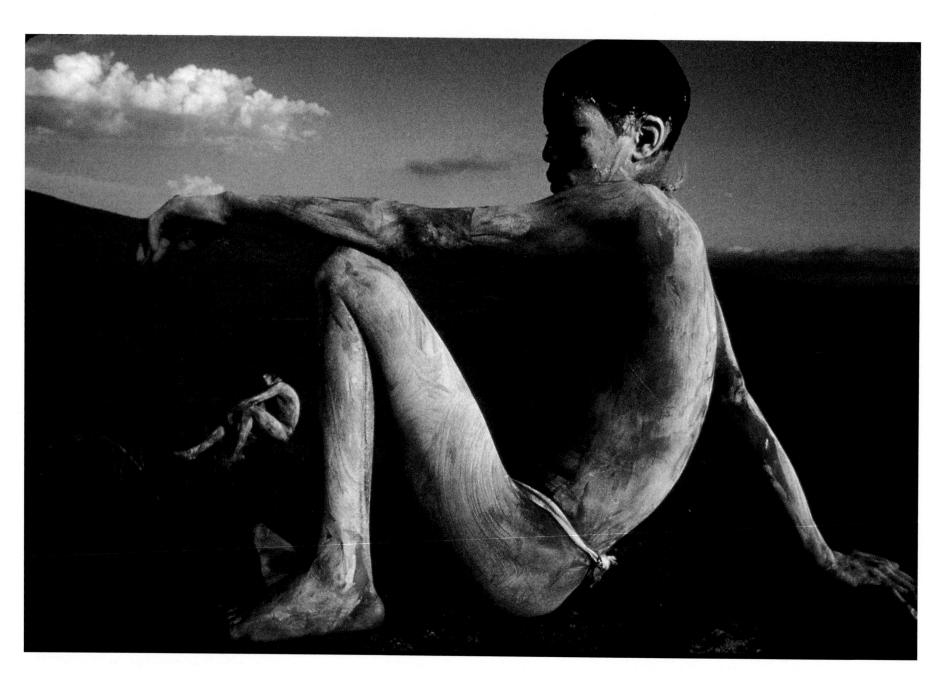

James Nachtwey Xhosa Initiation, 1992

A wide-angle lens takes in a large part of a scene and also lets you get closer to the main subject, while still showing a lot of background. This photograph typifies the wide-angle look—a stretched-out perspective and an exaggerated difference in size between the two figures. James Nachtwey/Magnum Photos, Inc.

Wide-angle focal length lenses are associated with two kinds of distortion. One, **barrel distortion,** is inherent in the optical design of the lens and shows up as a bowing out of straight lines along the edges of the frame. It occurs most often in ultrawide-angles (20mm and shorter), though the better the optical quality of the lens, the less likely the problem.

The other kind of distortion associated with wide-angle lenses is **perspective distortion,** an exaggeration of the proportions of a subject, especially noticeable at close distances. In tight shots of peoples' faces, the nose appears to bulge out; in full-length portraits, the head appears too large relative to the body. These distortions are further exaggerated at the corners and edges of the image. This is not really caused by the lens. Rather, it's the result of shooting a subject from the closer distances the lens's very wide angle of view allows which is why the effect is often called "apparent" perspective distortion.

TELEPHOTO LENS

Lenses with focal lengths much beyond 50mm (for 35mm cameras) are called both long lenses and telephotos. Whatever the term, long lenses offer higher magnifying power than a normal lens. This means they make the subject bigger (on the film and in the viewfinder) than it appears in life, without your having to move closer to it physically. In magnifying a subject, long lenses also take in less of the scene around it. The magnifying power of long lenses is useful when it's impossible to get close to the subject, such as in sports photography, or when getting closer might attract unwanted attention from the subject, such as in wildlife photography or candid portraiture.

200mm f/2.8

A telephoto lens magnifies the subject, much like a telescope. This is useful when you want to photograph something in the distance and you can't (or don't want to) get closer to the subject. Also, the effect of using the lens is to compress the picture space, making near and far elements seem physically closer together.

Long focal lengths cover such a great range that different long focal lengths are usually associated with different kinds of subject matter. Moderately long focal lengths of 105mm or 135mm, for example, are popular for both candid photography (spontaneous people pictures) and street photography (scenes of human activity in urban environments) because they allow you to position yourself at a distance from your subject, so you can work more discreetly. Lenses of similar focal length—90mm, 100mm, 105mm—are often used for close-up photographs (tight shots of small subjects) because you don't have to be as near to a small subject to make it fill the frame. This is useful when the subject is skittish, such as a butterfly; when moving in physically might disrupt the subject, such as a plant or spider web; or when extra room is needed for placement of artificial lighting.

Even longer lenses are needed for shooting sports and wildlife subjects: 180mm or 200mm for sports at close range (plays near a basketball hoop or football end zone) and 300mm and up for more distant action (tight shots of base-

ball plays). Wildlife photographers also routinely use lenses of 300mm focal length or longer—400mm, 500mm, and even 600mm. Often called super telephotos, these high-magnification lenses are the only way wildlife photographers can capture a close view of a wild animal from a distance.

But lenses of long focal length aren't just valuable for times when you need to take pictures from a distance. Their other major use is in controlling perspective—the relative scale of elements within the scene. Longer lenses have the effect of making elements of the scene appear to be physically closer together, sometimes called **compression.** (The effect is actually due to the greater lens-to-subject distance allowed by a longer lens.) Compression is the flip side of the stretched-out effect you get with wide-angle lenses.

barrel distortion
Characteristic optical effect of some wide-angle lenses that causes straight lines to curve out at the edges of the frame.

perspective distortion
Effect associated with wide-angle lenses in which the proportions of a subject are exaggerated, especially when it is photographed at close distances.

compression Effect associated with long lenses in which elements of a scene look closer together than they appear when you're looking at the subject.

internal focusing (IF)
Describes lenses that focus without moving all the optical elements, which makes these lenses more compact.

INTERNAL FOCUSING

One way some telephoto lenses are kept compact and easy to hold is with **internal focusing** capability, usually indicated by the abbreviation IF. This means that the lens focuses not by moving all its glass elements in and out at once (the usual method) but by keeping its front elements in a fixed position and changing the relative positions of other elements inside the lens. The net effect is that the lens does not get physically longer when it is focused at closer distances. Telephotos with internal focusing can also focus at nearer distances than lenses without IF, allowing you to photograph closer subjects.

| 28mm lens | 50mm lens | 100mm lens |

The choice of lens focal length has a dramatic effect on how a subject is represented in a photograph. With portraits in particular, a short focal length (28mm) can make the subject's nose or other protruding parts seem disproportionately large. Using a normal focal length (50mm), and backing away from the subject, brings the subject's features into a more natural scale. A longer focal length (100mm) helps create a slight compression in facial features, which is generally considered more flattering to the subject; such moderately long telephoto lenses are popular for portrait subjects.

Changing focal lengths—and the distance between you and your main subject—is also a way of altering the relationship between the subject and its background. In the wide-angle photograph, a considerable amount of background detail is visible, including the top of the fence. With the normal lens, standing farther away to keep the dog the same size in the frame, you can see less background (the top of the fence is no longer visible). With the long lens, you can see only part of the fence which is also much more out of focus.. If you want more background behind a subject, use shorter focal lengths; if you want a simpler background, use longer focal lengths.

Compression is useful in many different kinds of photography. Portrait photographers often use focal lengths in the 85mm to 105mm range for tight shots of faces or frame-filling head-and-shoulders portraits; these focal lengths help keep the subject's features in a more natural-looking and flattering proportion. When you shoot a tight portrait with a normal or wide-angle focal length, by contrast, the subject's nose and mouth usually appear too large in the photograph. This bulging quality is not just unflattering but makes it difficult to get a good likeness. In fact, lenses in the 85mm to 105mm range are often called portrait lenses because they eliminate this unattractive effect.

Landscape photographers sometimes use very long lenses—300mm, 400mm, and beyond—to add compression to a photograph. These lenses have such a narrow angle of view that they take in a very thin slice of the scene. To compress elements of the scene, you must therefore be at a considerable distance from them. When used effectively, com-

TELECONVERTERS

A **teleconverter** (also called a tele-extender) is a useful accessory that fits between the lens and camera body to increase the magnifying power of your lens. In practical terms, it increases the lens's effective focal length.

The most common teleconverters increase focal length by either 40 percent or 100 percent, indicated by 1.4X or 2X respectively. With a 1.4X converter, a 200mm lens becomes, in effect, a 280mm lens; with a 2X converter, the same lens becomes a 400mm. Converters are generally designed to make long focal lengths even longer, not to turn wide-angle or normal lenses into longer lenses.

One beneficial side effect of using a teleconverter is that it doesn't change a lens's **closest focusing distance**—the shortest distance at which you can focus a subject. And because the teleconverter increases the lens's magnification, you can focus on a closer subject—filling the frame more tightly—than you could if you were simply using a longer lens. A 200mm lens with a 2X converter would be able to focus closer than a 400mm lens, for example.

There is, however, a significant drawback to the use of a teleconverter: It reduces the effective maximum aperture of the lens, the size of the lens's largest opening. This means that the lens admits less light and thus requires a slower shutter speed (see Chapter 7) or a faster film speed (see Chapter 8). A 1.4X converter halves the maximum amount of light a lens can pass, and a 2X cuts the light by two stops, or one quarter of the maximum. This can limit your ability to shoot in lower light levels. But that disadvantage may be offset by the fact that a teleconverter is a lot cheaper than a whole new telephoto lens, and is much smaller and lighter, so it adds just a little extra weight to your camera bag.

Teleconverters fit between the lens and camera body, increasing the lens's magnifying power. The effect simulates that of telephoto lenses, making distant subjects larger in the frame, without the cost or bulk of an additional, longer lens.

pression lends a strong graphic quality to the image.

One other potentially useful attribute of long lenses is an inherently shallow depth of field—the depth of the zone of sharpness in your photograph. Sports, wildlife, and other photographers use this effect to soften the background of the photograph, and thus make the main subject stand out clearly and dramatically. And the longer the lens focal length, the more pronounced this effect.

Telephoto lenses are generally larger and heavier than normal and wide-angle lenses, and this sometimes determines the way you use them. A 400mm lens is difficult to handhold, for example, so using a tripod or monopod is often advisable, when practical (see Chapter 7).

Adjusting composition with a long focal length can require a significant amount of moving back and forth to fit the subject in the frame. To a great degree, this is a function of distance—of being farther from the subject. Moving two feet closer to a subject that is four feet away (with a wide-angle lens) produces a more dramatic change than moving two feet closer with a subject that is 20 feet away (with a telephoto lens).

ZOOM LENS

Zoom lenses provide an adjustable range of focal lengths in a single lens. This means to change focal length, you needn't change lenses; you just rotate or slide a ring on the lens's barrel, looking through the viewfinder to observe changes in the subject's size and/or the angle of view. (The lens makes this adjustment by repositioning its internal glass elements.)

teleconverter Optical attachment that fits between the lens and the camera body to increase the lens's magnifying power.

closest focusing distance Shortest distance at which you can focus on a subject with a particular lens.

Most current 35mm SLRs come with standard zooms that range from a moderate wide-angle focal length to a moderate telephoto focal length—for example, a 28–70mm or 35–80mm lens. But zooms are also available in exclusively wide-angle (such as 20–35mm) or telephoto (75–300mm) ranges.

The great advantage of a zoom lens is that it can replace two, three, or even more single-focal-length lenses—while providing in-between focal lengths not available in fixed focal-length models, for example, 87mm or 170mm. The popular 80–200mm telephoto zoom replaces at least four common single-focal-length lens sizes: 85mm, 105mm, 135mm, and 200mm. A 20–35mm wide-angle zoom replaces four common fixed-focal-length wide-angles: 20mm, 24mm, 28mm, and 35mm. There are even zoom lenses that cover extremely wide ranges such as 28–200mm, 35–350mm, 75–300mm, and even 28–300mm.

100-300mm f/4.5-5.6

A zoom lens combines a range of focal lengths, doing the work of several single-focal-length lenses. This spares you the need to change lenses constantly. It also saves you money, because you can buy one lens instead of two or three, and allows you to carry fewer lenses when you go out to photograph. And with a zoom lens, you can fine-tune your composition while standing at a fixed location—zooming in a little to get a tighter view or zooming out a little to show more space around your subject.

There are distinct advantages to photographing with one lens instead of three or four. Overall, it's cheaper, though high-quality zooms can cost much more than comparable single-focal-length lenses. It's lighter and less bulky, though individually zooms are often larger and heavier than comparable single-focal-length lenses. This last point is important if mobility is an issue, such as in photojournalism and nature photography.

Perhaps most important is that a zoom spares you the need to switch lenses often. This is especially valuable if you're shooting fast-changing subjects—subjects you might otherwise lose if you had to stop to switch lenses. With a zoom that covers your most frequently used focal lengths, you can keep one lens on the camera most of the time and photograph without interruption.

What's more, you can use the lens's zoom control to tweak and nudge your composition when it's difficult or impossible to change your physical position, or when doing so might cost you the shot. For example, if your lens is set at 100mm, and you want to make your subject bigger, simply zoom to the 110mm or 120mm setting. You should never use zooming, however, as a substitute for physically moving toward or away from the main subject, whenever possible.

There are disadvantages to zoom lenses. Because they must do the optical work of many different focal lengths, the quality of the image they produce

may not be as good as that of single-focal-length lenses, though many modern zoom lenses are optically excellent. And the greater number of glass elements in a zoom lens can also increase the effects of **flare**—of direct light striking the front of the lens and bouncing around inside. Flare reduces the photograph's contrast and even causes unwanted streaks or spots on the film. Using a lens hood (see illustration) on the front of your camera can help reduce flare by keeping direct light from striking the front of the lens.

A more practical drawback of zoom lenses is that they cannot have maximum apertures (see Chapter 6) as wide as typical single-focal-length lenses within their range. If you're shooting in low light conditions, this limitation may force you to use a flash or to set shutter speeds too slow to be safely hand-held, increasing the risk that camera shake will blur the image.

SPECIAL-PURPOSE LENSES

Lenses are available for all sorts of special purposes and effects, from close-up photography to soft-focus portraiture. Also,

A lens hood screws or clips into the lens's front thread, helping to prevent direct light from striking the lens's front surface and bouncing around inside. Such reflected light could cause flare, an effect that shows up as streaks, patches, and fogginess in the image. Make sure your lens hood matches your lens, however; if you have several lenses, you may need a separate hood for each. The wrong size lens hood can cause vignetting, resulting in a darkening of the print at the corners of the frame.

flare Streaky and/or foggy effect on film caused by direct light striking the front of the lens and bouncing around inside.

conventional lenses can be adapted to such purposes with filters, lens extension tubes, and other accessory hardware. But in terms of both optical quality and convenience, nothing compares with having special purpose lenses. Here are a few of the many such lenses available.

Macro Lenses A **macro lens** is specially designed to focus to a much closer distance than ordinary lenses—to within

100mm f/2.8 Macro

A macro lens is specially designed to focus closer than a regular lens, allowing you to photograph smaller subjects or capture small details in a larger subject. True macro lenses can often make subjects "life size," as large on film as they are in life. Using a macro lens is less cumbersome than using close-up attachments on a standard (non-macro) lens. Because they also focus at normal distances, macros also can do double duty as standard lenses.

macro lens Lens designed to focus very close, rendering subjects life size (or close to life size) on the film.

reproduction ratio Relationship between the size at which an object is reproduced on film and its actual size, such as 1:1 or 1:2.

image circle Size of the image projected by a particular lens into the camera and onto the film.

FOCAL LENGTH AND FILM FORMAT

Calling a focal length long or short is a relative thing—relative, that is, to what is considered "normal" for a camera's film format (see Chapter 8). Technically, a normal focal length is about the same as the diagonal measurement of a camera's film format (the size of the image it creates on film). With 35mm film, this measurement is slightly less than 50mm, so a 35mm camera's normal lens has a focal length of 50mm. But a normal focal length for the 6 x 7cm format (a popular medium format) is 90mm, because the diagonal measurement of a 6 x 7cm film image is about 90mm. And, for the same reason, the normal focal length for the 4" x 5" format (the format of 4" x 5" view cameras) is 150mm.

Within each format, focal lengths having numbers much lower than what is normal are considered short, or wide-angle, and focal lengths with numbers much higher than normal for a given format are considered long, or telephoto. Thus, the 50mm focal length that is normal for a 35mm camera is actually wide-angle for a 6 x 7cm model. The 90mm that is normal for a 6 x 7cm camera is actually a long focal length in 35mm. And, in the 4" x 5" format, a 90mm lens is considered wide-angle (see page 84).

Any lens, for example a 90mm lens, always makes a given subject at a given distance the same size on the film, regardless of the camera or format. The difference among the three lenses described above—the 90mm designed for 4" x 5", the 90mm for 6 x 7cm, and the 90mm for 35mm—is in their **image circle.** This refers to the size of the image they project inside the camera. To cover a whole sheet of 4" x 5" film, a 90mm lens needs a much larger image circle than it does to cover the 6 x 7cm format. And to cover the 6 x 7cm format, a 90mm lens needs a larger image circle than it does for the 35mm format. Basically, the larger the format, the more of the scene around the main subject is recorded on the film.

inches from a subject for close-up photographs. Close-ups can be made with regular lenses, either by screwing filter-like supplementary lenses into the front of the lens or by placing extension tubes between the lens and camera body. But a macro lens lets you dispense with such hardware and usually get better results too. And while regular lenses with close-up attachments can only focus close, macro lenses can be focused to any distance. This allows them to be used for general-purpose photography

as well. Note that you should usually use a tripod for close-up photos, because camera shake is more evident when focusing close than when focusing at a distance.

The closest distance at which a macro lens can focus depends on the lens's focal length and design, but most macros for 35mm SLRs focus close enough for a **reproduction ratio** of 1:1 or 1:2. This means that you can get close enough to a small subject to record it at its actual size (that is, an inch-long subject is an inch long on film) or half its actual size (an inch-long subject is a half-inch long on film). A

reproduction ratio of 1:1 is also called "life size," and 1:2 is called "half life size."

Many so-called macro zoom lenses have good close-focusing capability (sometimes allowing reproduction ratios of 1:4 or so), but nearly all true macro lenses are of single focal length. Macros for 35mm SLRs fall into three focal length categories. The shortest are basically normal lenses: 50mm, 55mm, or 60mm. These macros are especially useful for copy photography—making slides or negatives of artwork, documents, or other flat originals (photographic prints included).

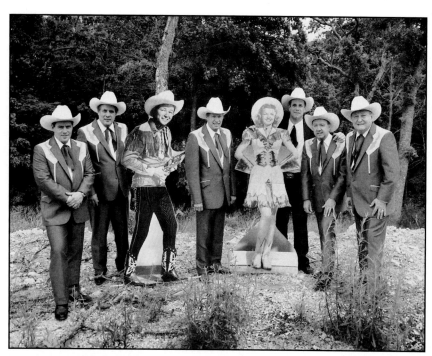

90mm lens in the 4" 5" format

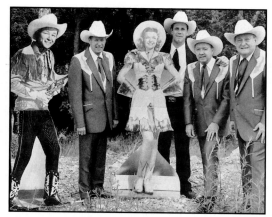

90mm lens in the 6 x 7cm format

These images all show the effect of photographing with just one lens focal length: 90mm. The differences reflect the varying amount of coverage this focal length provides for each film format. In the 4" x 5" format, a 90mm lens is wide-angle, recording a relatively large part of the scene. In the 6 x 7cm format (2¼" x 2¾") format, a 90mm lens is a normal focal length, recording considerably less of the scene. The only difference between the 6 x 7cm format and the 6 x 6cm (2¼" x 2¼") format is that the 6 x 6cm film records slightly less of the subject on the sides. With 35mm film, 90mm is a moderate telephoto focal length, recording a relatively small slice of the scene.

Note that the size of the figures remains constant from format to format. This is because a 90mm lens has the same magnifying power regardless of the format for which it's intended. What changes is the physical size of the film, shown here at near its actual size; the larger its area, the more of the scene it records. The real magnification takes place in enlargement: If all four images were blown up to 8" x 10", their wide angle and telephoto characteristics would be much more apparent.

Keep in mind that lenses are designed for a particular format. Even if you could physically mount it, the 90mm lens for a 35mm-format camera can't cover—produce a broad enough circle of light to evenly expose—the larger 6 x 7cm film area, nor can a 90mm lens for a 6 x 7cm-format camera cover 4" x 5" film.

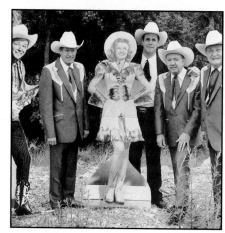

90mm lens in the 6 x 6cm format

*90mm lens in the
35mm format*

CLOSE-UP ALTERNATIVES

Macro lenses are expensive, so if you want to take close-up photographs, consider these alternatives. A **supplementary close-up lens** is a filter-like attachment that screws onto the front of a regular lens, allowing the lens to focus at closer distances. One important advantage of supplementary close-up lenses over the methods described below is that they don't reduce the amount of light reaching the film, so require no adjustment of the exposure.

Supplementary close-up lenses come in different strengths for specific distance ranges, indicated by a plus sign and a number—+1, +2, and so forth. You can buy them individually or in a kit, usually containing three lenses that cover different ranges. Many photographers prefer individual supplementary close-up lenses that have two elements, for their better quality. Just make sure anything you buy is optically compatible with the lens on which you plan to use it. And whatever you choose, also be certain that its filter thread diameter is the right size for the lens.

Close-up lenses

Extension tubes provide another economical approach to close-up photography, often allowing you to make small subjects even larger than with supplementary close-up lenses. The tubes fit between the camera body and a regular lens, increasing the lens's extension from the film so that it can focus closer. (You can also use them with macro lenses to focus even closer.) Extension tubes come in different lengths (indicated by millimeters) for different subject distances. Because their mounting hardware must be compatible, make sure you have the correct tubes for your camera model.

One disadvantage of extension tubes is that, because they increase the distance between lens and film, they reduce the amount of light reaching the film. Your in-camera light meter may be able to make the necessary adjustment, depending on your exposure mode and whether or not the tubes are specifically designed for your camera. Follow the manufacturer's recommendations when adjusting exposure, but also bracket the exposure (shoot additional frames with more and less exposure) for insurance.

Extension Tubes

Accessory **close-up bellows** are another option. They fit between the lens and camera body, much like extension tubes, but are made of light-tight cloth and/or rubber-like material that expands like a view camera's accordion bellows. Bellows are expensive, bulky, and more awkward to use than supplementary close-up lenses or extension tubes. But they don't have to be switched like supplementary close-up lenses or extension tubes, allowing a continuously adjustable focusing range, and usually much closer focusing as well. (This means you can make smaller things bigger.) They definitely require the use of a tripod, though tripods are generally recommended for all close-up photography.

supplementary close-up lens Filter-like attachments that screw into the front of a lens, allowing the lens to focus closer.

extension tubes Accessories that fit between the camera body and a regular lens, to increase the lens's extension from the film so that it can focus closer.

close-up bellows Accordion-like accessory that fits between the camera body and a lens, increasing extension to allow closer focusing.

Perhaps the most useful macro lenses come in moderate telephoto focal lengths: 90mm, 100mm, or 105mm. Like regular telephotos, macro lenses in this range let you shoot a subject at a greater distance away than 50mm or 60mm macros, but still fill the frame with it. This is very helpful if you're shooting close-ups of nature subjects (flowers, leaves,

Catherine Chalmers Praying Mantis eating a caterpillar, from "Food Chain," 1994–1996
Macro lenses allow you to focus at much closer distances than regular lenses. This means you can pho-
tograph much smaller subjects—even making them as large on film as they are in life. (This is called
"life size.") For her insect studies, Chalmers uses a macro lens with a long focal length. This means she
can take her pictures from farther away but still keep the subject just as large, lessening the chance she
will interfere with the action. Most insect photographs are made in a natural setting, but Chalmers
works in a studio with controlled light. Taking insects out of their normal context in this way empha-
sizes their strange, sometimes monstrous quality. Catherine Chalmers

insects) because it lets you set up a tripod with less chance of bumping your subject or throwing a reflection on it.

Macro lenses of even longer focal length—usually 180mm or 200mm—are also available, though much more expensive. These lenses let you further increase the lens-to-subject distance, leaving more room to position artificial lighting around a subject. Close-up photographers also like longer macro lenses because, as with any longer lens, they provide a narrower angle of view. This means that less out-of-focus detail is visible behind the subject, which creates a smoother, less distracting background.

Fisheye Lenses The **fisheye lens** is an extreme wide-angle lens that actually capitalizes on an aberration most optical

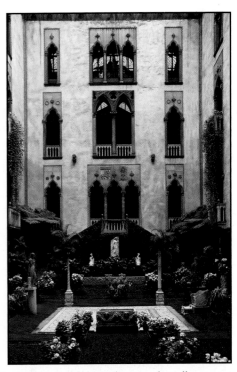

Perspective-control (PC) lenses are most often used for architectural subjects because they allow you to eliminate or lessen the convergence of vertical lines that happens when you point a camera up or down at the subject. The image at left was shot with a regular 28mm wide-angle lens. When the camera was tipped up to include the top of the facade, it caused the building's lines to converge because the film and building were not parallel. The image at right was shot with a 28mm PC lens. Rather than tilted upward, the camera was kept level and the lens shifted up on its mount to include the top of the building. Because the film and building remained parallel, the lines of the building didn't converge.

Fish-eye 15mm f/2.8

A fisheye lens has an extremely wide angle of view, usually 180°, and makes the middle of the photograph appear to bulge out. Photographers use fisheye lenses both because they like the distortion, and because they want to take in a very large subject area when shooting in extremely close quarters.

fisheye lens Extreme wide-angle lens designed to produce severe barrel distortion, giving the image a pronounced convex appearance.

designers strive to eliminate: barrel distortion, an effect in which the image appears to bulge out at the viewer. The fisheye lens's barrel distortion is so pronounced, in fact, that it gives the image a convex appearance, hence the name fisheye. The fisheye lens's short focal

lengths—usually falling within the 6mm to 16mm range—turn this seeming flaw into a virtue by providing a super-wide angle of view, often 180° or more.

The fisheye can do more than provide convex effects. Its extremely wide angle of view lets you dramatically exaggerate the relative size of near and far objects. It also permits nearly total sharp focus from foreground to background.

Some fisheye lenses produce a circular image on film, rather than filling the entire 35mm frame. (Almost all fisheyes are for 35mm SLRs only.) This may be useful for special effects, but limits subject matter to scenes that work compositionally within a round frame.

Even if they produce a full-frame image, however, fisheye lenses must be used thoughtfully, because their optical effect can easily overpower the subject. If you want to play up the distortion, choose subjects with strong vertical lines that the lens will "bend." If you want to minimize distortion and simply take advantage of the fisheye's wide angle of view, choose subjects that contain few or no vertical lines, and keep the horizon line of the subject centered in the frame, to avoid excessive curvature.

Perspective-control Lenses When you aim a lens up (perhaps to include the top of a building) or down (to include an

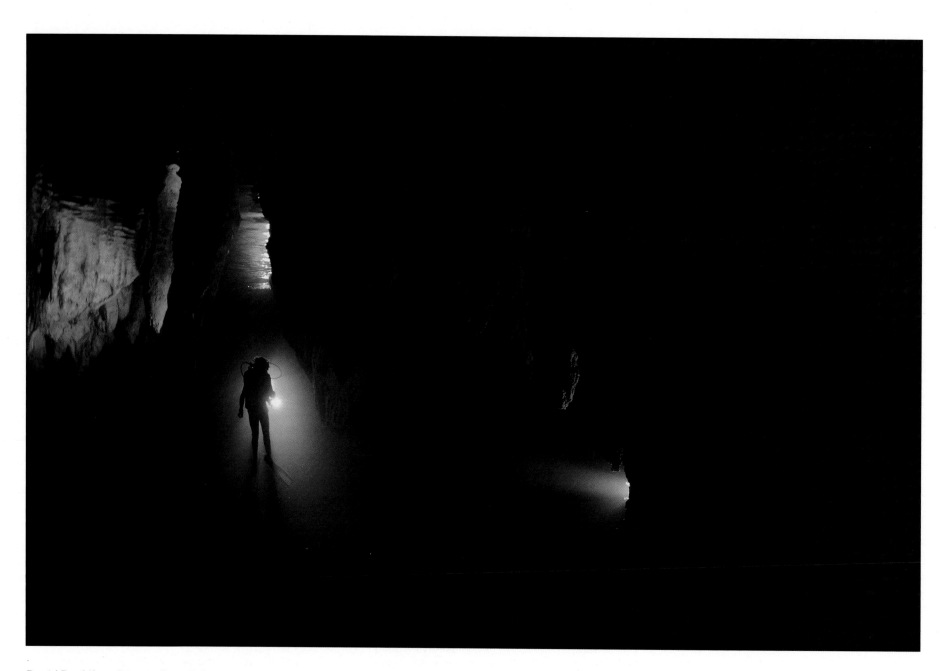

David Doubilet Diver in Cave, Palau

Though some photographers use a fisheye lens for its distortion characteristics, others simply want its exceptionally wide angle of view, so they compose their subjects to minimize the lens's customary "bowing-out" effect. Doubilet used a 16mm fisheye for this underwater image of a sea cave. The lens's 180° angle of view took in a wide swath of the cave's interior from a close distance. Little fisheye distortion is visible because there were no straight lines in the scene to bow out—and no horizon line. Doubilet Photography, Inc.

24mm f/3.5 Perspective-control lens

A perspective-control (PC) lens lets you prevent or minimize the convergence of parallel lines in a subject caused when you tilt the camera up or down. You do this by keeping the camera level and shifting the lens off-center (relative to the film) with a built-in thumbscrew.

object in the foreground of a landscape), it causes parallel vertical lines to tilt inwards toward the top or bottom of the frame. This is especially true with wide-angle lenses. A **perspective-control lens,** also called a PC lens, allows you to minimize or eliminate that distortion by shifting the lens up, down, or sideways on its mount, instead of having to aim the camera itself up or down.

You usually shift a PC lens by turning a thumbscrew that slides the lens off-center. With a tall building, you shift the lens up to include the top. With a landscape, you shift the lens down to include an object in the foreground. This control is very similar, to what is possible with a view camera's "movements," only not as extensive.

Perspective-control lenses are available in both 35mm and medium-format camera systems. In the 35mm format, they are mostly 24mm, 28mm, and 35mm wide-angles, though longer focal lengths are available. Some PC lenses supplement their ability to shift to the side with the ability to tilt on their mount. These are called **tilt-shift lenses.** Tilting allows photographers to increase the front-to-

back sharpness of an image without using a smaller lens aperture.

Soft-focus Lenses　The image produced by any lens can be softened with diffusion filters (see Chapter 10). The effect of diffusion filters is never quite

135mm f/2.8 Soft-focus lens

A soft-focus lens lets you reduce the overall sharpness of a subject in a controlled manner. It's used mainly for portraiture, to minimize skin blemishes and/or create a romantic quality. But it can also bring an impressionistic feeling to landscapes and still lifes.

the same, though, as that produced by a **soft-focus lens**—a lens that creates a deliberately unsharp image. Soft-focus lenses are often used in portraiture because they minimize skin wrinkles and blemishes. Their portrait applications explain why they are most available mainly in moderate telephoto focal lengths, usually 85mm to 135mm (portrait lengths). Soft-focus lenses also can be used effectively for landscapes and still lifes, in which they create an impressionistic quality. Their soft-focus effect is enhanced by their fairly wide maximum apertures, which allow photographers to throw confusing background detail out of focus.

Soft-focus lenses achieve their softening in a couple of different ways, but the net effect is to add controlled amounts of a distortion that lens designers ordinarily

try to eliminate, called spherical aberration. This aberration is either linked directly to the lens aperture (the larger the aperture, the greater the aberration, and thus the softness) or it may be controlled with a separate ring on the lens barrel.

Ultrafast Lenses　A "fast" lens is a lens with a wide maximum aperture to let a lot of light into the camera. An **ultrafast lens**

50mm f/1.0 Ultra fastlens

An ultrafast lens lets you set extremely wide lens apertures, such as f/1.2 or even f/1, for low-light shooting. Photographs taken at these apertures show extremely shallow depth of field, allowing you to visually isolate parts of the subject.

has an even wider maximum aperture, allowing still more light into the camera. This means, in turn, that you can set a higher shutter speed. Being able to set a higher shutter speed makes it possible to photograph while hand-holding your camera—and/or to shoot with a film of lower ISO—in dimmer light. Otherwise you'd have to use a tripod or switch to a film with a higher ISO.

While a standard 50mm lens often has a fairly fast maximum aperture of f/2 or f/1.8, it can also be had in a "faster" f/1.4 version, and a very few ultrafast lenses have maximum apertures of f/1.2 or even f/1.0. Depth of field—the depth of the zone of sharpness—is extremely

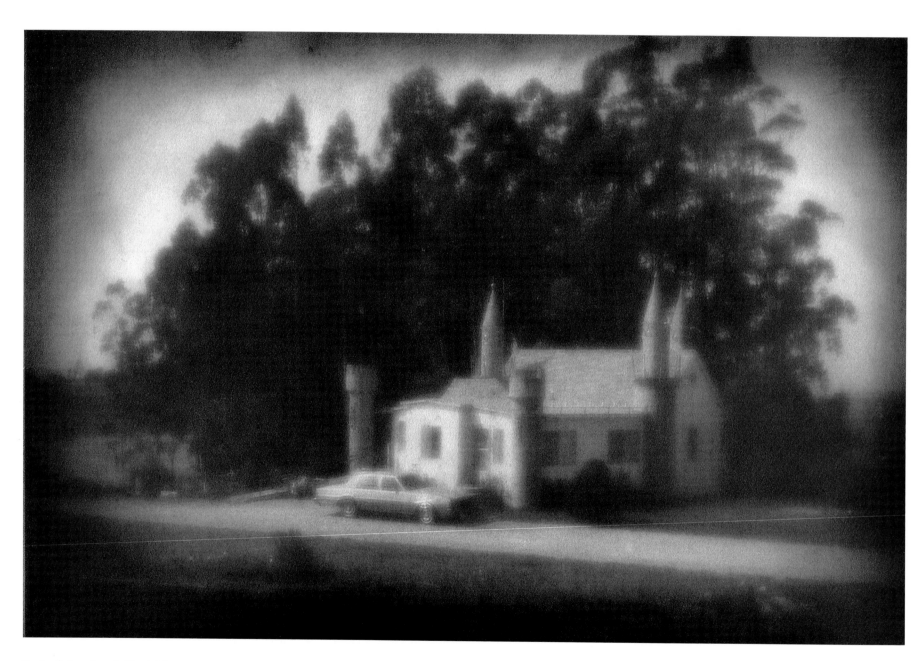

Rocky Schenck A Man's Home

Rocky Schenck combines a soft-focus effect (as well as various darkroom manipulations when print-
ing) to achieve this pictorialist quality. But by choosing subjects that are often jarringly modern, he
creates a dissonant feeling, which runs counter to the typically romantic content of Pictorialist
work. Rocky Schenck

With an ultrafast lens, you can photograph in extremely low light, at a shutter speed that's fast enough for you to hand-hold the camera. Here, a 50mm f/1.0 lens—an unusually fast lens—is set to its maximum aperture. The low-light gathering power of the lens is its primary appeal, but many photographers use ultrafast lenses for the way they throw backgrounds dramatically out of focus.

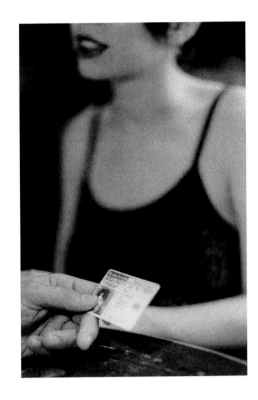

shallow when these lenses are set to their maximum aperture. But many photographers use ultrafast lenses for that very effect, as well as for photographing in low light. Note that the large amount of glass required for these lenses makes them not only quite costly, but extremely bulky as well.

Mirror Lenses Long focal lengths normally require lenses that are physically long and bulky. The **mirror lens** uses a clever design to keep long lenses much shorter, using curved mirrors that reflect the image back and forth inside the lens barrel. The resulting fat, cylindrical barrel is much shorter and lighter than that of a conventional telephoto lens, and less expensive, too. This shortening makes the mirror lens easier to handhold than conventional lenses of comparable focal length.

Typical focal lengths for mirror lenses are 300mm, 500mm, and 1000mm. The

A mirror lens is a long focal-length lens in a much shorter package than a lens of conventional design. This makes for a more portable lens, that's easier to handhold when you're photographing. To achieve this design, mirror lenses have a single aperture setting that lets in relatively little light—usually f/8 or f/11.

design makes it difficult to incorporate an adjustable aperture, so they generally have only one f-stop—usually f/8 or f/11, though sometimes f/5.6. This means that exposure must be controlled entirely with shutter speed changes, and/or by changing to a faster or slower film.

mirror lens Lens of very long focal length that is kept physically compact by using mirrors inside the lens barrel.

THE PINHOLE CAMERA

You don't really need a lens to form a photographic image. You can create pictures with a pinhole camera, a lightproof box with a tiny hole pierced in the side. This can be a commercial camera body, minus its lens—or it can literally be a box, of cardboard or other opaque material.

Pictures made with a pinhole can never be as sharp as those taken with a good lens. A smaller pinhole may produce a somewhat sharper image because it admits a thinner bundle of light rays, which represents each subject point with a smaller circle on the film. But the smaller the hole, the longer the exposure, and pinhole exposures are very long to begin with, often a matter of minutes and sometimes hours.

There's an optimal pinhole size for every pinhole-to-film distance, one that yields the greatest image sharpness. It can be correlated with the standard sewing needles best used to create the hole (see chart on page 94). But a pinhole cannot be focused to make its image sharper. A conventional camera lens brings its subject into sharpest focus when the film is placed at a specific distance away from it, and when you focus the camera, you're finding this distance.

With a pinhole, the main consequence of changing the pinhole-to-film distance is to change how much of the scene the camera takes in: it takes in more when that distance is shorter, less when it's longer. (Note that the needed exposure also changes.) In fact, pinhole cameras can be thought of in the same terms as lenses and lens focal lengths. They can range from "wide-angle" to "telephoto," depending on the physical dimensions of the camera itself (see illustration on facing page).

But there's no need to focus a pinhole camera. The pinhole's small size means that subjects will be relatively sharp whether they're a few inches or a mile away. Having both very near and distant parts of a scene rendered with equal clarity, yet with a dreamy softness, is part of pinhole photography's charm. And its decidedly low-tech approach—equal parts deliberation and accident—adds to that appeal.

Making a Pinhole Camera

The wonder of pinhole photography, though, is that any container you can make light-tight—a tin can or a shoebox—will serve as a camera. Many photographers choose a cardboard box that has long and short dimensions because the long one accommodates a fairly large piece of film (or photographic paper) and the short one keeps the pinhole-to-film distance relatively small. This both reduces exposure times and produces the "wide-angle" effect often associated with pinhole photography.

If your pinhole camera is a cardboard box or otherwise handmade, its interior should be spray-painted flat black to keep light from bouncing around inside it and possibly fogging the film. Light leaks (which you can look for by shining a flashlight through seams in the dark) should be plugged with opaque black photographic tape. You'll also need a dark card or a piece of opaque black tape (in effect, your shutter) with which to cover and uncover the lens. Most photographers simply tape the film or paper in place inside the camera.

You can load your pinhole camera with sheets of ordinary photographic film. Film's high sensitivity to light shortens exposures considerably, but it also means that loading, unloading, and processing must be done in total darkness. Many photographers use black-and-white photographic paper instead of film, which allows the camera to be loaded, unloaded, and processed by darkroom safelight. The resulting "paper negative" is then

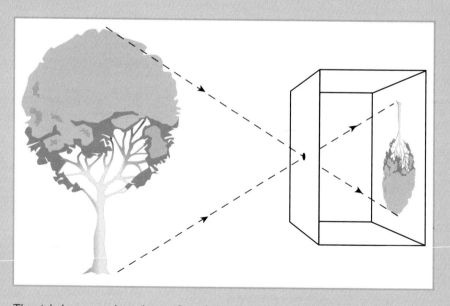

The pinhole camera depends on a fact of physics: that light travels in straight lines. Each point in a photographic subject reflects light rays in many directions. These rays of light cross paths at the pinhole, then continue inside the camera to form an inverted and reversed image of the subject on film. In order to let enough light into the camera to make an exposure, a pinhole must actually be much bigger than the thickness of a single light ray. So even the tiniest hole admits a small bundle of light rays from each subject point. The bundle expands as it travels, forming a small circle instead of a sharp point when it strikes the film. This is one reason pictures made with a pinhole camera are never as sharp as those taken with a proper glass lens.

In a pinhole camera, the distance between the pinhole and the film has no effect on focus. Instead, it determines the camera's focal length—and how much of the scene will be recorded on the film. If the pinhole-to-film distance is shorter than the film's diagonal measurement, the camera is wide-angle, and will take in a relatively large subject area. If the pinhole-to-film distance is longer than the film's diagonal measurement, the camera is telephoto, and will take in a relatively small subject area. Many pinhole photographers opt for fairly short focal lengths because they shorten exposure times, which in pinhole photography tend to be lengthy.

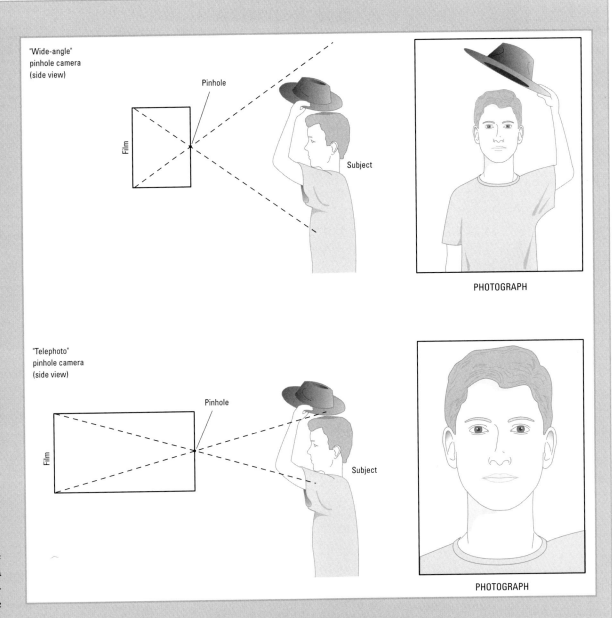

printed by contact—by placing the negative against the paper to make the print (see Chapter 16). (If you do this, remember that your negative print will be the same size as your final print. Use paper without lettering or manufacturers logo on the back, since they will be visible in the image.)

The pinhole itself can be poked in heavy-duty aluminum foil or a piece of aluminum pie plate. But the material of choice is shim stock, thin sheets of brass available in well-stocked hardware stores. (Purchase .002 or .003 thickness.) Make a small opening in the front center of your pinhole camera, then cut a piece of the material large enough to overlap it. Use a sewing needle to poke a hole in the middle of the material, pushing it all the way through; with shim stock, you can sand down the burr this raises on the other side. Either way, hold the pinhole over a candle flame to coat its inside edges and the surrounding metal with soot, again to minimize reflections. Then mount the pinhole, sooty side in, onto the front of the camera with opaque black photographic tape. (If you're using a regular camera body, remove the lens and attach the pinhole material carefully to the resulting opening in the camera body. Use opaque black photographic tape to make it light-tight.)

Finally, tape a small piece of opaque black paper or board so that it covers the pinhole. This serves as a shutter. Remove it to expose the film (or paper); replace it to stop the exposure.

You can use an ordinary commercial camera body to make a pinhole camera by simply replacing the lens with a pinhole. Cameras with bellows (view cameras) allow you to freely adjust the pinhole-to-film-distance, in order to control how much of the scene the camera takes in. Those with built-in shutters (35mm and some medium-format models) allow you to control the exposure without having to manually cover and uncover the pinhole.

The Hole Story

Once you've chosen or constructed your pinhole camera, measure the distance, in millimeters, from the film to the opening in which you will mount your pinhole. Find the closest distance in the left column of this chart, then read off the correct needle size for the camera in the right-hand column. When you make the hole, whether in a piece of aluminum pie plate or brass shim stock, be sure to push the needle all the way through to create the correct size.

Focal length (pinhole-to-film distance)	Sewing needle size
50mm	No. 14
75mm	No. 12
100mm	No. 11
125mm	No. 10
150mm	No. 9
200mm	No. 8
250mm	No. 7

Pinhole photographs may be taken with virtually any container that can be made light-tight. For photographer Eric Renner, the container used to make a pinhole camera—here, a nautilus shell—often has a conceptual importance. Renner explains that the nautilus is the only animal that has a pinhole for an eye.

Using a Pinhole Camera

Unlike conventional cameras, homemade pinhole cameras must ordinarily be reloaded for every shot. The usual practice is to load the film in a darkroom, a changing bag, or some other light-tight space, then seal up the camera with opaque tape and take it directly to the subject for the exposure. You must then return to the darkroom to unload and process the film. For this reason, some pinhole photographers carry additional cameras with film loaded in them, allowing more than one shot per excursion. If you're using a commer-

cial camera with a pinhole on it and have worked out your exposure times, you can more easily make more than one shot.

You'll need to run tests to determine the correct exposure. (Pre-drilled pinholes are commercially available, and come with exposure recommendations.) But once you've established the exposure needed for a given light level, you can even use a meter to roughly extrapolate the exposure for brighter or dimmer light. Of course, you'll also need to devise a way to secure the camera for such long exposures, whether by attaching it to a platform or simply by taping it to a table, chair, or stool (try the floor). And you will have to make an educated guess at composition. It's all part of the improvisation, and the serendipity, of the pinhole process.

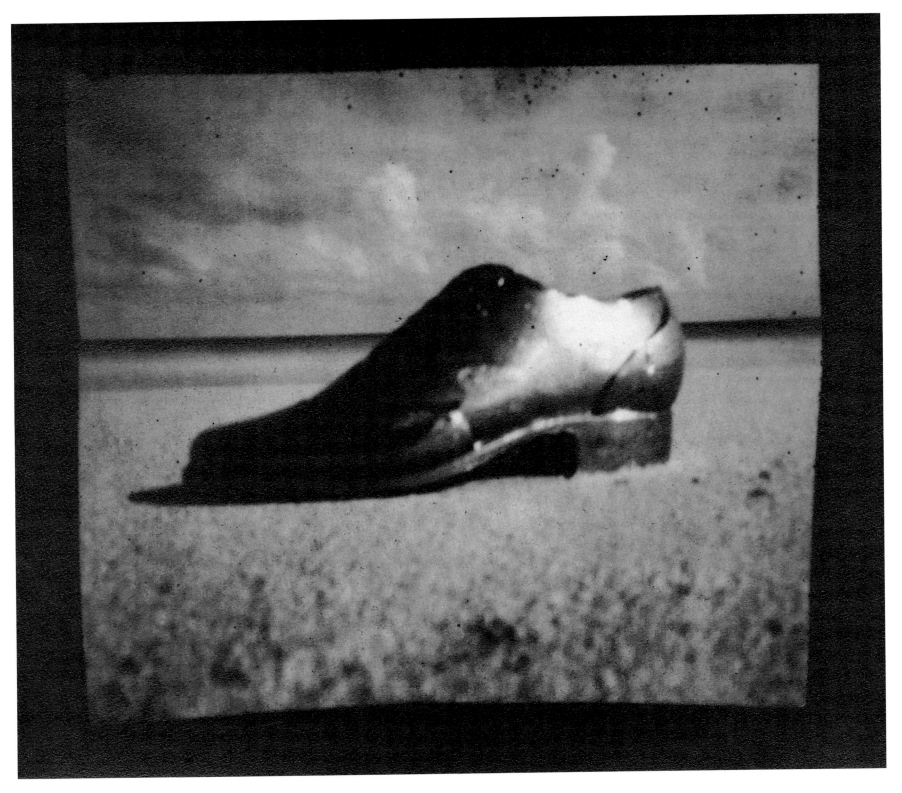

Ruth Thorne-Thomsen Silver Shoe, Mexico, 1978

Thorne-Thomsen takes artistic advantage of pinhole photography's odd combination of nearly infinite depth of field and overall softness. This unique image quality helps transform her small-scale set pieces into surrealist landscapes. Photograph Courtesy Schmidt/Dean Gallery, Philadelphia

JACK DYKINGA
Mojave National Preserve, California

Landscape photographers often try to create a sense of depth in their images by setting up strong, surging compositional relationships between foreground and background elements. Dykinga shot this desert view with a yucca plant prominent in the foreground, a composition made possible by his use of a wide-angle lens. To help keep both the plant and the distant mountains sharp, he focused in between the two (about one-third into the scene) and used a small lens aperture for greater depth of field. To get this amount of depth of field, you usually have to set an f-stop at least as small as f/16—and possibly f/22 or f/32, if available on your lens. Jack W. Dykinga & Associates.

THE LENS:
APERTURE AND DEPTH OF FIELD

diaphragm Mechanism inside a lens that forms an opening the size of which can be adjusted to control the amount of light that enters the camera and strikes the film.

lens aperture Adjustable opening formed by lens diaphragm.

wide open Term used to describe a lens set to its maximum (largest) aperture, which admits as much light as it possibly can.

stop down To set a smaller lens aperture (f-stop) in order to reduce the amount of light striking the film.

f-stop Numerical value that indicates the relative size of a lens aperture, and how much light it allows to enter the camera and strike the film.

Your camera's lens does more than gather scattered light rays from the subject and focus them into a recognizable image on film. A mechanism inside the lens, called the **diaphragm,** lets you vary the amount of light that enters the camera to create the image by changing the size of an opening, called the **lens aperture,** in the center of the diaphragm.

If you think of the lens as a pipe that carries light, the diaphragm functions like a valve. This valve can be opened up as large as possible—to what is usually called a "wide aperture"—so that it lets in a lot of light. It also can be closed down to a small opening—to a "small aperture"—so that it lets light through in a trickle. Or it can be set to apertures in between these two extremes. Keep in mind that the diaphragm and lens aperture don't actually start and stop the flow of light to the film. This task is handled separately by the shutter, which you will learn about in Chapter 7.

Controlling the flow of light to the film is crucial to getting the proper exposure—making sure your photograph is neither too light nor too dark. If you're taking a picture in dim light, you usually need to set a wide lens aperture to make sure enough light gets through to the film. If the light is bright, on the other hand, you will generally need to set a small lens aperture in order to prevent too much light from reaching the film.

Varying the size of the lens aperture does other important things. Chief among these is controlling depth of field:

the area in front of and behind your subject that appears reasonably sharp in the final photograph. Smaller apertures provide more depth of field; larger apertures provide less depth of field. A simple adjustment of lens aperture thus allows great control over the appearance of a photograph (see page 102).

Adjusting the aperture also affects how a photographer adjusts the shutter speed—the length of time during which light reaches the film. In practice, the lens aperture and shutter speed are adjusted in tandem to ensure that the film gets the correct amount of light. But considerable variation in this combination is usually possible. If you set a small lens aperture, for example, you will need to use a slower (longer) shutter speed to let enough light through the lens. If you set a large lens aperture, you will need to use a faster (shorter) shutter speed to quickly cut off the light pouring through the lens. (You'll learn more about balancing lens aperture and shutter speed to control exposure in Chapter 9.)

SETTING THE LENS APERTURE

If you look into your camera's lens, you will see a group of metal leaves or blades that overlap one another to form a rounded opening (see page 99). This group of blades is the diaphragm; adjusting the size of its opening is called setting the aperture. The size of the aperture does not affect how much the lens "sees." It simply makes the image darker or brighter.

There are several ways to set the aperture of a lens, depending on the camera system you're using. With many systems, you adjust the aperture's size by rotating a calibrated ring on the lens barrel. This ring has a number of "click" positions with numbers next to them. With many modern, electronically controlled cameras, you adjust the lens aperture by pushing, sliding, and/or rotating controls on the camera body while referring to numbers on an adjacent LCD panel.

Set to its largest opening, the aperture is as wide as the lens elements (the shaped pieces of glass or plastic that make up a lens) themselves. Using this setting is sometimes called shooting **wide open;** setting to the largest aperture is called "opening up" your lens. But the aperture can be changed from that setting to a very small aperture, or to any setting in between. When you set a smaller aperture, you **stop down** the lens.

However your lens is adjusted, the size of the aperture is indicated on the lens's aperture ring, on an LCD panel, and/or in the viewfinder with a number called an **f-stop.** Indicated with the prefix "f/," f-stop numbers appear in the following standard sequence: f/1.0, f/1.4, f/2, f/2.8, f/4, f/5.6, f/8, f/11, f/16, f/22, f/32, f/45, f/64, and so forth. Most lenses for 35mm cameras offer a range from about f/2.8 or f/4 to f/22 or f/32, but this varies from lens to lens.

Cameras with electronic displays on LCD panels quite often also show

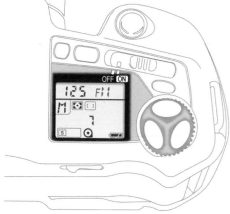

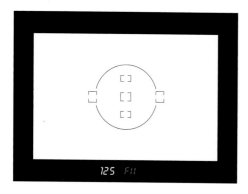

On most 35mm SLRs the lens aperture is displayed and adjusted in one of two ways, and sometimes both. With some models, you rotate a calibrated ring on the lens barrel until the f-stop number you want clicks into place above an index mark (top). With electronic models, you usually rotate a small thumb- or finger-wheel on the camera body to change the f-stop number on the camera's external display panel (middle). In many models, the chosen f-stop also is displayed in the camera's viewfinder (bottom) so you can make adjustments without having to take the camera from your eye. All three displays here indicate that a lens aperture of f/11 has been set.

in-between numbers, such as f/3.5 or f/9. Lenses with aperture rings, rather than LCD displays, usually have half-stop settings that "click" when set. But whether they click or not, these lenses can be set anywhere between full stops—though the settings may not be critically precise. (See the chart on page 100 for the complete sequence of full and fractional f-stops.)

Whatever your lens, the larger the f-stop number, the smaller the opening. In fact, the sequence of whole f-stop numbers actually represents an exact doubling or halving of the amount of light entering the camera. The aperture f/2 is twice as large as f/2.8, so it lets in twice as much light. The aperture f/11 lets in half as much light as f/8.

Because of this universal measurement, photographers nearly always express quantities of light in **stops.** An aperture of f/8 is said to let in one stop less light than an aperture of f/5.6. An aperture of f/2 is said to let in two stops more light than an aperture of f/4; f/2.8 lets in one stop more light than does f/4.

It's important to remember that an f-stop isn't the actual physical measurement of the size of the aperture, but rather, a number expressing how much light "fits" through the hole. The f-stop is derived by comparing a specific aperture's diameter to the focal length of the lens: If you set the lens to f/4, for example, the ratio between the aperture

diameter and the focal length is 1:4. In other words, the size of the aperture diameter is ¼ the size of the focal length. If you set the lens to f/8, likewise, the aperture diameter is ⅛ the size of the focal length.

The actual, physical size of a given f-stop thus depends entirely on the focal length of the lens. With a 50mm lens, f/4 indicates an aperture with a diameter of 12.5mm (¼ of 50mm, or about ½ inch wide). But with a 200mm lens, the same f-number represents an aperture of very different size, because the lens's focal length is much longer. For a 200mm lens, f/4 would represent an aperture diameter of 50mm (two inches wide)—again, ¼ the focal length.

This means that a given f-stop admits exactly the same amount of light into the camera regardless of the lens's focal length. An aperture of f/8 on a 24mm wide-angle lens causes the same amount of light to strike the film as does f/8 on a 600mm super telephoto lens, even though the physical dimensions of the aperture are different. An aperture of f/8 on a 35mm SLR lens provides the same exposure as does f/8 on a medium format or view camera lens.

Aside from focal length, the main way lenses are described is by their **maximum aperture**: the size of the widest aperture they allow. Two lenses can have the same focal length (or in the case of a zoom lens, the same focal

stops Expression of a quantity of light. A "stop" is twice as much light as the next, smallest stop, and half as much light as the next, largest stop.

maximum aperture
Size of the widest aperture possible for a given lens, expressed as an f-stop, as in "an f/2 lens."

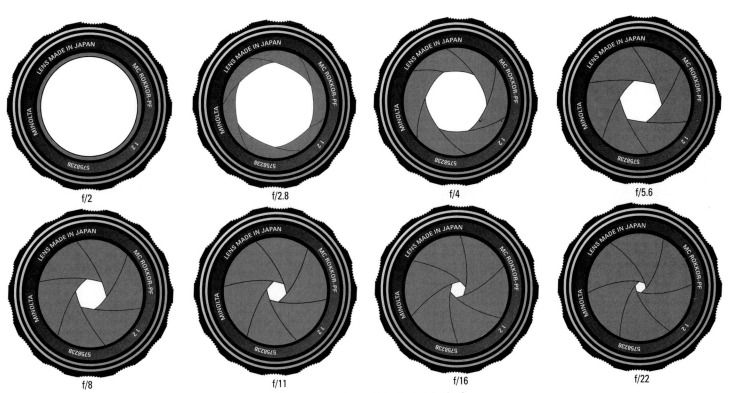

| f/2 | f/2.8 | f/4 | f/5.6 |
| f/8 | f/11 | f/16 | f/22 |

The lens aperture is a rounded opening formed by an adjustable set of metal blades inside the lens. You change the size of this opening to control both exposure (the amount of light entering the camera and striking the film) and depth of field (the depth of the zone of sharpness in your photograph). Different-sized openings are called f-stops. F-stops with lower numbers, such as f/2 and f/2.8, admit a relatively large amount of light into the camera, and produce very little depth of field. F-stops with higher numbers, such as f/16 and f/22, admit a relatively small amount of light into the camera, and produce much more depth of field. The range of f-stops pictured here—from f/2 to f/22—is typical of some lenses, but many lenses offer a wider or narrower range of choices.

fast lens Lens that has a relatively wide maximum aperture, which when set allows more light to enter the camera than with a "slower" lens.

slow lens Lens that has a relatively small maximum aperture, which when set allows less light to enter the camera than with a "faster" lens.

length setting) but have different maximum apertures.

A lens with a wide maximum aperture is called a **fast lens.** A lens with a smaller maximum aperture is called a **slow lens.** The "faster" the lens, the easier it is to photograph in low light or with faster shutter speeds (see Chapter 7) or with slower films (see Chapter 8). A 50mm normal lens, for example, may have a maximum aperture of f/2 or f/1.4. A 50mm f/1.4 lens

is said to be faster than a 50mm f/2 lens; a 300mm f/2.8 lens is faster than a 300mm f/4 lens; and so forth. Conversely, a 28mm f/2.8 lens is said to be slower than a 28mm f/2 lens, and a 200mm f/4 lens is slower than a 200mm f/2.8 lens.

Maximum aperture gets a bit more complicated with zoom lenses. The maximum apertures on some zooms are variable. But even at their widest aperture, these zooms are usually slower

than constant-aperture zooms of the same focal-length range. For example, a 28–70mm f/3.5–4.5 zoom is slower than a 28–70mm f/2.8 zoom (see page 107).

FOCUS AND DEPTH OF FIELD

There are several important means by which a photographer controls the "look" of a photograph. Perhaps the most obvious of these is how you compose the photograph. But two interrelated photographic

F-STOPS

Most cameras offer one of two ways to set the f-stop. Some models have lenses with built-in aperture rings that are calibrated in "full" f-stops and sometimes with click positions at half-stop settings as well. You simply line up the f-stop you want with an index mark on the lens. Other models have a small finger- or thumb-controlled wheel and/or pushbuttons on the camera body. You turn the wheel or push the button and the chosen f-stop is displayed numerically in the viewfinder and/or on an external LCD panel. In the second type, you'll see numbers that designate settings in between full stops; some models are calibrated in thirds of stops, others in half stops. The designated numbers may not represent exact thirds or halves, but setting them nonetheless causes third- or half-stop changes in exposure. Here are the sequences for each type of system:

Whole Stop	1/2 Stop	1/3 Stop
f/1.4	f/1.4	f/1.4
	f/1.7	f/1.6
		f/1.8
f/2	f/2	f/2
	f/2.3	f/2.2
		f/2.5
f/2.8	f/2.8	f/2.8
	f/3.4	f/3.2
		f/3.5
f/4.0	f/4.0	f/4.0
	f/4.7	f/4.5
		f/5.0
f/5.6	f/5.6	f/5.6
	f/6.7	f/6.3
		f/7.1
f/8.0	f/8.0	f/8.0
	f/9.5	f/9.0
		f/10
f/11	f/11	f/11
	f/13.5	f/13
		f/14
f/16	f/16	f/16
	f/19	f/18
		f/20
f/22	f/22	f/22
	f/27	f/25.3
		f/28

properties, focus and depth of field, are also very important.

For most pictures, you choose a specific object—for example, a face in a portrait or a tree in a landscape—on which to focus. With many photographs, you then set the lens aperture to achieve the maximum sharpness. For other photographs, however, you may prefer to set the lens so that only the main subject is sharp, with everything in front of and behind it unsharp.

The front-to-back zone within which objects appear to be sharp is called **depth of field.** When little else but the main subject appears sharp, there is "shallow" depth of field. When the scene is sharp from front to back, there is "good" or "great" depth of field.

Note that depth of field is usually described as extending between two particular distances—say, from five to 15 feet. However, there is no specific point at which elements of a scene stop being sharp. Instead, there's a gradual tapering off in sharpness away from the point at which you've focused. When you focus on one point—one specific part of the subject—all points in a plane to the right, the left, above, and below that point are also in focus. The farther an object is from this plane, the less sharply it will be rendered. This reduced sharpness becomes visually unacceptable at a certain distance from the plane, and thus falls out of the image's depth of field.

Three factors work together to affect depth of field:

- Lens aperture (f-stop)
- Distance from camera to subject
- Lens focal length

Of these three factors, the one used most often to control depth of field is the lens aperture. The smaller the aperture,

depth of field Zone from the front to the back of a scene within which elements will be rendered with acceptable sharpness.

Barbara Bosworth Salmon, Admiralty Island, Alaska, 1994

By setting a wide lens aperture (designated by a low f-stop number), you can create a photograph with shallow depth of field. This means that a specific part of the scene will stand out sharply, but most everything else (in front of and behind it) will be out of focus. Here, Bosworth used extremely shallow depth of field to transcend the familiar photographic cliché of a fisherman proudly holding his catch. If you're using shallow depth of field, focus especially carefully on the part of the scene you want sharp—or else the wrong thing will be sharp. © Barbara Bosworth

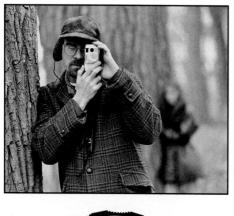

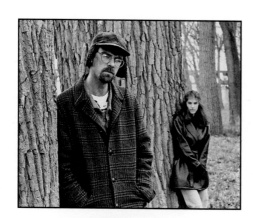

f/2

f/22

How Lens Aperture Affects Depth of Field

The wider the lens aperture, the shallower the depth of field. To make the main subject stand out sharply, set a wide f-stop (here, f/2) to throw the background out of focus (left). To make the overall scene as sharp as possible, set a smaller f-stop (here, f/22) to make both foreground and background appear sharp (right). Note that in both shots, the photographer focused on the front figure.

the greater the depth of field; thus, a subject will have greater depth of field at f/22 than at f/2 (see illustration above). If your aim is to make as much of the scene sharp as possible, set as small an aperture as circumstances permit. If you want to single out a subject—by making the rest of the scene unsharp—set as wide an aperture as you can.

Another way to control depth of field is by changing your distance from the

subject (see illustration on opposite page). To increase depth of field, back away; to reduce it, move closer. A subject shows greater depth of field when 15 feet away than when five feet away, all other factors being equal. Changing your distance from the main subject has the additional effect of changing your composition. Yet if you switch to a different lens or zoom focal-length setting to compensate for the change in dis-

tance—to maintain your composition—you offset any change in depth of field. (If you back away, you can compensate by cropping more tightly in printing and thus preserve the gain in depth of field.) This happens because focal length also affects depth of field.

From a given distance, at a given aperture, the longer the lens focal length, the shallower the depth of field; the shorter the focal length, the greater the depth of field (see page 104). Just keep in mind that the depth of field you get at a given f-stop varies with distance. A smallish aperture of f/11 will produce substantial depth of field with a 35–70mm zoom set to 35mm (from six to 20 feet with the lens focused at nine feet), but relatively shallow depth of field when the zoom is set to 70mm (from eight to 11 feet with the lens focused at nine feet).

As with adjustments to shooting distance, though, changing focal length to control depth of field is difficult because you'll rarely get the composition you want. This also changes the size at which the main subject is recorded on film, as well as the portion of the whole scene the lens captures. And it's true regardless of the film format: When used at the same aperture and distance, a 90mm wide-angle for 4" x 5" has the same depth of field as a 90mm telephoto for 35mm (see Chapter 5).

In general, it's best to use the f-stop to control depth of field and shoot from your preferred distance, with your preferred focal length.

It might seem as if the lens aperture is the ultimate photographic tool, letting you change depth of field and adjust exposure at will. But it's really not that simple. You can't choose an f-stop without affecting other factors. First of all,

the lens you're using may not have an aperture quite wide enough for your purposes. A 28–80mm zoom, for example, might offer a maximum aperture of only f/3.5 or f/4 at its 35mm setting, while a 35mm single-focal-length wide-angle typically offers f/2.8 or f/2—wider apertures that can make things in front of or behind the main subject fall out of focus more dramatically. Wide apertures (and slightly long lenses, such as 85mm) are often used for portraiture, for example, because they soften background detail more thoroughly, making it less likely to distract from the main subject. The same is true with wildlife subjects, though much longer lenses are typically used.

Yet even if the lens you're using has a wide maximum aperture, circumstances, such as the subject's light level, the film's speed, and the highest shutter speed available on your camera, may combine to prevent you from using wide apertures altogether. Say you're photographing in bright sun with an ISO 100 film; even a shutter speed of 1/2000, the fastest available on many 35mm SLRs, would cause overexposure of the film if you set an aperture of f/2 (see Chapter 9).

Newer camera models offering shutter speeds of 1/4,000, 1/8,000, or even 1/12,000 allow you to use a wider aperture. You can also switch to a slower film. And placing a neutral density filter on the lens to cut the amount of light is another option for reducing the light reaching the film, allowing you to set wide apertures (see Chapter 10).

Likewise, setting a small lens aperture to achieve greater depth of field may be easier said than done. Because small apertures admit less light into the camera, you must set a slower shutter speed

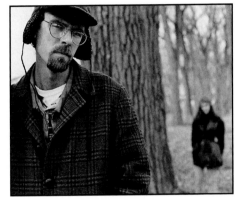

7 feet

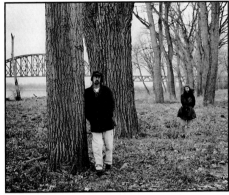

20 feet

Focused Figure

Focused Figure

Camera

Camera-to-subject distance 7 feet

How Distance Affects Depth of Field

The closer you are to your subject, the shallower the depth of field. At seven feet away from the subject, the background is unsharp (left). But at a distance of 20 feet, the depth of field increased, making both foreground and background sharp (right). Both pictures were taken with the same focal length lens at the same f-stop setting. Note that it's usually best to change f-stop to control depth of field, since changing distance also changes composition.

Camera

Camera-to-subject distance 20 feet

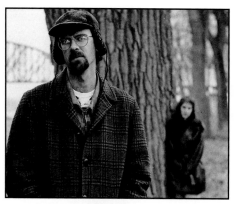

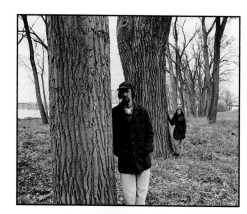

105mm

28mm

How Focal Length Affects Depth of Field

The longer your lens focal length, the shallower the depth of field. Using a moderate telephoto lens (105mm) caused the background to fall out of focus (left). Using a wide-angle lens (28mm) made the background sharp (right). Note that both photographs were taken from the same distance with the same f-stop. As with changing distance, changing focal length also changes composition, so it's usually best to change the f-stop to control depth of field.

to obtain the correct exposure—and that shutter speed may be too slow either to freeze subject motion or to prevent blur due to camera shake (especially with hand-held shooting). In such cases, you may need to use a tripod (or otherwise brace the camera); switch to a faster film; add flash (or other supplemental lighting); or simply wait until your subject is more brightly lit. When extensive depth of field is important, as it is in much landscape photography, many photographers use a tripod all the time so

they can set the slow shutter speeds that small apertures generally require.

ZONE FOCUSING AND HYPERFOCAL DISTANCE

Experienced photographers sometimes use their understanding of f-stop and depth of field for special focusing techniques, such as **zone focusing,** the creation of a zone of acceptable focus before photographing. It allows you to make the most effective use of the depth of field provided by a given lens aperture,

focal length, and focused distance. It's called zone focusing and is based on the principal that at most shooting distances, depth of field extends twice as far behind the point of focus as in front of it. The technique can be used with any lens, but it is most practical with wide-angles because of their inherently greater depth of field. It can also be used in two distinctly different ways, for nonmoving subjects and for active subjects.

Here's how to focus if your subject isn't moving. Imagine that you are photographing a friend standing in front of a house. The friend is seven feet away, a distance you can establish simply by focusing on him or her and reading the number off the foot scale on the focusing ring (see illustration on next page). Let's say you'd also like to include the front of the house in sharp focus in the picture. By focusing on the house and checking your focusing scale, you determine that it is 30 feet away from the camera. To make both the friend and the house sharp, you will need to set the lens's focusing ring to a distance roughly a third of the way behind your friend toward the front of the house. In this case, it would be a setting of about 14 feet. Now look at the lens's depth-of-field scale to see what f-stop will encompass both distances. If the lines representing f/16 fall at 7 and 30 feet when the focusing ring is set at about 14 feet, set your aperture to f/16, and everything between 7 and 30 feet will be rendered sharply, including your friend and the house.

This application of zone focusing is particularly useful for landscape photographs with extreme near-far relationships. With a wide-angle lens used at a small aperture, you can make the

zone focusing Focusing technique in which the photographer calculates the f-stop and focus settings needed to optimize sharpness from the front to the back of the subject.

READING A LENS'S DEPTH-OF-FIELD SCALE

Lenses that have a conventional aperture ring for changing the f-stop usually also have a scale for determining depth of field at a specific aperture and distance. Here's how to use it:

1. Focus the subject and set the desired shutter speed and f-stop. Let's say you've focused at 16 feet and that your f-stop is f/8.

2. Take the camera from your eye and look at the focusing ring, which is usually the wider ring farther out on the lens from the camera body. This ring is marked with distance scales in both meters and feet. A number representing the distance to your subject lines up with a line, dot, or diamond marking centered on the top of the lens barrel. The f-stop you've set also usually lines up with this mark. On either side of this line are more lines, each with a number beneath or beside it. These lines refer to f-stops and for each indicated f-stop there are two lines, one on either side of the focusing mark. These lines are the **depth-of-field scale.**

3. Find the two lines that correspond to your chosen f-stop—in this example, the two lines with the number 8 next to them. These lines indicate two distances on the focusing ring, and this is the range within which your subject will be sharp. Since your focused distance, 16 feet, lines up with the central dot (or line or diamond), the lines marked 8 on the depth-of-field scale fall at 12 feet on one side and around 30 feet on the other. This means that at an aperture of f/8, your depth of field will run from 12 to 30 feet when you're focused at 16 feet. Note how depth of field improves if you set your aperture to f/16; the zone of sharpness now extends from about 9 feet to the horizon, as indicated by the infinity symbol (∞). (These numbers will vary with different focal-length lenses, since focal length affects depth of field.)

Some lenses have a depth-of-field scale to help you determine the amount of depth of field you'll get at different f-stops. The scale appears on the lens barrel opposite the aperture ring. First, focus the subject, then set the f-stop and look at the scale. The lens pictured here is focused at about 16 feet from the subject and set to an aperture of f/8. The two lines marked with an "8" (for f/8), located on both sides of the focusing mark indicate the front and back distances of the depth of field at this distance and f-stop—here, about 12 to 30 feet.

On certain camera lenses the manufacturer has color-coded the lines on the depth-of-field scale to match the colors of the numbers on the aperture ring, eliminating the need for additional numbers. For example, f/11 on the aperture ring may be yellow, and the corresponding lines on the depth-of-field scale also may be yellow. Also, some camera systems that do not use an aperture ring to control f-stop still feature depth-of-field scales on the lenses. In this case, you simply read the f-stop number from an LCD display on the camera body or in the viewfinder, then determine the depth-of-field range as above.

depth-of-field scale
Markings on some lens barrels that allow you to determine the depth of field at a particular f-stop and focused distance.

THE VIEWFINDER AND DEPTH OF FIELD

Your SLR's viewfinder can be very misleading when it comes to depth of field. Even though you may have set a small aperture (say, f/11) on your lens, the camera doesn't actually set this aperture until you press the shutter button to take the picture. SLRs keep the lens aperture wide-open until the instant before you take your picture to allow as much light as possible into the viewfinder. This provides the brightest possible image for framing and focusing. But it also means that the depth of field you see when viewing your subject will not be the depth of field you get in the final picture (except when you've set the lens to its widest aperture).

Many SLRs therefore offer a control called a **depth of field preview,** a switch, button, or other device that lets you view your subject through the lens at the f-stop you've actually set. Using it will cause the viewfinder image to darken, because the aperture closes down and lets in less light; the smaller the aperture you set, the darker the image will be. This darkening can make it difficult to judge depth of field visually.

Another way to determine depth of field is by using a lens's depth-of-field scale, if your lens has one (see page 105) or by focusing to maximize depth of field. And always keep in mind that if you set the aperture to any f-stop smaller than the lens's maximum aperture, the final photograph will have more depth of field than you actually see in the viewfinder.

When you look through an SLR's viewfinder, you're seeing the subject through the lens's widest f-stop—that is, with its aperture as large as it can be. This helps keep the viewfinder image bright for framing and focusing purposes, but it also makes depth of field appear shallow (left). If you've set an f-stop smaller (that is, with a higher number) than the lens's maximum aperture, depth of field will be greater in the final image than it actually appears in the viewfinder. However, you can get a sense of the real depth of field that will be produced by a smaller f-stop by using the camera's depth-of-field preview button, if your camera has one. Pressing the button stops down the lens to the f-stop you've actually set, increasing the depth of field you see in the viewfinder (right). But it also lets in less light, causing the viewfinder to darken and making the image more difficult to see.

scene sharp from just a few feet away to infinity. The focused distance at which such maximum depth of field occurs is called the **hyperfocal distance.** It can be determined by setting your lens's focusing ring at infinity, then reading the distance that is indicated above the nearest mark on the depth-of-field scale that corresponds to the aperture you are using. You then set the focus to that indicated distance. Note that with longer lenses, however, the aperture

required by this technique may be impractically small.

With active subjects, zone focusing can save you the need to refocus every time the subject moves, but the technique is somewhat different than with static subjects. For example, if your subject is a child at play and you're fairly certain the child will remain within a certain distance range, you can set your focusing ring to a distance one-third of the way between the closest and farthest parts of this range,

then stop down your lens to an f-stop that will ensure both are in focus. In most circumstances, you need generous light and a reasonably fast film to make zone focusing work well with active subjects.

Note that if your camera is an auto-focusing model, you can still use zone focusing as long as your lens has a depth-of-field scale. Simply switch the lens to manual focus after you've checked your distances, then proceed as described above.

depth-of-field preview Switch, button, or other device on a camera that allows you to view the subject's depth of field at selected lens apertures.

hyperfocal distance Focused distance at which a lens of given focal length provides the most possible depth of field at a given aperture.

ZOOM LENSES AND LENS APERTURE

Zoom lenses are a great creative convenience, allowing you to both quickly match focal length to subject without time-consuming lens changes and to save the weight and bulk of several single-focal-length lenses. But those advantages come at a price. Zooms are generally slower—that is, they have smaller maximum apertures—than single-focal-length lenses within their range.

Because with an SLR you view the image through the lens itself, a zoom's smaller maximum aperture makes the camera's viewfinder image darker. This can make manual focusing difficult; it may even throw off some autofocusing systems. More significant, when you're shooting by low existing light—light that requires as wide an f-stop as possible—a smaller maximum aperture can force you to set shutter speeds too slow to safely handhold steadily. You end up having to choose between correct exposure and a sharp image, since you can't have both. You also may have to choose a faster film than you would normally prefer, so you can set a faster shutter speed.

Set to its maximum aperture of f/4, for example, a 35–80mm zoom at 35mm would require a shutter speed two stops slower, in a given light level, than a 35mm single-focal-length lens set to a maximum aperture of f/2 (fairly typical for such a lens). The single-focal-length lens would give you the ability to shoot at 1/60 at f/2, whereas with the 35–80mm zoom in the same light you'd be forced to set 1/15 at f/4 to obtain equivalent exposure. And that could make the difference between sharp and unsharp results if you are handholding the camera or if your subject is in motion.

This problem is most serious with **variable-aperture zoom** lenses, which actually change their effective aperture as you change the focal length. A typical 70–210mm zoom may start out, at 70mm, with a relatively small maximum aperture of f/4, then by the time it's zoomed to 210mm, it is operating at a still smaller f/5.6. (That would would be called a 70–210mm f/4–5.6 zoom lens.) So if you can afford it, you're probably better off with a **constant-aperture zoom.** These are bulkier and more expensive, but they are almost always faster than variable-aperture zooms—and just as important, the aperture you've set remains constant throughout their focal-length range. These lenses allow you to shoot safely in lower light levels and also make it easier to use slower, finer-grained films in such conditions.

variable-aperture zoom Zoom lens in which the maximum aperture gets smaller as you increase the focal length setting.

constant-aperture zoom Zoom lens in which the maximum aperture remains the same no matter what focal length is set.

CHESTER HIGGINS, JR.
PHOTOJOURNALISM

HIGGINS'S TOOLS

Two 35mm SLR camera bodies

80-200mm, 35-80mm, and 24mm SLR lenses

Dedicated on-camera flash (always bounced)

1200 watt-second strobe with one head (for environmental portraits)

Black backdrop (for portable studio, as needed)

Photographic umbrella (for bounce lighting)

Chester Higgins, Jr. lives a dual life. Workdays he makes his living as a general assignment photographer for the *New York Times*, photographing news conferences, fires, and society events ("Anything but sports," he says.). Nights, weekends, and vacations he spends on his own long-term projects. His best known personal project, *Feeling the Spirit: Searching the World for the People of Africa*, took him to over thirty countries, was eventually published as a book, and traveled as an exhibition worldwide.

These days a degree in photojournalism from a school of journalism is a virtual necessity for a newspaper job. Things were a little looser when Higgins started his career in the early 1970s. His training was in business and sociology and, while he learned photography in college, he never studied it formally. Coming to New York City after graduation, he taught for a while at New York University and worked as a freelance photographer. His success freelancing eventually led to a full-time job with the *Times*.

Most photojournalists use automated 35mm SLR camera systems. These are quick and flexible and allow the use of a wide variety of lenses and other accessories. However, Higgins prefers more basic equipment. For general purpose work, he uses a 35mm rangefinder. When he needs an SLR, such as when using telephoto lenses, he shoots with a manual-focus 35mm SLR.

While many photojournalists carry a lot of equipment, just in case they'll need something, Higgins prefers to keep it simple—one camera body (maybe a second as a backup when traveling), three lenses, flash, battery pack, and reflective umbrella. "For me, the greater the limitations, the more I need to be creative. Besides, too many options breed insecurity," he says.

Newspaper photojournalists almost always use color negative film. Negative film offers more latitude; if the exposure or lighting situation is a little off, it won't matter quite as much as it would with transparency film. And using color gives photo editors the option of running the image either in color or black-and- white. Higgins uses color negative film on assignment, but prefers black-and-white negative film when photographing for himself.

Film is processed at the newspaper using the same type of machine used by minilabs (so-called "one-hour labs"). Newspapers rarely use prints anymore. Instead the photographer (or photo editor) edits the negatives on a light-box, then scans the chosen images directly. The designer drops the scanned (and reversed) files into the page layout on computer and sends it off to the printer.

The right equipment is important, of course, but perhaps a photojournalist's most important tools are good judgment and a sympathetic soul. Photographing strangers, for example, can be awkward, as many beginning photographers know. "Immediately reach out," Higgins suggests. "If you like people and reach out, they'll reach back. Everyone wants acceptance and the fastest way to get it is to give it: Be human, direct, and honest—no bull. Ask your subjects what's going on and mean it. Be a good listener." Higgins believes that if you listen, people will lead you to other subjects and ideas. "Turn people into teachers," he says. "Exchange information and build a bridge of trust."

Higgins often finds himself working in areas where he is not known and doesn't really know anyone. This can be dicey and sometimes dangerous. He tries to meet and enlist spiritual leaders as allies—for example, priests and other pillars of the community. "This is an efficient way to work, especially since I usually have a limited amount of time to work. These people know everyone—good and bad—and they know how to direct me."

My Great Aunt Shugg Lampley
Alabama
1968

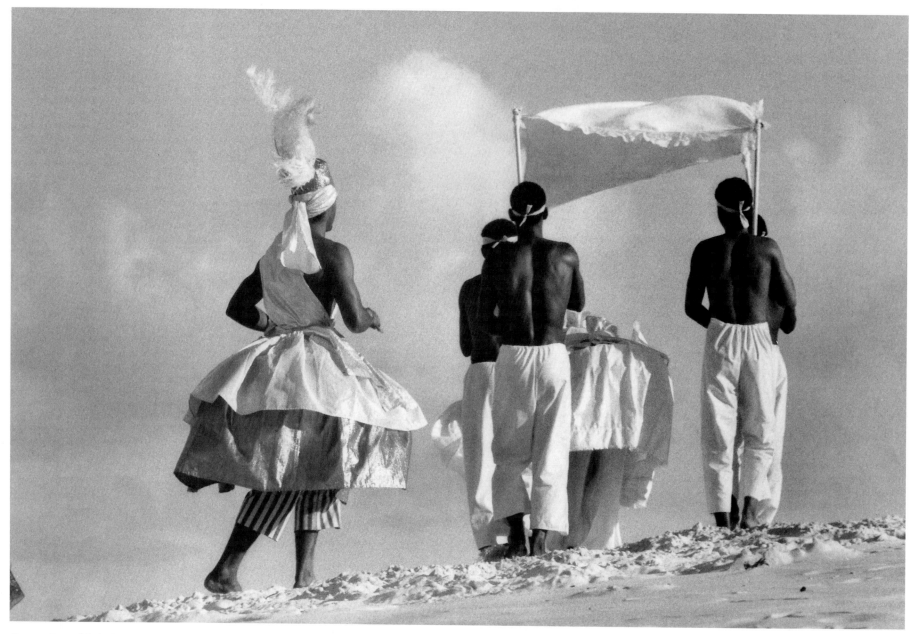

Procession of Oshala
Brazil
1990

Most photographers work freelance; in fact, working for a newspaper is one of the few jobs in photography that actually offers full-time employment. On a large newspaper staff photojournalists sometimes specialize in one area—for example, sports events or city hall activities. Most, however, are generalists. Higgins likes it that way. It's fresh—"I don't know whose face I'll be looking at tomorrow," he says—and it helps break the monotony of his long-range projects.

The fact that Higgins works on personal projects as well is relatively rare among newspaper photojournalists. The projects vary somewhat, but they all share certain common themes, frequently focusing on the state of African Americans. "Western media often lacks the ability to see and show three basic aspects of my people," he says, "our decency, our dignity, and our virtuous character. The view all too often presented in the media concerning people of

African descent is a limited one, focusing narrowly on pathological and deviant behavior."

Preparing for his projects is a true test of Higgins's powers of perseverance and organization. He spends whatever time he can find researching areas where he plans to travel. He reads the available books, talks to people who have been there, and even subscribes to newspapers and magazines from that country or region. He photographs when he has vacation time. (What most people call vacations he considers a waste of time.) The personal projects are all financially supported without the help of the *New York Times,* with a combination of grants, publishing advances, print sales, and personal investment.

On the surface, much of Higgins's work is about African American issues. Yet in a broader sense his photography is about the human condition. A current personal

PHOTOJOURNALISM: CHESTER HIGGINS, JR.

project, a book titled *Elder Grace*, focuses on the perception of age in our society. Having grown up in a community where age was revered (the small Alabama town of New Brockton), Higgins finds it disheartening that "cultural wisdom is not valued anymore."

Another reason Higgins is so focused on age may be his gratitude to older photographers who helped and influenced him—from Arthur Rothstein, who was best known for his work with the Farm Security Administration (see page 18) and later picture editor of *LOOK* magazine, to the great African-American photographers and teachers P.H. Polk, Gordon Parks, and James Vanderzee, and to Ernest Cole, an African photographer who documented Apartheid in the 1960s.

In a similar way, Higgins is leaving his own legacy. Over the years, he says "I have seen more willingness on the part of the media to report positively on our diverse cultures." Such progress is a testament to individuals like Higgins who see their jobs more as a mission than just a means of making a living.

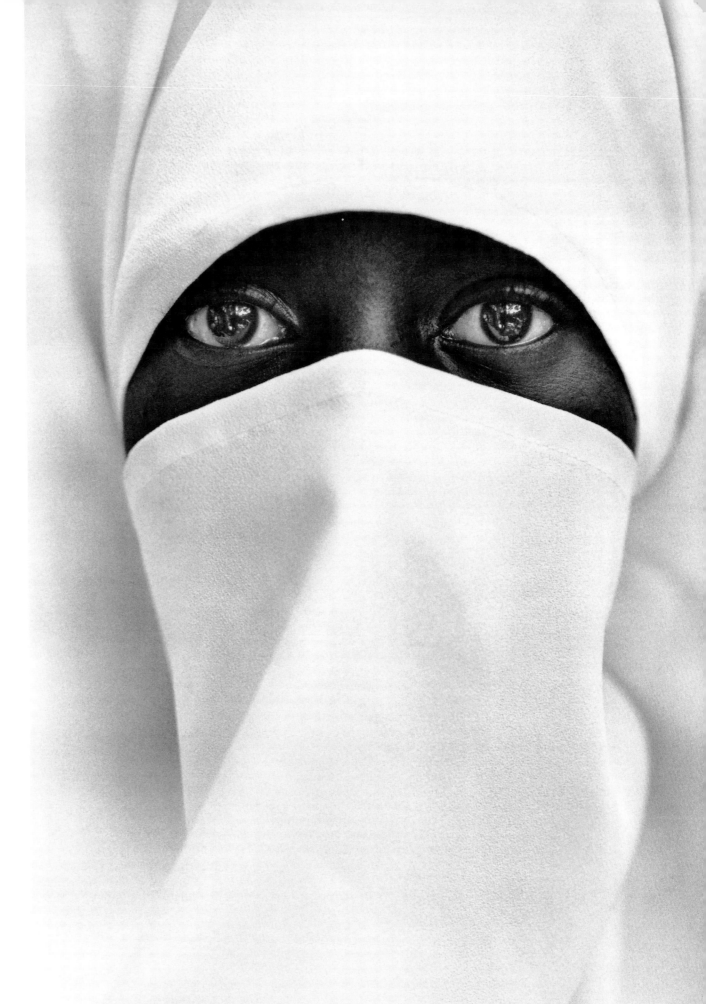

Moslem Woman
Brooklyn
1990

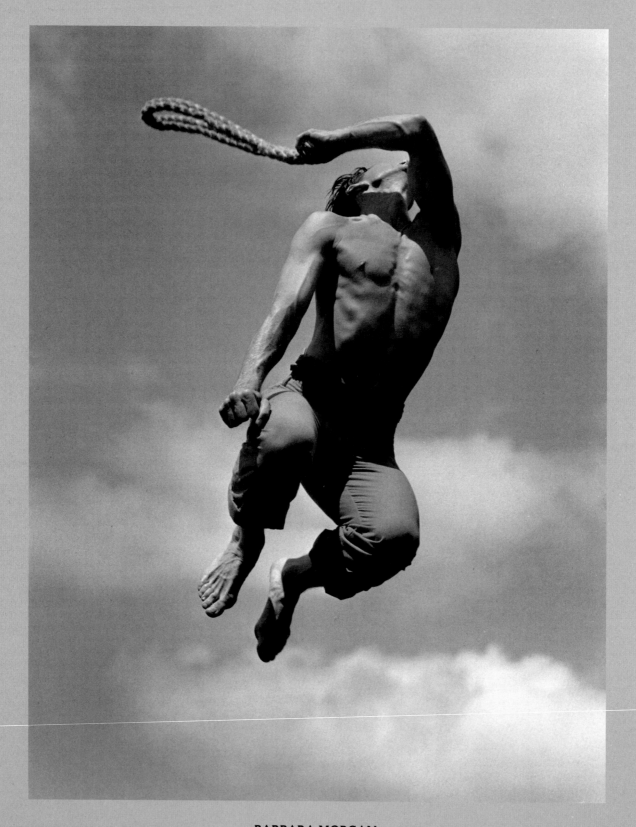

BARBARA MORGAN
Martha Graham, El Penitente, Erick Hawkins
Solo as El Flagellant, 1940

Photographing from a low angle to make the sky serve as backdrop,
Morgan used a high shutter speed (perhaps 1/500) to freeze this dancer
in mid-flight. She also waited until the dancer was at the height of his
leap—the point at which he seemed to hang in midair. Timing a shot
for such momentary slowdowns often produces the sharpest image of
a moving subject. Barbara Morgan/Lloyd Morgan, Printing & Graphic Services, Inc.

CHAPTER 7
THE SHUTTER

There are two main ways to control the amount of light striking the film inside the camera in order to give the film the correct exposure. One way is with the lens aperture, the size of the opening that admits light into the camera (see Chapter 6). The other way is with the **shutter,** which determines for how long light is let into the camera.

The shutter is a curtain or set of metal blades that serves essentially as a valve opening and closing to let light from the lens reach the film to create a photograph. The duration of time the shutter stays open is precisely regulated by the camera and is called the **shutter speed.**

Determining the correct exposure for a subject is a matter of balancing the shutter speed against the f-stop—adjusting one to compensate for changes in the other. Your choice of these settings is limited by sev-

eral factors, notably the existing light, the sensitivity of your film, and the available aperture choices on your lens.

Within those limitations, the choice of shutter speed is both an aesthetic and technical decision, one that may be very important to the success of your photograph. First, it allows you to determine how a subject's movement (if the subject is moving at all) will be represented in your photograph. And second, the shutter speed has an important effect on the sharpness of your pictures—even if the subject is not moving.

Most cameras offer a wide choice of shutter speeds, but for general-purpose photography such speeds are usually measured in short fractions of a second. A typical shutter speed often falls within the range of 1/60 to 1/250 (of a second). But some subjects require longer or

shorter durations, and many 35mm SLRs offer shutter speeds as long as 30 seconds and as short as 1/12,000. Note that most of the time you should not hand-hold a camera when the shutter speed is 1/30 or slower (see page 119 for more details).

The sequence of shutter speeds available to you depends on the kind of camera you have. If your model has a traditional shutter speed control—usually a rotating dial located on the top of the camera, though sometimes a ring on the lens—then the indicated sequence of speeds is geometric. The traditional sequence starts at one second, and each increment gets shorter by half as much time—i.e., 1, 1/2, 1/4, 1/8, 1/15, 1/30, 1/60, and so forth. These are called full shutter speeds (see the chart on page 116). Each shutter speed lets in half as

shutter Curtain or set of metal blades that opens and closes to regulate how long light is permitted to strike the film.

shutter speed Duration of time the shutter stays open, expressed in seconds. On most cameras, whole numbers stand for fractions; "30" and "125" represent 1/30 and 1/125, for example.

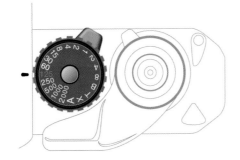

A traditional shutter speed dial is almost always found on top of the camera body, usually (but not always) on the right-hand side. You adjust speeds by rotating it to align your choice with a mark of some sort, here a white dash. This dial is set to 1/125.

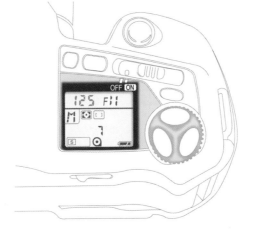

With most modern SLRs, the shutter speed is adjusted with a rotating thumb- or finger-wheel, usually located on the top or back of the camera body, and displayed along with other data on an external LCD panel (as well as in the viewfinder). The camera here is set to 1/125 (with a lens aperture of f/11).

Many SLRs also display the shutter speed, whether set manually (by you) or automatically (by the camera), in the viewfinder frame. This camera is also set to a speed of 1/125 (with a lens aperture of f/11).

113

much light as the setting before it and double the light of the setting after it.

Many modern 35mm SLRs allow you to set intermediate speeds for more subtle control. These speeds are a third or a half of the way between the full stops described above, and they produce incremental changes in exposure rather than a full halving or doubling of it. For example, you may be able to set a speed of 1/45, which is halfway between the full-stop speeds of 1/30 and 1/60. (Note that with most traditional mechanical cameras you can't set the shutter speed to in-between settings.)

READING SHUTTER SPEEDS

However you set your camera's shutter speeds, keep in mind that fractional speeds—those shorter than one second—are indicated with whole numbers on the camera controls, not with fractions. Thus, the number 2 represents 1/2 second; 15 is 1/15 second; 500 is 1/500 second.

Speeds longer than one second, if your camera offers them, may be denoted in one of several ways. On a dial they may have a different color than the fractional speeds, or have the letter S, for seconds, beside them. On an LCD panel they're sometimes indicated with the seconds symbol (") or with the letter S. In either case, the numerical sequence for speeds longer than one second looks the same as that for the fractional speeds—1, 2, 4, 8, 15, and 30—except that the numbers indicate seconds instead of fractions. Be sure that you understand which is which.

Note that some dials have information for the use of flash highlighted, such as the camera's top flash synchronization speed, usually 1/60, 1/125, or 1/250 (see Chapter 11). Or, they may have a separate setting exclusively for flash, marked

SHUTTER SPEED/APERTURE RELATIONSHIP

Controlling film exposure involves balancing the shutter speed with the lens aperture. The terminology can be confusing at first. The particular lens aperture is referred to as the "f-stop." But adjustments to either aperture or shutter speed may also be described in "stops," a general term that refers to changes of doubling and halving of exposure. For example, if you change your shutter speed from 1/125 to 1/60, you are increasing exposure by one stop (doubling the time). And if you change your aperture from f/5.6 to f/8, you are decreasing exposure by one stop (halving the amount of light).

This reciprocal relationship allows you to choose different ways to reach the same exposure. If you open up the lens aperture one stop to let in twice as much light, you can decrease the shutter speed to cut the time in half, maintaining the same overall amount of light. Thus, the following settings all yield the same exposure:

- 1/30 at f/22
- 1/60 at f/16
- 1/125 at f/11
- 1/250 at f/8
- 1/500 at f/5.6

with an X or a flash symbol. (This separate speed is often 1/90 or 1/100.)

Most shutter speed controls also feature a **bulb (B)** setting. Set to B, the camera opens the shutter when you press the shutter button and closes it when you release the button. The B setting is for manually-timed exposures longer than the longest speeds available on your camera.

Also found on some cameras is a **time (T)** setting. Set at T, the shutter opens when the shutter button is pressed and released, then closes when the button is pressed a second time. You should use a tripod (or other support) and cable release for sharp results with the B or T setting (see page 121).

LEAF VS. FOCAL PLANE SHUTTERS

Mechanically speaking, there are two common types of shutter: the focal plane shutter and the leaf shutter. Nearly all

35mm SLRs and many medium-format cameras have a **focal plane shutter**, a light-tight cloth or metal curtain positioned just in front of the film (where the lens focuses, called the focal plane). When you push the shutter button, the curtain slides to the side, or from top to bottom (depending on the camera model), to uncover the film, then a second curtain enters the frame to cover it up again.

Many medium-format cameras and all large-format lenses have a **leaf shutter** (as do most point-and-shoots). Built into the lens, these consist of a group of metal blades that open and close in a circular pattern to allow light to pass through the lens and reach the film.

One advantage of the focal plane shutter is its wide range of speeds, especially on the fast end. Typical 35mm models go as high as 1/2000, 1/4000, or faster. This allows you to freeze extremely fast-moving subjects. It also makes it possible to

bulb (B) Shutter speed setting for manually-controlled long exposures. Setting the shutter at B causes it to stay open as long as the shutter button is depressed.

time (T) Shutter speed setting for manually-controlled long exposures. At this setting, usually denoted with a T, the shutter opens when the shutter button is first pressed, then closes when the shutter button is pressed a second time.

focal plane shutter Type of shutter consisting of a metal or cloth curtain that opens horizontally or vertically just in front of the film to admit light.

leaf shutter Type of shutter consisting of a circle of metal blades built into the lens; the blades open and close to admit light.

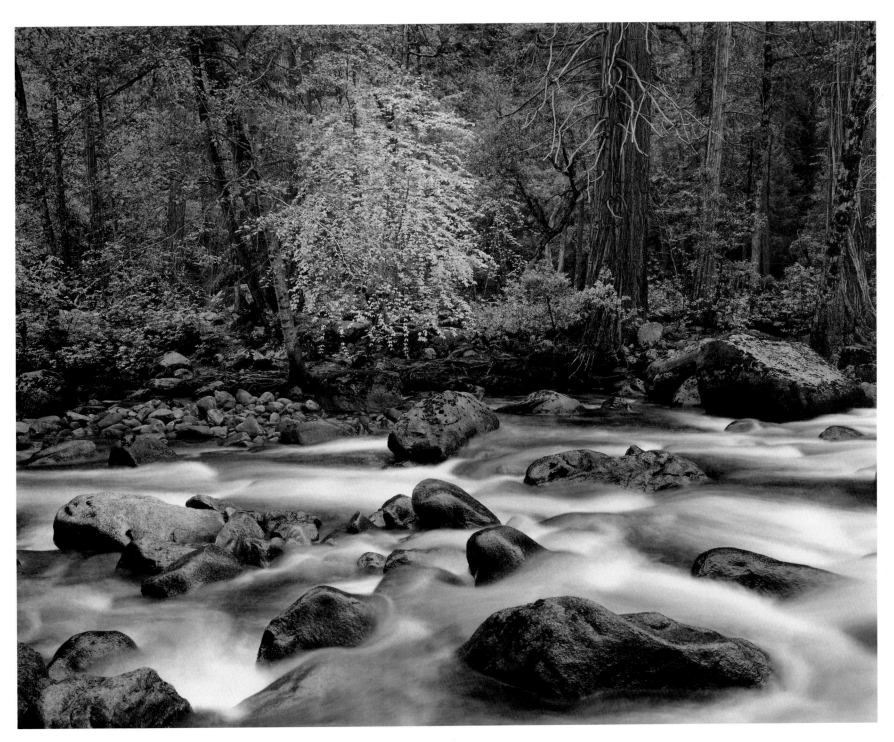

John Sexton Merced River and Forest, Yosemite Valley, California, 1983
A former assistant to the late Ansel Adams, Sexton photographs mostly middle-distance scenes rather than the grand views Adams favored, and works by soft, luminous light. Because he sets his lens at small f-stops (here, f/32) to get a lot of depth of field, his exposure times can run into minutes. Sexton capitalized on this seeming limitation for the river scene shown here; during the five-second exposure, the water blurred into soft streaks, creating an ethereal sense of motion.

THE SHUTTER SPEED SEQUENCE

Some camera systems let you set shutter speeds only in full increments, halving or doubling each successive time interval. Other models can set in-between speeds, either in third-stops and/or half-stops. Here are the standard progressions for each shutter speed increment; note that many cameras have timed speeds longer than the one second shown here, for example, 2, 4, 8, or 15 seconds. Also, some of the numerical designations are rounded off; 1/22, for example, is approximately—but not exactly—halfway between 1/30 and 1/15.

Full Stops	1/2 Stops	1/3 Stops	Full Stops	1/2 Stops	1/3 Stops
1/8000			1/60		
		1/6400			1/50
	1/6000			1/45	
		1/5000			1/40
1/4000			1/30		
		1/3200			1/25
	1/3000			1/22	
		1/2500			1/20
1/2000			1/15		
		1/1600			1/13
	1/1500			1/12	
		1/1250			1/10
1/1000			1/8		
		1/800			1/7
	1/750			1/6	
		1/640			1/5
1/500			1/4		
		1/400			5/16
	1/350			3/8	
		1/320			7/16
1/250			1/2		
		1/200			5/8
	1/180			3/4	
		1/160			7/8
1/125			1 second		
		1/100			
	1/90				
		1/80			

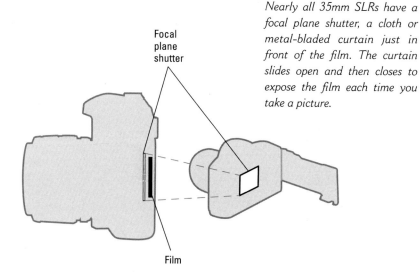

Nearly all 35mm SLRs have a focal plane shutter, a cloth or metal-bladed curtain just in front of the film. The curtain slides open and then closes to expose the film each time you take a picture.

Focal plane shutter

Film

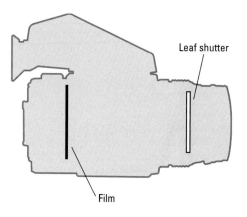

Many medium-format cameras and all large-format lenses use leaf shutters, metal blades that open and close in a circular shape to expose the film. Leaf shutters are built into the lens, so each lens must have its own shutter.

Leaf shutter

Film

get the proper exposure at wide lens apertures and/or to use "fast" films when you're shooting in bright light.

A major disadvantage of the focal plane shutter, however, is that it doesn't allow flash to be used at very high shutter speeds. The highest shutter speed for flash that ordinarily works with a focal plane shutter is 1/60, 1/125, or 1/250 (or somewhere in-between), depending on the camera model. This can limit your ability to use flash in certain situations.

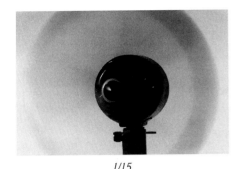

1/15

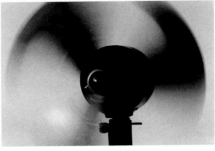

1/60

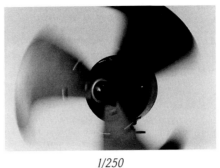

1/250

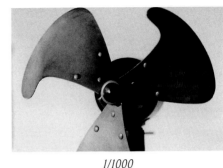

1/1000

The higher the shutter speed you set, the more likely you are to freeze motion. In the first shot of this spinning fan, a shutter speed of 1/15 caused the blades to blur into a circle. In the second and third shots, made at successively faster speeds, the blades are less blurred, but not completely frozen. In the fourth shot, made at a fast 1/1000, they are stopped completely. In most photographs, you'll need a fast shutter speed to freeze subject movement, but sometimes the slower speeds are actually more effective in depicting the feeling of motion.

Because focal plane shutters are built into the camera body, lenses for such models don't have to contain individual shutters, as is the case with leaf-shutter lenses. This makes interchangeable lenses often less expensive, and it also allows manufacturers to produce smaller-sized lenses with larger maximum apertures to let in more light.

Leaf shutters are quieter than focal plane designs, and allow flash to be used when the shutter is set at any speed. But the physical action of opening and closing a leaf shutter's metal blades ordinarily limits it to a top speed of 1/500. While this diminishes the ability to freeze fast motion, the types of cameras using leaf-shutter lenses (view cameras, many medium-format models, and 35mm point-and-shoots) are not really designed for shooting action anyway. Also, most leaf shutters don't offer calibrated speeds slower than one second; these must be manually timed on a B or T setting.

CONTROLLING MOTION WITH SHUTTER SPEED

There are basically two main ways to portray motion in a photograph of a moving subject. One is by "freezing" the subject: stopping its movement so that it appears sharp. The other is by blurring the subject. Although blur can be used for creative effect, most often you'll want to freeze a moving subject, whether an athlete in motion or random activity on the street.

You do this by setting as fast a shutter speed as is necessary and practical for the conditions. The needed speed depends primarily on how fast the subject is moving. A walking figure may require a moderate 1/125; a leaping long-jumper might need a high 1/500. In fact, many sports photographers routinely use shutter

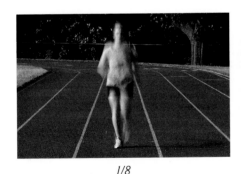

1/8

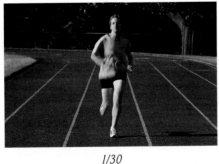

1/30

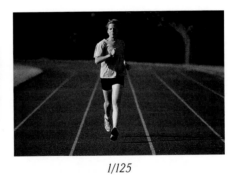

1/125

The direction in which a moving subject is traveling affects how high a shutter speed you'll need. When the subject is moving toward the photographer, a relatively slow shutter speed of 1/30 nearly "freezes" her (even though she is running), and 1/125 stops her motion completely. But when the subject is moving horizontally (from right to left), a shutter speed of 1/30 blurs her severely, and a fast speed of 1/500 is needed to freeze her motion.

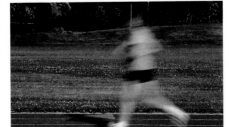

1/30

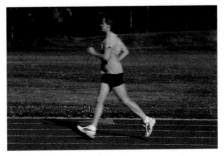

1/125

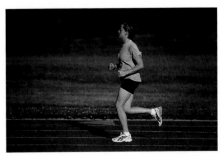

1/500

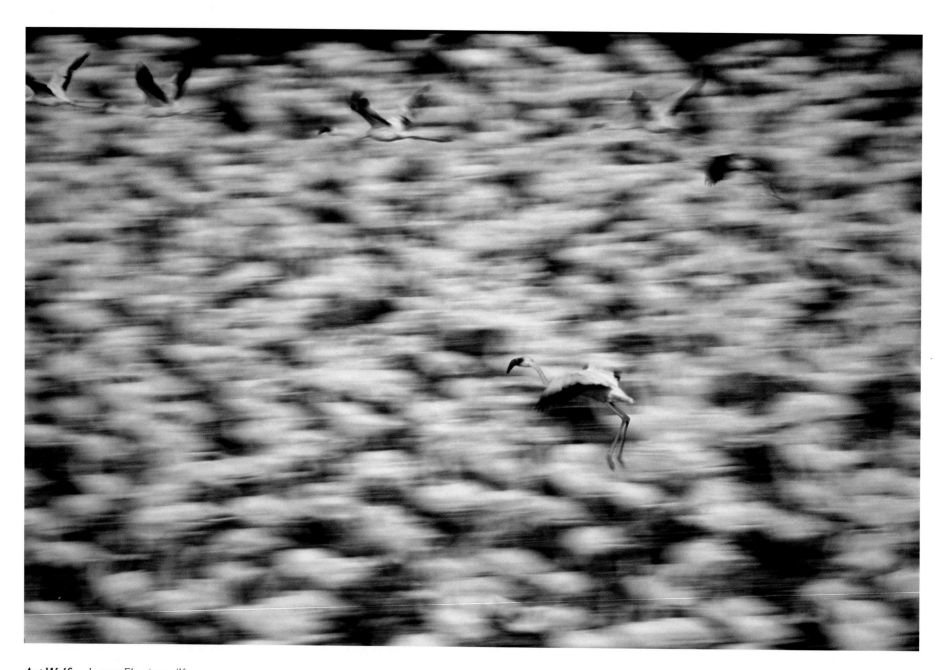

Art Wolfe Lesser Flamingos/Kenya

Nature photographer Wolfe used panning to create a sense of the movement of these African flamingos. As the birds flew, Wolfe followed one of them with his lens as he pressed the shutter button, making sure to keep that bird in the same position in the frame as he swung the camera—a little low and to the right of center. Panning made the bird appear sharp, but Wolfe's slow shutter speed caused the background to blur into directional streaks, evoking the feeling of flight. © Art Wolfe

Holding a camera steady is especially important in low light (when the shutter speed is slow) and with telephoto lenses (which magnify the effects of camera shake). These photographs were shot at 1/15 with a 135mm lens. For the shot at top, the camera wasn't steadied, resulting in severe image blur; for the bottom shot, the camera was steadied against a fence, producing a much sharper result.

panning Following a moving subject with the camera as it passes by, to create an image in which the main subject is sharp while the background is blurred by the camera movement.

camera shake Motions or vibrations from your body or your camera's moving parts that cause blur, especially when you are hand-holding the camera with slower shutter speeds.

speeds of 1/500 and 1/1000. There may even be times when you must use the still-higher shutter speeds (1/2000, 1/4000, and 1/8000) offered by many of today's 35mm SLRs—to freeze a racehorse as it passes by the grandstand, for example.

The subject's velocity isn't the only consideration in choosing a motion-stopping shutter speed. The direction of the movement is also a big factor. Freezing a subject requires a much higher shutter speed if it's moving horizontally across your field of view (that is, parallel to the film plane) than if it's moving directly toward or away from you (See page 117). If the subject is moving at a diagonal to you, the needed speed will fall somewhere in between.

A third factor is your lens focal length. The longer the lens, the greater the apparent motion due to its greater magnifying power and the higher the required

shutter speed. A wide-angle lens, by comparison, requires slower shutter speeds to stop the same degree of motion. Also, in a given light level, the more sensitive your film, the higher the shutter speed you'll be able to set. If you plan to shoot fast-moving subjects, you'll have an easier time if you load your camera with fast film (see Chapter 8).

Keep in mind, too, that active subjects rarely move at constant speed. In fact, if you time your exposure to the peak of a basketball player's jump shot or the moment a soccer player changes direction to sidestep an opponent, a given shutter speed will freeze him or her more successfully. Speeds fast enough to freeze a moving figure's body, however, may not be enough to stop faster-moving arms and legs.

If conveying a sense of motion is your primary goal, making a moving subject sharp isn't the only option. You can create a strong sense of movement by allowing the subject to blur against a sharp background. You do this simply by using a shutter speed too slow to freeze its movement. It has to be the right speed: too slow and the subject may nearly disappear. The effect generally works best when parts of the subject remain relatively sharp and recognizable.

Fast-moving subjects can be blurred with speeds in the range of 1/15 to 1/60. But whenever possible, shoot the subject with several different shutter speeds so you can choose the best effect when you look at the processed photographs.

Panning is another possibility for creating a sense of movement. To pan a subject, you literally follow it with the camera as it passes by. Depending on shutter speed (and your panning technique), this results in a sharp main subject against a streaky background.

Panning is best done at moderate shutter speeds—1/15 to 1/60 usually works, depending on the subject—so that the camera movement sufficiently blurs the background. It's important to keep the subject in the same position within the frame as you pan; centering it makes this easier. But if your composition places the subject off-center, keep it there throughout the panning motion. (This can be tricky since with SLR cameras you cannot see through the viewfinder while the shutter is open because the reflex mirror is up). Also, remember that the slower shutter speed may cause the subject's faster-moving parts, such as swinging arms or the spinning spokes of a bicycle wheel, to blur along with the background.

CONTROLLING SHAKE WITH SHUTTER SPEED

The other kind of motion you control with the shutter is **camera shake**: motion or vibrations from your hands and body movement, and sometimes even from the moving parts of the camera itself. Shake can be a factor with both moving and static subjects, and it can either visibly blur the image or just make it less sharp than it could be. In fact, photographers often mistake the effect of shake for incorrect focus. But an easy way to tell if shake has softened your picture is by looking to see if anything at all is sharp in the scene. If some area other than the main subject is sharp, then the problem is incorrect focus. But if the whole scene is unsharp—especially if that unsharpness has a streaky quality—then camera shake is probably the cause.

Setting a fast enough shutter speed counteracts the effect of shake. But the speed you need depends partly on how steady you are—how well you can use your body to brace the camera. Be careful to brace your arms against your chest

Jim Goldberg High Noon from *Raised by Wolves*

*Goldberg used the combination of a slow shutter speed and strong backlight to create an abstract
quality in this photograph from his widely acclaimed book,* Raised by Wolves. *The slow shutter
speed, while he moved the camera during the exposure, created the streaks that lend energy—and
edge—to the image.* Courtesy of Jim Goldberg

and press the shutter button after breathing out, to steady the camera so you can work at a slower speed.

The needed shutter speed also depends on the type of lens you're using. Longer focal lengths (telephotos) require higher shutter speeds to offset shake than do normal or wide-angle lenses. This is partly because longer lenses are generally larger, thus more difficult to hold steady, but mainly because their high magnification increases not just the subject size but the effect of camera shake.

There is a formula for determining the shutter speed needed to compensate for camera shake with a given lens focal length. The reciprocal shutter speed formula calls for a shutter speed at least as high as the reciprocal of the focal length. With a 50mm lens (or a 35–70mm zoom set to 50mm) that means 1/60, since it is the closest setting faster than 1/50. With a hand-held 200mm lens (or zoom focal length setting of 200mm), use a shutter speed of 1/250 or faster. (Though it follows that 1/30 is safe with a 24mm or 28mm wide-angle lens, many photographers avoid speeds slower than 1/60 for hand-held work.)

Using a faster shutter speed means you have to set a wider lens aperture to maintain the needed exposure. On the other hand, using a tripod (see below) allows you to use as slow a shutter speed as you want—unless, of course, you want to freeze a moving subject.

Just as with freezing subject movement, using a faster film can help you deal with camera shake. Assume the film is ISO 100 and the exposure is 1/125 at f/5.6. Switching to an ISO 400 film, which is four times more sensitive to light, would allow you to set a shutter speed two stops faster—1/500 rather than 1/125—and still get correct exposure at an aperture of f/5.6.

THE TRIPOD

Shake or not, there's probably no other tool that can improve the quality of your photography as much as a **tripod**, an adjustable three-legged support for your camera. To be sure, some kinds of shooting simply don't allow the time or discipline required to set up a tripod. But more often than not, failure to use a tripod is due to simple laziness—and the end result is a picture that could have been better.

And better in several ways. A tripod steadies the camera allowing you to set slow shutter speeds and still get sharp results. It also ensures sharpness at even high shutter speeds when camera shake might otherwise compromise it. And a tripod forces you to think more carefully about composition and, by holding your exact framing, to control it more precisely.

These advantages are especially important with long lenses. When you handhold a camera with a long lens, the viewfinder image may jump around so much that you often don't get exactly what you saw when you pushed the shutter button. The long lens's narrower angle of view makes a given amount of shakiness much more significant—a risk the tripod minimizes or eliminates.

Even with shorter lenses, many medium-format cameras are awkward to hand-hold because of their larger size and weight and are best used on a tripod. Almost all large-format cameras must be tripod-mounted.

The kind of tripod you need depends on the camera and camera format you use, the subjects you choose to shoot, and the lenses you prefer. Any choice is a compromise between stability and portability. The heavier the tripod, the more solid the plat-form, but the more burdensome it is to haul around. Heavier tripods are also usually more expensive. On the other hand, there's no point in taking it along at all if it doesn't provide adequate stability.

Some tripods are wooden, but most are made of metal. Wooden models are less adversely affected by temperature, but they're often much more expensive, so consider the metal variety, which has two basic parts: the head and the legs.

Leg Sections Each of the three legs on a metal tripod usually has two, three, or sometimes four telescoping sections. The biggest differences in tripod leg design

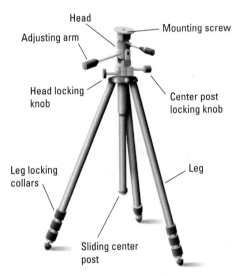

Head

Adjusting arm

Mounting screw

Head locking knob

Center post locking knob

Leg locking collars

Leg

Sliding center post

Tripods come in a variety of designs and sizes, but they all have one fundamental purpose: to steady the camera. This allows you to use slow shutter speeds without the risk of camera shake blurring the image, a particular problem when you're shooting in low light and/or at small f-stops. Using a tripod also enhances compositional control, helping you pay critical attention to the viewfinder frame and what you decide to include in it.

tripod Three-legged accessory used to steady a camera, especially useful for photography done with slow shutter speeds.

have to do with the mechanism that locks the sections in place. The traditional approach is a knurled, threaded ring that's twisted to tighten or loosen the section. An increasingly popular alternative is the clamping lever. Some photographers feel the knurled ring offers the greatest security. The clamp, on the other hand, makes tripod setup much faster; when it's released, leg sections usually just slide into place with the help of gravity.

The extent to which a tripod's legs spread apart also affects practicality. If you're a landscape photographer who works with a view camera, then you need only enough spread to insure stability. If you're a nature photographer who likes to do low-level close-ups, get a tripod with legs that can be spread wide enough to place the camera close to the ground.

Tripod height is another thing to think about. The maximum height includes full extension of the center post, an arrangement that makes the camera more prone to vibration. Choose a tripod that lets you shoot at or close to eye level with leg extension alone—that is, without raising the post, or by raising it minimally.

The Tripod Head The head is the part of the tripod to which you attach the camera. It features a small platform with a threaded screw in the middle; the screw fits the socket located in the camera's base. Most tripod heads are of pan/tilt or ball design. A pan/tilt head features two moving control levers, one to tilt the camera backward and forward, the other to tilt it from side to side; adjustments are usually locked in by twisting the lever. In addition, the pan/tilt head rotates ("pans") freely at the top of the legs, with adjustments locked in by a separate control.

A ball head, by contrast, really offers only one type of movement—but it's omnidirectional. Its ball joint allows full rotation and tilting of the camera, with adjustments held in place by a single locking knob. This means you can make a fast, one-step composition, without the need to operate two or three separate controls. Like pan/tilt heads, ball heads come in a variety of sizes; check the manufacturer's suggested weight limit to be sure a tripod is right for your camera.

Whatever type of tripod head you buy, make sure you can tilt it to the side a full 90 degrees for vertical composition. Otherwise you'll have to overextend the opposing leg section, which skews further adjustments in the height of the center post. And make sure the tripod has a center post; some models may not. The center post increases extension, when necessary, but more importantly allows small changes in camera height (and thus point of view) without adjustments to the legs (which might throw off vertical alignment).

TRIPOD ACCESSORIES

Quick-thinking photographers often use nearby surfaces—car tops, window sills, tree branches—to brace their cameras, especially when they have to shoot fast with a long lens and/or a slow shutter speed. That improvisatory approach is more effective if you cushion the lens or camera. A sweater or jacket will do in a pinch, but a beanbag is better.

To use a beanbag, place it on the support surface; if you're shooting with a long lens, push the part of the lens closest to the camera body into the bag to create an impression, and if you're using a short lens, nestle the camera itself into the bag. Be sure to press the shutter button gently.

The main drawback of a beanbag is that it limits your shooting position to the available support surfaces. The advantage is that you don't have the burden, nor the longer setup time, of a tripod.

Another steadying option is the monopod, which looks the way it sounds: a support with a single leg. That design makes it a less effective steadying device

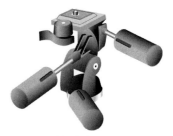

Pan/tilt head

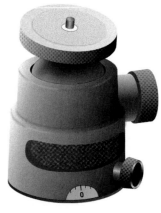

Ball head mount

than a tripod, but it does add enough stability to let you shoot safely at shutter speeds two or three stops slower than you'd have to use if you were shooting hand-held.

In dim light, these extra stops can make the difference between getting a sharp shot and one that's unacceptably softened by shake. In good light, it means you can set smaller apertures for better depth of field. And in either case, it lets you use a slower film, if you like, when fine grain is the priority.

Portability is the monopod's great advantage over a tripod. When you collapse its telescoping leg sections, it's compact and lightweight enough to be carried in one hand or strapped to a camera bag. But perhaps more important is that a monopod allows much more freedom than a tripod when you're photographing. It can easily be left attached to the camera as you move around, which is why sports and wildlife photographers are so partial to it.

Sometimes, for special applications such as aerial photography, photographers attach an accessory called a gyro stabilizer to the bottom of their camera, where the tripod normally attaches, to allow them to hold the camera steady at a slower shutter speed than otherwise possible—usually one or two full speeds slower or even more. At least one still-camera manufacturer makes special image stabilizer (IS) lenses that accomplish the same purpose with motion sensors and tiny motors that shift lens elements to keep the image steady and centered on the film.

Cable Release To realize the maximum stability a tripod offers, especially at slower shutter speeds, you should keep your hands off the camera—and use a **cable release** to trip the shutter.

There are two basic types of cable release: mechanical and electronic.

A mechanical cable release is basically a flexible tube with a wire running through it. It's screwed directly into the threaded hole in a shutter button (or on a few models, into sockets located elsewhere on the body). You hold the crosspiece on the other end between your middle and index fingers and press the plunger with your thumb, which pushes the wire into the release. (Push the plunger slowly to minimize vibration.) Mechanical cable releases tend to get their internal springs fouled up, so spend a little extra on a higher-quality one—and carry a spare.

Many newer 35mm SLRs won't accept mechanical cable releases. They require dedicated electronic ones, which are considerably more expensive. But whatever type of release you buy, make sure it's long enough so that you can leave slack in its length when you're using it. If it's too short, you may inadvertently tug on it during the exposure, and blur or soften the image.

Quick Release One of the chores of regular tripod use is constantly having to screw and unscrew the camera from the head. Over the long term this also wears down the threads of the camera's tripod socket, possibly leading to an expensive repair. That's why many tripod-minded photographers (monopod users too) fit their equipment with a quick-release system.

A quick release has two parts. One is a metal plate that screws into the tripod's platform just like a camera, and is left in place permanently. (Some ballheads have a built-in quick-release plate; some manufacturers offer special quick-release plates that replace the platform.) It has a cavity or channel that's surrounded by

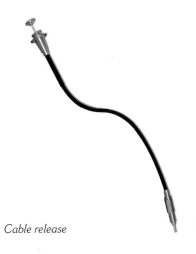

Cable release

Quick release

spring-loaded clamping jaws. The other part of the quick release is a (usually) smaller plate that screws into the camera's tripod socket, and remains there. This plate fits directly into the cavity or channel of the plate on the tripod head, and is tightened into position with a fast-locking knob or held in place with spring tension.

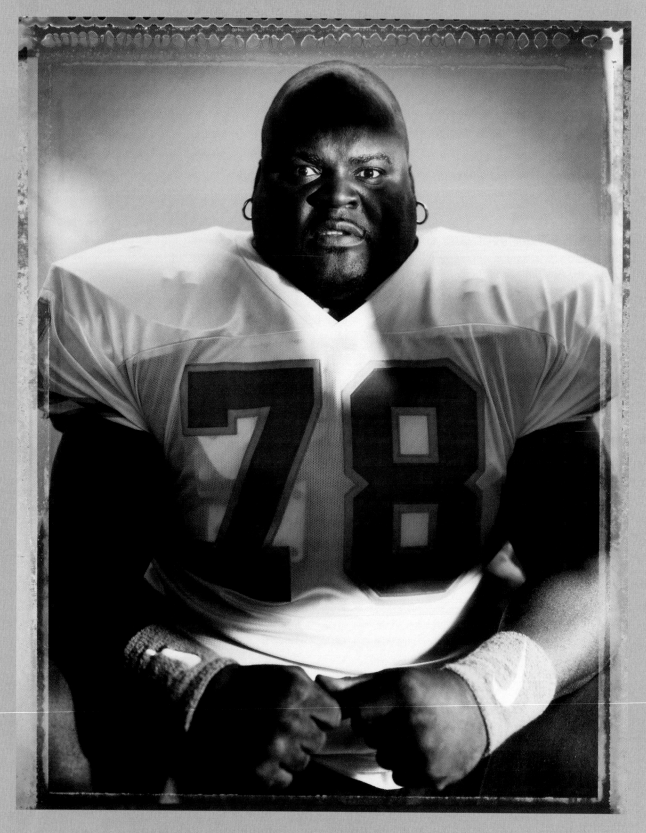

WALTER IOOSS
The Bear

To play up the massiveness of this football linebacker, Iooss composed so that he seems to be wedged inside the frame. He reinforced this effect by printing the edges of the negative beyond the image area, which in this case included byproducts from the development of his 4" x 5" Polaroid Positive/Negative instant film. By showing the edges of the negative, Iooss is also telling the viewer that his tight composition was a calculated creative decision—made in the camera, not by cropping the image when printing it. © Walter Iooss

FILM BASICS

Perhaps no photographic decision you make has more impact on a picture's intrinsic visual qualities than your choice of film. Film is the photographer's palette. Just as an artist can decide to work in oils or watercolors or pencil, the photographer can choose different films to obtain deeply saturated hues or a soft pastel rendition—or to eliminate color altogether. One film may produce a fine, creamy texture, another a coarse grittiness, a third something in between. A photographer can choose films to suit particular applications (portraits, landscapes, action) or to produce the best or most interesting results with a particular type of light (such as low light or artificial light).

It is possible to take pictures without film, using digital cameras, and also to mimic some of the effects of different films using computer software and digital printers. But film's traditional virtues—high image quality at low cost, universal availability, and the ability to use it in inexpensive (even low-tech) equipment—still make it the primary means of capturing a photographic image.

There are three basic decisions to make concerning film. The first and most obvious is whether to shoot black-and-white or color. You must also decide what form the image will take: a **negative,** in which tones (and colors) are reversed, light to dark, so that the images can be made easily into photographic prints; or a positive **transparency,** in which tones (and colors) are rendered more or less as they appear, for direct viewing, projection, or reproduction on the printed page (such as in mag-azines or advertising). Finally, you must choose whether to use a film that is very sensitive to light or one that is less so. (See film speed, page 130.)

BLACK-AND-WHITE FILM

Though nearly 99 percent of all film used is color, **black-and-white film** is still the classic choice—and probably the film you will be shooting first, especially if you're taking a class in photography. It is arguably the most versatile type of film—well-suited to the creation of graphic abstractions, for example. Many photojournalists prefer it over color for the raw, gritty character it can display. In recent years, black-and-white photography's artistic lineage and creative flexibility has also made it popular with advertising, fashion, and other professional photographers.

Black-and-white film's flexibility—and its great ability to "forgive" mistakes—also make it an ideal tool for learning about photography. Its contrast, tonal scale, image tone, and other characteristics are more easily manipulated in the darkroom than those of color, whether for creative effect or to compensate for technical errors. And black-and-white printing papers and processing chemicals allow even further control.

Nearly all black-and-white films are designed to create a negative, but special processing can turn certain emulsions into high-quality positive transparencies (see page 153). Black-and-white transparencies make dramatic projections. They're also shot by professional photographers for editorial and advertising assignments, eliminating the need to make a print.

COLOR NEGATIVE FILM

Color negative film is made primarily for amateur snapshot photography but also is used widely by photojournalists and fine-art photographers. In its professional versions it's the film shot by portrait and wedding photographers—indeed, by almost anyone needing a color print. For that reason, it's sometimes called color-print film.

Color negative film, usually identified by the suffix "color" (as in Agfacolor, Fujicolor, and Kodacolor), comes in a greater variety than any other type of film. Some films are designed to produce above-average contrast and more intense color for a punchy image. Others yield more naturalistic results, with lower contrast and less intense color. Some color negative films are designed specifically for portraiture, creating especially realistic skin tones, while others are better for non-human subjects, such as abstractions or nature and wildlife scenes.

Like black-and-white negative film, color negative film is very forgiving of exposure mistakes; that is, even if your exposure is somewhat off the mark, you can still make a good print. And while color negative film falls short of the flexibility of black-and-white negative film when making prints, there is a good range of creative options in manipulating the final look of prints from color negatives. In particular, if you make your own color prints, you have considerable ability to manipulate the overall color of the image (see Chapter 14).

negative Film image in which the subject's tones (and/or colors) are reversed from how they appear in reality.

transparency Positive film image in which the subject's tones (and/or colors) appear more or less as they appear in reality.

black-and-white film Film that renders the subject exclusively in shades of black, white, and gray.

color negative film Film that reverses the subject's colors and tones, designed for making color prints. Sometimes called color print film.

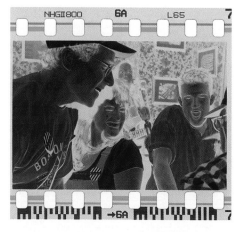

Film comes in several basic types. Black-and-white negative film (top left) renders the subject entirely with gray, white, and black tones that are the opposite of what they are in the subject—lights are dark, darks are light. Thus the negative must be printed to reverse it back to a positive image. With color negative film (top right), the colors also are reversed and there is an overall reddish-orange cast that helps in printing. A green subject is recorded as magenta, then becomes green again in printing; blue is recorded as yellow, then becomes blue again in printing. Color transparency film (bottom left) records the subject as a full-color positive, so printing is not required; this is why many photographers (especially those who shoot for reproduction in magazines, books, brochures, and so forth) use it as their final image. Though less common, black-and-white transparency film (bottom right) also creates a direct positive image, eliminating the need to make a black-and-white print.

Different color negative films have distinct personalities, qualities above and beyond the universal film variables of speed, grain, sharpness, and color balance—properties you'll learn about in this chapter. Thus, matching a color film to your subject matter can be an important creative decision.

COLOR TRANSPARENCY FILM

For sheer visual impact there's nothing like a projected color **slide.** A slide is simply a piece of positive transparency film—the same piece of film you exposed in the camera, after it's been processed—trimmed to a single frame, then mounted in a cardboard or plastic holder that can be inserted into a projector. Slides are usually on 35mm film, although larger size films can be mounted and projected, too. Even if you don't use transparency film for your own photography, you may need slides for audiovisual presentations, lectures, and copies of photographs and other artwork for review by galleries, museums, arts awards, and grants.

The color transparency (also called a **chrome**) has remained popular because of its richness and basic fidelity to the original subject. A color transparency is usually better at reproducing the full range of tones and colors in the original scene than a print from color negative film. Transparencies are also easier to edit: you simply spread them out for viewing on a light box.

Color transparency film is usually identified by the suffix "chrome," as in Agfachrome, Ektachrome, and Fujichrome. It has long been the standard for color reproduction of photographs in magazines, books, and so forth. It's used by working photographers for everything from fine-art photography to commercial product shots, often in sizes larger than 35mm (see pages 144–149).

Transparencies are easy to scan in compact desktop film scanners, which

slide Positive film mounted in a cardboard or plastic holder. Also referred to as a transparency or (if in color) a chrome.

chrome Positive color film image. Another term for a color transparency.

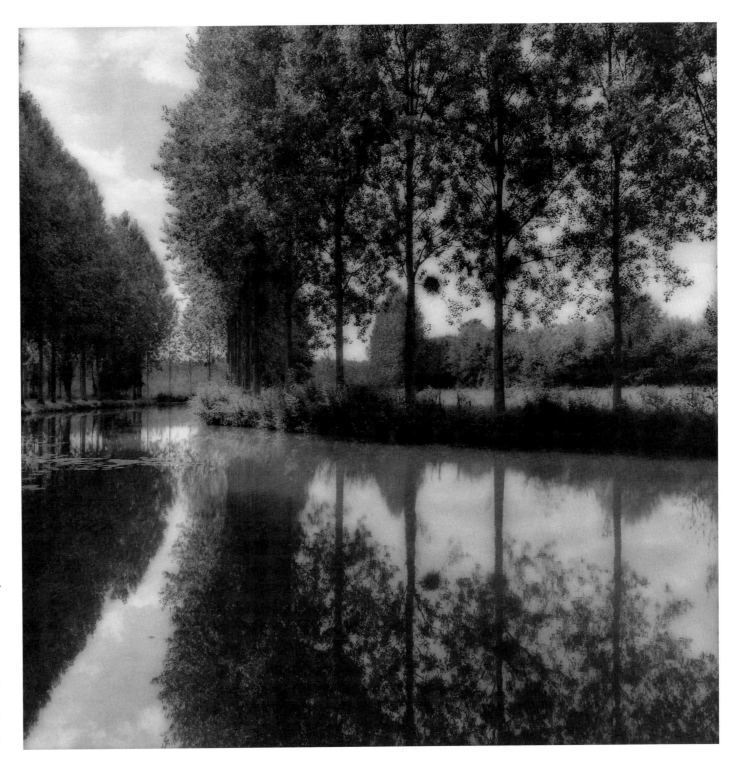

Sally Gall
Montresor, 1988
Photography can be used for either fine-art or commercial purposes, and many photographers do both kinds of work—helping to support their fine-art pursuits by accepting assignments, or doing "personal" work as a way of staying fresh in their commercial efforts. Gall shoots for both magazine and advertising clients, but her work also is widely exhibited and collected by museums, galleries, and individuals. Courtesy of the artist and the Julie Saul Gallery, New York City.

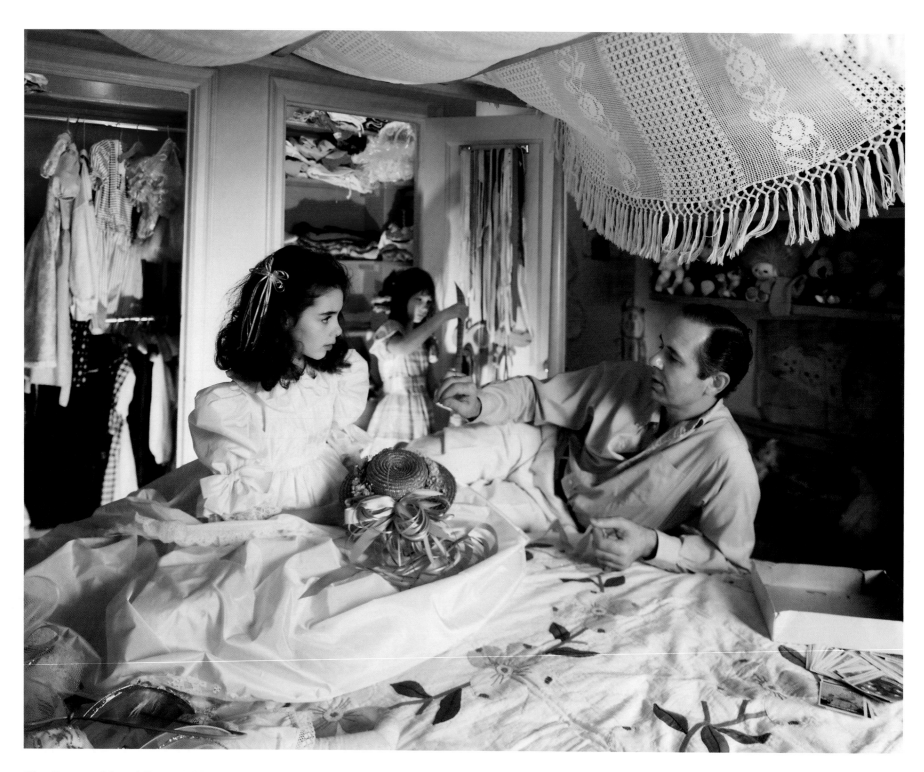

Tina Barney Marina's Room, 1987

Barney's personal access to upper-class society helps her create photographs of daily life among the wealthy. Though her pictures have a candid quality ordinarily associated with the use of a 35mm camera, she actually shoots with a 4" x 5" view camera. Barney does this mainly because the camera's large-format film lets her make large-scale prints—a trend in exhibition photographs that she helped establish—but still render her subjects with plush and abundant detail. Janet Borden, Inc.

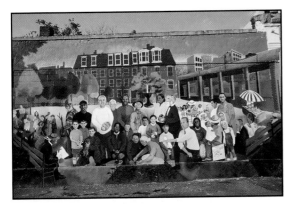

ISO 400

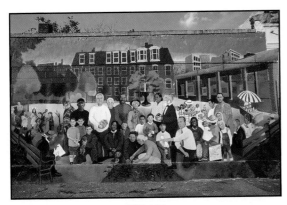

ISO 100

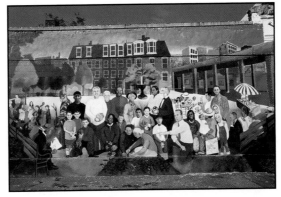

ISO 64 tungsten

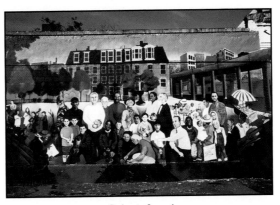

Color infrared

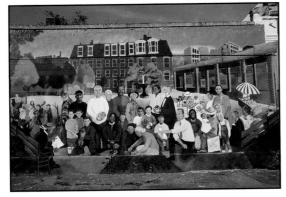

ISO 50

This mural was photographed at the same time with five different types of color transparency film, and shows that films of similar type and speed can reproduce the subject in very different ways. Some have higher contrast than others, creating more dramatic differences between the subject's tones. Some have higher saturation than others, rendering colors with more intensity. And some simply produce a warmer overall color than others. Most such films are of very high quality despite these differences, so the choice is a matter of personal taste, subject matter, and artistic intent.

produce digital images that can be viewed, retouched, and manipulated with a computer (see Chapter 17). This practice has become commonplace both in commercial photography and among photographic hobbyists, who use the resulting images to make prints on digital printers, send out as e-mail, or place in Websites.

Color transparency films are often described in terms of their "warmth." Some produce neutral, cast-free color—as faithful to the original subject's color quality as possible. These are generally the choice of studio photographers, who prefer to control their own color precisely with careful filtration and lighting when taking the pictures. Other transparency films produce a warmer (yellowish) image; these are often used by nature and wildlife photographers to counteract the unwanted bluish cast that some kinds of natural light produce on film. Some films are offered in a choice of "warm" and "neutral" versions.

FILM HANDLING AND STORAGE

Both unexposed and unprocessed film are perishable. Heat, humidity, and simply the passage of time can cause a deterioration in image quality. About the worst thing you can do is leave film in a hot place: inside a car's glove compartment, for example, or close to a radiator. This can cause ruinous color casts and unwanted exposure. But even a slightly high temperature or leaving film lying around for months before or after shooting it can cause a subtle loss of speed and contrast or an uncorrectable shift in color. It's important to store and handle film with care, both before and after exposure.

When you're photographing, try to keep your camera cool; its black surface heats up faster than lighter-colored objects. When it's sunny, cover the camera with something light or white if it's not in actual use, or keep it in the shade. Process the film as soon as possible after you've shot it to avoid deterioration in the latent image—the exposed but undeveloped photograph. Film is considerably more vulnerable to deterioration after it has been exposed than before.

If you can't process exposed film quickly, or if you've bought film that you don't plan to shoot immediately, it's a good idea to store it in your refrigerator, especially during the summer months. This is most important with color transparency film, though it's also a good idea with color negative and black-and-white film. Refrigerate unopened film in its original packaging; with exposed film, use 35mm's plastic canister or plastic food-storage bags to keep moisture out, and seal medium-format and sheet film in plastic bags. Allow 35mm and medium-format rolls to warm up to room temperature for an hour or more in their packaging before you shoot them; leave more time for sheet film. If you shoot film that is significantly colder than the ambient air, you risk condensation on the emulsion surface, and mottling of the image may result.

Refrigeration is especially important for professional films (see box page 156). Cold storage after purchase may allow you to safely use a film somewhat past its expiration date—as much as several months.

If you're planning long trips in hot weather (or even in mild weather when film must be left in a car) consider transporting film in insulated food coolers. Electric models that plug into the car's cigarette lighter are available. But even a few well-placed ice cubes sealed in plastic bags, or sealed "blue ice" freezer packs, may save your important film from harm.

Humidity is another threat to film, though it's usually a problem only with prolonged exposure to wet, tropical environments. In extreme cases mildew may actually form on emulsion surfaces. Store film with bags of desiccant, such as those packed with camera gear, in areas of very high humidity; desiccant is also available from select mail-order and retail suppliers.

Another quality of color transparency film is that it is less "forgiving" than any other kind of film, both of exposure error and of variations in the contrast and type of light. It must be exposed much more carefully than black-and-white or color negative films. With unintentional overexposure, for example, highlights (bright areas) can "burn out"—suffer an irretrievable loss of detail—whereas with negative films, detail is often easily restored in printing. Furthermore, color transparency film in certain circumstances must be shot with a filter over the camera lens to maintain natural-looking color (see Chapter 10).

FILM SPEED AND GRAIN

For each type of film—black-and-white, color negative, or color transparency—there is a wide choice of **film speed.** A film's speed is simply an index of its sensitivity to light, indicated by the letters **ISO** (International Standards Organization), followed by a number, as in ISO 400. (You sometimes see the outdated designation ASA, for American Standards Association, instead of ISO, but for practical purposes the numbers work the same.)

You set a film's ISO rating on your camera's built-in light meter, or, if you're using one, a separate hand-held light meter. Most modern 35mm SLRs can automatically set a film's speed by reading the bar code on its cassette, but most also let you set it manually, an important feature for creative exposure control.

film speed Sensitivity of a particular film to light, indicated by an ISO number.

ISO Index of film sensitivity to light. (ISO stands for International Standards Organization.) The higher the ISO number the more sensitive the film is to light; ISO 400 film is faster (more sensitive) than ISO 100 film.

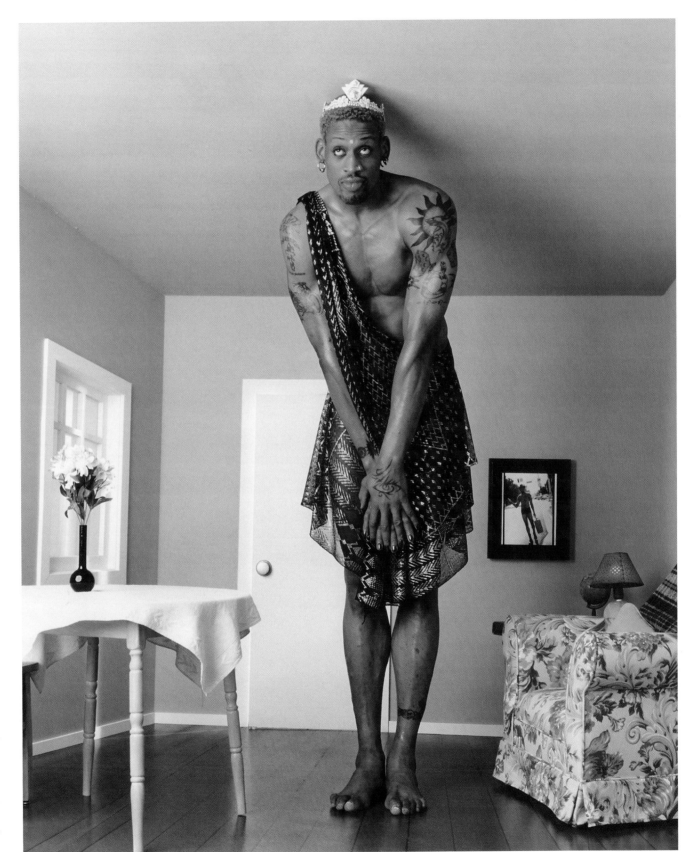

George Lange

Dennis Rodman

Editorial photographers take pictures mainly to illustrate magazine articles—here, Lange's whimsical portrait for a story about basketball star Dennis Rodman, famous for his outlandish attire. Lange shot this assignment with color transparency film. Color photography for reproduction has traditionally been done with transparency film, both because it eliminates the need to make a print and because it has been considered richer and more faithful in its depiction of the subject. But transparency film is less "forgiving" of exposure error than color negative film, so must be used with greater care. The flexibility of color negative film, along with improvements in its quality, have made it an increasingly popular choice for editorial work. © George Lange

FILM BALANCE AND COLOR TEMPERATURE

The way color films record a photographic subject is far more literal—and limited—than the way your eyes and brain perceive it. As you scan a scene, for example, your vision automatically adjusts for differences in both the contrast and the color of light. Thus, a red ball looks red whether in the cool light of open shade on a clear day or in the warm glow of late afternoon sun. And a white shirt looks white by artificial indoor light or at high noon outside.

Color film, on the other hand, is "balanced" when manufactured to give neutral results—to make that white shirt look pure white—only in light of a certain **color temperature.** Color temperature refers to the composition of light's wavelengths (not its physical temperature) and is measured with the Kelvin scale (see inset). Warm light—late afternoon sun, for instance—has a relatively low color temperature. Cool light—open shade—has a high color temperature.

Most color films are designed for a color temperature midway between those two kinds of light—about 5500K on the Kelvin scale. That's the average color temperature of bright sunlight, so such films are said to be **daylight balanced.** Electronic flash units, moreover, have light output that is set by the manufacturer around 5500K, to produce natural color rendition with flash shots made on daylight film.

Some films, on the other hand, are designed to give neutral results in artificial light—specifically, the incandescent photoflood lamps frequently used for photographic purposes. These films are said to be **tungsten balanced.** Tungsten light has a color temperature of 3200K.

Not all daylight conforms exactly to a 5500K color temperature, nor all tungsten light to 3200K. Shoot daylight film by late afternoon light and your result will have a reddish cast; shoot the same film in open shade, or on an overcast day, and it will take on a bluish cast. Tungsten light's color temperature varies partly with the bulb's wattage; room-level tungsten illumination produces a warmer, more yellowish result on tungsten film than do high-intensity photoflood lights.

Color temperature	Light source
1900K	Candlelight
2790K	60-watt bulb
2900K	100-watt bulb
3100K	Daylight at sunrise/sunset
3200K	500-watt photoflood bulb
3800K	Clear flashbulb
5500K	Daylight at noon/direct sun
5500K	Electronic flash
7000K	Daylight on overcast day
8500K	Daylight on dull/foggy day
10,000K and up	Clear skylight/open shade/no direct sun

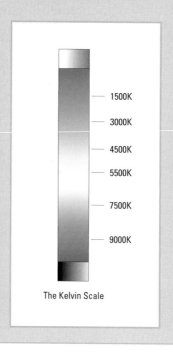

The Kelvin Scale

1500K
3000K
4500K
5500K
7500K
9000K

color temperature
Composition of light's wavelengths as measured on the Kelvin scale. "Warm" light has a relatively low color temperature; "cool" light has a relatively high color temperature.

daylight balanced
Color film manufactured to correctly reproduce a scene illuminated by daylight, measuring 5500K on the Kelvin scale.

tungsten balanced
Color film manufactured to correctly reproduce a scene illuminated by artificial light, measuring 3200K on the Kelvin scale.

In most cases these color casts look natural to the viewer of the photograph, actually helping to define the character of the light and even the time of day. But you can often eliminate them with filtration on the camera, bringing the color of the light part or all of the way back to the film's specific balance (see Chapter 10). And, to a great degree, color negative films can be filtered in printing to adjust for discrepancies in color temperature. To a lesser extent, color casts in transparency film can be corrected when making prints.

The tungsten-balanced color negative films, available only in medium and large formats, are sometimes called Type L. This indicates that they're designed to give good results with long exposures—the assumption being that tungsten light is usually less bright than daylight or flash, requiring more exposure—that could cause unwanted color casts with other films (see box page 141). For the same reason, tungsten-balanced transparency films allow longer color-correct exposures than their daylight counterparts.

Daylight-balanced film in tungsten light

Daylight-balanced film in daylight *Tungsten-balanced film in daylight*

To reproduce a subject's colors accurately, the color balance of your film must match the color temperature of the light in which you're shooting. For accurate color, shoot daylight-balanced film in daylight (left). If you shoot tungsten-balanced film in daylight (right), the result will have a blue cast because the film "sees" daylight as much cooler (bluer) than the light for which it's designed. Some photographers deliberately shoot tungsten-balanced film in daylight to give their images a cool feeling.

Tungsten-balanced film in tungsten light

If you shoot daylight-balanced film in tungsten light (top), the result will be warm—that is, it will have a yellowish-red cast—because the film "sees" tungsten light as much warmer than the light for which it's designed. Many photographers feel that the added warmth more effectively recreates the feeling of room light. But if you prefer a more accurate color rendition in tungsten light, shoot with a tungsten-balanced film (bottom).

Sunlight at 2:00 PM

Sunlight at 5:00 PM

Open shade

Tungsten light

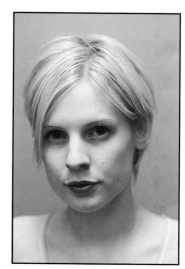

Fluorescent light

Most color film is balanced when manufactured to give neutral results in light with the same color temperature as bright sunlight. When this daylight-balanced film is shot in other kinds of light, the results can be dramatically different, as in these examples. These color shifts can be corrected with filters or during printing, or exploited deliberately for creative effect.

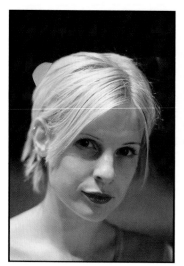

Street light
(sodium or mercury vapor lamp)

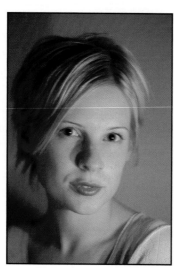

Candle light

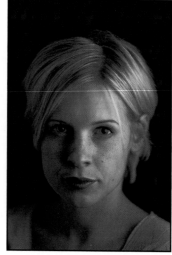

TV screen

Red neon light

Blue-green neon light

The more sensitive a film is to light, generally the grainier the image it produces, as shown by these two details enlarged from a full 35mm negative (left). The first detail (center) is from a negative shot on ISO 100 film; it has relatively fine grain, which creates a smooth texture. The second detail (right) is from a negative of the same subject on ISO 400 film, which is four times more sensitive to light than ISO 100 film; it has more pronounced grain, which creates a somewhat coarser texture. The more you enlarge an image when printing, the more visible this grain structure becomes.

slow films Films with a relatively low sensitivity to light, thus requiring more light for a correct exposure. Denoted by a low ISO number (under 100).

fast films Films with a relatively high sensitivity to light, requiring less light for a correct exposure. Denoted by a high ISO number (400 and higher).

grain Texture of the silver crystals that form the image. If grain is highly visible, image is said to be "grainy."

Setting the proper film speed allows the camera or meter to determine what combinations of lens aperture and shutter speed will produce correct film exposure.

Films are generally grouped according to the speed range within which they fall. Those with ratings under ISO 100 are considered **slow films**—that is, they have a relatively low sensitivity to light, and therefore need more light for proper exposure than required by films of greater sensitivity. Films with ratings in the ISO 100 to 200 range are considered medium speed. Films around ISO 400 and up are called high speed, or, more often, **fast films.** Because they react quickly to light, they need relatively little light for a proper exposure. Films of ISO 800, 1000, 1600, 3200, and higher speeds are considered ultrafast because so little light is needed to expose them correctly.

The ISO rating system is geometric: an ISO 400 film is twice as sensitive to light as an ISO 200 film. So to produce correct exposure, the ISO 400 film needs only half the light required by the ISO 200 film. (Likewise, an ISO 100 film needs only half the light of an ISO 50 film for correct exposure, and so forth.)

The main attribute that affects how quickly film can gather the light it needs is the size of its **grain:** the crystals of silver compounds and then, after development, the metallic silver that makes up the image. The larger the surface area of those individual crystals, the more light from the lens they can absorb

Joel Meyerowitz St Louis Art Museum

Meyerowitz's serene interior exploits a mismatch between his film's color balance and the color temperature of the outside light. He used tungsten-balanced film because it is specifically designed for the long exposures often needed when working with large-format film. But the film reproduced the daylight entering into the room as much cooler than the light for which it's designed, rendering it with an intensely blue cast, providing a luminous effect. Courtesy Joel Meyerowitz

Merry Alpern
Untitled. From "Dirty Windows," 1995
For a series of photographs of illicit activity plainly visible through a window across the air shaft of a friend's apartment building, Alpern used high-speed (ISO 3200) film in a 35mm camera. Together with extended development, this allowed her to set the high shutter speeds needed to freeze moving subjects in dim interior light. It also created a pronounced grainy texture that adds to the images' raunchy, voyeuristic feeling—lending them a crudeness that might ordinarily be associated with police surveillance photographs. Merry Alpern Photography

CONTRAST AND SATURATION

Film speed and grain are not the only characteristics to consider when choosing a film. You should also consider how a particular film will affect attributes such as contrast and color saturation.

Contrast is the relative range between the darkest and lightest values in an image. For instance, a high-contrast image has very bright highlights and deep shadow values that are far apart on the tonal scale, while a low-contrast image has less of a difference between these opposite ends of the range. You can control contrast with development (especially with black-and-white film, see Chapter 12), but the choice of film also is a strong factor. This means that while the tones of the scene you photograph are fixed, different films may make them seem brighter or deeper even when the exposure is correct. In effect—and within limits—your film has its own interpretation of the subject.

Likewise, the rendition of a subject's color intensity and richness—its **color saturation**—is dependent on what film you use. Some films represent a given subject's colors with great fidelity. Other less-saturated films produce a softer, more pastel rendition; there are even films designed to produce greatly heightened, "supersaturated" color. Higher saturation often goes hand in hand with higher contrast. Slower films (ISO 100 and lower) tend to have more saturated color, but this is not a hard and fast rule. You can get ISO 400 films with strong color saturation and above-average contrast, and slower films that deliver more neutral, naturalistic results. Experience and experimentation with different films will help you learn the characteristics of different films and which ones to choose for different photographic purposes.

in a given period, and the faster the film. An ISO 400 film has bigger silver crystals than an ISO 100 film; put in another way, an ISO 100 film is said to have "finer" grain than an ISO 400 film, and an ISO 400 film has "coarser" grain than an ISO 100 film.

In recent years manufacturers have used various chemical techniques to maximize the surface area of their films' silver crystals, thereby creating finer grain for a given film speed. Thus, two films with the same ISO may produce different degrees of graininess. But generally it's still true that prints from faster films usually have a more visible grain pattern—whether black-and-white's characteristic salt-and-

pepper pattern or color's multicolored texture—than prints of the same size from slower film.

CHOOSING A FILM SPEED

A prominent grain pattern actually can be a creative asset, giving a photograph an impressionistic feeling or a gritty, visceral quality, depending on its content. Some photographers choose fast films precisely for that effect, even when the subject is well-lighted enough to allow the use of slower emulsions. (Fast films can be push-processed to further emphasize their grain; see Chapter 12.) But by and large it's a good idea to use the slowest film your subject, equipment, shoot-

ing style and lighting conditions permit, so that you get the best possible image quality.

Say you want to do street photography—candid shooting as you walk around—with a 35mm camera. Because you're likely to encounter both a wide range of light levels and a great variety of subject matter, ISO 400 film is a good choice. Its high sensitivity to light lets you set shutter speeds fast enough to safely hand-hold the camera when you're shooting in dim conditions (see page 119). In brighter light, it allows you to set smaller f-stops, and thus increase depth of field to make both near and far elements sharp. A fast film's greater sensitivity also makes it valuable for rapidly moving subjects, as in sports, news events, performances, and when photographing children. It means you can set higher shutter speeds to stop action.

On the other hand, you may want to avoid fast films for portraiture because their graininess can overpower the sense of skin texture. A slower film, such as ISO 100, creates smoother skin tones and a heightened sense of detail, and also lends itself to the use of wider f-stops, to throw distracting backgrounds out of focus.

There are times when conflicting considerations complicate the choice of film. With landscape photography, for example, it's common practice to set small f-stops for better depth of field. Because small apertures reduce the light entering the camera, it might seem logical to use a faster film, and thus lessen the need for slow shutter speeds. But a faster film's more visible grain pattern can interfere with the rendering of fine detail in the landscape. If you need that level of detail, choose a slower, finer-grained film—and

contrast Difference between light and dark tones, and the steps between.

color saturation Intensity or richness of a photograph's color.

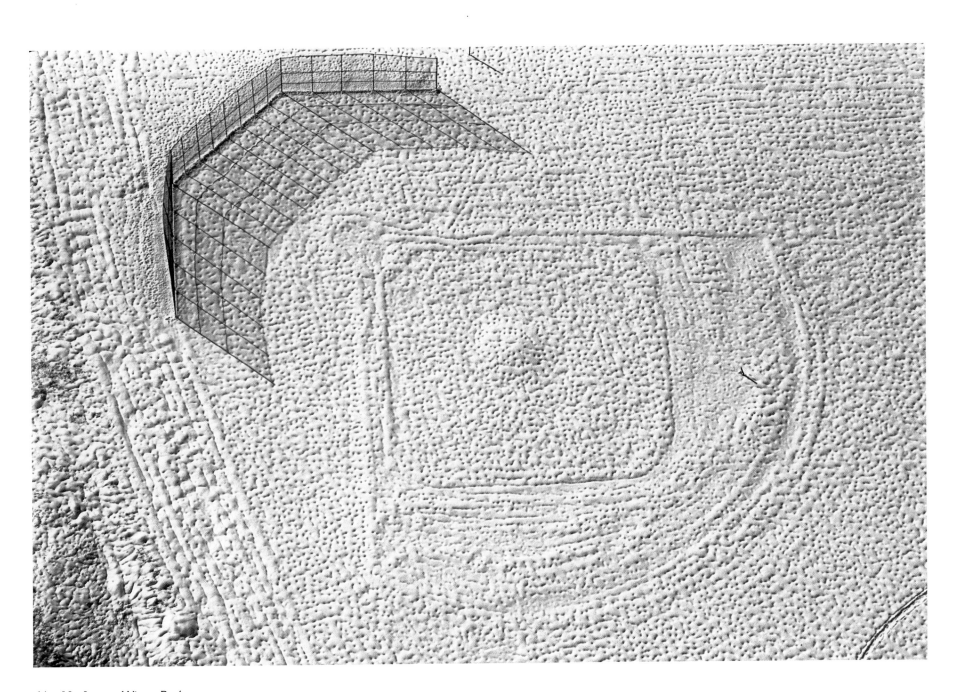

Alex MacLean Winter Backstop

Photographing from an airplane that he pilots himself, MacLean uses a bird's-eye perspective to reduce familiar features of the landscape to striking, often highly abstract patterns. He usually works with the 35mm format because the small camera gives him the mobility and flexibility he needs to shoot this way, but uses relatively slow, fine-grained transparency film to maximize image quality. © Alex MacLean

Photographic film has a complex physical structure despite the microscopic thinness of its emulsion—the coating of light-sensitive silver compounds on its plastic base. Even black-and-white negative film (left), the simplest type of film, incorporates protective and antihalation layers, the latter to keep light from spreading out and reducing sharpness when it strikes the film. Color negative film (middle) and color transparency film (right) are more complex mainly because they incorporate separate red-, green-, and blue-sensitive layers within the emulsion. Note in these illustrations that each layer's color represents what it contributes to the final image.

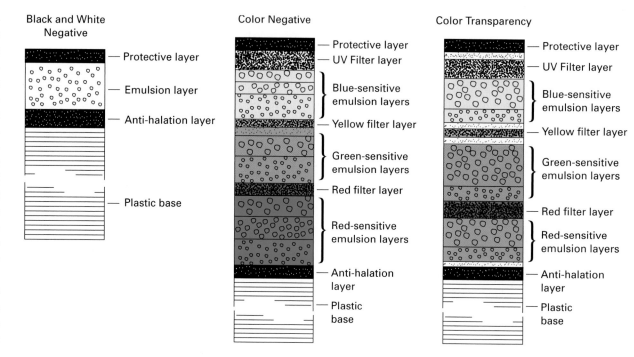

Black and White Negative
— Protective layer
— Emulsion layer
— Anti-halation layer
— Plastic base

Color Negative
— Protective layer
— UV Filter layer
— Blue-sensitive emulsion layers
— Yellow filter layer
— Green-sensitive emulsion layers
— Red filter layer
— Red-sensitive emulsion layers
— Anti-halation layer
— Plastic base

Color Transparency
— Protective layer
— UV Filter layer
— Blue-sensitive emulsion layers
— Yellow filter layer
— Green-sensitive emulsion layers
— Red filter layer
— Red-sensitive emulsion layers
— Anti-halation layer
— Plastic base

use a tripod, if necessary, to steady the camera.

The tripod is, in fact, an important consideration in your choice of film speed (see page 121). A tripod lets you set the slower shutter speeds that a less sensitive film and smaller apertures demand, without the risk of blur due to camera movement. And though it may slow you down, a tripod is a practical solution in this example because most landscape subjects are static.

HOW FILM RECORDS IMAGES

Whether black-and-white or color, fast or slow, positive or negative, the basic element of film is a light-sensitive **emulsion**—a microscopically thin coating of

chemical compounds, known as silver halides, suspended in flexible gelatin. It is these silver particles that form an image when you develop film after exposure. The emulsion is coated on a base (also called a support) of flexible, transparent plastic. Other layers are added to the film to control both light and chemical reactions, creating (with color film in particular) a complex sandwich in which layers interact. For example, the anti-halation layer absorbs light to keep it from bouncing back from the base and causing unwanted exposure. Whatever its final form, the film ultimately gets exposed to light from your subject that is focused on the film by the camera's lens.

Many black-and-white films incorporate the term "pan," for **panchromatic,** in their names; this means that though they record the subject in black and white, they're sensitive to all colors, and thus produce a scale of gray tones that looks natural.

Exposure causes no visible change in the film; it simply triggers invisible chemical changes to produce a **latent image** of the subject in the emulsion. When you remove and process the film, the developer acts on those changes, converting the emulsion's silver halides into crystals of metallic silver in proportion to the light from the subject.

In areas where more subject light strikes the film, a greater physical density

emulsion Microscopically thin coating on film base consisting mainly of light-sensitive silver compounds suspended in gelatin.

panchromatic Denotes film that is sensitive to virtually all wavelengths of visible light.

latent image The invisible image retained in exposed film's emulsion and made visible by development.

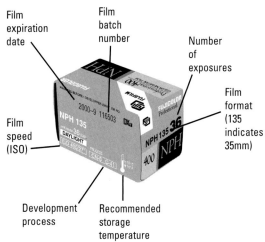

Film expiration date

Film batch number

Number of exposures

Film format (135 indicates 35mm)

Film speed (ISO)

Development process

Recommended storage temperature

The 35mm film box (left) contains a variety of useful information, including the number of exposures on the roll, the film's ISO rating and expiration date, and the chemical process needed to develop the film. Be sure to keep the film in its plastic canister (center) before and after shooting, to protect it from dust, moisture, and physical damage. The film cassette itself (below right) is imprinted with some of the same information found on the box, plus a DX code of black and silver bars (not visible here) that electronic cameras can read in order to set the ISO automatically.

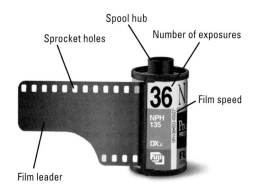

Spool hub

Sprocket holes

Number of exposures

Film speed

Film leader

then developed. It's during this second development that each emulsion layer's color couplers form the needed dyes, which recreate the original colors of the subject. One color transparency film, Kodachrome, contains no color couplers; its dyes are added during processing (see Chapter 12).

Unlike a negative, a color positive transparency is usually the photograph's final form—no print needed. But if you'd like to produce prints from color transparencies, there are two basic approaches. One is to make an internegative, essentially reexposing the transparency onto special color negative film, then printing it on the same paper used for standard color negatives. The other method is to print the transparency directly onto a reversal paper specially made for this purpose.

FILM AND FORMAT

Film **format** refers to the size of the film. It's a photographic axiom that the bigger the format, the better the quality of a given-sized print, other factors being equal. The corollary to this is that,

because the negative or transparency needn't be enlarged as much, a bigger format tends to be more forgiving of any lack of sharpness (or other flaws) in the image.

This suggests you should opt for as large a film format as possible in most cases. You'll need a camera made to shoot that format, and the design of the camera has a profound effect both on what kind of subject you can photograph and how you go about photographing it. For example, a 4" x 5" view camera mounted on a tripod is too slow and bulky for a sports photographer running along the sidelines of a football field. And candid photographers wouldn't ordinarily opt for a heavy 6 x 7cm SLR model, which is more suited for studio or landscape work (see Chapter 3).

A related matter that has both technical and aesthetic implications is the **aspect ratio** of a film format. This is a ratio comparing the short side and long side of an image on film. Because a 35mm film image measures 24 x 36 millimeters, for example, it has an aspect ratio of 2:3. This somewhat longish rec-

tangle is highly versatile for composition; it's particularly useful when you want to place objects off-center in the frame, whether for a deliberately imbalanced effect or to create relationships between foreground and background. But many photographers make very effective compositional use of the square shape of the 6 x 6cm format.

Not all kinds of film are available in every format. For example, quite a few color negative films are available only in 35mm, and some special films—tungsten-balanced color negative films, for example—are available only in larger formats. Formats do, however, break down into four basic groups: APS, 35mm, medium format, and large format. Here are brief descriptions of them, starting with the smallest.

Advanced Photo System (APS) This miniaturized film system is designed specifically for amateur photographers

format Size of the image created by a particular camera on film, such as 35mm, medium format, large format.

aspect ratio Proportions of a film image, comparing the length of the short side with the length of the long side. For instance, a 35mm film image has an aspect ratio of 2:3 (24 x 36mm).

HOW A COLOR IMAGE IS FORMED

Whether negative or transparency, modern color films exploit the scientific fact that nearly all visible color can be reproduced by combining different proportions of just red, green and blue—called the **additive primaries.** Each of these colors represents about a third of the visible spectrum of light—the range within which our eyes can detect wavelengths of light.

The basic structure of color film reflects this division by thirds. It contains three individual black-and-white emulsions, one sensitive only to blue light, one to green, and one to red (see diagram, page 140). Each emulsion's blindness to other colors is achieved with special sensitizing dyes and microscopic filter layers. When the film is exposed, light from specific subject colors affects each emulsion layer to varying degrees. A purplish object captured on the film may create an exposed area in both the red-sensitive and the blue-sensitive emulsion layers (but not the green-sensitive layer) because purple consists of red and blue light. Azure might affect both the blue- and the green-sensitive layers (but not red) because azure is somewhere in between those two colors. But in practice, all except the purest colors affect all three layers to some degree.

When the film is developed, the exposed areas in each of the layers combine to form a tonally reversed image of the subject—in effect, three superimposed negatives. (Each negative is essentially a record, in black-and-white silver densities, of where and how much of that particular color is present in the subject.) But while each negative is developing, the chemical action of the developer activates **color couplers,** chemical compounds built into the film that form dyes complementary in color to the light that struck the layer—a process called **chromogenesis.** (With transparency film, the three negative images are first reversed to positive, then developed again to form dyes.)

Yellow dye is formed in the blue-sensitive layer; magenta dye is formed in the green-sensitive layer; and cyan, or blue-green, dye is formed in the red-sensitive layer. The more exposure an emulsion layer receives from a given subject color, the more development it receives in that area, and the greater the dye formation. The result is a three-part image of both developed silver and dyes; the silver is later bleached out.

The colors of the three dyes—cyan, magenta, and yellow—are called **subtractive primary colors.** This is because when you print the film they act as filters, subtracting their complementary color from the enlarger's white light. (White light is made up of equal parts red, green, and blue.) In a color negative, green grass that has exposed the film's green-sensitive emulsion layer is represented by an area of magenta dye (its complementary color); in printing, that magenta area blocks the green component of the enlarger's white light, transmitting only red and blue light. (Because color transparency film is reversed in processing, you observe the effect in viewing the slide itself.)

In turn, the red and blue light expose only the red- and blue-sensitive emulsion layers in the printing paper, which has a structure very similar to the film's. When the paper is developed, those layers form cyan and yellow dyes. Cyan and yellow make the grass green. (That's because the yellow cancels out the blue component of cyan, leaving green.

Likewise, a red stop sign exposes the red-sensitive layer of the film, which in a color negative forms a considerable amount of cyan (blue-green) dye. That eight-sided patch of cyan in the negative transmits mostly blue and green light to the paper in printing, exposing the paper's blue- and green-sensitive emulsion layers. Those layers produce yellow and magenta dyes during development, and yellow and magenta make red.

additive primaries
Red, green, and blue.

color couplers Also called dye couplers. Chemical compounds built into the film's emulsion that, during development, form the dyes that create the visible image.

chromogenesis In color films and papers, image formation during development by the release of colored dyes built into the emulsion.

subtractive primary colors Cyan, magenta, and yellow

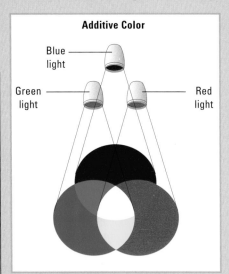

Additive Color

Blue light
Green light
Red light

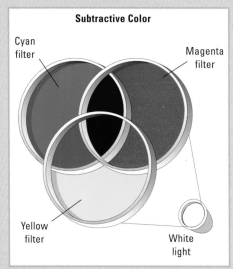

Subtractive Color

Cyan filter
Magenta filter
Yellow filter
White light

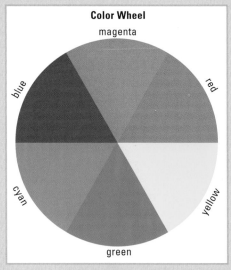

Color Wheel

magenta
blue
red
cyan
yellow
green

Color film works because visible colors can be recreated by mixing various amounts of pure red, pure green, and pure blue light—specifically, by recording how much red, green, and blue a given color contains (above left). Red, green, and blue are therefore called the additive primary colors. Primary colors are actually represented in the film by their complementary colors, in the form of cyan, magenta, and yellow dye. When you make a print or view a slide, these dyes recreate the original scene by removing their complementary color (again, red, green, and blue) from the enlarger's white light (above center). Cyan, magenta, and yellow are therefore called the subtractive primaries. Complementary colors are shown in the color wheel (above right); red is the complement of cyan, green the complement of magenta, and blue the complement of yellow.

35mm

6 x 4.5cm

6 x 6cm

6 x 7cm

Photographic film comes in various shapes and sizes, from long, narrow rolls to large single sheets. This range accommodates the many different formats—actual image sizes—for which cameras are designed. The most widely-used format, 35mm, fits on a perforated roll and has an image size that measures 24 x 36 millimeters. (Some specialized 35mm cameras produce longer or shorter images.) Medium format includes the greatest number of different image sizes, all indicated in centimeters; these include 6 x 4.5cm, 6 x 6cm, 6 x 7cm, and 6 x 9cm. (Less common sizes include 6 x 8cm, 6 x 12cm, and 6 x 17cm.) All medium-format cameras are designed to accept 120 and/or 220 rollfilm—2¼-inch-wide spools of unperforated film that differ mainly in length. Large-format film is supplied in individual sheets; the most common large-format size is 4 x 5 inches. (There are also large-format cameras designed for 5" x 7", 8" x 10", and 11" x 14" sheets of film.)

4 x 5

6 x 9cm

of silver is built up during development. In areas where less light strikes the film, less silver density is produced. In black-and-white film, this creates a black-and-white negative—a monochrome image that's the tonal opposite of the subject. Where the subject is bright (in highlights and white tones), the negative is dark (that is, has a greater density of silver). Where the subject is dark (in shadows and dark-colored objects), the negative is light (actually, more translucent). Middle tones are also reversed: light grays become dark grays, dark grays light, and so forth.

It may surprise you to learn that virtually all films, whether black-and-white or color, negative or positive, start out as a black-and-white negative. Other things that happen during or after development help determine the final form of the image of the particular film you're using. With black-and-white film, for example, all you need to do is treat it with chemicals that make the image permanent. After washing and drying, the film is ready to be printed.

Color negative film is similar to black-and-white negative in that it must be printed to create a positive color image, but its physical structure and development are more complex. As the film's individual red-, blue-, and green-sensitive black-and-white emulsion layers develop (see page 143), byproducts of development trigger compounds that form color dyes. The blue-sensitive layer forms yellow dye; the green-sensitive layer forms magenta (pinkish-purple) dye; and the red-sensitive layer forms cyan (blue-green) dye.

Combinations of these three dyes can form any other color. Silver and dyes combine to create a negative that is not only a tonally reversed image of the sub-

RECIPROCITY FAILURE

One frequent cause of unpredictable photographic results is a phenomenon known as reciprocity law failure, or just **reciprocity failure.** The reciprocity law says that a film should register the same image density no matter how the exposure gets there—by a lot of light striking the film in a short time, or by a little bit of light trickling onto the film over a longer time. That's the way it works in most cases. But with very long exposures (usually more than several seconds) or very short exposures (less than 1/10,000 or so) certain films may have a hard time recording all the light striking it. The effect increases as exposure times become more extreme—exposures of an hour, for example.

With both color and black-and-white films, reciprocity failure causes underexposure. A print made from a black-and-white negative may appear gray and muddy as a result, though many films are "forgiving" enough so that this can be compensated for in printing. To adjust for reciprocity failure when you're photographing, though, you will need to give the film more exposure than your light meter suggests.

With color film, reciprocity failure causes a further problem. The film's different color-sensitive layers will have different degrees of reciprocity failure, causing one color or another to predominate—and producing an overall color cast, often green or magenta. To correct for this you not only have to increase exposure but use filtration on the camera as well (see Chapter 10).

Film manufacturers sometimes include suggested corrections in exposure and filtration with film instructions, particularly for professional films (see page 156). Another strategy is to stay away from films with extreme reciprocity effects. In general, fast films are less subject to reciprocity failure than slow films, and color negative film shows less reciprocity-induced color shift than transparency film, in part because some of the effects are correctable when printing negatives.

ject, but one that is reversed in color as well. Because the dye buildup is proportional to the amount of developed silver, the silver is unnecessary to create the image, so it is bleached out during later processing steps, leaving only the color-forming dyes.

A color negative is printed just like a black-and-white negative: by projecting it onto photographic printing paper, which reverses the tones back to normal—the way you originally saw them.

With color transparency film, the silver compounds that provide its sensitivity to light are also converted to silver and finally bleached out. But before that can happen, the film's developed negative image must be reversed to a positive. This is ordinarily done with a chemical step that fogs (exposes) the unused silver compounds, which contain a latent positive image. (Thus, where more silver is developed, less silver compounds remain, and vice versa.) That positive image is

using commercial machine photofinishing. Spooled in 15-, 25-, and 40-exposure lengths, **APS** film comes in a small plastic cassette with no film leader protruding from it. After development, the processed negatives are returned as an uncut roll spooled in the original film cassette.

Each APS frame measures 16.7 x 30.2mm, for a film area about 60 percent that of a 35mm frame. When shooting an APS picture, the photographer can choose one of three print proportions, Classic (C), HDTV (H), and Panorama (P). Once one is selected with a switch on the camera, the viewfinder is automatically masked or marked to show the right proportions for composition. The photofinishing machinery then automatically makes the correct print shape by cropping the negative. "H" prints are made from the full negative area and measure 4" x 7" in size. "C" prints slightly crop the sides of the negative to produce a more familiar-shaped 4" x 6" print. "P" prints crop the top and bottom of the negative, resulting in a 4" x 10" or 4" x 11½" print. APS processing always includes a small index print, which contains tiny digital thumbnail images of all the pictures on a roll, helping with reprint and cropping decisions.

35mm Format The most popular format in the world, **35mm** film is widely used in both professional cameras and amateur point-and-shoot models. Its main advantage is that it offers very good image quality but is small enough so that 35mm cameras can be made easily portable and very maneuverable.

The designation 35mm refers to the metric width of the roll (about 1½"), which is perforated with **sprocket holes** on both edges so that small, gear-like teeth called sprockets can engage and advance the film from frame to frame. Thirty-five millimeter film is supplied in a light-tight cassette with a protruding, curved leader of film that is threaded (either manually or automatically) onto a take-up spool to start the roll. You must rewind the film by manual crank or motor (automatically) back into the cassette before it is removed from the camera.

Standard 35mm cameras produce an image area of 24 x 36mm, or about 1" x 1½". The short 24mm dimension runs across the width of the film, stopping just shy of the sprocket holes. The 35mm roll accommodates up to 36 frames, though rolls that come in 12- and 24-exposure lengths are also common. One of 35mm's great strengths is that it allows photographers to shoot many frames before having to change film and to shoot long, motorized bursts at several frames per second to capture the best rendition of a moving subject.

APS Advanced Photo System. Small-format film system that allows shooting in three different print proportions from full-frame to panoramic.

35mm format Most popular film format, with a roll measuring 35mm wide, usually providing an image area of 24 x 36mm (approximately 1 x 1½ inches).

sprocket holes Squarish perforations punched along edges of 35mm film so gears in back of camera can engage and advance the film.

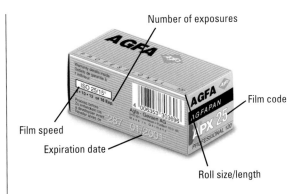

Number of exposures

Film code

Film speed

Expiration date

Roll size/length

Plastic spool

Sealing band

Film leader flap (underneath)

Paper backing

The medium-format rollfilm box (above left) is printed with much of the same information found on 35mm film boxes, but the spool of film comes sleeved in a light-tight wrapper (above center) that provides less physical protection than 35mm's plastic canister. The number of exposures on the roll (right) depends both on the specific format of the camera you're using and whether it's a 120 or 220 roll. Less widely used, the 220 roll is twice as long as the 120 roll and lacks its paper backing. With the 6 x 6cm format you can fit 12 exposures on a 120 roll, 24 exposures on a 220 roll.

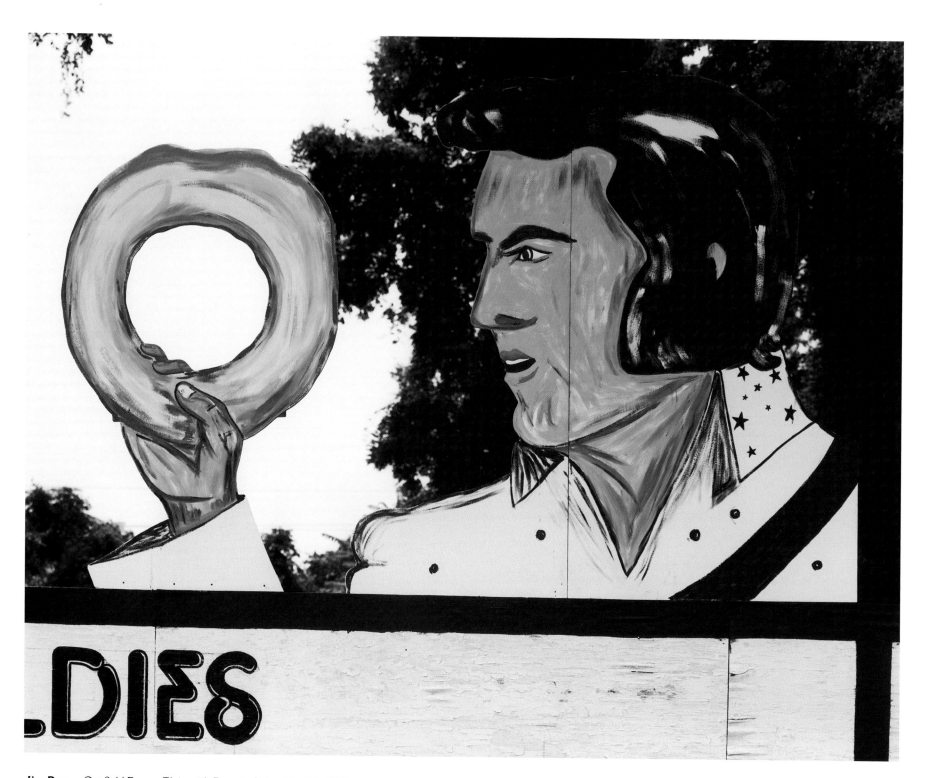

Jim Dow Outfield Fence, Elvis with Donut, Columbia, SC, 1992

Dow's work has always been highly representational, focusing on the color, form, tones, and texture of the physical world. To reproduce these elements with as much realism as possible he shoots with an 8" x 10" view camera, usually printing the negative by contact rather than enlarging to preserve great detail in the scene. Because the usual subject of Dow's "straight" aesthetic is whimsical popular art and architecture, his pictures often have a subtle humor. © Jim Dow

Medium Format This rollfilm format, widely used by professional photographers, uses a very different type of roll than 35mm film. Rather than enclosing the film in a cassette, the film comes in unperforated strips about 6 centimeters wide, wrapped in a spool made light-tight simply by a snug fit and an outer wrapping of opaque paper. There are two size designations for **medium format** film, 120 and 220. Both are the same width, but 220 is twice as long to allow twice as many pictures per roll; 120 is by far the more common length.

The number of frames you can fit on a medium-format roll varies, because there are actually several different formats within the medium-format category. Each medium format is described by the image's dimensions in centimeters; the three most common are 6 x 4.5cm, 6 x 6cm, and 6 x 7cm. All are much larger in area than a 35mm frame, so they are capable of delivering better image quality (finer grain and higher sharpness) when enlarged. And unlike larger formats, they generally combine their quality with a reasonable amount of portability and ease of handling.

The 6 x 6cm format, also called 2¼" (pronounced "two and a quarter") because the image it produces is about 2¼" square, has long been the standard of the medium formats. Some prefer it because if you shoot a square image, you don't have to worry as much about composition when you're shooting. You just crop to the shape you want after the fact—in the darkroom, on the computer, or with other methods. Others feel the square is an inherently satisfying shape and wouldn't consider tampering with it afterward.

The popularity of this format, which has a film area 3½ times that of a 35mm

medium format Film and/or camera system that produces film images ranging in size from 6 x 4.5cm to 6 x 6cm to 6 x 9cm.

DOWNSIZING YOUR FORMAT

Many, if not most, medium- and large-format cameras offer accessories that allow you to shoot a smaller film size than the camera is physically designed for. This means you can produce images in several formats with the same camera.

For example, 8" x 10" view cameras can be fitted with reducing backs. These are swapped for the camera's usual full-frame back and feature a centered, inset, spring-mounted ground glass under which you slide a 4" x 5" or 5" x 7" sheet film holder. For 4" x 5" view cameras there are medium-format rollfilm adapters. These usually slip under the ground glass back just like a sheet-film holder, and are available in three different formats: 6 x 7cm, 6 x 9cm, and a moderately panoramic 6 x 12cm.

Medium-format SLRs feature the greatest range of adapters for smaller formats. These usually allow 6 x 7cm models to shoot the 6 x 6cm and 6 x 4.5cm formats (all three formats use the same 120 or 220 roll) and 6 x 6cm models to shoot 6 x 4.5cm and 35mm. Thirty-five millimeter options often include a panoramic format that uses much more film in its long dimension than usual—24 x 55mm (about 1" x 2⅚"), for example.

frame, is reflected in the wide variety of 6 x 6cm cameras. (All models give you 12 shots per 120 roll, 24 shots per 220 roll.) Some of these are system SLRs—models with interchangeable lenses and other modular components. A few are styled similarly to 35mm SLRs. Other 6 x 6cm models are rangefinders, some with a small selection of interchangeable lenses; these offer operation almost as fast and quiet as you'd expect from a 35mm rangefinder, making them a good choice for high-quality candid photographs (see Chapter 3). Nearly all twin-lens reflex (TLR) cameras use the 2¼" format.

The smallest medium format is 6 x 4.5cm (about 2¼" x 1⅞"), which still has an image area nearly three times that of 35mm film. Again, the extra area means you can make a sharper, less grainy enlargement than is possible from a 35mm frame. Some non-SLR models must be held vertically for horizontal

composition, since the long dimension runs across the film's width and the camera advances the film horizontally, as in a 35mm camera.

The relatively small size of 6 x 4.5cm camera models makes the 6 x 4.5cm format a good compromise between the image quality of large format films and the handling ease of 35mm. Also, you can get about 15 frames per 120 roll, 30 per 220 roll—the most in medium format—so you can shoot more frames before changing film. The 6 x 4.5cm film frame has a 3:4 aspect ratio, not as long as 35mm's 2:3 rectangle. This allows it to be enlarged to a wide variety of standard print sizes—in fact, it fits 8" x 10" and 16" x 20" printing paper almost exactly.

The increasingly popular 6 x 7cm (about 2¼" x 2¾") format's image area is over 4 times that of 35mm. Its large area means you get just eight shots on a 120 roll, 16 on a 220 roll. These cameras are

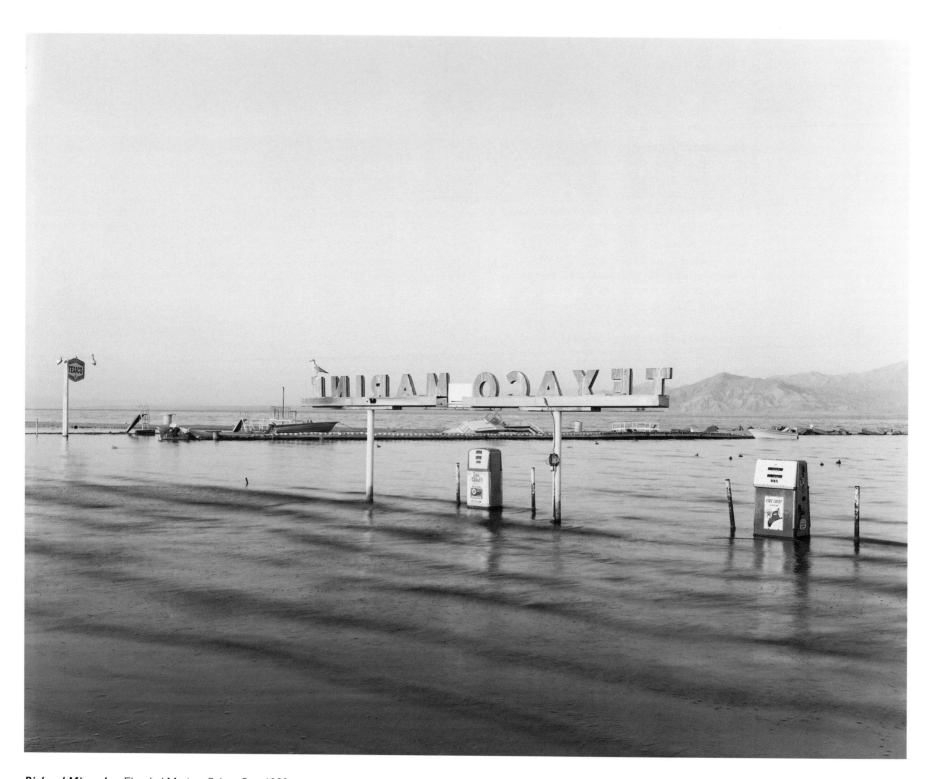

Richard Misrach Flooded Marina, Salton Sea, 1983

For many years Misrach has photographed the landscape of the American Southwest, covering its various calamities—fire, flood, and death, most of it brought about by humans—in installments he calls Desert Cantos. Often shooting late in the day to richen color and soften tonalities, he uses an 8" x 10" view camera because it renders this destruction in disturbingly fine detail. Courtesy Richard Misrach

available as both rangefinders and system SLRs; the rangefinders come in both interchangeable- and fixed-lens models. But the most advanced 6 x 7cm models are SLRs with 35mm-style electronics and a wide range of accessories. Often quite large, 6 x 7 models are used heavily by studio photographers and outdoors, for landscape and nature photography.

Finally, medium format also encompasses a variety of other cameras that use even more film for a single frame. These include 6 x 8cm and 6 x 9cm, as well as very long frame sizes (6 x 12cm and 6 x 18cm) created by special panoramic cameras.

Large Format With this format, film comes in sheets rather than rolls, reflecting the very different shooting style associated with it. Taking a photograph with a **large format** view camera is a more deliberative affair than shooting with 35mm or medium-format models because the bulky camera must be used on a tripod, focusing and composition must be done on a ground glass under a dark cloth, and separate film holders must be removed and reversed or replaced for each shot. (A holder contains two sheets of film, one on each side.) And while rollfilms of any format can be loaded into a camera in the light, large format's individual sheets must be loaded into holders in total darkness, either in a darkroom or a film changing bag. (A few films are available in special light-tight packets that are slipped into dedicated holders for each shot, eliminating the need for film loading.) Processing large-format film is also more deliberative: **Sheet film** is developed either by hand in trays or in large multisheet darkroom tanks (see Chapter 12). Either way takes more time (and chemicals) per pic-

ture than any rollfilm. Available sheet sizes include 4" x 5" and 8" x 10" (the two most popular formats) and the rarely used 5" x 7" and 11" x 14".

Despite its awkwardness, large-format film offers two great advantages. One is that the view camera—the type of camera for which sheet film is made—allows extraordinary control over an image's sharpness and perspective. The other is that large format's huge image area leads to dramatically improved print quality, and it also allows a very high degree of enlargement. In fact, many photographers use large format so they don't have to enlarge the film at all, making contact prints (prints exactly the same size as the negative), an approach that preserves all the quality of the original.

SPECIAL FILMS

When it comes to choosing a film, most photographers stick with the few types that best serve their work, whether advertising, fashion, photojournalism, or fine art. And most standard films, whether a speedy ISO 400 black-and-white emulsion or a fine-grained ISO 25 color negative, are designed to provide a reasonably straightforward representation of the subject. Images created with them are made interesting by external factors such as content, lighting, composition, and printing technique—all basic ingredients of a visual style.

Some films, however, have inherently special characteristics that can make them useful tools for achieving specific effects. Many of these films were originally designed for scientific or technical applications but have been adopted by other types of photographers, mainly for creative purposes. Just keep in mind that when a film produces a strong visual

effect, it's especially important to use that effect to complement an interesting image, and not to rely strictly on the film's unique rendition of reality in the final photograph.

Black-and-White Infrared Film Unlike ordinary films, **infrared film** "sees" radiation that's invisible to the eye—specifically, electromagnetic wavelengths just beyond the red end of the spectrum of visible light. This special sensitivity was originally intended for aerial photography, medical imaging, authentication of paintings, and other technical applications. But the eerie, often surreal effects it can produce have since made the film a favorite of fine-art and professional photographers.

Infrared film records both visible light and the heat energy emitted or reflected by organic materials, whether fabric or foliage. As a result, these objects are rendered on the negative with a much higher silver density than on a normal black-and-white negative. This in turn makes them appear very light or white in the final print. Colors in the blue range—sky, for example—print darker than they would normally be rendered because they produce less exposure than usual on the negative. In fact, the most frequent practice is to enhance this effect by using red filtration over the lens. The red filter blocks most of the ultraviolet radiation and blue and green light, so the image on the film is formed mainly by red light and infrared radiation, making skies appear clear on the resulting negative, thus printing dark, or even black. It also increases the overall contrast of the image.

A deep red No. 87 filter will screen out most visible light, recording mainly infrared. The drawback to this is that the

large format Describes film that comes in sheets measuring 4" x 5" or larger and/or the cameras designed to shoot it.

sheet film Film that comes in individual sheets rather than rolls, most commonly measuring 4" x 5" or larger.

infrared film Film that is able to record infrared radiation.

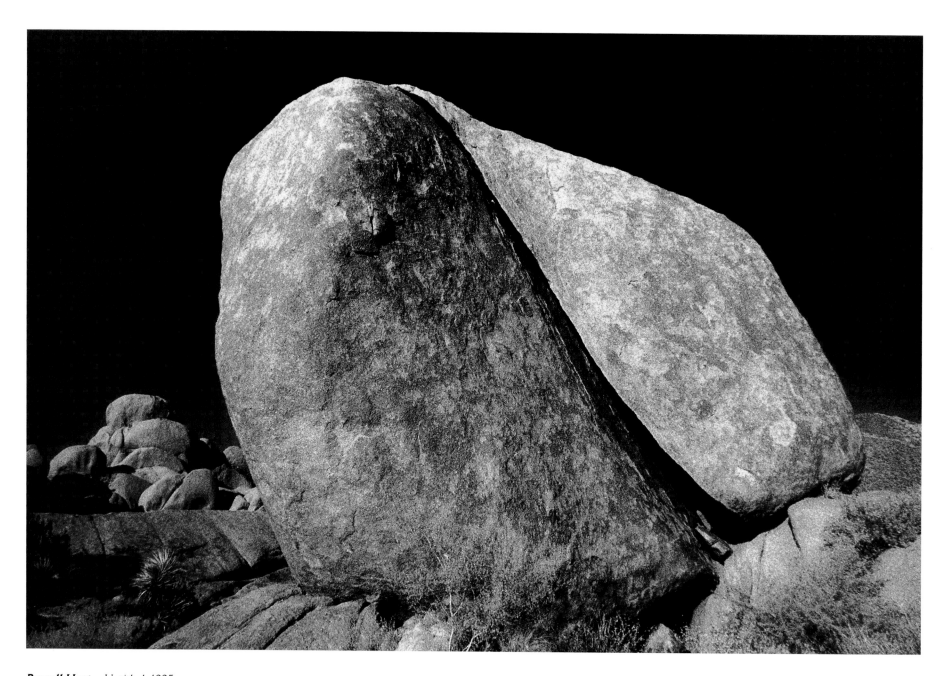

Russell Hart Untitled, 1995

Though it was originally developed for technical purposes, black-and-white infrared film is now often used by photographers for its pictorial effects. Chief among these is that it renders organic substances—foliage or cloth, for example—much lighter in tone than they appear to the eye, the result of their high reflectance of invisible infrared radiation. Depending on the brand, other effects of black-and-white infrared film include a sharp, crystalline grain pattern (most prominent in prints from 35mm negatives) and glowing highlights (due to the absence of an antihalation layer, which prevents the spread of light across the film surface). Hart uses the film with a red filter to darken blue sky and create a flat, planar space in the image. © Russell Hart

filter is nearly opaque—you can't see through it—so that if you're using an SLR, you can't focus or compose precisely with the filter in place. You'll have to use a tripod and attach the filter after you've framed and focused the shot. The No. 87 filter also produces a fairly high-contrast effect. An alternative, the No. 25 (red) filter, allows both some visible light and infrared radiation to reach the film, creating a subtler effect with more middle-gray values. And since you can see through the filter, you can view and photograph the subject with the filter in place.

The effect of infrared film varies from one film manufacturer to another. Kodak High Speed Infrared, for example, has relatively high overall sensitivity and a pronounced crystalline grain pattern, while Konica's IR 750, a slower film, has finer grain and additional sensitivity to visible light. Though most such films are available in 35mm, they aren't available in all formats.

Infrared films have no actual ISO rating because they record more than the visible light to which meters are sensitive. Manufacturers offer exposure recommendations for different light levels, but these aren't always reliable. Regular users of infrared film usually arrive at exposure settings through experience. A good starting point for Kodak High Speed Infrared in direct, hard sunlight is 1/250 at f/11; increase the exposure by one-half to one stop for hazy sun, and reduce it by one-half to one stop for bright beach or desert environments.

The additional sensitivity of infrared film makes handling and processing them trickier than with conventional films. With the Kodak version, for example, the 35mm cassette should be removed from its black plastic canister only in total darkness, whether for loading into the camera or for processing, so you'll need a film-changing bag to shoot more than one roll when away from home. In fact, newer SLR cameras using infrared in their frame-counting systems will fog infrared film. (If there's no reference to this in your camera's manual, call the manufacturer to be sure.) The only solu-

tion to this is to shoot with a camera that doesn't use this type of system.

Finally, though processing is done with the same chemicals used for other black-and-white films, infrared is much more delicate—very sensitive to fingerprints and other physical damage, so handle it very carefully.

Kodak Ektachrome Professional Infrared (EIR) Like its black-and-white cousin, color infrared transparency film was developed for practical purposes, like agricultural surveys and medical imaging. But the exotic, weird colors it provides make it appealing for fine-art and professional photographers.

This film is available in 35mm cassettes and records infrared radiation as false color. It also records visible wavelengths normally, resulting in an incredibly varied palette. Healthy plant foliage, in particular, registers intensely on the film, as do many flowers, so landscapes can take on exaggerated colors. As with black-and-white infrared, the effect can be further intensified through use of filtration that blocks some visible light but transmits mostly or only infrared. The usual filter is a medium yellow (Wratten #12), although any color can be used for varying effects.

Kodak's color infrared film can be processed in the same chemicals used for conventional color transparency films. But like black-and-white infrared, EIR has special handling needs. In addition to loading and unloading it in complete darkness, your processing lab must turn off any infrared sensors in its machinery before developing the film.

PolaChrome Instant Film This 35mm transparency film gets its unique visual effect from the additive method

Useful both for audiovisual presentations and fine-art effects, Polaroid 35mm instant films must be developed in a special processor. First you load the exposed film cassette and a cartridge containing the developing chemicals into the processor, threading the film leader together with a strip from the cartridge (top). Then, after closing the processor's top, you swing a lever to burst the cartridge's chemical pod and rotate a crank to spread the developer between the film and cartridge strip (bottom). After waiting for the recommended time (usually 60 to 90 seconds), you return the lever and quickly crank the film back into the cassette, where it safely remains until you're ready to mount it.

of color formation—an old-fashioned approach used by no other modern film. It sandwiches a black-and-white emulsion under a grid of microscopic red, green, and blue color filter elements; these break down the light into its red, green, and blue components before it reaches, and exposes, the emulsion. The emulsion is reversed from negative to positive in processing, and the filter elements remain in place to recreate the colors of the original subject when you view the transparency.

The grainy texture formed by the filter elements, plus the film's low contrast, give PolaChrome an impressionistic quality reminiscent of the early 20th-century autochrome, photography's first commercial color process. Though the film's instant processing is designed for quick slide presentations (its most common application), its special texture and color qualities offer unique creative tools.

A properly exposed PolaChrome image is darker (has more overall density) than a normal slide. A PolaChrome slide may therefore appear dim if you project it in sequence with regular slides, but this effect can be avoided if you have a lab copy (or "dupe"—for duplicate) it onto conventional film. Some photographers compensate for the film's high density when they're photographing, overexposing it slightly—perhaps by half a stop. At ISO 40 the film is slow to begin with, so you may need a tripod for proper exposure.

PolaChrome is developed in 60 seconds with a special Polaroid processor and a chemical cartridge that's supplied with each roll. The film also comes in a high-contrast version that's useful both for copy slides of graphics and to give low-contrast subjects extra "snap."

Other Polaroid 35mm instant films include an ISO 125 black-and-white transparency film called PolaPan. Though somewhat grainier than black-and-white negative films of comparable speed, PolaPans positive image has has an attractively warm image tone and rich gradation.

Polaroid Integral Instant Films

These instant films, made for amateur photography, include those for Polaroid's Spectra and 600-series models. They develop before your eyes after they are ejected from the camera. When **integral film** is ejected, the film passes through rollers that release and spread its built-in (integral) development chemicals. The 600 series includes both a black-and-white film and a color film with a matte surface that can be drawn on, in addition to the standard glossy-surfaced color. And Time-Zero film for older Polaroid model cameras has an emulsion that can be manipulated during and after processing (see Chapter 16).

Polaroid Peel-Apart Instant Films

For many working photographers, Polaroid's **peel-apart instant films** are essential tools. They are very widely used, especially by studio photographers, to shoot test photographs of their subjects. They give the photographer a color or black-and-white positive image with which to evaluate exposure, color, focus, and lighting before making a final exposure on standard color negative or transparency film. This way, corrections can be made or problems fixed beforehand so that there are fewer unwanted surprises when the film is processed.

Available in both black-and-white and color, the film comes in 3¼" x 4¼", 4" x 5", 8" x 10". Depending on the type, the film either comes in 10-sheet packs or

integral film Polaroid instant film that contains the emulsion and all the processing chemicals in a sealed packet and develops within minutes of ejection from the camera.

peel-apart instant films Polaroid instant films that develop in a paper envelope that is then peeled apart to separate the print from the negative and processing chemicals.

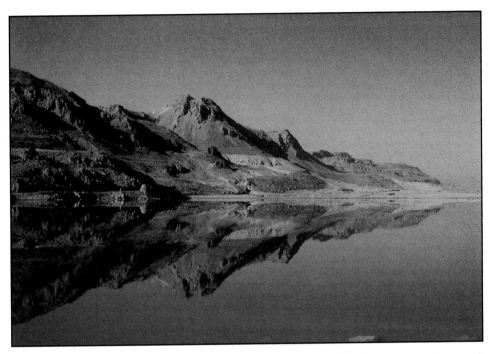

One of Polaroid's 35mm instant films, PolaChrome is a transparency film that creates its image with additive color technology rather than the subtractive system of conventionally-processed transparency films. It is basically a black-and-white positive with an overlying grid of minuscule red, green, and blue color filter elements that recreate the subject's color. This emulsion structure gives a properly-exposed PolaChrome image greater overall density than a conventional transparency, but also a prominent texture that creates an impressionistic quality.

tion, many photographers use instant color peel-apart films for special Polaroid image and emulsion transfer techniques (see Chapter 16).

Kodalith Ortho Originally designed for the printing industry, black-and-white **orthochromatic film** (ortho) is an essential tool for photographers using various darkroom manipulations (see Chapter 15). But its high-contrast negative image (needed for those techniques) also makes it an interesting film for use in your camera. The film has a sluggish speed of ISO 10, so be prepared to use a tripod if you photograph with it.

Though the film can reduce a full-toned subject to values of pure black and white, it also produces shades of gray if you process it in regular film or paper developers and print it like any conventional negative (see Chapter 15). Because the film is unforgiving of inaccurate exposure, be sure to bracket exposures (see page 177). The effect is still high in contrast, making the film a useful material for strong, graphic interpretations. Kodalith Ortho comes both in sheets and 35mm. The 35mm version is called Ektagraphic HC slide film.

Agfa Scala 200 Standard black-and-white negative films can be reversal-processed to produce a positive black-and-white transparency rather than a negative (see Chapter 12). However, Agfa's Scala 200 film offers an easy, consistent, and high-quality alternative. It has very fine grain yet has a moderately fast ISO 200 speed. The catch is that its processing is available only through a limited number of labs in major cities. These facilities are set up for mail-order processing of Scala 200, and they also sell the film directly. The film is sold by

orthochromatic film Film not sensitive to the red portion of the light spectrum. Often high-contrast, the films are used in the printing industry and for darkroom manipulations and non-silver processes.

individual sheets. Both types require the use of a special film holder or camera back. (Peel-apart sheet films are loaded into the holder and processed one at a time; pack films remain in the holder and are exposed and processed as needed.) One widely used back is the Polaroid Model 545, which slips under the ground glass of a 4" x 5" camera just like a regular sheet film holder; like other Polaroid backs, it contains rollers that burst and spread developing chemicals over the film when you pull it out of the holder after exposure. After development is complete—usually in 60 to 90 seconds or

less—the packet is peeled apart to reveal the completed photograph.

Some photographers use Polaroid images—especially in 4" x 5" and 8" x 10" sizes—as "final art," for their own unique color palette and processing artifacts (especially the residue of developer along the edges of the film). And many fine-art photographers shoot special Polaroid black-and-white positive/negative film because it produces not only an instant positive image, but also a high-quality conventional 3¼" x 4¼" or 4" x 5" negative that can be printed like conventionally processed films. In addi-

Available in 3¼" x 4¼", 4" x 5", and 8" x 10" formats, Polaroid's peel-apart films have become a standard tool for commercial photographers, both in the studio and on location. They produce a positive print in as little as 60 seconds, allowing photographers to evaluate lighting and exposure before shooting their final film. A special film holder is required for each peel-apart format. Once the film is exposed—in this case, 4" x 5"—it's pulled out of the holder through rollers that burst a pod of developing chemicals and spread them across the film surface (left). When the recommended time has elapsed, the film sleeve is peeled apart to separate the negative from the positive, stopping development (right).

mail-order retailers and specialty camera stores as well.

Scala is available in 35mm, medium format, and large format. It can be easily "pushed" one stop to an effective speed of 400, referred to as E.I. 400 (E.I. for exposure index) with no visible increase in grain and a slight, often useful increase in contrast. It can also be pushed to E.I. 800 and beyond, or pulled to E.I. 100, though these ratings cause more visible changes in contrast and tonality.

Scala is especially popular with advertising, editorial, and other photographers shooting in black-and-white for reproduction because it eliminates the need to make a print—an extra step that deadlines may not allow, and one that can compromise image quality, particularly if printing is not within the photographer's control.

Note also that a Scala (or other) positive transparency offers a good starting point for digital imaging also allowing input by way of film scanners rather than the flatbed or more expensive drum-type scanners required for prints (see Chapter 17).

Chromogenic Black-and-White Films These increasingly popular black-and-white emulsions, which include Ilford XP2, Kodak T-Max T400 CN, and Konica Monochrome VX400, have several advantages over conventional black-and-white films. **Chromogenic black-and-white films** are more forgiving of exposure errors (particularly gross overexposure). They are fast (all ISO 400) yet fine-grained and sharp. They are available in 35mm cartridges, APS cassettes, 120/220 rollfilm, 4" x 5" sheet film, and even single-use

cameras. But what makes chromogenic black-and-white films unique is that they are developed using the C–41 process for color negative films, which are also based on chromogenic principles (see page 143). (Chromogenic black-and-white films also work with dye—in this case, just one color—creating image density where silver was developed in the negative.) This means they can be developed essentially anywhere you find color print processing. If you can't process your own black-and-white film—or you just don't want to—you can shoot chromogenic black-and-white film, have it processed at the local photo lab, then simply make prints yourself.

Chromogenic black-and-white films do have their drawbacks. If you have them printed on color paper, the prints can have a color cast to them. (Sepia, magenta, and green are typical.) Some people like the tint, but others find it annoying. A good lab should be able to adjust color balance to produce a neutral result. And many color labs can print chromogenic film on chromogenic black-and-white paper, which eliminates any color cast. And you or the lab can enlarge the negatives onto black-and-white printing papers just as you would a standard black-and-white negative.

Push Films Some of the faster film emulsions on the market—Kodak's T-Max P3200 black-and-white negative film for example—are **push films** that produce their advertised speed ratings only with extended film development. T-Max P3200, for example, has a true speed rating of ISO 1000 or so, but increased development time allows you to shoot it at E.I. 3200 or higher. (There are also ISO 1600 color transparency films that require pushing to achieve their high effective speed.)

chromogenic black-and-white film Black-and-white film designed to be processed with standard C–41 color chemicals.

push films Special high-speed films that are designed for extended development.

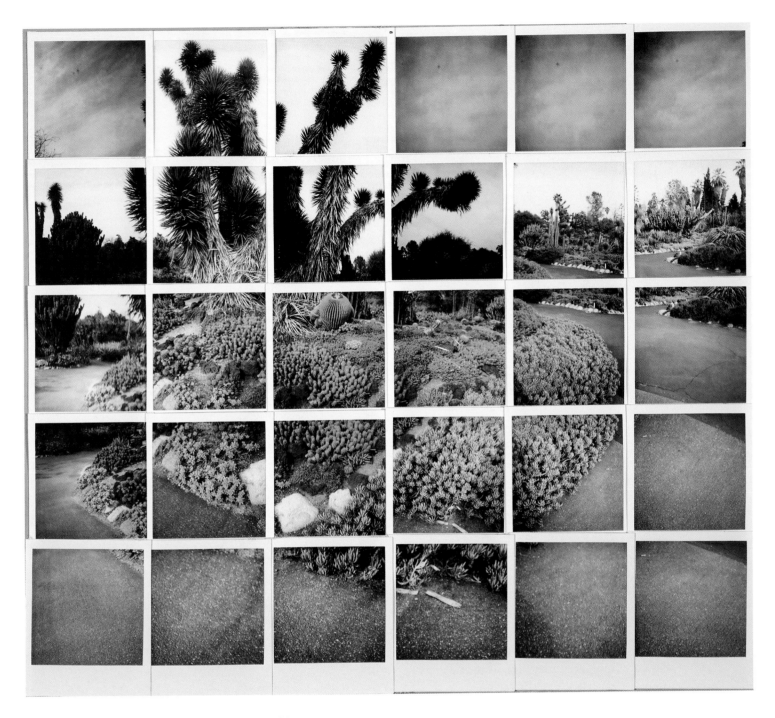

David Hockney Cactus Garden, Los Angeles, 1982

Painters have embraced photography enthusiastically in recent decades, sometimes seeing it as just another artistic tool, sometimes as an altogether new medium. Hockney has expressed his disdain for "one-eyed" photography—lone images made from a single point-of-view—by building collages from dozens if not hundreds of individual prints that show small sections of a scene. Because the effect is not seamless, and offers interesting shifts in perspective, his images sometimes have the quality of cubist abstraction. For this one, Hockney used a Polaroid SX-70 camera and instant film, but he also sometimes shoots with a 35mm camera, piecing together small machine-made color prints. Steve Oliver/David Hockney Studio, REF. C.P. 029

PROFESSIONAL VS. AMATEUR FILM

Because professional photography depends on highly consistent results, some emulsions are available in professional versions. This means that the film is actually kept and stored safely by its manufacturer after production, and sent to camera stores only when it meets critical standards of speed, contrast, and color balance. It is shipped in refrigerated conditions, and the dealer should store it in refrigerators, too.

Unless you plan to shoot and process professional film immediately, you should keep it in your own refrigerator. Some companies claim their professional films are treated to allow safe storage at room temperature, but it can't hurt to refrigerate these as well. For long-term storage, almost all film can even be frozen (see below), with the notable exception of Polaroid materials.

The data sheet supplied with some professional films gives you an effective speed (E.I., for exposure index; see Chapter 9), based on testing of that particular emulsion batch. If this varies at all from the film's official speed, it's usually by 1/3 stop—ISO 80 rather than ISO 64, for example. You simply reset your camera or hand-held meter to that speed. Certain emulsions may come with a recommended filter pack for more precise color control, though the correction is usually small.

All this special handling and information allows photographers to shoot professional films and feel confident they'll deliver virtually the same result every time. Though amateur films are reasonably consistent, they are released earlier and "mature" on a dealer's shelves at room temperature. That difference is reflected in the film's expiration date, which is printed on the packaging; professional films expire sooner. Either way, avoid buying and shooting film that is past its expiration date.

Almost all medium-format rollfilms, and all large-format sheet films, are considered professional films. Sometimes they're actually made to different specifications than their amateur counterparts, with slightly different color saturation, color balance, or even speed. If you want the ultimate in consistency—for a single project or a critical use—consider buying a quantity of film with the same emulsion batch number. (Batch numbers are printed on the film box.) Doing this ensures that you are getting films made at the same time from the same lot of film at the factory. Note that any film sold in a multiple-roll plastic-wrapped packages, called bricks, will be from the same emulsion batch. Keep the film in your freezer, and thaw it for several hours before shooting, if you plan to use it over a long period of time.

When using these films, pay attention to the ISO setting on your camera. Some of these films' cassettes don't have DX coding to let the camera automatically index the film speed you want, so you'll have to set the speed yourself; you can do this on most, but not all, cameras. If a lab processes your film, be sure to tell them the speed at which it was shot. The best way to remind them (or you) is to write the speed rating directly on the film cassette with an indelible marker.

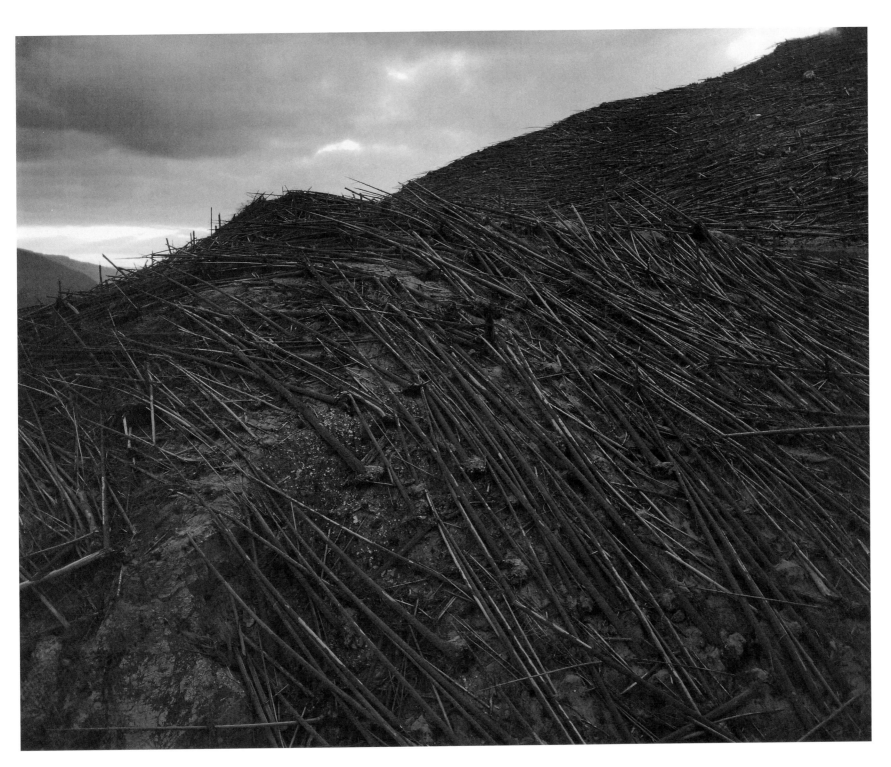

Frank Gohlke Blowdown Near Elk, 6 Miles Northwest of Mt. St. Helens, Washington, 1981

For two decades, Gohlke has made repeated trips to Mt. St. Helen's volcano in Washington to photograph the aftermath of the cataclysmic 1980 eruption. By rephotographing the same locations on each successive visit, he has created an evolving visual record of the recovering landscape. Since detail is so important to this project, Gohlke uses medium- and large-format cameras because their sizeable negatives render the image with considerable descriptive power. © Frank Gohlke

GRANT PETERSON
STILL LIFE

PETERSON'S TOOLS

8" x 10" field camera with 270mm lens

4" x 5" monorail view camera with 180mm macro lens

6 x 6cm SLR with inter-changeable lenses and magazines

6 x 6cm super-wide camera

Hand-held incident strobe/ambient light meter

Four 2400 watt/second strobe power packs with six heads

Six tungsten focusing spotlights

5,000-watt tungsten spotlight

Motorized strobe/tung-sten lightbank

PowerMac G3 computer with 750MB RAM, various peripherals

Drum scanner

Iris 3024 printer

It used to be a cardinal rule of commercial photography that still lifes be sharp from front to back. Then in the late 1980s a few daring photographers such as Grant Peterson started to break that rule in interesting ways. Leading the revolution, Peterson made still lifes in which some objects were sharp and others soft; in which some objects were part sharp and part soft; and in which other objects simply lingered outside the frame, contributing interesting shadows, breaking up the light, or adding color. Sometimes Peterson hid his supposed subjects—perfume and liquor bottles, cigarette packs, cosmetics—in visually intriguing puzzles of reflections, shadows, and out-of-focus detail, just as fashion photographers were creating pictures that were less about clothing than about a fashionable lifestyle. Peterson's approach has been influential for years now, so much so that it's unusual to see an editorial or advertising still life that is completely literal in its representation.

Perhaps because of his determination to stay original, Peterson feels most content when an assignment is difficult. "I love impossible projects," he says. "I like trying to fit a square hole in a round peg. I need the challenge of turning an ordinary subject into a beautiful picture." To make that happen, ad agency creative directors and magazine art directors know they have to cut Peterson some slack. "Six or eight hundred art directors have been through my studio in my career, and the ones that get the best photographs are the ones who aren't always looking over my shoulder," he says. "It's my job to find out what things the art director likes about my work, and try to apply them to the assignment. And I also need to understand what the client expects from the picture, in a marketing sense. But I think it's the art director's job to create an environment that nurtures creativity and experimentation. So shooting the picture is really a collaborative venture."

Peterson resists the idea of a "safety" photo: making a more conventional version of a still life to be used if the client finds the primary effort image too outlandish. "Safety photos are the hardest part," he says. "I try not to shoot them. I do if I must, but my hope is always to make the real picture so good they just *have* to use it."

Clients ordinarily don't come to Peterson with a concept; they come for a sensibility. That's fortunate, because Peterson's unorthodox working methods don't guarantee a specific outcome. A setup evolves as he's shooting, and it may end up radically restyled or relighted. "We sometimes expose dozens of sheets of film, and I don't mean brackets," he says. "The first arrangement is usually too studied, so I start moving the camera around. We often don't know what's going to work until we edit the film. The edit defines the assignment."

Even after the edit, the image often goes digital—retouched by a computer specialist who works with Peterson virtually full-time. In addition to his ample conventional gear, Peterson has a powerful digital arsenal that includes a drum scanner and a top-of-the-line Macintosh computer, and he also uses high-resolution digital camera backs and cameras for special assignments. "Digital imaging is especially good for more conceptual kinds of still lifes, where the elements are floating rather than fixed," he says. "Basically, you make the still life in the computer." But Peterson also uses computer retouching for subtle smoothing and reshaping, often completing the work begun with careful styling or a hand-built model. For Peterson, who was among the first commercial photographers to embrace digital imaging, the computer merely increases his control.

That control now extends into the prepress area. Peterson and computer expert actually prepare digital files for printing in magazines and catalogues— "separation" work that would otherwise be done by an independent commercial

Fabric Face

Eyes in Ball

outfit working for the magazine or ad agency. To ensure that the reproduction is as close as possible to the original, the photographer even has "approval" prints made, the same kind of pigment-based proofs that prepress houses return to an art director for color and density corrections. That enhanced control seems tailor-made for a photographer who considers the printed page an ideal photographic medium. "A lot of photographers see their chromes as the ultimate piece of art," he says. "My feeling is that a chrome always gets better when it's in print."

Whatever its final form, a Peterson image usually begins inside a tentlike structure that has for years occupied the middle of the photographer's spare Manhattan studio. When Peterson wants to work with strobe and/or tungsten lights—and these days it may well be a combination of the two, with HMI lights thrown in to mix up color temperature even more—he turns the cube-shaped tent away from his studio's big south-facing windows, blocking their copious light. But when he wants to use daylight he swings the tent around, and its black walls keep the studio's white walls from overfilling shadows. The effect is much more naturalistic.

Peterson has charted his studio's light throughout the day at different times of year. He has necessarily reversed the usual practice of adjusting lights to suit a fixed setup, keeping his still lifes on wheeled tables so that he can push them around to follow the light and rotate them to control its angle. He exploits natural light in much the same way as an outdoor photographer, sometimes waiting for the sun's last, warm rays to shoot, or even making a long exposure by a post-sunset sky to capture purplish-red hues that simply can't be created artificially. "I work less often with natural light these days, but when I use it I think more in terms of color than directionality," says Peterson, who sometimes also covers his windows with silk fabric as much for its warming effect as for its diffusion. All that flexibility is Peterson's way of keeping his still-life lighting fresh. "I've basically tried to dismantle my process," he says. "The last thing I want is to rely on formulas."

Connoisseur Honey

JOHN COHEN
Woody Guthrie Backstage at Cooper Union, NYC, 1961

Some of the most beautiful photographs depend on dark tones and deep shadows, as in Cohen's portrait of legendary folk singer Woody Guthrie, made by low light. In low light, though, there is a high risk of underexposure—of not getting enough light to your film. This in turn can produce an unattractively murky result, and, if you're using negative film, an image that is difficult to print. This chapter explains some of the strategies you can use to prevent such common exposure errors.

FILM EXPOSURE

exposure Quantity of light that reaches the film from the subject when you take a photograph, controlled by adjusting the lens aperture and/or shutter speed.

light meter Instrument used to measure light, indicating combinations of f-stop and shutter speed needed for correct exposure; sometimes called exposure meter.

built-in meter Light meter incorporated into the camera; nearly all 35mm cameras have one, as do many medium-format models.

hand-held meter Separate light meter, not incorporated into the camera body, used to determine exposure for cameras that have no meter and/or with advanced exposure techniques.

middle gray Gray tone that reflects 18 percent of the light that falls on it; most light meters are designed to assume that the varied tones of a typical subject average out to this middle value.

TTL meter Through-the-lens light meter, it measures light after it enters the camera through the lens.

The most important factor in creating a good negative or a good transparency is achieving the correct film **exposure** when you're taking the picture. Exposure refers to the amount of light from the subject that strikes the film. As you've learned, the main way you obtain the correct exposure is by adjusting your camera's shutter speed and lens aperture. And to arrive at the proper shutter speed and lens aperture settings, you need to measure a subject's brightness. You do this with an instrument called a **light meter** (sometimes called an exposure meter). Light meters come in various types and some require more careful use and/or interpretation than others. But all of them either guide you to the correct shutter speed and lens aperture, set one or the other for you automatically, or set both automatically, depending on their design and your approach to exposure.

To get the correct amount of light to the film with a bright subject—a sunlit landscape, for example—you usually have to set a small f-stop or a fairly fast shutter speed, or both, to keep the film from receiving too much light. To get the correct amount of light to the film with a dim subject—a lamplit interior, for example—you usually have to set a wide f-stop or a fairly slow shutter speed, or both, to keep the film from receiving too little light. Films of different speed, however, each need differing amounts of light for proper exposure.

Whatever type of meter or metering system you're using, the first thing you must do is set it to the correct film speed to tell the light meter what to base its measurements on. Film speed refers to the film's sensitivity to light and is measured with an ISO number (see Chapter 8). Most newer cameras can set the film speed automatically, based on the DX code printed on a 35mm film cassette. With other cameras you must set the number yourself, either with a calibrated dial or a pushbutton and LCD display panel. Usually you'll be setting the ISO recommended by the film manufacturer, but there are times you'll want to deviate from it. (SLR cameras that set film speed automatically also generally let you override the setting and select your own ISO number.)

Most photographers take light readings with their camera's **built-in meter.** These are found in nearly all 35mm cameras as well as many medium-format cameras. Photographers whose cameras contain no meters (such as many medium-format and all large-format models), or whose technique requires precise readings of small subject areas, usually use a **hand-held meter.** But with a few exceptions, all meters are designed to make the same basic assumption: that the varied tones of your subject "average out" to a **middle gray.** This gray is the midpoint on a scale from white to black (see box on page 169). Your meter tells you—or, in the case of an autoexposure system, instructs your camera—to set combinations of lens aperture and shutter speed that will correctly reproduce this middle-gray tone on film.

BUILT-IN METERS

Most built-in light meters offer a great advantage: In addition to eliminating the need to carry and use a separate hand-held meter, they measure the light that actually comes through the camera's lens. A **TTL meter** (for through-the-lens) measures light only from the part of the scene you see in the viewfinder—the part that is actually recorded on the film. This makes TTL meters more accurate for general purpose use than hand-held meters. (Note that a few built-in meters don't read light directly through the lens; rather, they have a light-sensing window on the front of the camera and measure light that falls near the lens instead.)

If you're using a telephoto lens, for example, the TTL meter's reading is based only on the lens's small slice of the scene (a narrow angle of view). If you're using a wide-angle lens, the TTL reading is based on a big slice of the scene (a wide angle of view). In the case of the long lens, the TTL exposure meter's recommendations are less likely to be thrown off by other things or lighting conditions outside the actual subject area. In the case of the wide-angle lens, the reading might actually take in more of the scene than would a hand-held light reading and might therefore include a more reliable mix of subject tones on which to base its recommendations.

Through-the-lens meters also automatically compensate for the reduction of light caused by the use of filters, teleconverters, or lens-extension tubes, and for the light loss that results when lenses are focused at very close distances. (This is a considerable advantage over hand-held meters, with which you yourself have to adjust the exposure to compensate for these accessories or this extension.) But TTL metering systems are not foolproof. They can be fooled by subjects

EXPOSURE BASICS

Correct film exposure is a function of three factors: film speed, lens aperture, and shutter speed. Whether the lighting is low or bright, you should be able to achieve correct exposure by manipulating one or more of these factors.

Film speed, as rated by ISO number, refers to the sensitivity of a particular film to light (see Chapter 8). A slow speed film (one with speeds lower than ISO 100) needs more light than a fast film (ISO 400 or higher) to achieve correct exposure. More light could come from the subject; a sunny day provides a lot of light and is thus more suitable for slower film than the low light of a nightclub, which will need fast or ultrafast film. Or more light could come from your primary lens and camera controls: f-stop and shutter speed. Using a wide f-stop will let in more light, as will using a slow shutter speed; for less light, close down your lens to a small f-stop and/or use a faster shutter speed.

Your light meter is the tool that sorts out these factors for you. It measures the subject lighting and recommends a suitable combination of f-stop and shutter speed to produce the correct exposure. For example, on a bright sunny day your meter might suggest an exposure of 1/250 at f/11—a relatively small lens aperture and fast shutter speed to allow just a little light to reach the film. In dim nightclub light, the meter might recommend an exposure of 1/60 at f/2—a relatively large lens aperture and slow shutter speed to allow more light to reach the film.

A meter must factor in the film speed as well as the lighting conditions when making its recommendations. When you load film into your camera, most modern 35mm cameras read a bar code from the film cassette and automatically set the meter's film speed for you. For cameras or hand-held meters that can't read the bar code, you must set the appro-priate film speed. But even in most cameras that can read the bar code, you can also set the film speed manually, which is very useful when you want to rate your film at a different ISO than the manufacturer suggests (see box on page 181).

Although your meter almost always recommends one combination of f-stop and shutter speed for a given lighting condition, you can actually use several different combinations because of the reciprocal relationship of shutter speed and lens aperture. For example, a setting of 1/125 at f/8 provides the same exposure as 1/250 at f/5.6. In effect, increasing the size of the lens aperture one stop (from f/8 to f/5.6) doubles the light let into the camera, while making the shutter speed one stop faster (from 1/125 to 1/250) permits that light to enter for only half the time. Thus, the same total amount of light reaches the film at both settings—and several other setting as well. The following combinations all provide the exact same exposure:

1/15 at f/22	1/250 at f/5.6
1/30 at f/16	1/500 at f/4
1/60 at f/11	1/1000 at f/2.8
1/125 at f/8	1/2000 at f/2

Note that built-in meters always display one exposure suggestion, but some hand-held meters actually display several exposure options for a given subject. While the resulting exposure is the same, the visual impact may be quite different. Opening the lens aperture, for example, will produce less depth of field. And using a slower shutter speed potentially creates more subject or image blur. These are critical tools to master if you're planning to have the most image control possible.

that are mostly bright, like a snowy field on a sunny day, or mostly dark, like a person in dark clothes against a black wall. This is because such scenes don't conform to the middle gray average tone assumed by the metering system.

The most common instance of this is when the subject is strongly backlit—that is, when most of the light is coming from behind it. When a TTL meter sees the bright backlight around your subject, it may recommend too little exposure to produce good detail in the main subject—resulting in underexposure that renders the subject a near silhouette. In fact, manufacturers have devised TTL metering systems for many newer cameras intended specifically to avoid such pitfalls. These are often called **metering patterns** and they subdivide or "weight" the viewfinder and scene in different ways.

Some cameras (especially 35mm models) may offer two or three different metering patterns, and depending on what areas of the image in the frame are light or dark, each may arrive at a somewhat different reading (all other things

metering patterns
Ways in which TTL metering systems subdivide or weight the subject in the viewfinder for more accurate exposure measurement.

Many cameras offer a choice of metering patterns—different systems of weighting and subdividing the scene you're photographing in order to analyze its light and arrive at combinations of f-stop and shutter speed that will produce the correct exposure. These illustrations show how different metering patterns interpret the viewfinder image. One common pattern is center-weighted averaging (left), in which the scene's tones are averaged together to arrive at an exposure; its central area is assigned more importance in this calculation than the outer areas. (Center-weighted metering may be the only available pattern on some SLR models.) The standard pattern on newer SLRs is usually multisegment metering (middle), in which the scene in the viewfinder is divided into at least three and often many more individual sections; the contrast and brightness of each section are individually analyzed to arrive at an exposure. This approach generally lessens the chance of exposure errors, making multisegment metering a good choice for all-around shooting. (On some models, it may be the only available pattern.) Many SLRs also offer spot metering (right), in which the meter's sensitivity is limited to a small area indicated by a circle.

centerweighted metering Metering pattern in which most of the exposure calculation is based on the subject area that falls in the center of the viewfinder, with less emphasis on surrounding areas.

multisegment metering Metering pattern in which the viewfinder divides the scene into sections, each of which is individually analyzed to determine the f-stop and shutter speed needed for correct exposure; also called evaluative or matrix metering.

being equal). With the shutter speed set to 1/60, one metering system might set or recommend an aperture of f/5.6; another might set f/6.3, which is halfway between f/5.6 and f/8. Such differences are typically a matter of fractions of a stop and, despite these slight discrepancies, each will usually yield a useable result. Here are the standard TTL metering patterns:

Centerweighted Metering A traditional metering pattern, **centerweighted metering** relies on the averaging principle—that the tones of different subject elements within the viewfinder, when mixed together, equal the middle gray tone the meter needs to determine correct exposure. But it provides one critical refinement: The center of the scene (usually the area roughly within the large-diameter circle inscribed in many viewfinders) is given more weight (more importance) in the final exposure calculation. The assumption is that the main sub-

ject is most likely to occupy the middle of the frame, while less important areas to the top, bottom, and side may be lit differently or may have dissimilar tones, and thus throw off the exposure calculation. Depending on the camera, center-weighted metering systems assign anywhere from 60 percent to 80 percent of the the total calculation to the center area of the frame, which means the large outside areas make up as little as 20 percent to 40 percent.

Multisegment Metering Made possible by camera computerization, **multisegment metering** (also known as evaluative or matrix metering) has become the basic metering mode on most newer 35mm SLRs. Instead of averaging and weighting the scene in the viewfinder, such systems divide it into anywhere from three or four to a dozen or more discrete sections, depending on the model. An in-camera computer and software then analyze each

section's individual brightness and the difference in brightness between each section and the others. The camera then chooses f-stop and shutter-speed settings on the basis of that analysis.

Multisegment metering systems are essentially programmed to compensate for distributions of tone or brightness that would cause center-weighted averaging systems to arrive at incorrect exposures. A multisegment system may ignore segments that are inordinately bright, for example, on the assumption that they are specular highlights—areas so bright that they would have no tone at all in a properly exposed photograph (a lightbulb or the sun, for example). Or it might discount or downplay bright segments in the upper portions of the viewfinder, for example, on the assumption they were sky areas or backlight that could otherwise cause poor exposure of a landscape. Some multisegment systems take their analysis a step further by linking their

Harry Callahan
Weeds Against Sky,
Detroit, 1948
Early in his career, Callahan was inspired by influential land-scape photographer Ansel Adams. But while Adams made grandiose views of the American West, Callahan—who went on to become one of the most important teacher of his genera-tion—did the opposite, finding a quiet, introspective beauty in ordinary things. Many of his most successful images incorpo-rate large areas of white or black space; in this photograph, he used bright sky as a background. Including large expanses of white can lend an image a pow-erful abstract quality, but may also cause your camera's meter to expose incorrectly—that is, to get too little light to the film. This may in turn result in prints with a muddy appearance or a lack of detail in shadow or high-light areas. Any time you include bright areas in a photograph (even blue sky) it's a good idea to increase the exposure over what your meter recommends. Copyright Harry Callahan. Courtesy Pace/MacGill Gallery, New York

metering pattern to the camera's auto-focus system—specifically, assigning more importance to segments surrounding the focusing point in use. This provides more accurate exposure with subjects that are composed off-center.

Multisegment metering is probably the most reliable type of metering system available, especially if you're shooting quickly using automatic exposure. In fact, some 35mm cameras offer only multisegment metering. But multisegment metering isn't entirely foolproof. When you're trying to achieve specific effects that depend on finessing the exposure, you may be better off using other types of metering patterns.

Spot Metering Typically an option on more advanced camera models, **spot metering** confines the meter's light measurement exclusively to a small circle in the center of the viewfinder. A spot meter reads only a small piece of the scene, rather than computing an average of the larger scene. For example, if you point the spot meter's circle on someone's white shirt, it will give you a reading only for that shirt, regardless of what else is in the viewfinder—light or dark.

To use a spot meter, you must place the circle on a subject area that you most want the meter to read. Some photographers simply take spot readings off a middle-gray tone in the subject, using them without modification. Others take highlight and shadow readings, then interpret them to arrive at an exposure.

It's not always the case that your final composition will place the viewfinder's metering circle on a part of the subject that gives you a correct final exposure reading. You may want to take a spot reading of your subject's face, for example, but what if you intend to put the sub-

ject's face in the upper part of a vertical composition? With manual exposure settings, you simply adjust the f-stop and shutter speed settings for your subject's face, recompose, and shoot. On the other hand, if you're shooting in an automatic exposure mode, and the viewfinder's metering circle falls on a dark area of your subject's clothing when you actually compose and press the shutter button, the exposure will be thrown way off—causing the subject's face to be incorrectly exposed.

To prevent this, many cameras have autoexposure (AE) lock capability. This allows you to lock in the desired reading quickly with a button or switch, then recompose and shoot without the camera reverting to incorrect settings (see box,

page 183). Using AE lock also is a good precaution with center-weighted metering, which assumes, sometimes incorrectly, that the most important part of the picture is in the middle of the frame.

(Note that in-camera spot metering is sometimes called narrow-angle metering because its "spot" is much larger, thus it reads a larger subject area than a hand-held spot meter, see page 170.)

HAND-HELD METERS
Though most photographers (and photography students) use built-in meters for the bulk of their work, specific techniques and situations call for hand-held meter readings. These include the use of studio flash systems and of most medium-format and all large-format cameras.

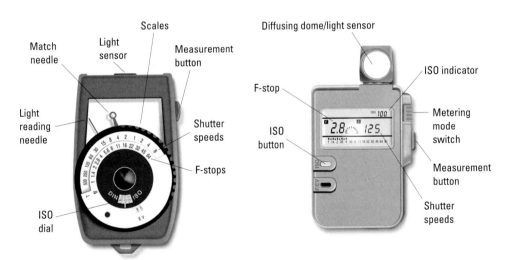

Hand-held meters measure light in one of two ways—and often both—in order to tell you which combinations of f-stop and shutter speed will produce the correct exposure. A reflected-light meter (left) measures light reflected by the subject; to take a reading with it, you point it at the subject. With the reflected-light meter shown here, you press a button, turn a dial to align two needles, then read correct combinations of f-stop and shutter speed from the dial. An incident-light meter (right) measures light falling on the subject; to take a reading with it, you point its diffusing dome at the camera position, making sure it's in the same light as the subject. With the incident-light meter shown here, you press a button and correct combinations of f-stop and shutter speed appear on its display panel.

Even photographers who rely on built-in meters for most of their shooting sometimes double-check or supplement their readings with hand-held meters because they can provide an extra measure of control, particularly in complex lighting situations.

There are several different kinds of hand-held meters. Most require that you click a button or hold a switch to take a measurement of the light. Some immediately display a combination of f-stop and shutter speed on a numerical LCD panel; you can rotate a wheel or press a button to display other combinations that will produce the same exposure. For example, if the initial display suggests a reading of 1/125 at f/8, other useable combinations might include 1/250 at f/5.6, 1/60 at f/11, and so forth. Other hand-held meters require that you rotate a calibrated dial to the correct position to read off the various combinations of f-stop and shutter speed that will produce correct film exposure.

Hand-held meters also differ in the way they read light. With a **reflected-light meter,** you take readings by pointing the meter at the subject—thereby measuring the light bouncing off the subject. (Built-in camera meters are almost exclusively reflected-light meters.) Reflected-light meters arrive at their middle-gray average by gathering light from a fairly broad area of subject, roughly the angle of view covered by a 50mm lens in the 35mm format. Their averaging approach works fine with many subjects. But they are especially vulnerable to error when the subject's mix of tones is, on average, lighter or darker than middle gray. And they're also more likely to be thrown off when the lens's angle of view is very different than the meter's, such as with a telephoto or a wide-angle—situations in which the meter isn't "seeing" the same things as the lens.

To sidestep this problem, photographers using hand-held meters sometimes take reflected-light readings directly off an accessory called a gray card, which reflects 18 percent of the light falling on it (see box on next page). This approach, which also can be used with built-in meters, shows the meter exactly what it expects to see—again, middle gray.

To use a reflected-light meter, stand as close as possible to your subject without throwing a shadow over it from your body or the meter itself. (If you inadvertently shade the subject, you will get an inaccurate light reading.) Aim the meter at the most important part of the subject and press the button. If there is brighter light coming from behind your subject, shade the meter with your hand by holding it between the meter and the unwanted light at a distance and outside the meter's measuring angle. This will keep unwanted light from throwing off the reading.

An **incident-light meter** offers protection against exposure errors similar to that of the gray card. Unlike a reflected light meter, however, an incident meter measures the light falling on the subject, not bouncing back from it. It does this by covering its light sensor with a translucent dome that blocks all but 18 percent of the light that falls on it. As with the gray card, this keeps the meter reading from being thrown off by a subject with an atypical mix of tones—a mix that does not average out to middle gray.

To use an incident meter, hold the meter up so that the light-reading dome is in the same light that is falling on your subject, and point the dome directly at the camera or at the position where the camera will be when you take the shot. Be sure not to throw a shadow over the dome with any part of your body. For accuracy's sake, keep the meter more or less in the same plane as the subject. If you're taking a picture of a standing person, for example, hold the meter up to the subject's face, parallel to the body, with the dome pointing back at the camera lens.

You take incident-light readings by pointing the meter's dome at the camera, not the subject, to directly measure the light that falls on the subject. Because they aren't influenced by the subject's actual tones, incident-light meters tend to be less error-prone than reflected-light meters. You also don't have to be particularly close to your subject to take an accurate reading. In fact, an incident-light meter can provide quite accurate exposure readings for distant landscapes, provided the reading is taken in the same type of light that is illuminating the scene.

Many hand-held meters are designed so that an incident dome can be slid over the light sensor when desired, allowing them to take both reflected- and incident-light readings. This allows the photographer to choose the kind of reading that best suits the subject and also to compare different kinds of readings for greater control.

Keep in mind that hand-held meters' exposure recommendations must be precisely modified if you're using filters, teleconverters, or lens extension for close-up photography. These all decrease the amount of light that passes through the lens to strike the film, making an increase in exposure necessary. Built-in meters that read the actual light coming through the lens don't have this problem; they automatically adjust for the reduction in light caused by these factors. Spot meters

reflected-light meter
Meter that measures light reflected from the subject; may be either built into the camera or hand-held.

incident-light meter
Hand-held meter that measures light falling on the subject.

THE GRAY CARD

The term "middle tone" or "middle gray" often comes up in any discussion of film exposure. This is because your camera's built-in meter reads all the tones in a scene from light to dark and calculates an exposure that averages out those values to middle gray. Knowing how a meter operates gives you several methods to determine the proper exposure.

One simple method is to make your light reading from a **gray card,** rather than from the scene you are photographing. A gray card is an inexpensive piece of cardboard, usually 8" x 10" (or so) finished in a flat, neutral gray color. This surface reflects 18 percent of the light striking it—a reflectance that is the equivalent of the tonal average your meter attempts to calculate. This is why middle gray is sometimes referred to as "18-percent gray." The card circumvents problems that might arise from subjects whose tones do not average out to gray. By reading off the gray card rather than from your subject's varied tones, you should arrive at the correct exposure most of the time.

To meter with a gray card, use your built-in camera meter in its manual mode or use a hand-held meter. Get so close to the card that it fills the viewfinder. If you're using a hand-held meter, get close enough so that you are taking a reading only from the gray card—and not from any part of the scene behind it. In either case, make sure you don't cast a shadow on the card as you take the reading, or the reading will be inaccurate. (Spot meters are very useful when using a gray card because they allow you to step back a little so that you won't cast a shadow, and they also allow you to better see what you're metering.) Now set your camera using the f-stop and shutter speed combination the gray card reading suggests. Step back

and shoot the entire scene at that setting, ignoring the built-in meter reading from this point on.

If you are shooting a portrait of someone, for example, you can have your subject hold the gray card in front of him or her while you take the reading off the card. To determine exposure for a still life, you can prop up the gray card in front of the setup, in the same light, and meter from the card. For an accurate reading, it's critical that the gray card is in the same light as the main subject and that nothing is casting a shadow on it.

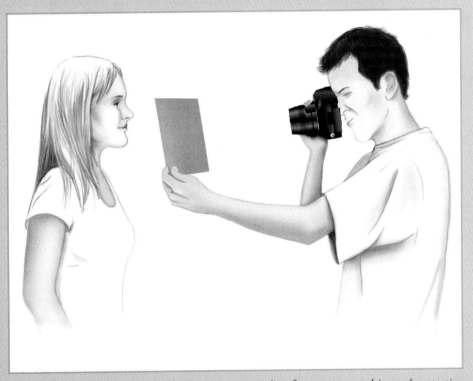

When you have the time to do it, taking a meter reading from a gray card is good protection against exposure error—a safe way of determining the correct exposure. Just be sure to hold the card in the same light as the subject, positioning it so that there's no glare or shadow on it. Then fill the camera's viewfinder with the card as you adjust the f-stop and shutter speed. If you're shooting in manual exposure mode, you can use the indicated f-stop and shutter speed without further adjustment. If you're shooting in an automatic exposure mode, you will have to hold your settings with the autoexposure lock before taking away the gray card; otherwise the camera may revert to incorrect settings when you establish your final composition.

gray card Small piece of gray cardboard that reflects 18 percent of the light striking it; sometimes used to determine the f-stop and shutter speed needed for correct exposure with either built-in or hand-held light meters.

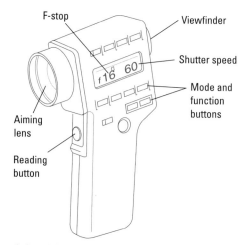

F-stop

Viewfinder

Shutter speed

Mode and function buttons

Aiming lens

Reading button

f16 60

A hand-held spot meter is photography's most precise metering tool, most often used to determine exposure with view cameras. The extremely narrow angle within which it measures light allows you to take readings from small areas of the subject, without having to move in close. To take such readings, you simply hold the meter's viewfinder to your eye, place its small central circle on the area to be measured, click a trigger-like button, and read the results off the meter's LCD display. But even more than light readings from a built-in meter, readings from a spot meter must be interpreted and carefully applied to arrive at the correct exposure.

are essentially reflected light meters designed to read an extremely narrow angle of view, usually 1°. Note that this is much narrower than the spot metering offered by built-in camera meters. In this sense, a spot meter is like a telephoto lens; it "sees" a small, specific portion of the scene.

Unlike other hand-held meters, spot meters are used by holding them directly to your eye, somewhat like a camera. To take a reading, you look through a viewfinder and center a small circle in the finder on the tone or object to be measured. Then you press the button (often a trigger-like device), and the reading is displayed by a needle or digital readout in the finder, or on a scale or LCD panel on the housing of the meter.

Spot meter readings are used to precisely evaluate the individual tones of a subject to determine not only the specific brightness of these areas, but also the overall range of brightnesses—the difference between bright highlights and deep shadows. This information can be useful

when that difference is so great that the film may not be able to record detail in both highlight and shadow areas. It helps you decide which one to sacrifice if necessary or, with black-and-white film, how to manipulate exposure and development to capture both. A spot meter's narrow angle of view is also very helpful when you can't physically get close enough to the subject to take local readings (small sections of the larger scene) with other types of meters, or when doing so would slow you down so much you'd risk losing the shot.

The basic idea of a spot meter is to arrive at an exposure that will render a specific tone in the scene with a specific density (darkness)—and thus a specific brightness—on the film. Sometimes a photographer will simply take spot readings from one or more middle tones in the scene, settling on combinations of f-stop and shutter speed close to what the meter recommends. Alternatively, the photographer can take a reading of a brighter or darker area such as a light shirt or the side of a dark building and

FLASH METERS

Flash meters are incident-light meters made specifically to measure the short-duration bursts of light emitted by electronic flash units. Though they are ordinarily fitted with a diffusing dome, the dome often can be slid away or removed entirely for reflected-light readings. Incident-type meters are used overwhelmingly in studio situations, in which multiple-light setups are the norm. With electronic flash heads aimed from above, from the sides, and behind the subject, a reflected-light meter could easily be fooled by stray light that's not reflected directly from the subject (see Chapter 11 for more on flash meters).

Flash/ambient meters combine the functions of flash, incident-, and reflected-light meters. Besides being able to take all these types of readings, advanced models can also recommend combinations of shutter speed and f-stop that will yield correct exposure when flash and existing light are mixed together. The popularity of these meters mirrors the wide use of photographic techniques such as mixing flash with other forms of artificial light (tungsten, for example) or with existing daylight. Whatever their configuration, flash meters incorporate a socket for a cord that connects the meter to a flash unit. Pushing a button on the meter then triggers the flash, which allows the reading to be synchronized with the flash burst. But they can also be triggered without an external cord, either by firing the flash independently or by using a radio or infrared remote control.

flash meter Hand-held meter that measures short bursts of light emitted by electronic flash units.

flash/ambient meter Multi-purpose hand-held meter that measures reflected, incident, and/or electronic flash light.

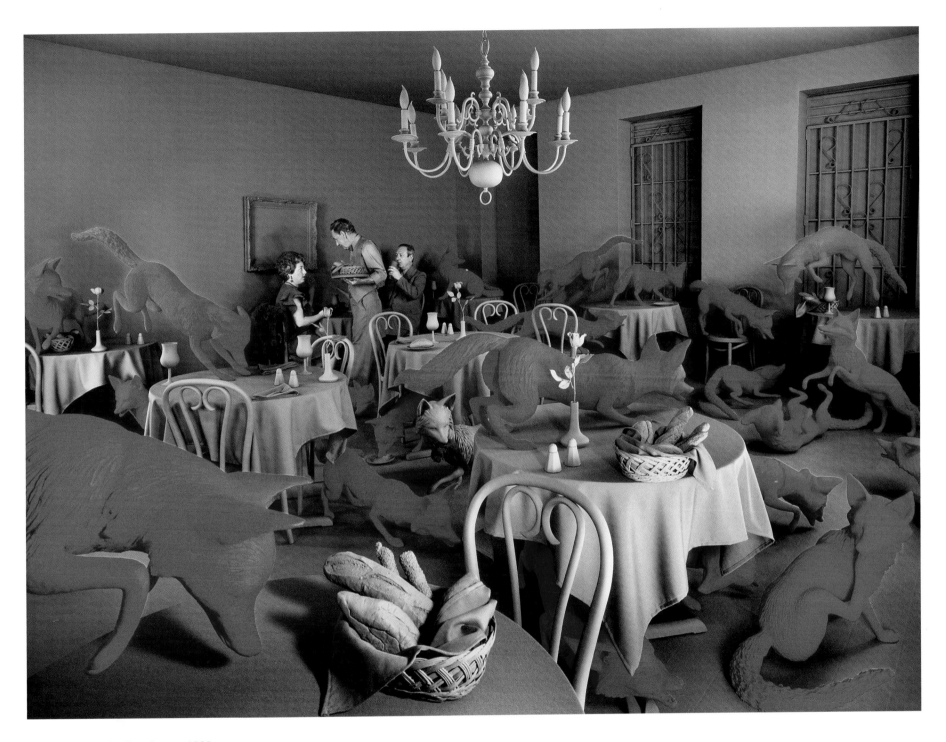

Sandy Skoglund Fox Games, 1989

Much recent photography revolves around elaborate sets conceived and built by the photographer, as in Skoglund's whimsical, often surreal images. In such cases, the photograph essentially becomes a record of a three-dimensional creation. Nonetheless, this kind of work involves many photographic considerations, and one of the most important of these is lighting. Lighting must be done with special care when you're photographing large subjects such as this. But once it is established, such controlled lighting tends to present fewer exposure problems than existing light. © Sandy Skoglund

EXPOSURE STRATEGIES FOR NEGATIVE FILM

Proper film exposure is the single most important step in achieving a printable negative. If you have a correctly exposed, carefully processed negative, making a good print is relatively easy. If you have an incorrectly exposed negative, making a good print is difficult, and sometimes even impossible.

A correctly exposed negative has good density and detail in its shadow areas—the dark areas of the subject and of the resulting print. On the negative, these areas should be light but not completely clear; unless the part of the original scene they represent was absolute black, you should be able to see texture in them. If you have adequate shadow detail, the final print's lighter tones—the grays and whites—will ordinarily fall into place.

Getting good shadow detail is almost entirely a matter of how you expose the film when you take the picture. Shadows are the areas of the subject that contain the least amount of light, so they are the most affected if the film is underexposed. When the film is underexposed, insufficient light from the shadows reaches it, and the resulting negative will be clear in these areas—that is, they will contain little or no detail. But when film is given extra exposure, enough light from the shadows reaches it—and the resulting negative will have detail and texture in those areas. For this reason, when in doubt, it's almost always better to overexpose than to underexpose negative film.

Underexposed negatives represent the most common mistake made by beginning photographers. Prints from these negatives generally appear too gray, with muddy, flat, empty shadows. The most common cause of underexposure is improper metering, usually due to a lack of understanding about how meters work. Your light meter assumes that all the tones in your subject average out to middle gray (see page 169). When they do average to middle gray, an overall meter reading should be accurate, producing correctly-exposed negatives. But when your subject's tones don't average out to middle gray—for example, if the subject has large, bright areas such as sky, water, windows, or white walls—your meter may recommend or set an f-stop and shutter speed combination that causes the film to be underexposed.

Suppose you're photographing a person standing in front of a very bright window. The meter "sees" the large, bright areas behind the person, and bases its exposure on what looks to it like bright light—when in fact the person is in shadow. The resulting negative may be correctly exposed for the window, but the person will be underexposed, appearing as a silhouette with little or no detail in the final print.

The best way to prevent such exposure errors is to take your meter reading directly from the most important areas of the subject and set the exposure accordingly. In the example above, this would mean stepping up close to the person and

set an exposure a stop or two greater than indicated by the reading for the shirt, or a few stops less for the building. Other times the photographer may average several readings from a variety of points in the scene. Various strategies for measurement and control of subject tones have been developed, such as the well-known Zone System (see www.prenhall.com/horenstein).

As mentioned, advanced models of built-in and hand-held meters may also incorporate spot-reading capability, though usually not with as narrow an angle of view as the spot meter. But even a standard reflected-light meter can be used to take readings of specific subject areas if you can physically get close enough. The problem is that with many subjects, you can't. With landscapes, buildings, and stage performances, for example, elements of the scene are too far away. A spot meter lets you take "local" readings without leaving the camera position.

EXPOSURE MODES

Cameras offer different ways of controlling lens aperture and shutter-speed settings—or of allowing the camera's electronic systems to assert that control. These are called **exposure modes.** With current 35mm SLRs, the choice usually includes four modes: manual exposure (M), program autoexposure (P), aperture-priority autoexposure (A or Av, for aperture value), and shutter-priority autoexposure (S or Tv, for shutter or time value). Autoexposure is commonly abbreviated AE.

Many cameras with built-in light meters offer a choice of exposure modes, and frequently all four described above. With other models, especially medium-format cameras, the choice of modes is typically more limited.

Modes are set in a variety of ways, depending on the camera model; there is very little standardization. Consult your camera's instruction manual for the details of setting exposure modes on your particular model. With some models,

exposure modes
Different methods of determining and controlling f-stop and shutter speed needed to produce the correct exposure; most current 35mm SLR cameras offer several such modes.

taking the meter reading directly from him or her, excluding the bright window light from the camera's viewfinder. When you step back to take the picture, maintain these exposure settings, either by using manual exposure mode or the autoexposure lock (see page 183), to prevent the meter from reverting to settings that will cause underexposure. This strategy is most practical for static subjects such as still lifes, portraits, and landscapes. It's difficult to take a close-up reading of a candid or far-off subject.

A simpler solution to this problem is to increase exposure when the subject has large, unusually bright areas, or is backlit. If your meter reading is 1/125 at f/8, for example, make your exposure instead at 1/125 at f/5.6, or even 1/125 at f/4. The needed amount of additional exposure depends on how dominant the bright values are. To be safe, bracket your exposure—that is, shoot more than one frame at several different exposures (see page 177)—to make sure you get a printable negative.

Another way to prevent underexposure is by basing your settings on a meter reading of the subject's shadows. To do this, identify the most substantial dark area in which you want detail— dark hair in a portrait or tree bark in a landscape. Take a close-up meter reading from this shadow area, being careful not to include any other areas in the viewfinder. (This is easier with a hand-held spot meter or with the spot metering mode in a built-in camera meter.) Let's say the meter recommends an exposure of 1/60 at f/5.6. To determine the final settings, adjust that exposure so that it reduces the light by two stops—1/250 at f/5.6, 1/125 at f/8, or 1/60 at f/11, depending on how much depth of field you want. Note that this technique bears a resemblance to the Zone System, a more complex system of film exposure and development control especially favored by large-format photographers.

When using negative films, some photographers set their cameras so that every frame always receives more exposure than the meter would normally recommend. You can do this in two different ways. If you're shooting in an auto-exposure mode, you can set the autoexposure compensation control to the plus side (+1/2, +1, and so forth; see page 178). Or you can simply fool the meter to begin with by setting it to a slower film speed (ISO); see page 181. This makes the meter "think" the film is less sensitive than it really is, causing the camera to set or recommend a combination of f-stop and shutter speed that lets in more light than is technically needed.

For example, if you rate ISO 400 film at E.I. 200, the meter will recommend an extra stop of exposure for every frame on the roll. The upside of this technique is that you'll get consistent shadow detail, and few if any underexposed negatives. The downside is that the extra negative density it creates can result in grainier prints, though you shouldn't see much effect if you limit the exposure increase to a stop or less.

manual exposure mode (M) Non-automated exposure mode in which you select and set both the f-stop and shutter speed needed for the correct exposure, usually with the help of a built-in light meter.

metered-manual exposure System in which f-stop and shutter speed controls are linked to a built-in meter, allowing them to be adjusted with the help of a viewfinder display.

modes are set using a dial on the top of the camera that may incorporate other functions. With models having external LCD display panels, you usually have to hold down a pushbutton while rotating a small wheel until the correct mode symbol appears. With cameras using lenses that have built-in aperture rings, you must set the lens to its smallest aperture (or a locking position just past the smallest aperture) to get shutter-priority AE operation. With cameras having calibrated dials for shutter-speed control, you must usually set an "A" or "Auto" position on the dial to get aperture-priority AE.

Whichever exposure mode you choose, remember that you can't use just any combination of shutter speed and f-stop. The range of combinations is limited both by the subject's light level and how you want to represent the subject. For example, you can't use an exposure setting of 1/1000 at f/22 in dim light and get the proper exposure— even with a fast film. Conversely, it might be difficult to set a wide lens aperture—f/2.8, for example—in very bright light unless you use a very high shutter speed (which your camera might not offer) and/or a slow-speed film.

Manual Exposure Mode (M) You independently set both the f-stop and shutter speed in **manual exposure mode (M).** Nothing is automated; the settings you make on the camera stay put until you change them.

Manual cameras with no light meters all operate this way. But most cameras with built-in meters offer what is known as **metered-manual exposure** control. This means that their f-stop and shutter-speed controls are linked directly to the meter, so that as you adjust them, a viewfinder display guides you to settings for the correct exposure.

This display takes several different forms, almost always found along the viewfinder's dark edges (and often on the camera's external LCD panel as well).

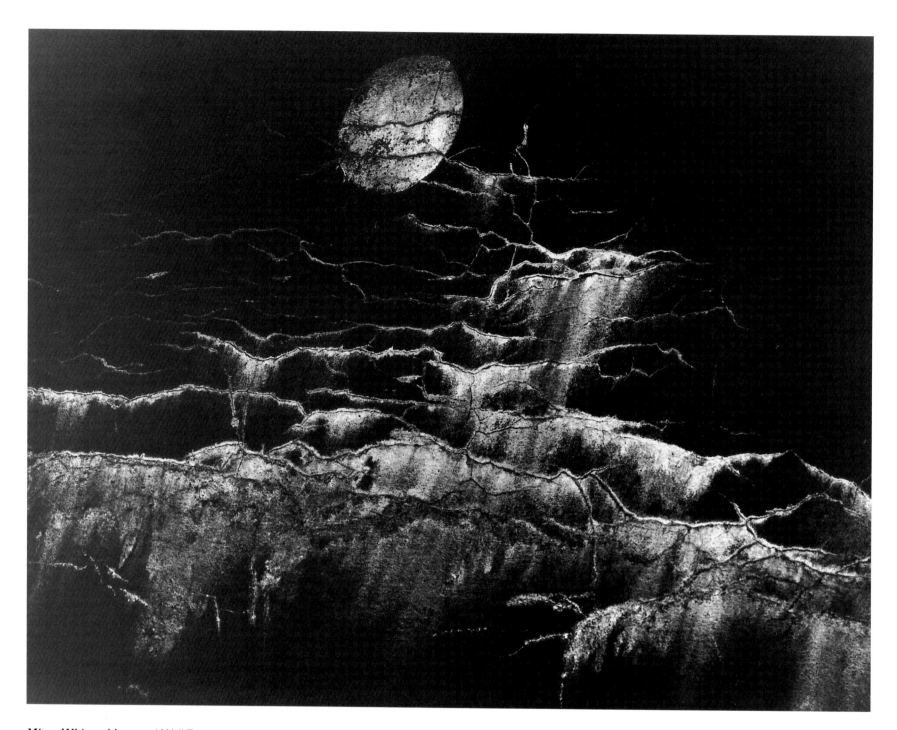

Minor White Moon and Wall Encrustations, 1964

An extremely influential teacher, White approached photography with a certain mysticism. Often highly abstract, his images scrupulously eliminate detail that might otherwise provide clues to depth, scale, and location—inviting the viewer to see what he or she wants to see, rather than what is physically present. But behind White's high-mindedness was a rigorous technique that depended on precise control of negative densities through manipulation of film exposure and development. White was one of the principal advocates of the Zone System, the most well-known strategy for such control.

On some SLR models you select an exposure mode by rotating a marked dial control on the top of the camera to the correct setting, as shown here. With others, you select a mode by pushing a button while rotating a wheel, until the correct setting appears on a display panel. In either case, exposure modes are indicated with letters. This dial is set for manual exposure (M), but the camera also offers aperture-priority autoexposure (Av), shutter-priority autoexposure (Tv), and program autoexposure (P) modes. It also features special "subject" programs for portraits, landscapes, closeups, and action, indicated with small icons.

(See page 176.) Some models may use a **match-needle** system, with which you change the f-stop and/or shutter speed until two needles line up, or a single needle lines up in a notch at the edge of the viewfinder. Other models may use **match-diode** systems, in which illuminated plus and minus signs (or a pair of arrows) guide you to the correct exposure; both usually light up when you reach the correct settings.

Another common manual display shows an illuminated scale of stops; you adjust the aperture and/or shutter-speed controls until an arrow points to its zero position. This system's advantage is that it tells you how far off your exposure is (the arrow may indicate +1/2 or −1, for example), which can help you in overriding or second-guessing the camera's recommendations. Most, but not all, cameras will display both the shutter speed and f-stop you have selected in the viewfinder and also on the external LCD panel, if they have one.

The main argument for manual exposure mode is that you can more easily depart from a built-in meter's exposure recommendation, either fine-tuning it or ignoring it entirely. In other words, you can give the film more or less exposure than the camera would give it on its own, either for creative effect or because you know that the metering

system otherwise will be fooled by a subject's tones or lighting. There are methods of accomplishing the same thing with autoexposure control, however, such as AE compensation (see box on page 178) or changing the film-speed rating (see box on page 181).

Program Autoexposure Mode (P)
The camera sets both the f-stop and the shutter speed automatically in **program autoexposure mode (P),** based on information provided by the metering system. Because you don't have to stop to think about the exposure nor to physically set exposure controls, this means you can usually shoot more quickly. Correct exposure is set as fast as you can press the shutter button.

Note that in program mode, the exposure—the actual amount of light transmitted to the film—is no different, other things being equal, than if you set both shutter speed and lens aperture manually according to the meter's exact recommendation. The difference is that the specific combination of shutter speed and f-stop selected by program mode may be different than the one you would otherwise choose.

Program autoexposure is not infallible. Even if the camera makes settings that should give you the correct exposure, they may be inappropriate for the kind of

picture you want to create. Suppose you're shooting a landscape, for example. The camera doesn't know that you want everything sharp from near to far, and it might choose a setting of 1/250 at f/5.6—an aperture that may not be small enough to make everything sharp. Instead, you might manually set an exposure of 1/60 at f/11—settings that provide the same overall exposure as 1/250 at f/5.6, only with a smaller aperture for greater depth of field.

For this reason, many SLRs with program autoexposure capability offer a feature called **program shift,** in which you rotate a dial or slide a switch to change the combination of shutter speed and f-stop without changing the exposure. For example, if the camera selects settings of 1/125 at f/8, with a single wheel-click you can change them to 1/60 at f/11 (for better depth of field) or 1/250 at f/5.6 (for more motion-freezing effect). Again, all these are equivalent exposures. Both f-stop and shutter speed are ordinarily displayed in the viewfinder and/or on the top of the camera, so such changes are easy to see.

Different cameras use different kinds of viewfinder displays to guide you to the f-stop and shutter speed needed for correct exposure. With some displays, called match needle, you adjust the shutter speed and/or f-stop so that two needles line up (top left), or a needle lines up in a notch. Some models feature up/down arrows that glow to indicate whether the exposure must be increased or decreased (top right). With other models, a pointer moves along a calibrated scale as you adjust the f-stop and/or shutter speed; the scale tells you how many stops you are under or over the correct exposure, and you center the pointer to get the correct settings (bottom left). And with others, you are guided by blinking numerical displays (bottom right). Note that not all viewfinders display both shutter speed and lens aperture numerically, so you may have to refer to calibrations on the camera's actual controls, or to an external display panel, to see exactly what you've set.

Much of the time, you may be best off using program mode. An autoexposure program's decision making is quite deliberate. Depending on the camera's level of sophistication, AE programs may factor in focal length, selecting a shutter speed high enough to counteract camera shake with hand-held shooting—1/200, for example, with a zoom set to 200mm. In this way, using an autoexposure program rather than manual exposure could actually lessen the chance of image blur.

Some cameras, in addition to their standard program, have **subject programs,** modes that are designed to optimize settings. In these, the camera still sets both shutter speed and f-stop, but the chosen combination is geared to a specific subject, represented by an appropriate icon on the control dial or LCD panel.

In "portrait" mode (usually symbolized by a head-and-shoulders icon) the camera typically favors wider apertures, thus less

depth of field, to soften distracting background detail. In "landscape" mode (a mountain shape) it favors as small an aperture as practical, to improve depth of field. And in "sports" or "action" mode (a running figure) it favors higher shutter speeds to freeze subject motion. These modes may be useful when you don't have the time to make exact exposure determinations yourself—or don't trust your ability to make them.

Aperture-priority Autoexposure Mode (A or Av) If you want more control over exposure choices than the program allows, choose a mode that allows you to select either the f-stop or the shutter speed and then automatically adjusts the other to achieve correct exposure. With **aperture-priority (A or Av)** autoexposure, you set the f-stop you want and the camera automatically sets the needed shutter speed. This gives you the speed and consistency of autoexposure but with quicker control over depth of field—the depth of the zone of sharpness in your picture—than you'd get in program AE. The camera displays its chosen shutter speed in the viewfinder and/or on the external LCD panel.

You can set a small f-stop to increase depth of field, which causes the camera to set a relatively slower shutter speed. Or you can set a wide f-stop to make depth of field more shallow, which causes the camera to set a higher shutter speed. Aperture-priority AE is widely used in low-light conditions; leave your lens set to its widest f-stop, and the camera will continually fine-tune the shutter speed to maintain correct exposure as your composition and/or subject change.

In brighter light, choosing a wide aperture may call for a shutter speed higher than the upper limit of the camera's

subject program
Program autoexposure (AE) mode option designed to optimize f-stop and shutter speed settings for different types of subject, such as portraits, landscapes, and sports.

aperture priority (A or Av) Autoexposure mode in which you set the f-stop and the camera automatically sets the shutter speed needed for correct exposure.

BRACKETING YOUR EXPOSURE

Even with careful technique, the exposure you set (or that the camera sets for you) may not always give you the exact effect you want. Your picture may end up a little too light or a little too dark for your taste. As insurance against this, many photographers make several slightly different exposures of the same subject. This practice is called **bracketing,** because you shoot one or more additional frames around the meter's recommended exposure, giving the film slightly more and slightly less exposure.

Typically you bracket by making an initial exposure at the meter's recommended setting. Then you make a second exposure allowing more light in, and a third allowing less light—providing a range of exposures around the meter's recommended one. For example, your camera's built-in meter may advise an exposure of 1/250 at f/8. You take a picture at this exposure. Then you take two more pictures: one with the aperture opened up a half stop (to between f/5.6 and f/8), and another with the aperture closed down a half stop (to between f/8 and f/11). Bracketing is commonly done with the lens aperture because f-stops can more often be adjusted in increments smaller than one full stop. You can also bracket the exposure by adjusting the shutter speed. However, with cameras on which the shutter speed can only be changed in full stops, you can't make as small a variation in exposure as you can with aperture adjustments.

Many autoexposure cameras have a feature called **autobracketing.** You set the amount of variation you want from the normal exposure; it can be done in half- or third-stop increments, or either, depending on the camera model. When you press the shutter button, the camera fires off three exposures, one below the meter reading (with less exposure), one right at meter reading (presumed correct exposure), and one above the meter reading (with more exposure). (The camera's built-in motor advances the film automatically between frames.) One advantage of autobracketing is that if a subject is changeable—for example, if it's moving—the three frames may be shot quickly enough to prevent or minimize unwanted changes between them.

Bracketing is a way of dealing with a film's exposure latitude—its ability to produce an acceptable image even when the exposure isn't exactly right. The technique is most useful with color transparency film, which allows little margin for exposure error, known in photographic terms as **narrow exposure latitude.** Exposure bracketing in increments as small as a third of a stop is therefore common with transparency films. Negative films—especially color negative films—can tolerate more substantial exposure errors and are thus said to have **wide exposure latitude.** As a result, bracketing is needed less often with these films.

Exposure bracketing is a form of photographic insurance against exposure error. To do it, you shoot extra frames of the same subject with more and less exposure than the "correct" exposure indicated by your camera's meter—that is, with f-stop and/or shutter speed settings that allow more and less light to strike the film. Once your film has been processed, this gives you images (negative or transparency) that are lighter and darker than the indicated exposure. You choose the one you prefer. More often than not, the best choice is the indicated exposure—as in this example, for which the photographer shot frames at 2/3 stop less and 2/3 stop more than the camera's recommendation. But sometimes, depending on the difficulty of the lighting, the accuracy of your meter, and the tones in the subject, you may prefer a lighter or darker rendition.

bracketing Technique in which you take two or more shots of the same subject with different exposures, to make sure at least one is correct.

autobracketing Feature on some autoexposure cameras that brackets exposures automatically at increments that you preset, advancing the film automatically between frames.

narrow exposure latitude Refers to films that have little margin for exposure error, such as most transparency films.

wide exposure latitude Refers to films that can produce acceptable results with a relatively high degree of exposure error, such as negative films.

range. The camera will usually warn you of this by blinking its display or some other signal lamp. If you don't want to reset to a smaller aperture (which will bring the shutter speed back within that range), you can use a slower film and/or neutral density filtration to cause the camera to set a slower shutter speed.

Similarly, in lower light, choosing a small aperture may cause the camera to set a shutter speed too slow to safely handhold. In this case, it may provide a similar blinking warning. If you don't want to reset to a wider aperture (which will raise the shutter speed and thus

AUTOEXPOSURE COMPENSATION

Cameras with autoexposure capability usually offer **auto-exposure compensation.** This feature allows you to easily deviate from the camera-selected exposure. Autoexposure (AE) compensation adjustments are often made with a calibrated dial, especially on older cameras. On more automatic cameras, autoexposure compensation may be set with a pushbutton/thumbwheel combination, and displayed in the viewfinder and/or on the LCD panel on top of your camera.

Depending on the camera, adjustments can be made in third- or half-stop increments, and sometimes both. Most systems allow the camera-selected exposure to be increased or decreased by up to two or three stops. To increase exposure, you set a plus correction (+1/2, +1, and so forth). To decrease it, you set a minus correction (–1/3, –2/3, –1). Every exposure, as long as this correction is set, will be made automatically at the recommended setting plus or minus the chosen compensation.

Suppose you're photographing someone standing in a field of snow. Since most camera meters assume that the scene averages to middle gray, if you allow the system to determine the needed exposure on its own, it will produce an underexposed result—and gray snow. In manual mode you can prevent this by setting a wider f-stop or a slower shutter speed (thus adding exposure) than the meter suggests, to get more light to the film. With autoexposure compensation, you can achieve the same thing by setting the control to the plus side—in this case, at least +1 (or possibly +1½ or +2).

Conversely, if a subject is very dark, such as a black cat on a black sofa, the camera's middle-gray averaging meter comes up with an exposure that in effect overexposes it—making the cat and sofa gray. The remedy is to set the AE compensation control to the minus side: –1, for example.

The value of autoexposure (AE) compensation isn't just in dealing with subjects that might throw off the camera's light-metering system. Some photographers use it as a way to make the film they're shooting conform to their tastes and technical preferences. With some transparency films, they might routinely set AE compensation to –1/3, for example, for slightly more density (or +1/3 for slightly less). With color negative film, they might routinely set AE compensation to +1/2 to improve shadow detail. You can make similar adjustments by setting a higher or lower ISO than is recommended for the film.

The autoexposure mode you're using determines whether the camera will make AE compensation with changes in f-stop or changes in shutter speed. In aperture-priority AE, it will increase or reduce the shutter speed, since you've set a specific f-stop. In shutter-priority AE, it will increase or reduce the

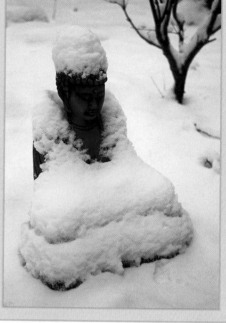

Because light meters assume that a subject's tones average together to a middle gray, subjects containing a lot of light or white areas—here, a scene with large areas of snow—can cause the camera to set or recommend an f-stop and shutter speed combination that underexposes the film (top left). With such subjects, it's wise to increase the exposure above and beyond what the camera recommends or sets. Here, an increase of a stop (+1) produced a more satisfactory rendition of the subject (top right). You make such adjustments in one of two ways: by changing the shutter speed and/or lens aperture in manual exposure mode or, when you're shooting in an autoexposure mode, with autoexposure compensation—manually modifying the camera's automatic exposure settings.

SLRs have different kinds of controls and displays for autoexposure compensation. With some, you rotate a calibrated dial from its zero position to the desired adjustment (left, in above insets). With other models, you hold down a button and rotate a dial until the desired adjustment appears on an LCD display panel (center, in above insets), either along a blinking scale or as a number (whole or fractional) with a plus or minus symbol. A few models incorporate a viewfinder scale that reminds you how much exposure compensation you've set (right, in above insets). With all the controls and displays shown here, autoexposure compensation is set to +1 to achieve an increase of one stop over what the camera would have automatically set, producing the lightening effect shown in the photographs.

f-stop, since you've set a specific shutter speed. And in program AE mode the camera will decide whether to change the f-stop or the shutter speed based on a progression determined by the subject's light level. It may even use a bit of both controls, depending on how much compensation you've set.

autoexposure compensation Feature in some autoexposure cameras that allows you to deviate in preset increments from the camera-selected exposure.

Mario Giacomelli

Paesaggio, 1971

Giacomelli's landscape photographs depend on bold contrasts of light and dark. This quality often begins with direct, angular light that creates strong shadows and pronounced textures. The photographer sometimes used a tractor to carve shapes and patterns into fields, knowing that the light would make them stand out. He performed similar contrast enhancement on the negative itself, scratching away the emulsion in some areas, painting on it in others. Contrast was further amplified in the darkroom. The end result of all this tonal and textural manipulation is a space that seems to tilt and shift from one area to another—a radical departure from the realistic interpretations associated with most landscape photography.

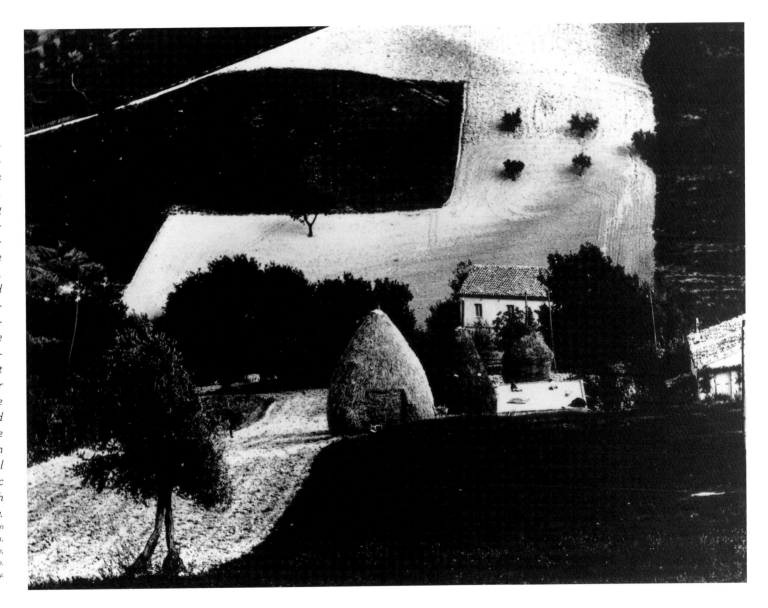

lessen the risk of image blur), you can use a tripod or otherwise brace the camera to steady it. Alternatively, you can use a faster film.

Shutter-priority autoexposure mode (S or Tv) If your picture needs a particular shutter speed, use **shutter-priority (S or Tv)** autoexposure; in this mode, you choose the shutter speed, and the camera sets the f-stop needed for correct exposure. Shutter-priority AE is useful when freezing subject motion or counteracting camera shake are your main priorities. But remember that if you set too high a shutter speed, your lens may not have a wide enough maximum aperture for correct exposure. This is a particular risk with popular variable-aperture zoom lenses that usually have small maximum apertures (typically f/4 to f/5.6 or so). Many cameras warn you by blinking their displays if they can't set an f-stop wide enough to offset a high shutter speed.

Actually, you can accomplish basically the same thing with both shutter-priority AE and aperture-priority AE: getting the specific f-stop or shutter speed you want. If you want a 1/500 shutter speed, you can use shutter-priority mode and set it directly, or you can use aperture-priority mode and adjust the f-stop until the camera selects 1/500. For this reason, many photographers do most of their shooting in one priority mode or the other.

WHAT IS CONTRAST?

Photographers use the term **contrast** frequently, but the word can mean many different things photographically. Essentially, it refers to the differences in tone—the range from the darkest to the lightest shade—within a photographic subject or image. But ultimately, the contrast of a printed photographic image is the end product of a number of factors: the relative tones of the objects in the actual scene; how the scene is lit; the characteristics of the film emulsion; and the way the negative or transparency is printed, or in the case of digital imaging, the way it is scanned, manipulated, and output.

Photographers devote much time and energy to manipulating contrast, either for special effects or simply to preserve a true-to-life appearance in the subject when the translation to a photographic negative and/or print might distort it. Contrast can be controlled at various stages in the photographic process.

Subjects or images in which there are relatively large differences in tone are said to be "contrasty" or, in extreme cases, to have high contrast—for example, someone with dark clothes on snow at noon on a clear, sunny day. Subjects or images in which there are small differences in tone are said to be soft or flat, or to have low contrast—for instance, a gray horse in late afternoon on a cloudy day. Such descriptions refer both to differences in the middle of the tonal scale—from one "gray" to another—and to the difference between the brightest and darkest values in the subject or image.

A photographic subject has its own inherent contrast, which can be quantified with a light meter. This is a function of two variables: the tones of the objects it includes (white shirt, blue jeans, black leather jacket) and of the character of the light that makes it visible. Some scenes have tones close in value, such as a white cat in snow, or a black cat in a coal bin. These scenes are said to have low contrast. And some scenes have disparate tones, such as a black cat in snow, or a white cat in a coal bin. Such scenes are said to have high contrast. Most subjects are made up of a variety of tones, and not all scenes contain pure white and pure black.

In fairly even or flat light, the tones of the scene's objects are the main factor in establishing its contrast. But in hard and/or directional light (bright, angular sun, for example), even a subject with close tones can have fairly high contrast—contrast that is at times beyond the ability of film to record.

When light can be controlled, such as with studio techniques (see Chapter 11), its contrast can be adjusted to suit the photographer's vision of a subject, and just as important, to keep it within the range film can record. Yet contrast-control techniques are possible in natural light as well. One way of reducing contrast is to place white or metallized reflectors off-camera so that they bounce existing light into the shadows, bringing them closer in tone to directly lighted areas. Black absorbers can be substituted for reflectors, literally subtracting light from the shadows to increase contrast, especially useful when light is flat. Translucent diffusers can be placed between source and subject to soften the light, also reducing its contrast. Yet another effective technique is to add a controlled amount of flash (or other light) to brighten shadows.

These approaches work when the main subject is fairly close—or in formal, not candid, situations. You can't use them with a broad landscape, for example, since most shadows would be too distant to be affected. The only certain way for landscape and nature photographers to control lighting contrast (or other lighting qualities) is with timing. This may mean shooting early or late in the day, when sunlight is gentler. Or it

shutter priority (S or Tv) Autoexposure mode in which you set the shutter speed, and the camera automatically sets the f-stop needed for correct exposure.

contrast Differences in brightness and/or tone, from darkest to lightest, within a subject or image.

FOOLING THE METER

Many autoexposure cameras have no provision for autoexposure compensation (see box, page 178). But there is still a way to deviate from the camera-selected exposure when you're in an autoexposure mode: by adjusting the film's ISO setting. In fact, this technique can be useful even with manual exposure techniques.

Ordinarily, you set the camera's meter to the exact ISO rating of the film. (Most autoexposure cameras do this automatically with their DX code-reading system.) If you set a different ISO from the film's rating, however, the camera's built-in meter will assume you're using a faster or slower film than you really are and will be "fooled" by your alternative setting.

If you want to increase exposure beyond what the camera would automatically give the film, you set a lower ISO number, which makes the camera "think" you're using slower film—and, therefore, provide a reading that gives you additional exposure to compensate. If you halve the ISO rating, for example, setting ISO 200 instead of ISO 400, you'll get a full stop more exposure; the effect would be the same as if you had set an exposure compensation dial to +1. If you use an ISO rating of one-quarter the film speed—ISO 100 in the above example—you get two more stops of exposure, providing the same effect as setting exposure compensation of +2. Such extra exposure might be valuable if you were shooting a series of backlit portraits, for instance, and wanted to give each picture a stop or two more exposure to ensure facial detail.

If you want to reduce exposure from what the camera would automatically give the film, you set a higher ISO number; the meter's reading will provide less exposure, on the assumption that "faster" film needs less light. Every doubling of the ISO number gives you a stop less exposure. For example, if you set your camera to ISO 800 while using an ISO 400 film, you'll get a stop less exposure (equal to –1 on an AE-compensation control). Four times the ISO rating—ISO 1600 instead of 400—gives you two stops less exposure (–2). You also can use this technique to "fool" a hand-held meter or the meter in a manual camera.

You'll often want to use smaller increments for such adjustments. Just remember that each increment on the ISO dial (or LCD panel) represents 1/3 stop. Setting your camera to ISO 320 with ISO 400 black-and-white film, for example, will give you 1/3 stop of extra exposure (+1/3).

It's crucial that you remember to reset your meter right after you've taken all the adjusted exposures you intend. If you leave the meter set where it is, you'll get unwanted exposure errors in all the rest of the pictures on the roll. To prevent this from happening with successive rolls, many cameras revert to reading the film cassette DX code when you change film. So if you want to maintain your exposure adjustment for more than one roll, you may have to reset it at the beginning of each.

may mean waiting for a change in the weather from cloudy to clear (if you want more contrast) or from clear to cloudy (if you want less contrast). It may even mean waiting for a certain time of year at which natural light creates a more pleasing balance of shadows and highlights.

Even films have their own individual contrast characteristics. One film may render a scene with more contrast (or less) than another, producing a more (or less) contrasty negative or slide. In fact, variations in contrast within film types is quite deliberate on the part of the manu-facturer—intended to match contrast to the taste of the intended consumer. Some color slide and print films, for example, are touted for their low contrast and soft palette, which serve well for portraiture; other slide and print films are made specifically to provide strong contrast and rich color, for nature and scenic photography, for example.

One way of tuning the contrast of a negative or slide is by using filters to control how the film "sees" the subject (see Chapter 10 for details). With black-and-white films, colored filters can be used to change tones; a yellow filter restores blue sky to its normal appearance, improving its contrast with clouds, while a red filter darkens sky considerably and increases contrast overall. With color films, a polarizing filter can increase contrast (especially the contrast between colors) or lessen it (by reducing reflections and glare), depending on the subject. Even a UV filter can "snap up" a landscape mildly by penetrating contrast-lowering haze.

What's more, film can be processed to compensate for subject contrast, especially black-and-white films. One common practice is to overexpose film to increase a negative's shadow detail,

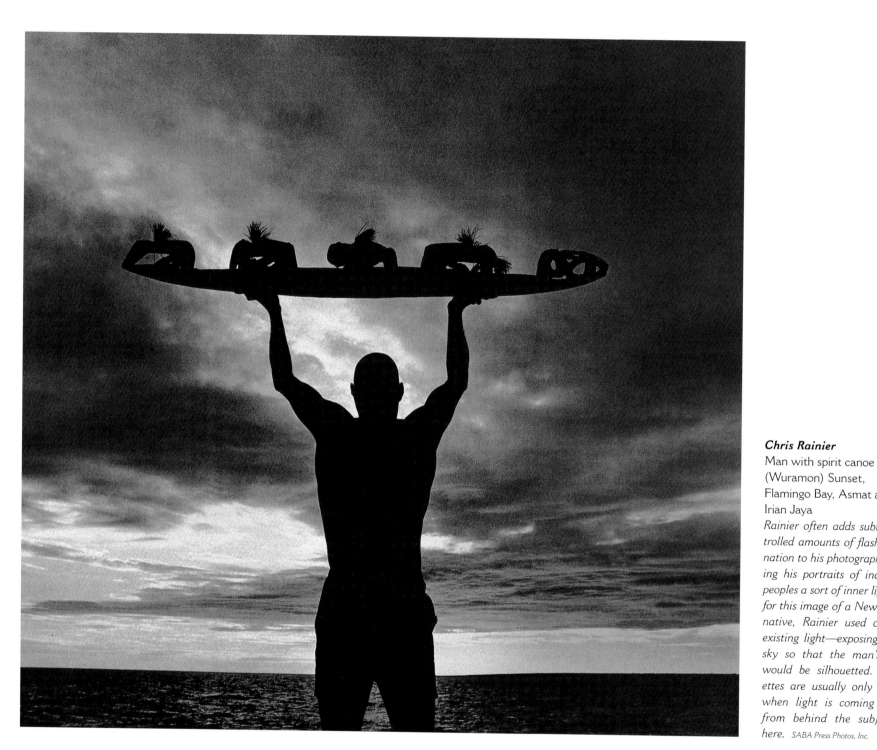

Chris Rainier

Man with spirit canoe
(Wuramon) Sunset,
Flamingo Bay, Asmat area,
Irian Jaya

Rainier often adds subtle, controlled amounts of flash illumination to his photographs, lending his portraits of indigenous peoples a sort of inner light. But for this image of a New Guinea native, Rainier used only the existing light—exposing for the sky so that the man's figure would be silhouetted. Silhouettes are usually only possible when light is coming mainly from behind the subject, as here. SABA Press Photos, Inc.

AUTOEXPOSURE LOCK

If you like the convenience of autoexposure but are concerned that subject variations will throw it off, you can combine it with your camera's **autoexposure (AE) lock.** Usually AE lock is a thumb-controlled button or slider on the back of the camera (though it's sometimes found on the front). Press it and the camera holds your autoexposure settings for as long as you keep it down.

Say you're shooting a landscape with a bright sky. The sky's brightness may cause the camera to set a combination of f-stop and shutter speed that will result in an underexposed subject. To prevent this error, point the camera down so that the sky is out of the frame (so only the land portion of the scene is visible in the viewfinder). Then push the exposure lock to hold the camera's settings, which will be based on the land portion of the scene only. Finally, recompose to include the sky in the viewfinder, and take the shot. With most modes, the camera will unlock the exposure for the following shot. (Some cameras, generally non-autofocus models, allow you to use the shutter button as an autoexposure lock. Light pressure on the button holds the shutter speed and aperture settings in place; once you've locked in the settings you want, you recompose in the viewfinder and press the shutter button all the way to take the picture.)

Autoexposure lock isn't the only way to prevent exposure error, or to override the camera's autoexposure settings for creative purposes. Autoexposure compensation and autoexposure bracketing are other options. But the simplest approach may be simply to stick with manual exposure control: Adjust both aperture and shutter speed while you exclude areas that may skew the exposure from the frame, then recompose and shoot. By doing this, you can take as many frames as you like with the same exposure settings, rather than having to lock exposure each time.

autoexposure (AE) lock Feature in some cameras that allows you to hold autoexposure settings while you recompose and take the picture.

then reduce development to keep highlights from becoming overly dense. This produces a negative with less contrast than it would have had with normal development, and is a way of ensuring that both shadow and highlight detail are recorded despite the contrasty light. Conversely, film is sometimes given less exposure, then overdeveloped to increase its contrast—a good remedy for flat light, though much the same result can often be achieved in printing. Transparency films, and, to a lesser extent, color negative films are agree-

able to the same methods, though neither type offers the extent of black-and-white's contrast changes.

You also can control contrast when printing—or, if you're bringing your film image into the digital realm, scanning, manipulation, and output. Traditional printing and digital techniques permit a high degree of contrast control. With black-and-white printing, a broad choice of paper grades and variable-contrast filters lets you make substantial adjustments in contrast, whether increasing it to make a flat or underexposed negative

look normal in printing; lowering it to hold shadow and highlight detail in a contrasty negative; or simply changing it to alter reality. And through "split filter" printing (in which the exposure is divided into two separate exposures through filters of relatively high and relatively low contrast); dodging and burning-in with different filters; and flashing (in which the entire print is additionally exposed to white light to lower its contrast and improve highlight detail), contrast can be controlled in small areas of the image, or just in one part of the tonal scale.

Black-and-white paper developers also influence contrast. Special formulas permit changes of up to a paper grade or more in either direction, and developers can be used at higher or lower concentrations to slightly increase or reduce print contrast (often a valuable technique when an in-between level of contrast is desired). Developers of different strength and characteristics can even be used in sequence. Similar techniques, including contrast-lowering print "flashing," can be used with color printing materials, but the range of contrast adjustment is more limited. Some color papers are available in two or three different contrast "grades."

In the digital realm, refinements in contrast control are unprecedented. Film can be scanned at specific levels of contrast, compensating for contrast problems in the original. Image-processing software allows not just overall adjustments in contrast, but mouse-click adjustments to the contrast "curves" of specific colors in the image. The internal contrast of highlights and shadows can also be individually adjusted. Further fine-tuning of contrast is even possible with digital printers.

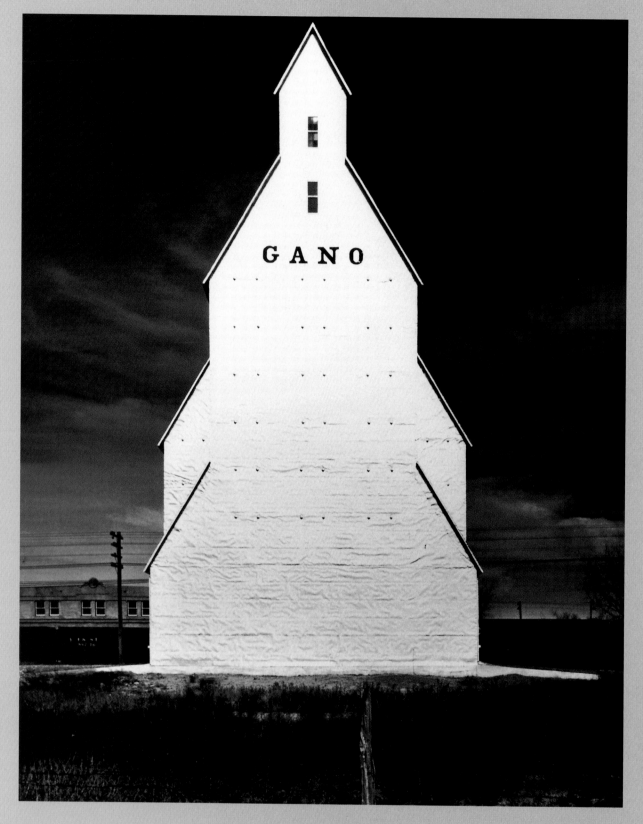

WRIGHT MORRIS
Gano Grain Elevator, Western Kansas, 1940

One of the great creative advantages of black-and-white photography is the ability to extensively manipulate an image's tones. And one of the most effective ways to do this is by placing a filter on your camera's lens when you take a photograph. In black-and-white work, filters are most often used to darken blue sky to varying degrees. For this dramatic image Morris probably used a red filter, which turned the sky nearly black and made the white building stand out boldly. But camera filters can create subtle changes too, and they are equally useful when you're photographing in color.

Photo permission, Josephine Morris; Photography by Wright Morris; Collection Center for Creative Photography, the University of Arizona.

Filters for camera lenses come in two main forms. The most common, at least for 35mm photography, are screw-in filters (left)—flat sheets of colored glass mounted in threaded metal rims. But filters are also available in unmounted squares of flat gelatin or optical plastic (right), designed for a variety of camera types and formats. To mount these on the camera, you need a separate holder that clips or screws onto the front of the lens; the filter slips into the holder, which keeps it flat against the lens.

A **filter** is a clear or colored lens attachment made of glass, plastic, or gelatin, usually added to the front of the lens for a variety of reasons and effects. Filters are among the most common and useful photographic accessories. While this chapter deals exclusively with filters used on the camera's lens for photographing, keep in mind that other types of filters also are often used when making both black-and-white and color prints (see Chapters 13 and 14).

There are several reasons you might use a filter when photographing. The simplest and most common use is to protect the front of the lens. But you also may use a filter to reduce the overall image sharpness or to control the quantity or quality of the light that passes through. This control may affect such qualities as color, contrast, tonal relationships (with black-and-white), saturation (with color), and glare. Or it may provide a special visual effect.

Physically, filters are flat and transparent or translucent in appearance and are made of various materials, usually glass, optical-quality plastic (such as resin or polyester), or gelatin (a very thin, very flexible sheet). Price varies depending on the material used and the brand; there are standard and premium-quality filters, and there are name-brand filters and filters from manufacturers that are less well-known. Glass and plastic filters are relatively sturdy, while gelatin filters are delicate and must be handled with special care. Glass and gelatin filters are sold individually, whereas plastic filters come either individually or in kits.

With 35mm cameras, you almost always place the filter on the front of your camera lens. Glass filters are the most common type, especially for 35mm equipment. They are usually set inside a round plastic or metal rim that you screw into the front of the lens. Note that some glass filters and all gelatin and plastic filters fit into a separate holder that either screws into or clips onto the front of the lens. Large, bulky lenses, ultrawide-angles, or telephotos often contain a spe-

cial slot in their barrel that accepts a special filter. View camera photographers may even tape or otherwise attach filters (usually gelatin or plastic) behind the lens because they believe that low optical quality filters placed in front of the lens may cause a loss of image sharpness.

Glass filter sizes are usually described in millimeters according to the diameter of the filter's thread; typical sizes are 49mm, 52mm, 55mm, 58mm, 62mm, 67mm, 72mm, and 77mm. The diameter is usually indicated somewhere on the rim of the filter; it should match the thread diameter of the front of your lens. A lens's diameter is indicated on the front of the lens or on the back of its lens cap.

The filter size is often confused with the focal length of the lens. Both numbers may be similar, but they are not the same. A 52mm filter, for example, may fit onto a 50mm lens—or it may fit onto

Standard glass filters screw into the front thread of your lens. They must exactly fit the lens's specific thread diameter, which is usually indicated near its rim. Manufacturers attempt to standardize their lenses to the fewest possible thread sizes, so that filters will fit more than a single lens. But if you do use lenses with different thread sizes, you may need a separate set of filters for each lens.

filter Thin sheet of translucent glass, plastic, or gelatin. Usually colored, filters are designed to be attached to the camera lens to modify tones and colors or to create special effects.

HOW FILTERS WORK

Most filters allow you to manipulate the color of light, which is important for both black-and-white and color photography. A colored filter allows light of its own color and similar colors to pass through the lens to the film, while blocking light of complementary (opposite) color and colors similar to the complement (see Chapter 8).

Thus, a yellow filter admits yellow light and blocks blue light. It also will allow some amount of green and red light to pass through, since yellow is made up of these colors, and will block some amount of magenta and cyan, blue's main components. The amount of passing and blocking depends on the color density (darkness) of the filter; the greater the density, the stronger the effect. Note that because most filters hold back light, their use generally requires an increase in film exposure (see box, page 189).

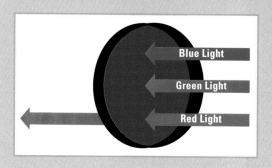

A filter of a given color—here, red—allows light of the same or similar color to pass freely, and blocks other colors to varying degrees. With black-and-white photography, this changes the image's tonal relationships, sometimes dramatically; a red filter makes reddish parts of the scene very light, and darkens green and blue parts. With color film, a filter simply adds its own color to the overall scene. Note that in practice, most filters (especially light-colored ones) allow some amount of light of other colors to pass through as well.

35mm, 85mm, or lenses of other focal lengths. The needed diameter varies with the brand and model of the lens you use. In the best of all possible worlds, the filter threads of all your lenses would be the same size so you would have to buy only one set of filters for all lenses. However, in practice, some lenses have a larger front diameter than others, especially many zooms, telephotos, ultrawide angles, and fast lenses. This means that if you own several different lenses you may have to buy more than one set of filters.

You can avoid buying different size filters by using a step-up adapter or stepdown adapter on the front of the lens. These double-threaded rings screw into the front of a lens. The step-up adapter allows you to attach a filter larger than the lens diameter; the step-down adapter allows you to attach a filter smaller than the lens diameter.

You can also get nonthreaded filters that mount on the front of the lens with a special holder. The most common of these are 3" or 4" squares of plastic resin, polyester, or gelatin, though they are also available in various sizes of round glass (called series filters). Some filter holders clamp or clip to the front of the lens barrel, allowing a single filter to be used on many different-sized lenses. Other filter holders must be screwed into the lens's front thread, which means a different-sized holder is needed for each thread size in your lens set. Make sure to get a holder that handles filters large enough to cover your largest lens diameter, since these will work for smaller lens diameters as well.

For best results, avoid stacking (combining) glass filters. Gelatin and optical-quality plastic filters are more versatile; you can stack two or three at a time and notice little if any loss of image quality.

LENS-PROTECTING FILTERS

The front of your lens is highly vulnerable to smudging, scratching, and the accumulation of dust and dirt. To prevent this, many photographers keep a clear filter on the front of all their lenses at all times so that these problems will affect only the filter, which is less expensive to replace than a lens. You can clean dirty filters the same way you clean lenses—with commercially available lintless tissues or cloth and lens-cleaning solution (see page 66).

The most commonly used lens-protecting filters are designated **UV (ultraviolet) filters** and **skylight (1A) filters.** Although neither has any appreciable effect on film exposure or image rendition, they may cut through haze to increase subject contrast. For this reason, they are sometimes called haze filters. (The haze these filters eliminate isn't visible to the eye, but it may be recorded anyway because of film's sensitivity to ultraviolet radiation.) These filters also may have a slight warming effect on color film.

Note that there are stronger forms of ultraviolet filters that have more of a warming effect on the image when you're using color film. Ultraviolet haze

UV (ultraviolet) filters Filters that reduce or eliminate the haze that film may record with distant outdoor subjects, often left on the lens to protect its front surface from damage.

skylight (1A) filters Filters that reduce or eliminate haze and sometimes warm the image slightly, often left on the lens to protect its front surface from damage.

typically causes a blueish image cast. Either a 2A or 2B filter, for example, has a stronger UV-reducing effect, that can help neutralize image color in cool lighting situations. Since electronic flashes often produce a lot of UV, for example, many flash units incorporate built-in UV filters.

Some photographers don't like to use filters at all because they believe that the addition of another piece of glass might adversely affect image quality. There's no conclusive evidence for such concern, but if you are worried about this you may opt to use more expensive premium quality filters—or not use lens-protecting filters at all. In practical terms, however, a dirty or scratched lens is more likely to degrade image quality than an inexpensive lens-protecting filter.

BLACK-AND-WHITE FILTERS

There are quite a few filters made specifically for photographing in black and white. Most are used to control tonal relationships or to adjust contrast. Some have more specialized uses.

Sky Filters With black-and-white film, skies often end up too bright in the print. There are a couple of possible reasons for this. In many cases the sky is much brighter than the ground, so when the ground is properly exposed, the sky is in effect overexposed—too dense on the negative and thus too bright on the print. Also, black-and-white films tend to be inherently more sensitive to the color blue, which causes increased exposure in clear sky areas—again, dense areas in the negative and bright areas in the print.

One solution to these problems is to use a **sky filter** when you're photographing to block some of the blue light; this will reduce the density of the sky areas in

sky filter Filter used primarily to darken blue skies with black-and-white film.

Wratten system Kodak's proprietary system of designating filters.

contrast filters Filters used primarily to increase contrast to varying degrees with black-and-white film.

CLASSIFYING FILTERS

Filters are classified in different ways. The most widely used designation is the Kodak **Wratten system.** Many types of Wratten filters are designated with a number, followed by a letter. The blueish Wratten 80-series filters, for example, include 80A, 80B, 80C, and 80D. They are grouped together because all block a certain amount of yellow light, with each filter blocking progressively more. The different letters indicate that each one balances daylight film with light of a different, lower color temperature. The 80A is made for 3200K light; the 80B for 3400K light; and so forth. (See page 132 for more about color temperature.)

Wratten designations are most common, but different filter manufacturers may use their own designations. For example, sometimes filters are classified according to their color, such as "Green" or "Dark Green." Then there are filters for specific uses that have no numerical designation, such as fluorescent and polarizing filters (see pages 192 and 195).

A second commonly-used filter designation is the color-compensating (CC) filter (see page 191). These are designated quite differently than Wrattens, with a number followed by a letter. The number indicates the color density of the filter, while the letter indicates the color. For example, a CC05Y filter, as it is expressed, is a weaker yellow (Y) than a CC30Y filter. The designation 05 stands for .05 density; it blocks 5 percent of the filter's complementary color. Typical densities of CC filters include: 025, 05, 10, 20, 30, 40, and 50. (You can also stack CC filters for in-between effects; combining a 10Y and a 5Y filter produces a 15Y. Likewise, a filter of one color will subtract from the overall value of its complement. For example, combining a 20Y with an 05B produces 15Y.) Note that the color and exposure effects of CC filters and CP (for color printing, see Chapter 14) filters are the same.

the negative, thus darkening them in the print. A yellow filter (Wratten No. 8, for example) will do this, giving blue skies a more natural-looking tonality; a green filter (No. 11) will absorb more blue and produce darker printed skies. Yellow and green filters are the most common sky filters because they render skies most naturally. A red filter (No. 25) will darken skies even more, making them appear dramatic or foreboding; intense blue skies may even turn black when a red filter is used. (See box on facing page for more on how filters work.)

Because sky filters darken blue sky, they emphasize clouds. Without a filter, clouds may barely show up—or not show up at all—because the sky itself is so light, again due to the higher sensitivity

of film to blue. By darkening the sky's blue, the filter effectively increases the contrast between sky and clouds. This makes the clouds visible—or with orange and red filters, even more pronounced. Note that this works only when the sky is blue; gray or heavily overcast skies will not be appreciably affected by yellow, green, orange, or red filters.

Contrast Filters Many different filters may be used to control contrast—the differences between tones—in black-and-white film. These include many of the same filters used for darkening skies. The reason **contrast filters** are sometimes needed is simply that black-and-white films render subjects as shades of gray, not color. Thus blue jeans might end

Original scene

No filter

This series shows the two most common uses of color filters in black-and-white photography: to darken blue sky and to change tonal relationships between areas of different color. In the original scene (left), there is a clear distinction between the deep blue sky and the bright red letters of the sign, due to their color difference. But in a black-and-white photograph taken with no filter (second from left), there is only a small tonal difference between the sky and letters because both reflect about the same amount of light—despite their different color.

When a yellow filter is mounted on the lens, it increases the tonal separation between letters and sky by blocking some blue light, which darkens the sky (below left). Because red reflects some yellow light, the yellow filter also brightens the letters. The filter also lightens the yellow-orange stains at the base of the sign. Switching to an orange filter (below center) increases this effect, blocking still more blue light to further darken the sky, and letting more light from the red letters pass through, thus lightening them. In this case, the orange filter arguably creates the best translation into black-and-white of the original scene.

When the orange filter is replaced with a blue filter the exact opposite effect takes place (below right). Because the blue filter allows so much blue light to pass through to the film, and also blocks colors similar to orange (such as red), the sky turns nearly white and the sign's red letters are significantly darkened. For the same reason, the blue filter darkens the yellow stains at the base of the sign.

Yellow filter

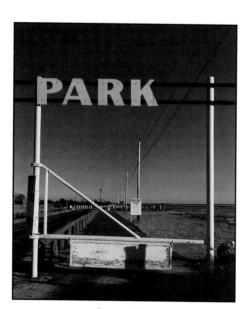

Orange filter

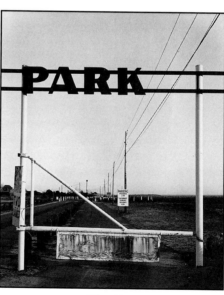

Blue filter

FILTER FACTORS

A few filters have no effect on film exposure, but most block a certain amount of light overall—requiring additional exposure. Sometimes this correction is as little as 1/3 stop but often is as much as several stops more. This means that using filters often requires the use of a larger lens aperture, which results in less depth of field, and/or a slower shutter speed, which increases the chance of blur from subject movement or camera shake. Using a faster film also helps by allowing smaller apertures and faster shutter speeds to begin with.

The filter may have a designation, called a **filter factor,** to tell you just how much additional exposure is needed. It may be indicated on the rim of glass filters or with instructions packaged with other types of filters. Otherwise, refer to general charts such as the chart here, or contact the filter manufacturer.

The manufacturer's information should be the most reliable since similar filters from different companies may have slightly different factors.

Because of filter factors, exposure readings when you're using filters can be complicated. Fortunately, if you have a through-the-lens metering system, you probably don't need to make any adjustments, because your meter reads the light after it has passed through the filter. If you use a separate hand-held meter, follow the chart at right to make your exposure adjustment.

Thus, if the meter reading of a particular scene is 1/250 at f/8 with no filter, a filter with a factor of 2x will require a compensation of +1 stop: 1/250 at f/5.6 or 1/125 at f/8. The filter factors require one full stop for every factor of 2, so add one stop for 2x, two stops for 4x, three stops for 8x, and so forth.

Filter Factor	Exposure Adjustment
1.2x	+⅓ stop
1.5x	+⅔ stop
2x	+1 stop
2.5x	+1⅓ stops
3x	+1⅔ stops
4x	+2 stops
5x	+2⅓ stops
6x	+2⅔ stops
8x	+3 stops
10x	+3⅓ stops
12x	+3⅔ stops
16x	+4 stops

up as the same shade of gray as a red sweater, if both the jeans and the sweater happen to reflect the same amount of light. Using a blue filter produces jeans with lighter tones by allowing more blue light to pass through to the film, thus darkening the negative and lightening the print in the jeans "area." At the same time the blue filter produces a darker tone for the sweater by blocking red light, thus lightening the negative and darkening the print. A red filter would have the opposite effect: darker blue jeans and lighter red sweater. The net effect in either case would be contrasting tones for both jeans and sweater.

Other Black-and-White Filters Filters are also used for a variety of specialized effects with black-and-white photography, often with scientific or technical applications. For example, there are nearly

opaque **infrared filters** (No. 87 and No. 89B). This maximizes the eerie effect of infrared films (see page 149).

COLOR FILTERS

Some filters are made specifically for color films, though they also may have some applications in black-and-white photography. The most common of such filters are used to alter the "color" of light, converting its color temperature either so it balances with the film or adjusts specific colors in a scene.

Note that many of the effects of filtering with color film in the camera can also be accomplished when you're printing. (Making color prints requires the use of color filters, see Chapter 14.) This makes filters less critical when you're using color negative film, which will be printed (thus filtered) at a later stage, than with color transparency film, in

which the transparency itself is usually the final form of the image. However, it may still help to use filters when you're photographing with color negative film, because filtering can produce a more easily printable negative (especially when strong color adjustments are needed).

Color Conversion Filters Designated Series 80 and Series 85, **color conversion filters** are intended for major color adjustments. These are most valuable when you have the wrong type of film for the subject lighting. If you have only daylight film and want to photograph in tungsten light, use a dark blue 80-series filter (usually 80A). If you have only tungsten film and want to photograph in daylight, use an orange 85-series filter (usually 85B).

In practice, there aren't many reasons to use conversion filters, unless you

One use of filters in color photography is to adjust the color temperature of the subject's light so that it matches the color balance of the film. For example, if you use daylight-balanced film to photograph a subject in tungsten light—an interior such as this—the film renders it with a strong yellowish warmth (top). Some photographers feel this effect strongly suggests the character of indoor light. But if you prefer a neutral rendition, you can use an 80B blue filter over the camera lens to cool tungsten light so that it matches daylight film's balance (bottom). Another way to achieve more neutral color in tungsten light is to shoot a tungsten-balanced film to begin with (see page 132).

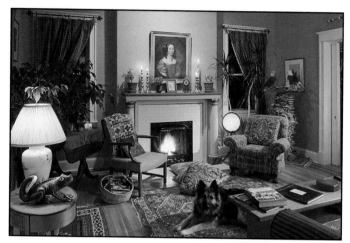

Daylight film in tungsten light with no filter

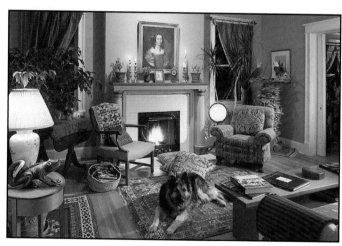

Daylight film in tungsten light with 80B filter

forget—or can't buy—the film you really need. But there are a few cases where using the "wrong" film can be an advantage, such as when you want or need to use a long shutter speed in daylight with transparency film. Tungsten films often have better reciprocity characteristics (their color changes less than daylight films at slow speeds). When you need to make long exposures in daylight, consider using a tungsten film and filtering it with an 85B filter to reach daylight balance. The filter will not only balance color but it will also allow a slower shutter speed, since it reduces the amount of light that passes through it (see box, Filter Factors, page 189).

Light Balancing Filters Designated Series 81 and Series 82, **light balancing filters** are used to fine-tune color, both for precise results and creative effect. The 81-series filters are most commonly used. These pale-to-medium amber-colored filters add an overall warmth to the subject by blocking blue wavelengths.

The best times to use an 81-series filter are when the subject might otherwise be rendered with an overall blue cast, such as on rainy or cloudy days, in open shade on bright sunny days, and when you're photographing with an electronic flash (in which case the filter can be positioned either on the front of the lens or on the flash). Many photographers even use an 81-series filter when it's not strictly needed, because they like the extra warmth it provides. In most cases, a mild 81A or 81B filter will do the job; stronger 81-series filters are sometimes used in combination with other filters for precise control when lighting is difficult.

light balancing filters Filters used to fine-tune color balance, for example to add warmth or coolness to a subject.

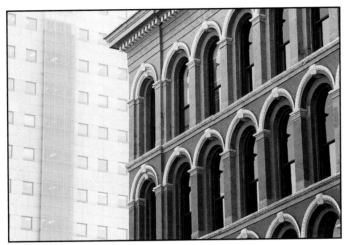

No filter

81B filter

Filters can also be used for subtle adjustment of color. For example, subjects photographed in open shade on a clear day usually take on a cool, bluish cast, because they are illuminated by indirect light from a blue sky (top). This cast can be offset by the use of an 81B filter, which has a pale yellow-amber color (bottom). Many photographers routinely use 81-series filters—81, 81A, 81B, or 81C, each progressively stronger—to add warmth to their pictures.

benefit much more from a little warmth than from extra coolness.

Color-Compensating Filters Unlike light balancing and color conversion filters, which affect the overall warmth or coolness of the subject, **color-compensating (CC) filters** affect a range of individual colors. In fact, CC filters are designated according to color (yellow, magenta, cyan, red, green, and blue), as well as in strengths of that color (10, 20, 30, and so forth—see page 187 for more on CC filter designations). Note that these are the same designations as color printing (CP) filters (see Chapter 14). You could use the two types interchangeably, except that CC filters are made of optical quality material, thus more suited for use in the image path (in front of or behind the camera lens).

CC filters work like other filters by blocking their complementary (opposite) color, thus adding more of their

color-compensating (CC) filters Filters used to produce precise changes in overall image color; designated by both color and density, for example CC30M (magenta).

The 82-series filters are pale blue and add coolness to the color of your subject: for example, if your subject has too warm a cast (perhaps the last sunlight in the late afternoon or early evening) or if you are photographing with tungsten film under common household light bulbs (which generally provide a warmer color even than photofloods and other bulbs for which tungsten color films are balanced). In practice, however, 82-series filters are rarely necessary unless you're aiming for critical color balance, such as when copying artwork. Most subjects

Because fluorescent light doesn't contain daylight's full spectrum of wavelengths, it produces a greenish cast on daylight-balanced color film (top). With most common types of bulbs, you can eliminate or minimize the cast by using a 30M or 40M color-compensating filter on the camera lens (bottom).

No filter

CC30M filter

own color to the subject. A magenta CC filter blocks green and therefore makes the subject more magenta. A yellow CC filter produces more yellow by blocking blue.

You'll need strong CC filtration to make major color shifts for color balance—for example, 30M to 40M (magenta) with typical fluorescent lights or 80B (blue) + 20C (cyan) with certain sodium vapor lamps (see chart on facing page). Adding a weak CC filter can help fine-tune certain colors; a 5M or 10M, for example, may clean up a green cast caused by photographing through window glass.

CC filters are available in gelatin, glass, and optical-quality plastic. Gelatin filters and premium plastic filters provide best quality when stacking; for example, you can combine a 20C and a 10C to produce 30C filtration. Thus you don't have to own every available CC filter to get a good range of color control. (Keep in mind that gelatin is easily damaged in handling, however.)

CC filters do affect film exposure, so you'll have to adjust exposure based on their filter factor (see page 189). Densities from 05 to 40 have a filter factor of 1.2x to 1.5x; lower densities (025) have no filter factor and most higher ones (50) have a factor of 2x. These factors vary somewhat with the subject color.

Fluorescent Filters Designed to balance the color of common fluorescent light sources with your film, **fluorescent filters** are magenta in color. Without such filters, photographs taken under most types of fluorescent light have a strong green cast (with daylight-balanced film) or a greenish-blue cast (with tungsten-balanced film). The cast can be partially or totally corrected with filters in printing, so you don't absolutely need a fluorescent filter with color-negative film. Its greatest value is with color transparency film, in

fluorescent filters
Filters used to create natural-looking color when photographing under fluorescent light, which otherwise produces a greenish cast.

DISCONTINUOUS LIGHT

Fluorescent and high-intensity discharge lamps (such as sodium and mercury vapor, used for such purposes as lighting streets, parking lots, and malls) are known as **discontinuous light** sources because they lack the full spectrum of color produced by most other sources. Therefore they tend to produce strong color casts in your photographs, making color difficult to balance. In most cases such light requires strong color-compensating (CC) filtration. In some cases you'll be lucky to reduce the cast to an acceptable degree.

One of the problems in filtering discontinuous light is that there are so many different types, all with their own color characteristics. For example, you can't count on a 30M filter to balance all fluorescent light. Some types of fluorescents need more or less filtration, and not always magenta. Also, you can't always identify the type of light you're dealing with; often the bulbs or lamps are physically out of reach. Use the following chart as a guideline only. It assumes you are using daylight-balanced film.

Type of Fluorescent Bulb	Suggested Filtration
Cool white	30M + 10R
Warm white	20M + 20B
White	40M
Cool white deluxe	10C + 10B
Warm white deluxe	30C + 30B
Daylight	50R
Unknown	30M or 40M

Type of High-Intensity Discharge Lamp	Suggested Filtration
Multivapor	20M + 20R
Deluxe white mercury	30M + 30R
Clear mercury	70R
Lucalox	20C + 80B

discontinuous light
Artificial illumination lacking a full spectrum of visible light, such as with fluorescent and special-purpose industrial lamps.

neutral density (ND) filters Filters used to reduce the overall amount of light reaching the film without affecting image color.

which the transparency itself is usually the final form of the image.

Most filter manufacturers offer one or more fluorescent filters, such as those designated FLD (for daylight-balanced films), and FLT or FLB (both for tungsten-balanced films). Most have a filter factor of about 2x. However, a CC 30M or CC 40M color-compensating filter actually works better in most conditions than a fluorescent filter.

Unfortunately, there are several different types of fluorescent tubes in wide use. In most cases, a fluorescent filter will help balance color, and sometimes fully correct it, but to be certain, you'll need to know exactly what type of fluorescent tube you're dealing with. Then you can ask the filter or film manufacturer for the required filtration for that type of light. A good camera store also may be able to provide you with that information.

BLACK-AND-WHITE AND COLOR FILTERS

Some filters are useful for both black-and-white and color films. These are the most common such types.

Neutral Density (ND) Filters Often referred to simply by the initials ND, **neutral density filters** are colorless gray and are used exclusively to reduce the amount of light that reaches the film. They have no effect at all on image color.

Neutral density filters are rated in 1/3 stops according to how much light they block, with each 0.1 increment representing a reduction of 1/3 stop. Thus, a 0.1 ND filter reduces light by 1/3 stop; an 0.3 ND filter reduces light by 1 stop (cuts the amount of light reaching the film in half); and so forth. Stacking the filters provides a compound effect. An 0.2 ND filter stacked with an 0.4 filter has the same effect as an 0.6 filter (producing a reduction of 2 stops). Follow the chart on the next page.

While they are not widely used, neutral density filters perform several valuable functions. Suppose you want to use a very fast film outside, for a grainy effect or because that's the only type of film you have available. An ND filter will reduce the light reaching the film so you're less likely to overexpose it in bright light. In effect, an 0.9 ND filter makes an ISO

Reflections and glare on smooth nonmetallic surfaces—windows, water, glossy paint, and so forth—can sometimes obscure the main subject (top). They can be controlled by using a polarizing filter on the camera; once the filter is mounted on the lens, you look through the viewfinder and rotate the filter's rim until the reflection is subdued or eliminated (bottom). Keep in mind that totally eliminating such reflections can make a surface lose its shiny character—wetness on leaves, for example, or waves on water—and appear unnatural. So you may want to rotate the filter only enough to reduce reflections without eliminating them.

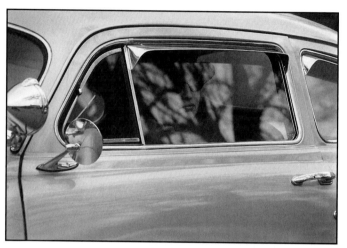

No filter

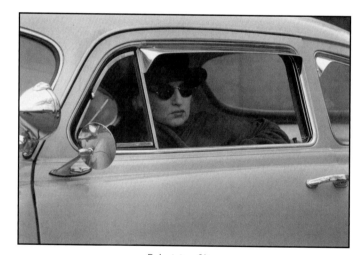

Polarizing filter

ND Filter	Cuts Light By (in Stops)
0.1	⅓
0.2	⅔
0.3	1
0.4	1⅓
0.5	1⅔
0.6	2
0.7	2⅓
0.8	2⅔
0.9	3
1.2	4
1.5	5

3200 film the practical equivalent of an ISO 400 film. The difference between the two film speeds is 3 stops—the amount by which the 0.9 ND filter cuts back light.

Neutral density filters also allow you to shoot at a wider f-stop for decreased depth of field, such as to soften the back-ground with portrait subjects, as well as to set a slower shutter speed than you'd otherwise have to use, for blurred motion effects. If the light meter suggests an exposure of 1/1000 at f/8, for example, you can use a 1.2 ND filter for a light reduction of 4 stops—to 1/1000 at f/2. Or, if the meter suggests 1/60 at f/16, the

No filter

Polarizing filter

With no filter on the camera, blue sky can end up very light in a color photograph (left). One way to darken the sky is by using a polarizing filter on the lens, rotating it until the sky appears darker to the desired degree (right). Because polarizing filters block the kind of light that tends to wash out surfaces, they also increase the overall intensity of colors. This is why some color photographers use them routinely.

same 1.2 ND filter will allow you to shoot at ¼ at f/16.

Polarizing Filters A very fine grayish-looking microcrystalline grid is built into **polarizing filters.** These filters are used to reduce or eliminate glare and reflection from smooth surfaces such as glass, plastic, and water. (They do not work with bare metal.) Polarizing filters also increase overall saturation in color photographs and can darken skies in both color and black-and-white photographs. The effect of the intensification can be adjusted, as described below.

A glass polarizing filter (the most common type) has two rims; the outside rim holds the glass and the inside one attaches to the front of the lens. To use the filter, you simply rotate the outside ring for various degrees of effect. With a single-lens reflex camera (or a view camera), you can actually see the effect as you view the subject while rotating the filter. If you have a camera without through-the-lens viewing, such as a rangefinder or twin-lens reflex, previewing the effect of the filter is less precise; you'll have to hold the filter to your eye, rotate it until you see what you want, then carefully place the filter in the same orientation on the lens.

Sometimes you'll want to eliminate all glare and reflection, if possible, but often you'll only want to reduce them; many subjects look more realistic when they retain at least some of their reflective quality. For instance, you may not want to completely eliminate reflections on wet leaves, because they'll lose their wet appearance. Also, too strong an effect may lead to exaggerated color or subjects that lack visual depth.

The effectiveness of the polarizing filter depends on several factors. The subject is certainly important; the filter won't eliminate direct reflections such as in a mirror or on chrome surfaces. The relative angle of the subject's surface is also critical, with the filter's maximum effect occurring when you photograph a

polarizing filters
Filters used to reduce glare and reflections in smooth surfaces; to increase color saturation; and to darken blue skies in both color and black-and-white photography.

When properly focused, good lenses make a subject sharp (top). So when you want to deliberately soften a subject, you can use a diffusion filter (bottom), which also makes bright areas seem to glow. The filter is most often used in portrait photography, in which it minimizes skin blemishes and often adds a romantic feeling. But it can also be used to give landscape and still life images an impressionistic quality. Diffusion filters come in various versions to produce different degrees of softness.

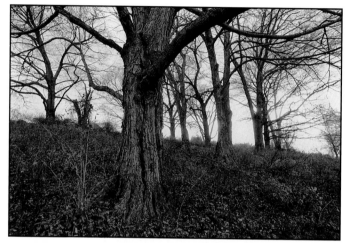
No filter

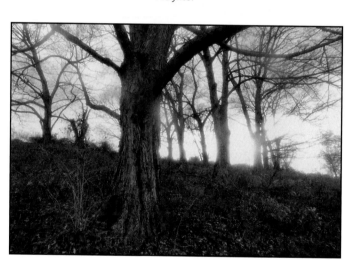
Diffusion filter

subject at an oblique angle (about 35 degrees to the primary plane of the surface of the subject).

Polarizing filters have an exposure factor of 2.5x (1⅓ stops), which remains more or less constant regardless of the amount of rotation. Standard types, also called linear polarizers, are compatible with most through-the-lens meters and manual focusing systems. With many electronic autofocus cameras, however, linear polarizers are not compatible with either the autofocusing or autoexposure system. You'll need a circular polarizer for these cameras. Once you get the right type of polarizer in place, your exposures will be accurate without additional compensation.

SPECIAL EFFECTS FILTERS

There is a wide variety of filters available for creating unusual photographic effects. Some of these effects are fairly subtle, while others are extreme. Different manufacturers offer their own versions of many of these filters, and some manufacturers make filters with unique characteristics. Following are among the most popular.

Color Polarizers To produce an overall color change as well as a polarizing effect **color polarizers** can be used. There are two main types. Single-color polarizers vary the intensity of one color when rotated; bicolor polarizers create a transition between two areas of color. Both types are available in a variety of colors and color combinations.

Diffusion Filters Among the most commonly used of the special effects filters are **diffusion filters.** These reduce the overall sharpness of the

color polarizers Filters used to produce an overall color change, adjustable in intensity, as well as a polarizing effect.

diffusion filters Filters used to reduce overall image sharpness and (sometimes in the process) contrast; often used in portraiture.

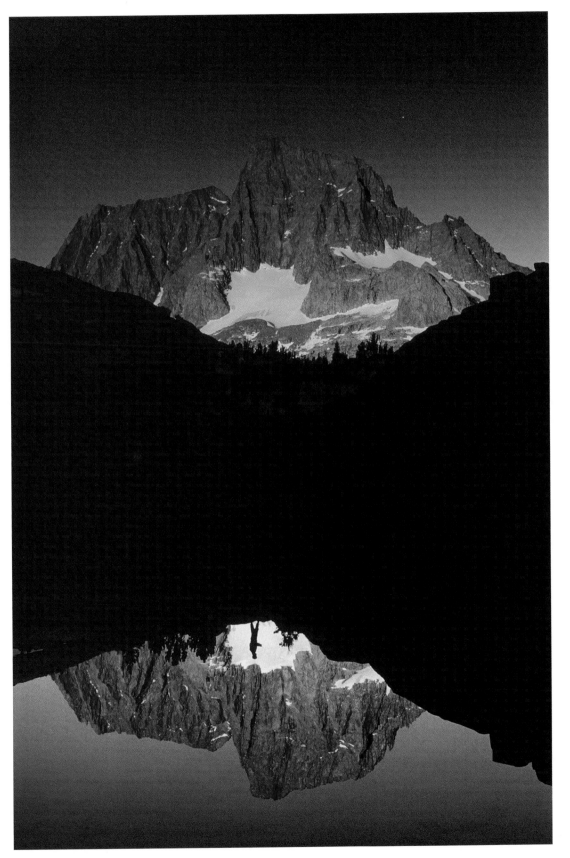

Galen Rowell Hiker's Reflection in Pond, Bugaboo Mountains, British Columbia, Canada, 1994

Dramatic natural light creates differences in brightness that are often beyond the ability of film to capture. This is especially true at the beginning and end of the day, when light is otherwise warm and rich. To balance a bright sky with the much darker water and reflection, Rowell used a split neutral density filter on the lens, orienting it so that the clear half of the filter was at the bottom of the frame. The density at the top of the frame reduced the exposure for the sky, thus darkening it, but allowed full exposure of the reflection. © *Galen Rowell/Mountain Light Photography*

No filter

Star filter

Special effects filters can produce a great range of unusual artifacts in photographs. Here, a star filter caused streaks to project from bright highlights on a car's hood ornament. But because such filters can easily overwhelm or distract from the content of an image, they must be used thoughtfully and with taste.

image to obscure detail and at the same time often lower contrast. The diffusion effect can make subjects appear more dreamy and romantic while hiding pimples, wrinkles, and other presumed defects. Most diffusion filters soften the entire image, but some create a vignetting effect—sharp in the middle and soft on the edges.

The effect of diffusion filters is extended by the use of fog filters. They simulate the quality of a foggy day, producing a misty glow from highlight areas of the subject. Lower contrast and substantially reduced sharpness are natural by-products of this type of filter, which is available in various strengths.

Graduated Filters Selectively added color or density to portions of an image can be accomplished by use of **graduated filters.** Half of the filter is clear and the other half is either colored or neutral density, with the two halves gradually blending together. A blue graduated filter, for example, can add blue to a sky while leaving the remainder of the image unaffected. A neutral-density graduated filter can darken just the sky, leaving the landscape portion of the image unaffected. Graduated filters come in a variety of colors and densities.

Multi-image Filters Flat on one side and with prismatic contours on the other,

multi-image filters are made of clear glass. The surfaces create repeating images, causing the same subject to appear in different areas of the frame. Rotating the filter in its mount allows you to control the placement of the repeating images in the frame.

Star Filters Rays of light appear to emanate from bright highlights within the image when you use **star filters.** The effects assume various shapes and degrees of exaggeration, depending on the type of star filter used. You can purchase different filters for different star shapes. Some such filters even rotate for a variety of effects.

graduated filters Filters that add color or density to selected areas of an image; often used to balance bright skies with darker land areas.

multi-image filters Filters used to create repeating images of the main subject in different areas of the frame.

star filters Filters used to make rays of light emanate from the subject's highlights.

COMMONLY USED FILTERS

Filter Type	Filter Factor	Film Type	Primary Purposes
No. 8 (Yellow)	2x	B&W	■ Darkens blue sky, preserving normal tonal relationship with clouds. ■ Renders yellow subjects as lighter gray.
No. 21 (Orange)	5x	B&W	■ Darkens blue sky considerably, creating dramatic contrast with clouds.
No. 11 (Green)	4x	B&W	■ Darkens blue sky to a similar degree as yellow filter; best choice if image contains Caucasian skin. ■ Renders green subjects, such as foliage, as a lighter shade of gray.
No. 25 (Red)	8x	B&W	■ Strongly darkens blue sky and anything blue or green; can create nearly black skies. ■ Renders red subjects as much lighter gray. ■ Increases overall image contrast. ■ Blocks blue light for more dramatic effects with black-and-white infrared films.
1A (Skylight)	None	B&W/Color	■ Protects the front of the lens from damage. ■ Mildly reduces haze and slightly warms image color.
UV (Haze)	None	B&W/Color	■ Protects the front of the lens from damage. ■ Blocks some ultraviolet rays to minimize loss of contrast in landscape subjects.
No. 87/89B		B&W	■ Maximizes effect and overall contrast of black-and-white infrared film.
80A	4x	Color	■ Balances daylight films with 3200K tungsten light.
81A	1.2x	Color	■ Adds overall warmth to image color. ■ Reduces blue light from overcast sky or open shade.
85B	1.5x	Color	■ Balances 3200K tungsten films with daylight.
30M/40M	1.5x	Color	■ Balances color under common fluorescent light with daylight-balanced films.
FLD (Fluorescent)	2x	Color	■ Balances color under common fluorescent light with daylight-balanced films.
FLT/FLB (Fluorescent)	2x	Color	■ Balances color under common fluorescent light with tungsten-balanced films.
ND	Varies	B&W/Color	■ Reduces light passing through the lens with no effect on image color.
Polarizing	2.5x	B&W/Color	■ Reduces or eliminates glare and reflection on certain smooth surfaces. ■ Increases overall color saturation. ■ Darkens blue sky and water.

MARK SELIGER
EDITORIAL PORTRAITURE

As chief photographer for *Rolling Stone* magazine, Mark Seliger has a tough act to follow: the great Annie Leibovitz held the job for many years. But when Seliger took over in 1993, that venerable rock-and-roll magazine didn't lose a beat, visually speaking. Seliger's remarkable portraits strike a delicate balance between casual and controlled, perfect for a magazine that must offer a coherent view of an often disorderly milieu. And they have a dependable visual richness—though the self-effacing Seliger is reluctant to call that consistency a style.

Like Leibowitz, Seliger seems to be in for the long haul. "Everybody always told me I'd start out as an editorial shooter and gradually move into advertising—that one was just a stepping stone to the other," says the photographer, whose exclusive contract with publishing giant Wenner Media also includes work for the equally successful *Us* magazine and *Men's Journal*. "But that seems backwards to me, because I can't think of anything more satisfying than having your name on every picture you get published."

For Seliger, this visibility makes editorial photography more "self-analytical" than advertising, in which even the most prominent shooters rarely receive credit on the printed page. "It gives you a special incentive to do the best you possibly can," he says. Which isn't to suggest that Seliger is always happy with his results: "I try to cover myself, so I know the magazine will have something usable. But some sessions just aren't as successful as others. I come back thinking, 'Maybe I shouldn't have tried that.'" Yet the photographer's freedom to experiment is one of the perks of working full-time for a single client (albeit three different picture editors and art directors, one of each for each magazine). Says Seliger, "I get to learn on the job."

Seliger discovered his penchant for people when he took a class called Environmental Portraiture at his alma mater, East Texas State University. "It was all about the way a subject reacts to a specific environment," he says. Those lessons took root: Seliger now relies heavily on location in his *Rolling Stone* work, rarely shooting in his Manhattan studio. He has even started taking subjects on overnight excursions to divorce them from familiar surroundings; he and actor Brad Pitt spent two days across the border in Mexicali, Mexico for a *Rolling Stone* cover story. "We were going for a city barrio feeling," he explains.

Shooting on location can contribute a valuable element of surprise to a photograph. But that isn't to suggest that Seliger doesn't plan. "I do a lot of research first," he says. "With movie actors, I see their films. With rock stars, I listen to their music. I draw pictures. I run ideas by my editors." One thing Seliger doesn't do is share those ideas with his subject before a session. "It gives them too much thought time," he explains. "You can totally bust a shoot that way."

Yet a concept may be altered or abandoned at the whim of Seliger's famous sitters—strong-willed people often trading on a specific self-image. Blues musician John Lee Hooker insisted on a polka-dot shirt. Actor Ralph Fiennes simply acted. "It was almost like recording a performance," Seliger recalls. "He went from funny to serious to sad." The photographer welcomes such improvisation; he describes his role as that of a director, and any good filmmaker knows the value of cutting actors some slack. "Often, despite having everything all planned out, the best pictures happen organically," he says. "The main thing is to get the subject to work as hard on the photograph as they would on their own projects, because that's the way you get special images."

For this to happen, though, Seliger needs to gain his subjects' trust. How does he do it? Mostly by being himself. "There's no formula," he says. "I just talk to them. Sometimes I'll stop in the middle of a shoot and act as if the photography is secondary, and have a conversation. That puts me and them on the same level, because the job is really a partnership."

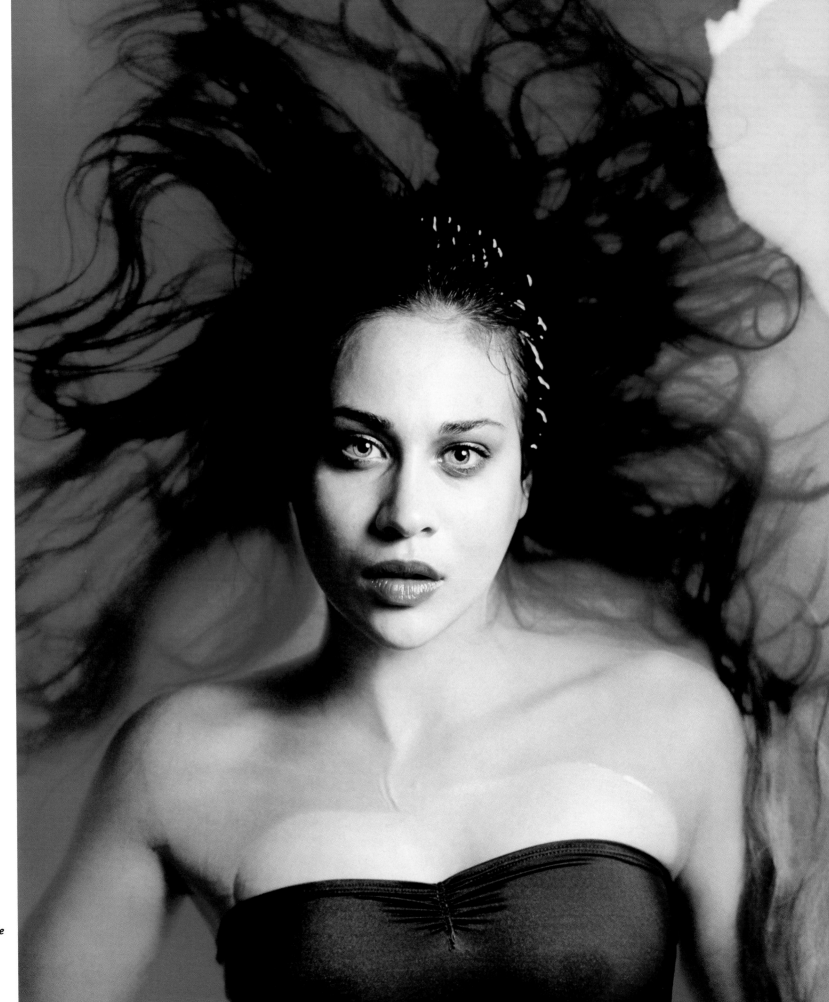

Fiona Apple

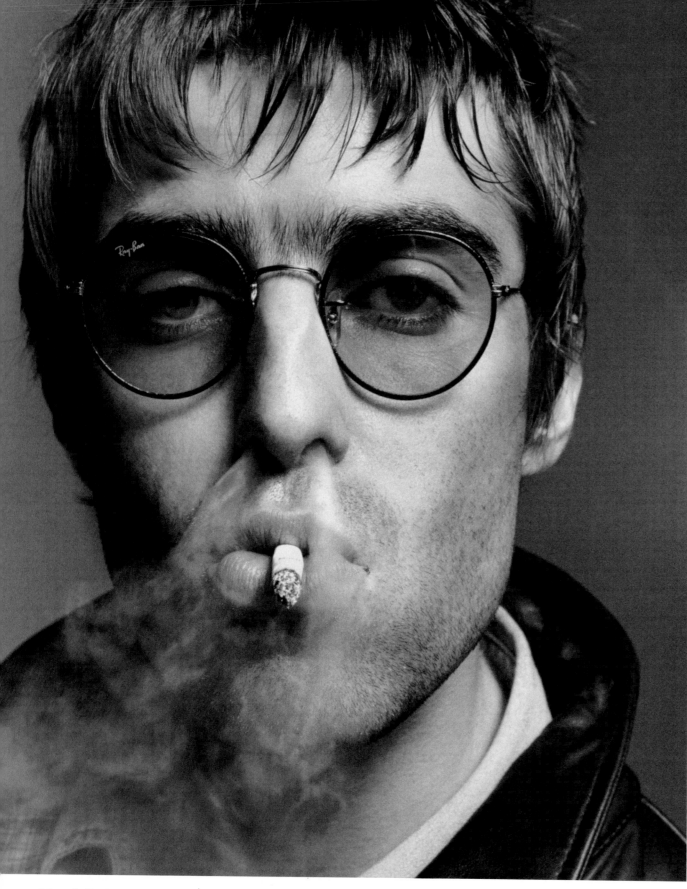

Indeed, photography's greatest portraits—and portraitists—are usually collaborative, though Seliger dismisses his own importance. "Being a celebrity photographer, I'm not going to go down in history," he says, ignoring the enduring images of yesteryear's stars made by such great photographers as the Frenchman Nadar and the American Mathew Brady. Indeed, as a record of our era's hopping pop culture, Seliger's work may be just as important.

Liam Gallagher of "Oasis"

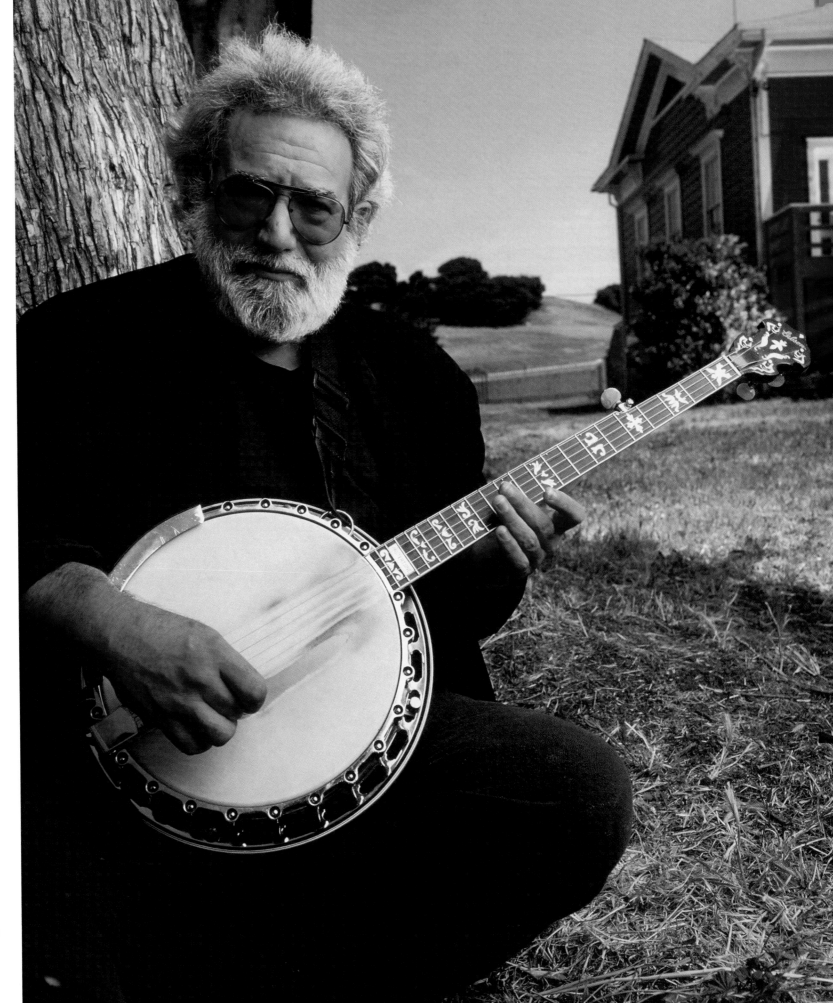

Jerry Garcia

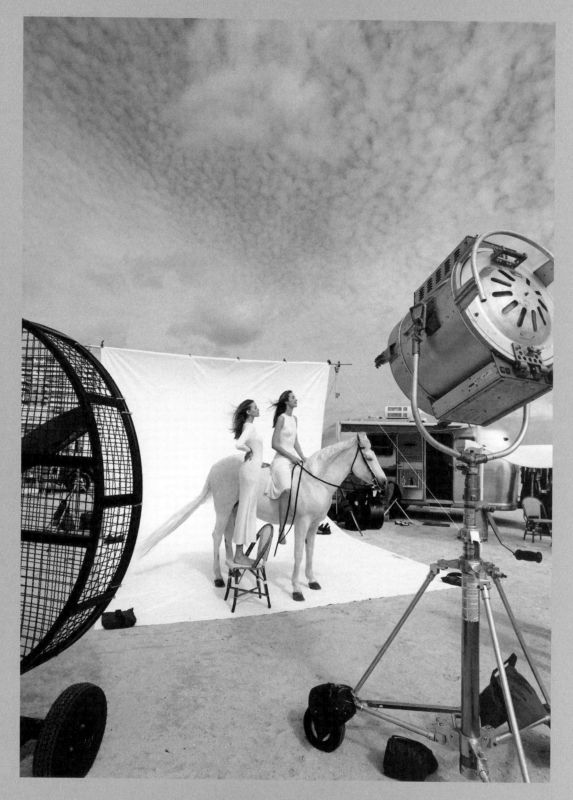

PATRICK DeMARCHELIER
Nadja Auermann and Cecilia Chancellor, Miami, 1993

The use of artificial light is a special photographic skill, requiring both practice and an under-standing of technique. Fashion photographers such as DeMarchelier often make heavy use of artificial light, even in outdoor settings such as this. But an arsenal of equipment isn't neces-sary for good results. A single artificial light source can be effective if used intelligently, and natural light can be manipulated in various ways as well. Ironically, the success of DeMarchelier's photograph—shot for a fashion magazine—depends not on the elaborate lighting hardware it depicts, but rather on his decision to step back and make his technique a visible part of the image.

LIGHTING TOOLS AND TECHNIQUES

One of the most important considerations in making a photograph is the quality of light. The light falling on a photographic subject, whether a tiny still life, a person, or a vast landscape, can be described and analyzed according to specific factors. Photographers can observe these different qualities and work with them in various ways, and they can even modify them when **existing light** is used. (Existing light is also called ambient or available light.) In a studio setting, moreover, photographers can exert virtually full control over the qualities of light.

Far and away the overriding quality of light is its softness or hardness—in equivalent photographic terms, whether it is diffused or directional. Think of the **hard light** of a winter morning on a sunny cloudless day, etching features of the landscape in bright highlights and deep shadows. This hard light tends to emphasize subject contrast and textures—the impression that the objects in your picture exist in three-dimensional space. Alternatively, think of the same scene but on a heavily overcast day. This **soft light** can be virtually shadowless, reducing the overall contrast and even making the scene look flat. Of course, other important factors also contribute to an image's feeling of depth.

The hardness or softness of light is influenced by several factors:

- the size (broadness) of the light source relative to the subject

- the distance of the light source from the subject

- whether the light rays travel mainly in one direction or are scattered in many directions (that is, are subject to **diffusion**).

Light that is small in area and far away tends to be hard. Light that is broad, close, and scattered tends to be soft.

existing light Natural or artificial illumination already present in a scene, as opposed to flash or other light added by the photographer; also known as available or ambient light.

hard light Light that is directional and not diffused, usually creating moderate to high contrast and emphasizing texture.

soft light Light that is diffuse and without clear direction, tending to reduce contrast and make a subject appear flatter.

diffusion Effect of light-scattering materials (such as translucent plastic), which soften a light source and thus reduce a scene's contrast.

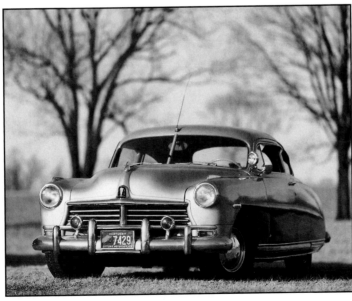 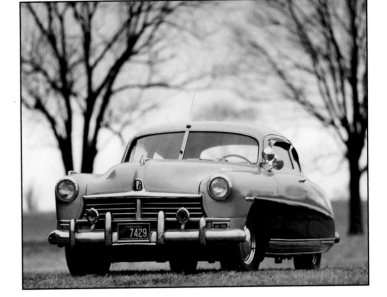

Quality of Light

The quality of natural light varies from hard to soft, depending on the weather and time of day. Strong sun (left) produces a hard, directional light that helps define the character of surfaces, such as in the metallic sheen of this car. Overcast conditions (right) often produce a soft, scattered light that may help describe the shape of objects, such as in the car's rounded contours. In the studio, light can be adjusted from hard to soft at will, using light-modifying accessories and materials. Outdoors, you may be able to manipulate natural light with flash or reflectors, as described later, but only if the subject is fairly close. If it isn't, the best strategy is usually to wait for the light to change. Courtesy of Bob Hower/Quadrant

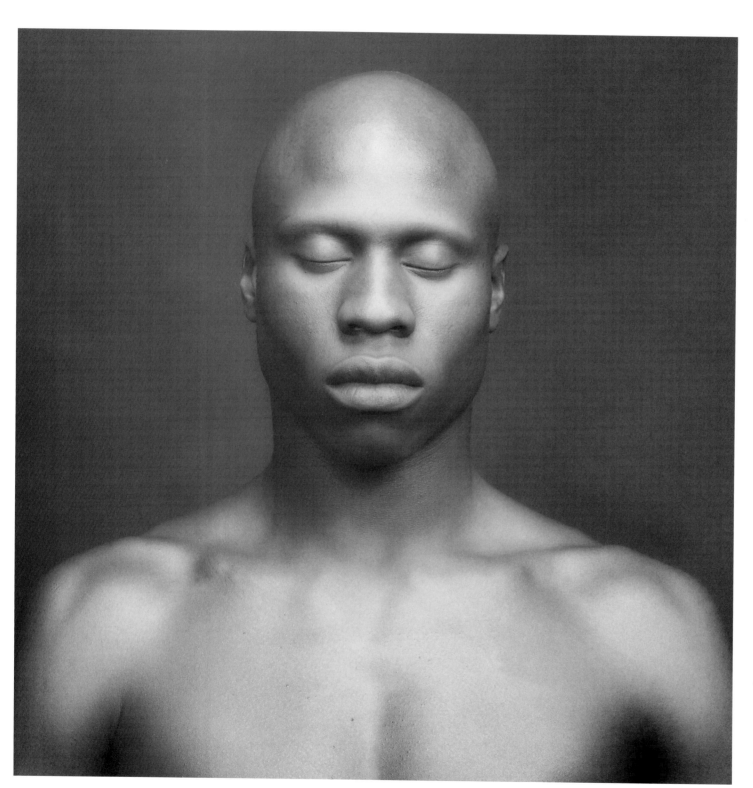

Robert Mapplethorpe
Ken Moody, 1983
Working in the studio, Mapple-thorpe brought a simple but elegant lighting style to his images. This helped place the emphasis on his subjects rather than his technique, whether he was photographing flowers or nudes. In fact, Mapplethorpe's refined look was often at odds with the sexually graphic content that made his work so controversial. This visual dissonance is part of his photographic signature. Copyright © 1983 The Estate of Robert Mapple-thorpe/Art+Commerce Anthology, Inc.

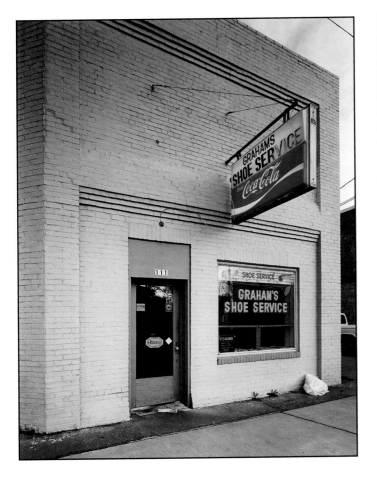

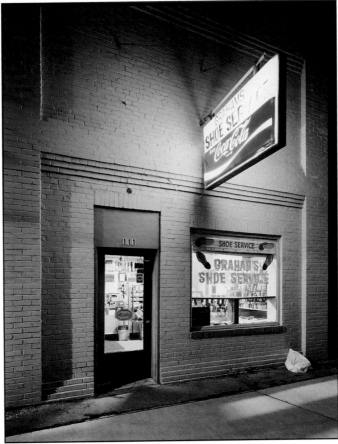

Color of Light

The color of light varies widely over the course of a day, but it's not always a function of factors such as weather and the sun's position. Nor is daylight necessarily the best light by which to photograph a subject (left). Here, the onset of night, and the color and interior detail contributed by artificial light, make for a more dramatic rendition (right).

The direction of the light, the type of light, and the color of the light also influence the overall character of a subject's illumination and can strengthen or offset the feeling of hardness and softness. To better understand how these factors work together to define light, consider two extremes of illumination: a fog light and fog.

A fog light—the beam from a lighthouse beacon or a searchlight—is a narrow-angle source that, with the help of a special lens, throws an intense, focused illumination. Its rays travel pretty much parallel to their target, creating a hard light that casts distinct shadows and emphasizes the texture of objects, particularly when it strikes them from the side.

Fog in daytime produces the exact opposite quality of light. Fog is spread over a broad area—close to and all around you. The sunlight that makes its way through fog is scattered every which way. Objects that are close enough to see (more distant ones being obscured) cast no shadows, show little texture, and appear flat and two-dimensional.

Variations in the distance and direction of the light can modify its softness or hardness. Highly directional light, for example, can in some instances actually produce diffused lighting effects. A familiar example is a portrait taken by backlight, in which the person's face, photographed against the sun, is illuminated solely by the open sky behind the photographer. The result is a soft and somewhat two-dimensional quality in the subject. In this case the large expanse of open sky functions as a huge natural **softbox** or banklight—terms for the large diffusers photographers often attach to studio lights to soften them (see page 227).

And lighting that would normally be described as soft sometimes can produce a very directional effect; consider hazy

softbox Diffusing device, usually with a large, translucent front panel, attached to studio light to soften it; sometimes called banklight.

Sunrise

One hour later

Direction of Light

Whether outdoors or in the studio, light's direction—the angle at which it strikes a subject—can make a dramatic difference in the way that subject is represented, as shown here. Outdoors, this is mainly a product of time of day. As the day progresses from sunrise (top row, left) to sunset (bottom row, right), the sun moves around the buildings, shown here, emphasizing their different facets. The color and the quality of the light change as well: Early- and late-day light are warmer, the result of the sun's oblique rays having passed through more atmosphere. When clouds move in (bottom row, center), they have the effect of a giant studio softbox, diffusing the light so that all the buildings' surfaces receive equal emphasis. In outdoor photography, finding the best light for a subject is more often than not a matter of timing—and waiting.

Midday, sunny

Midday, overcast

Late afternoon

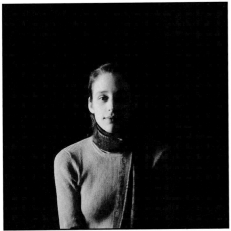

No reflector

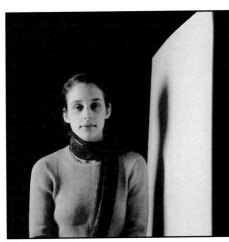

White reflector

A single, strong light source, whether the sun or a studio unit, can create dramatic contrasts in a subject—highlights and shadows that hold plenty of detail to the human eye. But photographic film is much more limited in its ability to handle such extremes of brightness, and may not be able to record adequate detail in both highlight and shadow areas of the subject (left). You can help the film by reducing the subject's contrast with a reflector: a white or metallic surface placed on the side of the subject opposite the light source, which bounces light back into the shadows to brighten them. A white reflector like a piece of foam core does this most simply (right), but a metallic silver or gold reflector adds more light. (With color film, a gold reflector also warms up the light.) Note that reflectors are useful only with relatively close, small subjects; you can't use them to fill the shadows in a landscape scene for example.

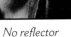

open shade Outdoor area that is shaded from the sun, such as in the shadow of a building or a tree.

backlight Illumination in which most or all of a scene's light comes from behind the main subject.

flare Reflections inside the lens caused by direct light striking its front, resulting in loss of contrast, fogginess, and/or irregular bright shapes in the image.

reflector Reflective surface ordinarily used on the opposite side of the main light source to "bounce" light into a subject's shadows, brightening them and thus improving their detail.

light pouring in through a window and creating strong shadows on a person sitting within the room. In this case, the light source is contained by the window and the lack of illumination inside the room keeps shadows dark, when outdoors they would ordinarily be filled by scattered light. The farther the window is from the subject, the more hard and directional its light. Positioning the subject very close to the window, on the other hand, will restore some of the softness to the light.

Another example of how light's direction can modify its quality is the effect produced by "on-camera" flash—a flash unit attached to the camera itself. Because the flash unit's light rays strike a subject directly from the front, its light creates few shadows. While this type of lighting is hardly considered flattering for portraiture, it can actually deemphasize facial wrinkles—or any other texture in the subject—precisely because of that lack of shadows.

WORKING WITH DAYLIGHT

Depending on conditions, the sun can produce virtually any kind of illumination, from fierce and hard-edged to soft

and shadowless. Its actual area in the sky is relatively small, so on clear, cloudless days its rays are thus quite parallel—providing very directional lighting. But the atmosphere and weather can have the effect of an immense diffusion filter. At the extremes—heavy haze or fog—sunlight can be rendered virtually shadowless.

The time of day also has a pronounced effect on the hardness of sunlight. Early and late in the day, sunlight casts long shadows that create striking dimensionality—a favorite effect of landscape photographers. When the sun is directly overhead, it casts shadows downward—a harsh light for portraits because it throws eye sockets and necks into heavy shadow. Yet beating down on a field of flowers, this same light can create intense, poster-like color saturation.

Several techniques are widely used by photographers to tame overly harsh sunlight. The simplest is to change your position or your subject's position. Even on a day with brilliant blue sky, the simple expedient of taking your portrait subject into the **open shade** of a building or tree changes the light dramati-

cally—to a soft, even quality. Turning your portrait subject around and photographing by **backlight** also changes the light from hard to soft. Make sure to increase exposure by two or three stops to get facial detail. Doing this, however, creates the risk that light will fall directly on the lens surface, creating unwanted **flare**—streaks, fogging, and/or a loss of contrast in the image. So it's important to shield the lens, in this case, with a lens hood or a piece of black cardboard.

You can also use a variety of devices to modify the direct sunlight itself. Simplest is a **reflector;** placed on the side of the subject opposite the light source, it bounces light into shaded areas to brighten them and thus to improve their detail and reduce overall contrast (see illustration above). A reflector can be as simple as a flat card or piece of foamcore board, but collapsible cloth types are also popular and are available with metallized surfaces for higher reflectivity—and thus more filling power at a given distance from the subject (see page 227). Some metallized reflectors are colored—for example, a gold color for warmer fill light.

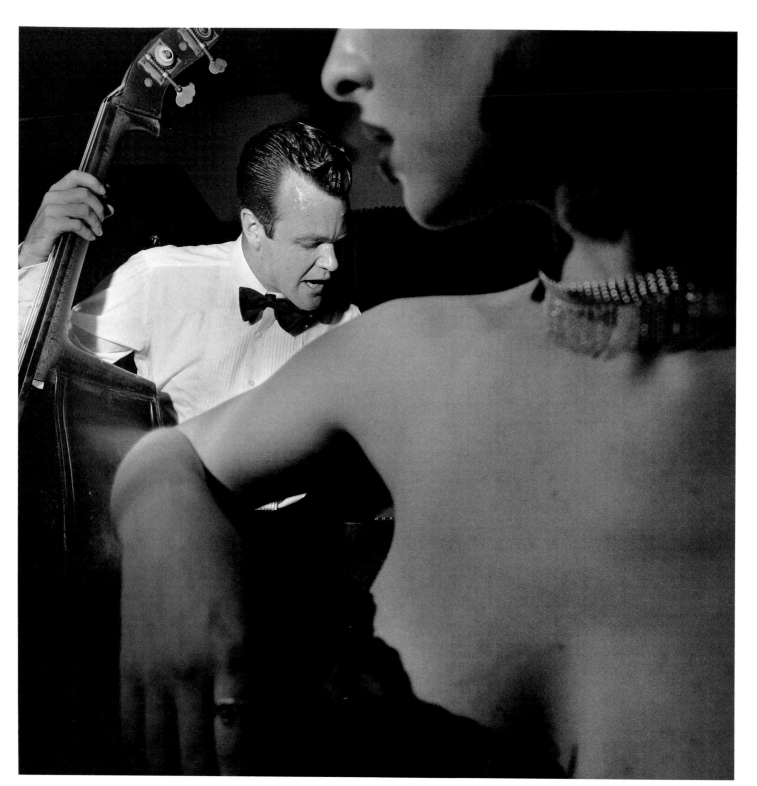

Larry Fink
Party, New York City,
August 1997
In the right hands, a single flash unit becomes a sophisticated lighting tool. Linking the flash to the camera with a special cable called a PC cord, Fink holds it at arm's length from the camera and angles it so that its beam of light strikes some parts of the scene directly and contributes relatively little illumination to other areas. The effect is quite different than the flat, frontal light typically produced by a flash mounted directly on the camera, and helps give the image a sense of atmosphere and mystery. © Larry Fink

 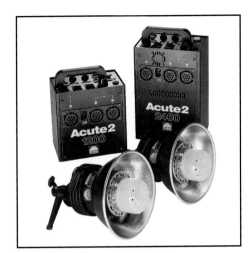

Flash equipment ranges from tiny, built-in units to high-powered studio models. Many 35mm SLRs have pop-up flashes housed in the top of the camera (left). These aren't very powerful, but are convenient because they eliminate the need for accessory flash equipment. Built-in flashes are most useful for snapshots in dim light and brightening shadows in harshly-lit outdoor subjects. Accessory flash units (center) are more powerful than built-in units, making them able to illuminate subjects at greater distances. They're also more versatile; you can usually tilt and swivel them to "bounce" light off reflective surfaces, and thus soften it. And they may offer special features such as repeating flash, in which the unit emits rapid pulses of light for multiple images of a moving subject. Studio flash units (right) offer the most power, as well as great creative flexibility. Unlike built-in and accessory flash units, which are used mainly for lighting in candid situations, they are used mostly in controlled settings such as a studio.

electronic flash Light source that is either an accessory unit or built into the camera body, providing a short burst of illumination. Often used when existing light on the subject is low; also called strobe.

recycling time Delay after a flash fires before it has recharged ("recycled") and is ready to fire again.

Yet another way to fill shadows is with electronic flash, balancing its output to brighten the shadows without overpowering the highlights (see pages 220–228). You can also diffuse the light to reduce its contrast by placing a scrim—a swath or panel of translucent cloth or plastic—in the sunlight's path.

Perhaps the most effective way to control the quality of natural light, though, is to wait for a different time of day, a change in the weather, or even another time of year. The low angle of the sun early and late in the day is usually better both for portraits and landscapes than noontime sun, for example. And simply waiting for clouds to cover the sun can keep high contrast under control.

Time of day and weather conditions also change the color of the light. Early and late-day sun casts warm, reddish-to-yellowish light; midday sun is, paradoxically, often quite cold in feeling, due to

both harshness and a higher level of blue. Overcast conditions cool down sunlight, while open shade on a clear day can be intensely bluish, the result of the high ultraviolet radiation recorded by color film (see Chapter 8).

ELECTRONIC FLASH

Fast, reliable, convenient, and flexible, **electronic flash** units—commonly called strobes—provide lighting firepower for everything from cheap point-and-shoot cameras to large studio cameras. An electronic flash is essentially a gas-filled tube through which a high-voltage electrical charge is passed. During this brief electrical discharge, the gas glows intensely for a short burst. Almost all electronic flash units also have a reflector behind the tube to direct the light forward. A key internal component of flash units is the capacitor, a sort of electronic storage tank in which voltage

is allowed to build up until it holds a charge sufficient to fire the flash. This buildup of electrical charge is called recycling, and the delay while this charge builds up to allow another full-powered flash is called the **recycling time.**

Depending on their size and intended use, electronic flash units can operate on tiny batteries (as with an SLR's built-in flash), AA cells and adapters (as with camera-mounted accessory flash units), or separate power packs usually connected to AC current (as with studio strobe units).

An electronic flash unit fires a burst of light in an extremely short amount of time, often less than 1/5000. Since the exposure is accomplished in such a brief period, the flash has the ability to freeze motion. This stop-action capability allows a degree of spontaneity and control in your work; even moving subjects will appear sharp in the final photograph.

35mm FLASH BASICS

Many new 35mm SLR cameras have built-in electronic flash units that are highly automated. Accessory flash units "dedicated" to a particular camera model offer a similar degree of automation. Basically, you just turn on the camera and flash, and the camera will automatically perform the basic and complex functions that modern flash units are admirably suited to do. The metering system built into the flash and camera will measure the light reflected from the subject after it passes through the lens and provide the right amount of light output to produce the correct film exposure. This is why such flash units are called through-the-lens flash.

Even with this degree of flash automation, many units (both built-in and accessory) allow you to manually deviate from the camera's automatic flash exposure. You do this in much the same way you use autoexposure compensation, by adjusting a scale on the unit that is calibrated in third- or half-stop increments. However, there is little standardization in the design and operation of these units, so be sure to consult your manual before using them.

The advantage of such flash automation is that you can shoot quickly, a very important feature with active, candid subjects. By contrast, manual flash requires more calculation and deliberation, but it can offer a greater degree of control over lighting effects. This is why manual flash techniques—usually utilizing a flash meter (see page 216)—are used by many professional photographers working in the studio or on location, especially by those using medium- and large-format cameras.

To use an on-camera flash, you usually mount the flash by sliding it into the camera's flash hotshoe, a small bracket on the top of the camera, above the pentaprism. (With some models, the hotshoe may be off to the side.) Such units are called shoe-mount. Other units designed for on-camera use are called handle-mount, because they attach to the camera with a bracket, offset to the left side of the camera. They usually feature a long handle for holding, and must be attached to the camera either with a special cable or a PC cord.

Another way to link most external flashes to the camera is with a PC cord (also called a synch cord), a cable that connects the flash to a socket on the camera body. A PC cord is also useful because it frees the flash from the camera position, allowing you to place it as far away from the camera as the cord allows, for different lighting effects. Shoe-mounts and PC cords are not mutually exclusive; many types of cameras and flashes offer both ways to make a connection.

Now you must set the shutter speed, or allow the camera to set it for you automatically. Every camera with a focal-plane shutter (for example, all 35mm SLRs) has a specific sync speed—the highest shutter speed at which flash can be used. If you use a higher shutter speed, you won't get a complete picture (see illustration page 214). But you can use a slower shutter speed, often with no ill effect. In fact, many photographers set deliberately slower shutter speeds to mix in some of a subject's existing light with the flash illumination (see illustration page 224). Setting a slower shutter speed has no practical effect on the flash exposure itself.

There are really two main ways to control flash exposure, in fact. One is by changing the distance between the flash and your subject, and the other is by adjusting the camera's lens aperture setting. The farther away your flash is from your subject, the less light reaches your subject. Close up to your subject, therefore, you'll be using a relatively small f-stop. As you move farther away from your subject, you'll need a larger f-stop to compensate for the reduction of flash light due to the increase in distance. If you are three feet from your subject and use an aperture of f/16, at 12 feet you may need f/4.

Manual flash units certainly work in this way. You can determine the required f-stop by reading from a chart or a dial printed on the flash unit itself, or you can use a flash meter. You also can run tests to see how the flash is responding to light in real-life situations. Make sure to set the film's ISO number on the flash, or the exposure recommendation it provides may be inaccurate. Automatic flash units may need you to set the ISO, but dedicated units usually set film speed automatically, by reading the bar code on the side of the film cassette.

A common type of automatic flash uses another method for controlling flash exposure. It actually reads the light coming back from the subject as the flash fires and cuts short the flash's burst when the correct amount of exposure is reached. Such units are called thyristor flash (see below).

Electronic flash also is popular because the light emitted is balanced to match daylight, which means it can be used with the widest variety of color films and it also can provide additional illumination when photographing in daylight—without introducing an undesired color cast. And unlike other types of artificial light, electronic flash doesn't emit much heat, making it comfortable for both the subject and the photographer.

Professional flash units usually have variable power levels, enabling the user to adjust light output up or down as needed. With studio units, the adjustment is typically made with dials or switches on the unit's power pack or on the flash itself. Power levels on these units are almost always indicated in **watt-seconds;** the higher the watt-second rating, the more powerful the flash output.

Flash output can also be varied by changing the duration of the flash burst. A long flash duration provides more light, at a given level of intensity, than a short flash duration. The small automatic flash units that attach to SLRs, for example, work by varying the duration of the flash. Almost universally, these **thyristor** flash units use a flash sensor to measure the actual flash illumination being bounced back from the subject toward the camera. When the sensor reads sufficient light returning to the camera for a good exposure, an electronic shutoff valve—the thyristor—cuts off the flash. Any flash charge not used is stored for subsequent flashes, which helps significantly in saving battery power and dramatically cuts recycle time.

watt-seconds Measure of the amount of electrical energy converted into a flash burst, used to designate the power of a flash unit.

thyristor Electrical circuitry built into many flash units that measures light reflected from the subject to the camera and cuts off the flash burst when sufficient exposure is achieved, thus saving battery power and shortening recycle time.

A more sophisticated variant of the thyristor flash is the **TTL flash** (through-the-lens). These systems work the same as ordinary thyristor units, except that the sensor that reads the light bounced back by the subject is built into the camera body, and actually "sees" through the lens that is taking the picture. TTL flash can thus provide accurate flash readings regardless of the lens being used (unlike non-TTL units that read the light striking a sensor on the flash itself). Because TTL flashes must be designed to work with specific camera models, they are commonly called **dedicated flash** systems. Some small portable flash units also allow you to manually vary the flash power. Typically, you can set these units to full power, half power, quarter power, and so on. When you do this, it is actually the duration of the flash burst that changes—getting shorter as the power is reduced. In fact, you can often freeze high-speed action more effectively if you reduce flash power in this way.

A crucial point to remember about electronic flash units in manual modes is that in most ways they behave like any other light source. Moving the flash farther away, for example, reduces the amount of light reaching your subject, the same as it would if you moved a household lamp farther away from someone. The rule for light loss is the same for flash units as it is for continuous sources: The light falls off (gets dimmer) in proportion to the square of the distance between source and subject. This principle is called the **inverse square law.** In other words, move a flash twice as far away and the light falling on the subject will be four times dimmer—that is, only one-quarter the amount of light will reach your subject (see illustration above).

Whatever type of artificial light source you are using, the brightness of the light is inversely proportional to its source's distance from the subject. This is called the inverse square law. If you double the distance between the light source and your subject, for example, the light falling on the subject is reduced to just a quarter of its original brightness. If you halve that distance, the brightness of the light is increased four times.

The quality of flash light can be manipulated in the same ways you manipulate the quality of sunlight. Reflectors and diffusion panels can be used with electronic flash with similar effect, as described in the next section. Varying the direction of the flash beam changes its quality, too. Flash aimed down at a subject at a gentle angle—say, 45 degrees—tends to be pleasant and natural-looking, while flash from directly overhead or directly below a subject is harsh and unflattering.

Likewise, the distance of a flash unit from the subject also strongly influences the quality of light. Flash units, even big studio flashes, are quite small relative to a natural light source like the sky. As a result, very small changes in distance can have a dramatic effect. An undiffused electronic flash unit at 10 feet from the subject produces very hard light. To produce soft lighting, a flash unit needs to be softened in some way and fired from a relatively short distance; just a few feet is common in studio situations.

MODIFYING FLASH

Direct frontal flash light is easily identified by its harsh, unflattering quality. That harshness can be an effective artistic device with some kinds of subject

TTL flash Abbreviation for through-the-lens flash, referring to flash systems that control exposure by measuring light from the subject after it passes through the camera's lens.

dedicated flash Flash unit designed to work with a specific camera model or system, usually TTL.

inverse square law Rule stating that a subject's illumination is inversely proportional to its distance from the light source.

matter, and it's usually not a concern with run-of-the-mill snapshot photography. But for portraiture in particular, direct frontal flash should usually be avoided, for a variety of reasons. Among these are that it can't model a subject's contours and it often turns the background into a dark, distracting mass.

Even if you're working with a single flash unit, there are various ways you can soften and otherwise modify the quality of its light—methods and hardware that may produce more attractive results even when you keep the unit mounted on the camera.

Diffusion One way to soften flash illumination is simply to diffuse it. You can do this by taping a piece of photographic light-diffusion film (available commercially) or other translucent plastic sheeting over the flash head. Even tracing vellum or tissue paper can be used. The semi-transparent surface scatters the light rays coming from the flash, making the light less directional and harsh. (If you select a nonphotographic material, like tissue, shoot a few test pictures to make sure it has no unwanted effect on the color of the light, when photographing with color film.) If your flash unit has built-in or snap-on filters, the wide-angle diffuser—a plastic panel ordinarily used to spread the angle of the light—may also have a slight softening effect. You can use a wide-angle diffuser on your flash with any focal length, including normal or long lenses.

Several companies offer flash attachments that have a stronger light-softening effect (see facing page). One is a box-shaped, translucent plastic attachment that clips over the front of the flash; its shape scatters light in all directions. (Most photographers use it with the flash

If you take a flash photograph at a shutter speed higher than a 35mm SLR's flash synchronization speed, you will get a partially-exposed frame. This effect is due to the inability of the camera's focal-plane shutter curtains to uncover the entire film surface before the firing of the flash. Most 35mm SLRs synchronize with flash at a shutter speed in the 1/60 to 1/250 range; it's OK to use shutter speeds slower than that speed. The synchronization speed is often highlighted on the shutter speed dial, if your camera has one, but otherwise be sure to check your instruction manual. Note that this problem doesn't occur with cameras having leaf shutters (shutters in their lenses), which include some medium-format and all large-format models. With these models, you can use flash at any shutter speed.

head tilted up.) Another is essentially a miniature softbox that diffuses the flash illumination with a translucent fabric panel. The panel is held in place away from the flash head with a metal or plastic framework or rods, and sometimes with an adapter ring that fits over the flash head; enclosed sides taper in toward the flash tube and help concentrate the light toward the panel. These devices come in a variety of sizes and vary considerably in their effectiveness. They work much better when you're close to the subject because their surface area is larger, relatively speaking. Do some experimenting to find the design that works best for you.

Bouncing The other way to soften flash illumination is to **bounce** it—that is, to cause it to be reflected off another surface before striking the main subject. This ability typically requires an on-camera flash unit that tilts and/or swivels (a very common design) so that its head can be angled in different directions.

You can tilt up the head to aim it at the ceiling between you and your subject, for example. This spreads the light over a

broad area of ceiling before it reaches the subject, so the light's quality is very diffuse—rather like outdoor light on a cloudy day. But if the light strikes the ceiling too close to the subject it can create unattractive shadows in eye sockets and under the nose. To minimize this problem, back away and use a longer focal length to put more ceiling surface area between you and your subject.

Similarly, you can swivel an adjustable flash unit sideways to bounce light off a nearby wall, creating a soft sidelight instead of toplight. Bounce at too steep an angle, though, and you may plunge the opposite side of your subject's face into complete shadow.

Whether you use a ceiling or a wall as your bounce surface, it should be fairly low or nearby to prevent excessive light loss. If you're shooting in color, the bounce surface should be neutral in color (perhaps white or gray); otherwise it may contribute an unwanted color cast to the subject. Ceilings are usually plain white, which is one reason they're used for bounce purposes more often than walls.

As with diffusion, bounce flash can also be softened with attachments. The

bounce Method of softening flash illumination by aiming the flash unit or "head" at a large surface such as a wall or ceiling, so that the light is reflected off that surface before reaching the subject.

The light from a camera-mounted flash can be softened with several different commercially available devices. One popular choice is a bouncer (left), which attaches with Velcro strips to a flash that has been angled up; its reflector surface softens the light, then throws it forward. Another option is a diffuser (center), which attaches to a forward-facing flash; it softens the light with a translucent panel that is larger than the flash head. Also widely used is the diffusion dome (right), which slips over the flash tube and softens the light by scattering it in all directions.

simplest of these is a 3" x 5" plain white index card. Since bouncing light off the ceiling makes nearly all the light fall on the subject from above, this technique can create shadows, underneath noses and chins, for example. Placing a reflective surface behind the top of the flash tube reflects some of the light forward, filling in shadows and complementing the light from the ceiling. Tilt the flash head up at a 45 degree angle or more, and attach the card to the back side of the unit with a rubber band so that it extends several inches beyond the top edge of the flash tube. The extent to which you bend the card over the tube determines how much of its light is thrown forward and how much goes to the ceiling; the more you bend it, the more goes forward.

Commercial versions of this concept are designed to attach quickly with Velcro strips; you tilt the flash head so that it points straight up, which angles the device's white interior at about 45 degrees to throw all or most of the light forward at the subject (see above left). The larger the reflective area (and different sizes are available), the softer the light.

Light Loss Whenever you bounce or diffuse a flash unit—or any light source—you "use up" some of the illumination. This is mainly the result of absorption and/or the greater distance the light must travel. If you're taking flash readings and setting the exposure manually, then you can adjust manually for the loss, though that's an awkward way of working with a single on-camera flash. It's easier to rely on a flash unit's automatic exposure control system—whether through-the-lens or controlled

by a sensor in the flash itself—to compensate for the light loss by automatically increasing its output. You just have to be certain that you have set (or with programmed autoexposure systems, that the camera has set) a wide enough lens aperture. This lets more light into the camera and thus compensates for the effective reduction in the unit's range. (Using a faster film increases that range, and/or lessens the need to set wide apertures.) Most flash units have an LED display that tells you if enough light has been reflected back to the camera for a correct exposure; flash systems designed by a manufacturer for its own camera models may even have a display in the camera viewfinder confirming correct exposure.

Off-Camera Flash For extra control of lighting effects with an accessory flash,

FLASH METER

Electronic flash can't be measured by conventional light meters, so studio photographers rely on a **flash meter** especially designed for this purpose. Flash meters look and operate for the most part like conventional hand-held light meters. In fact, many flash meters incorporate cells for reading existing (ambient) light as well, and some can take readings (and suggest exposure settings for) combinations of flash and ambient light. For general flash exposure readings, studio photographers usually take incident readings—readings of the light falling on the subject—by placing the meter (and its incident-reading dome) in the subject plane and aiming it back at the camera position. Flash meters can trigger the flash via PC cord or infrared trigger, or, alternatively, can be set to read the flash when the photographer or an assistant fires the flash manually.

Most professional-level meters have a number of advanced functions. Some allow the photographer to take a reading of a highlight and a shadow area, and will then calculate the proper overall exposure to set. Many can take cumulative reading of multiple flash bursts; some can calculate the number of successive flash bursts necessary to reach a certain exposure level. (These features are useful for photographs requiring such a large amount of light that several firings of the flash units must be made for exposure on a single piece of film.)

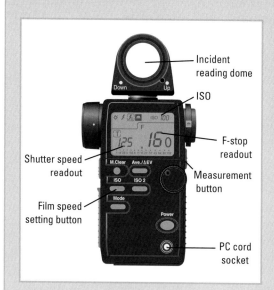

Shutter speed readout

Film speed setting button

Incident reading dome

ISO

F-stop readout

Measurement button

PC cord socket

Many flash meters can indicate exposure settings for either flash or existing light, or any mixture of the two. For this reason, such meters are often called flash/ambient meters. (Ambient light is another name for existing light.) This flash/ambient meter has a dome-covered sensor for incident light readings—measurements of light falling on the subject. To take a reading, you hold the meter in front of the subject, point the dome at the camera, and fire the flash by pushing a button either on the meter or the flash unit itself. The meter will then display the f-stop needed for correct exposure at the shutter speed you are using.

many photographers take the unit off the camera. Because it causes the light to strike the subject at an angle, **off-camera flash** can improve the subject's modeling (three-dimensionality) and give you greater control over the shadows it casts.

The simplest off-camera flash technique is to handhold the unit at arm's length from the camera, angling it back in toward the subject. For greater stability and control, you can also mount the flash on a nearby lightstand. To use either

method, you will need to link the flash to the camera.

If the flash unit is being used in a manual mode or is controlling the exposure automatically with an external sensor, you can use a **PC cord** to link it to the camera.

But many SLR makers now offer special cables that preserve the automatic through-the-lens exposure control of their dedicated flash units when the flash is used off-camera. Because the flash illumination reflected by the subject is measured and controlled at the camera position, you can more freely adjust the position of the flash. Some SLR flash systems even allow you to operate an off-camera flash unit wirelessly, even with through-the-lens exposure automation.

If you do place a single flash off-camera, try to envision where the shadows it creates will fall. This is especially important if you're not softening the light by diffusing or bouncing it. If the background is close to the subject, placing the flash just slightly off-camera can create a distractingly heavy line around the edge of the subject opposite the flash. It may be better to move the flash farther away, and make the shadows more visible so they look more deliberate.

Better still, you can soften the light from an off-camera unit so that shadows will be less dark and hard-edged. You can attach softening devices directly to the flash, as previously described. Or you can use special hardware designed for mounting the flash on a lightstand and bounce it into a photographic **umbrella,** a folding reflector used to soften direct light from a flash or other artificial source (see page 227). This technique requires that your unit

flash meter Light meter designed for determining exposure with electronic flash illumination.

off-camera flash
Lighting technique in which an accessory flash unit is not mounted on the camera body.

PC cord Extension cord that connects a flash unit to the camera body or a flash meter, usually for remote firing.

umbrella Folding reflector used to soften direct light from studio strobes and other artificial light sources.

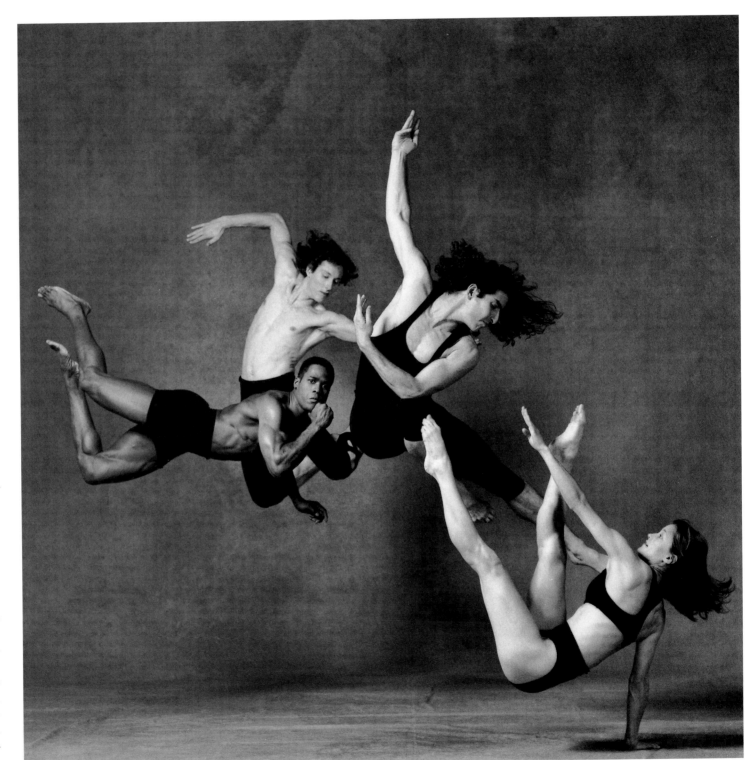

Lois Greenfield

Flipper Hope, Jack Gallagher, Daniel Ezralow, and Ashley Roland for Raymond Weil Watches

One of the great advantages of flash illumination is its short duration, which allows Greenfield to create her carefully choreographed stop-action photographs of dancers in mid-leap. The duration of a flash burst from a studio unit can vary from as short as 1/6000 to 1/250 or longer, depending on the capacity of the unit and the power level it has been set to. (Make sure to run tests before using flash to photograph very fast-moving subjects.) On-camera flash units may have flash durations of as short as 1/10,000, or even shorter. Lois Greenfield Studios

This series shows how modifying the light from a flash attached to the camera can change the way a subject is described. With no modification—direct, frontal flash—the subject appears flatly lighted (top). Angling the flash head up bounces the light off a large area of ceiling, thus softening it before it strikes the subject, and also creating gentle shadows (center). (A white card attached to the back of the flash head throws some light forward, brightening the shadows.) Attaching the flash to the camera with a PC cord or dedicated cable allows it to be held off-camera, which gives its light a more directional quality (right). This creates stronger shadows on the subject's face. Note that an automatic flash unit can compensate for the light loss caused by bounce techniques if it has adequate power, but to be safe, use as wide a lens aperture and as fast a film as possible.

be powerful enough to compensate for the resulting light loss.

FLASH SYNCHRONIZATION

All 35mm single-lens reflex cameras, as well as a number of medium-format 120-rollfilm cameras, employ focal-plane shutters. These are essentially two moving curtains; one slides open to expose the frame of film, then the other follows

to close the shutter. An electronic circuit in the camera throws a switch to trigger the flash when the first shutter curtain has opened fully, a process called **flash synchronization** (flash synch).

At higher shutter speeds, though, the shutter curtains fly open so quickly that they form a slit moving across the film; the curtains never open fully to expose the whole frame of film. If the flash

burst—which is of extremely short duration—occurs at one of these higher speeds, only the narrow band of film being exposed at that moment will receive any flash illumination reflected by the subject. At still higher speeds, no flash image may be recorded at all, because the moving slit will have sped completely across the film by the time the flash fires.

flash synchronization
Timing the flash so it fires only when the shutter is fully open; also called flash synch.

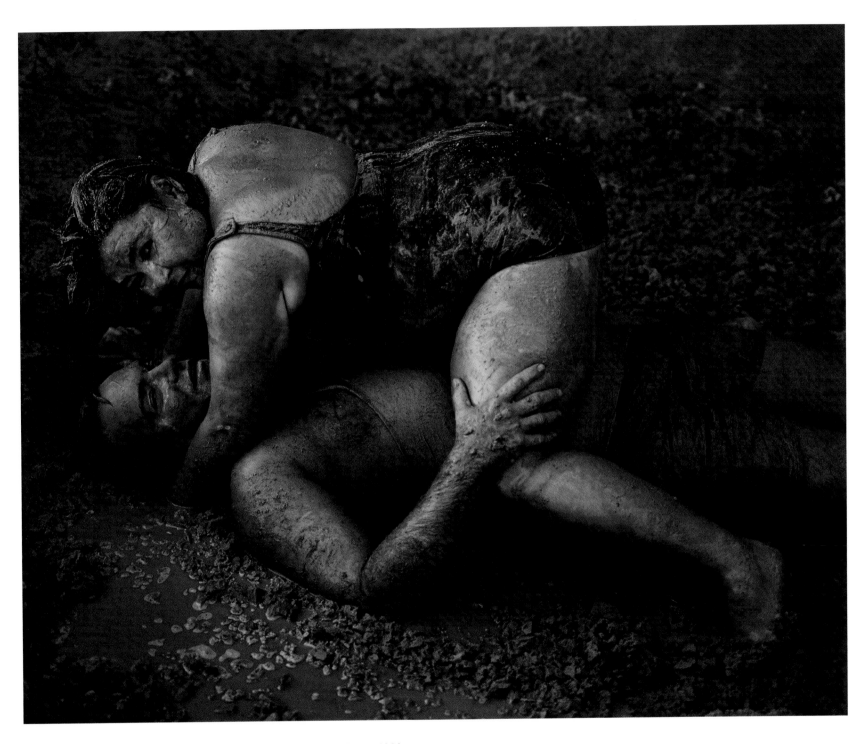

Annie Leibovitz Roseanne Barr and Tom Arnold, Malibu, California, 1990

Working outside rather than in a studio doesn't necessarily mean using only existing light. To shoot her celebrity portraits, Leibovitz may take along massive amounts of lighting gear—yet the effect, as here, is often so subtle that the viewer is unaware light was added. Some controlled lighting deliberately calls attention to itself, but the best lighting is often the most transparent. In this case it keeps the viewer's attention on the photograph's content, and emphasizes Leibovitz's trademark ability to get her famous subjects to do outrageous things for her camera. Annie Leibovitz/Contact Press Images Inc. From the book "Photographs Annie Leibovitz 1970–1990"

When you combine flash and existing light in a photograph, you're really putting two separate exposures onto the film, one on top of the other. Both of these photos were exposed at 1/15 at f/5.6. The first is created only by the existing light—here, seen through the room's open door (left). (The existing-light exposure is controlled both with the shutter speed and the f-stop.) The second exposure is created by the flash; in this case it lights the room's interior, which is too dark to be captured by the exposure for the existing light (right). (The flash exposure is controlled with the f-stop and the flash unit's power settings.)

The highest speed at which a focal-plane shutter can fully expose a frame of film is called the **flash synchronization speed,** or just flash sync. On some newer SLRs it can be as high as 1/250; other SLRs and medium-format models may sync at 1/125, 1/60, or even 1/30.

A focal-plane shutter's top flash sync speed may prevent you from using flash when the existing light is bright and overexposure might otherwise result, particularly with fast film. This is a major reason many professionals prefer cameras that have leaf shutters, normally located within the lenses. Leaf shutters, found in most medium-format cameras, and all view camera lenses, can synchronize flash throughout the entire range of shutter speeds. Some advanced SLR models have dedicated flash units that can pulse the flash rapidly as the shutter slit passes over the film, enabling you to synchronize flash at any shutter speed, up to the camera's highest speed.

FILL FLASH

Photographic film is far less sophisticated than your own eyes and brain in the way it "sees" the world. For example, as you scan a scene, your visual system constantly adjusts for differences in brightness, allowing you to perceive texture in brilliant highlights one moment and detail in deep shadows the next. Film can't do that. Even when an exposure is technically perfect, if a scene's brightness range (lights to darks) exceeds the film's capacity to record it, shadow detail is lost, highlights are burned out, or both.

One way to reduce a scene's contrast and thus to keep its brightness within the film's recording range, is to use **fill flash.** This is a technique in which flash is used to add just enough light to the existing illumination to brighten ("fill") shadows and other areas and in this way bring them closer to the scene's lighter tones.

The traditional application for fill flash is in photographing people by direct sunlight, which can otherwise cause harsh, unflattering facial shadows. When precisely controlled, its effect is nearly invisible—though many photographers have cultivated a shooting style in which flash and existing light are mixed together in an obvious way for creative effect.

The usual strategy is to make fill flash as little like flash as possible, while still maintaining all the detail you want in the picture. A typical example is a portrait of someone outdoors, either backlit or lit by harsh, overhead sun. Properly done, the addition of fill flash will soften the shadows and illuminate the face just enough so that it looks like a well exposed shot made only by existing light.

The key to this technique is understanding a basic principle: Every flash shot in existing light is really two exposures, occurring simultaneously but largely independent of each other. One exposure is made by the existing light, with lightness or darkness determined, as with any non-flash exposure, by the combination of f-stop and shutter speed set on the camera. The other exposure comes from the flash itself. Here, the lightness or darkness is determined by the output of the flash and the f-stop you set (see illustration above). As detailed previously, this light output varies with flash power, distance, and (with adjustable or auto units) flash duration. It's critical to understand that the shutter speed you set has no effect on an electronic-flash exposure provided you do not exceed the camera's flash synchronization speed. The flash exposure you get on film at 1/125 is the same flash exposure you get at 1/30 or 1 second.

The shutter speed you choose still has an effect on the existing-light exposure, though. For this reason, you can use the shutter as a sort of balancing valve to mix existing light and flash illumination.

Take the example of a portrait lit by harsh sunlight. First you would take an exposure reading of the general scene and set the lens aperture and shutter speed on the camera as your meter suggests. If you then took the picture with an automatic electronic flash set to pro-

flash synchronization speed Highest shutter speed at which a particular camera model will synchronize with a flash; also called flash synch.

fill flash Technique in which a flash unit's output is balanced to supplement existing light, usually adding just enough illumination to brighten ("fill") the shadows.

No fill flash

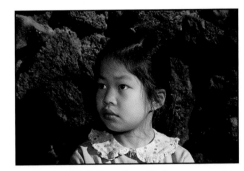

Automatic fill flash with no flash compensation

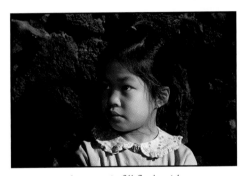

*Automatic fill flash with
–2/3 stop flash compensation*

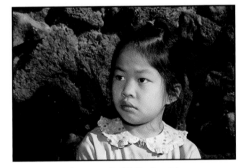

*Automatic fill flash with
+2/3 stop flash compensation*

Harsh light can create dark, distracting shadows that are especially unflattering with portrait subjects (top left). This can be prevented by setting a dedicated flash unit to its fill-flash mode, in which it provides an exposure that automatically lightens shadows without overpowering the existing light (top right). Most such units have pushbutton controls that allow you to deviate from this camera-selected output in third- or half-stop increments, a function called flash compensation. If you set flash compensation to the minus side—here, –2/3—the fill effect is less apparent, and shadows darker (bottom left). If you set flash compensation to the plus side—here, +2/3—the fill effect is more pronounced, and shadows lightened even more so than the flash system would have produced on its own (bottom right).

vide standard flash exposure, it would illuminate the subject's face fully—and would look more or less like a conventional flash shot, with your subject's face fully illuminated.

For a more subtle effect, adjust the flash unit so that its output is less than normally called for—one-half, one-third, or one-quarter the power needed for the "correct" exposure (called 1:2, 1:3, and 1:4 fill ratios respectively). Flash used this way is often called fractional fill. They are generally the most pleasing and natural-looking flash ratios, although photographers can and do deviate from them for different effects. This flash output will be sufficient to add brightness to the shadows under your subject's eyes, nose, and chin, but insufficient to cause any significant lightening of the sunlit facial highlights. And because the illuminating power of the flash falls off drastically with distance, the flash burst will have little or no effect on parts of the background farther than a few feet behind the subject.

What actually happens during a fill-flash exposure is as follows: The shutter opens, and light begins to enter through the lens onto the film. When the shutter is fully open, the flash fires for a brief moment and adds a secondary exposure to the film. After the flash burst, existing light continues to enter through the lens until the shutter closes.

Should you want the background to be lighter or darker, you can use the shutter to vary the background exposure—setting a faster speed to darken the background or a slower speed to lighten the background. The flash exposure, unaffected by shutter speed, will remain the same. Be careful that the shutter speed you set isn't too fast; many cameras won't let you set speeds faster than 1/125 or 1/60 with flash (see page 218). If your subject moves during this time, the image may have a slight blur due to the slow shutter speed (see illustration, page 224).

Arriving at the correct balance of flash and existing-light exposure can be simple or complex, depending on the type and sophistication of the flash units used, dedicated automatic flash units being the easiest.

Fill With Dedicated TTL Flash
When set to fill-flash mode, dedicated TTL flash units automatically adjust their output in proportion to the existing light—usually producing a pleasing balance of flash and ambient illumination. (Their light meters are directly linked to the flash system.) But in most cases you can deviate from the flash's automatic

Frans Lanting Aloe in Bloom, Spiny Desert

Fill flash can subtly enhance existing light, or it can produce unique and often spectacular visual effects. Its special qualities have led to its heavy use by very different kinds of photographers, from photojournalists to fine artists to nature specialists such as Lanting. In this image, it allowed the photographer to balance the green plant (which was in virtual darkness) against an intense, magenta-colored late-day sky. Frans Lanting/Minden Pictures

calculation, an ability called **flash compensation.** Such adjustments are usually made with pushbuttons on the back of the unit. You can set it so that the flash output is greater than or less than what the unit would produce on its own, with such variations calibrated in fractions of stops. The fill-flash system still controls the flash exposure automatically, and may actually make small adjustments to the existing-light exposure as well.

If you feel that automatic fill-flash systems add too much light to the subject, and overpower or interfere with the quality of the existing light, you might set flash compensation to the "minus" side. For example, a setting of –1/3 will cause the flash to add a third-stop less light to the subject than it normally would, making shadows slightly darker. On the other hand, if you prefer to create a less natural fill-flash effect, playing up the artifice of the technique, you might set flash compensation to the plus side. For example, a setting of +2/3 will cause the flash to add 2/3 stop more light to the subject than it normally would, causing the main subject to stand out more dramatically against the background.

Fill with Non-TTL Autoflash With flash units that have an external sensor, you set a control on the unit (dials and slider switches are common) for the lens aperture you're using on the lens. For fill flash with these units, though, you must deliberately set a smaller aperture on the lens than is set on the flash. Fill flash is often expressed as a ratio describing the flash's full power versus the fill setting. To get a strong fill ratio, for example, you set the lens a stop down from the setting on the flash unit (half power, or a 1:2 fill ratio). (For example, with the flash unit set for auto operation with f/8, you set

the lens to f/11.) To get a moderate fill, you set the lens a stop and a third or a stop and a half down from the flash setting (one third power, or 1:3 fill ratio); for a slight fill, you set the lens two stops below the flash setting (quarter power, or a 1:4 fill ratio).

Leaving the f-stop set where it is, you then adjust the shutter speed on the camera to get the correct exposure for the existing light. (Generally, this is easiest using full manual control on the camera, or aperture-priority automation.) Alternatively, you can set the correct existing-light exposure on the camera first, then adjust the aperture setting on the flash as if you were using bigger apertures. For example, if your camera is set to f/8, you set the flash to f/5.6 to get a stop less flash output (1:2), or set the flash to f/4 to get two stops less output (1:4), and so on.

Outdoor Fill with Studio Flash
These units can usually be set to specific output levels, which makes fractional fill flash a relatively simple matter. Set the shutter speed and f-stop on the camera for the existing-light exposure you want. Then, using a flash meter (see page 216), adjust the output of the electronic flash so that the flash meter reading is one stop, a stop and a third, or two stops less exposure than the camera setting for strong (1:2), moderate (1:3), or slight (1:4) fill ratios, respectively. Note that most studio strobes display output levels in a measurement called "watt-seconds." To reduce output by one stop, you halve the watt-seconds; to increase output by a stop, you double the watt-second readout (see page 212).

Fill with Manual Portable Flash
These units fire at one setting—full

power—only. Making a standard flash exposure with these is strictly a matter of setting an f-stop according to the distance from your subject, or moving the flash closer to or farther from the subject. To facilitate this, most of these units have a calculator dial. After entering your film's ISO speed on the dial, you can read the appropriate f-stop next to the scale numbers for the distance to your subject.

For fractional fill, you have to close the lens down from the normal flash reading—one stop for strong (1:2) fill, two stops for slight (1:4) fill and so forth, as detailed above. If the calculator dial says to use f/8 at 10 feet, for example, you would stop the lens down to f/11 to get a 1:2 fill flash ratio. Once this f-number has been set on the lens, you then calculate the existing-light exposure using this f-stop, and set the shutter speed accordingly. Again, it's easiest with a manual-exposure camera or with aperture-priority automation.

An alternative method of controlling the fill-flash ratio is simply to move the flash away from your subject, if you can, in order to reduce the flash-to-subject distance. One way to do this is to calculate the correct f-number for flash exposure, as explained, and to set this on the camera. Then determine the shutter speed that will give you correct existing-light exposure, and again set this on the camera. But now you need to reduce the amount of flash reaching your subject, so the flash must be moved back. Moving it back 1.4 times the distance (14 feet instead of 10 feet, for instance) will reduce light output about a stop, for a 1:2 fill ratio.

Doubling the flash-to-subject distance (20 feet instead of 10 feet) will reduce light output by 2 stops and give you a 1:4 fill ratio. For a 1:3 ratio, the flash would

flash compensation
Manually set deviation from the standard exposure determined by an automatic flash.

When you're using flash indoors, setting a normal flash sync speed—in the first example, 1/60— usually results in a dark (underexposed) background, because the background is illuminated mainly by existing light (top left). If you use a slower shutter speed—in the second example, 1/8 second—you can improve detail in the background (second from left). If the subject is moving, however, a faint image of it may be recorded, called "flash ghosting," as in the third example (top right). And if you use a slow shutter speed without bracing the camera with a tripod or other means, the background may end up blurred due to camera movement (bottom left). Sometimes such results are accidental, but photographers often exploit these effects for creative purposes. Courtesy of Bob Hower/Quadrant

have to be moved back about 1.7 times farther. Since the camera has to stay in the same position, you will need a long flash connector cord and either a light-stand or a helper to hold the flash back from camera position.

Indoor Fill Flash While fill flash is usually associated with daylight shots outdoors, it can be used to good effect in reasonably bright indoor light as well— for example, or someone in an office set-ting lit by overhead fluorescents. With a conventional flash shot in such situations, the backgrounds may go dark, destroying any sense of the interior space. Fill flash will provide more satisfactory pictures, and the methods are the same as previ-ously explained. Basically, set the correct exposure for the existing light in the scene, then set the flash unit for reduced light output.

When using fill flash with available indoor light, keep in mind that daylight-balanced color film will record the color of artificial light in the scene. A fill flash shot, remember, is two simultaneous exposures, and the interior scene beyond the range of the flash is recorded mainly by existing light falling on it. If that exist-ing light comes from fluorescents, which create a green cast on daylight film, these parts of the interior will be greenish in the picture. If the existing light is tung-sten (incandescent), which produces a yellowish light, these parts of the scene will appear yellowish in the photo. The latter might be considered desirable for certain applications, since it imparts a feeling of warmth to the picture.

Another key consideration with indoor fill flash is the brightness level of the exist-ing light. Many interior scenes are quite dim. Even when using fast film (ISO 400

and higher), you may have to set an expo-sure with a slow shutter speed—1/30 or even slower—to register the background of the picture on film. While the flash itself can effectively freeze a foreground sub-ject, the background may be blurry due to camera shake. If you put the camera on a tripod, this will keep the background sharp, but you can run into another prob-lem. Suppose your subject is moving rapidly—for example, you want to photo-graph a waiter hurrying by the camera with a stack of menus. The fill-flash por-tion of the exposure will register a sharp image. But the waiter is also lit by existing light, and, with a slowish shutter speed, the film will also register a blur super-imposed on the frozen flash image. The phenomenon is called **flash ghosting.**

Then again, that effect is just what some photographers want. This distinc-tive combination of an existing-light blur

flash ghosting Effect of using flash with slow shutter speeds so the film registers a blurred image of the subject superimposed on the sharp image created by the flash.

Jeff Jacobson Iowa Girls High School Basketball Tournament, Des Moines, Iowa, 1979

Jacobson's photographs depict scenes of American social and political customs, and take on a surreal and sometimes whimsical quality in part through his balancing of flash with low existing light. This technique, often called slow-sync flash, usually requires that you set a slow shutter speed to record existing light in addition to the flash illumination. The slow shutter speed can in turn can cause blur in the background—here, creating a visually exciting contrast with the sharp, flash-frozen mouth inside the megaphone. © Jeff Jacobson

STUDIO LIGHTING PARAPHERNALIA

Banklight. See Softbox.

Barn doors. Adjustable flaps hinged to the sides of a lighting unit and used to block light from reaching certain areas of the subject.

Boom. Type of support for a studio light, incorporating a counter-weighted, often telescope arm that allows the light to be placed above the subject; mounts on a lightstand.

Cuculoris. Panel with free-form shapes cut out of it, used in front of a light to cast a dappled pattern on the background or on the subject itself; also called a cookie.

Diffusion screen. Translucent, frosted panel of plastic or other material mounted in front of a lighting unit to scatter and soften its illumination.

Filter holder. Bracket that mounts to the front of a studio light to hold color filters, diffusion screens, grids, and other attachments over the light.

Fresnel. Type of lens used over spotlights, with circular ridges that focus and intensify light. Usually refers to an entire lighting unit, often a powerful quartz-halogen light with permanently attached fresnel lens.

Gobo. Opaque attachment used to diminish or block light on specific parts of the subject. Also used to shield the camera lens from light that might cause flare; also called a flag.

Grid. Thin, flat-black honeycomb-pattern screen that fits over a studio light to make the illumination hard and directional. Used to heighten dimensionality and drama of lighting; also called a honeycomb.

Head. Component of a studio flash incorporating the flash tube, modeling light, and sometimes a cooling fan.

Infrared trigger. Electronic device used to fire studio flash units from a distance without cumbersome cords.

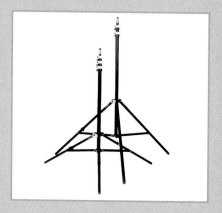

Light stand. Three-legged folding metal device designed to support lighting heads.

Modeling light. Incandescent lamp within a studio strobe that helps photographers previsualize the effects of flash illumination.

Muslin. Large swath of seamless cloth used for a studio background. Can be stretched taut or allowed to drape in folds; often painted or printed in patterns and colors.

PC terminal/PC cord. Flash socket on a camera, and the cord used to connect it to a strobe.

Polarizing screens. Filter that fits over studio lamp head to polarize the light output. Used to control glare in reflective subjects.

Power pack. Electrical supply for electronic flash units, containing a transformer to step up voltage to the level needed for the flash tube; a capacitor to store the built-up voltage until discharge; and a firing device such as a PC connection. Studio units typically have power settings allowing the light output to be changed, multiple sockets for several flash heads, and built-in slaves. Most allow varying power settings from head to head (called splitting) to allow for balancing fill to main light, and so on.

Radio slave. Remote flash trigger activated by radio transmitter. Used to set off a flash beyond the range of a photoelectric slave or infrared trigger, or in situations where a photoelectric device could

be fired inadvertently by other flash users, such as at a wedding.

Reflector. Panel used to bounce light into the subject's shadows to reduce the contrast between shadows and highlights. At its simplest it can be a sheet of white poster board, cardboard, or foam-core. Commercial reflectors consist of lightweight collapsible frames over which white or metallized cloth is stretched. May also mean the shaped metal attachment used to aim and concentrate light from a flash or tungsten lamp head; also called a flat.

Seamless. Wide roll of matte paper, supported by a stand, unfurled down to the floor or other shooting surface to provide a plain backdrop for working in a studio. Available in white, black, gray, and a wide variety of colors and patterns.

Slave. Photosensor that triggers a flash whenever another flash fires. Many studio strobe systems have built-in slave triggers. Small accessory slaves also can be connected to individual flash units.

Snoot. Cylinder or cone used to narrow the beam of a light. Used for accent lights such as hair lights.

Softbox. Box-like enclosure for a studio light with white walls on the sides and a diffusion panel on the front, designed to produce even, soft lighting. Very popular for portrait lighting, softboxes are available in soft-sided portable folding units

for lights and rigid-sided, permanent fixtures for the studio only; also called banklight.

Strip light. Long, narrow softbox used to throw diffused light on tall narrow areas or to light wide, shallow product still lifes, among other purposes.

Strobe. A type of photographic lighting that illuminates the subject with a strong, instantaneous burst of light; also the term used to describe such lighting units. Strobes come in many forms, from tiny self-contained units built into cameras to large, powerful models for studio use in which the strobe "head" and power pack are separate components. One of strobe's advantages is that it matches the color of daylight, allowing it to be used with daylight-balanced films with little or no filtration, and/or mixed with existing daylight. Its short burst also makes it valuable for freezing moving subjects.

Sweep. Gently curving backdrop made of rigid translucent white material such as acrylic, used for photographing products, still lifes, and so forth.

Tent. Enclosure of translucent white material, usually cloth, draped around an object and lit from the outside from several angles. A tent provides very soft, nearly shadowless illumination useful for photographing shiny objects that would otherwise reflect the surroundings. Usually have a narrow opening to allow the camera lens to poke through.

Umbrella. Folding reflector that looks and opens like a conventional umbrella and is used as a light-bouncing device. Umbrellas with silver interiors provide more reflection and stronger modeling of the subject; gold interiors do the same plus add a warmth to color photographs. Plain white umbrellas are sometimes used as diffusion screens, with studio lights trained through them.

Umbrella mount. Bracket or clamp used to attach an umbrella to a lighting head.

and a sharp, flash-frozen image is so appealing visually that it has become popular in applications ranging from studio photography to photojournalism.

Rear Curtain Synchronization The technique of mixing flash and existing light can be used for special effects above and beyond filling in dark shadows. Especially in lower light levels, it can help create a more powerful sense of motion with moving subjects.

To achieve the effect, set a fairly slow shutter speed—perhaps 1/8 or 1/15, though 1/30 or 1/60 may work with a fast-moving subject. This causes the existing-light portion of the exposure to be recorded as a blur. If the blur is due to camera movement—the result of shooting hand-held—you'll get an overall streaking or softening of the subject layered with a sharp, flash-frozen image. You can deliberately move the camera during the exposure if your own hand tremors don't create enough blur to suit your purposes.

If the blur is due to subject movement, you'll get more localized streaks and greater overall sharpness, especially in the background. Shoot at a couple of different shutter speeds to be sure you get the effect you want. In many cases, the best result is a combination of camera and subject movement.

If creating a sense of motion is your aim, the point at which the flash fires is critical. With standard synchronization, a flash is triggered immediately after the shutter curtains open. This means that any existing-light blur is recorded after the flash exposure. Because the subject continues to move after the flash is fired, any streaks appear in front of the subject. This may actually detract from the sense of forward motion.

To address the problem, more and more flash units have a feature called **rear-curtain synchronization.** With rear-curtain sync, the flash doesn't fire until the instant before the shutter closes, so that the existing-light exposure precedes the flash exposure. This means that any blur is recorded before the flash fires—and thus appears to trail the subject, enhancing the sense of it moving forward.

With that sequence of events, the main thing you have to worry about is where in the frame the subject will be when the flash goes off, since there is a lag between when you push the shutter button and when the flash fires. (The slower the shutter speed, the longer the lag.) Many dedicated flash units offer both automatic fill-flash and rear-curtain sync capability, a combination that allows you to create a sense of motion quite effortlessly.

WORKING IN THE STUDIO

Not long after the invention of the medium, photographers began experimenting with lighting methods in controlled environments—and the photo studio was born. Studio lighting is simply a craft that involves controlling the light to produce specific visual effects. Where the existing-light or candid photographer may go through considerable darkroom (or computer) manipulation to produce a photo with balanced tones, the studio photographer generally exerts this control before the picture is taken. The output from studio lights is therefore carefully measured and balanced so as to produce exactly the range of highlight and shadow detail you want in the final picture—a particularly crucial step with color transparency film, which has a limited recording range from light to dark

areas of the scene and is almost always the final product of your efforts.

Studio lighting design—whether for portraits, still life, or fashion—has the same starting point as photography in existing light: controlling the quality of light. This section concentrates on the use of different types of artificial light— electronic flash, or photoflood and quartz bulb-type lamps—and focuses on portrait lighting, which encompasses almost every technique used in studio lighting.

The decision about what kind of lighting to use depends ultimately on the purpose of the picture, its intended audience, and the personal style of the photographer. While soft, diffused lighting may be appropriate for a "romantic" portrait, fairly hard light emphasizing the weathered features of an experienced corporate executive may be the right look for a company's printed material. Brilliant hard lighting might give strong form to the innards of a pocket watch, while soft, diffuse lighting might highlight the subtle pastels of a still life of silk scarves. But as with any kind of decision in photography, there are no immutable rules for lighting, and the many formulas that do exist are being challenged by photographers all the time.

POSITIONING LIGHTS

In addition to the quality of light, the direction from which light hits a subject is a critical factor in the way the subject appears in the final photograph. Direction is controlled simply by where you position the lights—with the following typical positions: main light, fill light, and accent and background light.

Main Light The strongest and most significant light illuminating a studio scene is called the **main light** or key

rear-curtain synchronization Flash feature that times the flash so that it fires right before the shutter closes, instead of right after it opens.

main light Light source that provides a scene's primary illumination; also called key light.

A good studio portrait can be made with a single light source, but multiple lights can produce a greater sense of volume and texture. When you use more than one light, you must take care to avoid distracting double shadows—and doing so is often a matter of carefully building up the overall effect. In this series, the photographer first lit the subject from the left with a main light (top row, left). This light strongly defines the subject's facial features but creates unflattering shadows. To brighten those shadows, the photographer added a fill light of about half the strength of the main light, placed in front of the subject near the camera position (top row, right). The dark side of the subject's head still merges into the background, though, so the photographer aimed a third light at the subject from behind and to the right. This rim light glances off the subject's edges, creating an outline that helps separate him from the background (bottom row, left). To make the shape of the subject's head stand out more strongly, the photographer then aimed a background light at the surface behind him (bottom row, center). Finally, to give the subject's head even more definition, the photographer added a fifth light, called a hair light, aiming it from behind and above the subject (bottom, right).
Courtesy of Bob Hower/Quadrant

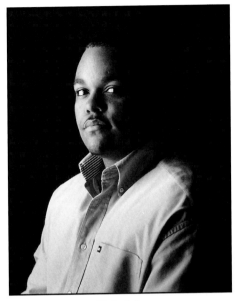
Main light

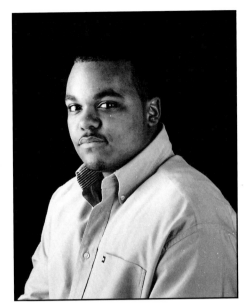
With fill light

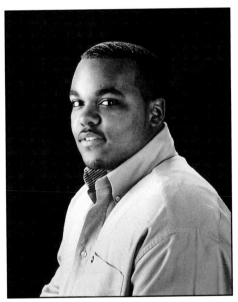
With rim light

With background light

With hair light

45 up/45 out Describes main light positioned at a 45° angle both horizontally and vertically relative to the subject.

light. The type, size, height, and direction of the main light largely determine whether the overall effect of the lighting will be soft or hard, or somewhere in between.

The first and most important consideration in the placement of the main light is its position relative to the subject—both horizontally and vertically. The most common placement of the main light for portraiture (and many other applications) mimics the illumination of mid-morning or mid-afternoon sunlight. The light is placed at a 45 degree angle out from the subject on the horizontal plane. It is then elevated so that it points down at the subject, also at a 45 degree angle. This setup is sometimes called **45 up/45 out** placement. The shadows cast by this type of light emphasizes dimen-

sionality and illuminates about three-quarters of the subject directly. With a portrait subject, shadows are cast under the nose, under the cheekbones, and under the chin—modeling the face in different planes without the excessive eye-socket shadows you'd get with more overhead light, and without the greater contrast you'd get if the light was placed on the side of the subject.

Bob Hower

Steel Worker, Trinec,
Czech Republic, 1991

Taken with a single flash unit, Hower's image proves that effective portraiture doesn't require complex lighting setups or posing. An accomplished studio photographer, Hower was able to create this powerful location portrait simply by placing the flash off-camera slightly to the right and using a slow (½ second) shutter speed to capture more existing light, which kept the background from becoming too dark. © Bob Hower/Quadrant Photography

TESTING: POLAROID OR DIGITAL

The traditional method of testing lighting and exposure in the studio is to take a shot on Polaroid instant film. Polaroid film holders are available for large format view cameras and nearly all medium-format cameras. Polaroid attachments for 35mm cameras are less common, but available for some models.

While the color and contrast characteristics of Polaroid film are considerably different from conventional films, a "Polaroid" provides a useful check. The Polaroid shows if all the lights are firing, if the flash is synchronizing with the shutter, if the exposure is good, if the lights are in proper balance, and how the composition looks in two dimensions. Polaroids are also used to get art director's approval as well as preliminary client OK.

Polaroid tests, however, are also time-consuming, expensive, and messy. The advent of digital studio systems is revolutionizing the process of exposure testing and picture approval. Using a digital back on a large- or medium-format camera, a photographer can view a studio image nearly instantly on a computer monitor. The image can be sent in low- to medium-resolution form within minutes to an offsite art director or client via e-mail. A photographer or art director can make suggested changes electronically, using image-editing software, and retransmit images for approval. If the final image is to be in digital form—as is sometimes the case in catalog and still-life photography—the job is done then and there, with no need to expose and process film.

Polaroid sheet film, also called peel-apart film, allows photographers to shoot tests to evaluate exposure, composition, and the effect of lighting before taking the final shot on conventional film. After making the exposure and waiting from 30 seconds to a minute or more for the image to develop, you peel apart the two halves of the Polaroid "sandwich." One half (left) contains the negative and chemicals that capture the image; you discard this half immediately. The other half (right) is basically a small positive print—either black-and-white or color, depending on the type of film.

Studio lighting technique involves a lot of simple solutions that result from direct observation of the light's effect. Eyes are an important part of any portrait, for example, but when a subject wears glasses there is the risk that reflections on the lenses will make it difficult to see his or her eyes clearly (top). The best solution is usually to adjust the position of the lights. Here, the photographer simply raised them higher, studying the subject through the camera until the reflections were eliminated (bottom).

sidelighting Describes main light positioned directly to the side of the subject.

underlighting Describes main light positioned directly in front of and below a portrait subject.

backlighting Describes main light positioned behind the subject.

axis lighting Describes light aimed directly at the subject from the camera position, such as with a camera-mounted flash.

Ordinarily a fairly broad light is chosen for 45 up/45 out placement to get relatively diffuse lighting. Most commonly, an umbrella, reflector, or softbox (see page 227) is used with a large lighting unit, fairly close to the subject, to keep shadows open and contrast down. This traditional placement of the main light is just one of many such strategies in use.

Other types of main-light placement include **sidelighting**, which produces strong contrasts with certain portrait subjects and product or fashion photos. For this effect, place the main light at the side of your subject, level with the person's head. Use a close placement—a few feet—to keep the light relatively soft, or position it at least six feet away for a more hard-edged look. Again, use of diffusion—umbrellas, softboxes, and the like—keeps the light fairly soft.

Underlighting, the placement of the main lighting source below a portrait subject's face, can produce a sinister quality, particularly with hard light; for this reason it is often colloquially termed "horror lighting." By the same token, soft lighting from below used as fill can cause a flattering reduction of dark circles under the eyes; as a result, this type of fill is called glamour lighting.

Even **backlighting** can be used to create a very soft, near-silhouette portrait effect; for this, the main light is placed directly behind the subject, with front reflectors (or weak fill lights) to provide some detail in the face. Place the main light so that your portrait subject blocks it from reaching the camera lens directly. Then, place reflectors (big white panels work well here) to either side of your subject, outside the picture frame, and angle them in to the subject so that

reflected light illuminates them adequately. If you angle the reflectors down at your subject a bit, you can pick up some interesting facial shadows.

Axis lighting—light that is trained on the subject directly from the camera position, such as with a shoe-mount flash—can be used to create a hard-edged effect. This type of lighting has found some favor in fashion work, particularly

with special **ring flash** units. With a ring flash, the flash itself encircles the lens, often creating a soft shadow all the way around the subject's outline.

Fill Light Even with a main light that is quite diffuse, there will still be shaded areas in the picture. Sometimes you may find these shadows acceptable, even desirable for a more dramatic effect. But other times you may think the shadows are too dark, and this is where the second component of studio lighting comes in: **fill light.** The secondary source of light illuminates shadows without brightening them too much.

Fill light can be achieved as simply as aiming a flat reflector at the subject from the other side to bounce light into the dark areas. The same types of reflectors used with sunlight can serve as studio reflectors: flat sheets of white or metallized poster board, foam-core board, or reflective cloth held in a frame. Many superb portraits have been taken with this simple main-plus-reflector setup.

For more control of shadows, though, an additional light is used for fill. This is a light with lower brightness than the main light, aimed in the same way as a reflector card: about 45 degrees out from the subject, on the side opposite the main lamp, and generally level with the subject. The difference between the shadows and the highlights defines the subject's form. If the fill light were the same power as the main light, it would eliminate the three-dimensionality of the lighting because it would fully illuminate the shadows.

The classic **lighting ratio** for portraiture (as with outdoor fill flash) is a fill light one-third the power of the main light. The relationship is expressed as a ratio, so a fill light of one-half power pro-duces a 1:2 ratio; fill of one-third power is a 1:3 ratio, and fill of one-quarter power is a 1:4 ratio. These ratios are set by taking readings with an exposure or flash meter and adjusting light output accordingly: for strong fill (1:2), the fill should read a stop less than the main, for moderate fill (1:3), about a stop and a third less, for slight fill (1:4), two stops. Visually, the fill light should noticeably brighten the shadows but should cast no shadows of its own.

Accent and Background Lights A main source plus fill is perfectly adequate lighting for a variety of subjects—people as well as things. But sometimes, photographers use still more lights to define the subject and separate it from the background. Accent lights and background lights are examples.

An **accent light,** commonly used in portraiture, is a light that is trained at a particular area of the subject. The light's beam angle is narrowed either with a focusing system or a snoot (see page 227); it's typically trained on the subject from behind and to the side in order to create highlights that "rim" the shoulders and hair. (It is also called rim light or hair light for this reason.) This effect makes the subject stand out from the background and creates a more three-dimensional rendering.

Another way to separate the subject from the background is to light the background itself. This can be done with a light held high on a **boom**—a long, counterweighted horizontal support attached to the top of a lightstand—and pointed down on the backdrop behind the subject. Another approach, if the lower part of the subject is not in the picture, is to place a light on the floor directly behind and below the subject, pointed up at the background. The latter method creates a sunset effect in which the background darkens from bottom to top. In general, accent and background lights should be set to no higher an output than a fill light, unless used to deliberately wash out a light background or make a dark background appear much brighter.

TYPES OF STUDIO LIGHTING

Studio lighting can be broadly divided into two types: **hot lights** (also known as incandescent lights) and electronic flash units (also known as strobes, mentioned earlier in this chapter). Hot lights are continuous sources; they burn at a steady output before, during, and after exposure. Strobes, on the other hand, create a brilliant but extremely brief flash of light by sending a high-voltage charge into a gas-filled tube.

Hot Lights Hot lights offer continuous illumination in the studio. You turn them on and leave them on, and what you see is what you get. Being able to see the exact lighting at all times is one of the chief advantages of using hot lights over strobes. In most cases, you'll have to turn off the room lights or risk reducing your lighting control.

Hot lights can be used with long exposure times which lets you move the lights during exposure to "paint" in areas that would ordinarily be shadowed. Also, a frozen picture isn't always desirable. Movement, in fact, is often better depicted by controlled blur, and hot lights are the appropriate system for this, because they don't offer the subject freezing qualities of strobe. Usually, you cannot adjust the output of hot lights as you can with strobes. To increase or decrease the light from a hot light, you have to use screens to cut illumination or

ring flash On-camera flash unit with a bulb that encircles the lens, producing axis lighting.

fill light Light that supplements the main light source, used for such purposes as to brighten shadows on portrait subjects.

lighting ratio Difference between the brightness of highlight and shadow areas in a scene, expressed in stops of exposure.

accent light Describes light aimed at a specific area of the subject to make it stand out, commonly used in portraiture; also called rim light or hair light.

boom Long, weighted, often telescoping horizontal support attached to a lightstand to allow placement of light over the subject.

hot lights Studio lights that emit continuous, steady illumination, such as photofloods, quartz-halogens, and HMIs.

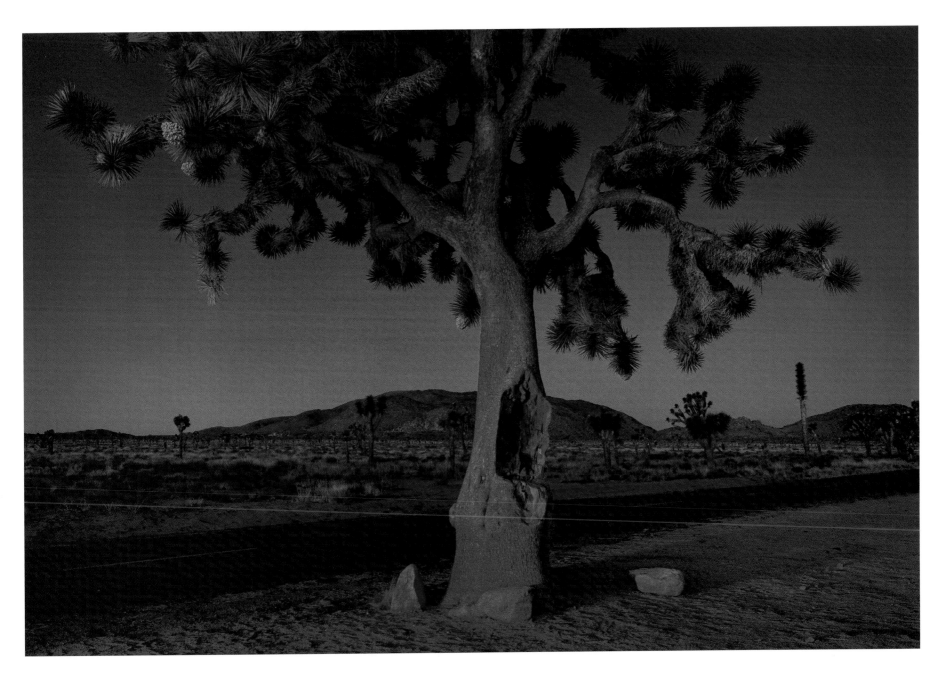

Len Jenshel Joshua Tree National Monument, California, 1990

Sometimes the most interesting light is improvised. For this desert view, Jenshel shot by the brake lights of his car—tinting the subject with red light that could almost be mistaken for the red glow of a rising or setting sun. The dimness of the illumination required that the photographer make a long, tripod-mounted exposure. In Jenshel's work, seemingly commonplace subjects and scenes are often transformed by odd or unusual lighting effects. © Len Jenshel

FEATURES OF STROBE, PHOTOFLOOD, QUARTZ-HALOGEN, AND HMI LIGHT

Strobe Features

- Run cooler than continuous lights, but must be used at relatively slow shutter speeds with focal-plane shutters in order to synchronize.
- Daylight color balance works with the widest variety of color film, without corrective filtration.
- Can be used in combination with daylight with no color balance problems.
- Plug-in units allow power to be divided among several heads from a single power pack.
- Most units allow power variation for balancing output from several strobe heads.
- Instantaneous light prevents blur from slight subject motion.
- Available in portable studio units that can run off battery packs.
- Can be triggered wirelessly.
- Allow "multipop" repeating-flash special effects.

Photoflood and Quartz-Halogen Features

- The light you see is the same light that will illuminate the final photograph, but they run hot and can melt lighting accessories like gelatin or acetate filters or plastic snoots.
- Can be used with all shutter speeds and all types of shutters.
- Allow use of slow shutter speeds for deliberate blur, streaking, and other effects.
- Tungsten color film balance limits use of color films to tungsten types, unless corrective filtration is used or unbalanced color is desired, but allows use in conjunction with household lamps without producing variations in color.
- Can produce unwanted color casts when used in conjunction with daylight.

HMI Features

- Many of the advantages of photofloods and quartz-halogens, but more expensive.
- Daylight color balance works with widest variety of color films.
- Run somewhat cooler than equivalent photoflood or quartz-halogen lights.
- Light output is far greater than a photoflood or quartz-halogen lamp of equal wattage.

change the distance between the light and your subject.

Bear in mind that hot lights are aptly named—the bulbs and the surface of the light's housing reach extremely high temperatures and must be handled carefully. They also tend to heat up the set—and your subjects. Grip hot lights only by the handles or knobs built into them; never touch the bulb or metal parts around the bulb. If a hot light on a stand tips over, let it fall. You could burn yourself if you reach for it.

Hot lights include three major categories, increasing in cost and sophistication (and, for the most part, brightness) as follows:

- **Photofloods** are tungsten-filament bulbs in a screw base; they resemble household light bulbs except that they are larger in size and higher in wattage. Most types come in frosted white and have a 3200K color temperature for use with tungsten-balanced color films. Photofloods are usually used with metal reflectors, though they also are available in a conical shape that lessens the need for reflectors.
- **Quartz-halogen** lights use quartz-filament bulbs filled with an inert gas that makes them burn longer and at a more consistent color temperature. Their light is also intended for tungsten-balanced films.
- **HMI** lights use high-efficiency xenon gas-discharge lamps. Producing light from the glow of gas through which electrical discharges are pulsed at high speed, they have considerably higher output per watt than quartz-halogen lamps (and are much more expensive). They are also balanced for daylight color films, which is

photofloods Type of hot light that is tungsten-balanced and uses a filament bulb in a screw base, similar to household light bulbs; also called floods.

quartz-halogen Type of hot light that is tungsten-balanced and uses a quartz bulb that burns longer and at a more consistent color temperature than photofloods.

HMI Type of hot light that is daylight-balanced and uses xenon gas-discharge lamps that burn brighter than floods or quartz-halogen lights.

another reason HMIs are finding increased acceptance in photographic work.

Strobe Lights The overwhelming favorite light source for studio photographers, a **strobe** illuminates your subject with a brief, strong burst of light when you press the shutter button. The flash from a strobe is instantaneous—the longest-peak studio units fire a pulse that lasts about 1/300, while small, automatic units can fire a pulse 1/10,000 or faster.

Because of these high speeds, strobes freeze action. Whether capturing dance movements or ensuring that slight movements of a portrait subject don't blur the shot, strobes provide an almost certain action-stopping effect. And they run cool, so they don't raise the temperature of a set nearly as much as hot lights.

The burst of light from a strobe is so short that you cannot see exactly what the lighting is. To aid your judgment, most units include **modeling lights.** These are built-in incandescent lights that remain on during use and approximate the illumination of the actual strobe pulse, though the illumination is much weaker. While they are rarely perfect, modeling lights do provide a fairly accurate preview for judging light placement and other factors.

Most strobe lights offer adjustable output. For example, you can have your main light firing at full power, while the fill light is at half or quarter power or less. Because the illumination of strobes is quite high relative to existing room light, you generally do not have to turn off room lights when shooting by strobe.

Strobes come in a wide range of types, as follows:

- **On-camera** (shoe-mount or handle-mount) units are portable flash units, designed primarily to operate on small cameras, such as 35mm SLRs, usually attached to a "hot shoe" electric fitting on top of the camera body, or on a bracket attached to the camera. On-camera flash is designed primarily for work outside the studio. Many such units, however, employ connector cords or even wireless triggers that allow the units to operate automatically when attached to an umbrella or other lighting accessory, and these can be pressed into service for occasional light-duty studio work.

- Bulb-base units are inexpensive small strobes that can be screwed into a standard household bulb socket. These manual units operate by PC connector cord or slave (see pages 216 and 227, respectively); some even have modeling lights. These units also tend to be fairly short on power and coverage.

- Portable studio strobes consist of small light heads that attach by cable to rechargeable-battery power packs. They accept a wide range of studio lighting accessories, though they are generally smaller in size than their larger studio units.

- **Monolights** or monoblocs are moderate- to high-power AC strobe units that contain all their power-pack electronics within the lamp head housing.

- Plug-in or power-pack units use individual strobe heads that plug into a

central AC power pack that regulates and distributes voltage. They range from small portable kit devices to very large and powerful studio units. Most of these allow several flash heads to be plugged into a single power pack, with voltage split among the units.

Mixing Strobe and Hot Lights
Strobes and hot lights are not mutually exclusive. Studio photographers often take advantage of the differing color temperatures of the lights in creative ways. They may add quartz-halogen fill to a strobe shot, for example; because daylight film is color balanced to match flash and daylight, the quartz light will show up as a warm, reddish-yellowish undertone. Similarly, a photographer may use tungsten-balanced film and light certain parts of the subject with strobe, creating a strong bluish effect. Even more exotic effects can be achieved by placing a colored "gel" filter over the lights to achieve different color casts in different parts of a picture.

Strobe and hot light can be mixed for another popular effect: flash ghosting, and its specialized application, trailing synchronization (see rear-curtain synchronization, page 228). If a moving subject is photographed at a slow shutter speed with both electronic flash and continuous light, the main subject will appear as a sharp image (the flash exposure) within a blurred, ethereal "ghost" secondary image (the slow exposure by the continuous light). This technique is popular in fashion and advertising photography. With trailing synchronization, the flash is fired at the end of the long exposure, which results in a blurred ghost extending behind a moving object.

strobe Electronic flash, providing brief, intense bursts of light; often refers to studio flash units.

modeling lights Incandescent lamps built into strobe heads that remain on during use, helping photographer preview the strobe light's effect.

on-camera Refers to portable flash units that fit directly on the camera body's hot shoe (known as shoe-mount) or a bracket attached to the camera body (known as handle-mount).

monolights Electronic flash units that incorporate flashtube and power pack in a single unit that is mounted on a lightstand.

JOHN LOENGARD
The Negative Project: Henri Cartier-Bresson's
Behind the Gare St. Lazare, 1932
Hands: George Fevre. Paris, May 11, 1987

John Loengard's photograph of the negative to one of Henri Cartier-Bresson's most famous images is illuminating—literally. The acknowledged master of the "decisive moment," Cartier-Bresson shot the picture through a fence that blocked part of the view, creating a clear band on the left that he cropped out in printing. The negative was later cut from its 35mm strip for safekeeping during World War II, a trimming that may also account for the missing sprocket holes on one side. A long-time Life *magazine photographer and picture editor, Loengard made the image as part of a project to document important negatives, work published in a book called* Celebrating the Negative. Copyright © John Loengard

Many photographers use commercial labs for processing film and making prints. This is especially true when they are photographing in color; very few process their own color films. However, many photographers do process their own black-and-white film and prints—and even their color prints themselves. You can too, if you have access to the right equipment and an efficient **darkroom.**

Processing your own film and prints offers several advantages. It's usually less expensive, provided you use processing solutions and printing paper efficiently. It also offers more control over the final results, once you have the experience to achieve what you want. Some photographers even enjoy darkroom work more than photographing.

There are some disadvantages to doing your own processing. It's time consuming. It also can be expensive if you don't work often enough, since equipment is costly and solutions and papers may go bad over time. And for a very few individuals it can be unhealthy, especially for those with certain allergies and respiratory problems (see accompanying box).

Whether you choose to do your own processing or not, it's useful to know what goes into processing film and making prints. This will give you a better basis for providing instructions to, or judging results from, a lab. It also may give you a better sense of what you're doing right and wrong when photographing.

A darkroom is the room (or rooms) used to process film and/or make prints. The term is really a misnomer because darkrooms are not always kept dark, but they do need to be light-tight. For example, you load 35mm film for processing into a light-tight tank in total darkness, but you can turn on the lights after closing the tank. You must work by dim reddish or amber (or other colored) light when processing black-and-white prints, but these **safelights** provide enough illumination so you can actually see what you're doing.

Ideally, a darkroom should be a dedicated room, used only for that purpose. However, many photographers manage to do good work with makeshift dark-rooms—closets, kitchens, small bedrooms, bathrooms. If you must use a makeshift darkroom, take extra care to ventilate it when handling processing solutions; this may be difficult in closets and other rooms with no window. In particular, don't mix chemicals in kitchens or other rooms where food is prepared, and keep mixed and stored chemicals safely out of the reach of children and pets.

Rather than build your own darkroom, you may find it most practical to rent

darkroom Room for processing photographic film or prints, often light-tight to allow handling under a safelight or in total darkness.

safelight Bulb and/or fixture in the darkroom that emits red, amber, or other colored light. Certain light-sensitive photographic papers and a very few films can be handled safely under this light.

DARKROOM HEALTH AND SAFETY

Most individuals have no trouble working safely in the darkroom. However, you must take care when using any chemicals. With photographic chemicals, some of this care is simply common sense. But even if you use common sense, you could have problems due to the nature of the chemicals. Some are mild irritants and others, such as some color processing chemicals, are more toxic. Here are some basic darkroom safety rules.

1. Work in a well-ventilated space and limit inhalation of chemical fumes as much as possible.

2. Don't eat or drink or allow food or beverages in the darkroom since they can absorb airborne chemicals, and you may then ingest them. Also, avoid biting your fingers or nails, and wash your hands fully after you finish in the darkroom, especially before you handle food.

3. Keep solutions in unbreakable containers—plastic or stainless steel, not glass.

4. Carefully follow instructions when mixing any chemical.

5. Store chemicals safely, below eye level, to avoid splashing. Keep them away from children and pets.

6. Wear rubber gloves when mixing and handling chemical solutions.

7. If chemicals get in your eyes, wash them out with a steady flow of running water for 10–15 minutes.

If you do have a serious reaction to any chemical, call your doctor for advice. The most common complaints are dry skin (usually relieved by applying skin cream), skin rashes (change developers and wear protective gloves), shortness of breath (exacerbated by respiratory problems due to colds, flus, allergies, and smoking), and dizziness (take regular breaks from the darkroom). It's rare but not unheard of for an individual to be allergic to particular chemicals.

darkroom space from another photographer or from a school or other institution. Schools that offer part-time courses in photography often include darkroom use, which may be worth the price of tuition.

For a proper darkroom, the room must be effectively darkened. You can block out windows with sheets of plywood or cardboard. Or you can buy special opaque window shades or just tack up opaque rubberized cloth, available from professional camera stores and select mail-order suppliers. Whatever material you use, block out light leaks around its edges or around the door with weatherstripping or opaque tape. Also, make sure to install a good ventilation system to replace chemically laden air with fresh air every few minutes.

You also should have plenty of solidly built counter space and shelves to hold an enlarger and the other required equipment, chemicals, and materials. Running water is not absolutely necessary, but it's a big plus. If running water is not available, you can use pails to carry water into the darkroom for mixing solutions and washing processed films and prints. You can buy darkroom sinks made of rubber, plastic, or stainless steel. Or you can make your own for relatively little cost using plywood and waterproofing it with a coat of epoxy paint or fiberglass.

Aside from a room to work in, you'll need equipment. See pages 240–241 for a list of required darkroom equipment for film processing and pages 286–287 and page 331 for required darkroom equipment for print processing.

PROCESSING FILM

Photographers are far more likely to process their own black-and-white negatives than any other category of film

(color negatives, color transparencies, or black-and-white transparencies). There are several reasons for this. It's a fairly simple process that doesn't even require a darkroom. Good lab processing of black-and-white film is relatively costly and dependent on the quality of the lab; some do excellent work and others do spotty work. Also, black-and-white processing is less standardized than other film processes. For example, the choice of **developer**—the chemical that causes the exposed image to appear—and how it's diluted can have a critical effect on the final results, and a lab may or may not offer the developer and dilution you want. You also can choose to adjust the development time (increase or reduce it) to produce negatives with a little more or less contrast (see pages 255–263); professional labs will do this for you for an extra charge, but you can do it yourself quite easily and often with better results.

While you can buy processing kits with all the needed chemicals for color film, for black-and-white film you must buy individual chemicals. There are a lot of choices from different manufacturers, and you can buy in small quantities or in bulk, which is a significant cost saver. The chemicals have a long shelf life if stored properly.

Processing black-and-white film on your own is a routine matter. With 35mm and medium-format rollfilms, you load the exposed film onto a spiral reel, then place the reel in a light-tight processing tank—all in total darkness. Then you turn on the lights and pour a succession of solutions in and out, "agitating" the tank by inverting and rotating it at specified intervals. With sheet films, you use either trays or deep tanks to hold the film and the processing solutions.

The procedure is largely automatic if you have access to an automated processor. You still have to mix and pour the required chemicals and load the film onto reels. Then the processor takes over such tasks as agitating, changing solutions, washing, and even drying the film—all the while keeping temperature at a constant level. (There are various models of automated processors, offering a range of features with semi- to fully-automatic operation.)

GENERAL INSTRUCTIONS

Processing is routine, but it's also subject to error. You might load the film incorrectly on a reel or turn the lights on before the reel is in its tank. Or you could mix or measure chemicals inaccurately, use them out of order, or lose track of the developing time. And you can inadvertently scratch, nick, or otherwise physically damage the processed film. With all these possibilities for error, you must take special care when film processing. Mistakes made at this stage may lead to unprintable negatives.

These are general steps for processing 35mm and medium-format (sizes 120 or 220) films. More specific steps follow for both black-and-white and color films, and for processing sheet films, as does an explanation of what each step actually accomplishes. Note that given processing times are approximate. They will vary with many factors, including the brand of chemical used and its dilution; refer to packaged instructions for specifics.

Loading Film on a Reel

The simplest way for an individual photographer to develop rollfilm is to load it onto a reel in total darkness, and place the reel in a light-tight tank. Once you've

developer Chemical that brings out the exposed image by converting the emulsion's light-sensitive silver compounds to metallic silver.

After it has been exposed in the camera and rewound, you must remove the film from its cassette for processing. Turn off the lights and use a bottle opener to pry off the metal cap on the flat end of the cassette—the one opposite the protruding spool.

Once the film is removed from its cassette, press your fingers against the ends of the spool to keep it from unraveling and cut off the curved film leader at the end of the roll. Try to cut in between the sprocket holes, so that the film's leading edge is smooth all the way across. This may make it easier for you to roll the film onto the processing reel.

done this, you can close the tank, turn on the lights, and go to work. Processing tanks have a light trap that allows solutions to enter while keeping light out.

This sounds easy enough—and it is—but loading film on a reel in total darkness takes getting used to. Practice in room light with a dummy roll of film. Once you have the idea, close your eyes and practice again before trying with a roll of exposed film.

There are two common types of processing reels and tanks—plastic and stainless steel. Both types work on simi-

lar principles, but one loads a little differently than the other. Also, consider that there are different brands of each type and these may vary slightly in how they operate.

Regardless of the type of reel and tank, you must load the film in a light-tight room or a special photographic changing bag. The room should have a counter or some other surface to hold the film and processing equipment. Follow these directions to load 35mm film:

1. Clean the counter and make sure it's dry before you proceed.

2. While lights are on, place all the things you need for film loading on the counter so you'll be able to locate them in the ensuing darkness. This includes your roll(s) of film, reel(s), processing tank, pair of scissors, and bottle (or other) opener.

3. Turn off the lights; the remainder of the steps must take place in total darkness. Open the roll of film. For 35mm film, pry off one end of the cassette with the opener; you can just pull or unscrew the end off some types of cassettes. Then push the spool holding the film out of the cassette. The film is tightly wound on the spool; hold it to keep it from unwinding if possible.

4. Take the scissors and cut off the leader (the short, tapered end at the beginning of the roll of 35mm film). Cut as evenly as possible across the film; try not to cut at an angle. Cutting between the sprocket holes, rather than through them, will reduce the chance of the film's front edge snagging on the reel, especially if you're using plastic reels.

5. Put down the scissors and hold the film almost at its end between your thumb and forefinger of one hand—usually your right hand if you're right-handed and left if you're left-handed. Pinch the film very slightly so it will curve down, and try to handle it by its edges only; this can be awkward at first, but you'll get used to it with experience.

If you are using plastic reels, proceed with steps 6–10:

6. Insert the cut end of the film into the slot located on the outside rim of the reel.

7. Push the film in until the sprocket holes engage on ball bearings inset into the reel's outer rim.

8. Hold the film and reel over the counter and grasp the reel with two hands. Try to keep the film in the palm of one of your hands, but you can let it drop onto the counter, if necessary.

9. Rotate the sides of the reel back and forth in a ratchetlike motion; as you turn one side away from you, turn the other toward you. This motion will automatically thread the film into the coils of the reel, starting from the outside of the reel and moving toward the inside.

10. When you have wound the entire roll of film onto the reel, remove the spool. Some types of film are held to their spools with tape, which must be cut or torn off; other types are held in a slot in the spool and easily pull off.

FILM-PROCESSING EQUIPMENT

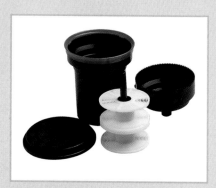

Processing tank and reel. These are the primary pieces of equipment for processing 35mm and other roll-films. The top of the tank has a light trap that allows solutions to enter while keeping light out.

Tanks and reels come either in plastic or stainless steel. You may find it easier to wind film onto plastic reels—they are virtually self-loading—but the plastic tends to wear out more quickly.

You must use the right size reel for your film—either 35mm or medium-format rollfilm. Steel reels come in one or the other; most plastic reels are adjustable to either film size. Processing tanks also come in different sizes. Some tanks hold one reel only, while others hold multiple reels for processing several rolls at the same time. For 35mm film, tanks usually hold one to four reels; even larger tanks are available, though large tanks are more awkward to handle and use.

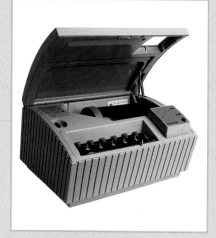

Automated processor. Most individuals process film in tanks and reels, but schools, some professional labs, other institutions, and a few individual photographers use automated processors. There are several types, but all offer a degree of automation and consistency—useful features for black-and-white processing and especially for color film processing.

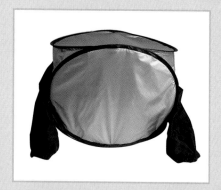

Changing bag. These light-tight pouches or tents are useful when you don't have a darkroom in which to load film onto reels and into your processing tank. A typical model has a zippered opening for the film, tank, reels, scissors, bottle opener, and two light-tight sleeves for your hands to manipulate the film.

Protective gloves. Plastic or rubber gloves keep physical contact with chemicals to a minimum, though some photographers find them awkward to work with. This especially helps people whose skin is sensitive (or even allergic) to photographic chemicals. Virtually any type of protective glove will do.

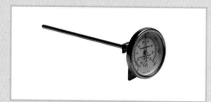

Thermometer. Temperature is a critical factor when processing film, so you'll need a good thermometer to monitor solutions, both when mixing and when using them. Analog and digital models are available; the latter are easier to read accurately but generally more expensive. In any event, use a thermometer made for photographic processing in order to assure a wide measuring range—from about 25° to 125°F. If you process your own color film, you'll need an especially good thermometer since temperature control is even more critical with color materials than with black and white.

Scissors. Any good pair of small scissors will work for cutting film.

Bottle opener. You'll need the blunt end of an opener to open 35mm film cassettes in order to remove exposed film from them. There are several types available, but a church key-type bottle opener is inexpensive and is easy to use.

Graduate or beaker. You'll need graduated cylinders (graduates), or beakers of various sizes to mix and measure processing solutions accurately. Most photographic beakers come in plastic, though stainless steel and glass are also used. Required sizes depend on the quantity of solution needed, but usually a one-gallon (128 ounces), 64-ounce, and/or 32-ounce graduate will do to mix the working solution—plus a smaller graduate (6-ounce or less) to mix smaller quantities with precision.

Consider buying five large beakers and dedicating each to a particular solution. For processing black-and-white film: developer, stop bath, fixer, fixer remover, wet-

ting agent. This minimizes the likelihood of chemical contamination and makes mixing and using solutions a little easier; simply mix the working solution in a graduate and use it directly without transferring it to another container. (You can write the name of the dedicated solution on the side or bottom of the graduate with a waterproof marker.)

Stirring rods. You will also need plastic stirring rods (available in camera stores) to mix chemical solutions.

Storage containers. You can mix and save most film processing solutions in plastic containers; make sure the cap screws tight. Collapsible or squeezable plastic containers are best to keep air out. Make sure containers are chemically resistant and clean; keep fresh and used solutions of the same chemical in separate containers.

Funnel. You'll need a funnel for pouring in the solutions if you use storage containers with a small opening.

Timer. You must carefully time each processing step. You can use a standard clock or watch that measures minutes and seconds, but darkroom timers are preferable, since they count down from a specific time and then stop automatically; many models emit a sound when the set time is up.

Film washer. You can wash film on its reel in a processing tank or beaker, but film washers are a little more efficient. Most are made of heavy, clear acrylic or stainless steel and have a hose at the bottom that pushes running water over the top to guarantee a fresh supply for a thorough wash.

Towel. You should have a few old towels or rolls of paper towels available for a variety of darkroom uses—in particular for drying your hands (after washing them) before handling negatives, printing paper, and equipment. They are also useful for wiping up chemical and water spills.

Sponge. You can use a soft sponge (or chamois or other soft cloth) to remove excess solution from the film before drying. Special soft photo sponges are available for this purpose. There is some disagreement about whether you should use a sponge or not; improperly used, a sponge could cause film scratching and/or chemical contamination. (If you use a sponge, soak it with wetting agent before using and store it between uses in a well-sealed plastic bag to keep out dust and other contaminators.)

Drying cabinet and film hangers. There are special cabinets made to hold drying film. These are great for keeping film dust free. Most commercially available models are heated for faster drying. If you don't need the speed, air dry the film or keep the heat at a relatively low set-ting to prevent curling. If you don't have a film-drying cabinet, you can fashion your own at a far less cost using freestanding cabinets available in department stores, or you can use a piece of string or light gauge wire in the darkroom (or any room); stretch it taut, like a clothesline, with film clips (or spring-type clothespins) to hang the film from the wire.

Negative and slide storage pages. You should store dry negatives and slides safely to protect them from scratches, dust, and other physical damage. There are many types of storage materials available. The most common are pages made of clear plastic, with separate slots for individual strips of film or slides. Place the pages in a box or notebook (if pages have holes) for further protection.

Waterproof marker. You'll need waterproof markers, to write on plastic containers or on plastic storage pages—for example, to identify or caption your subjects.

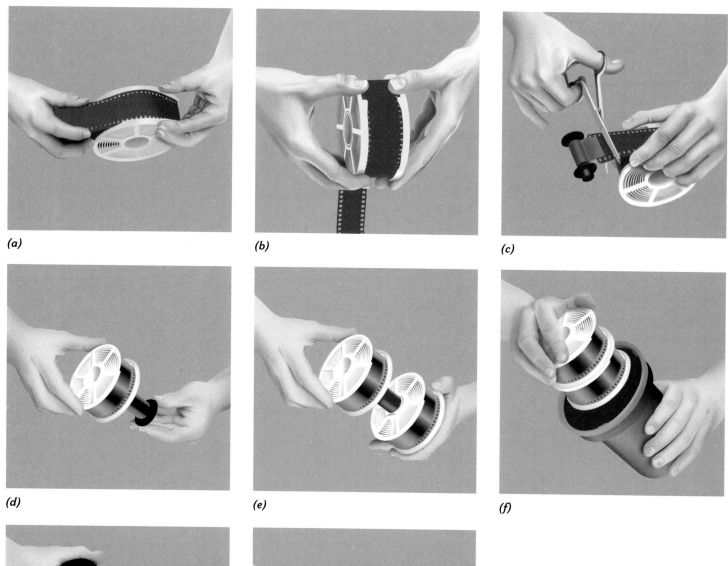

To load film onto a plastic reel, clutch the spool in the palm of your hand and slip the leading (cut) edge into the notches on the reel's rim. Slightly squeezing the edges of the film to keep it from curling, push or pull it in far enough to make its sprocket holes engage the inset ballbearings in the rim (a). Then grasp the sides of the reel and rotate them slowly back and forth in opposite directions; in other words, turn one side toward you as you turn the other away (b). Continue until the whole roll is threaded onto the reel. Then, cut or pull the end of the film off the spool and rotate the last bit of film onto the reel (c).

Next, slide the loaded reel fully onto the plastic center tube (d). Load any additional reels (e) and place them on the tube, then drop the reels and tube into the processing tank (f). Place the light-tight top on the tank, making sure that it screws and/or clicks securely into place (g). Then put the watertight cap on the tank (h).

To load film onto a stainless-steel reel, clutch the spool in the palm of your hand and hold the reel so that the end of the coil faces the hand holding the film. Then slip the leading edge of the film into the slot or clip in the center of the reel (a). Gently squeeze the edges of the film so that it's slightly arched in the middle, and start rotating the reel away from the film so that it is threaded onto the spiral coil (b). When you reach the end of the roll, cut or pull the end of the film off the spool (c). Then drop the reel into the tank (d), adding other reels to fill it, and push the light-tight top with its watertight cap securely onto the tank (e).

(a)

(b)

(c)

(d)

(e)

If you're using stainless-steel reels, follow steps 6–10:

6. Position the reel so the end of the spiral coil (on the outside rim) faces the hand holding the film (see illustration). If the end of the spiral faces away from the hand, the film won't load properly on the reel. Insert the cut end of the film into the slot or clip located in the center of the reel. Note that different types of stainless-steel reels have different types of slots and clips. Some are narrow with a sharp point to grab the film and hold it in place, while others have wide-open slots that hold the film in place.

7. Carefully squeeze the film's edges so that it's slightly arched in the middle. If you imagine the reel is a clock, the film enters at three o'clock if you're holding it in your right hand, or nine o'clock if you're holding it in your left hand.

8. Place the reel upright (preferably on the counter) and turn it counterclockwise if you're holding the film in your right hand, or clockwise if you're holding the film in your left hand, for about one full turn. Use your other hand to hold the film steady to help feed it into the reel. Turn the reel only, not the film, and make sure the film enters the reel straight on (not at an angle) and remains slightly arched.

9. Keep turning the reel on the counter until the film is wound completely around. The end of the film will be at the outer rim of the reel and even may extend beyond the end of the spiral a little bit with a 36-exposure roll; the end of a 24-exposure roll (or other shorter length) will fall short of the outer rim. During loading, check a few times for a slight amount of slack in the film. If you don't feel that slack, there may be a problem with the loading.

10. When you have wound the entire roll of film onto the reel, remove the

spool. Some types of film are held to the spool with tape, which must be cut or torn off; other types are simply held in a slot in the spool and easily pull off.

Follow these instructions regardless of the type of reel you use:

11. Place the loaded reel in the processing tank. With stainless-steel reels you just drop them into the tank one by one; with plastic reels you slide them onto a plastic center tube, which is critical in keeping film protected from light, and then lower them all at once into the tank.

12. When you've loaded all your film, or when the tank is full, put the top on the tank. If there is room in the tank—for example, if you're only developing one roll in a tank that takes three—fill the tank with empty reels. This prevents the reels from floating up and down during agitation, which will help to achieve consistent development.

13. Turn on the room lights and begin processing.

If you're using 120 or 220 rollfilm you must have the appropriate size reels and tank. Reels for 120 film are about twice as wide as 35mm reels, but they fit in the same tanks; a tank handling two 35mm reels will typically handle one 120 reel. Reels and tanks for 220 film are harder to find; they are larger than those for 120. This size film is usually used by professional photographers who will send the film to a lab for processing.

The instructions for winding 35mm and rollfilm on reels are about the same. The main differences are in handling the film. Rollfilms are wider, so they are easier to crimp or otherwise physically

damage. Also, 120 rollfilms are protected from light by a paper backing, unlike 35mm films, which are covered by a light-tight cassette. You must separate the film from its backing while it's being rolled onto the reel. This is a little awkward and takes getting used to.

MIXING CHEMICALS

The term **stock solution** is generally used to describe a chemical solution in concentrated form. If you buy the chemical in powdered form, mix it with water according to directions on the packaging to create the stock solution. The term **working solution** describes the solution you actually use when processing. Most working solutions are a diluted form of a stock solution, but sometimes you may use an undiluted stock solution as a working solution.

Kodak D-76, for example, is a popular film developer that comes in powdered form. You mix the powder with a quantity of water; the quantity depends on the package you buy, but assume it's one gallon, a common size. The mixed gallon of liquid D-76 is the stock solution. You can use that stock solution for processing (which, in effect, also makes it a working solution), but most photographers mix it with water for a diluted working solution. The most common dilution is 1:1— one part of stock D-76 to one part of water. Note that the developing time for the diluted working solution is longer than the time for the undiluted solution.

Fill the beaker with slightly less water than the total solution volume you are mixing, making sure it is at the recommended mixing temperature.

Gradually mix in powder or liquid concentrate, stirring continuously until fully dissolved or mixed. With powder, be sure to empty the entire packet; with liquid, measure concentrate precisely.

Add enough cool water to reach the total volume and transfer the solution to a storage bottle with an airtight cap.

Set Up

Once the film is loaded on reels in the tank, you're ready to begin processing. Processing film requires a series of chemical steps and washing baths. For a summary of these steps and their duration, see the chart on the facing page.

stock solution Chemical solution in concentrated form. Sometimes this mixture is diluted with water for use; other times it is used full-strength.

working solution Dilution of a chemical you use to process film (or paper). Usually, but not always, the working solution is created by adding water to the stock solution.

BLACK-AND-WHITE NEGATIVE FILM PROCESSING: STEP BY STEP

The amount of time the film must be in the developer is linked to several factors. One is the type of film; different brands and speeds of color films can be developed in the same batch, but this is not true of black-and-white films. Even films of the same speed from different manufacturers usually require different developing times. Other factors include type of developer and dilution, solution temperature, and even the size of the processing tank. Thus, you must monitor temperature and refer to a chart packaged with the developer (and often the film) for a recommended developing time. Following is a step-by-step guide:

Step	Time in Minutes*	Agitation
Water presoak (optional)	1	None
Developer	Variable**	First 30 seconds to one minute, then for 5 seconds every 30 seconds thereafter
Stop bath	½–1	At least half the time, intermittently
Fixer	2–4 or 5–10***	At least half the time, intermittently
First wash	2	Frequent complete exchange of water
Fixer remover	1–2	At least half the time, intermittently
Final wash	5–10	Frequent complete exchange of water
Wetting agent	½–1	None
Drying	Variable	

*Processing at 68°–72°F is recommended, though you can generally use a range from about 65°–75°F, without varying the times for solutions other than the developer.

**Development times vary widely depending on the type of film used, type and dilution of the developer, film exposure, and temperature of the working solution. See time/temperature chart on page 249.

***Use two minutes (minimum) for fresh rapid fixer and five minutes (minimum) for fresh standard fixer. Extend these times by 25–100% with previously used fixer solution. Note that Kodak T-Max films need to be fixed for about twice as long as other films.

Here's what each of the above steps actually accomplishes:

- *Water presoak* softens the film and allows developer to soak in more quickly, promoting more even development.
- *Developer* converts the film's exposed silver halides to black metallic silver, in proportion to the amount of exposure the silver halides have received in the camera.
- *Stop bath* neutralizes the development activity.
- *Fixer* removes the unexposed silver halides, allowing the film to be safely viewed under room or natural light.
- *Fixer remover* alters the chemical composition of the fixer remaining in the film so it can be easily washed away with water. Popular brands are Perma Wash, Hypo Clearing Agent, and Record.
- *Wetting agent* promotes even drying, preventing water spots and scum by reducing water's surface tension so it can't stick to the film. One popular brand is Photoflo.

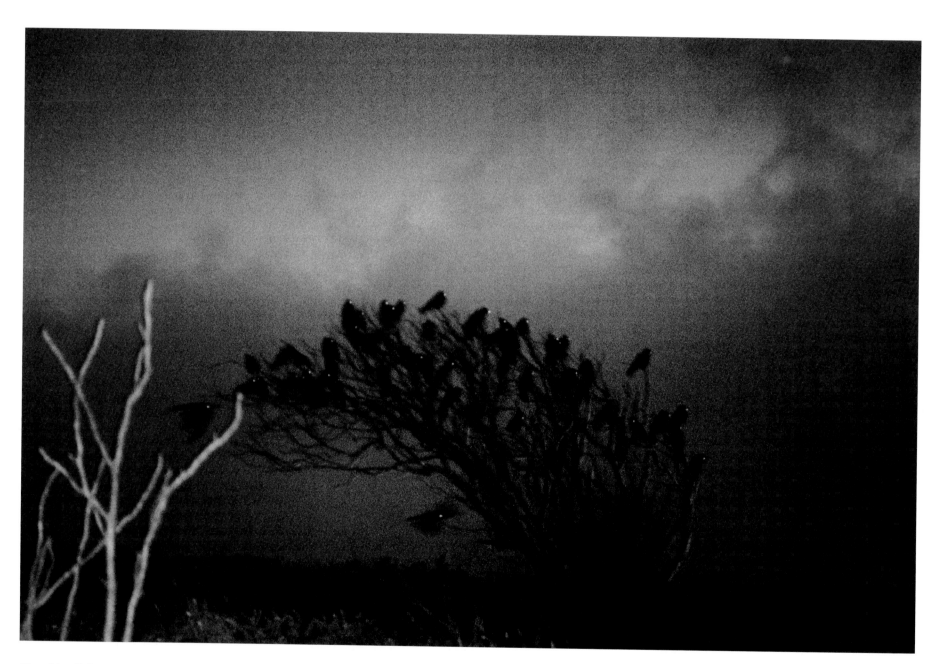

Masahisa Fukase Wakkanai, 1978

Pushing film—deliberately underexposing it, then extending its development beyond the usual time—allows you to set a faster shutter speed or smaller f-stop when you're shooting in low light. But the increase in an image's graininess and contrast caused by pushing can also be a creative tool. It contributes to a sinister quality in Fukase's photograph of crows perched on a tree, turning the birds into dark, empty shapes against a coarse-textured sky. The highlights in the crows' eyes are direct reflections from the photographer's camera-mounted flash unit. Photograph by Masahisa Fukase/Courtesy Robert Mann Gallery

WHY AGITATE?

Proper **agitation** is a critical factor when processing film. With 35mm and medium-format rollfilm, proper agitation means moving the tank at regular, frequent intervals to circulate fresh developer across the film surface. With sheet film, it means shuffling sheets through trays of processing baths or lifting sheets on hangers in and out of deep tanks of solution.

Good agitation produces even and consistent image density; poor agitation may produce streakiness and inconsistency. Agitation is especially important in the developer stage, since this is when the image is formed. If the film is underagitated, the developer, as it comes into contact with the film surface, becomes exhausted; it needs to be refreshed by agitation in order to do its job fully and evenly—to convert exposed areas of the light-sensitive silver compounds to black metallic density.

If the film is overagitated, it may cause uneven and streaky results by accelerating the action of the developer along the edges of the film. This is a problem with 35mm film, because sprocket holes may intensify the effect, and with 120 and 220 rollfilms, which need more careful agitation to cover their large surface area.

If you agitate too long, you get overagitation, and if you agitate for too short a time, you get underagitation. But agitation is also a function of the direction and intensity of the motion. There is some room for disagreement as to exactly what constitutes proper agitation. The techniques described here for 35mm and medium format rollfilm (see page 248) and sheet film (see page 253) are commonly recommended. Other techniques may also work well. However you do it, agitate film in the developer with consistency and patience. In particular, don't agitate too little or too much; usually a 30-second to one-minute initial agitation with a five-second agitation for every additional 30 seconds is recommended for 35mm and medium-format rollfilm.

Note that agitation in solutions other than the developer is also important, though not as critical. Usually, agitating for at least half the total time in a solution is adequate to ensure that the film gets full treatment from these solutions, but with some chemicals, you also may choose to agitate the entire time the film is in the solution. Thus, extra agitation is okay for chemicals other than the developer, but avoid too little agitation.

agitation Causing fresh developer to circulate across the film's emulsion continuously, either by moving the developing tank or moving the film itself in the developing solution.

presoak Optional short water bath before processing film used to soften the emulsion and make it more receptive to the developer.

Make sure the working solution of developer is at the correct temperature before processing. Temperature accuracy is extremely important. Use the best quality thermometer you can and treat it with care to keep it working accurately.

Fill processing tank with developer by tilting it slightly, pouring as quickly as possible without causing the solution to overflow.

1. In a "wet area" (preferably a sink, but possibly a counter where all wet operations take place), set up five beakers of processing solution—one each of developer, stop bath, fixer, fixer remover, and wetting agent.

2. Check the temperature of each solution, trying to keep it steady at a consistent temperature between 68°–72°F (warmer when processing color films). Consider using a water bath to accomplish this (see page 252).

3. Bring the tank, loaded with film, to the wet area to begin processing in order not to drip solutions and contaminate dry areas.

Check Developing Time

4. Take the temperature of the developer one more time and calculate the correct developing time (see chart on page 249).

5. Remove the water-tight cap from the top of the tank. Be careful not to remove or loosen the light-tight top of the tank when you remove this cap.

6. Set the darkroom timer, if you have one, at the calculated developing time plus about 10 seconds—approximately the time it takes for the tank to fill up. If you don't have a darkroom timer, use any watch or clock that measures time in seconds.

Note that some photographers use a one-minute **presoak,** which is a plain water bath at the same temperature as the developer, to soften the emulsion and allow the developer to penetrate more evenly. The presoak is an optional step, more commonly used with sheet film; not all manufacturers recommend it.

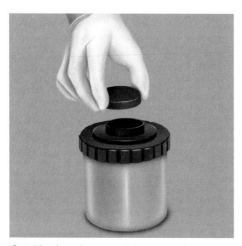

Quickly place the watertight cap on the processing tank, making sure it is secure.

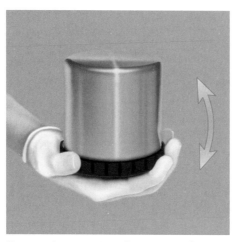

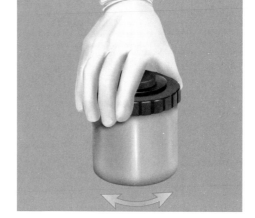

Proper agitate consists of two types of motion. First, invert the tank top to bottom (left). Second, rotate the tank around its vertical axis (right).

Start Development

7. Hold the tank in one hand, tilt it slightly and start pouring in the developer. When the tank is full, the solution may leak out of the top. If that happens, pour a little out since you should leave a space in the tank to allow the solution to agitate freely.

8. As soon as you've filled the tank, tap the bottom a few times on a counter or the bottom of a sink. This will dislodge any air bubbles that might have formed on the surface of the film when you poured in the solution. Air bubbles can prevent those areas of the film from being fully developed, producing **air bells,** small round spots on the film (see page 260).

Proper Agitation

9. Place the cap on the top of the tank and start agitating by gently inverting the tank twice, then rotating it in a circular motion twice. Continue inverting, then rotating, for 30 seconds to one minute.

10. Stop the agitation, rap the bottom of the tank a few times on the counter or bottom of the sink, and set the tank down for 25 seconds.

11. Pick up the tank again and resume agitating, inverting and rotating for five seconds only.

12. Stop the agitation, rap the bottom of the tank a few times, and set the tank down for 25 seconds.

13. Continue this agitation pattern for the entire developing time.

14. About 15 seconds before the time is up, remove the water-tight cap of the processing tank (just the cap, not the light-tight top of the tank) and start pouring the developer solution out of the tank. Pour reusable or replenishable solutions back into the beaker for storage later.

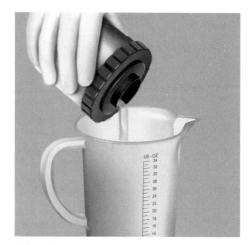

When the developing time has elapsed, quickly pour the developer back into the beaker and immediately pour stop bath into the processing tank. Proceed with fixer, first wash, and fixer remover (see text).

Stop Development

15. As soon as the tank is drained of developer, pour in the **stop bath.** The film will continue to develop until the developer is neutralized by

air bells Small round spots on the film caused by air bubbles that cling to the emulsion during processing.

stop bath Chemical that neutralizes the developer and stops the development process.

TIME/TEMPERATURE CHART

Film developing times depend on many factors. These include the type of film and the type of developer, certainly, but also the dilution of the developer: The more concentrated the solution, the shorter the developing time. Other factors include the film format (even the same type of film may require different development times in different formats), the size of the developing tank (large tanks require more time), and whether you're using a tank, tray, or automated processor. Note that these factors may also have an effect on exposure, requiring you to set a higher or lower film speed when photographing.

Solution temperature is particularly critical; the warmer the solution, the shorter the required time. For example, if a film needs 11 minutes of development at 70°F, it may only need nine minutes at 75°F. Instructions packaged with most black-and-white films and developers include a time/temperature chart; if the packaging doesn't include a chart, you can obtain one from the film or developer manufacturer. Write or call them, or check their website for specifics.

Here is a sample time/temperature chart. It is for processing Kodak T-Max 400 film in processing tanks and trays with these variables: type of developer, developer dilution, film speed ratings, and solution temperatures.

KODAK T-MAX 400 FILM

Type of Developer	Dilution*	Exposure Index (E.I.)	Development Time in Minutes				
			65°F	68°F	70°F	72°F	75°F
35mm rolls (in small tanks)							
T-Max	1:4	400	NR**	7	6½	6½	6
T-Max RS	1:4	400	NR	7	6	6	5
D-76	1:1	400	14½	12½	11	10	9
HC-110	1:3	320	6½	6	5½	5	4½
Microdol-X	None	200	12	10½	9	8½	7½
Microdol-X	1:3	320	NR	NR	20	18½	16
Sheets (in trays)							
T-Max RS	None	400	NR	8	7½	7	6
D-76	None	400	9½	7	6½	6	5½
HC-110	1:7	320	9	7½	7	6½	6

*Refers to one part of developer solution to stated amount of water; thus 1:4 means one part developer to four parts water.

**Development not recommended at this temperature.

the stop. Timing is most critical in the development stage because this is when the image is formed.

16. Keep the stop bath in the tank for 30 seconds to one minute. Agitate for at least half the time, then pour the solution into the beaker for subsequent rolls or for storage once processing is complete.

Fixing

17. Pour out the stop bath and pour in the **fixer.** In general, film fixing takes about two to five minutes, depending on whether you use a standard or "rapid" (high-activity) type. Used solutions take longer to work than fresh solutions. Note that Kodak T-Max films take about twice as long to fix as other films.

18. Agitate for at least half the total fixing time, in 15- or 30-second intervals. So, if the total time is five minutes, agitate for a total of two-and-one-half minutes or more throughout.

19. When the fixing time is up, pour the fixer back in its beaker to use for subsequent rolls or for storage once processing is complete.

20. Now you can remove the top of the processing tank for the first wash.

First Wash and Fixer Remover

21. Complete the first wash with the film on the reels and the reels in the processing tank (see facing page for details on washing film). First wash time is about two minutes.

22. Pour the wash water out of the tank and pour in **fixer remover** to make fixer more soluble, thus shortening your wash time.

When washing film, dump the water and refill at regular intervals. After the final wash, slowly pour in the wetting agent, avoiding agitation.

23. Replace the top on the tank and the cap on the top. (It's best to rinse the top and cap with water before placing them back on the tank.) The fixer remover time is one to two minutes; agitate intermittently for at least half that time.

24. Pour the fixer remover back into the beaker for processing subsequent rolls or for storage once processing is complete.

Final Wash and Drying

25. If you have a separate film washer, remove the reels from the tank and place them in the washer. If not, wash the film on the reels in the processing tank. Final wash time is about five to ten minutes.

26. Place the reels in the beaker of **wetting agent,** or pour the wetting agent into the processing tank to prevent streaking and spotting on your dry film. Pour wetting agent gently to keep excessive amounts of

After the recommended time in wetting agent, carefully remove the film from the reels and hang it up to dry in a dust-free environment.

bubbles from forming. Wetting agent time is about one minute, and the solution can be reused often.

27. Take the film, one reel at a time, from the beaker or tank and slowly remove it from its reel. Then hang the film to dry from a taut wire or string. Use film clips or spring-type clothespins to hang the film on the wire and place a clip or clothespin at the bottom of the film so the roll won't curl up as it dries. Make sure to rinse the processing tank thoroughly before putting the reels back.

28. You can simply let the film dry at this point because the wetting agent is designed to flow smoothly off the film. However, some photographers use a photo sponge, chamois, or other soft cloth made for this purpose to gently wipe both sides of the film in order to facilitate more even drying. Make sure the sponge, chamois, or cloth is completely

fixer Chemical that removes unexposed and undeveloped silver from the emulsion to densensitize the film to light and allow you to view the image.

fixer remover Chemical used after fixer to shorten washing times.

wetting agent Chemical used after the final wash to prevent streaking and spotting and promote even drying.

FILM WASHING

Film needs a thorough wash (including fixer remover) to rid it of fixer and help guarantee long-term image stability. This doesn't take much time—or any special equipment—but it does require efficiency and care. The wash water must reach all areas of the film evenly, with fresh water constantly replacing fixer-laden water. Also, keep in mind that the film emulsion is soft when wet and therefore very susceptible to scratching.

To wash 35mm and other rollfilms, leave the processed film on its reel throughout the entire wash cycle—from the first wash through the wetting agent—to allow solutions to efficiently reach the entire roll. Also, leave the film reels in the processing tank, with the top of the tank removed. Wash the film by putting the tank directly under a water faucet or placing a hose running from a faucet down the center of the tank. Every 30 seconds or so, dump water from the tank and refill it to help flush out the fixer, providing a constant exchange of fresh water.

You must monitor the temperature of the wash water to make sure it remains constant, preferably at 68°–72°F. Minor fluctuations in wash water temperature shouldn't cause a problem, but wide swings could lead to an increase in image graininess and in extreme cases even **reticulation,** the appearance of a wrinkled, cracked, or clumpy texture on the overall image (see page 262).

You don't really need running water for an efficient wash. Simply fill a bucket (dedicated to this purpose to avoid contamination) with water at 68°–72°F. Fill the tank (loaded with film) with water from the bucket, put the top on, and agitate for 15 seconds. Dump the water from the tank, then fill it up with more water from the bucket. Agitate again for 15 seconds, and repeat for the entire suggested wash time—or a little longer.

There are special film washers that automatically provide a constant supply of fresh water with agitation (see page 241). Though they aren't necessary, they are convenient and generally work very well. If you use a film washer, however, you'll still have to monitor the wash temperature manually.

To wash tank-processed sheet film, you can keep the sheets on their hangers, reel, or rack. Keep the hangers, reel, or rack in the processing tank, and wash the same way as you would wash rollfilm. If you tray process sheet film, you'll have to run water gently in a wash tray, preferably with a siphon or a rubber hose. Washing more than one sheet at a time requires shuffling the sheets, as you do during processing (see page 254). This must be done with great delicacy or you'll scratch the film. Use a sheet film washer, if at all possible, for a thorough wash and to avoid physical damage to the film.

Once the film is dry, carefully cut it into strips that fit your negative sleeve, usually five or six frames for 35mm film. Be sure not to cut into the image area.

Handle the film strips by the edges only, and place them in sleeved protective pages.

reticulation Wrinkled, cracked, or clumpy texture that sometimes forms in film emulsions that are subjected to wide fluctuations in chemical or wash temperature while processing.

clean and soaked in wetting agent (not plain water) before wiping. A dirty sponge or cloth—or too much wiping pressure—may scratch or otherwise damage the film.

29. Drying time is about two hours or so, but it varies depending on the room temperature, humidity, and other considerations. The entire roll is dry when the bottom feels dry to the touch (film dries from the top to the bottom when hung vertically).

Sleeve and Store Negatives

30. To keep dust from accumulating, take the film off its hanger as soon as it is dry and place it on a clean, dry surface. With 35mm film, cut strips of five or six exposures each and slide them into clear plastic negative pages—one strip only in each slot—to keep film clean and scratch free. (Most types of pages take strips of either five or six exposures, though some may take other lengths.)

31. Store negative pages in a clean enclosure that keeps dust out, such as a box or a three-ring notebook with a slipcase (some pages come with punched holes for this purpose).

PROCESSING SHEET FILM

You can easily process your own black-and-white sheet film and expect excellent results. Processing color sheet film is

Clear pages can be contact-printed directly (see page 290), eliminating the need to remove negative strips until enlargements are made.

USING A WATER BATH

Keeping the solution temperature constant is critical for best film processing. You should try to maintain all solutions, including washes, at the exact same temperature throughout the process. If the temperature of chemicals other than the developer varies slightly (a few degrees) from one bath to another, it probably will make little significant difference to the final results, especially with black-and-white films. However, variations in temperature by several degrees can cause an increase in image graininess or in extreme cases reticulation, the appearance of a wrinkled, cracked, or clumpy texture on the overall image, due to the contraction and expansion of the emulsion.

You can best control temperature consistency by using a **water bath**—a large, deep tray filled with plain water. Fill the tray with water at the desired processing temperature, then place the containers of mixed solutions in the bath. The processing solutions will eventually reach the same temperature and remain there as long as the containers stay in the bath. This will take only a few minutes with stainless steel containers; plastic will take a lot longer.

The water bath (and solutions) will eventually settle at room temperature. This may be fine for processing black-and-white films as long as that range is about 65°–75°F (preferably 68°–72°F). For warmer and colder room temperatures, you'll need to monitor and adjust the temperature of the water bath, by keeping a slow flow of temperature-adjusted tap water into the tray. You'll especially need to adjust the bath temperature to process color films. Most color processing solutions require high temperatures, often around 100°F.

Here is one method of using and maintaining a water bath at the desired temperature:

1. Fill up a deep tray with tap water at a slightly higher temperature than you'll need for processing; it will soon cool off. The water level should be just below the solution level of the containers to keep them from floating.

2. Place a thermometer in the water bath to monitor the temperature.

3. Place the closed processing tank with film (loaded on reels) in the water bath so the temperature of the tank won't change the temperature of the first solution (presoak or developer). If the tank floats in the water, you'll have to weigh it down such as with a clean beaker or tank filled with water.

4. Place all the containers with the mixed processing solutions in the water bath.

5. Monitor the presoak or developer solution and begin processing when it reaches the desired temperature.

6. Keep the processing tank and all containers in the water bath except when you need to remove them to add or pour out solutions.

7. Monitor temperature by checking the thermometer constantly. If the temperature of the water bath drops, maintain it by running warm water into the bath; if it rises, drop in ice cubes or run cold water into the tray. Circulate the water in the bath periodically with your hands to keep the temperature constant throughout the bath.

To set up a water bath for film development, fill a large, deep tray with water at the desired processing temperature. Then place the containers of mixed solutions in it, and wait until they reach the correct temperature. This takes longer with plastic than with stainless steel containers.

When processing reels or tanks are stored in very cool or warm conditions, they must be brought up to processing temperature, or close to it. Otherwise, they could lower or raise the temperature of the first processing solution when it's poured into the tank. Place the reels in a tank to keep them dry and place the tank in the water bath, taking care to keep water from entering. After a few minutes, remove the tank (with reels) from the bath and dry it thoroughly. Then you are ready to load film on the reels and begin processing.

water bath Deep tray of water kept at a constant temperature. Beakers containing processing solutions will maintain a consistent temperature when placed in a water bath.

To tray-process sheet film, quickly and carefully slip sheets (up to six or eight with 4 x 5 film) into developer one by one, creating a small stack.

To agitate, rotate the stack of sheets by sliding the bottom sheet out and placing it on top, pressing it gently into the developer by the edges.

tray processing
Method of developing sheet film (and photographic papers) in open trays of solution. Sheets of film are shuffled through the various trays of chemicals in total darkness.

another matter, however. You should probably rely on a professional lab, unless you have access to an automated processor that will provide consistent control of temperature and agitation, both of which are crucial for best results.

Sheet-film processing uses the same basic system as rollfilm processing—for black-and-white films, successive dunks in developer, stop bath, fixer, fixer remover, and wetting agent, and then the required washes. The major difference is in the hardware. Some photographers use open trays or deep tanks to process sheet film; others use sophisticated film processors that have some degree of automation. Professional labs use larger, more automated processors. These processors are expensive, but they offer many advantages. For one thing, they require less handling of the film; with trays and tanks you handle the sheets of film a lot more than with rollfilms, which can lead to scratching and other physical damage. Fortunately,

sheet film generally has a thicker base than rollfilm, which makes it more resistant to damage.

Still another advantage to automated processors is that you can turn the lights on after loading the film into the processor. With trays, on the other hand, most of the process must take place in complete darkness—no safelights are allowed with most types of film. The same goes if you use open, deep tanks for processing, though some types of deep tanks close up to allow processing with lights on.

Processing Sheet Film in Trays The least costly method of processing black-and-white sheet film is **tray processing**. You can use the same trays as you use for processing prints, but it's best to use trays the next size up from the film you are using. Since most large-format photographers use 4" x 5" film, process in 8" x 10" trays; if you use 8" x 10" film, process in 11" x 14" trays. Start by preparing four or five trays in your dark-

room sink or on a counter; you won't need running water until you're ready for the wash. Pour plain water into the first tray for a presoak (if you use one), then working solutions of developer, stop bath and fixer, and plain water (in that order) in the other trays; you can also set up trays for fixer remover, final wash, and wetting agent at this time—or you can wait until after the processing to set up these trays.

Make sure the room where you're processing the film is between 65°—75°F. Critical temperature control is difficult with tray processing since solutions generally settle quickly to room temperature. Color films, especially color-transparency films, require even more stringent temperature control—a strong argument against processing your own color sheet films.

While the lights are on, place your exposed film (either still in its holders or in a light-tight box) on a clear, clean surface so it will be easy to find in the dark. Also, take the temperature of the developer solution and check your time/temperature chart to determine the correct development time. Now turn off the room lights and follow these instructions, being careful to handle the film one sheet at a time when adding or removing it from each solution.

1. Remove sheets of exposed film from their holders or box, handling them by the edges and stacking them to one side. You can safely process a maximum of about six to eight 4" x 5" sheets at a time when using trays (a maximum of five 8" x 10" sheets). You might want to process fewer the first few times until you're comfortable with the process.

2. Slide each sheet (again, one sheet at a time) into the tray containing the water for the presoak, if you use one. Always place the film in solution emulsion side up; the emulsion faces you when the film notches are on the upper-right or lower-left corner with the film positioned vertically. (For easier film handling during processing, position the trays vertically—with the short side facing you.) Make sure each sheet is fully immersed in the water and that it doesn't float up before adding the next sheet. Let the film rest in the presoak; agitation is unnecessary.

3. After about one minute, remove the film from the presoak and place it (one sheet at a time) in the tray containing developer. Start timing the development.

4. Using plastic or rubber gloves throughout the process (to protect your skin), stack the sheets of film together in the developer to make agitation easier. Agitate by constantly shuffling—sliding the bottom sheet out of the solution and placing it on the top of the stack. Keep the entire stack submerged in solution by gently holding down the top sheet by the edges as you shuffle. Try to avoid contact between sheets, particularly the corners, since that's where scratching is most likely to occur. Agitate until about 15 seconds before the developing time is up.

5. Begin removing film from the developer one sheet at a time. Briefly hold each sheet over the developer tray and angle it so a corner faces down. This allows excess developer to drip back into the tray. Continue to use

this tilting and dripping method throughout the process.

6. Place film in the stop bath one sheet at a time and agitate by shuffling the film constantly. Stop-bath time is generally 30 seconds to one minute.

7. Remove film from the stop bath and place it in the fixer, again one sheet at a time. Agitate by shuffling the film constantly for two to 10 minutes, depending on the freshness of the fixer and whether you are using a rapid or standard fixer.

8. After about half the total fixing time, you can turn on the room lights for the remainder of the process.

9. When the time is up, remove film from the fixer and place it in the tray of plain water, one sheet at a time.

10. Wash the film for two minutes in the tray with gently running water from a siphon (see page 312), or water running directly from the faucet. Or, use a dedicated film washer with separate slots for each sheet. A film washer requires no manual agitation; with tray washing, you'll have to shuffle the sheets from bottom to top.

11. Now set up trays for fixer remover, final wash, and wetting agent. If you have one, use a film washer for the wash rather than a tray.

12. Remove film from the water and place it one sheet at a time in the fixer remover solution; agitate by shuffling the sheets for one to two minutes.

13. Remove film from the fixer remover and place it in a tray for washing, one sheet at a time. Or, use a film washer. Follow the

instructions in step 10. Final wash time is about five to 10 minutes. You can also wash film with several complete changes of water and constant agitation. Fill a tray with water, place the sheets of film in the tray, and shuffle them for about 30 seconds. Then pour out the water, refill the tray, and shuffle them again for 30 seconds. Ten or 12 complete water changes after the fixer remover should provide an adequate wash.

14. Remove film from the wash and place it in the tray of wetting agent for 30 seconds to one minute. Agitate (gently, to keep the solution from getting too bubbly and causing drying marks on the film) by shuffling.

15. Hang each sheet to dry by one corner, using a clothespin or film clip to hold the film from clothesline or string (or from a bracket in a film-drying cabinet).

16. Take the film down when it's dry and place it in a plastic protective page, similar to those used for 35mm and medium-format rollfilm (see page 251); most types have slots for four 4" x 5" negatives.

Processing Sheet Film in Tanks

Trays are a simple and inexpensive way to process sheet film; metal hangers and deep tanks cost more, but some photographers find them easier to use. In **deep tank processing,** hangers hold the film and the tanks hold the solutions—one each for presoak, developer, stop bath, fixer, fixer remover, wash, and wetting agent. You load the hanger by sliding a sheet of film into slots on the sides and bottom. Then you fold the hanger's

deep tank processing
Method of developing sheet film using metal hangers and deep tanks of solution. The film and hangers are dipped in and out of the tanks vertically through the various solutions.

Dim light produced a flat, underexposed negative on this ISO 400 film. The resulting print lacks contrast and shadow detail.

The same film exposed at E.I. 800 and developed for 50 percent longer than the recommended time—a technique called push processing—produced a more contrasty negative by increasing density in the highlights more than in the shadows, and a better print on the same paper.

hinged top slot over the upper edge of the sheet of film to hold it in place.

With an open tank, you'll need to be in total darkness for the entire process, or until the film has been in the fixer for at least half the required time. If you want to see what you're doing, you can use a light-tight daylight tank that can be sealed for lights-on processing. Even with these, you may want to shut the lights off so that you can remove the top to facilitate pouring the solutions out and in, then turn the lights back on for agitation. Some models of daylight tanks allow you to do this easily and some don't.

Following are handling tips specific to processing with hangers and deep tanks. Most processing steps and times are the same as when processing in trays.

push processing (pushing) Overdeveloping film intentionally to achieve greater contrast and to simulate an increase in film speed.

pull processing (pulling) Underdeveloping film intentionally to reduce image contrast and achieve smoother tonal gradation.

- Lower one or more (up to six at a time) loaded hangers into the processing tank.
- Agitate constantly for the first 30 seconds and then for five of every subsequent 30 seconds. To agitate, lift the hangers straight out, tilting them to one side, dipping the hanger back in and out of the tank, tilting them to the opposite side, then repeating. As you

lower the hangers back into the solution, tap the top bar of the hanger on the rim of the tank a few times to dislodge any air bubbles that may have formed on the surface of the film. Be careful not to gouge film with the corners of the hangers while agitating.

- Move the hangers from tank to tank for the requisite time to complete the process, keeping film on hangers until you're finished with the wetting agent.
- Take hangers out of wetting agent. Open the top of each hanger, remove the film, and hang each sheet by one corner (with the opposite corner pointing down) to dry. Or simply hang up the hanger still loaded with film (if you don't immediately need it for further processing).

Deep tanks require more solution than trays; you have to keep them filled almost to the top. For this reason, it's best to have a lot of film ready for processing; otherwise, store solutions properly for reuse, with the exception of developer, which should be tossed out or replenished (see page 263) and stored for

reuse. Some deep tanks have lids that float on top of the solution, allowing solutions to remain fresh when stored in the tanks for extended periods.

PUSHING AND PULLING FILM

Film and developer manufacturers recommend standard developing times for their products. These times vary with the type of film, type of developer, and developer dilution and temperature. Under most conditions, the recommended times will produce optimal quality. However, departing from the recommended times sometimes produces even better results—for both negatives and transparencies.

Push processing (pushing) refers to developing film longer than the manufacturer recommends. **Pull processing (pulling)** refers to developing film for less time. Following are some of the reasons why you might want to push or pull film.

Push processing increases image contrast. This can be useful when the subject lighting is soft or flat, such as on cloudy and rainy days and in many low-light conditions. Also, by pushing film you

When a subject has high lighting contrast, a normally-developed negative—here, from an ISO 400 film—may suffer from "blocked" highlights or "thin" shadows. This makes it hard to achieve a good print with full texture and detail throughout the images.

If you give the same film more exposure and less development—in this case, rating it at E.I. 200 and reducing development time by 20 percent—you increase shadow detail (due to increased exposure) without blocking highlights (due to reduced development). Called pull processing, this technique keeps more detail in the negative, making a good print easier to achieve.

simulate an increase in film speed; for example, you might use ISO 400 negative film and rate it at E.I. 800. The resulting negatives, developed at the standard time, would be thin (lack density); this is because you're telling your meter that the film has more sensitivity to light than it really does, thus giving it less exposure than it needs.

Pushing the film will compensate somewhat for that lack of density. The added development increases the density in the highlight areas of your negative. (With transparencies, pushing increases contrast by creating more density in the shadow areas.) This partially compensates for the underexposure that naturally results whenever you rate your film at a higher speed than the manufacturer suggests.

There are many situations when you might want to push film. The most common is to photograph at lower light levels

and still get reasonable film density; for example, when setting the aperture wide open, and the shutter speed at the slowest setting possible (without a tripod), won't provide enough exposure. With film rated at a faster speed, you have more flexibility in your camera settings, particularly in dim circumstances like photographing musicians at a club or family celebrations indoors without a flash. Even in more brightly-lit conditions, increased film speed can be helpful by allowing the use of a smaller aperture when you need greater depth of field, and/or a faster shutter speed when you want to "freeze" action.

The most common reason to pull film is to reduce image contrast. Less development means less density in the highlight areas of your negatives, which generally reduces the overall image contrast. (With transparencies, pulling reduces contrast by lowering the shadow den-

sity.) Often you must also reduce your effective film speed—that is, overexpose the film—when pull processing. For example, you might have to rate ISO 400 film at E.I. 200, thus giving it a full stop more exposure to light than it would ordinarily receive.

Another reason to push or pull process film is to compensate for a mistake when setting the film speed—assuming you realize the mistake before processing the film. For example, if you inadvertently rate ISO 400 film at E.I. 800, you can push process to compensate for the underexposure; or if you rate ISO 400 film at E.I. 200, you can pull process to compensate for the overexposure.

Pull processing film is less common than push processing. However, this depends a lot on the type of photographing you're doing. Black-and-white landscape photographers, for example, are

much more likely to pull film (for reduced contrast and greater range of tones) than sports photographers, who may push film to get more "speed" for freezing action.

Developing times for push and pull processing vary with many factors, most notably the type of film and the type and dilution of developer. Note that only the development times need adjusting; times in stop bath, fixer, fixer remover, wash, and wetting agent need not be changed for push or pull processing. You may find manufacturers' recommended times with the product packaging—or contact them for such information. Or you may run your own tests. Following is a chart of possible changes in development time for many black-and-white negative films and developers. It's meant as a starting point only; you may need to adjust the times for subsequent rolls.

Adjustment	Push Processing* Increase developing time by	Pull Processing Decrease developing time by
Slight (about ½ stop)	10–25%	5–10%
Average (about 1 stop)	35–50%	15–20%
Strong (about 2 stops)	75–100%	25–30%
Very strong (about 3 stops)	150–200%	Not recommended

*Note that push times are more extreme in terms of percentage of time change than pull times.

So, if the standard recommended development time for your film/developer combination is 10 minutes, use 13½–15 minutes (35–50% more) for an average push and 7–7½ minutes for a strong pull (25–30% less). The equiva-

Manufacturer's Film Speed Ratings	Adjustments of*					
	½ stop faster	1 stop faster	2 stops faster	½ stop slower	1 stop slower	2 stops slower
ISO	E.I.*	E.I.	E.I.	E.I.	E.I.	E.I.
100	160	200	400	80	50	25
400	640	800	1600	320	200	100
1600	2500	3200	6400	1240	800	400

Note that these speeds are rounded to the nearest third stop since the exact numerical equivalents are not always indicated.

*E.I. refers to exposure index: The speed, other than recommended, for which you choose to rate film.

lent film speeds for these adjustments are shown in the chart above.

If you're using ISO 400 film and the recommended development time is 10 minutes, for example, rate the film at E.I. 640 and increase the development time to 12½ minutes (25% more) for a half-stop push. Or rate it at E.I. 200 and reduce the development time to 8 minutes (20% less) for a one-stop pull. See page 164 for more on the film speed/exposure relationship.

You don't always have to adjust your film speed when push or pull processing, especially with negative films, which have a lot of exposure latitude. For example, on a cloudy day you may rate ISO 400 film at 400 and overdevelop it by 10% or so to slightly increase negative contrast, or underdevelop it by 5% on a sunny day to slightly reduce contrast. More extreme pushing or pulling usually requires an adjustment in film speed, especially with transparency films, which have very little exposure latitude.

When working with sheet films, you can develop each exposure for a different time, making push and pull processing very precise; each image can receive individual treatment. With 35mm and other rollfilms, you must push or pull the entire roll. This is usually not a problem if an entire roll is shot in the same lighting conditions. But if the roll is shot in different conditions, you may have to compromise some frames when deciding how long to process the film. Or you can rewind the film before it's finished and load a new roll for a subject that would best be rendered with a different development time. This tactic may waste a few frames of film, but it should provide more consistent results.

Keep in mind that there are more disadvantages to push and pull processing that should be weighed against the advantages, although many new films push and pull with less loss of quality than older films. These apply when using either black-and-white or color film. Pushing may produce increased graininess and reduced sharpness (because of the denser image); too much contrast (inherent in overdevelopment), and/or reduced detail in the shadow areas (because of underexposure caused by rating the film at a higher speed). Pulling may produce images with a flat and muddy appearance (due to underdevelopment). Developing times that are too

BLACK-AND-WHITE NEGATIVE PROBLEMS

Problems with black-and-white negatives may be due to mistakes made when the picture is taken or mistakes made during processing. Some are correctable in the darkroom, but most are not—until you shoot or process film again. Following are the most common of the many possible problems you may encounter. Note that some of the solutions presented here require the opportunity to photograph your subject again; other solutions assume you'll use existing negatives and make adjustments in the printing process. Also note that these causes apply to film exposed in lighting conditions of average contrast. Thus, high-contrast conditions will inevitably increase the contrast of the negative, just as low-contrast conditions will reduce it.

Symptom
Density too light overall.

Probable causes
1. Too little film exposure (most likely).
2. Film developing time too short.

Solutions
1. Expose film properly.
2. Develop for correct amount of time.

Symptom
Density too dark overall.

Probable causes
1. Too much film exposure (most likely).
2. Film developing time too long.

Solutions
1. Expose film properly.
2. Develop for correct amount of time.

Symptom
Contrast too low overall, with inadequate shadow detail.

Probable causes
1. Film underexposed in camera (most likely).
2. Film underdeveloped.

Solutions
1. Expose film properly.
2. Develop for correct amount of time—or extend developing time for greater contrast.
3. Print with a higher-contrast grade paper or higher-contrast variable-contrast filter (if you're using a variable-contrast paper, see Chapter 13).

Symptom
Contrast too low overall, with adequate shadow detail.

Probable causes
1. Subject had low contrast due to flat light or narrow range of tones (most likely).
2. Film underdeveloped.

Solutions
1. Photograph under more contrasty subject lighting conditions.
2. Develop film for correct amount of time—or extend developing time for greater contrast.
3. Print with a higher-contrast grade paper or higher-contrast variable contrast filter (if you're using a variable-contrast paper, see Chapter 13).

Symptom
Contrast too low overall, with dense shadows but inadequately dense (thin) highlights.

Probable cause
Film overexposed and underdeveloped.

Solutions
1. Expose film properly and develop for correct amount of time—or extend developing time for greater contrast.
2. Print with a higher-contrast grade paper or higher-contrast variable-contrast filter (if you're using a variable-contrast paper, see Chapter 13).

Symptom
Contrast too high overall, with inadequate shadow detail and/or dense highlights.

Probable causes
1. Film underexposed and overdeveloped.
2. Subject had very high-contrast lighting or extreme range of tones.

Solutions
1. Expose film properly and develop for correct amount of time.
2. Photograph under less contrasty subject lighting conditions, or use fill-flash or a reflector to brighten shadows.
3. Print with a lower-contrast grade paper or lower-contrast variable-contrast filter (if you're using a variable-contrast paper, see Chapter 13).

Symptom

Contrast too high overall, with good shadow detail and overly dense highlights.

Probable causes

1. Film overdeveloped.
2. Film overexposed.
3. Subject had high-contrast lighting.

Solutions

1. Develop for correct time, or reduce development for less contrast.
2. Photograph under less contrasty subject lighting conditions.
3. Print with a lower-contrast grade paper or lower-contrast variable-contrast filter (if you're using a variable-contrast paper).

Symptom

Dark or black specks or spots that create light specks or spots in print.

Probable cause

Dust, dirt, or grit on negative blocking light from reaching paper.

Solution

Clean dirty negatives before printing with canned air, air blower, or other means.

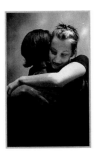

Symptom

Dark or black specks or spots (in spite of blowing dust off negative) that create light specks or spots in print.

Probable cause

Dust, dirt, or grit physically stuck on negative.

Solutions

1. With great care, use film cleaner and soft cloth or cotton ball to dislodge particles.
2. Rewash film, soak it in wetting agent, and dry it in a clean location.

Symptom

Light or clear specks, pinholes, or spots that create dark spots in print.

Probable cause

Dust, dirt, or grit on emulsion surface in the camera when picture was taken.

Solution

Clean out the camera's interior (and/or the film holder, if you're using sheet film) with canned air, air blower, or other means.

Symptom

Dark crescent shapes that print light.

Probable cause

Film bent or crimped in handling, probably while loading onto processing reel.

Solution

Handle film with care; don't bend or crimp it. Don't force it onto the reel. If you feel resistance, remove film and reload.

Symptom

Dark streaks or swirls that print light.

Probable cause

Static electricity from friction, usually from fast winding or rewinding of film in camera—or rapid handling of any sort—in cold, dry conditions.

Solution

Advance and rewind film manually, if your camera allows it.

Symptom

Cloudy overall appearance or opaque light-brown colored strip running lengthwise in processed negatives.

Probable cause

Inadequate fixing due to fixing time too short, fixer dilution too weak, or fixer used beyond capacity.

Solution

Refix film in freshly mixed solution for the correct amount of time. Be sure to rewash the film (with fixer remover, water, and a wetting agent) before hanging it up to dry.

Symptom

Film fully developed only along one lengthwise edge or side of film throughout the roll.

Probable cause

Not enough developer solution to cover entire film.

Solution

Fill processing tank fully with developer solution, even if you're processing only one roll in a multi-reel tank.

Symptom

Irregular clear or creamy-colored areas on processed film.

Probable cause

Sections of film touching other sections on processing reel, most likely with stainless-steel reels.

Solution

Roll film on reel with care, making sure no sections touch.

Symptom

Gray or black density overall or in sections that are normally clear.

Probable cause

Film fogged (unwanted density). Could be caused by a variety of factors, including accidental opening of camera back, a light leak in the camera or darkroom, expired film, extreme push processing, or exposure to high temperatures (such as from a radiator).

Solutions

1. Keep undeveloped film from stray light and heat.
2. Use in-date film.
3. Push film for less time.

Symptom

Small, light, or clear, round blotches or spots on film that print dark.

Probable cause

Air bells on film (see page 248).

Solutions

1. Tap processing tank just after pouring in developer solution and after each agitation.
2. Presoak film in plain water for one minute prior to development (see page 247).

Symptom

Negative image streaky and/or mottled (uneven density).

Probable cause

Underagitation in the developer.

Solution

Agitate for more time, more vigorously, or with more regularity during film development.

Symptom
Frames partially exposed and partially blank (or very lightly exposed) in either a horizontal or vertical band.

Probable causes
1. Shutter speed set too fast or to synchronize with flash.
2. Flash or camera malfunctioning.

Solutions
1. Make sure correct shutter speed is set for flash exposures.
2. Have flash or camera repaired.

Symptom
Totally clear film, with no edge numbers or product identification.

Probable cause
Film treated in fixer solution prior to developer.

Solution
Use processing chemicals in correct order.

Symptom
Film clear in image area, with edge numbers and product identification showing.

Probable causes
1. Film not exposed before processing either because it didn't advance through camera or because lens cap was left on (most likely with rangefinder or twin-lens reflex cameras).
2. Shutter stuck (not opening).

Solutions
1. Load camera with care, making sure film is correctly positioned or attached to take-up spool prior to making the first exposure.
2. Remove lens cap before taking pictures.
3. Repair shutter.

Symptom
Negatives denser along edges of image area than in the middle; or extra density next to sprocket holes and/or in bands running across the film.

Probable cause
Overagitation in the developer.

Solution
Agitate for less time or less vigorously during film development.

Symptom
Some or all negative frames overlapping.

Probable cause
Film winding mechanism in camera slipping and film not advancing at a constant rate.

Solutions
1. If camera has manual rewind crank, tighten take-up spool after loading film.
2. Have film-advance system repaired.

Symptom
Staining or darkening sometime after film is processed.

Probable cause
Inadequate fixing or washing.

Solution
Follow correct fixing and washing procedures, using fresh chemicals with thorough agitation while in the fixer and complete water exchanges during wash.

Symptom
Extreme image graininess.

Probable causes
1. Severe overexposure.
2. Substantial overdevelopment or pushing.
3. Very large variations in temperature from solution to solution during film processing.
4. Very fast film, especially combined with above causes.

Solutions
1. Expose film properly and process film for the correct time.
2. Use developers specially formulated to produce fine-grain results.
3. Keep temperature of processing solutions and water washes as consistent as possible during the entire process.
4. Use slower speed film.

Symptom
Reticulation, a tiny wrinkled or cracked texture throughout the image.

Probable cause
Extreme variations in temperature from solution to solution during film processing.

Solution
Keep temperature of processing solutions and water washes as consistent as possible during the entire process.

Symptom
Image unsharp overall.

Probable causes
1. Camera movement during exposure.
2. Incorrect focus.
3. Smudged or dirty lens.

Solutions
1. Focus with care.
2. Hold camera steadier.
3. Use a faster shutter speed.
4. Use a tripod when photographing.
5. Clean the front and/or rear surfaces of lens.

Symptom
Image in focus in some areas and blurry in others.

Probable causes
1. Incorrect focus.
2. Film not held flat or is out of alignment in camera.
3. Note: This could also be a printing problem.

Solutions
1. Focus more carefully.
2. Have camera pressure plate or camera back repaired or realigned.
3. Make sure sheet film is under guide rails in film holder with large format.
4. Make sure film and lens planes are parallel (with cameras having adjustable backs and/or fronts).

Symptom
Magenta cast overall with processed Kodak T-Max films.

Probable cause
Inherent in film emulsion.

Solution
Fix for longer time.

Symptom
Film surface shows water streaks, spots, or slime—creating irregular white outline shapes in prints.

Probable causes
1. Not using wetting agent when processing film.
2. Using wetting agent improperly, such as mixing too concentrated a solution, too much agitation during wetting agent step, or using a dirty squeegee (or sponge) or a squeegee (or sponge) not soaked in wetting agent.
3. Bad water supply; undesirable chemicals or other contaminants in water.

Solutions
1. Rewash film and soak it in a fresh, correctly mixed solution of wetting agent with minimal or no agitation.
2. Clean film with film-cleaning solution before printing.
3. Use filtered or distilled water for all solutions, especially wetting agent.

PROFESSIONAL PROCESSING EQUIPMENT

Photography labs typically use two types of processing equipment: dip and dunk and roller transport. Both types are capable of producing excellent results. With dip-and-dunk units, racks hold the film on reels or hangers, and a technician or an automated mechanism lifts them in and out of various tanks of solution to complete the processing cycles. Agitation is accomplished manually or with jets of inert gas passing through the solutions. With roller-transport systems, a technician simply inserts the roll of film, which is then automatically moved by rollers through the solutions.

Dip-and-dunk processing is the more flexible option—and generally preferred by professionals. In particular, it allows push and pull processing much more easily. However, it also requires more attentive technicians. Roller processing is used by most minilabs for processing color-negative films; it requires somewhat less attentive labor because there is less film handling involved. Still, solutions must be kept fresh and rollers must be kept clean to avoid contamination, color shifts, and scratches.

replenishment Adding a small amount of developer, or a special replenishment solution, to an existing developer bath to renew its strength. Replenishment extends the working life of the developer.

produce an unnatural color rendition. This is because color films have different dye layers to record colors, and these develop (and produce color dyes) at different rates.

However, for optimal image quality—fine grain, sharpness, full shadow detail, neutral color, and so forth—you should use film at its suggested film speed rating and develop it normally. On the other hand, the disadvantages can sometimes affect image quality in a positive way. Many photographers have used pushing and pulling to advantage—to purposefully achieve such qualities as extreme graininess and oddball color.

ONE-USE VS. REPLENISHED DEVELOPERS

Many types of film developers are diluted for single use. Once diluted and used, the solution must be thrown out and a new batch mixed for subsequent rolls. With other types of developers, you may reuse the stock solution over and over again, as long as you replenish it. (Some developers can be used either way.)

Replenishment sometimes involves adding a small amount of fresh developer to the solution in use; other times it means adding a replenisher solution made especially for that developer. Although replenished developers can be used for many rolls of film, most replenishment has its limits at which time a fresh batch of solution must be mixed. The amount of replenishment and the limits of replenishment vary with the developer type. See instructions from manufacturers for details.

Replenishment provides consistent results when monitored carefully; in fact, professional labs routinely replenish their developers. However, take special care when replenishing since sloppy measure-

short may even create streaky highlight areas from uneven development. (Using a plain-water presoak before development may help reduce this likelihood.)

With color films, push and pull processing may also alter color balance and

ment or contamination of any sort can compromise your results. Since the development is the key step in forming the image, it's especially important that the solution provide peak performance.

HOW FILM DEVELOPMENT AFFECTS CONTRAST

The longer you develop film, the greater the image contrast; shorter development times produce less contrast. Time in the other solutions (stop bath, fixer, fixer remover, or wetting agent) usually has no effect on final image contrast. In most cases, however, even a minor adjustment in development time will have an effect. Let's say the recommended development time for a particular film and developer combination is ten minutes. If you extend development time to eleven minutes, you'll see a slight but noticeable increase in image contrast. Lowering development time—perhaps to nine minutes—should visibly reduce contrast.

The illustration on page 264 traces the progress during development of shadow and highlight areas in a well-exposed black-and-white negative. (Remember, shadows are dark parts of the subject that are rendered with low density in the negative and thus print as dark tones; highlights are bright subject areas that have high negative density and are rendered light on a print.) For this example, a 10-minute development time is standard. Specific results will vary with such factors as the type of film and developer and the lighting conditions of the subject.

PROCESSING : BLACK-AND-WHITE TRANSPARENCY FILM

Almost all photographers shoot negatives when they work in black and white. However, there are also uses for black-and-white positive transparencies, such

How Development Affects Negative Density

At three minutes: *Overall density is quite thin, both in shadow and highlight areas. The shadows are areas that have received relatively little exposure, so they are especially light and show very little detail. Note that the number and text on the film's edges develop too. Here they are light because they also are only partially developed.*

At seven minutes: *The increased development produces more overall density. Note that the shadows now have good detail—in fact, they are almost fully formed at this point. The highlights are noticeably denser than they were at three minutes; despite this, there still isn't a lot of difference between shadow and highlight density, which means the image is low in contrast.*

At 10 minutes: *Overall density is normal, since more development darkens the negative—not so much in the shadows, which have about the same density as at seven minutes, as in the highlights. The growing difference in density between shadows and highlights produces increased image contrast.*

At 15 minutes: *This trend continues—shadow density shows little change but highlight density continues to increase—producing still more image contrast. Note that despite increased density, highlights still show plenty of detail.*

At 20 minutes: *Highlights are even denser, producing still greater image contrast. If the negative has been exposed normally, the added density is so great that the denser areas actually may lose contrast within themselves—that is, they may "block up" and lose the subtle differences in tone that give an appearance of texture to the subject's lighter areas.*

as making copy slides or making original images for reproduction in print (such as ads or magazine stories). You can even use the positives for making prints, either with an internegative or with a direct color-printing process, such as Ilfochrome (see Chapter 14). Or, if you don't have a darkroom, you can scan the positives (if you have a film scanner), converting them to digital files for a Web page or other computer-based use, or for hard copy output (see Chapter 17).

There are several ways to create black-and-white transparencies. Perhaps the easiest is to use a special film, such as Agfa Scala 200 or Polaroid Polapan 35mm instant (see pages 152–154). You must send Scala for processing to a lab licensed by Agfa; you hand-process Polapan in a dedicated processor using the

separate chemical pack packaged with the film. Alternatively, you can shoot standard black-and-white negative film and process it to create positives, using reversal chemicals. Such chemicals are available in kits: Kodak's T-MAX 100 Direct Positive Film Developing Outfit is the most widely available version.

Reversal processing to make your own black-and-white transparencies allows you to use a wide variety of films; though made for a specific film (Kodak T-MAX 100), the kit works with almost any black-and-white negative film. It's also less expensive, since both film and processing cost less than with special films. A very few professional labs will do black-and-white reversal processing, but at a cost premium.

Note that reversal processing of black-and-white films is time-consuming and

requires especially critical time and temperature control. (Follow the manufacturer's instructions faithfully.) Also, you'll have to mount the slides yourself—or find a lab to mount them for you. Polapan requires hand mounting, while labs routinely provide mounted slides for processed Scala 200.

If you plan to create black-and-white transparencies from standard negative films, you'll have to adjust the film speed rating when photographing. Kodak recommends rating ISO 100 film at E.I. 50 for normal contrast results. These ratings are suggestions only and may need adjustment. You'll have to test other films for effective speed and developing times to achieve your desired results. (You can also push and pull process black-and-white transparency film by changing the

COLOR NEGATIVE FILM PROCESSING (C-41): STEP BY STEP

Step	Time in Minutes (100°F)*	Agitation
Water presoak	1	No agitation necessary
Developer	3½	First 15 seconds, then for 5 seconds every 30 seconds thereafter
Bleach	6½	First 10 seconds, then for 5 seconds every 30 seconds thereafter
Fix	6½	First 10 seconds, then for 5 seconds every 30 seconds thereafter
Wash	3	Frequent complete exchange of water
Stabilizer	1½	First 15 seconds
Drying	Variable	

*Most C-41 processing kits allow a range of temperatures, but you'll have to change the times of the developer and bleach/fix. Instructions with the kit will give adjusted times.

Here's what each of the above steps actually accomplishes:

- *Water presoak* softens film and allows the developer to soak in more quickly, promoting more even development.
- *Developer* creates separate black-and-white layers within the film emulsions by converting the exposed silver halides on each layer to black metallic silver. As the image is formed, chemical byproducts of development activate color couplers built into each layer. It's the couplers that form the color dye image.
- *Bleach* breaks down the metallic silver by converting it to a more soluble form.
- *Fixer* dissolves the silver, leaving only the negative dye image. The bleach and fixer are usually a combined step, sometimes called **bleach/fix** or **blix.**
- **Stabilizer** acts to prevent color fading. It also includes a wetting agent to promote more even drying.

Note that several of these chemicals have a moderate to somewhat high degree of toxicity.

bleach/fix (blix) Step in color processing that removes the metallic silver in the film emulsion, leaving only the image formed by color dyes.

stabilizer Final solution used for processing color film to help prevent color fading and promote even drying.

C-41 process Standard chemical sequence for developing virtually all color negative films.

chromogenic Refers to color materials that use built-in color couplers to form dyes during processing.

color couplers Dye elements, built into most color films (and papers), that form color during development.

film speed and increasing or decreasing times in the first developer; all other processing times remain the same.)

PROCESSING: COLOR NEGATIVE FILM

Kodak's **C-41 process** is the industry standard chemical sequence for developing virtually all color negative films. Other film manufacturers have their own proprietary processes with their own designations, such as Agfa AP-70, Fuji CN-16,

and Konica CNK-4, but any manufacturer's color-negative films can be developed using any other manufacturer's process. C-41 compatible films and virtually all color transparency film and color printing papers are **chromogenic,** which means that development activates **color couplers** built into the film to form the color-dye image.

In some ways, processing color negatives is similar to processing black-and-white negatives; you load film onto a reel,

put it in a tank, and pour chemicals in and out until processing is complete. However, solution temperatures, processing times, and agitation techniques are even more critical than with black-and-white films. Also, with rare exceptions, you can develop all color negatives, regardless of brand and speed, in the same film tank—using the same processing times.

Very few photographers process their own color negative film. They almost always send it to a professional lab.

COLOR NEGATIVE PROBLEMS

Problems with color negatives may be due to problems in the camera during exposure or in processing. Some are correctable, but many are not—until you shoot or process film again. Following are the most common of the many possible problems you may encounter that are unique to color negative film. Many of the problems described in "Black-and-White Negative Problems" (see pages 258–262), such as streakiness and spots, also may apply.

Symptom
Density too light overall.

Probable causes
1. Too little film exposure (most likely).
2. Film developing time too short.

Solutions
1. Expose film properly.
2. Develop for correct amount of time.

Symptom
Density too dark overall.

Probable causes
1. Too much film exposure (most likely).
2. Film developing time too long.
3. Bleach exhausted or too diluted.

Solutions
1. Expose film correctly.
2. Develop for correct amount of time.
3. Use freshly mixed bleach.

Symptom
Streaks on surface of film.

Probable cause
Stabilizer mixed incorrectly or not used at all.

Solution
Use correctly mixed developer.

Symptom
Magenta negatives with dense edges near sprocket holes.

Probable causes
1. Developer too warm.
2. Development time too long.
3. Overagitation during development.

Solutions
1. Develop at the correct temperature and time.
2. Agitate correctly.

Symptom
Poor contrast/color overall.

Probable causes
1. Overdevelopment.
2. Contaminated developer.

Solutions
1. Develop for correct amount of time.
2. Use freshly mixed developer.

However, there are C-41 processing kits available, providing all the chemicals you need to process color negatives yourself; individual chemicals are harder to find and offer no practical advantage. The steps on page 265 are representative, but follow the instructions packaged with your kit for specifics.

Note that the processing temperatures here are quite high; to maintain solutions at 100°F, you'll have to use a water bath (see page 252). Some kit brands allow you to process at lower temperatures that require proportionally longer developing times.

Processing temperatures and times are critical, especially when the image is formed—in the developer, which should vary no more than ±¼°F. Temperature consistency is not as critical in the other steps, but it's good practice to keep temperature as constant as possible throughout the entire process.

PROCESSING: COLOR TRANSPARENCY FILM

Kodak's **E-6 process** is the industry standard for developing virtually all color transparency films (with the notable exceptions of Kodachrome and a few rarer films, see box at right). Other film manufacturers have their own proprietary processes with their own designations, such as Agfa AP4 and Fuji CR-56, but any manufacturer's color-transparency films (with the above exceptions) can be developed using any other manufacturer's process.

In some ways, processing color transparencies is similar to processing black-and-white or color negatives: You load film onto a reel, put it in a tank, and pour chemicals in and out until processing is complete. However, there are more steps and solution temperatures, pro-

cessing times, and agitation techniques are even more critical. As with color negative films, you can process virtually all transparency films, regardless of brand and speed, in the same film tank, using the same processing times (except when pushing or pulling development).

Very few photographers process their own color transparency film. They almost always send it to a professional lab. However, there are E-6 processing kits available, providing all the chemicals you need to process color transparencies. The steps on page 268 are representative, but follow the instructions packaged with your kit for specifics.

Note that the processing temperatures for E-6 are also quite high; to maintain solutions at 100°F, you'll have to use a water bath. Some kits allow you to process at lower temperatures that require proportionally longer developing times.

As with C-41, processing temperatures and times are critical, especially when the image is formed—in the developers, which in most cases should vary no more than ±¼°F. Temperature consistency is not as critical in the other steps, but it's good practice to keep temperature as constant as possible throughout the entire process.

CROSS PROCESSING

The C-41 process is for color negative films and E-6 is for color transparency films. However, you can also **cross process** film. You can develop color negative film as transparencies by processing in E-6 chemicals (E-6-compatible films only—not Kodachrome). Or you can develop transparency film to create negatives by processing in C-41 chemicals. The results won't be natural in color—

KODACHROME

Kodachrome was the first practical modern color film and remains (in improved form) a popular color transparency film. There are good reasons for this; it provides excellent image sharpness and remarkably neutral color balance. It has long been considered one of the most stable color films available, but many recent E-6-compatible films are said to be just as stable.

Kodachrome is the only common non-chromogenic color film. It contains no color dye couplers; rather, it is made up of three separate black-and-white emulsion layers, responding to blue, green, and red sections of the color spectrum. With chromogenic materials, development releases color couplers built-in to the film to form the color dyes. With Kodachrome, the processing (designated K-14) actually adds the color dyes. This is a far more complicated matter than standard E-6 processing and requires special processing equipment that isn't as widely available as E-6 equipment.

they'll have an exaggerated or false palette—but they will be dramatic. Cross processing is particularly popular with photographers who don't want to create a literal representation, such as in advertising, fashion, and fine-art work.

The results are sometimes unexpected, which is part of cross processing's appeal. In general, negatives from transparency film tend to have highly saturated (text continues on page 272)

E-6 process Standard process for developing virtually all color transparency films.

cross process Processing color-negative film in E-6 chemicals or processing color-transparency film in C-41 chemicals.

COLOR TRANSPARENCY PROCESSING (E-6): STEP BY STEP

Step	Time in Minutes (100°F)*	Agitation
Presoak	1	None
First developer	6½	First 15 seconds, then for 5 seconds every 30 seconds thereafter
Wash	2	Frequent complete exchange of water
Color developer	6	First 15 seconds, then for 5 seconds every 30 seconds thereafter
Wash	1¼	Frequent complete exchange of water
Bleach	6	First 15 seconds, then for 5 seconds every 30 seconds thereafter
Fixer	4	First 15 seconds, then for 5 seconds every 30 seconds thereafter
Wash	6	Frequent complete exchange of water
Stabilizer	1	First 15 seconds
Drying	Variable	

*Most E-6 processing kits allow a range of temperatures, but you'll have to change the times of the developer and bleach/fix. Instructions with the kit will give adjusted times.

Here's what each of the above steps actually accomplishes.

- *Presoak* softens the film and allows the developer to soak in more quickly, thus promoting more even development.
- *First developer* creates separate black-and-white negatives on each of the film's emulsion layers by converting the exposed silver halides on each layer to black metallic silver.
- *Color developer* has two primary roles. First, it's a chemical foggant, exposing areas of the film that weren't exposed in the camera (and developed out in the first developer) and converting them to black metallic silver, thus creating a positive black-and-white image. Second, it creates the color. As the image is formed, development releases color couplers built into each layer. The couplers form the color dye image.
- *Bleach* breaks down the metallic silver, forming the negative and positive images by converting it to a more soluble form (silver bromide).
- *Fixer* dissolves the silver bromide, leaving only the positive dye image. The bleach and fixer are usually a combined step, sometimes called *bleach/fix* or *blix*.
- *Stabilizer* acts to prevent color fading. It also includes a wetting agent to promote more even drying.

Note that several of these chemicals have a moderate to somewhat high degree of toxicity. In particular, take special care with the color developer, bleach, and stabilizer.

COLOR TRANSPARENCY PROBLEMS

Problems with color transparencies may be due to problems in the camera during exposure or in processing. Some are correctable, but most are not—until you shoot or process film again. Following are the most common of the many possible problems you may encounter that are unique to color transparency film. Some of the problems described in "Black-and-White Negative Problems" (see pages 258–262), such as streakiness and spots, also may apply.

Symptom
Density too light overall.

Probable causes
1. Too much film exposure (most likely). Note that this is the opposite of negative film, for which overexposure produces too much density.
2. Film developing time too long.

Solutions
1. Expose film properly.
2. Develop for correct amount of time.

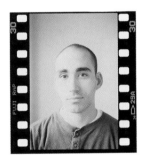

Symptom
Density too dark overall.

Probable causes
1. Too little film exposure (most likely). Note that this is the opposite of negative film, for which underexposure produces too little density.
2. Film developing time too short.

Solutions
1. Expose film correctly.
2. Develop for correct amount of time.

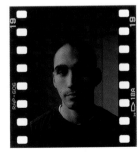

Symptom
Black film with frame numbers.

Probable causes
1. Film not exposed in the camera.
2. Shutter not opening.
3. Lens cap left on (usually with rangefinders and twin-lens cameras).

Solutions
1. Make sure film is correctly loaded in the camera.
2. Have shutter repaired.
3. Remove lens cap.

Symptom
Clear film with no frame numbers.

Probable causes
1. Film fogged.
2. Film developing time much too short, or film not developed at all.
3. Processing solutions used out of order.

Solutions
1. Protect film from unwanted light.
2. Use solutions in correct order.

Symptom
Unusual color overall or in specific areas.

Probable causes
1. Film lightstruck in camera.
2. Film out-of-date or incorrectly stored.
3. Film and light source don't match.
4. Contaminated solutions.

Solution
1. Use fresh film.
2. Use correct film and/or filtration for the light source and color temperature.
3. Process correctly with fresh solutions.

Symptom
High contrast overall.

Probable cause
Overdevelopment.

Solution
Develop for correct amount of time.

Symptom
Cyan cast with weak color overall.

Probable cause
Underdevelopment.

Solution
Develop for correct amount of time.

Symptom
Scum on film surface.

Probable causes
1. Weak or contaminated stabilizer.
2. Water residue.

Solution
Use fresh stabilizer.

Symptom
Gray/silver streaks and/or blotches.

Probable cause
Weak or contaminated bleach/fix.

Solutions
1. Use fresh bleach/fix.
2. Use corrective filtration on camera lens.

Symptom
Blue cast overall.

Probable cause
Daylight scene shot on tungsten-balanced film.

Solution
1. Use daylight-balanced film.
2. Use corrective filtration on camera lens.

Symptom
Green cast overall.

Probable cause
Fluorescent-lit scene shot on daylight-balanced film.

Solutions
1. Use corrective filtration on camera lens.
2. Turn off fluorescents, and light the subject with strobe or hot lights.

Symptom
Yellow/orange cast overall.

Probable cause
Indoor (tungsten-lit) scene shot on daylight-balanced film.

Solutions
1. Use tungsten-balanced film.
2. Use corrective filtration on camera lens.

Symptom
Overall smoky-looking film.

Probable causes
1. Fogged film.
2. Contaminated processing solutions.
3. Film pushed too much.

Solutions
1. Protect film from light.
2. Use only fresh solutions.
3. Don't overdevelop film as much.

High contrast and intense color saturation can be achieved by processing transparency film in the C-41 chemicals normally used to process color negatives. Called cross processing, this technique results in a negative with a very different density and color characteristics (left) than a conventional color negative (right).

color and high contrast when you print them (remember you must print them because they are now negatives). Transparencies from negative films generally have low contrast and a reddish-orange cast (due to the color-negative film's built-in orange mask) and bluish or cyan casts in shadow areas.

Different films respond differently to cross processing. Feel free to experiment with exposure and processing times. Here are some guidelines. Rate trans-

parency films at half the manufacturer's suggested film speed (E.I. 50 instead of ISO 100, for example), then process in C-41 chemistry for the normal time or push process one stop. Rate negative films at half or even one-quarter the manufacturer's speed (E.I. 25, instead of ISO 100) and push process in E-6 chemistry at least one stop. Note that these are guidelines only. Cross processing allows more flexibility than standard processing, so experiment with different

speeds and processing times to get the results you want.

You may have to search around for a lab that offers cross processing. Some will refuse to do it—especially when cross processing to make transparencies from negative film—for fear of chemical contamination or lack of quality control. (The rate of chemical replenishment might be affected.) If you can't find a willing lab, you can always cross process the film yourself.

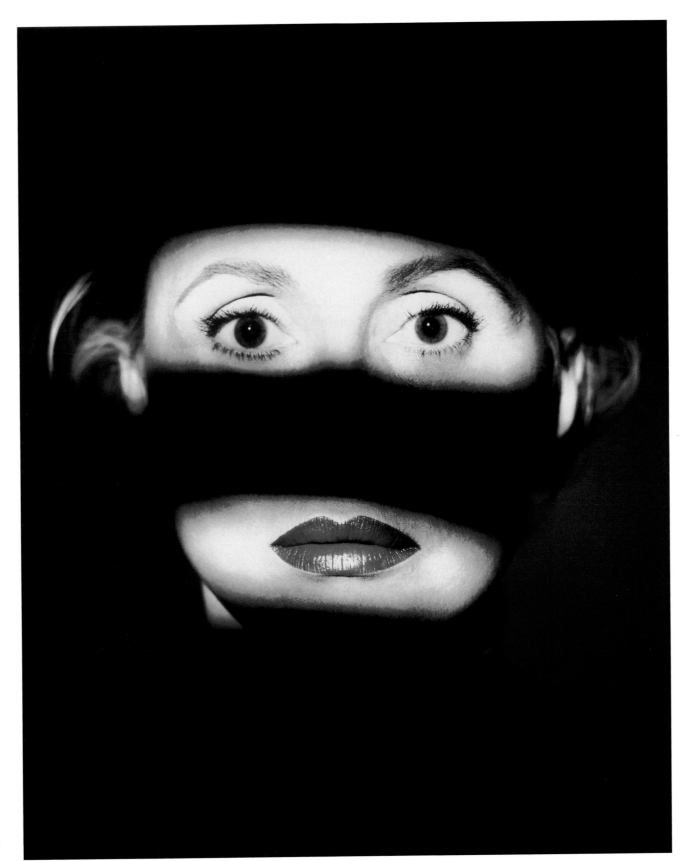

Matthew Rolston

Faye Dunaway

Fashion photographer Matthew Rolston took cross processing a step further for this evocative portrait of actress Faye Dunaway. He shot tungsten-balanced transparency film, processing it in C-41 chemistry to create a bluish tinge in the final print. MatthewRolston/Outline

ALBERT WATSON
FASHION PHOTOGRAPHY

To call Albert Watson a fashion photographer is to vastly understate his artistry. Though he has shot hundreds of covers for *haute couture* mainstay *Vogue*, and made photographic icons of our culture's stars for *Life*, *Newsweek*, and other mainstream magazines, his visual talents go way beyond the ability to make good-looking subjects look good. Watson's pictures both flatter and reveal, which is why they are sought as passionately by collectors as by art directors.

Watson is both a master of lighting and a masterful printer, and in his most interesting work those two talents intersect. "There's a magic line that runs straight from the eye of the photographer as he takes the shot to the darkroom where he makes the print," says Watson, who insists on doing all his own exhibition printing—a rare thing in the world of successful shooters. "When I look through the viewfinder, I'm already seeing the things I'm likely to do in the darkroom."

But the tonal *tour de force* of a Watson image isn't just a matter of printing. Whether the photographer is working with strobes in the studio or shooting by existing illumination on location, lighting is the beginning. "My whole system of lighting is based on contrast," he explains. "The closer the light, the higher the contrast." That strong contrast is due to the light's natural falloff: "A forehead can read f/22, a chin f/11. Back the light away a few feet, and you can reduce that two-stop difference to a half-stop."

Watson urges any aspiring photographer to put this principle into practice. "Set aside a day, get a studio, and test your lighting," he advises. "Start with a basic raw light; put it just two feet from the person's face, then take a shot. Move the light back a bit, correct the exposure, and take another. Then back again. Repeat the whole thing with one reflector, then two. Figure out at what point a white background flares, and at what point a black background really goes black. Record each variation on a card within the frame. It sounds boring, but on one roll you'll get an amazing amount of information. You'll conquer contrast. You'll conquer the entire mood of light."

Indeed, distance is everything in Watson's lighting technique. First there's the surprisingly long distance between his subject and background—often as much as 50 feet. This allows the photographer to "layer" his light, and in particular to keep background illumination from spilling forward and softening his subjects' clean, crisp contours. But the more startling distance is the one between Watson's lights and his subject—as little as 18 inches. Keeping lights so close lets Watson create dramatic differences in brightness within small areas such as a face or in a head-and-shoulders shot. And it allows him to control those differences with very small repositionings of strobe heads, which are all mounted on booms.

Watson's lighting ratios range from the hottest highlights to a deep, dense, trademark black. That black is made possible by Watson's skillful use of "flags," opaque cards or boards that most photographers use simply to keep light from striking the lens and causing image-fogging flare. A "black tunnel" of flags surrounding Watson's subject keeps stray light from filling in shadows, but the technique does much more than that. "By extending flags into the light path, you can dramatically alter the light's quality," he says. "I can put a razor blade of raw, nasty light on you, and by moving a flag into the beam I can take it back to the softest light." In fact, flagging is Watson's substitute for the softbox, that old diffusion standby; he may squeeze as many as four or five small flags into a two-foot space between light and subject.

Yet Watson, who considers lighting "one of the most misunderstood things in photography," is as likely to swaddle his subjects in broad, soft illumi-

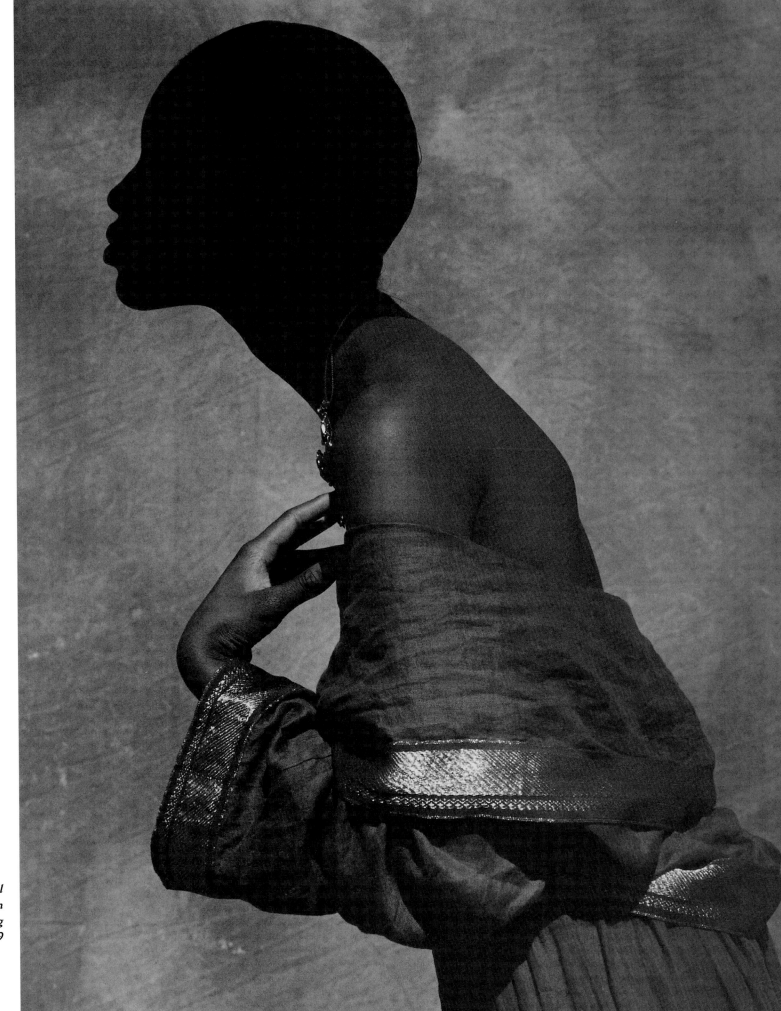

Naomi Campbell
Callahan
Palm Spring
February 1989

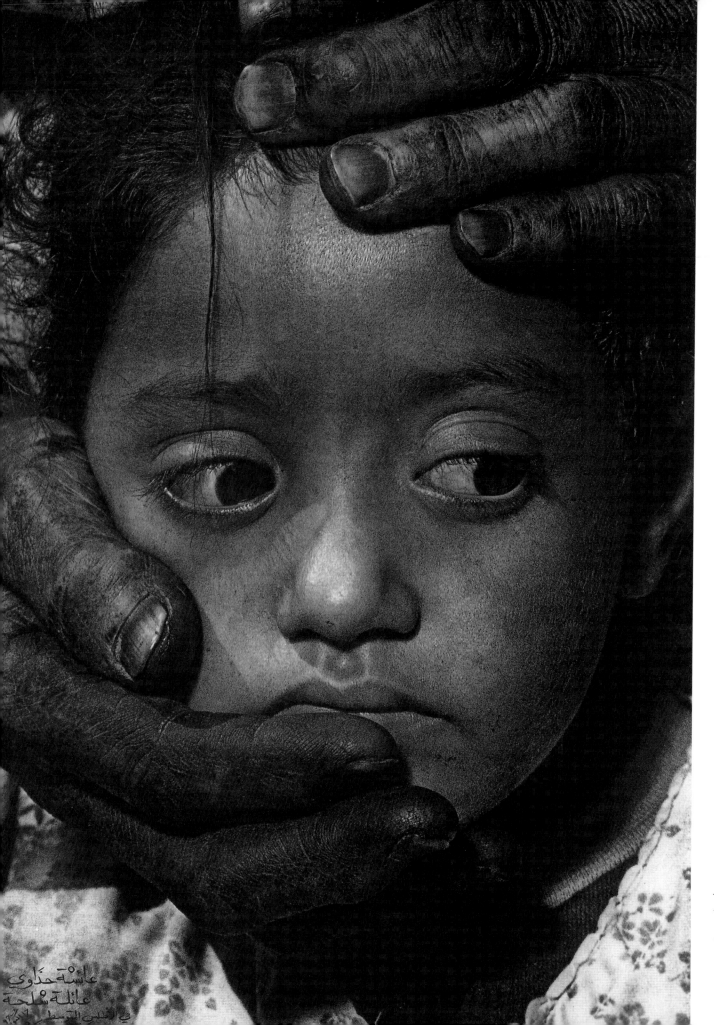

عائشة حدّاوى
عائلة صالحة
في الأطلس المتوسط

Aicha Haddaoui,
Berber family in the middle Atlas
On the road from Meknes to Marrakesh
October 17, 1997

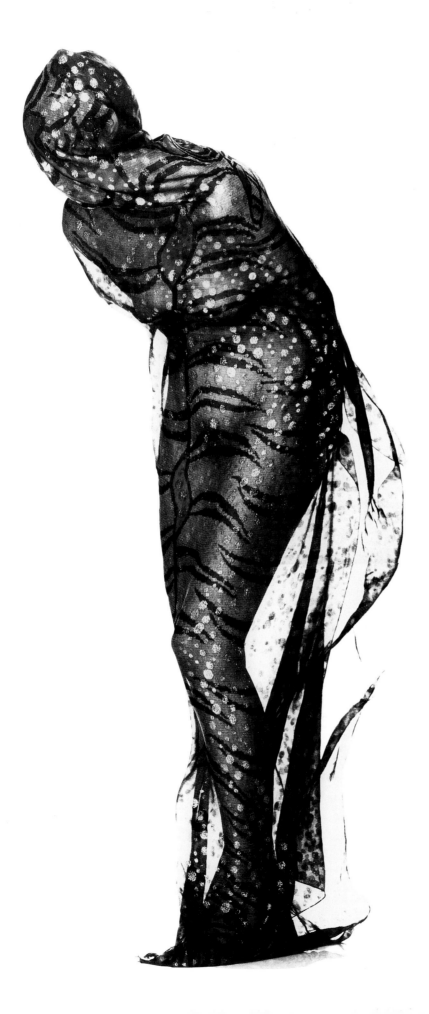

nation as he is to plunge them into shadow. "Good lighting comes in many different forms," he says. "Unfortunately, the light in today's fashion photography is mostly flattened out. It's rare that you see something and say, `My God, that's wonderfully lit.' Photographers hit on a certain formula and then just drop in the current models and the hot hair and makeup. I'm not against simple; there's nothing wrong with ring flash, the most mindless of lighting. What's wrong is to use it over and over again."

What's right about Watson's lighting technique is that it never seems to get in the way of capturing his subject's personality. "There's a delicate balance to photographing people," he says. "Fiddle with technique too much, and by the time you've got it right you've lost the subject. It's best to work out your lighting before the person steps in. I'd rather have a good shot of someone with the top right corner of the background a bit bright than have the top right perfect and the person not connecting. And if you're shooting black and white, you can always tone down that corner in printing."

But printing is more than a corrective measure for Watson; it's intensely personal. "If you leave the printing to someone else, every print will end up having the same pulse," he opines. "Look at prints by Strand and Weston; they may not be perfect, but they look great. The photographer made a conscious decision to accept them. By any technical standard, Tina Modotti's platinum prints are too dark—that's my natural inclination, too—but they look great. So they're really not too dark after all. Ansel Adams' prints may be technically perfect, but they lack emotion."

That challenge to a photographic deity is pure Watson. It embodies the sort of fresh thinking that makes his editorial and advertising work transcend its commercial purposes. Says Watson, "I'm caught between being an artist and a fashion photographer." Apparently, that's a good place to be.

Gianfranco Ferre
Silk Scarf, NYC
June, 1989

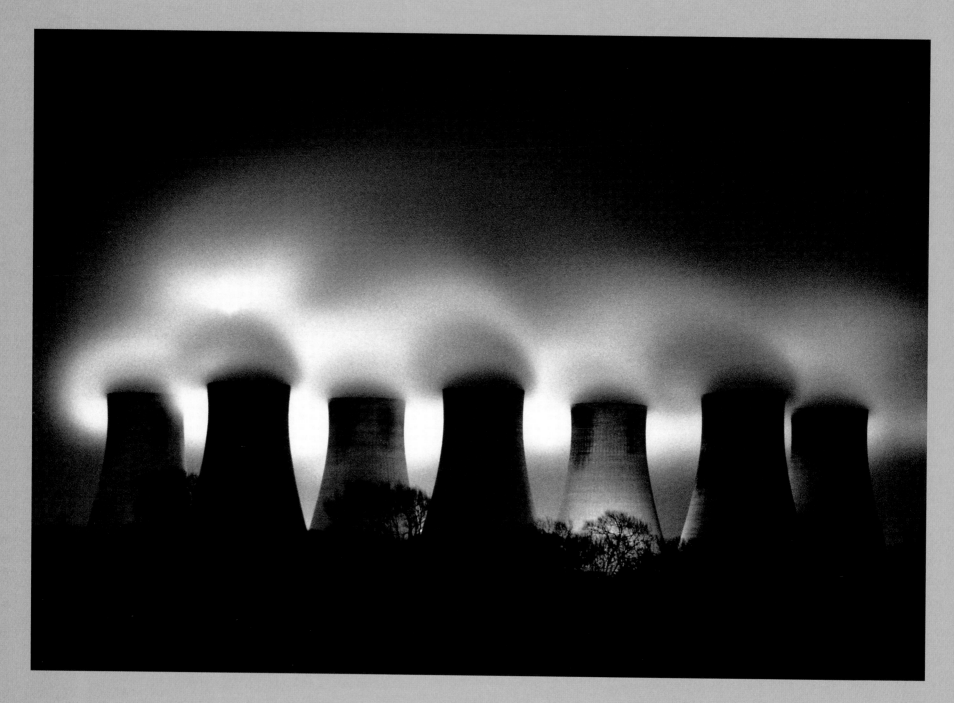

MICHAEL KENNA
Ratcliffe Power Station, Study 31, 1987

Making a print in the darkroom can be as vital to the creative process as actually taking the photograph. Kenna's work is highly sought after by galleries and collectors of fine-art photography in large part because his prints are finely crafted objects. Since he frequently shoots at night, his images often contain large expanses of darkness. But through long exposures in the camera and careful manipulation of the print's tones in the darkroom, he is able to preserve a sense of depth and detail in these areas. Stephan Wirtz Gallery

CHAPTER 13

BLACK-AND-WHITE PRINTING

Black-and-white printing may seem, at first, to be a purely technical task. It's true that you must follow specific steps and procedures, and also have an appreciation of the chemistry and materials involved, to produce the desired results. But like most of photography, making a print demands both technical and creative decisions. If taking a photograph is the moment of conception, making a print is the moment of creation—and offers great opportunities for personal exploration and expression. How you choose to print an image—your selection of paper and chemistry, the ways in which you manipulate the light striking the paper, and the adjustments you make in contrast—are major factors in determining the visual impact of your photograph.

For almost all photographers, printing is a negative-to-positive process. You start with a negative in which the original subject's tones are reversed, and finish with a positive print in which the tones represent the subject the way it originally appeared. To make a print, light is passed through the negative onto light-sensitive material (photographic paper), which is developed in specific chemical steps to create a positive image. As with film, paper development involves successive baths of developer, stop bath, and fixer, followed by a thorough wash.

For the printing process, the enlarger functions much like a camera when making the exposure onto paper. Through a combination of exposure time (analogous to a camera's shutter speed) and the size of the opening in the lens (f-stop) you control how much light hits the paper and consequently the overall lightness or darkness (overall density) of the image.

Here's how printing turns a negative into a positive. Like film, photographic

paper is coated with an emulsion containing light-sensitive silver compounds called silver halides. Also like film, these compounds turn black when exposed to light and developed. When placed in the enlarger, the negative allows light to pass through in varying degrees. Where the negative is dark (the highlights, or light and white areas, in the original scene), little light passes through. As a result, the paper is not exposed as much in these areas and produces little density when developed. Where the negative is clear or nearly clear (the shadows, or dark and black areas, in the original scene), more light passes through, creating greater paper exposure. When developed, these areas are rendered with greater density, creating the darker shadow areas. The intermediate densities of the negative are translated in a similar manner to produce a range of gray tones in the print.

There are two main types of conventional prints: contact prints and enlargements. A **contact print** is the same size as the negative from which it's made; the negative is pressed firmly against—placed in "contact" with—the paper. Usually, a piece of heavy glass is used to hold the negative in place, but you can also buy special contact printing frames to do the job. An **enlargement** can be almost any size and is made by shining light through the negative and projecting the image through a lens onto a piece of light-sensitive paper. You place the negative in an **enlarger,** which contains both the light source and a lens to project, focus, and expose the image. Enlargers also allow the distance between the lens and the paper to be adjusted to create different size enlargements (see pages 295–299).

There are different kinds of enlargers. Condenser enlargers are the most com-

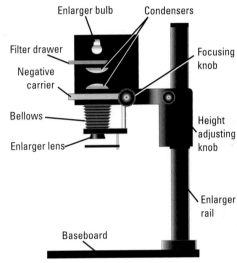

An enlarger is the basic tool for making photographic prints. It incorporates a movable housing, called a head, on a vertical rail that is attached to a flat board, called a baseboard. The negative is placed in a special holder, called a negative carrier, that is then inserted into a slot in the enlarger head. A built-in light source casts a beam downward through large condenser lenses (as shown here) or a diffusion panel (to even out the light), and sometimes through filters (to control print contrast or color balance), then on through the negative. The enlarger lens projects the negative's image to the baseboard, usually onto an enlarging easel that holds the printing paper. You raise or lower the head (typically with a knob or crank) along the rail to make the image larger or smaller, then raise or lower the lens (with a knob or crank) to focus the image.

monly used for black-and-white printing; they produce prints with maximum sharpness and contrast, but they also make defects such as scratches and dust on the negative more visible. Diffusion enlargers, usually used for color printing,

contact print Print made by pressing a negative against a piece of photographic paper during exposure. The resulting image is the same size as the negative.

enlargement Print made with an enlarger, for which light passing through the negative is projected through the lens so that the image is larger than the negative.

enlarger Printing equipment that allows you to project a negative on to photographic paper to make a print larger than the size of the negative.

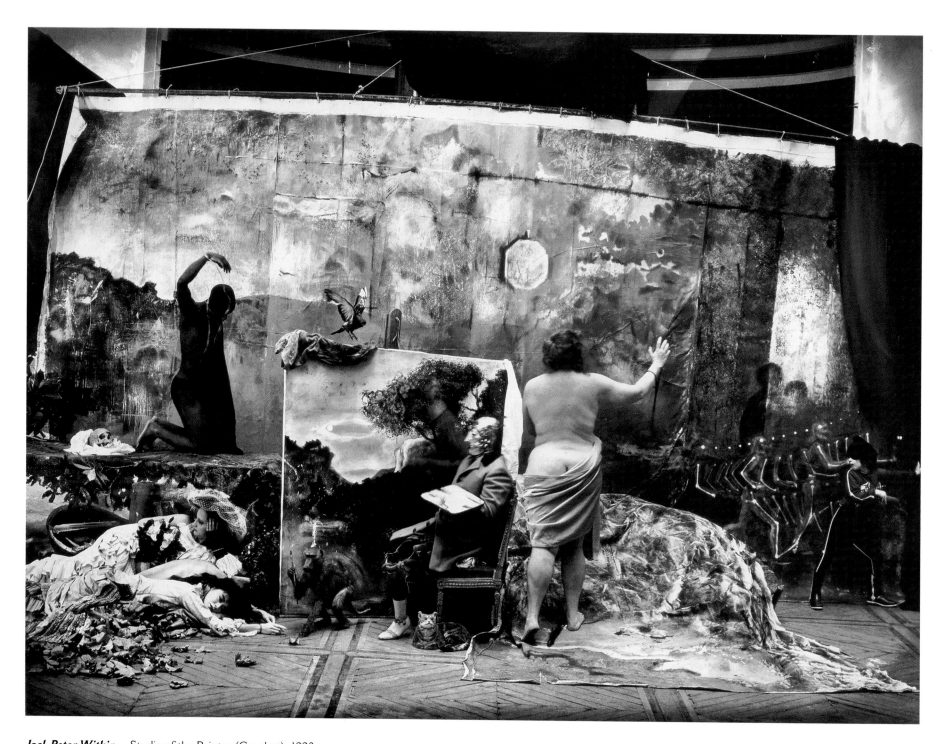

Joel-Peter Witkin Studio of the Painter (Courbet), 1990

Witkin's photographs appear to be the antithesis of the finely crafted print, but they are in fact very deliberate in their "distressed" quality. In addition to traditional techniques such as toning, Witkin deliberately introduces imperfections into his negatives and prints, both by chemical (staining) and physical (scratching) means. These seeming technical flaws actually complement his often bizarre subject matter—scenes of deformity, perversion, and human degradation. In his work, content and print quality are thus inseparable. Copyright Joel-Peter Witkin. Courtesy Pace/MacGill, New York

have a light-mixing chamber or screen to soften the light and lower the contrast of the resulting print. Cold light enlargers resemble diffusion enlargers but are almost always used for black-and-white printing. These contain a fluorescent-like light source, which produces a softer result with a broader range of image tonality. Both cold light and diffusion enlargers make a negative's scratches and other defects less visible on the final print.

BLACK-AND-WHITE PRINTING PAPERS

Printing papers consist of a base (a supporting sheet) and a light-sensitive emulsion thinly coated on top. The makeup of the emulsion varies with the type and brand of paper. In black-and-white materials, this emulsion consists of light-sensitive silver-halide compounds suspended in gelatin.

There are two kinds of black-and-white paper: resin-coated and fiber-based. **Resin-coated (RC) papers** are most commonly used. Their base is paper covered on both sides with a thin, water-resistant plastic coating. **Fiber-based (FB) papers** have a paper base and no plastic coating. Your choice of resin-coated or fiber-based paper is very important and will affect the times for which the paper is processed, its overall look, and possibly even the long-term permanence of the resulting prints.

Printing papers also are described according to the thickness, or weight, of the paper base. Resin-coated papers are usually medium weight. Fiber-based papers are usually double weight. Heavier weight and single-weight fiber-based papers are also available; note that one manufacturer's paper may be heavier or lighter than another's, even though they

resin-coated (RC) papers Photographic papers in which the base is coated in waterproof plastic or resin, making print exposure, processing, and drying faster.

fiber-based (FB) papers Photographic paper in which the base has no plastic coating, requiring more print exposure, processing, and drying time.

contrast Tonal difference between blacks and whites, and the steps of gray in between.

contrast grades Numerical ratings of printing paper contrast. You can increase or decrease print contrast by changing paper grades or variable-contrast filters.

CONTRAST GRADES AND FILTERS

Whether you're using graded papers or variable-contrast (VC) papers with filters, this principle applies: The higher the paper grade or filter number, the greater the contrast. Following are typical grades and filters for controlling print contrast. Not all manufacturers (or papers) offer all choices.

	Paper Grades	VC Filters
Low contrast		0
		½
	1	1
		1½
Normal contrast	2	2*
		2½
	3	3
High contrast		3½
	4	4
		4½
	5	5

*A #2 filter produces approximately equal contrast to VC paper used without any filter.

are rated the same. The thinner the paper, the more difficult it is to handle without physical damage.

Paper is commonly available packaged in envelopes or boxes, usually 10, 25, 50, 100, or 250 sheets in a package. Sizes vary, but in the United States typically include 5" x 7", 8" x 10", 11" x 14", 16" x 20", 20" x 24", and larger—with 8" x 10" being the most commonly used size. (Rolls of paper also are available, mostly for commercial labs.) While these paper sizes are standard, they do not always match the proportions of standard negative formats. For example, 35mm negatives are more rectangular than standard 8" x 10" size paper.

Paper and Contrast Print **contrast** refers to the difference between how bright the light tones look and how black the dark areas appear, as well as the difference among the grays in between. A high-contrast print has very bright whites and very deep blacks with big differences between gray tones. A low-contrast print has a greater range of grays in between. In black-and-white printing, you control print contrast primarily with the paper you use and/or the printing filters (see pages 304–305).

The contrast range for black-and-white paper is rated numerically in **contrast grades.** The ratings vary somewhat with different brands and filters, but

low numbers (grade #0 or #1) produce low-contrast prints, and high numbers (grades #4, #5) produce high-contrast prints. Grades #2 and #3 generally produce average contrast. Note that these grades are relative. A #4 grade always produces a higher contrast print than a #1 grade from the same negative. But the tonal range of the negative is an important factor. A very low-contrast negative may still produce a relatively low-contrast print even with a #4 grade.

Black-and-white printing papers are available in fixed grades or variable contrast. A **graded paper** yields one contrast grade only. Each package you buy contains a particular grade: grade #2 for "normal" contrast and grade #5 for high contrast, for instance. If you are printing on a grade #2 paper and wish to increase contrast, you must switch to a different box of higher-graded paper.

Most black-and-white printing papers, however, are **variable contrast (VC) paper,** sometimes called polycontrast or multigrade. Each sheet is capable of producing any grade of contrast, usually in a range from #0 to #5. (The actual range varies with the manufacturer, and the same numbers from different manufacturers may produce a slightly different contrast.) To change the contrast, you place a **variable-contrast (VC) filter** in the path of the light source, either under the lens or (preferably) in a filter drawer above the enlarger's negative carrier. (Adjustable filters built into enlargers for color printing or enlarger models dedicated to VC printing can be used instead of separate filters; see box on page 303.)

Filters change the color of the light that strikes the paper. Different colors produce different contrasts; in general, magenta filters increase contrast, and yellow filters decrease it. For example, if

you make a print using a #2 filter and decide it is "flat" (low contrast), you can increase the contrast using a fresh sheet of paper with a #3 filter. If you decide the print with a #2 filter is too contrasty, you can decrease contrast by switching to a #1.

VC filters are available in kits from a variety of manufacturers. Filters can be used interchangeably—an Ilford filter kit, for example, can be used with Kodak paper—though it's usually best to work with the same manufacturer's filters and papers. If you are using an enlarger that allows you to dial in the filtration, check the filter values recommended by the manufacturer's data sheet in your package of paper, or use the recommendation in the box on page 303 and expect to make adjustments.

A major advantage of variable-contrast papers is that you have to buy only one package of paper to produce a range of contrast. Every sheet of VC paper can produce low to high contrast. Another advantage is that VC filters offer more precise contrast control than graded papers. Most kits include filters in half grades—#½, #1½, #2½, and so forth—whereas graded papers are available only in whole grades. Variable-contrast papers also often are less expensive than graded papers. On the other hand, graded papers are often thought to produce richer results, though in practice many variable-contrast papers are a close match. So called "premium" papers are generally (but not always) graded. (Premium papers are more costly and offer such characteristics as richer image tone and a thicker base.)

Resin-Coated vs. Fiber-Based Papers
When making black-and-white prints, you have a choice between resin-coated

(RC) papers (which have a water-resistant plastic coating on both sides of the paper base) or fiber-based papers (which have no plastic coating). Each type of paper has different qualities, and you'll probably use both in your darkroom work.

RC papers generally require shorter exposures. Processing, washing, and drying times also are much shorter—about one-third to one-half of the time of fiber-based papers. (Some types of RC papers even have dry developer incorporated into the emulsion for even shorter development times.) They also require shorter washes, which saves water as well as time, and RC prints dry flatter than fiber-based prints. And some types can be processed in an automated processor, which provides less tedious and more consistent processing than trays.

But for important reasons, many serious black-and-white printers still prefer fiber-based papers. Fiber-based papers generally capture a wider tonal range than resin-coated papers and produce more subtle differences in the print's appearance. The paper surface is also less reflective (most noticeable with glossy surfaces), and most photographers agree they have a less "synthetic" look than the plastic-coated RC papers.

Fiber-based papers allow for other types of fine-tuning as well. Different developers, for example, generally have more effect on fiber-based papers in terms of contrast, color, and overall richness. Also, with fiber-based papers, you have more control in terms of print development times, allowing them to be varied subtly to adjust image contrast and tonality. By comparison, many RC papers fully develop after a minute or so. More developing time has little effect, and less developing time can often cre-

graded paper Black-and-white paper that produces a single grade of contrast.

variable-contrast (VC) paper Black-and-white paper that produces a range of contrast grades when exposed with variable-contrast filters.

variable-contrast (VC) filter Colored filter designed to be used in an enlarger, allowing you to adjust contrast levels with variable-contrast papers.

ate muddy and sometimes streaky results.

Other advantages of fiber-based papers include more effective toning (see pages 315–317) and easier spotting and retouching. Also, properly processed, washed, and stored fiber-based prints are less susceptible to physical deterioration and image fading and staining (see Chapter 15).

Note, however, that the quality of RC papers has markedly improved over the years. Recent products are much better in terms of tonality and surface quality than products of the past, and they even allow for more fine-tuning than earlier versions. The archival qualities of RC papers also are improving. In general, the choice of one type of paper over another is a personal matter, and the final application may dictate your choice. Many photographers use fiber-based prints for their personal or professional portfolios and when mounting an exhibition, and use RC prints for contacts, quick proof prints, and most other uses, such as for reproduction in magazines and other print media.

Tone and Surface Each black-and-white printing paper has its own unique characteristics, and the paper you choose can have a marked effect on the appearance of the final print. Probably the most notable such characteristics are image tone and surface.

Image tone refers to the inherent color quality or tint of a paper's black and gray tones—its relative "warmth" or "coolness." Part of the reason that papers vary in image tone is the chemical makeup of their emulsion. Another factor is the tint of the paper base, which acts as the background for the image. **Warm-tone paper** tends toward greenish or brownish blacks and often has a

<div style="margin-left:auto">
warm-tone paper
Printing paper with brownish- or greenish-black tones.

cold-tone paper Printing paper with cool or neutral black tones.
</div>

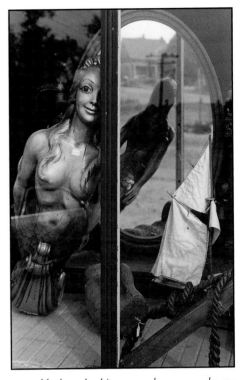

A black-and-white print is often not black and white; most black-and-white papers have some degree of color, which is known as their image tone. While many popular papers have a neutral image tone (left), others are warm-toned, with brownish or greenish blacks (right). Neutral- and cold-tone papers usually have a bright white base, while warm-tone papers often have a yellowish-white base that makes them seem warmer still. Paper developer also influences print color; like the paper itself, a developer can tend towards warmer or color results.

creamier (more yellow) base; **cold-tone paper** has more neutral blacks with a base that tends to be bright or neutral white. The labels on boxes of printing paper usually note a paper's tonal characteristics, but one manufacturer's warm-tone paper may be noticeably cooler or warmer than another's. Note that some manufacturers offer more than one cold- or warm-tone paper, and these may have very different looks as well.

The brand and type of paper developer may also have a noticeable effect on image tone. Some developers produce

warmer or cooler prints than others. Again, these characteristics are generally specified on the developer's label. Other factors related to processing that can affect image tone include the time of development and the developer's dilution and temperature.

For paper surface, you can usually choose from glossy, semi-matte (sometimes called luster or pearl), or matte. Other textured surfaces, such as "silk" or "tapestry," are occasionally available. Not all types of printing papers are available in all surfaces. Prints made on

PRINT HANDLING

Photographic paper is easily damaged, so you have to be very careful when handling it. Sloppy handling can result in nicks, crimps, and creases, as well as fingerprints and other surface staining. In some cases, touching the emulsion of the paper before processing can even inhibit the action of the solutions and cause blemishes.

Some types of paper are more sturdy than others, and this sturdiness is not always related to the thickness of the paper base (weight). Resin-coated papers are rated medium weight, but their plastic coating helps make them more resistant to damage. Double-weight fiber-based papers are sturdier than single-weight fiber-based papers. Also, papers are always more vulnerable when wet: Resin-coated paper becomes slippery but maintains its rigidity better than fiber-based paper, which becomes limp and pliable.

In general, you should always handle paper at its edges or corners—never in the image area. Larger-sized prints (16" x 20" and above) are especially vulnerable; handle them by two corners to gain better control and to prevent creasing, buckling, or crimping. Hold the paper fairly taut; don't let it sag. Never rush when handling prints. Be deliberate and careful throughout. Printing is time-consuming and expensive; don't waste your efforts by damaging good prints with sloppy handling.

Photographic prints must be handled with care, especially when wet. Mishandling may cause crimping, creasing, or even tearing. Don't hold a print in a way that causes it to bend or fold over itself (a particular risk when it's wet) and avoid touching the image area. Handle prints by their edges and/or at corners. This is especially important with very large prints. With 16" x 20" and above, use two hands and hold the print at two corners.

To process black-and-white prints, set up trays of chemical solutions in the following order: developer, stop bath, fixer, and a holding bath of plain water. If possible, label trays with a waterproof marker so that they are used for the same solution each time; this reduces the chance of chemical contamination. For the same reason, separate tongs should be reserved for each tray, with one tong for both fixer and water baths. To avoid contamination, never dip the tongs for one solution into a different solution.

SETTING UP FOR TRAY PROCESSING

The first thing you do when you begin to work in a darkroom is to set up your chemical solutions. The most common method of processing black-and-white prints is in open trays, though automated processors are sometimes used (see page 341). Set up your trays in a "wet" area, either a sink or a counter located at least a few feet away from the enlarger. This will prevent splashes or spills on your negatives, printing paper, and enlarging equipment.

You'll need a minimum of four trays. The trays should be at least as large as the largest prints you intend to make during your printing session. They also can be larger—for example, 11" x 14" trays for 8" x 10" paper. Larger trays are recommended when making a lot of prints because heavy use, inadequate quantities, and use over a long period of time can result in an **exhausted solution**—a chemical that is weakened, ineffective, or contaminated. The more solution you have to begin with, the less often you have to replace it. Use smaller trays (or use a smaller quantity of solution in larger trays) when making only a few prints, to save money and minimize waste.

glossy-surface papers appear sharpest and most contrasty; prints on matte-surface papers may seem less sharp and can appear somewhat lower in contrast.

Surface characteristics vary from one paper type to another. A matte paper from one manufacturer may be slightly more or less reflective than a matte paper from another. In particular, you'll see a great difference in surface between resin-coated and fiber-based prints. For instance, glossy resin-coated paper has a much glossier sheen than the equivalent fiber-based paper.

exhausted solution
Describes photographic chemicals that have become weak, ineffective, or contaminated, usually due to heavy use over a length of time.

Line up the trays for the following solutions:

- First tray: developer
- Second tray: stop bath
- Third tray: fixer
- Fourth tray: holding bath (plain water)

If you can, use trays for the same chemicals each time you print; designate one tray each for developer, stop bath, fixer, and plain water. This will help avoid contamination through build-up of residual chemicals over time. You can label dry plastic trays with a waterproof marker.

The last tray, of plain water, is sometimes called a **holding bath** because it holds prints until they're ready to be washed. The holding bath may be just a tray of standing water, in which case you should dump and replace the water at least every 30 minutes to prevent the buildup of fixer (and fixer by-products) as fixed prints are added to the holding bath. This will help prevent prints from becoming overfixed, a condition that can make them more difficult to wash thoroughly and in extreme cases can lighten or stain them, or even cause physical deterioration over time after the prints are dry. If possible, use a holding bath with running water.

After arranging the trays, mix developer, stop bath, and fixer one solution at a time and pour each solution into its proper tray. Place print tongs next to each tray or dipped into the solution, with the handle end of the tongs leaning against the top of the tray to keep it dry. Don't mix up the tongs during processing, or you may contaminate the chemicals. In fact, it's a good idea to dedicate tongs to a particular solution, labeling

holding bath Tray of standing or running water for keeping accumulated prints wet after the fixer bath until you are ready to wash them.

TRAY PROCESSING TIMES

Times for processing black-and-white prints can vary widely depending on several factors, including the brand and type of the processing chemicals, the dilution of the solution, and the type of paper used. Temperature is also a factor; the warmer the developer solution, for example, the faster the processing. Also, fresh chemicals work more rapidly than used chemicals.

With some RC papers and most fiber-based papers, you can vary the developing time to fine-tune the overall contrast and/or image tone of a print. In general, longer development times produce more contrast and a cooler tone, while shorter times produce less contrast and warmer results. The differences are fairly subtle, however, and depend on the receptiveness of the particular paper. If you want a strong change in print contrast, use a different filter (with VC papers) or a different grade of paper. If you want a strong change in image tone, use a different type of paper or developer.

Note that RC papers take less time to process than fiber-based papers. Keep in mind that the following times are only guidelines. Refer to the instruction sheet packaged with your processing chemicals (and/or paper) for their recommended times:

Resin-Coated Papers

Step	Time
Developer	1–1½ minutes
Stop Bath	15 seconds
Fixer	3–5 minutes (standard) 1–2 minutes (rapid)
Wash	5–10 minutes

Fiber-Based Papers

Step	Time
Developer	1½–3 minutes
Stop Bath	30 seconds
Fixer	5–10 minutes (standard) 2–4 minutes (rapid)
First Wash	3–5 minutes
Fixer Remover	2–3 minutes
Final Wash	20–30 minutes

You position the negative emulsion-side down, close up the carrier, and insert it into the enlarger in its proper location, between the lens and the light source.

the glass firmly to the base, ensuring that the paper and negatives are held flat.

from negatives before printing. You can also use a soft, wide brush.

Enlarger. The primary piece of equipment for making enlargements. The guts of the enlarger include a "head" with a system to spread out the light evenly and to direct it through the lens. Condenser (and occasionally cold light) systems are used for black-and-white printing and diffusion systems for color.

Negative (or film) carrier. Different enlargers take different types of carriers, but most are two metal plates hinged together to hold the negative flat and in position while enlarging. The negative carrier has a rectangular or square hole in each plate, the size of the negative or slightly larger, as well as grooves or raised pins to hold the negative flat.

Lens. The enlarger lens is almost always attached to a separate board which fits onto the bottom of the enlarger head, beneath the negative carrier, to project the negative image onto printing paper. As with camera lenses, enlarger lenses have an adjustable aperture, with openings measured in f-stops. For 35mm negatives, you'll be using a 50mm to 80mm enlarging lens, but different film formats require different size focal-length lenses (see page 300).

Glass. A heavyweight piece of plate glass used for making contact prints. The glass should be larger than your paper size—10" x 12", for example, for the usual 8" x 10" or 8½" x 11" paper. For safest handling, have the glass supplier smooth down the edges of the glass. There are also commercially made contact printers, which are typically a piece of glass hinged against a base, just the right size for using 8" x 10" or 8½" x 11" paper. These incorporate clamps or some other device to hold

Easel. A device for holding printing paper flat and in place under the enlarger and for controlling print borders and cropping. Most models have either two or four blades to hold the paper down; you set the image size by adjusting the blades, using a calibrated rule incorporated into the easel. Once the size is set, you lift the blades and position the paper on the easel's base (usually in a sized slot).

The blades create the print's borders. Only the area of the paper inside the rectangle formed by the blades is exposed; the areas under the blades receive no exposure and print white. Adjusting the image size also affects border size; a 6" x 9" image on an 8" x 10" sheet of paper will have a smaller border than a 5" x 7½" image on the same size paper. (There are also easels that produce "borderless" prints.)

Compressed air. For removing surface debris such as dust and dirt

Grain focuser. A microscope-like device with a magnifying eyepiece and a mirror that allow you to focus on the actual silver grain in the negative. If the grain is sharp, the image will be as sharp as it can be.

Scissors. Handy for cutting strips of photographic paper. Any kind will do the job, but blunt tips are safest when working in dim light.

Cardboard. Pieces of cardboard or opaque poster board, useful for making both test strips and masks for burning and dodging. You'll need a thin, stiff wire to dodge areas in the center of your print.

Timer. Connects to the enlarger and controls duration of the exposure. Digital models are generally more accurate than analog ones, allowing settings accurate to tenths of a second.

Safelight. Dim amber or red light used to illuminate the darkroom when making black-and-white prints. Photographic papers may be safely exposed to such light for short periods of time, since they have little sensitivity to the red portion of the light spectrum. There are many types of safelights available. Some look like colored lightbulbs; others hold a low-wattage lightbulb in a housing that incorporates a colored filter. Some safelights have special fluorescent or sodium-vapor lamps; others use standard fluorescent tubes covered with a color filter sleeve.

Trays. Plastic, stainless steel, or rubber pans that hold the chemical

solutions for processing black-and-white prints. Trays typically come in the same size designations as printing paper—5" x 7", 8" x 10", 11" x 14", 16" x 20", 20" x 24", and so forth—but are slightly larger to allow easier paper handling.

Tongs. Flexible clamps to handle prints in solutions to allow you to avoid direct skin contact with the chemicals. Use separate tongs for each solution.

Washer. A device used for washing prints. These come in many shapes and sizes. The simplest version is a processing tray with a siphon that constantly drains water from the bottom. The tray should be at least as large as the largest print being washed and as deep as possible. More sophisticated archival washers are made of heavy acrylic and resemble home aquariums divided into slots to form many thin compartments. (Each compartment holds one or two prints.) Jets fill the slots, keeping

water moving across the surface of the prints at all times for an efficient wash. Other types of washers include circular trays and drums in deep trays. Both deliver water on one end and drain on the opposite end for a more efficient wash.

Squeegee. For removing water from a washed print to promote more rapid, even drying. Alternatively, you can use a soft, clean photo sponge, available at most camera stores.

Dryer. An electric dryer or screens for drying prints (see pages 308–310).

Paper safe. A light-tight box for holding paper during a printing session. The paper safe protects the paper from light. You don't absolutely need a safe, but it makes paper handling much easier; without a paper safe you'll be unwrapping and wrapping the packaging every time you need a sheet of paper for printing.

Variable-contrast filters. Color plastic filters inserted into an enlarger to change contrast with variable-contrast papers, rated in half-grade increments.

Miscellaneous. Other equipment needed for printing is similar to equipment used for processing film. This includes beakers, funnels, and stirring rods for mixing chemical solutions and an accurate thermometer for measuring and monitoring solution temperatures. You should also have a towel handy.

After you've exposed your print, slide it into the tray containing developer with a smooth but rapid motion, submerging it as quickly as possible (left). (Some photographers first place the print face down in the solution, then flip it over.) Agitate by gently lifting one corner of the tray repeatedly (center), to ensure even development. Five to ten seconds before the development time is up, carefully lift the paper out of the tray by one corner (right), then allow excess solution to drain for a few seconds before placing it in the tray of stop bath. (Draining helps increase the useful life of the successive chemicals.) Repeat the same technique with every transfer to a new solution.

them with a marker (developer, stop, fixer) and using them accordingly in all future printing sessions. Note that tongs can be awkward to use—and may even cause damage—with prints larger than 11" x 14".

TRAY PROCESSING BLACK-AND-WHITE PRINTS

Once the trays are set up and filled with solution, you're ready to print. Turn on the safelight, turn off the room lights, and expose your paper. (To make a test strip, contact sheet, or enlargement, see pages 290–299.) Then bring the paper to the first tray for processing. Proceed as follows:

1. Slide the paper face down into the developer bath and immediately agitate the solution by gently rocking the tray. Cover the entire sheet in solution as quickly as possible, or the print may develop unevenly. Resin-coated papers should be developed for 1 to 1½

minutes, fiber-based papers for 1½ to 3 minutes. Begin timing the developer step as soon as the print is fully submerged.

Good **agitation** ensures that fresh developer is constantly in contact with the paper's emulsion. Rock the tray for the entire time the print remains in the developer. A few seconds after the print is fully submerged, turn the paper over so you can watch the print develop; except for large prints (larger than 11" x 14") use tongs to grab the paper by one corner and lift it out of the solution to turn it over. (See illustration above) Depending upon the type of paper, you should see the image gradually appear in around 30 seconds or less.

2. Five to 10 seconds before the suggested development time is up, lift the paper out of the developer. Again, use tongs, grabbing the paper by one corner and holding it over the tray so

excess developer will drip off. For critical timing, don't let it drip for more than a few seconds, since development continues as long as the paper is soaked with solution. Also, to avoid contamination, be careful not to dip the developer tongs into the stop bath.

3. Place the paper in the second tray (stop bath), gently sliding it in face down so the entire print is submerged in the solution. Again, agitate by gently rocking the tray until the time in stop solution is almost up. The time in this bath is not as critical as the time in the developer; 30 seconds is generally adequate for fiber-based papers, 15 seconds for RC.

4. Lift the paper out of the tray using the designated stop-bath tongs. Let the solution drip off for a few seconds.

agitation Gently rocking trays of solution when processing prints to ensure even results. Agitation also may be done by carefully moving around the exposed paper in the solution (with tongs or gloved hands) or by shuffling prints through solutions, when processing more than one print at a time.

Philip Trager

Villa Pogiana, 1984

Some of the most compelling subjects have an inherently narrow tonal range—no solid blacks, no bright whites, and even few variations of gray. This makes it more difficult to apply traditional printing strategies, which depend on evaluating the image's highlight and shadow tones. Trager's architectural detail of an Italian villa is a case in point. To make this print, the photographer had to pay special attention to his print exposure: too much would have caused the walls to be too dark, and lose their airy quality; too little would have caused the walls to be too light, and lose their all-important surface texture. In his final print, Trager struck the right balance between the softness of the light and the solidity of the walls. © Philip Trager

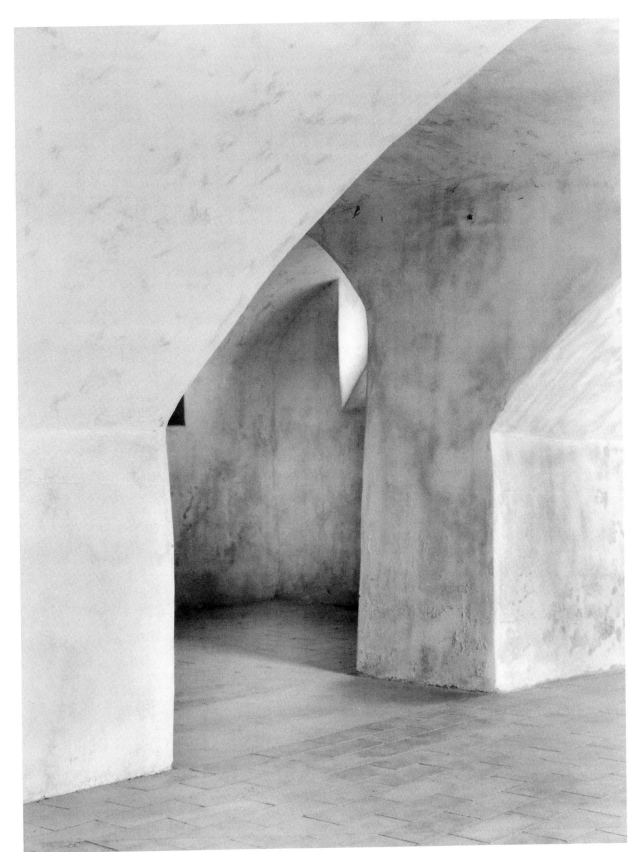

5. Slide the paper into the fixer bath and rock the tray (don't get fixer on the stop-bath tongs). Fixing time depends on the type and freshness of the fixer and the type of paper. In standard fixers, RC papers require about 3–5 minutes, fiber-based papers about 5–10 minutes. In rapid fixers, times are halved: about 1–2 minutes for RC paper and 3–5 minutes for fiber-based. If you've been using the same tray of fixer for some time, you may need to increase your fixing times. (You can check the effectiveness of your fixing bath with commercially-available fixer-check solutions.)

6. You can actually view processed prints in room light after about half the recommended fixing time. If you're the only person using the darkroom, you can turn on the room lights for viewing; if there are others printing with you, take processed prints into another, lighted room (but place the prints in a dry tray so you won't drop solution on the floor). Either way, return prints to the fixer for the remainder of the time after viewing. If your fixing time is too short, it may lead to staining and otherwise adversely affect a print's longevity. (Note that overfixing also may be harmful. It can result in image bleaching and/or staining and make the print more difficult to wash.)

7. Remove the processed print from the fixer and slide it into the holding bath. You can let several prints accumulate in the holding bath before you begin the wash. But again, it's a good idea to change the water in the tray every 30 minutes or so to prevent fixer from building up in the water, or to use a holding bath with running water.

8. The final wash time and method depend on the type of paper used. Resin-coated prints need only a 5- to 10-minute final wash after the fixer, but with fiber-based prints you'll need a 3- to 5-minute first wash, then 2–3 minutes in fixer remover, and a 20- to 30-minute final wash. Required times vary with the type of fixer remover and the efficiency of the washing method.

With fiber-based papers, fill a clean tray with fixer remover (again, use the same tray for this step in every printing session, if possible). After the first wash, place each print in the fixer remover, one at a time but in quick succession, to ensure that the solution covers each sheet. It's a good idea to use rubber or plastic gloves to protect your hands from contact with the solution. Agitate for the entire time by carefully shuffling the prints from the bottom to the top of the pile. When the time is up, pull the prints out of the fixer remover and place them in the washer for a final wash.

Alternative Fixing Strategies Some printers prefer to use a two-bath fixer, especially for fiber-based prints. This helps ensure that the fixer is fresh, and it also extends the useful life of the bath. In this method, you mix two separate trays of fixer and place them side by side. Soak processed prints in each bath for half the recommended overall fixing time.

Discard the first bath after around 25 8" x 10" prints have been processed (the number of prints depends on the amount of solution in the tray). Replace the discarded first bath with the second bath and mix a fresh second bath. Use these two solutions for another 25

8" x 10" prints or so and repeat the procedure. The two-bath fixing method ensures that the paper always spends the last half of its fixing time in a fresh solution.

Another fixing method is to use a single bath of rapid fixer at a much stronger concentration—about twice as strong as normal paper fixer. (This method does not apply to standard fixers.) When mixing the fixer, use twice as much of the fixer concentrate recommended by the manufacturer, in the same amount of water. (With many brands, this is the same dilution used when mixing fixer for film.) A stronger concentration makes fixing time much shorter—usually one to two minutes.

Shorter times are more convenient, and they also help prevent fixer from soaking as deeply into the paper's base, which in turn promotes more effective washing. But because the fixer is so strong and the times so brief, you must be more exact when timing your print in the solution, being especially careful not to overfix, and with constant agitation.

Note that some print fixers have hardener built-in and some require you to add it separately. Hardener makes the print glossier and more durable, but it also increases the print wash time.

MAKING A CONTACT PRINT

A contact print is made by sandwiching the negative against the paper under a sheet of glass. The resulting print is the same size as the negative: A 35mm negative produces 1" x 1½" contact prints; a 4" x 5" negative produces 4" x 5" prints; and so forth. Most of the time, contact prints are used for reference. They show what's in your negatives, allowing you to decide which pictures to

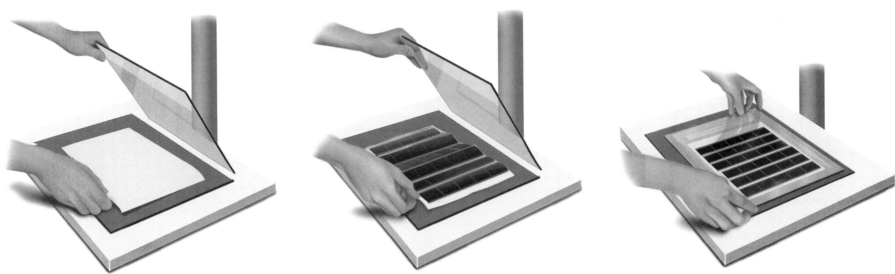

You make a contact sheet by sandwiching negatives directly against photographic paper under a sheet of glass. Be sure the glass is clean; spots, scratches, or particles on its surface will be visible in the print. Put the glass on the baseboard of your enlarger, then position a piece of unexposed printing paper emulsion-side up beneath it (left). Some printers like to place an additional piece of glass or some other firm, smooth surface underneath the paper, too. Then place the negatives emulsion-side down on the paper (center). Removing the negatives from their clear plastic storage page makes the images appear sharper, but for efficiency's sake many photographers make the contact sheet through the page, without removing the negatives, as shown here. In either case, carefully lower the glass on top of the negatives and paper (right).

enlarge, and also provide a convenient means of filing and storing your work; you can assign the same number to the back of your contact print and to the negative sleeve that matches it, to make it easier to find negatives when you want to print them.

For final prints, most negatives are enlarged. However, in the early days of photography, there were no enlargers, and contact prints—usually made from relatively large negatives—served as final prints. Even today, photographers using large-format negatives (such as 8" x 10") sometimes make contact prints, not enlargements, as final prints.

contact sheet Contact print of an entire roll of negatives on one sheet of paper to provide a visual reference of the images on that roll.

Following is a step-by-step guide to making contact prints from a roll of 35mm film. You can just fit most of a 36-exposure roll on a sheet of 8" x 10" paper. The resulting print showing all the frames

on the roll is called a **contact sheet.** You can use 8½" x 11" paper to fit the entire roll more comfortably, but this size paper is sometimes harder to find than 8" x 10" and requires that you buy an extra package just for contact printing.

You use the same equipment to make a contact print as you do for an enlargement, with one important exception. Instead of an easel to hold and crop the printing paper, you use a sheet of glass or a contact printer to hold the negatives against the paper. The basic steps for making a contact print are also pretty much the same as when making a final print or an enlargement, except that a contact sheet is quickly executed for purposes of reference only. Partly for that reason, and also because it costs less and processes more quickly, most printers use RC paper rather than

fiber-based paper for contact printing. Glossy-surface papers also are preferred for their better contrast and sharpness characteristics.

1. Clean the glass used for contact printing with household glass cleaner and dry it completely.

2. Close down the lens aperture to f/8 or f/11. For control of exposure increments, you may choose to set the lens to a wider or smaller f-stop after your initial test. Make sure the negative carrier is not in the enlarger.

3. With room lights turned off and safelight on, turn on the enlarger.

4. Raise the enlarger head so that the circle of light it projects on the baseboard of the enlarger is significantly broader than the size of paper you'll be using.

Because it allows you to see all the images on a roll of film at once, a contact sheet is an important tool for both editing and cataloguing your work. Be sure to place all the negatives emulsion side down so that the numbers along the edge of the film read correctly; also, place the strips so that they are in numerical order and face in the same direction. If you store your negatives in transparent pages, you can make the contact print without removing them from the sleeves.

Most photographers use resin-coated (RC) paper for contact sheets to save time (they require shorter exposure and processing times than fiber-based papers) and expense (they cost less than fiber-based papers). Note that a full 36-exposure roll of 35mm negatives doesn't quite fit on 8" x 10" paper; you generally lose at least a frame, and some of the sides of the images may be cut off. Consider using 8½" x 11" paper, which fits a full roll more comfortably, as shown here.

5. Turn off the enlarger and set the timer. Exposure times will vary depending on the enlarger, bulb strength, lens aperture, height of the enlarger head, paper type, and other factors—but most notably on the density of your negatives. You may have to run a test print the first few times you make contact prints (see pages 298–299), but for the purposes of this example, start with a 10-second exposure.

6. You may choose to place or dial-in a variable-contrast filter (see box, page 303, and illustration, pages 304–305) in the enlarger at this point, to create a more readable contact sheet—one with more or less contrast.

7. Remove a sheet of printing paper from its box. The paper in the box is covered with an envelope or wrapper to protect it from unwanted exposure. Open the wrapper carefully, taking care not to rip it, so you can reseal the paper after you've removed the sheet you need.

8. Position the sheet of paper on the enlarger baseboard so the center of the paper is directly under the lens. Make sure the emulsion side of the paper is facing up. The emulsion is sometimes hard to identify. In most cases it is shinier than the base side, particularly with glossy-surface papers. Also, fiber-based papers tend to curl slightly toward their emulsion side.

9. Place the strips of negatives emulsion side down on the sheet of paper. The emulsion of the negatives is easier to identify than the emulsion of the paper; it's duller (less glossy), and the negatives tend to curl toward it.

You can place each strip individually on the paper, but contact printing is easier when the negatives are stored in a plastic page (see page 291). Such pages serve several useful functions, the most important of which is that they protect negatives from excessive handling that can lead to scratches or other physical damage.

Note that it's best to line up the negatives in their correct order and orientation on the paper or in their storage pages. It will be easier to read the final contact print this way.

10. Place the sheet of glass on top of the negatives and printing paper so the negatives and paper are in tight contact. (Without the glass, the printed image would be unsharp.) Before making the exposure, be sure the negative strips are aligned on the paper; as the glass is pressed against them, loose negatives sometimes shift position slightly.

11. Turn on the timer and expose the paper for 10 seconds, or whatever exposure time you've chosen. Time is generally established by making a test strip (see pages 298–299) or by estimation, with experience.

12. Remove the glass and the negatives, and take the exposed paper to the trays for processing (see pages 288–290).

13. When the print is processed, turn on the room lights (if you're the only one working in the darkroom) or take the print out of the darkroom to examine the results.

14. If the contact print looks too light overall, reset the timer to increase the exposure—say, from 10 to 15 seconds or so, depending on how

Cropping is a valuable tool for altering composition in the darkroom, after the photograph has been taken and the film processed. This portrait was originally composed with the subjects slightly off-center and at some distance from the camera (left). To place more emphasis on the mother and child, the photographer first raised the enlarger head to make them bigger, then used the enlarging easel's blades to crop out background areas mainly on the top, right, and bottom, thus centering the figures (right). Keep in mind that cropping can make a print appear grainier and less sharp, since you are usually enlarging a smaller portion of the negative. This is especially true of 35mm negatives, since they are already small compared to other film formats.

light the print is. If it looks too dark, decrease the time—perhaps to 8 seconds. (If it looks extremely light or dark, you may want to adjust the exposure by opening up the lens or closing it down by one or two stops to let more or less light in. Then repeat steps 5 through 12 until you get a contact print with good overall density.)

Since contact prints are usually for reference only, don't spend a lot of time—or waste paper and chemicals— trying to make them look perfect. Individual frames can vary in both density and contrast, so it's unlikely you'll get all the images on a roll looking exactly right anyway. Do your best to get results that allow you to see clearly what's on each frame, and leave it at that. However, if an entire roll looks too flat or too contrasty, you may choose to make another contact print with a higher or lower paper grade or variable-contrast filter.

If you use the same enlarger and lens every time, you can generally standardize your contact printing. Remember the location of the enlarger head on the rail and the position of the focusing knob;

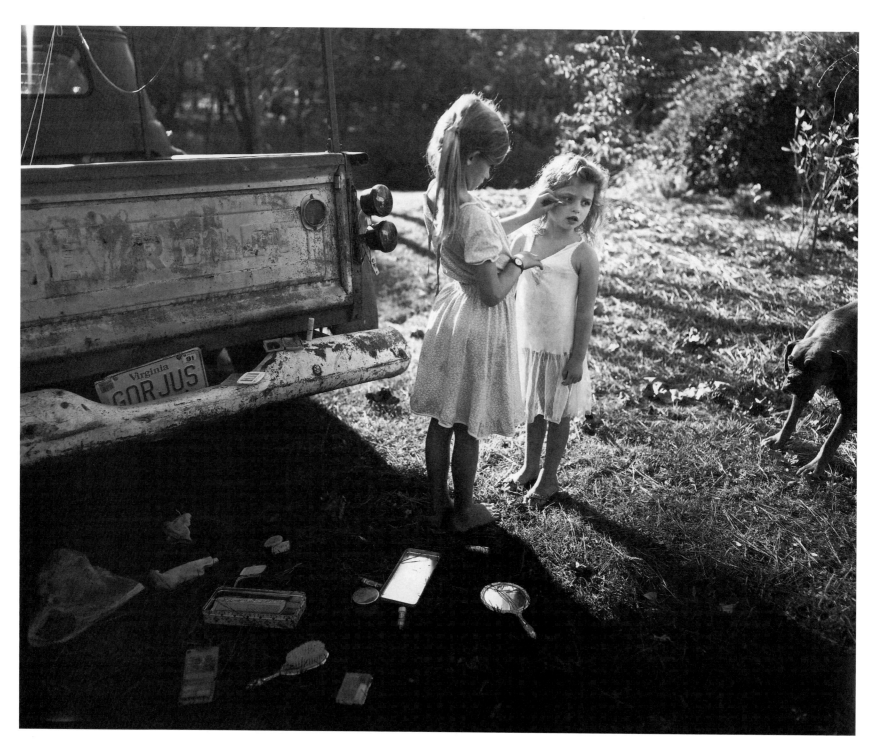

Sally Mann Gorjus, 1989

Mann's richly-printed, inward-looking black-and-white images explore the process and psychology of growing up, mainly through the photographer's own children. Made with an 8" x 10" view camera in and around her rural Virginia home, the photographs demonstrate a keen awareness of light. But in this image, the strong backlight required careful attention to film exposure and printing to maintain good detail in both the bright areas and the deep shadow that contains the "grown up" articles scattered on the grass. Courtesy Edwynn Houk Gallery, New York

mark them with pieces of tape or make careful notes. And use the same f-stop and exposure time—depending on the density of your negatives.

MAKING AN ENLARGEMENT

Enlargements are prints larger than the negatives from which they're made. In theory, negatives can be enlarged to any size at all. However, there are many practical considerations that limit your choices. Making very large prints, for example, requires a lot of space and, sometimes, special equipment or a redesigned darkroom. And large prints are more expensive to make than small prints because the paper is more costly and requires more chemistry.

Printing papers come in a variety of sizes, in the United States typically 5" x 7", 8" x 10", 11" x 14", 16" x 20", and 20" x 24". Enlargements can be made to the full size of the paper, but most printers make them a little smaller with a white border around the image. If you make a border that measures ½" on all four sides, for example, you'll have a 7" x 9" size image on a sheet of 8" x 10" paper.

Film format also plays an important role in determining the final image size. A 35mm negative's image area measures 1" x 1½" (24mm x 36mm). If enlarged fully with a small border around the image to a sheet of 8" x 10" paper, it would produce a print image area approximately 6" x 9". You could choose to cut off—or **crop**—part of the image and make it more square to fill the full 8" x 10" paper size.

Most photographers prefer the option of printing the negative without cropping, sometimes called printing **full frame**. This provides a print of the subject more or less as it was originally seen through the camera's viewfinder. It also provides the best possible image quality. When cropping, you often must enlarge the negative more than when you print full frame. And the more you enlarge a negative, the greater the potential for image degradation.

Some photographers have a strong dislike of cropping. They argue that the picture should be composed in the viewfinder, not after the fact. It's true that you'll almost always get better results by composing your subject carefully when photographing. (This is especially true in 35mm, in which the greater enlargement usually needed for cropping can reduce image quality.) But there is nothing sacred about the particular image shape (whether rectangular or square) your camera produces. Cropping can be a useful tool, especially for fine-tuning composition—for example, to eliminate a distracting element on one edge of the image.

Because the dimensions of the negative and the printing paper are usually different, printing full frame means that your white borders may not be even all around the final image. As mentioned, a full 35mm negative produces a 6" x 9" image on an 8" x 10" sheet of paper. If your easel allows you to center the image on the paper, this makes a ½" border along the 8" sides and a 1" border along the 10" sides. Note that a couple of film formats—6 x 4.5cm, a common medium-format size, and 4" x 5"—do enlarge nearly full frame with even borders on 8" x 10" and/or 16" x 20" paper, but they do not on 5" x 7", 11" x 14", or 20" x 24" paper.

Following is a step-by-step guide to making enlargements, which includes making an initial test called **test strip.** Refer to pages 290–295 on making con-tact prints for guidance; many of the basic steps are similar.

1. With the room lights on, place the negative in the negative carrier emulsion side down.

2. Gently remove dust, dirt, and other grime from the negative, using film cleaner, canned air, or a soft brush.

3. Place the negative carrier securely in the enlarger. Most enlargers have grooves or other guides to help position the carrier.

4. Set the lens to its widest aperture to make the projected image brightest for easier sizing and focusing.

5. If you're printing black and white with variable-contrast filters, start with a #2 (normal contrast) filter in the enlarger's filter drawer. You also can print without a filter and get normal contrast results, similar to using a #2 filter. If you decide to add a filter later, though, you may have to adjust the exposure time significantly, since the filter affects the amount of light passing through the lens (see pages 304–305 about choosing filters).

6. Set the blades of the easel to mask off the paper for the desired image size. Make sure the easel is positioned on the base of the enlarger directly below the lens.

7. Now turn off the room lights. The following steps must be done under safelight illumination. You can use safelights for room illumination when printing black and white, but not when printing color.

8. Remove a sheet of printing paper from its box and place it in the easel to help focus the image. The sheet helps you to focus at the exact height

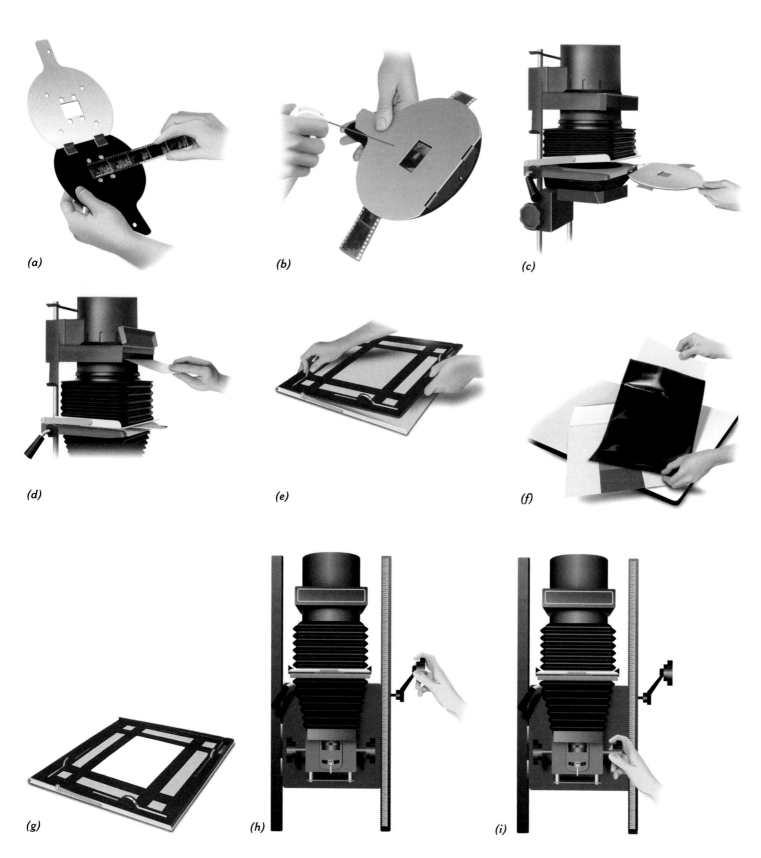

(a)

(b)

(c)

(d)

(e)

(f)

(g)

(h)

(i)

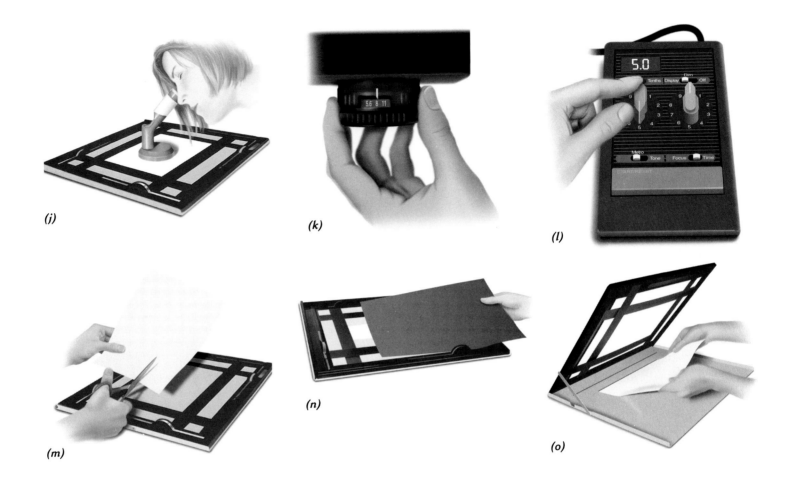

(j)

(k)

(l)

(m)

(n)

(o)

Making an Enlargement

To make an enlargement, place the strip of negatives emulsion-side down in the negative carrier (a). Make sure the frame you want to print is centered in the opening of the carrier, and blow off dust from both sides with several bursts of compressed air (b). Don't shake the can, and keep it upright when using it. Insert the negative carrier into the enlarger (c); with most enlargers, you position it in a slot and/or between pegs to insure that it is centered in the path of the light.

Open the filter drawer on the enlarger head and insert a variable-contrast filter, if needed, making sure the enlarger is turned off so that light doesn't strike unprotected paper (d). Adjust the enlarging easel's blades to the desired image size, lifting the top of the easel to prevent stress on the blades (e). Remove a piece of printing paper from its package to use as a focusing sheet (f), and place it in the easel (g).

To make the image larger or smaller, turn the crank on the enlarger rail to raise and lower the head (h). When the projected image fits the opening in the easel blades, adjust the focusing knob to make it sharp (i). You may have to alternate between focusing and adjusting the height of the head

until the image is both sharp and the correct size. If you are using a grain focuser, place it in the center of the image and look into it without blocking the light from the enlarger with your head (j). Looking through the grain focuser, turn the focusing knob back and forth until the texture of the grain appears sharpest. Remove the focus sheet from the easel.

Set the enlarger lens at a middle aperture such as f/8 (k). Then set the timer to the desired exposure increment for your test strip, in the text example, five seconds (l). Take another sheet of paper from its package and cut off a small piece to use for a test strip (m). Return the rest of the sheet to the package and place the cut piece in the easel. To make a test strip, cover almost all of the strip with an opaque board and expose it for five seconds (n). Move the board to uncover more of the strip, and make another exposure. When moving the board, lift it up and lower it onto the next portion of the strip; don't slide it or you may physically move the strip. Repeat this procedure, removing the opaque board entirely for the final exposure, until the whole strip has been exposed. Process and evaluate the test strip for the best exposure. Then insert a fresh, full sheet of paper into the easel to make a print (o).

5 secs.	10 secs.	15 secs.	20 secs.	25 secs.

 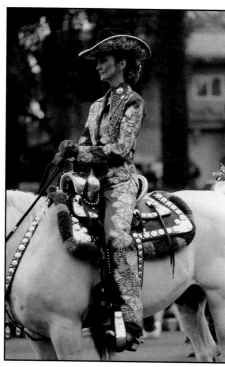

A test strip is the best way to gauge the right exposure for a given negative. A properly-made test indicates a range of possible exposures, in increments, from too light to too dark. In this example, the test strip was exposed in five second increments with the enlarger lens set at f/8 (left). From left to right, the first two increments (five and ten seconds) are too light; they have weak, gray dark tones and highlights that lack detail. The last two increments (20 and 25 seconds) are too dark; the highlights lack brilliance and the middle-gray tones look murky.

The third increment (15 seconds) represents the highlights as bright but detailed, and the varied tones within the clothes and saddle are well defined, making this the best exposure for the image (right). Keep in mind that the correct exposure may not always fall exactly on a visible increment. Here, if ten seconds had been too light and 15 seconds too dark, an exposure of 12 or 13 seconds would have been best.

10. Now focus the image. For more accuracy, use a grain magnifier, which is like a microscope that lets you see the grain of the film. If the grain is in focus, the image is as sharp as it can be.

11. When you focus the projected image, its size may change slightly. If it does, move the enlarger head up or down and refocus until you achieve the desired image size and focus. Then tighten any knobs that lock in focus and secure the position of the enlarger.

12. Close down the f-stop to f/8 or f/11. (Be careful not to shift the lens and accidentally throw off the image size or focus.) Closing down will improve the print's corner-to-corner sharpness and also make your exposure time an acceptable length. You should aim for an exposure that is at least 10 to 20 seconds—a good range to accommodate burning, dodging, and other manipulations (see pages 300–303, 306, and 310). Note that you may have to stop down more or less, depending on the density of the negative, the type of printing paper, the brightness of the enlarger bulb, and the degree of enlargement.

13. Turn off the enlarger and take the focusing sheet out of the easel.

14. Set the timer. Start with a 5-second exposure time to make a test strip. (You may have to adjust this time depending on the enlarger, the lens aperture, the height of the enlarger head, the paper type, and other factors.)

15. Take a fresh sheet of printing paper from its box and cut it into a few more-or-less equal strips for testing

of the paper emulsion, rather than the easel's surface. (This ensures maximum sharpness.) Moreover, the sheet provides a bright white background for easier viewing. Mark the back of the paper with an X to identify it for reuse. Remember to close the box of paper again, so it is light tight.

9. Turn on the enlarger and raise or lower the head until you've framed the image the way you want it, using the easel blades as a reference. With most enlargers, you crank or manually push the head up and down along a rail. Some models have motors that you activate with the flip of a switch.

exposure. (You can make the strips thin to save paper, or wide for a larger viewing area if you don't mind the expense. If you're using an automated processor, you may have to use a full sheet for your test, or the processor will jam.)

16. Put one of the strips in the easel, emulsion side up, with the blades holding it down so it won't move or curl during the test. Then put the other strips safely away in the paper box. Make sure the box is closed tight so the paper won't be accidentally exposed if the room lights are turned on.

17. Make a test strip in six or more 5-second increments, using an opaque board, such as cardboard, to block the light. It is better to use more increments rather than less to get a greater range in which to judge the exposure.

18. Remove the exposed strip from the easel and process it (see pages 288–290).

19. Turn on the room lights for viewing the strip, or bring the processed paper into a lit room. You should place wet paper in a dry tray for handling; it's easier to see this way, and the paper won't drip onto dry surfaces. For best print viewing, use an area with good, even illumination—not too bright or dark. Otherwise you may be surprised how different your final print looks.

20. Examine the results. In a good test strip, the six or more sections will show a range of densities from light to dark. If the entire strip is too dark, make another test with less time (perhaps with 3-second instead of 5-second increments) or with the lens aperture closed down one or two more stops (to f/11 or f/16 instead of f/8). If it's too light, make another test with longer exposure increments or (if necessary) a wider aperture.

21. Suppose the density at 15 seconds looks best. Set the timer accordingly.

22. Take a fresh sheet of paper from its box, then close the box tight. Put the entire sheet emulsion side up in the easel and make a single 15-second exposure.

23. Process and examine the results. Be prepared to make several prints, adjusting the exposure to get the print density exactly as you want it.

Black Borders Some photographers make their prints with a black border framing the image. The border is created by printing the clear, unexposed film surrounding the image area of the negative. As enlarger light passes through these transparent edges, it fully exposes the paper in the corresponding areas and causes them to turn black when developed.

The easiest way to create black borders is to use a negative carrier with an opening that's slightly larger than the image size. Some carriers are made this way, but most have an opening only as large as the image—for example, 1" x 1½" with a 35mm negative.

If necessary, you can enlarge the opening of a negative carrier by carefully filing it out with a flat file. Don't make the opening too large, however, or the carrier may not be able to hold the negative flat. A negative that's not flat may produce prints that lack edge-to-edge sharpness.

Once you enlarge the opening, file down all rough edges to keep the carrier from scratching the negatives. Most neg-

Some photographers prefer their prints to have a black line around the image, as shown here. The black line comes from the clear film base that surrounds the negative's image area; the clear base prints as a black tone. Use a negative carrier with an opening slightly larger than the image size (you may have to file out the opening to make it larger), and adjust the easel blades so that a thin line of clear film base surrounds the projected image.

ative carriers are painted flat black to absorb light; filing may remove the paint and uncover the underlying metal, which could cause unwanted reflections. To guard against this, paint over the filed areas with flat black paint.

Once you have a carrier with a large enough opening, making black borders is simply a matter of setting up the negative and the easel to accommodate them. Position the negative in the film carrier so

FILM FORMAT AND LENS FOCAL LENGTH

The focal length of the lens you must use with your enlarger depends on the film format you are using. Because films come in different sizes, you need to use a lens that provides adequate coverage and projection distance for each type of film. The following chart contains general recommendations.

Film Format	Lens Focal Length
35mm	40mm to 80mm
120/220	80mm to 105mm
4" x 5"	120mm to 150mm
8" x 10"	210mm to 300mm

You can use a longer lens to cover a smaller format. For instance, you can print 35mm negatives with a 105mm lens. If you do, however, you will have to raise the head of the enlarger higher, which will increase the needed exposure times. You should not use a lens with a shorter focal length than recommended; for example, don't print a 4" x 5" negative with a 50mm lens. Shorter lenses will not provide adequate coverage—that is, the image area they project is not large enough to include the whole negative.

PRINTING VOCABULARY

Photographers use a variety of special terms when describing a print. Here are some of the most common, with short definitions. Most apply to either black-and-white or color prints:

Density: Overall darkness or lightness.

Image tone: The color of a print, as in "warm tone" or "cold tone" papers.

Tonality: The scale and character of a print's white, black, and gray tones.

Highlights: White and light areas of a print.

Shadows: Black and dark areas of a print.

Shadow detail: How much texture or information can be seen in the print's shadows and other dark areas.

Contrasty/hard: High in contrast. Shadows are quite dark and highlights quite light, with strong differences between the gray tones.

Hot: Area that's too light in a print that has otherwise good overall density. Burning adds detail to a hot area.

Flat: Low in contrast. Prints are grayish, with inadequate differences between highlights, shadows, and among gray tones.

Soft: Low in contrast. Can also refer to unsharp focus.

Muddy: Dark and/or gray, without enough separation in tones. To correct a muddy print, you usually need to reduce the exposure time and/or increase the contrast.

Straight print: A print made without any dodging, burning, flashing, or other such manipulative techniques.

Full frame: Printing the entire negative without cropping it.

its clear edges are visible on all four sides. Put the carrier in the enlarger, then adjust the easel blades so that the clear area around the negative image falls within them.

BURNING AND DODGING

Burning and dodging are the main tools used to fine tune the quality of a print. **Burning** allows you to selectively darken areas of the print without affecting its overall density. **Dodging** allows you to selectively lighten areas without affecting the print's overall density. Burning and dodging are needed on most prints because of the variable tones of many subjects. The correct print exposure may leave a white T-shirt too bright, even though the rest of the print looks fine. Or it may make the shadows under a bridge too dark and impenetrable. In order to maintain the proper overall exposure, you can burn in the T-shirt, or dodge under the bridge to correct just these areas, leaving the rest of the print looking unchanged. (See illustrations pages 306, 308.)

When used carefully and subtly, burning and dodging are also important creative tools. The ability to lighten or darken areas selectively means you can manipulate the visual impact of a photograph. They also allow you to draw the viewer's attention toward or away from specific details.

burning Selectively adding exposure to a portion of a print to make it darker.

dodging Selectively holding back exposure from a portion of a print to make it lighter.

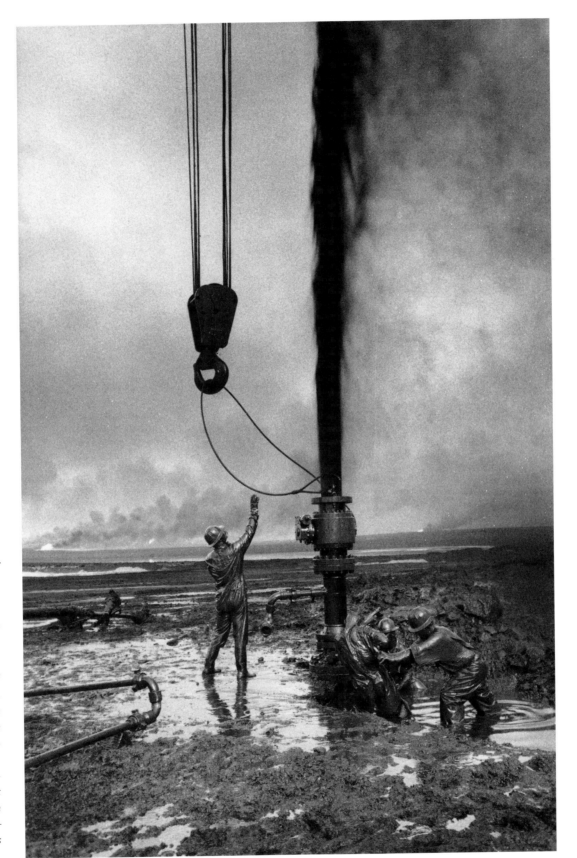

Sebastião Salgado
Operation Desert Hell, 1991
Salgado has made a lifelong cause of photographing the workers of the world—here, men capping a runaway oil well in Kuwait after the Persian Gulf War, but more often manual laborers being exploited in the developing world. Heir to a long tradition of socially committed documentary photography, he combines his compassion with a keen sense of composition and timing. To reach a wide audience for the issues he considers important, Salgado shows his work through magazine assignments, exhibitions, and books. Unlike many working photographers, he makes the time to print his own images—for him, an important part of the process— and is known as a meticulous printer. Contact Press Images Inc.

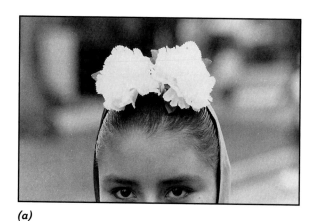

(a)

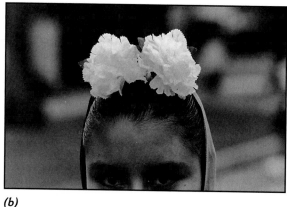

(b)

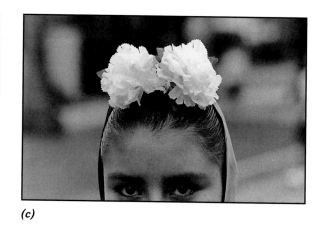

(c)

Judging a Print (see text pages 295–299)

To make a print, you must first determine the needed exposure, which is controlled by the combination of time and the f-stop you set on the enlarger lens. If a print receives too much exposure, it will be too dark. If it receives too little exposure, the print will be too light. It is difficult if not impossible to make the other decisions involved in printing—concerning contrast, dodging and burning, and so forth—without first establishing the correct exposure.

The first print in this series—made at a lens aperture setting of f/11 for a time of 10 seconds—is underexposed (a). The highlights (light areas) lack detail and the shadows (dark areas) are gray rather than black or near-black. To make a darker print, increase the exposure, as in the second print (b), for which the time was increased to 18 seconds (also at f/11). This proved to be too great an increase, however, resulting in an overexposed (overly dark) print. The shadow areas are too dense, obscuring detail, and the brightest highlights are gray rather than white. The final print (c) was made at an exposure time of 14 seconds (again, at f/11), and has the correct balance of detail in light and dark tones. The highlights are white but with texture, and the shadows are deep and full without losing their detail.

To burn or dodge, follow these steps:

1. Make a print with good overall density and contrast. Suppose the required exposure is 10 seconds at f/8 with a #3 filter.

2. Examine the print for areas that are too light or too dark. Let's say the lower right-hand corner of the print is too light and an area in the middle is too dark.

3. Expose a fresh sheet of paper for the initial time and contrast (10 seconds, f/8, #3 filter).

4. During the exposure, use a dodging tool (see box, page 309) to hold back light from the middle of the print. Keep the tool in constant motion over the area that's too dark, so that the edges of the dodged portion will blend seamlessly with the areas you don't want affected. The amount of dodging will vary with each print, but it's often helpful to think of the amount in terms of percentages of the overall exposure. For this example, dodge for 20 percent to 30 percent of the original exposure, or two to three seconds.

5. After the initial exposure, cover the lens with an opaque burning tool, and again turn on the enlarger. Slowly move the tool into position so that the projected light exposes only the corner of the image that prints too light (here, the lower right corner). The time of this additional exposure will vary with the particular negative, but 50 percent (here, five more seconds) or even more is common. Make sure the burning tool is in constant motion during exposure to prevent a sharply visible tonal edge in the image.

For fine printing, you may need to burn and/or dodge several areas of a print. Dodging almost always requires far less time than burning. A dodge of as little as 10 percent of the initial exposure is usually noticeable, and a dodge of more than 40 percent rarely blends without showing; the dodged area may look foggy or muddy compared to the areas around it. A burn

of at least 25 percent of the initial exposure is often needed to be noticeable, and a burn of 100 percent to 200 percent—or even greater—is not unusual.

FLASHING

A far less commonly used tool for fine-tuning prints than burning or dodging, **flashing** can still be invaluable in certain situations. It involves making the initial exposure (with burning and dodging, if required), then removing the negative carrier and exposing the paper to a brief "flash" of light from the enlarger.

There are two main reasons to flash a print: to lower overall print contrast and/or to add tone to highlight areas that are too difficult to burn in. The latter is the most common reason. Some areas are too irregular in shape, too small, and/or too widely scattered to burn seamlessly. In such cases, flashing provides an easier and more effective method of adding tone (see illustration on page 310).

A controlled flash pushes invisible detail over the threshold of visibility, actually adding texture and tone to the image. Because it involves a relatively small amount of light, the technique has little visible effect on middle or dark tones. But it also reduces the overall print contrast, so you should start out with contrast at least one grade higher than you would use for an unflashed print.

Determining the correct flash exposure is critical. It's best to think of it in relation to the initial exposure. Ordinarily the flash must be very short—less than 10 percent of the time of the initial exposure. It would be less than 1 second on a 10-second initial exposure, for example. This is easier to control precisely when the initial time is longer. If your initial exposure is five seconds, a one-second flash is a 20 percent difference—almost

flashing Briefly exposing an entire piece of paper to an even burst of light, in addition to the main exposure, to add tonality to highlight areas that are too large or irregular to burn effectively.

USING COLOR HEADS WITH VARIABLE-CONTRAST PAPERS

Most photographers use filter kits when working with variable-contrast papers. These kits are inexpensive and readily available. However, you also can use enlargers designed for color printing instead of filter kits. Such enlargers have a color or dichroic head (see pages 329–330) built-in to permit you to change the color of the light passing through the negative; these heads have dials or knobs to adjust the cyan, magenta, and yellow components of the light beam. You increase the magenta filtration to increase contrast and, to decrease contrast, you increase the yellow filtration.

Set the cyan dial at zero and leave it there—variable-contrast papers need only yellow and magenta-colored light. (Note that there are also enlarger heads designed specifically for variable-contrast black-and-white printing. These heads also use built-in filters with graduated adjustment controls comparable to separate VC filters.)

The filtration on color enlargers is marked in units that can be dialed in, usually in a range from 1 to 200 or so. The higher numbers also increase the density of the filtration, thus affecting print exposure; the higher the number, the greater the required exposure. Increasing magenta filtration (for higher contrast) requires a relatively greater increase in exposure than increasing yellow (for lower contrast).

The effect varies with the type of paper and the type of enlarger. Check the instructions packaged with your filter kit or variable-contrast paper for specifics, but be prepared to experiment to get the results you want. The following chart provides a rough idea of the relative effects of dichroic filters on contrast with some common paper and enlarger brands. Keep in mind that your actual results may vary, but once you establish a setting for your enlarger, it offers a perfectly acceptable contrast control.

Variable Contrast Filter	Equivalent Dichroic Filter
#0	80Y
#½	55Y
#1	30Y
#1½	15Y
#2	0
#2½	25M
#3	40M
#3½	65M
#4	100M
#4½	150M
#5	200M

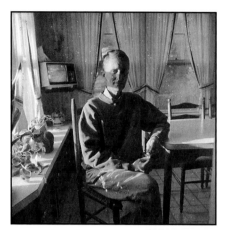
#0 filter

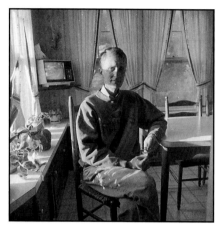
#½ filter

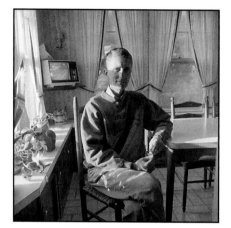
#1 filter

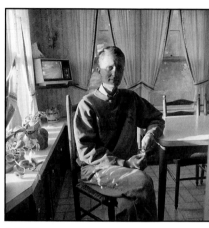
#1½ filter

Variable-contrast (VC) filters and papers offer a high degree of control over print contrast. VC filters, which are placed in the enlarger before exposing the paper, are typically rated from #0 (lowest contrast) to #5 (highest contrast) in half-grade increments, as shown here. The #2 filter is considered to have "normal" contrast—contrast suited to a typical, well-exposed negative. Without a filter, VC paper also produces normal contrast, similar to what you would get with the #2 filter. But unless you're sure your image will print best with normal contrast, it's a good idea to start your tests with a #2 filter in place, to keep exposure times more consistent should you change filters.

Each of these prints was made to yield the same highlight tone; differences in image contrast are due to the filter used. Whether you use graded papers or VC papers with filters, adjusting contrast involves modifying the tonal relationship between bright areas (in this example, the highlight on the side of the face) and dark areas (the shadowed side of the face and the front of the sweatshirt). Changing to lower contrast "opens up" the shadows-lightening the dark areas and thus revealing more texture and detail. Changing to higher contrast "punches up" the shadows—darkening them and thus making them richer, but sometimes obscuring detail.

When you're evaluating the contrast of a test strip, the best approach is to first identify the exposure increment in which the most important highlights look best—bright, but with good detail. Then study the dark tones in the same exposure increment. If they seem too dark, switch to a lower-contrast filter. If the dark tones seem too gray, switch to a higher-contrast filter. Adjustments in exposure are often necessary after such changes.

certainly too long. But with a 20-second initial exposure, a one-second flash is only five percent, and may work just fine.

Through experience, you can learn to estimate the correct flash exposure. If your initial results are too dark, reduce the flashing time slightly; if they are too light, increase it. Follow these general steps:

1. Make the initial print with good overall density, but with about one grade more contrast than you would ordinarily use. Let's say that the required exposure is 10 seconds at f/8 with a #4 filter for contrast.

2. Remove the negative carrier from the enlarger so that only plain white light will reach the paper. Set your timer for a very short exposure time, generally one second or shorter. (Digital models allow fractions of seconds, for greater control.) You may want to raise the enlarger head higher on its rail to reduce exposure and/or to get a broader beam of light.

3. Expose the paper for that brief time. Make sure that the light from the enlarger evenly covers the entire sheet of printing paper.

4. Process the print normally.

5. Examine the results. If the overall print is too dark and/or flat, repeat steps 1 to 4 with a shorter flash exposure; if the highlights remain blank, repeat these steps with a longer flash exposure.

Making the flash exposure before exposing the negative also works. But logistically it's easier to flash after an initial exposure. Also note that using a second enlarger for flashing, if one is available in a group darkroom, can save time by eliminating the need to remove the negative carrier and to raise the enlarger head for each exposure.

Another way to achieve a very short flash exposure is to reduce the light by stopping down the enlarger lens's f-stop after making the initial exposure. If you're using f/8 for the initial exposure, for

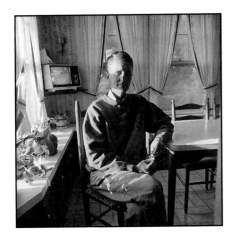

#2 filter

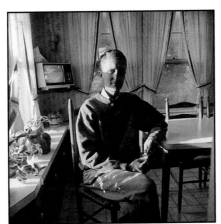

#2½ filter

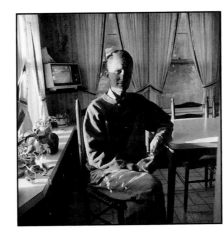

#3 filter

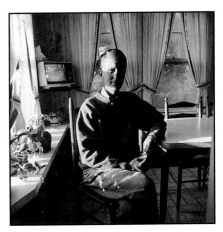

#3½ filter

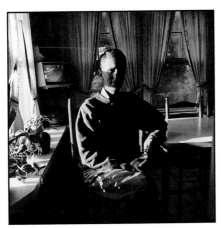

#4 filter

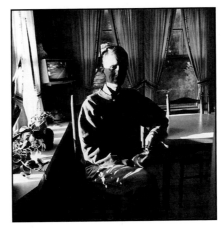

#4½ filter

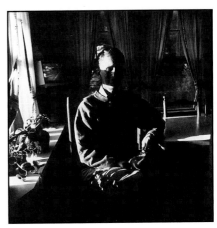

#5 filter

example, you might close down to f/16 for the flash. (Be sure to reset the lens before making another print of the same negative.)

WASHING PRINTS

Good print-washing technique is critical. If a print isn't washed thoroughly, it retains fixer and other contaminants that can lead to image discoloration, staining, or even fading within a very short period of time (see Chapter 15 for information on image permanence).

There are two main factors to consider when washing prints: time and efficiency.

Correct washing time varies with the type of paper used. Different brands may have slightly different washing-time requirements, but by far the most important difference is between RC and fiber-based papers. RC papers require only a short wash immediately after fixing, because their thin plastic coating keeps fixer and other chemicals from fully penetrating the paper fibers—and there's less paper in RC papers to begin with. In contrast, fiber-based papers require a much longer wash, preceded by a bath of fixer remover.

Regardless of the type of paper used, don't start the timing of a wash until all prints are in the water. Don't add prints

to a wash that has already started; these will contaminate the prints already in the wash and require that you start timing the wash from the beginning.

The efficiency of the wash is probably more important than the timing—especially since you almost always have to wash several prints at the same time. The wash water must flow over each print, which won't happen if prints are sticking together or if your washer doesn't distribute water evenly.

There are several methods of washing prints. If you use an automated processor, it probably has a built-in unit (or optional accessory) for automatic washing. For tray processing of RC prints, you can manually wash prints in a tray slightly bigger than the prints you're washing. Fill the tray with water at 68°F–70°F or so. Place the prints in the water, emulsion side down—one print at a time—making sure that each print is fully submerged before putting the next one in. This keeps prints from sticking together, which would prevent a thorough wash. Limit the number of prints you're washing with this method to a maximum of 10 or so. You may want to use rubber or latex gloves to keep your skin from contact with residual fixer or fixer remover.

Once all the prints are in the water, agitate then by shuffling the print on the bottom of the stack to the top—always submerging the top print. Flip through the stack twice, then pour out the water and refill the tray. Repeating this process six to eight times should produce a thorough wash with RC papers.

Print washers are much easier to use and more efficient than manual tray washing for either RC or fiber-based papers. There are several kinds available, all requiring running water. One of the

Burning
(see pages 300–303, 308)

Burning allows you to darken one area of a print without changing the overall density (darkness) of its other areas. In the print on the left, the lower-right corner is distracting because it is so bright. In the print on the right, the corner was burned in with an opaque piece of cardboard, which blocked out the rest of the image while additional light was allowed to strike just that area. Burning produced more texture and detail in the area, keeping the viewer's attention where it belongs—on the performer.

Dodging
(see pages 300–303, 308)

Dodging is the opposite of burning, allowing you to lighten one area of a print without changing the overall density (lightness) of its other areas. In the print on the left, the dark mass of the jellyfish's body at the top of the photograph seems at odds with the weightless quality of its tendrils. In the print on the right, the center of the body was dodged with an opaque piece of shaped cardboard mounted on a thin wire, blocking out the area for a portion of the initial, overall exposure. This brought out more detail in the area, providing a better overall tonal bal-

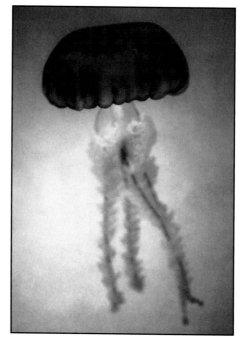

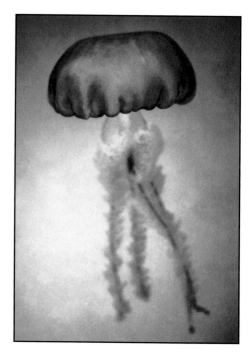

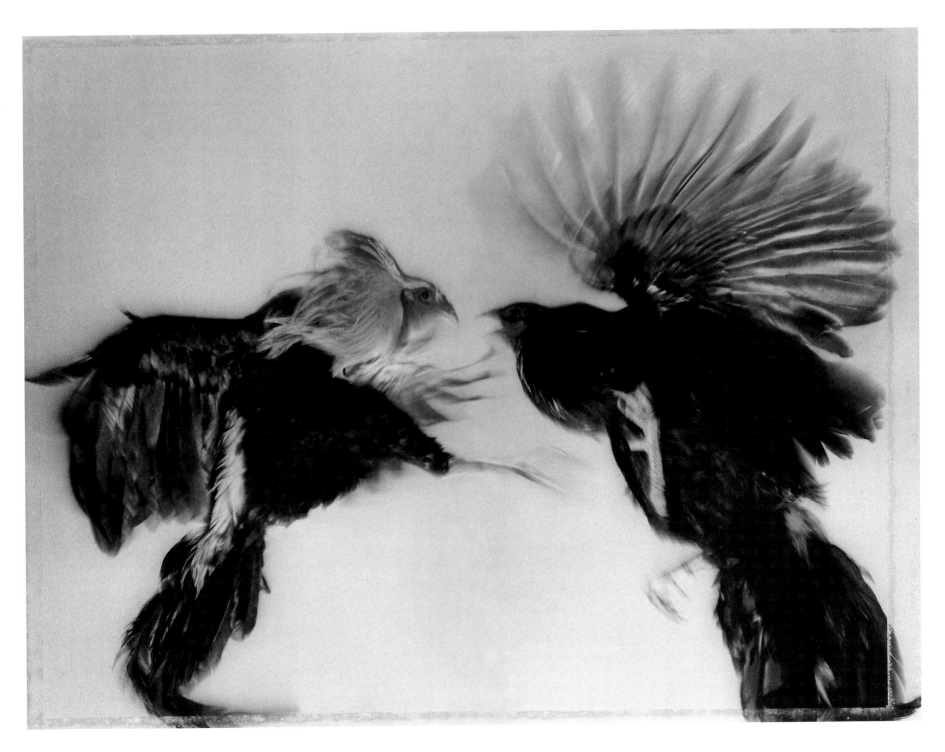

Hiro Fighting Birds, 1981

Hiro got his start as an assistant to legendary fashion photographer Richard Avedon, but has long since established an international reputation of his own. Even with the demands of his commercial assignments, he has always pursued personal projects. One of his best known is a series of fighting fish and fighting birds that took more than a decade to complete. In these images, shot in both black-and-white and color, there is a powerful tension between violent content and the graceful, fluid forms of the animals.

simplest and least expensive is a tray with a hose and siphon that both carries the wash water into the tray and drains it. The front of the siphon shoots fresh water into the tray while the bottom drains the old water. However, you won't get an efficient wash with this setup without manually agitating the prints (and, ideally, even completely emptying the tray several times).

Rotary washers cost more, but they are more efficient. They can, however, damage prints that are 16" x 20" and larger. The rotary design causes prints to circulate on their own, providing automatic agitation, but you must monitor the wash to make sure the prints stay separated and in motion during the entire wash time. Archival washers don't require as much attention and provide the most efficient wash. These units are made of heavy acrylic and resemble fish tanks divided into slots the long way to form many thin compartments. Each print is held in its own slot. A built-in manifold carries fresh water in through tiny holes at the bottom or side of the unit; these holes create a flow of water over the surface of the prints so that no other agitation is needed. The water flows over the top of the unit, ensuring a constant fresh supply of water. (See illustration, page 312.)

DRYING PRINTS

Once you have thoroughly washed your prints, they must be dried completely before you handle or store them. Air drying is the least expensive drying method, and it's best for long-term image permanence. However, it does take longer than an electric dryer and requires more space.

There are two widely used methods to air dry prints: hanging them like clothes on a clothesline or placing them

Burning (see pages 300–303, 306)

You can use one of two methods to burn an overly light area of the print, depending on its location, size, and shape. If the light area is within the image, use an opaque board with a hole cut in the center (left). Once you've made the initial overall exposure, make a second exposure during which you block most of the image with the board and allow additional light through the hole only to the area that needs darkening. If the light area is at the edge or a corner of the image (a pale sky, for example), you can use the edge of an opaque board, or your hand, to burn it in (right).

An effective burn should never be obvious to the viewer. To blend in burned areas with the surrounding areas, keep the opaque board moving during the burning exposure; otherwise, there may be a visible tonal disparity between the burned area and the rest of the print.

Dodging (see pages 300–303, 306)

Special tools can be used to dodge an area of the print that is too dark. If you want to dodge a dark area within the image, attach a small cut-out piece of opaque board to the end of a thin, stiff wire; use this tool to block the light from that area for a portion of the initial, overall exposure (left). (Commercially-made dodging tools also are available; see box on facing page.) If the area to be dodged is along the edge or at the corner of the image, you can often dodge it with your hand (right).

As with burning, you must move the dodging tool on your hand, constantly to prevent a visible line around the dodged area in the developed print. But you also must be careful not to dodge for too long. This can cause the lightened area to appear washed out or cloudy.

BURNING AND DODGING TOOLS

You can buy commercial burning and dodging tools, or you can make them yourself. Most printers prefer to make their own as the need arises. It's less expensive, and you can customize the tools to conform to virtually any shape that needs burning or dodging.

You can use a number of materials to make these tools, but cardboard works as well as anything. It's opaque, it's stiff, it can be easily cut and bent, and it's cheap. Black or dark-colored cardboard is best because it absorbs light, but gray cardboard also can be used effectively. Best of all is cardboard (or poster board) that is black on one side and white on the other—use it white side up to provide a good surface for viewing the projected image, and black side down to prevent reflected light from causing unwanted paper fogging.

Sheets of cardboard work well for burning and dodging corners or entire sides or edges of a print. To burn in the center of a print, cut a hole (or square, or whatever shape is needed) in the center of the board. If the board is held near the lens for burning, the hole will allow a large circle (or other shape) of light to shine through. If it's held closer to the paper, the circle will be smaller. Make sure the cardboard is large enough so it covers the entire sheet of paper at the desired height; otherwise, it may allow light to strike the edges of the image, causing unwanted additional exposure.

To dodge the center of a print, cut a small piece of cardboard to the needed size and shape and attach it to a thin, stiff wire long enough to let you keep your hand outside the projected image. The cardboard shape at the end of the wire will hold light back, but the thin wire should have little or no visible effect if it is kept in constant motion. You can even make tools that conform to an outline of a specific area or element you want to lighten; trace that area on a piece of cardboard as the image is projected in the enlarger onto the cardboard, then cut it out.

Prefabricated dodging tools are available both at professional photography stores and from mail-order suppliers. They come in various sizes and shapes, from circles and ovals to triangles and rectangles. However, you can make your own tools by cutting out various shapes from cardboard and mounting them on thin, stiff wire.

on fiberglass screens. Either way, you should first squeegee each print carefully on both sides. This will eliminate excess water and promote faster, more even drying and lessen print curling and buckling. Photographic squeegees are available, but you can also use a commercial window squeegee or make one yourself from a fresh automotive windshield wiper blade.

Place the print emulsion side down on a piece of heavy glass (or plexiglass). Make sure the surface is rinsed clean.

Gently move the squeegee across the back of the print. Don't push too hard, or you may damage the print. Lift the print up and squeegee the excess water off the glass before placing the print back down on it, this time face up. Then squeegee the emulsion side of the print; be especially gentle and slow this time or you may scratch the image.

Peel the print off the glass for drying. You can hang it by one corner on a taut piece of string or rope if you're using RC paper. Use spring-type clothespins, but make sure they grip on the border of the print—safely away from the image area. For fiber-based paper, hang two prints back to back to dry. Place clothespins all around the edges of the fiber prints to prevent the prints from curling.

Alternatively, you can place the squeegeed print on a drying screen—a frame with fiberglass window-screening material stretched across it. Such screens are available through camera stores and mail-order suppliers, or they can be homemade.

Flashing (see pages 303–305)

Print flashing is a way to add tone and detail to a print's highlight areas when burning is impractical or tricky. For example, the sky in the print on the left is too light—a common problem usually remedied by burning. But burning in the sky might darken the irregular edges of the horse's head and rider's body, or leave light areas around them. Flashing adds an even tone to the sky without significantly darkening the horse and rider (right), and improves the sense of detail in other light areas as well. Note that flashing reduces overall contrast, so make the print with at least one grade more contrast than you would otherwise need; the flashing should lower the contrast to the desired level.

When screen-drying fiber-based prints, place them face down on the screen to minimize curling. With RC prints, place them face up so the screen won't leave a pattern in the print surface. Air-drying times vary with the type of paper and room conditions (especially humidity and temperature). RC papers may take as little as 15 minutes or as much an hour to dry fully; fiber papers may take six to eight hours or longer.

Electric or automatic dryers speed up the process, drying prints within minutes. Some are made for RC papers only; others will dry both RC or fiber-based papers. If kept clean, such dryers can produce fast and acceptable results. But many models, especially those using

cloth or other absorbent material to hold prints during drying, can retain chemical contaminants from previous poorly-washed prints.

FACTORS AFFECTING PRINT SHARPNESS

Different enlarging lens apertures produce a different depth of focus—the depth of the area above the lens within which the negative (or transparency) will produce a sharp image. The smaller the opening (larger f-stop number), the greater the depth of focus. This would seem to be a minor consideration when you're enlarging, however, because the film carrier keeps the negative (or transparency) in a single flat plane. As long as

the film lies perfectly flat in the carrier, the lens is focused accurately, and the enlarger is in alignment, the entire projected image should be in sharp focus even at a wide lens aperture (when depth of focus is most shallow).

In practice, however, film has a tendency to curve or curl, and some carriers don't hold film as flat as other carriers. In addition, enlargers are sometimes out of alignment—that is, their various components aren't perfectly parallel to one another. Closing down the lens to a smaller aperture will increase the depth of focus, which can compensate for any lack of film flatness.

A glass film carrier can also help. Such carriers sandwich the negative between

SPLIT-FILTER PRINTING

Split-filter printing is a useful technique for making black-and-white prints, with a full range of tones, with variable-contrast papers. You make two exposures—one with a high-contrast filter and the other with a low-to-average-contrast filter—in order to get a print with a full range of grays as well as good density in both the highlights (light areas) and shadows (dark areas). While split filtering works with almost any negative, it's especially valuable with thin (light) negatives—those that would otherwise print flat and gray.

The purpose of the first exposure with a high filter is to establish good shadow density; the second exposure establishes the mid- and light-gray tones and highlights. Specific instructions vary with the density and contrast of the negative, but start with these general steps and modify them as needed.

1. Set up your negative in the enlarger as you would to make any print.

2. Place a high-contrast filter in the enlarger. A #4, #4½, or #5 will usually do. With thin negatives you'll need higher contrast than with normal negatives. For this example, let's use a #4 filter.

3. Make your first test strip with the #4 filter in place.

4. Process and examine the results.

5. Choose the first exposure increment that produces shadow areas the way you would like them in your final print—dense black with detail. This will be your first exposure time. For this example, let's say that time is 10 seconds.

6. Determine your second exposure time by making another test strip. To do so, place the strip of paper in the easel under the enlarger and make an initial overall exposure—in this case for 10 seconds.

7. Leave the exposed test paper in place. Remove the #4 filter from the enlarger and replace it with a lower-contrast filter, generally two or three increments; for this example, a #1. Be very careful not to move the enlarger when switching filters.

8. Make your test strip with the #1 filter and a series of exposure increments on top of the 10-second overall exposure.

9. Process and examine the results.

10. Choose the first increment that produces highlights the way you would like them in the final print—bright whites with detail. This will be your second exposure time. Let's say it's three seconds. It will usually be shorter than the initial (high-contrast) exposure.

11. Now use a full-sheet of paper to make your final print—here, for ten seconds with a #4 filter and three seconds with a #1 filter.

The second exposure will have little if any effect on the shadow areas because it is so short. However, it will "fill in" the highlights to provide a good, full shadow-to-highlight range. The exact filters you'll need vary. And you can adjust the times with each filter to make the print lighter or darker, after viewing your initial result.

Split filtering boosts the contrast of prints made from thin negatives, but it also evens the overall tonality of prints from good negatives. This will reduce or eliminate the amount of burning and dodging you'll have to do.

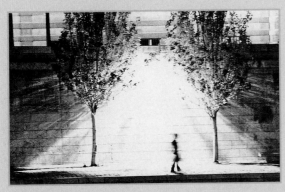

Split-filter printing—making two separate exposures on variable contrast (VC) paper, one each through high- and low-contrast VC filters—was used to achieve better detail in both highlight and shadow areas than would have been possible with a single exposure. The paper was first exposed for 10 seconds through a #4 VC filter, which created higher contrast within the shadow areas—areas that were thin and lacking in contrast in the nega- *tive, and might have been gray and murky in a single-exposure print. The effect of this exposure is shown at left. Then the high-contrast filter was replaced with a low-contrast #1 VC filter and the paper exposed for an additional three seconds, which increased detail and tone in the highlight areas. The center example shows the effect of this exposure by itself; the right exposure shows the final, combined effect. See above for details.*

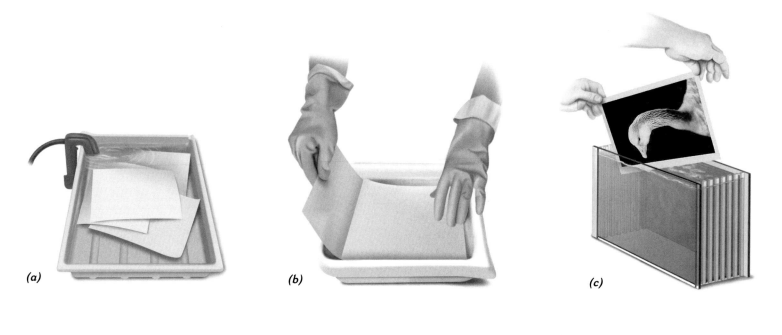

(a)

(b)

(c)

(d)

(e)

(f)

Washing and Drying Fiber-Based Prints

When your printing session is over, rinse the prints in a tray of running water for three to five minutes, making sure to shuffle them throughout (a). Then immerse the prints in fixer remover for two to five minutes. (This is an important step because it breaks down the fixer, making the final wash more effective.) Wear gloves and shuffle the prints from bottom to top the entire time (b).

For greatest image permanence, the final wash should be done in a slotted print washer. Carefully insert the prints one by one into each slot (c) and start timing for a minimum of 20 to 30 minutes once the last print enters the washer. Keep the prints from sticking to the walls of the slots by gently separating them with a clean Plexiglas rod (d) that comes with the washer; you can also use this rod to gently remove prints from the slots. Then remove the prints one at a time and squeegee both sides of each print firmly but carefully against a clean piece of glass or Plexiglas (e). Prints are very limp and pliable when wet, so handle them gently to avoid crimps and creases.

The last step is to dry the prints. The simplest method is to hang two prints back-to-back from a wire with clothespins (f). Clip the bottom of the prints together to keep them from curling; use extra clothespins along the edges if necessary. A more common method is to lie the squeegeed prints on clean fiberglass screens (g). Place fiber-based prints face down to minimize curling.

(g)

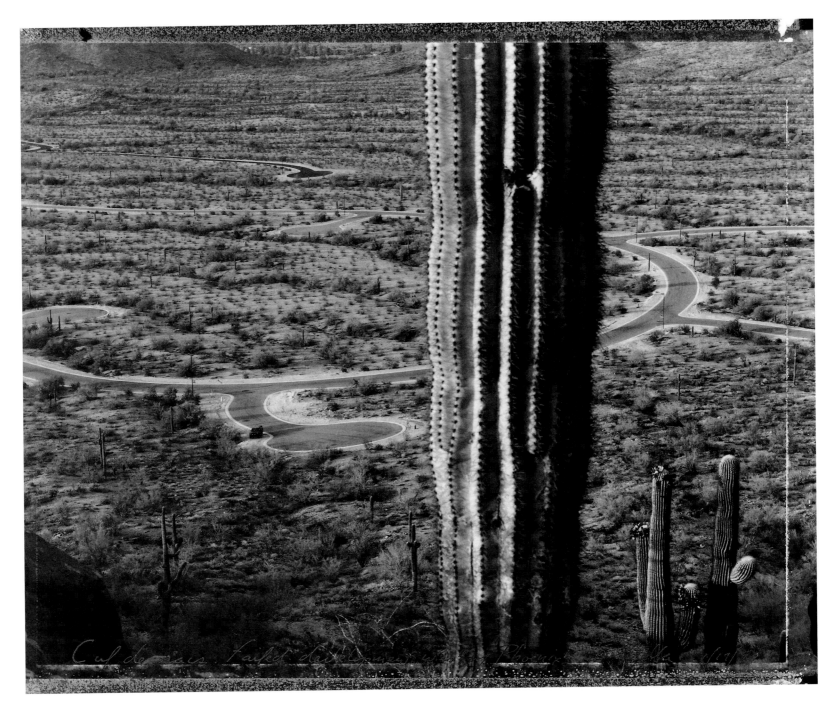

Mark Klett Cul de sacs; failed development west of Phoenix, "Estrella," 1990

The landscape of the American Southwest is a subject that has been intensely documented since government-sponsored surveys over a hundred years ago. Yet Klett shows that you can respect photography's past while making a contemporary contribution to it, in large part through his creative printing style. The edge effects of his Polaroid Positive/Negative film suggest the rough borders of hand-coated glass plates, while the descriptions and dates handwritten across the bottom of the image mimic the notations of 19th-century expeditionary photographers. Klett's form and content are thoroughly modern, however—here, his abrupt, horizonless composition a comment on the intrusions of modern life into the West's open spaces. Mark Klett. Courtesy of Etherton Gallery, Tucson, Arizona

DRY DOWN

Black-and-white prints often look darker when dry than when wet. This effect, known as **dry down**, depends partly on the type of paper used. Some brands dry down hardly at all, while others dry down significantly. Additional factors, such as the overall density or contrast, the print surface, and the brightness of the viewing light in the darkroom, also may have an effect on how dark a dry print looks.

The obvious solution is to print a little on the light side and let the drying darken the print. (You should get pretty good at judging how much a particular paper dries down once you've used it a few times.) You also can choose to make two or three prints at different densities—say, one that looks right when wet and one or two that are slightly light. When the prints dry, you can then choose the one that looks best.

If you think these solutions are too imprecise, you can dry each finished print before judging its overall density. With RC papers, this is fairly easy to do; fiber-based papers take a lot longer to dry, and may slow down the printing process unacceptably. For a quick dry, particularly with RC paper, use a portable hand-held hair dryer after you squeegee the print. Set the dryer to medium heat level and position it about six inches from the surface of the print. Move the dryer in a circular motion as evenly as possible over the entire surface of the print. In a minute or two the print should be dry enough to evaluate it accurately.

two thin sheets of glass and are standard on some enlargers but optional on most. Glass carriers hold film almost perfectly flat, which allows you to use a wider lens aperture if you choose. Make sure you keep the glass clean since it can trap dust and dirt; also, scratched glass can adversely affect print quality.

Note that printing with a wide aperture, such as f/2.8 or f/4, is not usually a good idea, and should be avoided unless you need a lot of light to expose a dense negative or for a very short exposure. Most lenses, whether for cameras or enlargers, produce more sharpness and distribute light more evenly at middle apertures, such as f/8, than when wide open or closed down totally.

Another important (and often underrated) factor in print sharpness is enlarger alignment. The film carrier must hold the film so it is perfectly parallel to the base of the enlarger, where the printing paper sits. In some cases, an alignment tool should be used to adjust the enlarger; in other cases, shimming the easel with pieces of cardboard will help maintain parallelism.

Another potential factor affecting print sharpness is the stability of the enlarger. Any vibration during exposure, however slight, can reduce image sharpness. Most enlargers are reasonably sturdy, and those that are more expensive are generally the sturdiest. However, you might consider bracing the enlarger rail to a wall or table to better steady it, particularly if your darkroom is near a road, subway, or train tracks (which could cause occasional enlarger shaking), or in a house or a group darkroom where there are a lot of people walking around.

You're more likely to see the effects of vibration when you have long print exposures or when making large prints, which require extended exposure and greater elevation of the enlarger head, which can make the enlarger less stable. An exposure that is quite long, such as several minutes, will even heat up the negative in some enlargers, causing it to "pop," or shift in position during the exposure—an effect that results in a loss of sharpness.

MONOCHROMATIC COLOR

It's a common misconception that the earliest photographs were in black and white. In fact, many early photographs, were monochromatic, made up of various shades of a single color—usually brown, but often blue, red, or other colors.

You can still make prints with monochromatic color in a variety of ways, in addition to the many still-usable antique processes. (See Chapter 16.) Perhaps the easiest technique is to print your black-and-white negatives on a warm-toned paper, and/or develop them in a warm-toned developer. Depending on the type of paper and developer, this creates a warm black (greenish or brownish) print, though this may be a fairly subtle effect.

Many paper manufacturers offer warm-toned papers. They generally publish samples of their offerings, which you can usually find at darkroom-oriented camera stores. Examining these will give you a good idea of the tonal effects pos-

dry down Difference between a print's appearance when it is wet and when it is dry. Usually a print appears darker (denser) after it has dried.

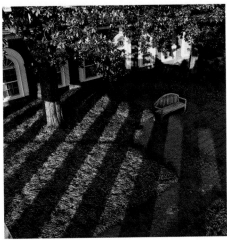

ducing monochromatic color prints. You start with a finished black-and-white print and then treat it in a separate **toner** bath after the print is thoroughly washed. You do not have to tone a print the same day it was made; prints can be resoaked and toned any time after they have dried.

There are several reasons for toning. First, and most obvious, is the change in image color it produces. Second, toning will usually improve the longevity of your prints. A true toner chemically alters the developed silver in a print, making it less susceptible to fading and contamination over time. In fact, some photographers routinely use a diluted solution of selenium toner to improve a print's longevity without affecting its color (see page 317).

Longer toning times and stronger dilutions generally produce a more dramatic color change than shorter times and weaker dilutions. Several manufacturers offer toners in a variety of colors. Some create a strong change in the image color, turning it from black-and-white to brown-and-white or red-and-white (or even blue, gold, or silver). Others create a subtle change, from cold- to mildly warm-toned, for example, or from warm to cool.

Some toners, like selenium toner, come in liquid form. You dilute the concentrate according to the packaged directions, pour the working solution into a tray, and immerse the fully washed prints in the tray for a few minutes. When you have finished toning the print, you must wash it thoroughly to stop the coloring action of the toner and prevent print staining.

Other toners come in powdered form and require two different baths. These are typically sepia toners and come in a

Different toners can create a wide variety of colors in black-and-white prints. One of the most common colors is brown, but the particular shade varies depending on such factors as how long the print is immersed in the toner, the strength and dilution of the toner, and what kind of paper is used. Here, the first print is untoned (top left). Treating a print on warm-tone paper with sepia toner produces a soft brown color (top right). Toning a print on the same paper for less time yields a richer brown (bottom left). But sepia toning a print on cold-tone paper results in a much more subdued, neutral brown (bottom right).

toner Chemical bath that changes the tone or color of a print, sometimes improving its long-term permanence.

sible with a particular type of paper. Varying the dilution of the developer solution may also produce a warmer-toned print. Generally the more diluted the solution, the warmer the result. Don't forget to extend the time in the developer, but consult package directions or contact the manufacturer for product specifics.

Toning Toning is generally a more reliable and more versatile method of pro-

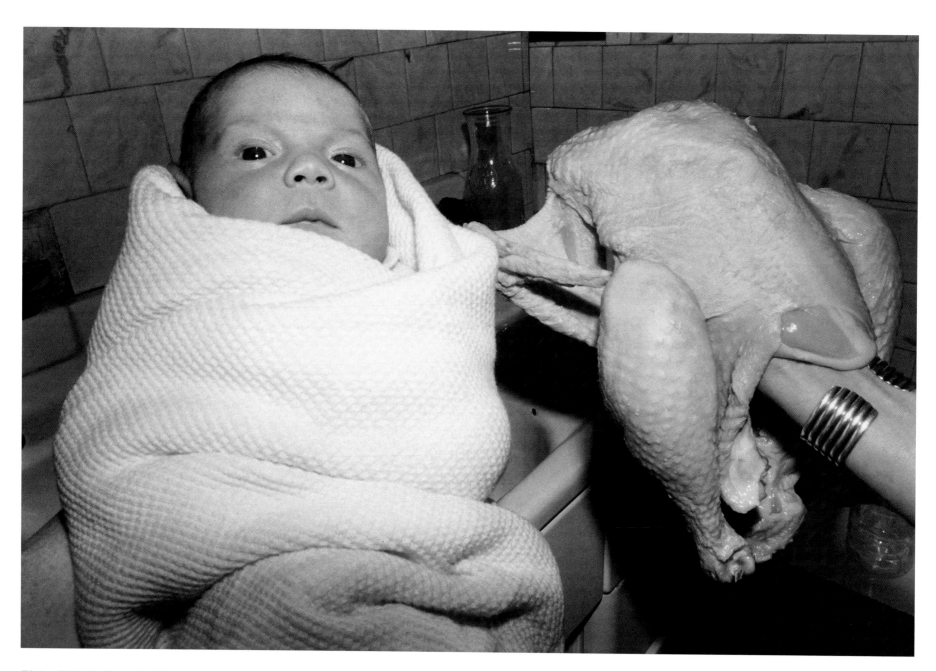

Elaine O'Neil 7 pounds, 2 ounces

O'Neil's image is a reminder that the most effective photographs sometimes come from the simplest observations—such as noticing the textural similarity between the baby's blanket and a plucked chicken. This similarity is much easier to see when the image is monochromatic, without the distraction of color. But not all monochromatic photographs are black-and-white. Toning is the main technique used to change a black-and-white print's color; the colors produced by toners range from brown to red to blue. O'Neil used a combination of sepia toner and bleaching to create a warm brown color in this print, from a continuing series on her daughter. Toners also can be used to improve the permanence of black-and-white prints, even when causing little or no color change. © Elaine O'Neil

SELENIUM TONING

Many photographers use selenium toner for their black-and-white fiber prints to richen and intensify the deeper tones and improve image permanence. You'll get different effects, from subtle cooling to a strong purplish or reddish-brown color, depending on your paper and how you use the toner. Different techniques can be used, but you must usually wash the print thoroughly before toning (with a first wash, fixer remover, and final wash). Selenium toner is often mixed in with a solution of fixer remover.

It is possible to selenium-tone resin-coated prints, but it's rarely done. The technique is used almost exclusively by printers who are very fussy about print quality, who would only use fiber-based papers to begin with. Follow these instructions; results will vary depending on the type of paper used:

1. Mix 1½ ounces of selenium toner to one quart of fresh fixer remover in a clean tray. (You can use more or less toner for weaker or stronger results.)

2. Fix and thoroughly wash the print in your normal manner. If you're toning a previously-washed dry print, first place it in fresh fixer remover alone for a minute or so, then move on to step 3.

3. Place the print directly in the fixer remover/selenium toner bath. Agitate constantly for two to five minutes or longer depending on the desired effect.

4. Remove the print from the toning bath, then wash it for at least 20 minutes.

An easy test can help you determine your ideal time for selenium toning. Take a finished print and cut it in quarters. Place one quarter in a tray of plain water and place the other three quarters in the toning bath for various amounts of time—say, one, five, and 10 minutes to begin with. As each time is up, place each quarter print in the tray of plain running water along with the untoned quarter. Then compare all four quarters to see how the different times affect the image color. You can use this test for any type of toning, but it's especially useful for selenium because its effect is often subtle.

oughly. (Again, follow the package instructions specific to the brand of toner you're using.) Sepia toning tends to lighten prints, so make the initial print a little darker to compensate.

You must be especially careful and accurate when preparing prints to be toned. Sloppy or careless processing and washing when making the print can leave residual chemicals in the paper that will cause stains, blotches, or fading when you tone the image. Chemical contamination is the major culprit. Make sure your equipment is clean and solutions are mixed and handled with care. Also, hardener can inhibit toning, so use only fixers without hardener if you expect to tone prints.

Be especially careful when mixing and using toners, since many are toxic. Mix and use them only outdoors or in a well-ventilated darkroom.

PRINTING BLACK-AND-WHITE ON COLOR PAPER

Another way to produce monochromatic color is to print black-and-white film onto color printing paper. The process is the same as making any color print. (In fact, a minilab can even make a monochromatic color "machine" print for you in snapshot sizes from black-and-white negatives.) The easiest approach is to use a black-and-white negative and the RA–4 process (for prints from color negatives, see Chapter 14 for details on color printing). But you may also use a black-and-white transparency and make a color reversal print with either the Ilfochrome or the R–3000 process (see the photograph on the next page and pages 344–346).

When working with color printing papers, it may be difficult to produce a

package with two separate powdered chemicals—one a bleach and the other the toner itself. You mix each powder with water and pour them into separate trays. Then you take a fully washed print and place it in the bleach bath for about 1–2 minutes with constant agitation; the bleach removes all but a faint trace of the silver image. Wash the print

for about two minutes, then place it in the second tray—the toner—for up to one minute. You will see the image appear again, but with a warm brown color. The strength of the brown color depends on how long you bleach the print in the first bath. Leave the print in the second bath for about two minutes, then pull it out and wash the print thor-

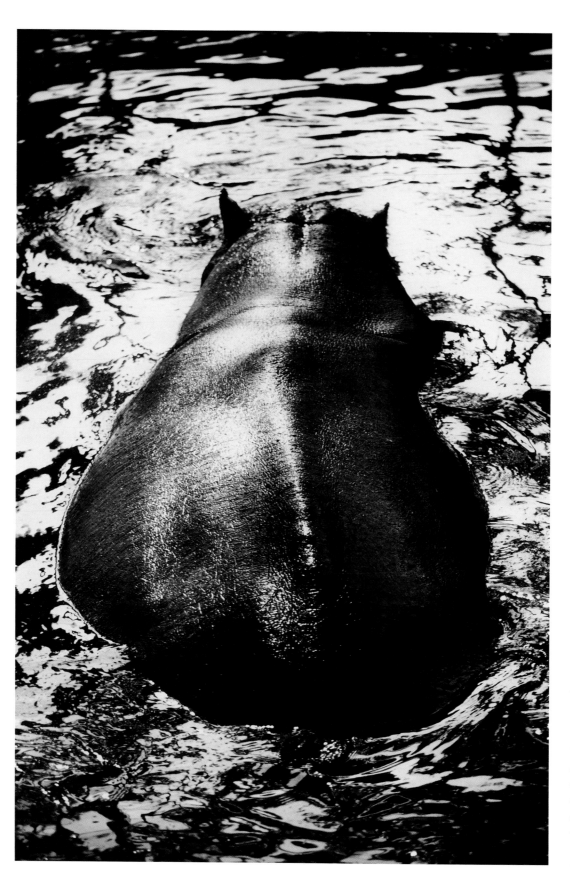

Henry Horenstein

Hippopotamus, *hippopotamus amphibius*, 1997

You don't have to start out with a color negative or transparency to make a color print. You can print black-and-white film with color printing processes—once you decide what color you want. For his impressionistic series called Creatures, *Horenstein shoots with black-and-white transparency (positive) film, then makes reversal prints on color reversal paper (Ilfochrome). The print's brown tone was achieved by adjusting color filtration in the enlarger, as covered in Chapter 14.* © Henry Horenstein

completely neutral black-and-white result. The image will almost always have a tint, perhaps more visible in one part of the tonal scale than another. The brand of paper, the density of the negative (or transparency), and many other factors affect the final result.

Try a starting pack of 120Y + 90M for printing black-and-white negatives using the RA–4 process. If you want the image tint to be more red, subtract some magenta and yellow from the pack; if you want it to be more yellow, subtract yellow. Once you get a filter pack that pro-duces the desired results, use that as your standard pack the next time you print black-and-white using a color process. However, you'll almost certainly have to adjust the pack from print to print, if only slightly, for consistent results.

BLACK-AND-WHITE PRINT PROBLEMS

Problems with prints may be due either to problems with negatives or to problems during the printing process. Some are correctable after the fact, but most are not—until you reprint or shoot a new negative. Here are the most common of the many possible problems you may encounter when printing black-and-white negatives.

Symptom
Image too light overall.

Probable causes
1. Too little paper exposure.
2. Too little development.
3. Paper exposed face down in easel.
4. Paper out of date.

Solution
Make a new print with the emulsion facing up; with more exposure (a longer time or wider aperture); at the correct developing time; and/or with fresh paper.

Symptom
Image too dark overall.

Probable causes
1. Too much paper exposure.
2. Too much development.

Solution
Make a new print with less exposure (a shorter time or smaller aperture) and/or at the correct developing time.

Symptom
Contrast too low overall.

Probable causes
1. Film underexposed in camera.
2. Subject lighting was low in contrast.
3. Paper contrast grade or filter too low.
4. Film underdeveloped.
5. Paper developer weak or exhausted.
6. Paper out of date.
7. Paper fogged by stray light.

Solution
Make a new print with a higher-contrast graded paper or higher-contrast variable contrast filter. Use fresh developer, fresh paper, and plug any dark-room light leaks.

Symptom
Contrast too high overall.

Probable causes
1. Subject lighting was high in contrast.
2. Film overdeveloped.
3. Paper contrast grade or filter too high.

Solution
Make a new print with a lower-contrast graded paper or lower-contrast variable contrast filter. Or in extreme cases, flash the print.

Symptom
Light or white specks, spots, or scratch marks on print.

Probable causes
1. Dust, dirt, grit, or other foreign matter, or a scratch on negative.
2. Dust, dirt, grit, or a scratch on glass film carrier.

Solutions
1. Spot blemished print with brush and spotting fluids (see Chapter 15).
2. Clean negative with canned air, air blower, or other means and reprint. If necessary, clean glass negative carrier.

Symptom
Dark or black specks, pinholes, or spots on print.

Probable cause
Dust, dirt, or grit on film emulsion during exposure in camera.

Solutions
1. For future photographing, clean out the camera's insides (and/or the film holder if you're using sheet film) with canned air, air blower, or other means.
2. For finished print, remove blemishes with bleach or white spotting pigments and then use black or colored spotting fluids to cover the white spots (see Chapter 15).

Symptom
Dark or black scratch marks on print.

Probable cause
Emulsion scratched.

Solutions
1. For future photographing, clean around the camera's pressure plate or the film holder (if you're using sheet film) with canned air, air blower, or other means. Also, handle film with care when loading and processing.
2. For finished print, bleach or spot out blemished scratches with white spotting fluid, then use black or colored dyes or pigments to build up the density of the areas and cover the white spots.

Symptom
Print has uneven density or mottled look overall.

Probable causes
1. Too little developer solution used.
2. Inadequate agitation during development.
3. Paper outdated.
4. Developer solution exhausted.
5. Developer too diluted.

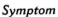

Solutions
1. Make a new print with a fresh sheet of paper and constant agitation.
2. Use an adequate level of properly mixed developer.

Symptom
Unwanted density variation from one print to the next.

Probable causes
1. Voltage fluctuations in enlarger's electrical line.
2. Timer malfunctioning.
3. Variations in paper emulsion batches.

Solution
1. Use voltage regulator on enlarger line.
2. Repair or replace the timer.
3. Reprint using paper from the same emulsion batch—for example, the same box.

Symptom
Print has uneven density or mottled look in shadow areas.

Probable cause
Print pulled from the developer before full development time.

Solution
Make a new print, developing for full amount of time (at least one minute with resin-coated papers and 1½ minutes with fiber-based papers).

Symptom
Overall grayness most visible in print margins and image highlights.

Probable cause
Paper fogged (unintentionally exposed). Possible causes include a light leak in the enlarger or darkroom, too much exposure to a safelight, a loosely packed or accidentally opened paper box, expired paper, and heat damage.

Solution
Reprint using fresh or unfogged paper. Make sure neither room nor enlarger leaks light. (You can test the rest of the paper in a box by developing a sheet without exposing it, then fixing it. Compare its whiteness to the white edge of a previously made unfogged print; if it's unfogged, it will be clear white.)

Symptom
Small, dark round blotches or spots on prints.

Probable cause
Air bells on negative due to poor agitation.

Solution
Spot print, lightening blemishes with bleach or white spotting fluids, and then use black or colored spotting fluids to match the area around them.

Symptom
Irregular blotches, patches, or spots on prints, usually yellowish brown or purplish brown in color.

Probable causes
1. Poor fixing, probably weak or exhausted fixer.
2. Contamination or exhaustion of processing solutions.
3. Inadequate washing.

Solutions
1. Reprint using fresh solutions and agitate continuously for at least half the fixing time.
2. Make sure the wash time is adequate and the washing method is efficient. Agitate manually during the final wash or use a print washer that separates prints physically.

Symptom
Fingerprint marks on prints.

Probable causes
Handling prints in image area with wet, greasy, or chemical-contaminated fingers.

Solutions
Reprint, handling prints only by edges with clean, dry hands.

Symptom
Small blotches, patches, or spots on prints, usually reddish brown in color.

Probable cause
Rust in water supply.

Solution
Reprint using filtered water to wash prints.

Symptom
Print image blurry or unsharp overall.

Probable cause
1. Fingerprints, smudges, or dust on enlarger lens.
2. Image out of focus in camera or in enlarger.
3. Enlarger vibrations during exposure.
4. Negative "popping" in the film carrier.

Solutions
1. Reprint, checking enlarger focus with a grain focuser.
2. If image is still out of focus when the grain is sharp, reshoot if possible.

Symptom

Print image always blurry or unsharp in the same area from print to print.

Probable causes

1. Enlarger out of alignment.
2. Pressure plate in the camera out of alignment (if grain is sharply focused).

Solution

Reprint after aligning enlarger or shimming the easel with pieces of cardboard.

Symptom

Print image sharp in some areas and blurry in others, but in different areas from print to print. (Grain focuser indicates lack of sharpness from edge to edge.)

Probable causes

1. Film carrier not holding negative flat.
2. Film buckling due to heat from long exposure time.
3. Easel not holding printing paper flat.

Solutions

1. Reprint, making sure negative and film carrier are properly positioned.
2. Reprint using a shorter exposure time.
3. Reprint using a glass film carrier.
4. Reprint, making sure paper and easel are properly positioned.

Symptom

Print curls or buckles excessively when dry.

Probable causes

1. Too little humidity in air when drying.
2. Too much hardener in fixer.
3. Prints laid face up on drying screen.
4. Prints not adequately squeegeed.

Solutions

1. Resoak and dry prints in room with higher humidity.
2. Place black-and-white prints to dry face down on drying screens.
3. Place dry fiber-based papers in dry-mount press for 30 seconds or so, then place under heavy weight to cool off.
4. With future prints, use a nonhardening fixer (or reduce the amount of hardener) and squeegee thoroughly.

Symptom

Faded printed image.

Probable causes

1. Fixer too strong, if fading appears immediately.
2. Poor fixing and/or washing technique if fading occurs later.

Solutions

1. Reprint, using the correct fixer concentration.
2. Reprint, fixing for the correct amount of time in fresh solutions.
3. Use fixer remover before final wash for fiber papers. Make sure the wash time is adequate and the washing method is efficient. Agitate manually during the final wash or use a print washer that separates prints physically or with rotary or other agitation.

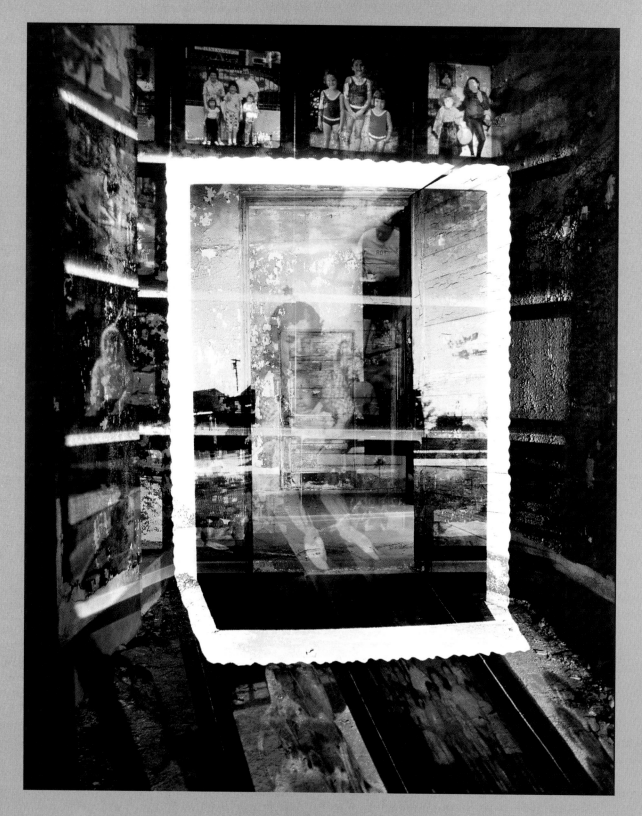

LORIE NOVAK
Altar: Ellis Island, 1988

Novak uses family snapshots as source material to explore the relationship between photographs and memory. She often projects copy slides of old prints—here, a deckle-edged black-and-white among smaller color images—into three-dimensional interiors, then photographs the resulting setup on color negative film so that she can make large-scale color prints. The results resemble collage or montage, but are given added complexity and interest by the way the scene's surfaces interrupt and distort the projected images. In recent years, Novak has extended her investigations to include video, installations, and the Internet. © Lorie Novak

CHAPTER 14

COLOR PRINTING

In its basic technique, traditional color printing is similar to black-and-white printing. You place a negative or a transparency into a negative carrier, put the carrier in the enlarger, focus the image with the lens, and expose a sheet of printing paper for a certain amount of time at a particular f-stop. After exposure, you process the paper in a series of chemical baths that make the image visible. Then the paper needs to be washed and dried. A finished color print requires the same careful handling as a black-and-white print.

But there also are significant differences between printing in color and printing in black and white. Color materials require more critical control over temperature and agitation than black-and-white prints. Also, while you can process your prints by hand (in a special tube, not in open trays), it is better to use an automated processor.

Making a color print is a far more standardized procedure than making a black-and-white print. Darkroom manip-

ulations have much less effect and are generally less useful than in black-and-white printing; extending development time, for instance, won't increase contrast or make the dark tones richer as it does with many black-and-white papers.

Still, color printing does offer opportunities for creative control, such as in the variety of papers used and the approaches you can take. For instance, you can start from either a color negative or transparency. There are several processes and paper, each with a different feel and color quality. Most of all, you have great control over image color as you make the print. The type of paper you choose and how you balance the color in your final print are critical in determining your image's impact.

(Note that you can also print color with a great deal of control using digital technology. See Chapter 17.)

The illustration on the following page shows a **color wheel**—a useful reference for both photographing and printing in color.

The six colors on the color wheel are commonly grouped in sets of three "primaries" for color printing. The visible spectrum is made up of red, green and blue light (RGB), which are known as the **additive primaries.** Combining all three additive primaries in equal amounts forms white light. Combining any two additive primaries, however, produces the color between them on the wheel. Thus, yellow consists of equal parts of green and red, cyan of blue and green, magenta of red and blue.

The colors formed by combining two additive primaries—cyan, magenta, and yellow—are called the **subtractive primaries.** On the color wheel, therefore, each subtractive primary is depicted in between two additive primaries. **Complementary colors** are opposite one another on the color wheel. Yellow is the complementary color to blue, magenta is complementary to green, and cyan is complementary to red.

The subtractive primaries absorb (block) one-third of the light spectrum—

color wheel Pie-shaped diagram that shows the relationship between additive and subtractive primary colors. These relationships form the basis for color printing.

additive primaries
Red, green, and blue. These colors are the main components of visible light, and form white light when combined in equal portions.

subtractive primaries
Cyan, magenta , and yellow. These are the colors formed by combining two additive primaries.

complementary colors
Two colors that are situated directly opposite one another on the color wheel.

DIFFERENCES BETWEEN COLOR AND BLACK-AND-WHITE PRINTING

The main differences between black-and-white and color printing are as follows:

Strict controls. The temperature, time, and agitation of each step are more critical in color processing. The chemistry is also more susceptible to contamination.

Different chemistry. Color paper is similar to black-and-white paper, but the final image is made up of dyes that form during development, rather than silver. Color paper uses silver to form

its dyes, but a chemical bleach removes the silver during processing.

Greater hazards. The chemicals used in color printing are more toxic than those used for black-and-white processing, both for individuals and for the environment. You must use them with special care.

Fine tuning print quality. You can easily modify a print's density through a combination of exposure time and aperture, but you have less ability to adjust contrast. You change contrast

within limits by changing grades of paper, but there are no variable-contrast color papers.

Color control. You use special filters (either built-in or inserted manually) to change the color of the light emitted by the enlarger. These filters allow you to control the overall color of the final print.

Less safelight. Color papers are sensitive to light of all colors; thus you can use only a very dim safelight—and many color darkrooms have no safelight at all.

COLOR TERMINOLOGY

Most terminology from black-and-white printing applies to color as well. But there are a few common terms that are specific to color, for example:

Hue. A technical term for color. For example, a red object is said to be red in hue. Red, yellow, green, and blue are common hues. White, gray, and black have no hue.

Saturation. Color purity. The higher the saturation, the stronger and richer the color. The lower the saturation, the grayer or more washed out it is. (Saturation is also called chroma or intensity.)

Value. Overall lightness or darkness of a color. Sometimes value is confused with saturation, but the qualities are actually different. Hues can be high or low in saturation, whether they are light or dark. For example, a highly saturated yellow is likely to have a much lighter value than a highly saturated blue.

Color cast. Predominance of a particular hue in a color print, either overall or in a specific area. If a white shirt looks pinkish, for example, it is said to have a red color cast. Such casts are corrected by adjusting the color filtration of the enlarger. Though not a technical term, color cast is part of the vocabulary of color printing.

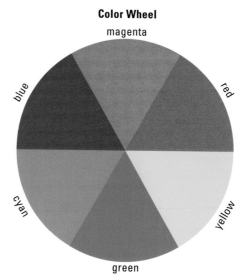

Color Wheel

A useful darkroom reference, the color wheel depicts the six primary colors used to balance color in color printing. Specifically, it shows the relationship between the additive primary colors (red, green, and blue) into which the subject's original colors can be broken down, and the subtractive primaries (cyan, magenta, and yellow) formed by the dyes with which the film recreates those colors. (Cyan is blue-green.) Colors opposite one another on the wheel are called complementary colors. Thus, red is the complement of cyan, green the complement of magenta, and blue the complement of yellow. Also, each color is formed by the two colors adjacent to it; thus, red is made of equal parts magenta and yellow, green of equal parts yellow and cyan, and blue of equal parts cyan and magenta. Conversely, magenta is made of blue and red, yellow of red and green, and cyan of green and blue.

the one-third occupied by their complements—and allow the remaining two-thirds to pass. For example, yellow absorbs blue, but transmits red and green. In varying amounts, the subtractive primaries can create all colors.

The principles behind the color wheel form the basis of color printing. The filters for printing color negatives manipulate only cyan, magenta, and yellow light (the subtractive primaries), which allow you to alter the overall color of light emitted by the enlarger. Manipulations that add or remove color in this way are called **color corrections.**

You can correct the subtractive primaries directly with a color enlarger. For example, to change the yellow cast of a print, change the yellow filtration. But you cannot directly change red, blue, and green—the additive primaries. To modify an additive primary, you must use its complementary color. Thus, when you

want to change the amount of green in a print, you adjust the magenta filtration. This can be confusing at first, but quickly becomes second nature (see box, page 333).

COLOR PRINTING PAPERS

You have a much more limited choice in color printing papers than you do in black-and-white papers. For one thing, not as many manufacturers offer them. And the ones that do offer fewer types. Most are resin coated (RC), though some are available with a stronger (and more expensive) polyester base; there are no fiber-based color printing papers.

The biggest difference among color printing papers has to do with the process for which you are using them. There are papers for printing from negatives; you can identify them easily because their names usually end in the suffix -color (as in Ektacolor). And there are papers for

printing from transparencies, which usually use the suffix -chrome (as in Ilfochrome). Papers for one are not compatible with papers for the other. Also, there are two different processes for printing from transparencies, and papers made for one process cannot be used for the other.

color corrections
Adjustments to the color of light projected by an enlarger, to change the color rendition in a photographic print.

Though color papers don't offer the great range of contrast control you get with black-and-white papers, some brands come in two or three different contrast grades. These examples show the range possible with one particular color paper, from the lowest contrast (top) to the highest (bottom). As you can see, the degree of difference is usually the equivalent of no more than about one black-and-white paper grade.

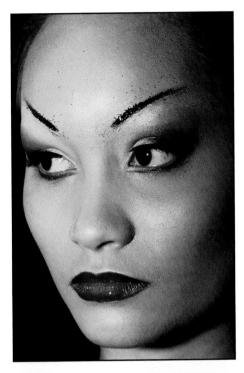

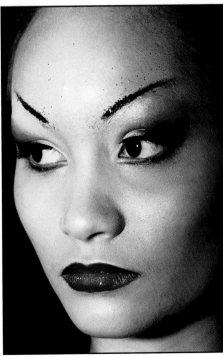

palette Particular color qualities of a brand of photographic paper (or film).

Regardless of brand or type, you can use all papers made for printing negatives in basically the same way, even with the same chemicals. Papers made for transparency printing are not as interchangeable; one process (Kodak R-3000), is compatible with other manufacturers' solutions, but the other, Ilfochrome, is not (see pages 344, 346).

Color printing papers are generally available in semimatte (also called luster and pearl) and glossy surfaces. You can sometimes find matte and specialty surfaces, often with a texture. The glossier the surface, the sharper and more contrasty a given image usually seems; most important, the glossier the surface, the greater the color saturation. Papers with less glossy surfaces are less reflective and are better for hiding fingerprints and other surface markings.

There are no variable-contrast color papers. Instead, color papers let you control contrast like graded black-and-white paper; different emulsions are manufactured for different contrasts. These papers generally come in two or three separately packaged contrast grades only: normal for most purposes, low-contrast for high-contrast subjects or portraiture, and sometimes a higher contrast for low-contrast subjects or those that need a bolder effect. Increased contrast results in sharper-appearing images and more saturated color. While the difference among the contrast grades is noticeable, it's not dramatic—with each grade about the equivalent of one-half to one grade with black-and-white papers.

Choosing one paper over another is an important individual matter. Papers from different manufacturers, and even types from the same manufacturer, generally have a different "feel" and "look." Some have slightly heavier bases than others,

making them easier to handle without causing physical damage. Note that color printing papers can be very vulnerable to damage from handling; problems such as crimping and surface fingerprints and other marks, especially with glossy-surface papers, are common—so handle with care.

Even more important than the feel of a particular paper is its **palette.** Palette refers to the color qualities of a color paper—its "look." In large part, this is a function of the dyes used to form the color; one manufacturer's red dye may appear more or less vibrant than another's red. Or, the overall look of one type of paper may seem either warm (yellow-red) or cool (blue-purple) due to a combination of the dyes and the paper base; some bases are more creamy and, therefore, produce warmer results than others.

You can't control palette with color developers as effectively as you can control image tone with black-and-white developers. The color produced by different brands may vary, but only marginally; there are no warm-tone color developers, for example. However, improper use of the developer, such as contamination or incorrect dilution, temperature, or time, can produce color casts and shifts, but these are rarely desirable and usually unrepeatable.

You also may notice that the color quality of papers may vary from one box to another. This is partly because paper emulsions, like film emulsions, are made in separate batches; one batch can differ from another because of when and how they are made. For maximum consistency, for example when working on a project requiring many prints, you might note the emulsion batch number packaged with each box of paper and buy at

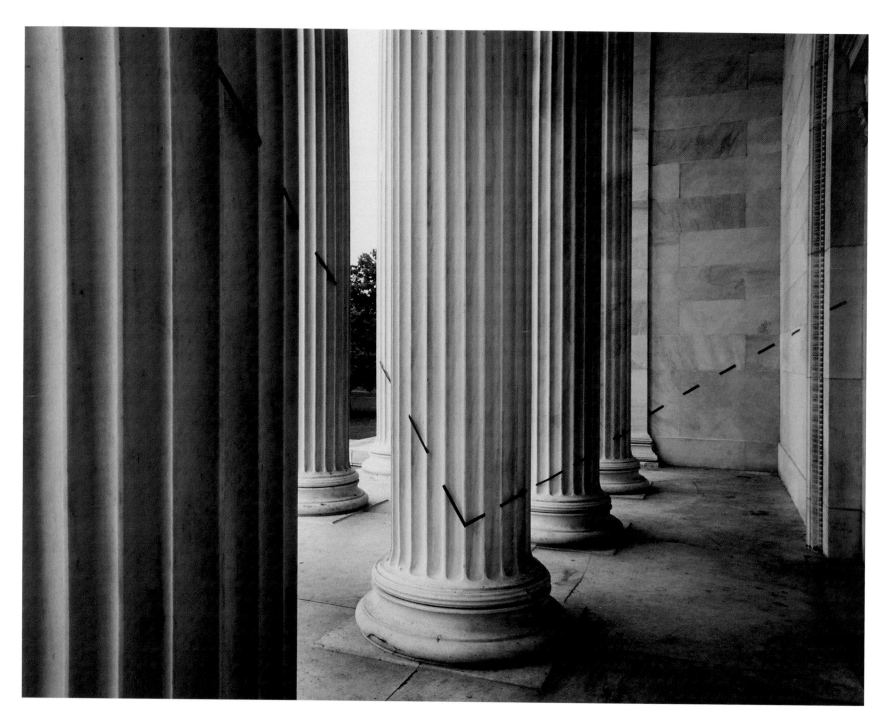

John Pfahl Blue Right-Angle, 1975

Part of Pfahl's Altered Landscapes *series, this image toys with the fact that a photographic print reduces a three-dimensional subject to a flat plane. Yet the line of dashes that appears to be marked on the print itself is actually in the original scene. Before taking the photograph Pfahl carefully positioned dashes made of colored paper on the subject, cutting them so that they were progressively larger as they receded from the camera. The result is that the line remains the same thickness throughout, creating the illusion that it is on the print surface. This illusion disappears on closer inspection, however—deliberately given away by a slight crudeness in Pfahl's handiwork and the play of light on the scene's surfaces.* Janet Borden, Inc. Albright-Knox Art Gallery, Buffalo, NY, Sept. 1975

least enough paper from the same batch to complete your project.

Also, printing papers, especially those made for color, are subject to change over time. Their sensitivity to light may lessen somewhat, requiring longer exposure times. More important, their color characteristics may shift, which may make things difficult when it comes to controlling the final print color. To minimize such changes, store paper in a cool, dry environment. Refrigerate or even freeze it between uses. (Note that professional photo suppliers keep color printing papers refrigerated.) Just be sure to keep the paper sealed in its box during storage. If it's unopened, you can just put the box in the refrigerator or freezer. It's best to seal previously opened boxes in a plastic bag, such as a trash or large food-storage bag, before refrigerating them. Let the box reach room temperature before using the paper. Removing paper from its box when it's cold may result in damage from condensation. If you keep the box sealed in plastic, let the whole package reach room temperature before removing the box from the plastic.

THE FILTER PACK

As in black-and-white printing, you must calculate the correct exposure and contrast level for your color print. Once you have established these, however, you must fine-tune the color of your print. This process is called **color balancing,** and you control it with a **filter pack.**

The filter pack is a combination of colored filters positioned in the path of the beam of light in the enlarger head. These filters alter the color of the light, and therefore the response of your color paper. For instance, if your subject's skin has a blue cast in your first print, you can adjust the filter pack to make the skin appear more natural in a second print.

Color balancing with the filter pack is the most important basic skill in color printing. The filters are always necessary, but not always predictable. For example, if you shoot the same scene with the same camera under the same light, but use two different brands of film, the required filter pack will probably be different for each. Other factors that affect your filter pack include the emulsion batch of the film and printing paper, the processing temperature, and the age and type of the enlarging bulb.

The filter pack is made of a combination of subtractive color filters—yellow, magenta, and cyan (see box page 333). These filters are represented by numerical units of density that correspond to how much light they block. For instance, a 5M filter value blocks a small amount of green light. A setting of 80M, on the other hand, blocks a good deal of green light.

The filter pack is described according to its density and color. Thus, 80Y + 60M represents a pack with 80 units of yellow and 60 units of magenta. Filter packs always consist of two of the three subtractive colors: yellow plus magenta when printing negatives (and yellow plus cyan, yellow plus magenta, or magenta plus cyan when printing transparencies).

When combined in equal proportions, cyan, magenta, and yellow create gray or black. You therefore never use all three subtractive colors, since they would cancel each other out and create **neutral density.** This reduces the light from the enlarger, increasing the required exposure time with no useful effect on color balance. If you have a filter pack that uses all three filters, you can reduce it to two by subtracting the density of the weakest

The easiest way to achieve a desired color balance in your print is to use an enlarger with built-in cyan, magenta, and yellow dichroic filters. The amount (density) of a given color is controlled by turning dials to adjust a continuous numerical scale on the front of the enlarger's head (top). The higher the number, the more the filter modifies that color's rendition in the resulting print.

If you do not have access to a color enlarger, you can use a "pack" of color printing (CP) filters in a standard enlarger. These change the color of the enlarger's light in the same way as built-in filters, but you must insert them manually, usually into a filter drawer above the lens (bottom). Unlike built-in dichroic filters, CP filters come in all six primary colors; however, their smallest increment is 025 (2.5 units of color). Note that CP filters are not of optical quality, so should not be used below the enlarger lens.

ADVANTAGES OF NEGATIVES OVER TRANSPARENCIES

Printing negatives is a lot easier than printing transparencies, both in the process and its flexibility. Negatives don't always have to be perfect—or even near perfect—to produce an excellent print. Transparencies do.

This applies to all aspects of printing—density, contrast, and color balance. Underexposed (light) negatives can produce a weak, flat print, but overexposed negatives (by up to a stop or two) usually print very well. With transparencies, unless film density is just right (or within one-third to one-half stop of the correct exposure), you probably won't get a good print.

Tricky subject lighting is also easier to handle when printing negatives. You rarely have to use a filter on the lens when you're photographing; if the light's color isn't exactly balanced for the film, simply make a filter pack adjustment when printing and you'll probably have

a good print. If the contrast is a little high or low, using a different contrast paper will often correct the problem.

When printing color transparencies, you generally have fewer contrast grades to choose from. But more important, changes in the filter pack are not as effective in balancing difficult lighting situations as they are when printing color negatives. So when you're using transparency film, it's best to control the lighting as much as possible—by using artificial light, by changing the subject's position in relation to the light source, by waiting for better light, and/or by filtering the light to create the color balance or color effect you want in camera. The best prints from transparencies usually come from originals that already have the color you want, or close to it—not from those you have to "correct" heavily in the darkroom.

Begin with a starting filter pack to make your first print. The starting filter pack is a first try at the appropriate color balance. It will rarely be exact, but it gives you a consistent starting point. Many paper manufacturers recommend a starting pack in their data sheet. You can also trust personal experience or guidance from others to establish your own starting pack—one that generally suits the materials and equipment you use. Or, use one of the following combinations until you have the experience to establish your own pack:

Printing from color negatives:
60Y + 50M

Printing from color transparencies:
20C + 10M (Type R)
30Y + 35M (Ilfochrome)

Note that some sources recommend extensive tests with several brands of film and paper to establish different starting filter packs for a variety of situations. While it's not wrong to do this, it's a lot of effort for little effect; there are so many variables at work that it's much easier and more efficient to establish a single starting pack, begin printing with that, and then make adjustments after viewing and evaluating the initial print.

MAKING A COLOR PRINT

Establishing the correct filter pack is the most critical step in making good color prints. But it's impossible to accurately judge color balance and finalize the filter pack until you have made a print with good overall density and contrast.

Start by making a test strip to determine the correct print exposure (see pages 295–299). The procedure is basically the same as when printing black-and-white except that you'll need to use a starting filter pack when printing color.

filter. Thus in a filter pack of 90Y + 75M + 15C, the 15C cancels an equal amount of magenta and yellow, and can therefore be removed. A pack of 75Y + 60M—removing 15 units of density from each subtractive primary (90Y – 15Y and 75M – 15M) to compensate for setting cyan to zero—has the same effect on color balance.

Color enlargers use built-in **dichroic filters.** The filters have a special coating that reflects a particular color of light to remove only it from the enlarger's beam, while allowing the rest of the light to pass through. Color enlargers have dials that allow you to move dichroic filters in and out of the beam to add or subtract color in incre-

ments and therefore affect either subtle or substantial changes to the filter pack.

If you have a black-and-white enlarger, you make up the filter pack by placing **color printing (CP) filters** in the enlarger, in the filter drawer between the negative and the light source. CP filters come in standard increments for color balancing. To make a correction of 40Y to your filter pack, for example, you can use either one 40Y filter or two 20Y filters, and so forth. Both dichroic and CP filters produce approximately the same results, but color enlargers with built-in filtration are much more convenient to use and allow more fine tuning because they are calibrated in smaller increments.

dichroic filters Cyan, magenta, and yellow filters built into a color enlarger, used to balance a print's color.

color printing (CP) filters Individual filters placed in an enlarger to balance a print's color.

COLOR PRINTING EQUIPMENT

When color printing, you will need much of the same equipment required for black-and-white printing: an easel, scissors, dodging and burning tools, and so forth. But there are some materials and tools that are different for, or only used with, color printing. They are:

Carrying bag. A light-tight bag (or box) for carrying paper. Automated processors in many schools and labs are in a separate room from the enlargers. You will need a bag, such as the opaque plastic bag paper is packaged in, or a light-tight box to carry the paper from one room to the other. You can also use a paper safe for this purpose.

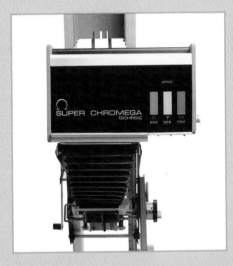

Dichroic head. A special enlarger head that contains built-in cyan, magenta, and yellow (dichroic) printing filters. Calibrated controls on the head allow you to adjust the strength of these filters and thus control the color balance of your prints. You can also make color prints with an enlarger having no built-in filters, by placing a pack of separate color printing (CP) filters in the head's filter drawer (see illustration on page 329). But if possible, use an enlarger model with a diffusion light source rather than a condenser system;

diffusion enlargers are more suited to the contrast of color print materials, and help hide dust, scratches, and other flaws in the negative or transparency.

Processing drum. A light-tight tube for processing color prints, it allows you to develop color prints in much the same way you process film—with lights on.

Gloves. Rubber or latex gloves to protect your skin from exposure to caustic chemicals, especially if you are using a drum processor.

Grain focuser. You can use a grain focuser for color negatives. Since the image is not formed by silver grain but by less-distinct color dyes, you may have a harder time finding a texture on which to focus (see illustration on the following page). Try to judge sharpness when focusing with a clearly defined edge within the image.

Safelight. A #13 dark green filter covering a dim 7½-watt light bulb. Color materials are sensitive to light of all colors, so most color printers work

in complete darkness. This safelight, however, can be used for a limited amount of time without fogging the paper as long as it is positioned at least four feet away from the enlarger.

Automated processor. A self-contained machine for processing color (and sometimes black-and-white) prints. These processors use rollers and troughs of chemicals to automatically take exposed paper through all the stages of processing. (See box, page 341.)

Tape. Pieces of masking tape placed on the easel or counter can help you

feel the correct position for your paper and other materials in the dark.

Viewing filters. Colored filters for viewing prints. These filters help you determine the needed changes to your filter pack when color balancing a print.

Voltage stabilizer. This device detects and corrects changes in the electric current to the enlarger. Fluctuations in the current may affect paper exposure and print color by altering the intensity and color of the enlarging light

The grain structure of a color film image—here, shown in a greatly-enlarged detail (right) from a high-speed 35mm color negative film—is actually made up of tiny flecks of cyan, magenta, and yellow dye. (Little cyan is visible in this example because the intense orange color is reproduced almost entirely with magenta and yellow.) These dyes "remember" the pattern of the silver crystals that actually captured the image, but which are bleached out during film processing. Just as with black-and-white film, the higher a color film's speed (its sensitivity to light), the grainier the resulting enlargement will be. This makes it easier to focus the enlarger with a grain focuser. However, a color grain pattern rarely appears as sharp as the grain in a black-and-white enlargement.

For a quick review, the steps for making a test strip are:

1. Position the negative in the enlarger and project the image onto an easel so it's the correct size and cropping.

2. Set your starting filter pack on your dichroic enlarger, or assemble CP filters for a starting pack if you are using an enlarger without a dichroic head.

3. Place a sheet of paper (or a section of a sheet) in the easel for a test strip, and expose it in short increments of time; start with five-second increments at f/8 or f/11. Use an opaque object such as a piece of cardboard to block light from areas of the paper until you're ready to expose them.

4. Process the test (see pages 341–344). You must completely process and dry color paper before you can accurately determine whether density, contrast, and color balance are correct. Color prints look very different in color and density when wet.

5. Examine the test to determine which exposure looks best. You may have to make another test with longer or shorter exposure increments (or a larger or smaller lens aperture) if the test appears too light or too dark. Once you have a color test or print with the correct density, you can decide if the contrast and color balance are where you want them; if the test or print is too dark or too light, it won't indicate accurate contrast or color.

6. Now look at the contrast. If it's too low, use paper with greater contrast, if available; if it's too high, use a less contrasty grade of paper. If you change the contrast, you may need to change the exposure time as well. Make a new test print and adjust the exposure until you get a print with good overall density and good contrast.

7. Judge color balance. Take special note of areas with less intense color, such as whites, grays, beiges, pastels, or light skin values; this is where color casts and imbalances are most evident. Areas of the print with strong, saturated colors more easily mask unbalanced color and should be downplayed when judging color balance.

The required amount of change to your filter pack can vary widely. A unit or two of filtration may make a difference, but usually you'll have to change the pack by 5 or 10 points to have a significant effect on color balance. You may have to add or subtract much more—20, 30, or even 40 units in extreme cases. Start with larger changes and, as the balance gets closer to where you want it, move to more subtle adjustments.

For example, if your starting filter pack is 60Y + 50M and your first print is too green, make a second print with a pack of 60Y + 40M, subtracting 10M from the starting pack. By decreasing magenta, you are allowing more green light (magenta's complement) to pass through to the paper, which will result in a print that looks more magenta. If it's still too green, try 60Y + 35M. Keep adding or subtracting filters from the pack until your print has the desired color balance. And keep a notebook with the final filter packs of your finished prints. The filter pack will change with different emulsions and enlargers, but the last filter pack from a successful print is often a good starting point for the next one.

FILTER ADJUSTMENTS FOR COLOR BALANCING WHEN PRINTING NEGATIVES

Filter pack adjustments are based on the subtractive primaries—yellow, cyan, magenta. But for printing color negatives, it works in the opposite fashion than you might expect. That is, to decrease the amount of yellow in the print, you must increase the yellow in the filter pack. This is because increased yellow filtration blocks more blue light, and the print's color balance will be proportionally less yellow.

Moreover, you almost always work only with yellow and magenta when printing color negatives. To affect other hues, you must manipulate their complementary colors, since a change in a color causes the equal and opposite change in its complement. For example, to reduce the green content of your print, adjust the magenta filter. Since you do not use the cyan filter, you must change combinations of both yellow and magenta to affect cyan and its complement, red. The following chart provides general directions for adjusting your filter packs when printing color negatives; note that the rules are different when printing color transparencies (see page 347).

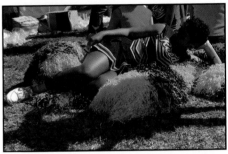

If your print looks too:	Adjust filter pack by:
Magenta	Adding magenta
Green	Subtracting magenta
Yellow	Adding yellow
Blue	Subtracting yellow
Red	Adding yellow and magenta
Cyan	Subtracting yellow and magenta

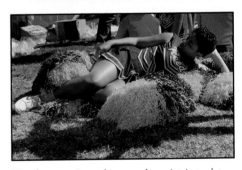

The first step in making a color print is to determine the correct exposure—one that produces a print that is neither too dark nor too light. As with black-and-white printing, exposure is controlled by a combination of lens aperture (f-stop) and time. In this example, the top print is too light and needs more exposure. Its colors are slightly washed out, the light areas lack detail, and the dark areas look weak and muddy. The middle print is too dark because it received too much exposure. Its colors and highlights lack brilliance, and its shadows lack detail. The bottom print is properly exposed, striking a good balance between bright highlights and "open" shadows—dark shadows with detail.

Changing the filter pack often requires increasing or decreasing the print exposure. This is because filters affect the brightness of the light that passes through to the paper. When you change the filter pack's color balance, you usually change the exposure, too.

With small adjustments, you may not have to compensate by changing the exposure time. If you make large changes to the filter pack, however, you may have to make significant adjustments in the overall exposure. There are formulas available to determine the amount of required change, but following these won't always give you totally accurate results. Your best bet is usually to adjust the time moderately until you get the desired print density or to a make new test strip and base the new exposure on that.

TOOLS FOR COLOR BALANCING

With experience you'll usually be able to tell roughly how much of which colors you'll need to add or subtract for the

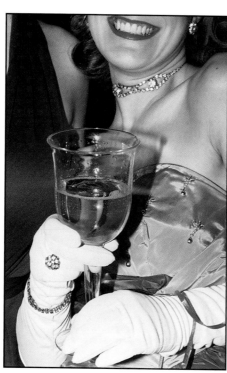

A useful tool for color balancing, Kodak's Color Print Viewing Filter Kit contains six cards, each representing a different color of the color wheel. Each card has three small windows holding colored plastic filters of increasing density. If you think the print has a particular color cast, view it through the card of that color's complement; if the print looks too magenta, for example, view it through the green card. Hold the card in front of the print, but away from its surface, and move it in and out of your line of sight. Do this as you view the print through each of the windows. Then read the needed correction off the window that gives you the preferred degree of change.

After you determine the needed print exposure, the main task of color printing is to find the right color balance for an image. Color balancing involves deciding whether a particular color is too prominent in an image, and, if so, adjusting the enlarger's filtration (filter pack) to eliminate it. Keep in mind that it is often easiest to determine this by studying a print's lightest tones, and/or those that have the least strong color. In the print at left, skin tones are too pink, a clear indication that the print is too magenta.

To produce the corrected print at right, the magenta filtration was adjusted to add green, magenta's complement. With color negative printing, you do this by increasing the magenta level. In this example, the original filter pack of 60Y (yellow) + 50M (magenta) was increased to 60Y + 70M.

results you want. However, there are several tools available to help you decide.

A color enlarging analyzer is placed on the easel below your enlarger. You project the enlarged image onto the analyzer, and it takes a reading that provides exposure and filter pack recommendations. Unfortunately, using an enlarging analyzer is not as easy as it sounds. You have to program the analyzer ahead of time, such as by entering

a starting filter pack, and any variation in the type of film or printing paper may require reprogramming. Most printers find other color balancing tools easier and at least as reliable.

The **ringaround,** illustrated on page 337, provides a good general idea of the effect of various changes in a filter pack. Such charts are available in many printed sources, though reproductions on the printed page look somewhat different than photographic prints. You

can make your own ringaround by taking a single negative and printing it several times using a variety of filter packs, with incremental changes of 5 or 10 points. Be sure each print in the ringaround has the same overall density or the color variations will be hard to evaluate. When you change the filter pack, you must often change the exposure time as well.

The Kodak **Color Print Viewing Kit** provides another useful method for evaluating color print balance. The kit has six cards, each holding three filters representing various densities—5, 10, or 20 for printing from negatives—of a single color. The set includes all the colors from the color wheel: blue, cyan, green, yellow, red, and magenta. Following are guidelines on how best to use the viewing filters when printing color negatives.

1. Make an initial print with correct density and contrast.

2. When the print is dry, make a rough evaluation of the color balance. For example, you might decide that the overall print is too magenta or too blue.

ringaround Series of reference prints made to illustrate the effects of various combinations of color balancing filtration.

Color Print Viewing Kit Hand-held cards made by Kodak with transparent color filters through which you look at a print to judge color corrections.

3. Pick the card that has filters which are complementary to the color cast you want to correct. For a print that is too magenta, use the green card; for a print that is too blue, use yellow.

4. Look at the print through the filters on the card. Hold the card at least 6 to 12 inches away and move it in and out of your line of sight with a rapid back-and-forth motion, to compare its effect with the unfiltered print. Don't place the card directly on the print, and don't look through it without moving it.

5. As you move the card in and out, examine key areas to determine if the color correction you see through the filter is what you want. Concentrate on pale or neutral colors—whites, grays, beiges, pastels, or light skin values—when evaluating the required color changes.

6. When you've determined which filter provides the needed color change, read the recommended change to the filter pack printed on the card below the filter. It will suggest either adding to or subtracting from the filter pack used to make the initial print. For example, if a print is too green, to make it more magenta the card will suggest subtracting 5M, 10M, or 20M, depending on which density filter makes the desired correction.

7. Change your filter pack by only half of the recommended values. So, if the card suggests subtracting 10M, subtract only 5M. (The recommendations printed on the card are for when it is placed directly on top of the print, which is not as effective a method as holding the card several inches away and flashing it back and forth, as suggested.) Note also that

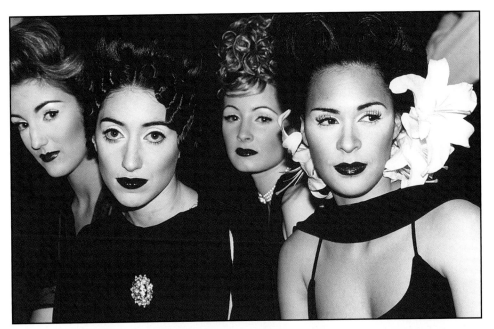

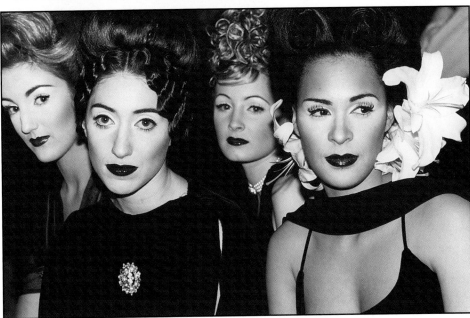

This print's skin tones provide a good indicator of how to correct its color imbalance. In the print at top, the skin tones lack warmth, suggesting that the print's color balance is too blue. To correct this, the yellow filtration was changed from 60Y (yellow) + 50M (magenta) to 40Y + 50M to produce a print that was less blue, bottom. With color negative printing, you increase a color's density in the filter pack, or reduce the density of its complement, to lessen its presence in the print.

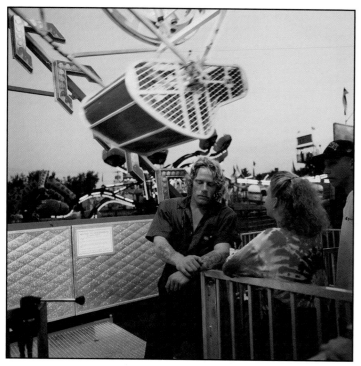 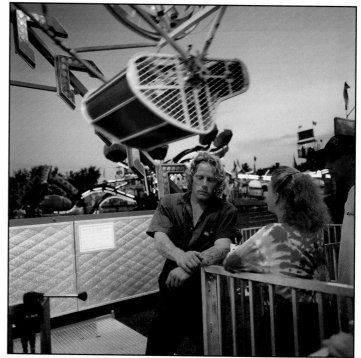

As with black-and-white printing, you can use burning and dodging to control the relative brightness of different areas of a color print. The overall exposure for the print on the left, 10 seconds, is fine for the main subject, the carnival worker, but causes the sky to be washed out. In the print on the right, the sky was darkened by burning in the upper portion of the photograph for an additional 10 seconds; this improved the overall tonal balance of the print and made the sky bluer in the process. Keep in mind, however, that burning can cause color shifts, and may require an adjustment in filtration before making the additional "burn" exposure.

you may always use in-between filter changes—for example, subtracting 7M instead of 5M or 10M. With experience you'll be able to rely on your own judgment over the printed instructions.

Each card has two sides; one for use when evaluating prints made from negatives and the other for prints from transparencies. The guidelines above apply regardless of the side you use. The only difference is that prints from transparen-

cies require approximately twice the filter pack changes for comparable results. Thus the filters on the transparency side of the card represent filter densities of 10, 20, and 40 instead of 5, 10, and 20.

FINE-TUNING COLOR PRINTS
Once you've made a color print with good overall density, contrast, and color balance, you may still have to do a bit of fine tuning for the best possible results. The techniques for fine-tuning color and black-and-white prints are similar. Three

of the most useful manipulations are burning, dodging, and flashing.

Burning selectively darkens areas of a print that would otherwise appear too light. After making the initial exposure, use some opaque mask, such as a piece of cardboard or your hand as your burning tool. Position the mask to block light from the areas that don't need darkening while letting additional light strike the areas that do. Keep your burning tool in constant motion during the entire additional exposure to prevent the edge of

A ringaround shows how changes in color filtration affect the final print. To create one, choose an image with a good mix of colors and make a print with correct overall color balance (above). Then, in increments of 10, 20, and 40, make additional prints that show the effect of increasing each of the six colors in the color wheel. Remember that to make a print more cyan, magenta, or yellow, you decrease those colors' values. To make a print more red, green, or blue, you increase the value of those colors' complements, cyan, magenta, and yellow. (Note that you'll need to adjust exposure to keep the print density consistent. Also, the adjustments in this example are for prints made from color negatives.) Mark each print with the filter pack you used to make it.

The final set of prints serves as a useful reference when you are printing. For instance, if you have a print that is slightly red, the ringaround shows that you might add 10M and 10Y to the filter pack to make the color balance correct. If it is very red, it suggests a stronger change—adding 40M and 40Y.

the darkened area from having an abrupt change in tone that is obvious to the eye (see pages 300–303, 306, 308).

Dodging selectively lightens areas of a print that would otherwise appear too dark. During the initial exposure, you prevent light from reaching dark areas using an opaque mask. As with burning, keep your dodging tool in constant motion during the entire dodge.

Note that when printing from a color transparency, burning and dodging work in the exact opposite way. To burn (darken), you must hold back light during the initial exposure and to dodge (lighten) you must add exposure to a selected area of the print.

Almost all prints can benefit from at least a little burning and dodging. Flashing is rarely needed, but it can be a useful tool with certain difficult prints—particularly those that have irregular areas that need burning. To flash, make the initial exposure, remove the negative carrier, and then expose the entire paper with a very short burst of light. The result is an overall density showing up mostly in the highlight areas. Flashing will also reduce image contrast, sometimes dramatically, so you may want to print on the highest contrast printing paper available, expecting the flashing to bring contrast down to the desired level (see pages 303–305, 310).

Although the basics of burning, dodging, and flashing are the same for black and white and color, there is one significant difference. All these fine-tuning methods may affect a print's color balance as well as its density. Let's say you make a print and dodge the left side for better overall density. The color balance of the dodged area may be noticeably different from the color of the rest of the print.

Color balance differences may or may not matter. They may be so minor as to

VIEWING LIGHT FOR COLOR PRINTING

The viewing light you use when evaluating color prints is critical. A print that looks well-balanced under tungsten light may look too cool in daylight, for example. Ideally, you should evaluate your print in the type of light under which it will be displayed or viewed. Unfortunately, you may not always know this ahead of time; furthermore, a print may be viewed in different lighting conditions at various times.

If you're making prints for reproduction, the best viewing light approximates daylight. Special daylight-balanced viewing booths are available for this purpose. However, most prints are displayed or viewed under some sort of tungsten light, such as an incandescent bulb. Common household bulbs therefore make an acceptable light source for evaluating prints. Or, use a mix of tungsten and daylight-balanced bulbs. Also, make sure the viewing light isn't too bright; keep it positioned several feet away from the print, or you may end up making prints that will appear too dark when displayed.

be undetectable. Or, the color of the dodged area may otherwise blend into the rest. If the difference in color balance is unacceptable, however, adjustments to the filter pack prior to burning, dodging, or flashing may solve the problem.

When burning, make your initial print, then change the filter pack before adding exposure in the area that needs darkening. When dodging, hold back light for the entire exposure time in the area that needs lightening, then change the filter pack and burn the area back in to properly expose it. When flashing, change the filter pack before the flashed exposure. You may also have to use a different filter pack for your initial exposure, since the flash exposure will affect the entire print. When flashing, it may help to put a clear (unexposed, but processed) piece of negative film in your negative carrier to provide an orange filter for better color balance.

There are useful variations on the above techniques whether you need to darken or lighten areas of the print. For example, if an area has a blue cast (such

as with shadow areas on a bright day), you can dodge that area during the initial exposure with a blue CP filter—not to lighten the area but to reduce its cast.

Determining what changes to make to the filter pack can be time-consuming. There are no easy rules; you have to make tests. For example, when dodging, make a test of the image section that needs lightening to determine the needed exposure. Then make a print of that area only, adjusting the filter pack until you achieve the desired color balance; use sections of paper and test strips, when possible, to minimize expense.

These changes complicate print fine-tuning, of course, and they are time-consuming, but they are sometimes necessary. You also may occasionally want to deliberately cause color imbalance as well.

COLOR PRINTS FROM NEGATIVES
Kodak's **RA-4 process** is the industry standard for making color prints from negatives. Such prints are called **chromogenic prints;** they are also

RA-4 process Kodak's industry-standard process for making color prints from negatives.

chromogenic prints Generally refers to prints made from a color negative using the RA-4 process. Chromogenic prints also are called C-prints, dye-coupler, or color-coupler prints.

Jan Groover Untitled, 1979

Groover brings a fresh approach to the tabletop still life, a photographic genre that includes every-thing from images of food in chain-restaurant menus to product shots for cosmetics advertisements. Yet her work also makes reference to photographic history, its soft-and-sharp quality invoking the early experiments of calotype pioneer William Henry Fox Talbot. Using mundane objects such as kitchen utensils, bottles and jars, and fruits and vegetables—the standard props of still-life images—she gives her work power not by what she shows but by how she shows it. Janet Borden, Inc.

RA-4 DRUM PROCESSING

Color printing paper for printing color negatives has three separate emulsion layers. Each layer is sensitive to just one of the primary colors of the light spectrum (red, green, and blue). These emulsions contain light-sensitive silver compounds, just like black-and-white paper, but the silver compounds are coupled with dye-forming agents. This means color papers form color in much the same way as most color films.

When you expose a piece of paper, a separate image is formed by the silver on each of the three layers. Each image is a representation, in black-and-white silver densities, of the proportion of that particular color in the subject. Superimposed on one sheet of paper, they reproduce the entire picture.

In a final print, all traces of silver are removed, leaving only a three-layer color dye image. These layers overlap in various proportions to create the full spectrum of color.

Here's what each of the steps actually accomplishes:

Presoak softens the paper and promotes more even development.

Developer creates separate but superimposed black-and-white images on each of the paper's three emulsion layers by converting the exposed silver

Step	Time in Minutes (95°F)*
Presoak	½
Developer	1
Stop bath	½
Wash	½
Bleach/fix	1
Wash	1½
Drying	Variable

*Most RA-4 processing kits allow a range of temperatures, but you'll have to change the times of the developer and bleach/fix. Instructions with the kit will give comparable times.

halides on each layer to black metallic silver. As the image is formed, it releases **color couplers** built into each layer. The couplers form the color dye image.

Stop bath cuts off development. It also helps prolong the useful life of the bleach/fix.

Bleach/fix converts the metallic silver that forms the paper's three black-and-white images into a more soluble form. **Bleach/fix** then dissolves the silver, leaving only the negative dye image. This step, which is sometimes divided into two (separate bleach and fix, depending upon which manufacturer you choose) requires totally fresh and uncontaminated solutions. Also, handle any bleach solution with special care, since it is caustic.

Final wash removes whatever chemicals and contaminants remain, helping to ensure print permanence. Color prints are on resin-coated paper (or polyester), so the final wash is short, as with black-and-white RC prints.

referred to variously as dye-coupler, color-coupler, and **C-prints.**

In terms of general procedure, processing color prints is similar to processing black-and-white prints. But solution temperatures, processing times, and consistent agitation are even more critical, and the solutions are more toxic. For these and other reasons many photographers send their color negatives to a professional lab for printing (see pages 346–347). However, printing from color negatives is not difficult once you get the hang of it,

particularly if you have access to a darkroom with an automated processor. (Many school programs have such processors.) Also, there are RA-4 kits available for **drum processing,** providing all the chemicals you need. These kits all follow the same basic procedure, but may vary in their times and temperatures. Drum processing a color print is functionally like developing film in a small tank. In total darkness, you place an exposed sheet of paper in a drum that keeps light out but allows chemical solutions to be poured in

and out. The steps here are representative, but refer to the instructions packaged with your kit for specifics.

Processing temperatures and times are critical, especially in the developer, which should vary no more than ½ degree in most cases. Temperature consistency is not as critical in the other steps, but it's good practice to keep temperature as constant as possible throughout the entire process.

To maintain solutions at 95°F with a drum processor, you'll have to use a

color couplers Chemical agents built into color film and paper emulsions that react with developer byproducts to form color dyes.

bleach/fix Color print processing chemical that bleaches and removes developed silver, leaving only the image formed by color dyes.

C-prints Another name for chromogenic prints.

drum processing Developing color prints by placing them in a light-tight tube, then adding solutions in sequence, with agitation by rotation.

water bath; automated processors automatically maintain whatever temperature is needed. Some kits allow you to process at lower temperatures (again, see packaged instructions), which would require proportionally longer developing times.

DRUM PROCESSING COLOR PRINTS

Though automated processors offer the best method of processing color prints, drum (or tube) processors are more practical and affordable for individual users. Drums are plastic tubes that come in various sizes to accommodate 8" x 10" and larger printing paper. They work much like film-processing tanks (without the reels), allowing you to process with the lights on. You load exposed paper in the drum in total darkness, or with a very dim green safelight (see page 331), then attach the cap, turn on the lights, and pour solutions in and out through a spout on the cap until the processing is complete. You must agitate continuously after pouring in each solution.

You can use processing drums for printing negatives or transparencies. They are economical both because the initial cost is relatively small and because they use only ounces of solution to process each print. For example, you'll need about three ounces of each solution to process an 8" x 10" print; the exact volume will vary somewhat with the brand of drum used (check the instructions packaged with, or printed on, the drum for specifics).

Begin your printing session by mixing enough solution in separate beakers for each step. When printing from negatives the chemical steps are: presoak (plain water), developer, stop bath, and

AUTOMATED PROCESSORS

In most cases, black-and-white prints are processed in trays and color prints in drums or automated processors. Such processors automatically perform all, or nearly all, the steps of developing, fixing, and washing a print. They offer reliable standardization of temperature and agitation, and some models offer a lot more, such as replenishment of depleted solutions and automatic washing and drying. You put in the exposed paper and it comes out fully processed (and often dried) in a few minutes.

Automated processors are usually used for color processing because temperature, time, and agitation must be strictly monitored. Some processors handle both color and black-and-white processing, but most are dedicated to one or the other.

There are two main types of automated processors. With one, you load the exposed paper into a light-tight compartment, and rollers carry the paper through troughs of solution like an assembly line; with the other, you load the exposed paper in a light-tight tube similar to that used for drum processing, put the tube into the processor, and solutions automatically fill and drain the tube for processing (or you fill and drain them manually). Various models of the two types offer different features and different degrees of automation. Another advantage of automated processors is their closed housing, which helps keep chemical fumes contained. Once the exposed paper is placed in the processor, you can turn on the lights for the rest of the process.

Most models of automated processors are expensive and large and require too much plumbing and maintenance for individual users (though small, relatively affordable and portable models are available). For this reason, they are found mainly in school, professional, and industrial labs.

Automated print processors perform all or most of the steps required to produce a finished color print, usually advancing the paper through troughs of chemicals with a system of rollers. They're particularly valuable in color printing because they reduce contact with toxic chemicals and provide the precise temperature control that is required. Most, though not all, units can even wash and dry the print.

Color prints can be processed in special tube-like drums designed for manual agitation, similar to film processing tanks. You load your exposed paper into the tube in total darkness or with dim safelight, gently curling it toward its emulsion side and placing its edge against an inside ridge (top). Once you attach the tube's light-tight cap, you can pour solutions in and out with the room lights on (center). To agitate the print during each chemical step, you roll the tube on its side along a flat surface such as a counter top (bottom). Motorized bases are available to rotate the tube automatically.

bleach/fix. Place the beakers in a water bath (see Chapter 12) to maintain a constant temperature. The required temperature will vary with the brand of processing kit (some solutions offer a range of temperature choices.

Place the water bath (with beakers containing the solutions) in the "wet" area of the darkroom. Once the solutions are set up, place the drum next to your enlarger so it will be easy to find in the dark; remember, you can't use bright safelight illumination with color printing the way you can with black-and-white printing. Also, remove the cap from the end of the drum. Turn out the lights and expose your paper to make a contact sheet or enlargement. Follow these steps:

1. Load the exposed paper into the drum. Curl the paper so its emulsion faces the middle of the drum. The inside wall of the drum has a paper "stop" or ridges that you place one end of the sheet against.

2. Place the end cap on the drum and turn on the room lights.

3. Make sure the solution temperatures are correct. If they're too high or low, adjust the water bath temperature accordingly to heat up or cool off the solutions.

4. Begin processing with the presoak. Take the top off the cap and pour a few ounces of water into the drum. Use the amount recommended for the drum you are using, and use water from the container in the water bath so it is the correct temperature. Replace the top on the cap, and leave the paper in the drum for the presoak time, usually one minute. You can start the timing as soon as you complete pouring the solution.

5. Agitate the drum throughout the presoak and the steps that follow for even, consistent results. You can use a motorized base (available with some drums or as an accessory) for the most convenience and best consistency, or agitate manually by rolling the drum back and forth along a flat surface.

6. A few seconds before the recommended presoak time is up, take the top off the cap and pour the water out of the drum. Make sure the water is completely drained and discarded; never reuse the presoak.

7. As soon as the presoak is drained, pour the developer into the drum and start timing the development. With each step, use only the amount of solution specified for the size drum you're using.

8. Agitate the drum until the last few seconds of the recommended developer time, then pour out the solution.

9. Immediately pour in the next solution (a stop bath or water wash, depending on the process).

10. If it's a stop bath, agitate continuously, again until the last few seconds of the recommended stop bath time, and pour out the solution. If it's a water wash, fill it with water at the recommended temperature. Pour the water out as soon as the drum fills up, fill it again and pour it out again until the wash time is complete.

11. Pour in the required amount of bleach, agitate, and pour the solution out of the drum when the time is up. With some processes, the bleach is combined with a fixer. In other processes the fixer follows the bleach, in which case you add the fixer, agi-

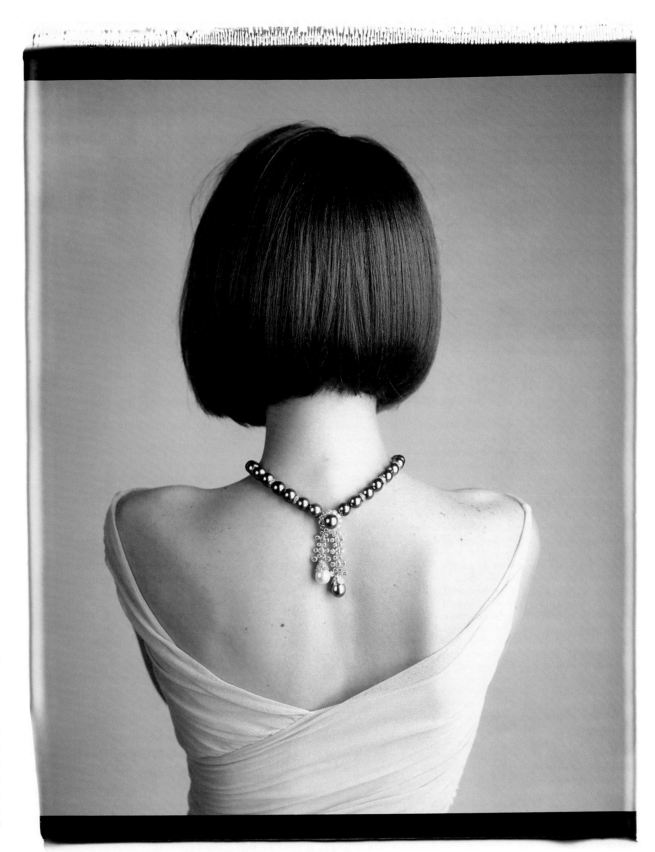

Timothy Greenfield-Sanders
Black Pearls
Working in a style that is both unadorned and cultured, Greenfield-Sanders has created a huge body of portraiture, often photographing the art world's most influential people. But his style transfers readily to non-portrait subjects, such as this image of exotic jewelry shot on assignment for a luxury magazine. Part of the photographer's distinctive look comes from working with large-format Polaroid color peel-apart films.
© Timothy Greenfield-Sanders

COLOR PRINTS FROM TRANSPARENCIES: ILFOCHROME P-30P PROCESS

You can use either drum or automated processors to make Ilfochrome prints, but automatic systems are much preferred. The process requires careful control of temperature, timing, and agitation. Also, the chemicals are more toxic than RA-4 chemicals, so be sure to handle solutions with care in well-ventilated areas. And be sure to dispose of the solutions appropriately; in particular, neutralize the bleach by mixing it with the developer before discarding it. See packaged instructions with Ilfochrome kits before proceeding. The chart at right offers some very general guidelines.

Step	Time in Minutes (75°F)
Presoak	½
Developer	3
Wash	½
Bleach	3
Fix	3
Wash	3
Drying	Variable

tate, and pour out the solution in the same way as with previous solutions.

12. Open the end of the drum and wash the print with water, following the instructions in step 10.

13. Dry the print before evaluating the results.

14. Wash and dry the drum thoroughly; color-processing solutions are highly susceptible to contamination from chemicals and moisture.

COLOR PRINTS FROM TRANSPARENCIES

Photographers who use transparencies are usually professionals whose final goal is either to reproduce their work in print or to project it—but rarely to make photographic prints. Still, it is possible to make excellent prints from transparencies, and prints from transparencies have unique qualities that can be quite beautiful.

Prints from transparencies involve a **direct reversal** process—"direct" because it uses a positive transparency to make a positive print, and "reversal" because in the processing the image is initially made into a negative and then reversed chemically to a positive. You'll have to begin with a good original; making good prints from poor transparencies is very difficult, particularly since reversal processes are much less flexible than the RA-4 color-negative printing process.

There are primarily two direct reversal processes: Type R and Ilfochrome.

Type R (for reversal) printing is a chromogenic process, similar to the RA-4 process for color negatives. This means that the dyes built into the paper form the color during development. Several manufacturers make papers and chemicals for Type R prints, but the Kodak **R-3000** process is standard.

Ilfochrome (formerly called Cibachrome) is a proprietary process that forms color in a very different manner from chromogenic materials. As with Type R, Ilfochrome requires specialized paper, chemicals, and processing. In Ilfochrome paper, the dyes are present in the emulsion before exposure; during processing, dyes that are not needed to form a color are bleached away, leaving the positive image. Most photographers looking for high-quality prints from transparencies use Ilfochrome because of its rich color and depth.

Though the principles are somewhat different, many of the basics of printing from negatives and printing from transparencies are similar. For example, both use the same equipment—enlargers and CP or dichroic filters to make the exposure and drum or automated processors to process the prints. (Note that many processors are dedicated to either negative or transparency processing, but not both.) Negative carriers are available to hold transparencies in their slide mounts, though with some models of carrier you must first remove the mounts. And both use similar techniques for contact and test printing, as well as making the final print. Also, you can apply certain fine-tuning techniques, particularly burning and dodging, whether printing negatives or transparencies.

You'll still have to dry prints to evaluate the results. And you must first make sure density and contrast are good before you can accurately judge color balance. Use experience, a ringaround, or the Kodak Color Print Viewing Filter Kit. Be sure to use the correct side of the kit's cards—the side labeled for transparency printing (see pages 334–336).

direct reversal
Process of making a positive print from a transparency.

Type R Refers to color prints made from transparencies using a chromogenic chemical process.

R-3000 Kodak's proprietary chemical process for making Type R prints.

Ilfochrome Formerly known as Cibachrome, Ilford's proprietary process for making color prints directly from transparencies.

Sheila Metzner Time, 1988

Metzner started her career as an art director and graphic designer, and has always done commercial photography for fashion clients alongside her own work. Her photographs often have an impression-istic quality that she enhances through the use of exotic printing techniques. Her minimalist image of a rotating sphere demonstrates that a color print needn't have a full range of color; subtle shifts in hue create an effect that falls somewhere in between color and black-and-white. © Sheila Metzner

PRINTING TRANSPARENCIES USING INTERNEGATIVES

An **internegative** is a negative that is made from a transparency. You make an internegative by rephotographing or enlarging the transparency onto a special-purpose color negative film.

An internegative is a good solution to making prints from transparencies, especially if you want to make your own prints and have only RA-4 capability available to you. It's also cost-effective if you need to make multiple prints from one transparency, since RA-4 printing is relatively inexpensive. With multiple prints, the initial cost of making the internegative becomes less significant.

When printing, you treat internegatives like any other negative, using the standard RA-4 process. The results can be excellent, but only if you have a high-quality internegative to begin with. This is highly dependent on both good technique in making the internegative and starting with a good original transparency.

You can make a 35mm internegative using a commercially-available slide-copying device. But for serious applications, an enlarger works better. Using the enlarger, you expose the transparency onto a sheet of film made specially for the purpose. Any size film is acceptable in theory, but most internegatives are 4" x 5" (or occasionally 8" x 10"). The film is then processed in standard C-41 chemicals.

In practice, making a good internegative is tricky. Because an internegative is another step between the original and the print, your results may suffer from various problems, such as lack of image sharpness and incorrect density, contrast, and color balance. If done with care, you can make your own high-quality internegatives. Usually, however, it is better to have a professional lab do the work for you. The cost is generally worth it to better guarantee a high quality result.

burn (darken) an area of the print, you hold back light during the initial exposure; to dodge (lighten), you add light after the initial exposure. Overall exposure times will be longer—as much as twice as long as when printing negatives. Also, note that dust and scratches on transparencies print as black, not white, which makes them very difficult to retouch. This makes it even more important to keep the original transparencies clean.

The filter pack when printing transparencies may include cyan, linked with magenta or yellow, but not both. You'll have to make more extreme adjustments to the filter pack to achieve color balance than when printing color negatives—about double the change in filtration.

WORKING WITH LABS

Many photographers prefer to do their own darkroom work; others send their work out, either because they don't have certain skills or the necessary darkroom facilities to do so. For instance, a lab may offer special processes or make prints that are too big to do in a home darkroom. With many processes, you can learn to do a better job than a lab, if only because you're exercising your own judgment about how your work should look and not relying on the personal taste (and time restraints) of a technician. You'll also generally work harder to get the work right. Other tasks, such as developing transparencies, are best left to professional labs.

You can get excellent work from a lab, but you must be very careful to choose the right one. And you must constantly monitor the results; the quality of any lab's work can change with many factors,

Transparency

Internegative

If you're used to printing negatives (black-and-white or color), you'll find many of the mechanical steps are reversed when printing transparencies. For example, the longer you expose the paper, the lighter the print. Thus, to

internegative Negative made by rephotographing or enlarging a transparency onto special film, then using the resulting negative to make a print.

FILTER ADJUSTMENTS FOR COLOR BALANCING WHEN PRINTING TRANSPARENCIES

When you are printing transparencies, the general rules for adjusting the filter pack are the opposite from negative printing, but they are more logical. If the color is too yellow, for example, subtract yellow from the filter pack. Or, add magenta and cyan—the equivalent of yellow's complement—to make the correction. Follow this chart:

If your print looks too:	Adjust filter pack by:
Red	Adding cyan or subtracting magenta and yellow
Green	Adding magenta or subtracting yellow and cyan
Blue	Adding yellow or subtracting magenta and cyan
Cyan	Subtracting cyan or adding magenta and yellow
Magenta	Subtracting magenta or adding yellow and cyan
Yellow	Subtracting yellow or adding magenta and cyan

including the departure of a key technician. There are two basic types of labs: amateur and custom. Some amateur labs are mass-market operations that handle film from department stores, drug stores, and camera stores; others are retail minilabs—camera stores or other places offering on-location processing.

Both types are best when processing color negative film and making snapshot-size prints. (Most on-location labs send out their own conventional black-and-white orders, but they will process chromogenic black-and-white films; see pages 154–156.) Both types are capable of producing excellent work, assuming they keep their equipment clean and their chemicals fresh. However, amateur film processing is a volume business that aims at quick turnaround and competitive prices; it doesn't allow for much personal attention to each image.

Custom labs are far more expensive than amateur labs. Typically used by professional photographers and fussy amateurs, they provide standard services, such as processing film and making prints in black and white and color. Most also provide a broad range of specialized services, such as pushing and pulling film (see Chapter 12), making duplicate transparencies ("dupes") and internegatives, digital retouching, processing, and output (see Chapter 17).

Custom labs offer other advantages besides a breadth of services. They generally have well-trained technicians who are responsive to individual customer needs (many custom lab technicians are photographers themselves). And they usually maintain and monitor their equipment and solutions constantly for consistent results.

Nonetheless, you are always taking a risk putting your work in someone else's hands. Even a good technician has bad days, and even the best maintained processing equipment occasionally breaks down. Also, your personal taste and a technician's judgment may simply clash. Custom labs will often redo a job once or even repeatedly, but fussy customers will have to pay a premium for this level of personal service. Labs generally have a different price structure to reflect the amount of care they take with a print, for example. "Commercial-level" service might be most basic (and inexpensive), while "exhibition-" or "reproduction-level" might provide more care and cost the most. (The particular designations for different levels of service will vary from lab to lab.)

In most parts of the country, you can choose from several different custom labs. Larger cities will have dozens. Or you can send film by mail to other locations for processing. So choose your lab carefully. Professional photographers are the best source for a referral; they depend on custom labs for their business so they'll know which ones are most reliable. You'll get the best service from a lab if you're a steady customer—and they'll get to know your particular needs—so once you've found a lab you like, stay with them. It's not unusual, however, to use specific labs for different jobs—say, one lab for processing transparencies and another for making prints.

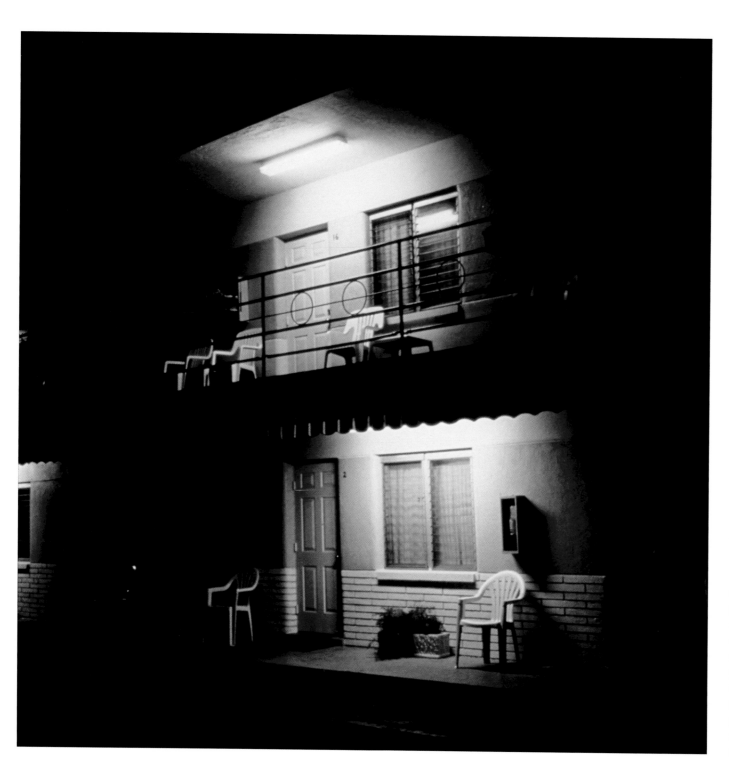

Shellburne Thurber
Tampa, Florida: Motel Exterior at Night, 1996
Thurber's work is an unusual but congruous mixture of unstudied photographs of friends and family and more formal images of interiors and building exteriors such as this. She makes large-scale color prints to give these subtle images maximum impact, and often uses the Ilfochrome direct-reversal printing process for the heightened saturation with which it renders colors. © Shellburne Thurber

PROBLEMS WITH PRINTS FROM NEGATIVES (RA-4 PROCESS)

Problems with prints made from negatives may be traced either to the negatives themselves (see Chapter 12) or the printing process. Most can be corrected only by reprinting. Following are some of the most common problems. Note that symptoms and causes depend partly on the brand of printing paper and chemicals you use.

Symptom
Print too light overall.

Probable causes
1. Too little paper exposure.
2. Too little development.
3. Paper exposed emulsion side down in easel.

Solution
Make a new print with more exposure (a longer time or wider f-stop), with the correct developing time, or with the emulsion facing up.

Symptom
Print too dark overall.

Probable causes
1. Too much paper exposure.
2. Too much development.

Solution
Make a new print with less exposure (a shorter time or smaller f-stop) and at the correct developing time.

Symptom
Density variation from one print to next.

Probable causes
1. Voltage fluctuations in enlarger.
2. Timer inaccurate.

Solutions
1. Use voltage regulator on enlarger electrical line.
2. Repair or replace the timer.

Symptom
Light or white specks or spots on print.

Probable causes
1. Dust, dirt, or grit on negative.
2. Dust, dirt, or grit on glass film carrier.
3. Dust, dirt, or grit on print.

Solutions
1. Clean negative with compressed air, bulb blower, or other means (see page 361) and reprint. If necessary, also clean glass film carrier.
2. Spot blemished print with brush and spotting dyes or pigments (see pages 357–361).

Symptom
Light or white lines on print.

Probable causes
1. Foreign matter, such as strand of hair, on negative.
2. Scratches on film base from processing or handling.

Solutions
1. If the foreign matter isn't embedded in the film, clean negative with compressed air, bulb blower, or other means (see pages 361) and reprint.
2. If it is embedded, spot finished print with brush and spotting dyes or pigments (see pages 357–361).
3. Handle all film with care.

Symptom
Print has uneven tones or mottled look overall.

Probable causes
1. Too little developer solution used.
2. Inadequate agitation during development.

Solutions
1. Use an adequate amount of developer.
2. Make a new print with constant agitation.

Symptom
Random streaks in printed image.

Probable causes
1. Unlevel processing drum.
2. Inadequate agitation.

Solutions
1. Use presoak step before developing.
2. Use level counter for drum.
3. Increase agitation.

Symptom
Random streaks of color in the border and the image area.

Probable causes
Light leak in the darkroom, paper safe, safelight, or processor.

Solutions
Reprint using fresh paper in a light-tight environment.

Symptom
Contrast too low overall.

Probable causes
1. Film underexposed in camera.
2. Subject lighting low in contrast.
3. Film underdeveloped.
4. Paper contrast too low for negative.

Solutions
1. Reshoot, exposing film correctly.
2. Reshoot in higher contrast lighting.
3. Use correct developing time when processing film.
4. Make a new print with a higher-contrast paper.

Symptom
Contrast too low, with green shadows and magenta highlights.

Probable causes
1. Underdevelopment.
2. Inadequate agitation in developer.

Solution
Make a new print with adequate development and/or agitation.

Symptom
Contrast too high overall.

Probable causes
1. Subject lighting had high contrast.
2. Film overdeveloped.
3. Paper contrast too high for negative.

Solutions
1. Reshoot in lower-contrast lighting.
2. Use correct developing time when processing film.
3. Make a new print with a lower-contrast paper.
4. Flash paper when printing (see pages 303–305).

Symptom
Contrast too high, with cyan stains and/or cyan shadows and pink highlights.

Probable causes
1. Overdevelopment.
2. Overagitation.
3. Bleach/fix contaminated presoak or developer.

Solution
Make a new print with adequate development and agitation using uncontaminated solutions.

Symptom
Borders creamy rather than bright white.

Probable causes
1. Poorly mixed developer.
2. Temperature of developer too high or development time too long.
3. Outdated paper.

Solutions
1. Make a new print using fresh developer at the right temperature and time.
2. Use fresh paper.

Symptom
Pink, magenta, or red stains overall.

Probable causes
1. Paper wet before processing, possibly due to damp processing drum.
2. No presoak used.
3. Exhausted developer.
4. Inadequate wash after bleach/fix.

Solutions
1. Make a new print, after drying drum thoroughly.
2. Use presoak, fresh developer, and wash adequately.

Symptom
Pink or red spots.

Probable cause
Unprocessed paper touched by fingers damp with water, skin oil, or perspiration.

Solution
Make a new print, being careful not to touch the paper surface prior to processing.

Symptom
Blue cast in shadows.

Probable causes
1. Developer solution diluted too much.
2. Too little development.
3. Presoak not drained adequately from the drum before development.

Solutions
1. Make a new print with fresh and undiluted developer and develop for the correct amount of time.
2 Drain presoak totally before pouring in developer solution.

Symptom
Yellow cast in highlights.

Probable cause
Paper outdated or stored in high heat or humidity.

Solution
Make a new print, using fresh paper.

Symptom
Cyan stains.

Probable causes
1. Bleach/fix contaminated presoak or developer.
2. Fogged paper, possibly due to excessive exposure to a safelight.

Solution
Make a new print using fresh, unfogged paper and uncontaminated solutions.

Symptom
Green or yellow highlight casts.

Probable cause
Presoak temperature too high.

Solution
Make a new print using a lower presoak temperature.

Symptom
Small, dark, round blotches or spots with soft edges on prints.

Probable cause
Air bells on negative due to poor film agitation.

Solution
Spot print by bleaching or spotting out blemishes with white dyes or pigments and then using black or colored dyes or pigments to build up the density of the areas and cover the white spots (see pages 357–361).

Symptom
Dark or black specks, pinholes, or spots with hard edges and irregular shapes on print.

Probable causes
1. Dust, dirt, or grit on emulsion side of film during exposure in camera.
2. Rusty water or developer sludge.

Solutions
1. For future exposures, clean out the camera's insides (and/or the film holder, if you're using sheet film) with compressed air, bulb blower, or other means.

2. For finished print, bleach or spot out blemished areas with white spotting dyes or pigments and then use black or colored dyes or pigments to build up the density of the areas and cover the white spots (see pages 357–361).
3. Make a new print, using filtered water and fresh chemicals.

Symptom
Dark or black scratch marks on print.

Probable cause
Negative emulsion scratched by mishandling, grit in camera interior, or film-processing equipment.

Solutions
1. For future photographing, clean the area all around the camera back (a possible culprit) or clean the film holder (if you're using sheet film) with compressed air, bulb blower, or other means. Also, handle film with care in camera and when processing.
2. For finished prints, bleach or spot out blemishes with white spotting dyes or pigments and then use black or colored dyes or pigments to build up the density of the areas and cover the white spots (see pages 357–361).

Symptom
Print image sharp in some areas but not others, in different areas from print to print.

Probable causes
1. Film carrier not holding negative flat.
2. Film buckling due to heat from long exposure time.
3. Easel or contact-printing glass not holding printing paper flat.

Solutions
1. Reprint, making sure negative and film carrier are properly positioned.
2. Reprint, using a shorter exposure time.
3. Reprint, using a glass film carrier or a heavier contact-printing glass.
4. Reprint, making sure paper and easel are properly positioned.

Symptom
Print image focus unsharp overall.

Probable cause
Image out of focus in enlarger or in camera.

Solutions
1. Reprint, checking enlarger focus (preferably with grain focuser).
2. If image properly focused in enlarger is still unsharp, reshoot if possible.

BILL GALLERY
CORPORATE PHOTOGRAPHY

GALLERY'S TOOLS

35mm autofocus SLR with 35mm, 100mm, 200mm, and 300mm lenses

35mm rangefinder camera with 35mm lens

Hand-held incident light meter

Small tripod with ball head

Lightweight studio strobes

Professional photographers sell more pictures for business use than for any other purpose. Sometimes these photographs are widely exhibited or published, such as in store displays or major ad campaigns in magazines and on billboards. But more often than not they are made for limited, less public audiences, such as in training manual illustrations for a company's sales force or an annual report for the stockholders of a corporation.

Photographers working on these kinds of business projects are often called corporate photographers. A common misconception is that such photographers produce only flattering portraits of company executives. Yet in practice their subjects are often decidedly uncorporate: stunt pilots in Kansas, Egyptian tombs, the Miss America contest, astronomers in Chile, discos in Tokyo, Saudi Arabian royalty, the Vatican, street gangs in Pittsburgh, animators in Hollywood, diamond cutters in Amsterdam, and farmers in Brazil.

The list of subjects comes from Bill Gallery, who has been one of the most successful corporate photographers in the United States over the last decade. Gallery's services are widely in demand by such top clients as IBM, Coca-Cola, Apple Computer, Time Warner, Netscape, and Reebok. It's important to note that despite being known as corporate photographers, Gallery and others in the field are almost always freelancers and are rarely employed full-time by a corporation.

When Gallery started his career he had no idea the field of corporate photography existed. He was trained as a filmmaker at New York University and then as a fine-art photographer at Rhode Island School of Design, where he studied under legendary photographers Harry Callahan and Aaron Siskind.

After school he went to work first in film and then in the burgeoning world of "multi-image," making photographs for audiovisual shows. In the 1970s and 1980s, such shows were used extensively by companies to promote their products, train their employees, and raise money. Gallery became a top photographer in this industry, winning many awards and developing a national client base. But by the late 1980s, as companies began using more video and computer-based multimedia, the photographic slide show was becoming extinct. Gallery's move into the world of annual reports was a natural one.

His first annual report was shot for the prominent software company Lotus Development in 1985. Gallery's unusual approach matched with striking designs from then-Lotus art director Tom Hughes to win many top design awards. Gallery describes this work as "corporate photojournalism."

Gallery's photographic approach is somewhat unusual for the field. He considers himself basically a chronicler of corporate life, shooting mostly in black and white in an informal style. He works candidly, often using a single camera and a couple of lenses, resorting to artificial light only when absolutely necessary. "I shoot black-and-white photo essays, customer stories, and working portraits," he says. "I often work in places where photographers are generally not welcome—boardrooms, trading floors, emergency rooms—places where the work is critical and interruptions are not tolerated. I manage this by working quietly and unobtrusively without lights like a fly on the wall."

Sometimes corporate photography is confused with advertising photography. While there is some crossover, they are actually quite different. Advertising is generally used to promote a company's products or services to customers; corporate photography promotes the companies themselves, informs their customers, and trains their employees. An advertising shoot also usually involves a crew. On any given day there could be a dozen or more people on an advertising set—photographer, assistants, stylists, art director, clients. Corporate work

Truck Silhouette
Bank marketing brochure
Boston, Massachusetts

**Computer Engineer
Silhouetted Against
Glass Wall
Company profile
Silicon Valley, California**

may involve a few people, but often it's just the photographer and perhaps an assistant. Although he sometimes works with an assistant and an art director, Gallery prefers to work alone, and because of his informal approach he can often do that. "I don't need any of a subject's time or attention, just permission to be in the same place," he says. "No posing, no lights, no assistants, no disruptions."

Another significant difference between corporate and advertising photography is the budget. A top corporate photographer can make a very good living, but advertising day rates are usually two or three times more. The stress level in advertising is accordingly higher; there are more people to satisfy in advertising, and there is more money at stake.

Which is not to say that corporate work is relaxing. In a typical busy month, Gallery may be traveling, spending two to three weeks away from home. Shoots and itineraries are often changed at the last minute, and the photographer must go with the flow. When not traveling, Gallery is also busy trying to get more work: advertising, sending out portfolios, writing estimates, and following up.

Still, Gallery finds that the rewards exceed the demands, making corporate photography the work of choice for him. "The extreme variety of subjects, locations, and situations make it exciting," he says. "It's also an education in that you find out what makes things tick. You broaden your views and take less for granted. The work can satisfy on so many different levels." Successful corporate photographers get to travel, make good pictures, and learn from their experiences, plus they get to make a comfortable living. Not all fields of photography can make the same claim.

Man Reading Papers
Financial services company
Annual Report
New York, New York

DOUG AND MIKE STARN
Some Saint's Fingernail

Whether your photographic work requires a simple, well-cut mat or an elaborate multimedia treatment such as in this piece by the Starn Twins, its presentation can make a big difference in its impact. The Starns often tear, tape, stain, and bleach their prints, in an approach that seems to reject photography's tradition of clean, straightforward display. But in fact, their work's presentation is calculated, part of a systematic exploration of photographic effects and loaded with references to both popular culture and art history. © Doug and Mike Starn

Making a print is not always the final step in making a photograph. If it's a good image—one you want to save and show to others—you should take some additional measures to ensure that the print is worth displaying.

Good prints are too often compromised by poor presentation. First, you must "spot" the print, eliminating unwanted spots, scratches, and other marks that detract from the image. Then you should mat or mount the print both to protect it and to present it in a clean and finished form. And you also must consider appropriate storage to guard against damage and deterioration.

SPOTTING PRINTS

Scratches, dust, dirt, fingerprints, and other blemishes on negatives routinely show up on photographic prints. To avoid or minimize this, you must be vigilant in keeping your darkroom and your negatives clean when printing (see box on page 361). But even the most finicky darkroom worker can produce blemished prints. The most common problem is dust and other marks on the negative that produce white or light spots on the print. The only way to correct these after the print has been made is to carefully fill them in to blend them with the surrounding image tone or color.

Spotting is the technique most commonly used to cover up such imperfections. You use a brush and liquid dyes, or special pencils or pens, to fill in the unwanted marks so that they blend seamlessly into areas around them. While spotting most prints is easy enough, it requires time and patience—and a steady hand. You'll soon discover that taking the extra care to keep the

negative clean will make the final prints nearly spotless, saving you the additional and very tedious work of spotting. (Note that photographers working with a digital image—from a digital camera and/or scanned image—can spot or retouch in a very different way than described here.)

Fiber-based prints are easier to spot than resin-coated prints because spotting dyes are absorbed into their paper base more readily. Resin-coated prints tend to resist such absorption, so spotting dyes applied to an RC print may take longer to seep into the surface of the paper. Whatever kind of paper you're using, the glossier the surface, the more it will resist spotting and the more patience it will take to spot well.

General Instructions for Spotting
Follow these general directions for spotting your prints:

1. Clear an area on a table or counter top to do the spotting. Make sure that the surface is dry, clean, and brightly lit. Put the print on it.

2. Place the scrap from the white border of a sheet of paper on top of the print, next to an area with an unwanted dust spot or other mark. It's a good idea to use a piece of clean, smooth, non-photographic paper to protect the print surface when you rest your hand or arm on it.

3. Put a small amount of dye on the mixing dish. Note that a little spotting dye goes a long way—with liquid dyes a few drops will do.

4. Dip the brush into the dye. With liquid dyes there are two strategies.

One is to dip the brush into the dye while it is liquid. Another is to let the dye dry on a dish or a piece of glass. Then touch a wet brush to the dried dye to lift it from the surface. In effect, this liquifies the dye on the brush and may offer more subtle control. (If you are using dry dyes to begin with, this is how you use them.)

5. Touch the tip of the brush lightly on the white scrap of paper. Spot it; don't make a brush stroke.

6. Compare the density of the mark you just made with the area adjacent to the spot. If it's too dark, dilute the dye by dipping the brush in a small amount of water, then blot the brush to keep it fairly dry to remove excess moisture. If the density of the mark is too light, make it denser by dipping the brush in more dye solution, then blot it.

7. Keep adding to or diluting the density of the dye—and testing it on the white paper scrap—until you have matched the tone surrounding the light mark you want to spot. The ideal density is usually slightly lighter than the tones around the mark. It's better to make the spots too light and to build up the tones with repeated applications. You can easily build up the density with more dye, but reducing the density (if the dye is too dark) is difficult. Making spots too dark is by far the most common spotting problem; it results in sloppy-looking prints and often brings more attention to the image defects than the spots themselves.

spotting Filling in unwanted spots or marks on photographic prints, usually with a brush and dye.

357

TOOLS AND MATERIALS FOR SPOTTING

Spotting brush. A good spotting brush is a necessity. Use a high-quality, fine-tipped watercolor (sable) brush; #000 to #00000 sizes are best. More zeros indicate finer tips; thus a #0000 brush is finer than a #000. Camera stores sometimes carry spotting brushes, but art supply stores are usually better sources for such fine sizes.

Cleaning tools. A camel's hair brush, **compressed air,** or a bulb blower (a bulb that you press to create a burst of air) work well for removing loose dust from the surface of a print, so you can identify the areas that really need spotting. A broad brush (at least two inches wide) works best, used carefully to avoid surface scratches (a special risk with unhardened prints, glossy surfaces, and resin-coated papers).

Spotting dyes. Spotting dyes and pigments come in liquid or dry form. (You mix the dry type with water or wetting agent to liquefy it.) Standard liquid kits are available that offer different "colors" to match the image tone of specific black-and-white and color papers. For cold-tone prints there is a neutral-black dye, and for warm-tone prints there are olive-black and brown-black dyes. There also is a full spectrum of dyes in different colors for use with color prints. Many times you can do all your spotting with only one dye—usually the neutral black. But other times, you may have to mix various dyes—including the color dyes—to match the areas you're trying to spot.

Cotton gloves. Lintless cotton gloves should be used whenever handling prints—for spotting or any other

reason—so you won't leave skin oils or fingerprints on the print surface. These gloves are available in most camera stores, mail-order suppliers, and drug stores. A blotter or sponge, or simply a paper towel are needed to dry out your brush if it becomes too wet.

Paper scrap. A scrap from the white border of a processed sheet of paper is helpful to test the tone or color of the solution on your brush before actually spotting the print. The scrap should be from the same type of paper as the print you are spotting, since some papers have a warmer or cooler base than others.

Mixing dish. A mixing dish is needed to dilute the spotting solution with water. A small white ceramic or plastic plate will do the trick. Have a small cup of water ready for moistening the brush or for adding water to the dyes.

Good lighting. A desk lamp can also help a lot. Spotting requires careful attention to detail, and a well-lit work area is a big plus.

compressed air Containers of air for blowing dust and grit off the surface of negatives, transparencies, prints, and photographic equipment; also called canned air.

To spot a print, keep a scrap of white border from a processed print right beside the area of the print on which you're working (top). After dipping the brush into the spotting dye, apply it to the scrap before applying it to the print, to determine if the amount of dye is correct. If there's too much dye (which could make the spot too dark), eliminate the excess with additional strokes on the scrap, then apply the brush to the print when the density matches the area surrounding the spot (bottom). If there's too little dye, reload the brush with dye and try again. Use light pressure when you apply the brush; build up density with repeated applications rather than a single stroke. Fill in larger spots a little bit at a time.

8. Spot the print by lightly touching the very end of the brush to the paper. Apply the dye by making little dots, rapidly bringing the brush straight down several times on the print surface. Never use brush strokes to try to fill in entire areas or scratches in a single stroke. If you do, the spotted area will be obvious. If there is a visible grain pattern to the image, try your best to mimic it with a cluster of dots. Be very patient; it takes time and multiple dots to fill in most areas seamlessly.

9. If the spotted area looks a little light, build up the density by applying more dye. If it looks too dark, you may be able to blot it away if you act immediately. Use an absorbent paper or a soft cloth. If you make a mistake or create a very dark blemish, you can wash the print to remove the water-soluble dyes. Then you'll have to wait for the print to dry before you can respot.

10. Once you've spotted an area satisfactorily, look for other unwanted marks needing similar dye density and spot these while you have the right concentration of dye on your brush. Work quickly; the dye density changes as the brush dries.

White spots on a photographic print as shown in this detail (left) are usually caused by dust on the negative surface when the print was made. To minimize the need for spotting, be sure to blow or brush off the negative before printing it; spots caused by dust embedded in the emulsion can sometimes be removed by gently rewashing the film in fresh water. If spots persist, you can eliminate them by carefully filling them in with spotting dyes (right). Apply dyes with a finely-pointed watercolor brush, as shown above.

David Graham Places of Learning, Orlando, Florida

Graham's work finds whimsy in human recreational activities; his prints' color scheme often has a synthetic quality that derives from their kitschy content. Color prints tend to need less spotting than black-and-white prints because the diffused light of a color enlarger minimizes both graininess and image defects. But if you need to fill in spots on a color print, you must match the surrounding area's color in addition to its tone. The best approach is avoid such problems by being fastidious with your darkroom technique, and thus to keep attention on the photograph's content. © David Graham

Spotting Color Prints The same basic steps apply whether you're spotting a black-and-white or color print. With color prints (and toned black-and-white prints), building up the density of unwanted marks with the correct shade of neutral black dye is sometimes enough to hide these defects if the spots are minor. However, with larger spots, a specific dye color is often needed for a critical match.

Color dyes come in sets of several colors that can be mixed to create different hues; special dyes are also available for spotting Ilfochrome prints. You match the color in the same way you match blacks and grays—with a white scrap of similar photographic paper and spots from the tip of the brush. Note that color dyes may change color when they dry, so wait a minute or two before evaluating the success of your spotting.

DRY MOUNTING

A good photograph looks even better when it's well displayed. This generally means **dry mounting** or placing it in a **mat** and possibly framing it. These finishing steps also provide good protection against nicks, scratches, tears, bending, crimping, and other possible damage to the print. They also help facilitate easier and safer handling, shipping, and transportation of prints. Visually, they isolate the image, creating a space between it and its environment for more focused viewing.

One way to display a print is to fasten it to a flat surface. A common and secure method of doing this is dry mounting, attaching a photograph to mat board using a thin sheet of heat-sensitive adhesive tissue as a glue. (Mounting with a wet spray adhesive is an option, but it's generally sloppier, less reliable, and less permanent than dry mounting.) The procedure is fairly easy, but it requires spe-

dry mounting Permanently adhering a print to the surface of mat board, using dry mount tissue, mat board, and a dry mount press.

mat Piece of presentation board for the finished display and protection of a print.

KEEPING NEGATIVES CLEAN

To lessen the tedium of spotting, take extra care to keep your negatives clean and free of defects. This isn't always easy; some environments are dirtier than others, and air quality is often a factor. Also, low humidity sometimes creates a static electricity charge that attracts dust to film. If you work in a group darkroom, you have additional problems. Fellow printers may be far less careful about how they treat your negatives than how they treat their own. For cleanest negatives, hang your processed film to air dry in the cleanest, most dust-free environment you can find.

As soon as your negatives are dry, place them in protective plastic sleeves (see page 241). If you place the entire roll on a counter to cut strips of images, first make sure the counter is clean and dry. Once the negatives are in sleeves, place the sleeves in a closed box or other enclosure to keep dust from getting in. Many photographers keep their negative sleeves in three-ring binders, which is a good way to organize them. But to keep them clean, put the binder in some type of enclosure, such as a plastic bag.

When you're ready to print, make sure the area around the enlarger and the film carrier are clean and dry. Handle negatives only by their edges. Blow off any accumulated dust or dirt from both sides of the negative with compressed (canned) air or a bulb blower; don't use your breath to blow on it as this might leave moisture. Be careful to keep the can of air upright. Don't touch the film with anything at this point. Also, expend a few blasts before applying air to the negative; the gas will sometimes leave a deposit of propellant, especially if the can has been shaken up or tilted when sprayed. For stubborn grit or water marks, you can use film-cleaning solutions and special film-cleaning cloths, but only as a last resort; any time you touch negatives you risk scratching them.

Enlarge the negative and examine your test print carefully. Hopefully, it will show few if any marks and defects. However, if it does contain a lot of spots, you should give the negative another blast of canned air; sometimes it takes more than one cleaning to dislodge dust from the film surface. If that doesn't do the job, take the negative out of the holder and clean it carefully with a camel's hair brush or, if necessary, film-cleaning solution and a cotton ball. If you do use a brush or cloth, make sure it's totally free of dirt or grime. Store brushes and cloths in plastic bags between uses to keep them clean.

cial equipment. The accompanying box explains what you'll need.

Instructions for Dry Mounting The following basic instructions for dry mounting prints assume that you have a dry-mount press (see page 361) available to you:

1. Make sure both the platen of the press and the cover sheet are clean and free of grit; if they aren't, they could cause bumps on the surface of the treated print.

2. Turn on the press; set it to 180–200 degrees if you're mounting resin-coated prints, and 225–250 degrees

EQUIPMENT FOR DRY MOUNTING

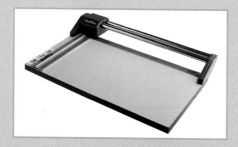

Dry-mount press. A **dry-mount press** is basically a large iron. It has two main sections hinged together—a base and a platen. The base holds the board and photograph; the platen is a flat, smooth piece of metal that heats up to press whatever is placed beneath it. Dry-mount presses come in various sizes to handle different size mat boards. Usually you'll have to use a dry-mount press at a school or other institutional darkroom, because they are fairly expensive and not needed all that often. You can also use a heated dry-mount press to flatten fiber-based black-and-white prints.

Dry-mount tissue. Dry-mount tissue is a thin sheet that turns to glue when heated. It's available from a few different manufacturers in various size sheets. Make sure you have a size at least as large as your largest print; you can always cut down large sheets to dry mount smaller prints.

Tacking iron. A **tacking iron** is a small iron with a round tip and a handle, which when heated is used to attach the dry-mount tissue to the mat board or the back of a print. You can use a standard clothes iron for tacking if you like, but make sure that it has no water in it. Also, be careful when tacking not to puncture the tissue or print; the tip of a clothes iron is sharp while the tip of a tacking iron is blunt and much safer to use.

Paper trimmer. A paper trimmer makes the job of cutting mat board to size and trimming the borders off prints easier. Make sure the blades are sharp and properly aligned; the cutting arm (or wheel, in some models of paper trimmers) may loosen up with use, which could make crooked cuts. There are board cutters more rugged than paper trimmers, made to cut through thicker sheets; you can use them for cutting paper, but you generally can't use paper trimmers for cutting board.

Sharp utility knife. You can also use a ruler (or straight edge) and cutting knife (such as an X-acto knife or a utility knife) to cut board and paper. This solution is simpler and less expensive, but you have to measure very carefully and hold down the ruler very securely.

Mat board. Mat board is often available in good camera stores, but the best places to buy it are art supply stores and mail-order catalogues. These sources offer more variety of boards than camera stores. Unlike mail-order suppliers, art supply stores allow you to see what you're buying. However, mail-order suppliers tend to cater more to photographic needs, and their stock may be unavailable in general art supply stores.

Cover sheet. A protective cover sheet can be thin, smooth mat board (usually one- or two-ply thick; see the box on the opposite page for a discussion of board thickness). Its purpose is to protect the surface of the print from the heated platen of the dry-mount press. The sheet should be as large or slightly larger than the platen. A heavier protective board (for example, four-ply board) should be used under the board on which the print is matted.

Cotton gloves. Lintless cotton gloves are useful for handling mat board (and photographs) to keep the surfaces clean and free of skin oils. These are available through most camera stores, mail-order suppliers, and, even drugstores. A kneaded eraser may be used to clean off soiled mat board. Rub gently.

dry-mount press
Device for dry mounting prints. It consists of a base and hinged top, which contains a smooth, heated platen. A dry-mount press also can be used for flattening prints until they are ready to be mounted.

tacking iron Small iron with rounded tip, mounted on a handle, used to adhere dry-mount tissue to mat board and print.

MATTING CONSIDERATIONS

There are many different types of mat boards available. Some of the considerations when making your choice are size, weight (thickness), color, surface, quality, and archival characteristics.

Board comes in a wide variety of sizes, generally from 8" x 10" and larger. Most boards come in large sizes, such as 22" x 30" or 32" x 40", which you'll usually have to cut down for use. Cutting large board accurately takes care, plenty of working space, and the right equipment. Most art supply stores and mail-order sources will cut mat board to custom sizes for a small charge; some of them will precut board, and also stock a supply of standard smaller sizes.

With this in mind, it's often best to plan for a standard mat and framing size when possible. It's easier and less expensive to find board and frames (and storage boxes if needed) in standard sizes than to try to customize for each print. The box on page 364 has a list of recommended board sizes for different image sizes.

Mat board is available in various thickness or weights, often (but not always) rated in **ply.** More ply means a heavier (and usually more expensive) board. Photographs are usually mounted on two- or four-ply board. For example, you might use four-ply board when dry mounting, and two-ply or four-ply board for backing (four-ply is sturdier but also heavier and more expensive) and four-ply board for the window mat, when overmatting. Four-ply board will give you a thicker, more effective "bevel," which is a cut sliced at an angle. Thinner board is more difficult to handle and more easily damaged since it's not very rigid.

Thicker board is more costly and may be awkward to store or heavy to transport.

Photographs are usually displayed on white, gray, or black mat board, though sometimes color photographs are displayed on a colored board. This is a matter of taste, but the board should generally spotlight the photograph and not distract from it. For that reason, white board is most commonly used. However, there are many shades of white—from a bright neutral white to a warm cream. Consider the more neutral white for untoned black-and-white photographs and a warmer white for brown-toned monochromatic and color photographs and warm-tone prints. When in doubt, choose neutral tones since overly warm mat bard can be distracting. Also, the surface of some mat boards has a smooth finish, while others are rough and textured. Photographs are usually displayed on boards that are matte in surface, with little or no texture.

The overall quality of mat boards varies widely. Poor quality (and generally less expensive) boards are more likely to discolor and disintegrate over time, possibly causing long term damage to the print. Good quality (and more expensive) boards are more stable. Some of the best boards for photographs are **100% rag** (all cotton) and/or **acid-free** (made of high alkaline, non-acidic materials).

Rag and/or acid-free boards provide the most stable and permanent support for photographs and are recommended for critical archival use (see pages 371–373). Some non-acidic mat boards are buffered with alkaline chemicals; use **buffered boards** for mounting and matting black-and-white prints and nonbuffered boards for color prints.

ply Thickness of a piece of mat board, for example 2-ply (thinner) or 4-ply (thicker).

100% rag Refers to mat board constructed entirely from cotton fiber.

acid-free Refers to presentation and storage materials that do not contain acids that can be harmful to a photographic image.

buffered boards Mat board made with alkaline chemicals that reduce its acidity to prevent or minimize damage to a black-and-white print.

for fiber-based prints. Resin-coated prints can melt if the temperature gets too hot.

3. Turn on the tacking iron by plugging it in. Set the heat to a low- to mid-range setting.

4. While you wait for the press and iron to heat up, prepare for mounting by cleaning off a counter or table and placing the untrimmed print on it, face down. Place a sheet of dry-

mount tissue (at least a little bigger than the image) on the back of the photograph. Wipe off the back of the print, as you did with the platen of the press to remove any grit that could create bumps or dents when the print is pressed.

5. Gently press the tip of the heated iron to the middle of the dry-mount tissue and the back of the photograph, and drag the tip for a couple

of inches. The tissue should turn to glue when heated and attach itself to the photograph. (You may have to drag the tip of the iron two or three times for a good attachment.)

6. Carefully cut off the white borders of the photograph, using a paper trimmer or ruler and cutting knife. Now the photograph and the tissue are the same size. Make sure you cut so the corners of the image are

SUGGESTED IMAGE AND MAT SIZES

You can make your mats almost any size you choose. The usual rule of thumb is to make them about 6 inches longer in each dimension than the image size (not the printing paper size). Smaller than that usually makes the print look a bit cramped; larger may leave the print looking dwarfed.

The size of the board needed for a print is basically a matter of taste, but it depends in large part on the size of the photograph you're planning to mount or mat (and in some cases the size of an existing frame you're trying to fit). There are no set rules, but generally you'll want to leave at least a 2½" or 3" mat border around most photographs. A typical guideline is to position the print in the center of the board with the bottom margin slightly larger than the top margin and the two side margins equal in size. Thus, if you have 3" on each side, 2½" on top, and 3½" on the bottom, you'll need a 12" x 15" mat board for a 6" x 9" (image size) print, a 14" x 18" board for an 8" x 12" print, and so forth. If you buy mat board in standard sizes, such as 11" x 14" and 16" x 20", you'll have to cut these down or accept somewhat smaller or larger borders.

The image sizes that follow are also suggestions only. Different film formats and cropping solutions will naturally change the suggested and standard mat sizes; just add 6" to each dimension of the actual image and use that measurement as a guide for picking the closest standard size. Use your best judgment based on the particular image.

You may want to use precut mats (or frames), which come in standard sizes. However, standard sizes of both vary with the supplier. These sizes are common: 8" x 10", 8½" x 11", 11" x 14", 12" x 16", 14" x 17", 16" x 20", 18" x 24", 20" x 24", 24" x 30", 26" x 32", and 32" x 40". Some suppliers offer more variety in standard sizing; you may, for example, be able to find precut mat board in some of the following suggested mat sizes.

Paper Size	Image Size	Suggested Mat Size*	Commercial Mat Size**
8" x 10"	5" x 8"	11" x 14"	11" x 14"
8" x 10"	6" x 9"	12" x 15"	11" x 14" or 12" x 16"
8" x 10"	7" x 9"	13" x 15"	11" x 14" or 16" x 20"
8" x 10"	7" x 7"	13" x 13" or 13" x 15"	11" x 14" or 16" x 20"
11" x 14"	9" x 13½"	15" x 19½"	16" x 20"
11" x 14"	10" x 13"	16" x 19"	16" x 20"
11" x 14"	10" x 10"	16" x 16" or 16" x 20"	16" x 20"
16" x 20"	12" x 18"	18" x 24"	18" x 24" or 20" x 24"
16" x 20"	15" x 19"	21" x 25"	22" x 28"
16" x 20"	15" x 15"	21" x 21" or 21" x 25"	22" x 28"
20" x 24"	15" x 22½"	21" x 29½"	20" x 30" or 22" x 28"
20" x 24"	19" x 23"	25" x 29"	24" x 30"
20" x 24"	19" x 19"	25" x 25" or 25" x 28"	24" x 30"

*Image size plus 6" or so on each dimension.

**Commonly available sizes; you may have to choose a larger commercial size and trim it to suit your image.

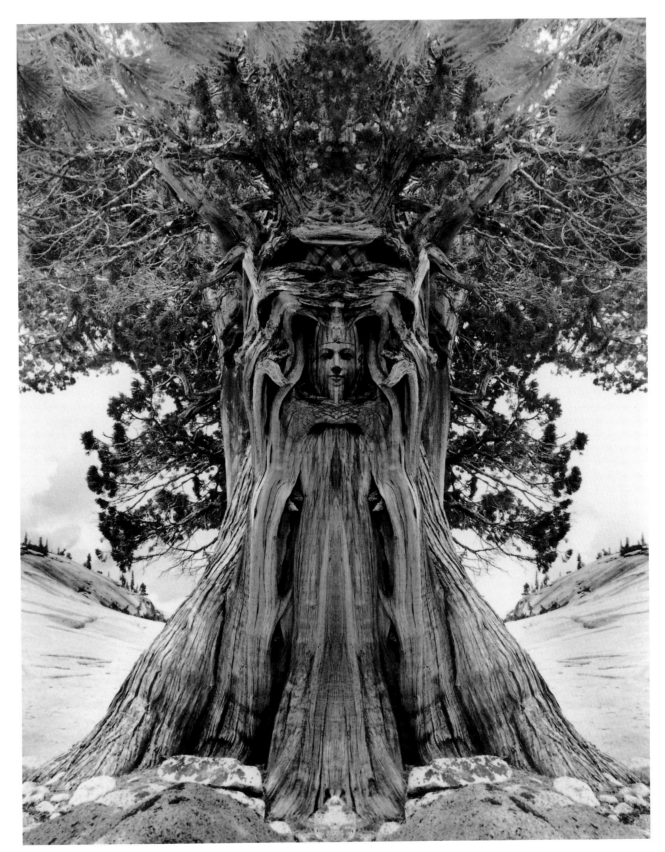

Jerry N. Uelsmann
Untitled, Yosemite, 1994
The printing technique known as montage—the creation of a single photographic image from two or more separate negatives—was once a means of overcoming the limitations of light-sensitive materials. Uelsmann brings a modern vision to the technique, using it instead to overcome the limitations of physical and optical reality. Setting up several enlargers in sequence, he carefully manipulates the print with dodging, burning, masking, and other darkroom methods, to create surreal scenes that seamlessly blend elements from different negatives. Despite this complicated technique, the final result is a discreet image, its presentation no less important than with straight prints. Jerry N. Uelsmann, Inc.

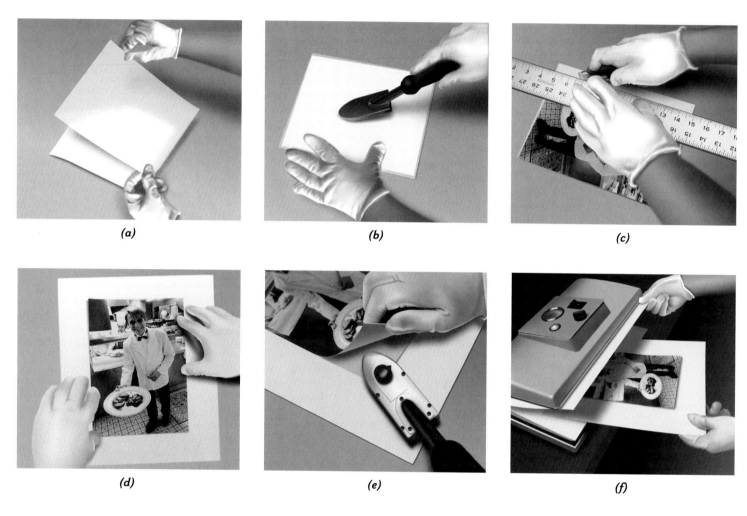

(a)

(b)

(c)

(d)

(e)

(f)

(g)

Follow these steps to dry mount a photographic print: First, place the print upside-down, untrimmed, on a clean surface. (Wear white cotton gloves to prevent smudges or fingerprints on the print surface or mat board.) Then position a sheet of dry-mount tissue so that it covers at least the entire back of the print (a). Touch the tip of a preheated tacking iron to the middle of the tissue and drag it an inch or two, to secure the tissue to the print (b). Turn the print over and carefully trim off its white borders together with the underlying tissue (c). You can use a straightedge and utility knife, as shown here, or a paper cutter. Position the print, with attached tissue underneath, on the mounting board (d). When the print is in place, rest a weight on it to keep it from shifting, carefully lift one corner, and tack the dry-mount tissue to the board (e). Repeat this step for the opposite corner. Then place the print face-up in a preheated dry-mount press with a piece of smooth, heavy board beneath it and a clean protective sheet on top (f). Clamp the press down and heat the board from 30 to 60 seconds (g), then remove the mounted print.

square. When using a trimmer, place the print squared up against the guide rule before making the cut. When using a ruler and cutting knife, follow the edges of the image area carefully, assuming they are square.

7. Place the print (with tissue attached) face up on the mat board, and measure the borders until you get the desired positioning.

8. When the print is in the desired position, put a weight (such as a paperweight, a book, or a small, dry drinking glass) on top of it to keep it there. Before placing the weight, cover the surface of the print (perhaps with a clean piece of paper) to avoid marring the surface.

9. Lift one corner of the print and heat that corner's dry-mount tissue against the board with the tacking iron; light pressure should be enough to attach the tissue to the board. Be very careful to maintain the position of the print on the board while you tack the corner of the tissue. Lay down the corner of the print and remeasure the borders to make sure nothing moved in the process; if it did, strip the tissue from the board and repeat steps 7 through 9 until you get it right.

10. Tack the opposite corner of the dry-mount tissue in the same manner as in step 9. Remeasure and make sure the print is still in the desired position on the board.

11. Place the board and loosely attached print in the dry-mount press face up, with the protective sheet covering the surface of the print and board and a clean piece of four-ply or other heavy board underneath. Clamp down the press

and heat the board for at least 30 seconds to one minute—long enough for the print to be completely fixed to the board.

12. Open the press and remove the board. Immediately place it face down under a flat, heavy object (such as a large book) until it cools off. Make sure you protect the surface of the print with a clean sheet of smooth paper or board before you place anything on it (place it face down on a clean sheet and put the heavy object on top). Also, for best flattening make sure the heavy object completely covers the image area or (better still) the mat board.

13. When the board has cooled off, remove the heavy object and test the print's adhesion by gently bending the board back and forth. In particular, check the edges and corners of the print to make sure they remain firmly in place on the board.

Sometimes mat board and even dry photographs contain enough residual moisture to prevent them from fully adhering to each other. If you find this to be a problem, try preheating both board and print separately in the dry-mount press for about one minute. Make sure the protective sheet is covering the platen of the press at all times.

Heating a fiber-based print in a dry-mount press also helps flatten it. Put a print (one at a time) in a press heated to 225–250 degrees (with the protective cover sheets on top of and beneath the print in place) for one or two minutes. Take the print out of the press and immediately place it under a flat, heavy object (such as a large book) until it cools off, protecting the print surface as in step 12.

Flush Mounting Most dry-mounted photographs are attached to a board that is larger than the print, but some are **flush mounted**—mounted with no border. The procedure is the same as when dry mounting with a border, except that you don't have to be as careful when positioning the print on the board. Simply attach the dry-mount tissue, as in steps 4 and 5, and lay the print and tissue anywhere on the mat board. Tack the two opposite corners down, as in steps 9 and 10 (don't worry about measuring and remeasuring).

Then, attach the print and board by placing them in the dry-mount press (steps 11–13). When the board cools off, cut off the borders of the print and the underlying board with a ruler and cutting knife or a board cutter. As in step 6, make sure you cut so the corners of the image are square. When using a ruler and cutting knife, follow the edges of the image area carefully, assuming they are square. When using a cutter, position the print so it's squared up against the guide rule before making the cut.

OVERMATTING

The technique of **overmatting** uses two pieces of mat board—one underneath to support the photograph and the other on top with a window cut out to display it. Sometimes you dry mount the photograph directly to the supporting board, but more often you attach it by the top edge with tape or on all four corners with mounting corners.

Overmatting is generally the preferred display method of museums and galleries of fine photography—both for the way it looks and for the way it protects. Materials inherent in the dry-mounting tissue and even in the mat board may in time contaminate the photograph and cause

flush mounted Dry mounting a print without borders, to the edges of a piece of mat board.

overmatting Mounting a photograph between two piece of mat board, with a window cut out in the top board to display the print.

TOOLS AND MATERIALS FOR OVERMATTING

Overmatting is a little more involved than dry mounting. The two presentation techniques have some tools in common, but overmatting requires items and materials with slightly different properties. The following are useful or necessary for overmatting:

Mat board. You'll need two pieces of mat board to overmat: One for a support and one for a window. Photographs are usually displayed with white matboard, but any color can be used (see page 363).

Mat cutter. A mat cutter holds a blade and is shaped for your hand. (In schools or other institutional settings you may also have access to professional mat-cutting systems that are sophisticated tools used mostly by framing shops.) A mat cutter allows you to make clean cuts using a pushing or pulling motion. It also allows you to

adjust the position of the blade so you can make a beveled (angled) cut. You must set the depth of the blade, however, to expose a little more than the thickness of the overmat board. If too little of the blade is exposed, it won't cut completely through the board; if too much is exposed, it may bend and leave an uneven cut.

Pencil. A sharpened pencil is used for marking the back of the overmat when measuring the window for cutting.

T-square. A T-square—a ruler with a straight-edge attached at 90° to one end—can also help you make even and square markings on the back of the overmat for tracing the window.

Burnishing tool. An emery board or other burnishing tool is useful for smoothing out rough cuts and window corners.

Mat scribe. A mat scribe, an optional but useful device, is a tool for quickly measuring and tracing that provides a way of quickly drawing the perimeter of the window you will cut. The scribe holds a pencil and grabs on to the outside edge of a piece of board. You set the border dimension and attach one end of the scribe to an edge of the board. As you glide the scribe along that edge, the pencil traces one side of the desired window opening.

Linen tape. Available from art supply stores and mail-order suppliers, linen tape is recommended for attaching the corners of photographs to supporting mat board and also for hinging the supporting board and overmat. If you use other types of tape, such as masking tape, they may eventually stain and damage board and photograph. Linen is safest for long-term image permanence (see pages 371–373).

Mounting corners. A simple way to attach photographs to the supporting board is with mounting corners. You can buy pre-made plastic or paper corners (some of which are self-adhesive) or you can make your own.

Scissors. A pair of scissors is useful for a number of tasks, such as cutting tape or even making your own corners.

damage. Overmatting requires no direct adhesion of photograph to board—allowing you to salvage the photograph even if the supporting board is damaged—and places no potentially damaging material in between the two. It also holds the print between two protective layers of mat board, thus guarding against damage to the front and back of the print.

General Instructions for Overmatting Following are basic instructions for overmatting photographs:

1. Measure the image size of your print and determine the desired mat size (see box on page 364 for guidance). For example, let's say the image size is 5" x 8" and you want an 11" x 14" mat.

2. Cut two pieces of mat board to that size—or buy that size precut. The supporting mat should be either two-ply or four-ply—perhaps the former if you're also framing the print or the latter (for more support) if you're not.

3. Place the overmat board face down on a clean, flat surface.

4. Measure the window size and placement on the back of the overmat; trace the window by marking out the borders with a pencil. There are several ways to do this to ensure evenness and square corners. You can measure out the required window opening by simple math; if you have a 5" x 8" print and an 11" x 14" board, you'll need 3" borders on each side. It is often visually preferable to make the bottom of the mat slightly larger than the top. For example, measure a board to be 3" larger on each side of the image, but cut the mat so that the top is 2¾" and

the bottom 3¼". Measure and mark out these dimensions on the back of the board; making several measurements on each side helps increase accuracy, or you can use a T-square.

You also can use a mat scribe to mark out the border of the window dimensions. You must set the scribe for the width of the border: 3", 2¾", whatever.

As a precaution, you may want to make the window slightly smaller than the print by about ⅛" on all sides. For example, if the image size is 5" x 8", make the window dimensions 4⅞" x 7⅞" in case the measurements are slightly off, the photograph slips a little when attached to the supporting board, or to hide the edges of the print. Some photographers prefer to have the image "float" in the window. This means showing the edge and a border around the image; usually the border is thin, in which case make the window dimensions ⅛" or so larger than the image size on all sides. Floating serves two purposes; some like the "look" of a thin, white paper border; it also allows you to display the image without cropping it with the overmat.

5. Place the ruler flat along one of the marked borders and hold it down tightly to prevent slippage. Make your cut slowly and steadily with a mat cutter (starting close and pushing the cutter away from you). Start the cut inside the corner of the window, or just before. Never allow the blade to go past the corner of the marked window.

Cutting a mat cleanly takes practice. Make a few cuts on scrap board

before proceeding. Once the window is traced out accurately, the keys to a successful overmat are keeping the ruler (and blade) from slipping and not extending the cut past the corners. Moreover, keep constant pressure on the cutter as you approach the corner; if you ease up or press harder, your cut may curve off. The goal is to have clean corners, straight cuts, and a consistent bevel (angle).

6. Cut all four sides of the window in the same manner, and gently punch out the cut board to open the window. Take care not to tear the edge of the bevel when removing the cutout. You may have to to gently shave rough corners for a clean finish.

7. Use a burnishing tool to smooth rough edges or unsquared corners of the window.

8. Place the backing board face up. Then, butt the top of the overmat, face down, against the top of the backing board. Connect them with a long piece of linen tape. To prevent slippage, allow the linen tape to dry before moving on.

9. Lay the photograph on the support board and close the overmat so it rests on the photograph (and the support board).

10. Lift the overmat and adjust the position of the photograph so it shows through the cut window, with the window positioned to hide the edges of the image or to allow the image to float (with a border showing through).

11. Place a weight (perhaps a paperweight, a book, or a small, dry drinking glass) on top of the photograph

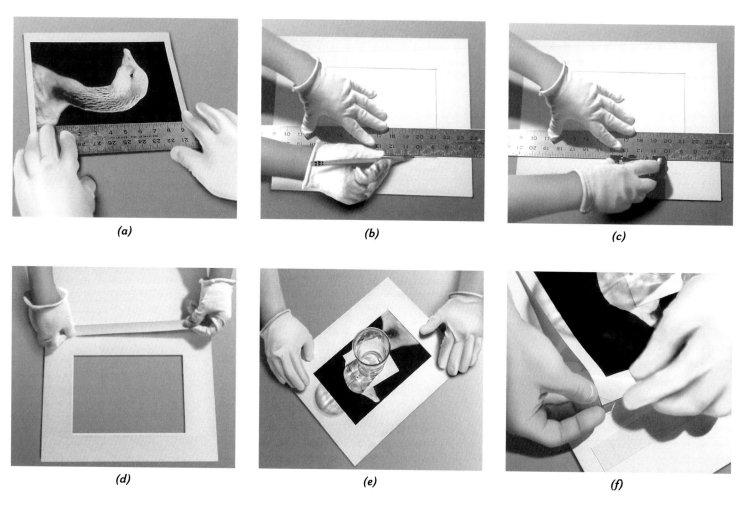

(a) (b) (c)

(d) (e) (f)

(g)

Follow these steps to overmat a print: First, measure the size of your image (a) and, once you've deter-mined the width of your borders, cut two pieces of board to the desired outside dimensions of the mat. Pencil in the needed window size on the back of the overmat (b); make it slightly smaller than the image if you don't want any paper border visible. Using a mat cutter, carefully cut out the window (c), making sure the blade passes through the entire thickness of the board and taking care not to overex-tend the cut at the corners. Use linen tape to hinge the back of the overmat to the front of the back board along the top edge (d). Once the tape is dry, fold the mat closed. Then, lifting the top of the mat, place the print inside so that the image is positioned correctly within the window. When the print is in place, use a weight to keep it in position (e). Attach the print to the back board with mounting corners or linen tape (f). Then close the mat to verify that the image is properly positioned in the window (g).

so it won't move; first cover the surface of the print (perhaps with a clean piece of paper) so the weight doesn't mar the print surface.

12. Lift the overmat and attach the photograph (taking care not to move it out of position) to the support board with four mounting corners; you can use commercial self-adhesive corners or handmade paper corners. You'll need to place a small strip of linen tape diagonally over handmade corners to attach them to the board. You may want to secure opposite corners of the print first to make sure it stays in position. Check after securing the first two corners to make sure the print has not moved.

13. Close the overmat.

IMAGE PERMANENCE

It is possible for photographs to last without significant deterioration for a very long time. In fact, many of the earliest photographs ever made survive virtually unscathed. But it's also possible for photographs to fade, stain, or otherwise deteriorate within a very short time—a few years or even less.

With some photographs it doesn't really matter if they last or not. But in many other cases it's very important to ensure long life—for example, when photographs are meant to be collected as art or used as historical documentation. You should even take steps to preserve simple snapshots, since these provide an irreplaceable visual record of friends and family.

You don't always have to go to great lengths to ensure that your photographs will last. Sometimes it's simply a matter of common sense. For example, if you

Improper storage materials and conditions can cause processed photographic film and paper to fade, stain, and shift in tone and color over time. This old color print's cyan and yellow dyes have faded more than the magenta dye, giving it a strong pinkish cast. Color materials (both negatives and prints) are especially vulnerable because their dyes are inherently less stable than the silver that forms a black-and-white image. But black-and-white prints that are poorly processed and stored are also subject to deterioration. To prolong the life of photographic negatives, transparencies, and prints, you must process, present, and store them properly.

leave negatives, transparencies, or prints lying around untended they can easily suffer physical damage. Store them safely away in a box, album, or other enclosure. However, simply being careful when putting materials away is no guarantee of long-term image permanence. There are many other factors to consider, such as the inherent stability of the materials.

Important prints and negatives should be stored in archival containers such as these reinforced boxes. Also known as acid-free, archival materials contain no chemicals that could harm the photographic emulsion over time; for example, these boxes are constructed with metal brackets rather than damaging glues. For individual works, you can purchase archival paper or plastic sleeves to provide an extra layer of protection; avoid storage materials such as cardboard, wood, and glassine, which can release substances injurious to photographic emulsions. Keep in mind, though, that such measures may not help if an image is improperly processed or inherently unstable.

Some films and papers are by their nature more stable than others. Surprisingly, many of the oldest photographic processes are the most stable. With modern, commercially-made materials, specifics vary depending on the brand, but properly processed black-and-white materials are more stable than color. There are a number of reasons for this. With very few exceptions, black-and-white films and papers use metallic silver to create their final image, whereas color films and papers use dyes, which are inherently less permanent.

The film and paper base are also important factors in image permanence. In particular, fiber-based papers are considered more stable than RC papers because the plastic resin is more likely to physically deteriorate over time.

Methods of processing also are important. For maximum image permanence, you should use fresh, uncontaminated chemicals at the suggested processing temperatures and times. In particular, be sure the fixer solution is fresh and properly used; don't underfix or overfix. Many fussy black-and-white printers use a two-bath fixer (see page 290) to guarantee a thorough and fresh fix and a fixer-check solution to monitor that freshness. A fresh bleach is also critical when processing color materials.

The wash step is also important for ensuring image permanence. Wash all films and papers thoroughly, using a fixer remover for black-and-white films and fiber-based papers. Archival film and print washers are highly recommended for maximum efficiency. The term **archival** is widely used when referring to materials and processes that ensure print permanence. (See pages 305, 308 for details on good washing techniques.)

Other factors affecting image permanence relate to the way processed films and papers are stored. To some degree this depends on the type and brand of film and paper you use. However, the following conditions are generally to be avoided: strong light, high temperature, high humidity, and storage containers made of materials not intended for long-term storage of photographs.

Light The stronger the light source, the more likely it is to cause fading and other image deterioration. This is especially true of sunlight and other sources with a high ultraviolet content. For maximum protection, keep processed negatives and transparencies in boxes or other containers that totally protect them from light. Also, don't project transparencies for any longer than necessary; light from a slide projector is extremely strong and damaging. In fact, it's much better to avoid projecting originals altogether. Make duplicates for projection and store the originals safely away.

Keep prints away from light as well—in boxes or other storage containers or under reduced light if displayed. Don't hang framed prints opposite windows or any other source of direct light. This is especially important with color prints, which are generally more likely to fade than black-and-white prints. There is special UV-protecting Plexiglas available, if you must display photographic prints in bright light. This Plexiglas protects the print from ultraviolet, the most damaging portion of the light spectrum.

Temperature Ideally, you should store all negatives, transparencies, and prints in cool conditions—below room temperature. Some photographers even go to the trouble of refrigerating and in some cases freezing their processed films and prints (though this requires special packaging to avoid physical damage).

When possible, most museums and archives store their valuable materials in temperature (and humidity) controlled environments. While this is a practical impossibility for most individual photographers, you can get by using common sense. Storage in room temperature is usually acceptable (unless you live in

archival Term describing a processing step or display material that enhances the long-term stability of photographic films and prints.

tropical conditions). Avoid storage in a place that might experience wide temperature fluctuations, such as an attic or basement.

Humidity Excessive humidity can cause fading, staining, and even physical damage to the image; dry conditions can cause cracking and peeling. Museums and archives usually store photographic materials at a relative humidity between 25–50 percent. Individuals should avoid damp areas, such as basements and bathrooms, for storage. Wide fluctuations in humidity

can also cause physical damage to photographic materials. Try to keep conditions stable and consistent.

Storage containers Store processed film and prints in mats, envelopes, boxes, and/or other enclosures to protect them from physical damage. But be careful. Some storage containers are made of materials that may react with and even damage their contents. Most camera stores and other suppliers carry "safe" containers, but check to be sure they meet archival guidelines.

Store negatives and transparencies in sleeves and envelopes made of acid-free paper or chemically inert plastic. The following types of plastic are safest: polyester, polypropylene, and polyethylene. Avoid enclosures made of polyvinyl chloride (PVC) and glassine.

Prints should be stored in similar plastic enclosures or boxes or other containers (or with mats) having a low or preferably no acidic content. Avoid containers coated with or made of oil-based paint, tacky adhesives, cardboard, styrofoam, wood, and rubber cement.

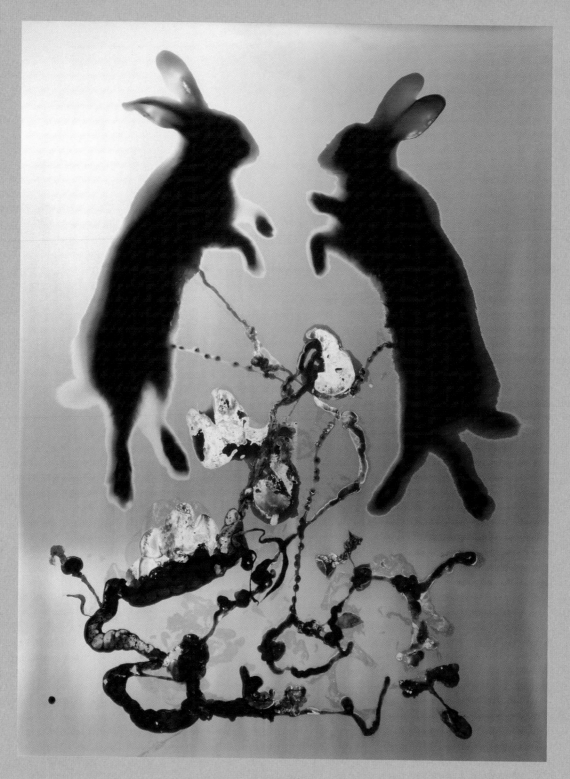

ADAM FUSS
Love, 1992

Though modern materials and digital technology have created new frontiers for experimental imagery, contemporary photographers continue to break ground with some of the medium's oldest techniques. First used by calotype inventor Fox Talbot and later revived by surrealist Man Ray, the photogram is a cameraless image made by placing objects in contact with photographic paper. Fuss uses the technique to create large-scale color reversal prints rather than the usual small-scale black-and-white prints. This not only causes the objects to be reproduced as positive (dark) rather than negative (light) shapes, but allows the use of filters to control color. Fuss often takes his images another step away from custom by using moving light sources and organic subjects, which sometimes react chemically with the paper where they rest against it. Cheim and Read Gallery, N.Y.

Creating a photographic print does not always require the use of conventional black-and-white or color techniques. There are a number of ways to manipulate black-and-white and, to a lesser degree, color prints. There are also special processes for creating prints with older, non-silver materials, Polaroid films, and other specialized materials. Some of these don't even require a darkroom. All are reasonably easy to try and simple enough for you to become proficient with them after some experimentation.

The main reason to experiment with these techniques is to achieve a different "look" for your work. They allow you to depart—radically, if you wish—from a literal representation of a subject, changing the image's tonal character, adding or subtracting color at will, or even destroying and recreating the original image.

DARKROOM MANIPULATIONS

Following are basic instructions for several special darkroom techniques. Note that these techniques are not suitable for all your photographs. It's best to experiment and to be patient. Be prepared for some pleasant surprises.

Photograms Some of the very earliest photographs were actually **photograms**—images made without a camera. The most common way to make a photogram is to place one or more objects directly onto photographic paper and expose it to light. When the paper is developed, the objects produce shapes of various densities against a dark background. You can use any type of sensitized material to make a photogram, including film or photographic paper (black-and-white or color) or non-silver

emulsions(see pages 380–381). You can even use a scanner to make a digital photogram (see pages 407–410).

The basic technique is simple, and easy to accomplish with standard materials. Follow these steps to make photograms with black-and-white paper in your darkroom.

1. With the negative carrier in the enlarger, raise the enlarger head high enough to project an area of light that generously covers the size of the paper you intend to use. There is no need to focus, as the carrier contains no negative. (Avoid increasing the size of the illuminated area by adjusting the lens, since this may cause dust in the enlarger's condenser to be visible in the print.)

2. Set the lens at f/11. This setting may change based on your initial results.

3. Turn on the safelight and turn off the room lights. Place a strip of printing paper on the enlarger's baseboard. (You can use an easel to hold it flat.)

4. Make a test strip, exposing the paper to light in three-second increments. You can filter the light, or use a higher paper grade, for increased image contrast.

5. Process the paper and examine the results.

6. Find the first band that produces a maximum black tone. If the nine-second and twelve-second exposures both produce maximum black, your starting exposure for the photogram is nine seconds. You may have to adjust this time to produce the gray tones you want.

7. Position a full sheet of paper under the enlarger. Then place one or more objects on the paper and expose for nine seconds (the determined time).

8. Process the paper and examine the results. Adjust exposure and positioning of objects to better achieve the desired results. More exposure may cause light to creep under objects, for example, creating an increased sense of dimensionality.

In the developed photogram, totally opaque objects create blank white shapes and translucent objects show a

Photograms are exposed with unfocused light, so you can even make them with a low-wattage household bulb as a light source. It's easier to use an enlarger, though, because you can control the exposure by adjusting both the time and the lens aperture. At its simplest, the technique involves placing objects in direct contact with the printing paper, as shown here. But you can control the sharpness, shape, and shading of the objects by suspending them above the paper, or by changing the angle of the light (for example, making the exposure with a flashlight or other movable source).

photograms Film or print images created in the darkroom without a camera, usually by placing real objects in contact with photo paper (or film) and exposing it to light.

375

range of tones, depending on their shape and how much light they transmit. You also can experiment with moving objects in and out of the path of light during exposure or collaging three-dimensional objects with flat items containing images that "print" onto the paper (for example, negatives or magazine pages). Angling the light source from the side of an object can create a three-dimensional effect.

Note that with color materials, the basic process for making a photogram is the same. However, the filter pack and the color of the objects you choose naturally become critical factors in the appearance of the final print.

Negative Prints There are many ways to make **negative prints.** Probably the easiest way is by contact, placing a positive print and against an unexposed sheet of photographic paper, then putting a clean sheet of glass over them and exposing the unexposed sheet to light the way you would a contact print. Although a print is not as translucent as a film negative, it allows enough light to pass through to make a good exposure on the paper, assuming you use a long exposure time and/or a wide aperture on your enlarger lens. When developed, the exposed paper will yield a negative print—the opposite of the positive to which it was exposed.

An RC print works better for the positive than a fiber-based print. It is faster to expose and process, and it stays flatter for more even contact and thus better overall sharpness in the negative-print image. It also may create a less pronounced texture than fiber-based papers, because RC papers contain less actual paper fiber in their base. Note that some paper types have the manufacturer's name or logo printed on the back; such printing will likely show up on the final print, which makes them unsuitable for this type of negative printing. You can use either resin-coated or fiber-based paper to make the final negative print.

You can make negative prints any size you want. But since this is a contact print process, the final negative image is only as large as the positive print you start with. Follow these instructions:

1. Make a standard positive print from a film negative. If you want the negative print to "read" in the same orientation as the original image, and not be reversed from side to side, you'll need to "flop" the image by placing

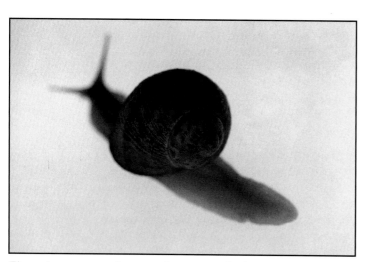
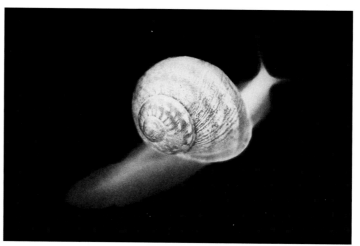

The easiest way to make a negative print—a final image in which the subject's normal tones and/or colors are reversed—is to start with a positive print (left). Simply contact-print the positive print, positioning it face-down against another piece of printing paper under a sheet of heavy glass (right). Because the print's paper base doesn't transmit as much light as a negative, you need a bright light source to achieve adequate exposure; with an enlarger, you'll probably have to set the lens wide open. Best results are usually obtained from a positive print made on RC paper because it lies flatter and contains less texture-producing paper fiber.

the film negative emulsion side up (instead of the usual emulsion side down) in the negative carrier. Wash and dry the positive print.

2. Raise the enlarger head high so it projects a large enough area of light on the enlarger's baseboard to cover the size of the paper you intend to use.

3. Open the lens to its widest aperture setting.

4. Place a fresh sheet of unexposed paper emulsion side up on the baseboard of the enlarger. (You can use an easel or another smooth surface if the baseboard is too rough or uneven for good contact.) Place the positive print face down on top of the paper, just as you would position a negative for a contact print.

5. Place a clean sheet of plate glass over the two pieces of paper to hold both flat against each other.

6. Expose the paper. To determine exposure time, make a test stirp (see pages 295–299) with exposures in five-second increments.

7. Process the paper and examine the results.

8. Determine which exposure time looks best. If the entire image appears too dark, make another test with the lens closed down one stop or with increments reduced to three seconds; if it's too light, try eight-second increments. You may also adjust contrast as you see fit; use a high-contrast filter with variable-contrast paper to increase contrast and a low-contrast filter to decrease contrast (or use a high- or low-contrast graded paper).

9. Expose a fresh sheet of paper for the correct time.

10. Process and examine the print.

11. Fine-tune the results by adjusting exposure and contrast. Burn and dodge as necessary.

Another way to make negative prints is to print directly from a positive film image—either an original color or black-and-white transparency or a **film interpositive** made from a negative. You can either enlarge or contact print the original or the interpositive onto printing paper, essentially following the same steps as above.

Sandwiching Negatives You can combine two (or more) negatives in your enlarger to create a composite image on one sheet of paper. You do this by **sandwiching negatives** together in your negative carrier—one on top of the other. Then insert the carrier into the enlarger and make a print as you would with a single negative. In areas where one negative is dense, it will hold back detail from the other negative; where one negative is thin, detail from the other will pass through. The result is a single print comprising a mixture of elements from each negative.

Sandwiching two negatives together creates a greater than usual amount of density, which can lead to long exposure times and reduced contrast in particular areas of the final image. Printing more than two negatives can compound these effects significantly. Here are some tips for best results when sandwiching negatives:

■ Simple images, for example a close portrait and a cloud-filled sky or textured landscape, often provide the best results. If the original images are highly detailed, the results may appear

Sandwiching negatives is a simple way to combine separate images for an abstract, montage-like effect. To do it, place two or more negatives together in the enlarger's negative carrier, then make the print as you normally would. (Keep in mind that the extra density this creates usually necessitates longer print exposure times.) If you use existing negatives, choose at least one simple, uncluttered image so the result won't be overly complicated. If you shoot negatives specifically for sandwiching, plan your compositions to control the way they interact visually, and consider reducing exposure in the camera to keep print exposure times manageable.

too busy, so many photographers prefer one simple image sandwiched with a more complex image.

■ Usually it's best to sandwich negatives that have somewhat less density than you'd want in a normal negative. Two light (thin) negatives might approximate the density of a single negative. If you're photographing for the sole purpose of sandwiching the results, you might underexpose slightly for each image—for example, set an f-stop between f/8 and f/11 when your meter calls for f/8.

Sabattier Effect (or Solarization) The **Sabattier effect** involves reexposing paper or film to plain white light

film interpositive Positive film-based image, usually used as an intermediate step for purposes such as making a negative print.

sandwiching negatives Printing technique in which two or more negatives are positioned one on top of the other and exposed onto paper.

Sabattier effect Result of exposing film or paper to white light while the image is developing.

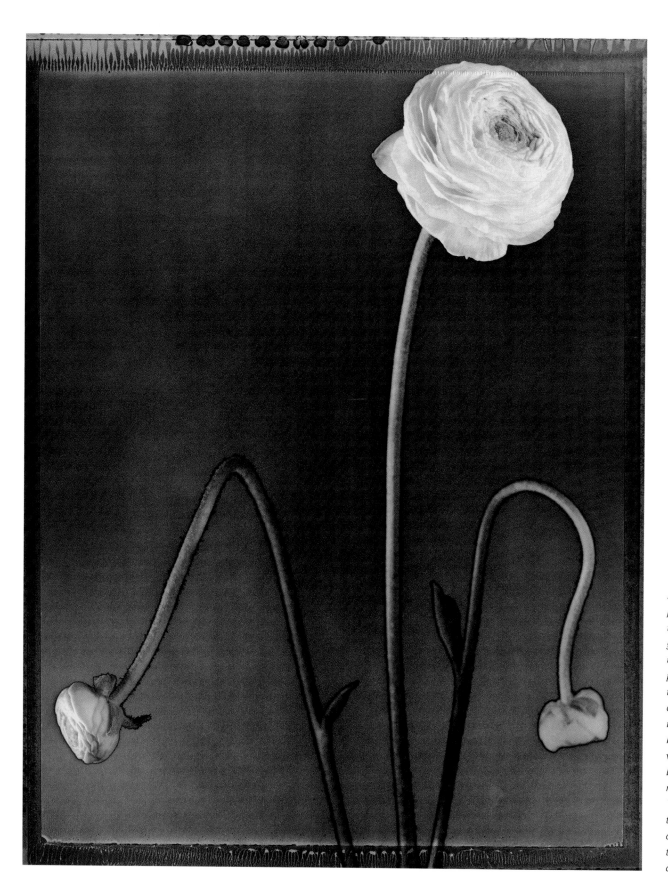

Tom Baril
Ranunculus, 1996
Formerly a printer for fine-art photographer Robert Mapple-thorpe, Baril achieves a rich, elegant look through the thoughtful use of special techniques such as pinhole photography, solarization, and a unique combination of print toning and staining. This image is from a 4" x 5" Polaroid Positive/Negative black-and-white instant-film negative that Baril solarized, then printed normally on a very warm-toned "portrait" paper. The print was then selenium-toned, washed, and soaked in a final bath of tea to add color to the paper base and image highlights. © Tom Baril

during development. The results are unpredictable, but when it works well the technique produces a partially reversed image—something that looks like a cross between a negative and a positive. The overall effect is often eerie; highlights can turn dark, and intermediate tonal values become silvery. Boundaries separating tonal values often become light (with prints) or dark (with negatives), creating dramatic outlines around shapes or areas of the image. While the proper name for this technique is the Sabattier effect, it's commonly referred to as **solarization.**

There are various methods of producing the Sabattier effect. Following is the most basic when making prints:

1. Expose a sheet of paper to your negative as though you're making a standard print. Make a test strip first, then make an exposure on a full sheet based on what you determine is the correct exposure. High-contrast images generally work best, so you might want to expose using at least one grade more contrast than you would if you weren't solarizing; don't be afraid to further increase contrast for more dramatic results. You also may want to reduce the exposure time (by 10 percent or more) to compensate for the additional overall exposure the print will receive in step 6.

2. Remove the negative from the negative carrier and close down the lens to f/11 or smaller. Remove the easel and place newspaper, plastic sheeting, or a towel on the baseboard of the enlarger to protect it from getting wet during subsequent steps.

3. Place the exposed paper in the developer tray and agitate immediately and

vigorously. Casual agitation at this point may lead to streaky results.

4. When no more than half the development time—and usually less—has elapsed, remove the paper from the developer and place it in a tray.

5. Squeegee the paper to remove excess developer.

6. Put the print in a clean, dry tray and place it beneath the enlarger, centered under the lens. Work quickly, since the print is still developing.

7. Expose the print to white light very briefly. Experiment to determine an exact time, but expect no more than one or two seconds—and maybe a fraction of a second. A small amount of light typically has a significant effect. The time depends on many factors, including distance of the light from the print, f-stop, degree of development, and, of course, the desired result. If the print becomes too dark, even with a short white-light exposure, close down the lens to a smaller f-stop and try again.

8. Return the print to the tray of developer for the remaining development time and process it normally in the stop bath and fixer.

There are many variations to the above steps. For example, you can make the white-light exposure while the paper is actually in the developer, either by briefly turning on a dim light above the tray (if available) or by bringing the developer tray over to the enlarger (be careful that the solution does not drip in the "dry" area), or by another light source.

Another important factor is the timing of the white-light exposure; the results will be very different if you expose one-quarter of the way through the develop-

To solarize a print, you need to expose it to plain light while it's still developing. You can use the enlarger to do so, as described in the text, but this requires that you remove the negative from it, which means you have to set it up again each time. For this reason, photographers working alone in a darkroom sometimes make the exposure with a separate, low-wattage household lightbulb. They place the paper to be solarized in a clean tray underneath the bulb (which can even be plugged into a darkroom timer for greater control), and, after exposing it, return it to the developer tray.

ment process than if you do so halfway through. You'll have to experiment to determine how best to control these factors; results will vary depending on the density and contrast of your negative, as well as the type of paper and developer (and dilution) you use.

solarization Commonly used term for the Sabattier effect.

ALTERNATIVE PROCESSES

During much of the 19th century, photographers had to mix their own light-sensitive emulsions, coating them onto glass or paper to create films and printing papers. There were no mass-produced, prepackaged photosensitive materials, as there are today. Because hand-coating is a tedious and somewhat unpredictable process, most photographers now buy film and paper at the camera store. But some still like to experiment with such techniques, which are known by various names including alternative processes, antique processes, historical processes, and non-silver processes. The term non-silver refers to the fact that unlike most modern materials, these techniques usually involve the use of light-sensitive compounds made from metals other than silver, such as iron and platinum.

Photographers are drawn to alternative processes by their hands-on aspect, and the satisfaction of making their own materials. But the real attraction is their look—usually much different, and often much richer, than modern commercial materials. Some of these processes also have superior archival qualities; that is, they produce images that are more long-lasting. And just as each alternative process has its own look and feel, each requires a different combination of chemicals both for mixing and developing its emulsion. This generally makes them more complicated than working with silver-based materials, but if you have a little patience they can be accomplished without great difficulty. Kits are even commercially available for some of the most popular techniques.

Early printing papers had a very low sensitivity to light compared to modern papers. Prints were usually exposed by sunlight; even electric lighting, once it arrived, wasn't bright enough to produce sufficient exposure with slow 19th-century emulsions. Because enlarging wasn't practical, prints were ordinarily made by contact, as explained in Chapter 13. To do this, photographers used **contact frames,** special holders to keep a negative pressed firmly against the coated paper. Such frames are still available and commonly used by photographers for the same purpose.

While sunlight is a convenient and economical light source for alternative processes, it is not reliable. An exposure that takes seconds in direct sunlight might require several minutes or more on a cloudy day. For greater control and predictability it's better to make your exposures using an **ultraviolet exposure unit,** which produces light that is both intense and consistent. Such units are available commercially, though many photographers build their own using special fluorescent lamps that emit a high level of ultraviolet rays. You place the contact frame loaded with coated paper and negative at the

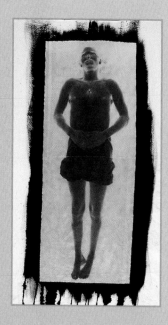

One of the most popular and versatile alternative printing processes is the cyanotype, which renders the image with a strong blue rather than the black produced by most silver gelatin papers. This distinctive color is the direct effect of the iron salts used to create a light-sensitive emulsion. Cyanotypes can be made on many different kinds of materials, both paper and cloth. For this image, the photographer soaked a six-foot long piece of cloth with the sensitizing solution and used two separate 20" x 24" black-and-white prints as her "negatives." By exposing the prints pressed against the cloth, she was able to make this composite, life-size image.

bottom of the unit to make your exposure. Use such equipment with caution; ultraviolet radiation can be dangerous to your eyes.

In the early days of the medium, virtually every photographer shot with a large-format camera. The big negatives these cameras produced made equally large prints when contact printed. Today, many photographers still use large-format cameras to make their original negatives. But if you want to use alternative processes to make prints from 35mm or medium-format negatives, or if you want prints even bigger than your large-format negatives, you'll have to make enlarged black-and-white internegatives. There are several ways to accomplish this.

You can enlarge your original negative onto a sheet of film to create a positive image, then contact-print that positive onto another sheet of film to produce a negative. Special emulsions are available for this purpose, though conventional films may also work. (There is even a special film that produces a negative image directly when exposed to a negative and processed normally.) Another option is digital: scanning the negative and outputting it as a negative image to a clear-based material. (Some inkjet printers allow printing on special clear-based media.) One advantage of this approach is that the contrast of the enlarged internegative can be precisely controlled with image-editing software. Many alternative processes work best with a higher-contrast negative, which can also be achieved by conventional chemical techniques.

contact frame A special holder for contact printing, incorporating a sheet of glass and a pressure plate to hold a negative firmly against photographic paper during an exposure.

ultraviolet exposure unit A box- or table-like unit incorporating special fluorescent bulbs that emit high levels of ultraviolet radiation, used for contact printing with alternative processes.

The simplest way to use alternative processes is to dispense with the negative entirely and make photograms (see pages 375–376). You do this just the way you would with conventional photographic paper: by placing objects on a sheet of hand-coated paper, exposing it, and processing it. Some of the earliest prints in the history of photography were created just this way.

Following are brief descriptions of some of the more common alternative processes, as well as resources for obtaining the necessary materials and suggestions for further reading.

Cyanotypes. One of the simplest alternative processes, the cyanotype is distinguished by its strong blue color. In fact, the technique was once used to make architectural and engineering "blueprints." Because iron salts are the light-sensitive ingredient, cyanotypes are inexpensive to make. Like most alternative processes, the cyanotype is a **printing-out process,** which means that the image becomes visible during exposure, not during processing. Once an image has reached the desired density, you simply wash the print in running water for five minutes to eliminate the unexposed emulsion. Cyanotypes can be printed on nearly any kind of paper or cloth.

Platinum Prints. Platinum printing is one of the most delicate and expensive of the alternative processes. Palladium is a less costly alternative that provides very similar results; some photographers actually use a mixture of platinum and palladium to vary the image tone from cool black to warm brown. As with many alternative processes, the type of paper you choose also has a strong effect on the look of the final image. Whatever the choice, the main appeal of platinum/palladium printing is its ability to register subtle nuances of tone.

Van Dyke Brown Prints. Also called kallitype, this process creates a soft, warm-brown image. A Van Dyke brown print doesn't have quite the subtlety of a platinum/palladium print, but creates a similar feeling at far less cost. There are different ways to develop the image; these range from a simple method involving a water bath and a fixing solution to a more complicated approach using developer, clearing, and fixing baths. You can also use different toners after processing to modify the color of a Van Dyke brown print—for example, to achieve a less warm black.

Gum Prints. With gum printing you can make an image of virtually any color, or an image made of several colors achieved by multiple applications. You create the emulsion and control the image color by combining gum arabic solution with a sensitizer, then adding pigment. In fact, you can even use the technique to create a full-color image, by making separations—individual black-and-white negatives that represent only the red, green, and blue components of the scene—then printing them sequentially, in register. To develop a gum print, you simply soak it in a tray of water with gentle agitation. Gum printing also can be applied over prints made with other alternative processes, for example gum over cyanotype or gum over platinum.

SUGGESTED READING

New Dimensions in Photo Imaging by Laura Blacklow, Focal Press, 2000.

Making Digital Negatives for Contact Printing by Dan Burkholder, Bladed Iris Press, 1999.

The Keepers of Light: A History and Working Guide to Early Photographic Processes by William Crawford, Morgan and Morgan, 1980.

Breaking the Rules: A Photo Media Cookbook by Bea Nettles, Prairie Book Arts Center, 1992.

Alternative and Non-Silver Photographic Processes: Working Notes by Christopher James, Delmar Publishers, 2000.

RESOURCES

Bostick & Sullivan, Santa Fe, NM
(505) 474-0890
www.bostick-sullivan.com
Extensive catalogue of platinum/palladium supplies; cyanotype and other chemical kits

Luminos Photo, Yonkers, NY
(800) LUMINOS
www.luminos.com
Cyanotype and Van Dyke brown kits

Photographers' Formulary, Condon, MT
(800) 922-5255
www.photoformulary.com
Wide range of photo chemicals and equipment; platinum/palladium, cyanotype, Van Dyke brown and other kits

Rockland Colloid, Piermont, NY
(845) 359-5559
www.rockaloid.com
Cyanotype, Van Dyke brown kits

printing-out process A photographic printing process in which the image becomes visible during exposure rather than being brought out by a developing chemical.

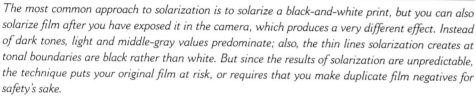

The most common approach to solarization is to solarize a black-and-white print, but you can also solarize film after you have exposed it in the camera, which produces a very different effect. Instead of dark tones, light and middle-gray values predominate; also, the thin lines solarization creates at tonal boundaries are black rather than white. But since the results of solarization are unpredictable, the technique puts your original film at risk, or requires that you make duplicate film negatives for safety's sake.

An easier method is to make a negative on resin-coated (RC) black-and-white paper from a positive print (left), as described in the section on negative prints (pages 376–377). You can also do this by enlarging a color or black-and-white transparency onto black-and-white paper. Then simply solarize the resulting paper negative the same way you'd solarize a regular print (center). Finally, dry that print and make a straight (unmanipulated) contact print from it (right). Note that this reverses the image back to its correct right-to-left orientation. One advantage of a solarized negative, unlike a solarized print, is that it can be used to make any number of consistent final prints.

Many printers feel that solarization works better when the developer has been well used, or is even close to exhaustion. Alternatively, there is a proprietary developer called Solarol that is specifically designed for the process. Solarol makes it much easier to obtain good solarization effects, allowing paper to be exposed more effectively to white light while in the developer tray, without turning too dark. (To avoid turning dark with conventional developers, some photographers reimmerse the print in diluted developer after the white-light exposure.) Note that Solarol is not a widely available product and may be difficult to find.

Consider using fiber-based paper rather than resin-coated paper. Fiber-based papers have a longer development time, which gives you more flexibility and

more time in which to complete the white-light exposure. Fiber-based papers are generally also less sensitive to light than resin-coated papers, which means you're less likely to overexpose the paper during the white-light exposure.

You can also dilute the developer solution below the recommended strength, which allows you to extend the developing time. Again, longer developing times give you more control and flexibility in making the white-light exposure.

You'll need to position the print carefully under the enlarger when making the white-light exposure. It's important that the light reach all areas of the print equally. Sometimes it's best to lift the enlarger head higher after removing the negative carrier to guarantee a broad enough light source.

Rather than enlarger light, you may use a separate light source in the darkroom for the white-light exposure, such as a hanging low-wattage (15W) light bulb positioned three to four feet from the paper. (You can even attach a timer to the hanging light bulb.) However, enlarger light guarantees more even distribution of light and makes use of a timer to provide precise and reproducible exposures.

The solarization technique is normally used with prints. However, you can also produce solarized negatives. An advantage of the technique is that once you have a negative solarized the way you want, you can make any number of virtually identical prints from it. Note, however, that the results of solarizing a negative are just as unpredictable, if not more so, than solarizing a print.

Robert Heinecken L is for Lemon Slices #3, 1971

Heinecken's work has often relied on unconventional approaches to printing, from the use of hand-coated emulsions on canvas to contact-printing of magazine pages. This image combines two of the techniques covered in this chapter, the photogram and handcoloring. Heinecken exposed lemon slices in contact with black-and-white printing paper, then added small amounts of color by hand to the finished print. Despite its simplicity, the image makes a double reference to nineteenth-century photography—echoing both Fox-Talbot's photograms of vegetable forms and the use of subtle handcoloring to add realism to early black-and-white work. © Robert Heinecken. Courtesy PaceWildensteinMacGill

You can directly solarize rollfilm by removing it from its tank during development (in total darkness), stretching it taut, sponging off the excess developer, and briefly exposing it to white light. Then put the film back on its reel and finish the developing process. This method is physically awkward, however, and the length of the roll makes it difficult to achieve an even result when the film is exposed to white light.

Sheet film is easier to solarize. The instructions are basically the same as described for paper. You can't use safelights, however, unless you're using ortho film. And film is more sensitive to light than printing papers, so you'll need a much shorter, more controlled white-light exposure time and/or a dimmer light source.

You have a few choices when solarizing sheet film. Though you can shoot sheet film in the camera and solarize when developing the original, this produces unpredictable results. It's often better to make a copy negative from the original and solarize it instead. That way, if you don't like the results, you can always try again. To create a copy negative, make an interpositive (see below) from the original roll or sheet film negative, then make an internegative from it. Or make an internegative from a positive transparency. Either way, solarize when developing the internegative (see Chapter 4). Yet another way to create a solarized negative is to enlarge a positive (a color or black-and-white transparency) onto RC paper, solarize the paper, then contact print the result.

High Contrast Prints with **high contrast** are dramatic and graphic. But how much contrast you want in a partic-

ular print is a matter of taste. Following are some of the ways to either heighten contrast moderately or to create maximum contrast—black-and-white areas with no grays in between.

It helps to start with a negative that has fairly high contrast to begin with. There are several ways to achieve this. One is simply to photograph contrasty scenes, such as on bright sunny days or indoors by bright window light. You also can process the film in a high-contrast developer. Likewise, overdeveloping the film generally increases image contrast. However, if you overdevelop a lot, you'll need to reduce exposure when you take the picture.

The easiest method of increasing print contrast is to use a high-contrast paper grade or variable-contrast filter, such as a #4 or #5 (see pages 304–305).

However, these procedures will rarely produce an image made up of only pure blacks and whites. For this effect, you'll need to photograph with special high-contrast film and probably print with a high-contrast paper or filter as well. Or you can use an existing negative and copy it onto high-contrast film; the most common of these is the litho film, such as Kodak's Kodalith. Litho films come in a variety of sizes. You can make your copy negative on 4" x 5" litho film and enlarge the resulting negative, if you have access to a 4" x 5" enlarger. Or you can make your copy negative 8" x 10" or larger and contact print the resulting negative to make your final print. Follow these instructions:

1. Take a sheet of film from its box, cut it into a few sections and use one to make a test strip. Be sure the emulsion side of the film is facing up. The

emulsion side is usually duller and the film curls slightly toward it. If there is a notched code on the edge of the film, the emulsion is facing up when the notch is on the top right corner.

2. Set up the negative in your enlarger as though you were making a print. You can use a red safelight with litho films, though a normal safelight for making black-and-white prints may also work.

3. Develop the test in either standard paper developer or in special litho-film developer for about two minutes. Stop and fix the film normally.

4. Examine your results under white light to determine the best exposure.

5. Expose and develop a full sheet of film for that time.

6. The result will be a high-contrast interpositive that will probably still have some gray tones. If the positive is too dark, cut back the exposure time and try again; if it's too light, increase the exposure.

7. When you have an interpositive with good density, wash it in a tray of running water for one to two minutes and soak it in a tray of fixer remover for the same amount of time. Then, wash the film for about five minutes, soak it in wetting agent for one minute, and hang it to dry by its edges with spring-type clothespins or film clips.

8. Allow the film to dry, which usually takes one to two hours.

9. When it's dry, contact print the interpositive onto another sheet of litho film to produce a negative. Use the same approach you would use to contact print on photographic paper;

high contrast Typically describes subject or image made up either of markedly different shades of gray or exclusively blacks and whites.

make a test strip, then expose and develop the film. You can even burn in or dodge to darken or lighten areas of the image. Process the film in litho developer to create a high-contrast internegative.

10. Using the highest-contrast graded paper you can find or a variable-contrast paper with a high-contrast filter (a #5), print the negative, either by contact or by enlargement depending on the size of the film negative. Process and dry the print using standard methods.

In most cases, following these steps will produce a print with extremely high contrast—all blacks and whites. In rare cases, when the contrast isn't high enough, you may have to use contact printing methods to make another generation of interpositive and negative; each step will increase the film's and ultimately the print's contrast. Because you may be making multiple contact prints, be especially careful to use a clean sheet of heavy glass so that each film generation is as clean and sharp as possible.

A more direct option is to use original positive images shot on color or black-and-white transparency film. Simply enlarge the transparency onto litho film to produce a large film negative, then enlarge or contact-print that negative on the highest-contrast graded paper you can find or on a variable-contrast paper with a #5 filter.

HANDCOATING AND HANDCOLORING

In the early days of photography, photographers had to handcoat their own films and papers with light-sensitive liquid emulsions that they mixed themselves

from raw chemicals. And if they wanted a color image, they had to paint on the surface of the print. When precoated and color materials became commercially available, photographers generally opted for the convenience and consistency they offered.

Handcoating Some contemporary photographers continue to coat by hand so that they can use nineteenth-century printing processes (see box pages 380–381). Others handcoat with **liquid emulsion,** a relatively new product.

The reasons for handcoating are almost always creative. In terms of quality, handcoated materials can't match up to modern, mass-produced materials. They are hard to coat evenly and therefore may respond inconsistently to light. Results are often unpredictable, but that's just what draws many photographers to these techniques.

Liquid emulsions are basically light-sensitive black-and-white emulsions in a bottle. They can be used with almost any kind of paper. But while artist's papers are usually the support of choice, liquid emulsions also may be used on many different types of other materials, such as cloth, metals, wood, fabrics (such as canvas and cotton), and even ceramics or glass.

You can coat liquid emulsion in various ways. Use a brush or sponge, or just pour it on and drain the excess. You also may use a spray gun or simple household spray bottle. When spraying, consider diluting the emulsion with warm water; be careful not to inhale the spray. Liquid emulsions may react chemically with brass, copper, aluminum, and other metals, so use only containers and implements made of glass, plastic, enamel, or stainless steel.

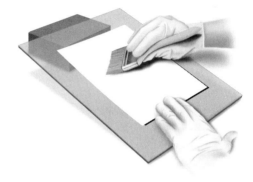

Liquid emulsion can be applied with a brush or sponge to a variety of surfaces, allowing you to print images on a wide range of materials, including three-dimensional objects. But some photographers use it simply to create images on artists' printmaking and watercolor papers without having to resort to mixing emulsions from scratch, as required by alternative processes. If you apply liquid emulsion to a sheet of paper or other flat surface, do so with a soft brush on an angled surface to promote more even coating, as shown here.

In general, you use materials coated with liquid emulsion in much the same way as you use conventional papers and films. You expose the coated paper (or other material) under an enlarger in a room lit by safelight; expect a longer exposure than with printing paper since the emulsion is less sensitive to light. Process it in standard black-and-white chemicals, then wash it. Air drying and careful handling are advised since the emulsion is relatively soft and vulnerable to damage.

The following suggestions apply specifically to Liquid Light, the most popular of the liquid emulsions. However, you can use these guidelines when using most other brands, such as

liquid emulsion Pre-mixed light-sensitive, black-and-white emulsion, used for hand coating paper or other material.

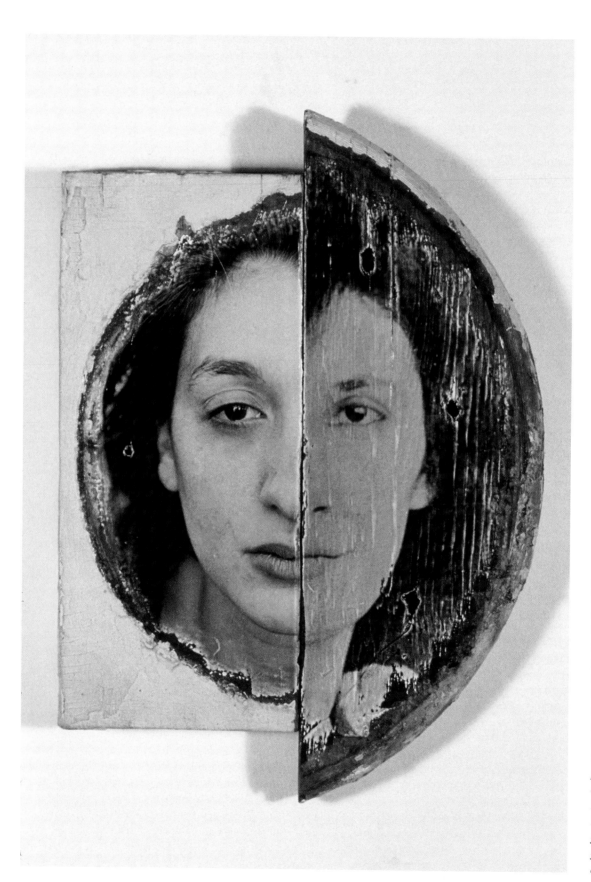

David Prifti

Lineage: Angelina 1927, Amy 1997

Prifti uses a commercially available liquid emulsion to print photographic images on three-dimensional found objects—ceramic shards, stone fragments, and pieces of weathered wood, as here. This not only gives his work a sculptural aspect, but sets up a relationship between the photographic image and the object on which it lies. In this image, two pieces of wood join likenesses of the photographer's great grandmother and her great granddaughter, taken 70 years apart. © David Prifti

Luminos Silverprint. Regardless of which liquid emulsion you use, read the packaged instructions carefully—but consider them just a starting point. Experimentation and experience produce the best results.

Some materials need preparation before coating with liquid emulsion. Most porous surfaces like fabrics and papers, such as watercolor papers, do not. However, with metal, wood, and other non-porous materials you must first prepare the surface for better adhesion. Try a thin coat of alkyd primer paint or a glossy, oil-based polyurethane varnish and let it dry overnight before applying the liquid emulsion.

Liquid emulsion is generally a thick gel at room temperature, so you'll have to warm it up to liquefy it before application. Liquid Light, for instance, liquifies at about 115°F. Place the container of emulsion in hot water in a deep tray or beaker for 10 to 15 minutes. Keep the container still; shaking it can create air bubbles, which will make it more difficult to achieve even coating.

When you're ready for coating, turn off the room lights and turn on a safe-light. Most surfaces need only one coat, lightly and evenly applied. Porous surfaces may need two coats. Apply the first coat, allow it to set up (for a few minutes), and then apply the second coat. If you're using a brush or roller, apply the emulsion at right angles to the first coat. Some liquid emulsions don't have to be totally dry for exposure and development unless you are making a contact print, for which the negative must rest against the emulsion surface. But they should be dry or drying—slightly sticky to the touch. You can pre-coat several pieces of material and store them away in a light-tight container for

later use. If you do this, it is also a good idea to coat at least a few scraps of paper and store them for test strips later on.

Keep processing temperatures relatively cool—under 72°F. Warm temperatures may act to melt the soft emulsion. Don't use an acid stop bath since this will further soften the emulsion. Instead, use a cool water rinse. Fix the image with a standard fixer containing hardener, not a rapid fixer, which might cause the emulsion to lift off the surface. Wash for five minutes in cool water, followed by a bath of fixer remover. Then wash for at least another 10 minutes. Again, keep the water cool throughout the process.

If your exposed material won't fit in a tray—for example, if you've coated a three-dimensional object—apply the developer and the other chemicals with a brush or sponge, swabbing them gently but continuously over the coated area. To ensure that the developer penetrates evenly, wet the emulsion with cool water first, then apply the developer.

A finished liquid-emulsion print can be delicate, but you can tone or handcolor it (see next section) just as you would a standard black-and-white print. Applying a final thin coat of polyurethane varnish may further protect the image from long-term damage.

Handcoloring Prints Almost from the beginnings of photography, people searched for a way to reproduce the colors of the world along with the sharp detail of a photographic image. Early photographic processes, however, produced monochrome black-and-white or brown-and-white prints. To incorporate color, early practitioners used **hand-coloring,** painting directly on the surface of the print. Sometimes the paint

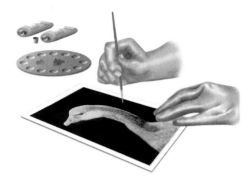

By selectively adding color to a black-and-white print with paints and a brush or other applicator, you can create an image that departs from a literal representation of the subject's colors. (Oil-based paints made specifically for this purpose are available, as are handcoloring pencils.) Depending on your technique, the effect can be subtle and pastel, or, with heavier application, strong and brilliant. The more transparent the application, the more the subject's tones and details will show through, retaining a more photographic quality.

was heavily applied, making the image look like a full-color photograph. Other times it was applied in spots to accentuate certain features, such as rosy cheeks or gold buttons.

With the advent of practical color photography in the 1930s, almost all photographers abandoned handcoloring. The process was resurrected years later as an aesthetic tool by fine-art and commercial photographers. Handcoloring makes a visual reference to earlier days, but more importantly it allows for much more control over the color palette than standard color photography. You can choose hyperrealistic or subtle color, make what was a blue sweater pink, or apply color so it either sits heavily on the surface or delicately sinks into the fibers of the paper.

handcoloring Creating a color print with oils, dyes, markers, or other means applied to the surface of a print—usually a black-and-white print.

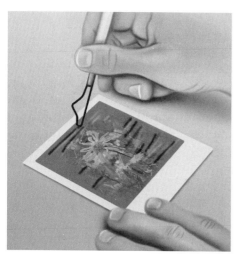

Polaroid's Time-Zero film—one of several Polaroid instant films that develop in front of your eyes—can be manipulated during development to obtain qualities ranging from painterly to highly distorted. To produce these effects, apply pressure to the print surface with a small, blunt burnishing tool, as shown here, immediately after the print is ejected from the Polaroid camera. You can heat the print with a hair dryer if its dyes start to harden before you've completed your manipulation.

Handcolored prints have a "one-of-a-kind" quality, giving them a uniqueness akin to painting. The technique alone won't guarantee strong images, but used with taste and discretion, handcoloring offers a powerful tool for personalizing your vision.

You can use many types of dyes, oil paints, markers, pencils, or even food coloring or watercolor for handcoloring photographs. There are also some oil, dye, and pencil products sold specifically for this purpose. The trick is to find a method that provides the color and texture you want and that causes color to adhere reliably to the print surface.

Whichever coloring materials you use, mix them so that they remain somewhat transparent; if the original tones of the photograph are allowed to show through, it preserves the photographic character of the image. Coloring does add some density, however, so it's usually best to make the print a little on the light side. It's also often best to make your prints with slightly heightened contrast since coloring may reduce image contrast. Note that transparent coloring hardly shows over dark or black tones, so prints with a lot of shadows may not be well-suited to hand-coloring.

You can apply color with a brush, cotton ball or swab, or cloth or paper wipes—whichever provides the control and evenness of stroke you desire. For fine work, use a Q-Tip or brush; for more detailed work, use a fine spotting brush (see page 358).

Make multiple prints of the image to be colored. That way, you can try different approaches until you achieve the effect you want.

The surface of the printing paper is an important consideration. The glossier the surface, the more the color "sits" on the image and the less it becomes an integral part of it. This makes matte and semi-matte fiber-based papers the preferred choices for handcoloring. There are no hard-and-fast rules, however. You can handcolor a glossy RC-surfaced print, but it will show brush strokes more readily than a matte surfaced print, and it will also dry more slowly. Some photographers consider this an advantage because it allows them to make adjustments over a period of time if they don't like the results they are getting.

Pretreating papers with a spray of base solution, such as Marshall's P.M.

Solution or Marlene, will help the surface accept color, even with RC glossy papers. You also can correct mistakes by removing applied color from most print surfaces prepared with these solutions.

As with less conventional processes, handcoloring benefits from experimentation—with both the products you use and the way you apply them.

POLAROID MANIPULATIONS

Many photographers use professional Polaroid materials for testing purposes, but some use them for "final" art, as well—images that will be displayed or reproduced. Sometimes this simply means using the Polaroid original, rather than making separate prints from conventional negatives or transparencies. Other times it means taking the Polaroid image one step further by manipulating it. Over the years, several manipulative techniques have proved popular with both fine-art and commercial photographers, notably integral film manipulation, image transfer, and emulsion transfer.

The reasons for such explorations vary. To some, they provide a method for abstracting the image. Others use them to gain more control over the palette and surface of the image than conventional techniques allow. Still others simply like the impact of an image that has a different look than a standard photograph. The Polaroid "look" draws as much attention to the process of picture making as to the image itself.

Whatever the reason, all three Polaroid techniques are fairly simple to execute. All can be done in room light with very little extra equipment. (You can use enlargers for image and emulsion transfers, but you don't have to.) All allow for individual control over the final result. Following are brief descriptions of

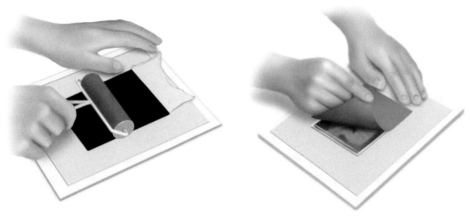

Polacolor image transfer takes advantage of the way color dyes diffuse from the negative to the positive in Polaroid peel-apart instant films. Once you pull the film "sandwich" through the rollers that spread the developing chemicals, instead of allowing it to develop for the normal time you peel it apart almost immediately, and place the negative (normally discarded) face-down against a sheet of artists' paper. Then you apply pressure to the back of the negative with a hard rubber roller and/or a burnishing tool to adhere it to the paper (left). After the negative has been in contact with the paper for at least one-and-a-half minutes, carefully lift one corner and slowly peel it away (right).

2. Immediately place the film face up on a hard, smooth surface.

3. Move your burnishing tool across the image surface. You can use either light or heavy pressure in any direction to achieve subtle or more extreme effects.

The results vary with the amount of pressure you apply and the stage the image development has reached. In the earliest stage—before the image even appears—try softening or blurring the image with light pressure. When the image begins to appear, apply heavy pressure to mix the dyes and produce new color combinations, or stretch the image by varying the amount and the direction of pressure. As the dyes harden, you'll have less ability to manipulate them. However, heating the film will resoften the dyes, allowing them to be manipulated further. Use a portable hair dryer at a medium setting, using constant motion to heat the entire image evenly.

You can make the image transparent by taking the manipulated film apart. Using rubber gloves to protect your skin from the chemicals inside, carefully open up the white border overlay with an X-acto knife and peel off the Mylar surface that holds the image. Then, wash the Mylar in a tray of running water to remove all traces of developer. You can display the transparent Mylar image on its own, superimposed over other images, or collaged with other images.

Image Transfer With some Polaroid films, you can apply the image to another surface to achieve a very different look. Often called Polacolor transfer, **image transfer** requires peel-apart Polaroid color film, ordinarily used in medium- and large-format cameras. Once you peel the

each technique and some suggested step-by-step instructions. Keep in mind that none of these techniques is totally predictable. As always, experiment and expect surprises.

Time-Zero Film Manipulation The simplest of the Polaroid manipulations involves Time-Zero film, an "integral" film that develops before your eyes (see Chapter 8). Note that there are other types of Polaroid integral film, but this one (which is accepted only by certain models of Polaroid cameras) is most suitable for this technique. The print that ejects from the camera contains chemicals that develop and produce color dyes to form the image. It takes about five minutes for the image to develop, but much longer—about twenty minutes, depending on heat, humidity, and other conditions—for the dyes to harden. Dur-

ing that time you can alter the image's appearance by rubbing or otherwise applying pressure to the Mylar surface of the film to move around the dyes underneath. The results range from surreal to amusing.

The primary tool you'll need for Time-Zero manipulation is a burnishing tool, which is primarily a printmakers' implement available at art supply stores. You also can use almost any small, smooth, rounded utensil, such as the rounded back of a spoon or pen, dental tools, wooden dowels, or even your fingers. Just make sure the tool has no sharp points since these can break through the film's Mylar surface. Follow these steps to manipulate a Time-Zero image.

1. Take the picture. It will start to develop as soon as it ejects from the camera.

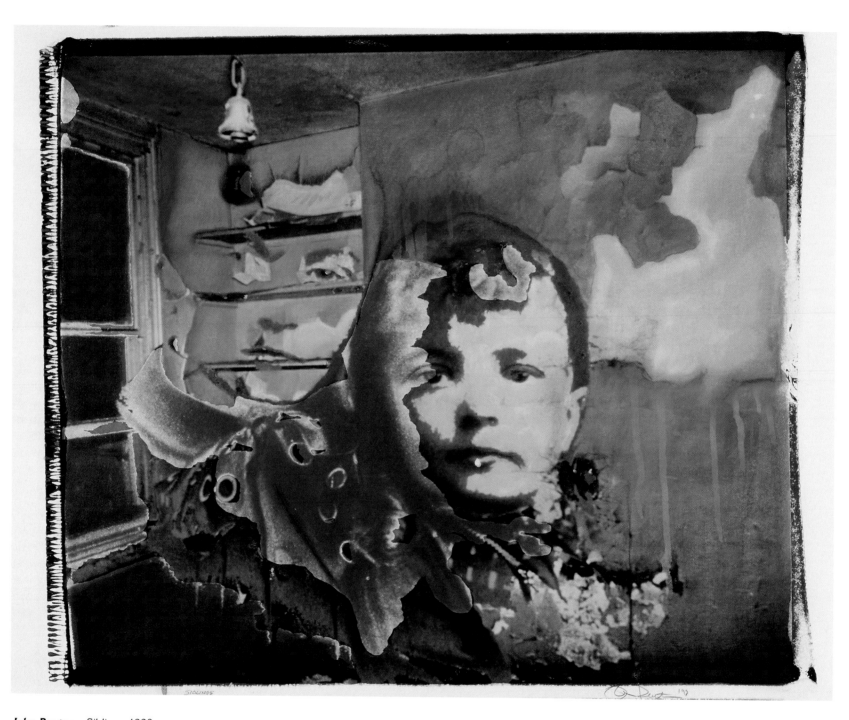

John Reuter Siblings, 1993

Using the Polacolor image transfer technique, Reuter rephotographs existing works of art (often medieval or Renaissance painting) and combines them with other images to create works that seem to have a familiar, classical beauty but with a modern edge. The photographer smooths and blends these various elements with both digital techniques and hand-applied media such as pastels. He often makes his transfers with very large-format Polacolor film, sometimes arranging them in multiple panels to achieve even bigger scale. John Reuter Photography

film apart, you have a color print and a color negative containing color dyes. Normally you discard the negative, but for this process you use the dyes remaining in it to make an image on another surface. The results will vary depending on the material you transfer to—watercolor paper is popular—but they generally look very painterly. You'll need the following materials for image transfer:

- Polaroid peel-apart color film (Types 108, 669, 59, 559, 809, or 64T)
- Polaroid camera or camera back
- Watercolor or other paper
- Enlarger or slide printer (optional, see box, pages 392–393)
- Darkroom tray with distilled water
- Thin rubber gloves
- Smooth, flat surface (such as plate glass or plexiglass)
- Burnishing tool
- Portable hair dryer

The following instructions should provide good results most of the time. But again, feel free to experiment.

1. Soak the watercolor paper in water for one to five minutes, depending on its thickness. Polaroid recommends warm water (about 100°F) but water at room temperature will work. While distilled water is best—it provides more consistent results—regular tap water will also do. Use a darkroom tray that's at least a little larger than the paper.

2. Remove the paper from the tray and drain it. Place the paper on a smooth, flat surface and gently blot off excess water from both sides, using a blotter or paper towel. Be careful not to crimp

In the Polacolor emulsion transfer technique, a fully-processed positive print made with Polaroid color peel-apart film is removed from its paper backing and transferred to a new support. To do this, you first soak the dry print in a tray of hot water, then move it to a tray of cold water with a sheet of Mylar on the bottom. Use your fingers to gently slide the emulsion off the print (left) and press it onto the Mylar sheet, stretching it out to remove wrinkles if you wish. Then place the Mylar emulsion-side down on a damp sheet of paper and rub the back of it to make the emulsion stick. After adjusting the shape and position of the image, apply light pressure with a roller to adhere it to the paper (right).

the paper. The paper should stick to the surface, which helps make the transfer easier to accomplish; don't let the paper shift during the process. (Dry paper can be taped down.)

3. Expose the Polaroid material, either with a camera or by copying an existing negative, slide, or print onto Polaroid film (see box on pages 392–393). Note that you'll usually get best color balance in daylight by adding a 20R or 30R (or 20M or 30M) gelatin filter over the lens when exposing the film. This will require a slight exposure increase (about 1/2 stop).

4. Pull the exposed Polaroid film out of the camera or back to begin processing—but do not process it fully. Instead, peel it apart (that is, separate the negative from the positive sheet) about 10 to 15 seconds after the pull,

rather than the recommended 60 to 90 seconds. You can vary the time for different effect, but peeling too early or too late may keep the image from transferring. Use gloves when handling the Polaroids since the processing gel may irritate your skin; if you do get gel on your skin, wash it off thoroughly and immediately.

5. Immediately after peeling, carefully place the negative sticky side down on the wet paper. Place one end of the negative against the paper and lower the rest of it down to make contact until it is flat. Don't touch the negative directly during any of these steps.

6. Using a burnishing tool, apply moderate pressure to the back of the negative to transfer the dyes from the negative to the paper. Rub with firm, smooth strokes.

PRINTING ONTO POLAROID FILM

There are several methods of exposing Polaroid sheet film for image and emulsion transfer. The easiest but least efficient method is to expose the film directly in a camera; this requires that your subject be available to be photographed when you are ready to make the transfer. Keep in mind that because transfer processes are unpredictable, you may have to shoot the scene repeatedly until you get the results you want.

It's easier to print an existing transparency onto Polaroid material. This way you can choose from photographs you've already made rather than having to create new ones. And if you make a mistake, or if the results are not what you want, you can simply start over again.

There are two main methods of printing onto Polaroid film. The first is to copy a transparency using a slide printer made specifically for use with Polaroid film. The second method is to use your enlarger to print an image onto the Polaroid.

Slide printers are easy to use. They have a light source, a slot for the transparency, and a lens positioned above a Polaroid film holder. Different brands of printers use different size film, from 3¼" x 4¼" pack film to 8" x 10" sheet film (a rarely used size that requires a special, separate processor). The basic steps are:

1. Put the transparency in the slot and the Polaroid film in its holder.
2. Pull the tab or protective sleeve to uncover the film and press a button to make an exposure.
3. Pull the film out through the holder's rollers and wait to peel it.

Slide printers allow limited adjustment of exposure and little ability to crop the image or to burn in or dodge during the exposure. For this amount of image control you must use an enlarger. Whether you use a slide printer or an enlarger, note that you should use a 10R or 20R (or 10M or 20M) filter for best color balance in the final image.

To enlarge, follow these steps:

1. Set up your "easel," an empty Polaroid film holder under the enlarger. You can use any size Polaroid holder—3¼" x 4¼" pack, 4" x 5" pack or sheet, or 8" x 10" sheet. For more accurate focusing and easier framing, place a sheet of plain white paper or thin white mat board in the holder. Prop up the holder with a box or magazines to make it parallel to the film carrier.
2. Put the transparency in the negative carrier and the carrier in the enlarger.

7. Leave the negative on the paper for 1½ to 2 minutes. You'll get best results if you keep the negative and paper warm. There are many ways to do this, such as floating both in a tray of hot water, preheating the surface that the paper rests on, or lightly heating the back of the negative with a portable hair dryer (set at a low to medium temperature and kept in constant motion).

8. Once the time is up, pick up one corner of the negative and slowly but steadily peel it from the paper to reveal the transferred image.

9. Air dry, either by hanging up the print with clothespins or clips from a taut piece of wire or string, or placing it face up on a drying rack.

Colors and blacks will have more saturation if you mix gelatin (any unflavored type from the supermarket; follow package instructions) and wetting agent (no more than one capful of concentrate) with the distilled water bath (step 1). They will have more brightness if you soak them for up to one minute in a weak solution of stop bath before drying; agitate for the entire time and then wash the print for about three minutes.

You may also draw or paint on image transfers after they dry. Use soft colored pencils, pastels, watercolors, inks, spotting dyes, acrylics, or markers for this purpose. A protective UV coating can be sprayed on the surface of the image to increase its long-term stability.

Most image transfers have a paper support. However, you may choose from

a wide variety of other supports, such as rice paper, vellum, and even wood. Fabrics such as silk are also very popular. Note that steps 1 and 2 describe soaking the paper before transferring the image. With fragile materials such as rice paper, it's advisable to skip the presoak; simply tape the paper down and start with step 3. While presoaking provides the softest and most painterly results, transferring the image to dry paper produces a sharper, more photographic look.

Emulsion Transfer Like image transfer, **emulsion transfer** uses Polaroid color peel-apart film. But instead of pressing the dyes onto another surface to make the picture, you remove a fully processed and dry emulsion from its paper backing and reposition it onto a

emulsion transfer
Technique used to transfer the entire Polaroid emulsion layer to a piece of watercolor paper or other material.

3. With the lights turned off and the lens open wide, project the image onto the film area of the holder. Compose and focus.

4. When the image is set up the way you want it, close down the f-stop as small as it will go. (Polaroid materials are more light sensitive than printing papers, so exposures are very short.)

5. Turn on the lights.

6. Take out the white focusing sheet and load the holder with Polaroid film. Be careful not to move the holder. (Set up tape or cardboard guides to mark the exact position of the holder or secure the holder in place with tape or other means.)

7. Set the timer initially to two seconds for a test strip. Time will vary with the circumstances.

8. Shut off the lights again; you can't use safelights when exposing Polaroid films.

9. Pull the dark slide out of the holder to allow it to be exposed.

10. Make a test strip of five or six sections by sliding the dark sleeve back in two-second increments, using the dark slide to block the light.

11. After the final two-second exposure, slide the dark slide all the way in.

12. Turn on the lights.

13. Pull the exposed film through the rollers.

14. Wait for 60 to 90 seconds (the full processing time), then pull apart the film and receiving sheet.

15. Examine the results for best exposure. Try to choose a time of at least four or five seconds; this causes the daylight-balanced Polaroid film to "shift" so that the enlarger's tungsten light source produces reasonably accurate color. Let's say that six seconds (three two-second exposures) looks best.

16. Repeat steps 6 through 9.

17. Expose the film for six seconds, then slide the dark sleeve back over the film.

18. Turn on the lights.

19. Pull the exposed film through the rollers.

20. Wait for the prescribed time (about 15 seconds for image transfer and 60 to 90 seconds for emulsion transfer) and peel apart the film.

sheet of watercolor paper or some other material. While the results look very different than image transfers, they also have a painterly feel. You'll need the following materials:

- Polaroid peel-apart color film (Types 108, 669, 59, 559, 809, or 64 Tungsten)
- Watercolor paper or other support
- Two darkroom trays
- Thermometer (with a scale as high as 160°F)
- Timer
- Print tongs
- Thin rubber gloves
- Vinyl contact paper
- Clear Mylar (or acetate)
- Soft rubber roller
- Hair dryer (optional)

Both the vinyl contact paper and the Mylar should be at least a little larger than the size of the Polaroid material you're working with.

As with any of these processes, the most successful emulsion transfers often come from experimentation. The following step-by-step instructions are intended as suggestions only.

1. Start with a fully processed print on Polaroid peel-apart film.

2. Dry the Polaroid fully, either naturally (for at least eight hours at room temperature) or with a portable hair dryer (in constant motion at a medium setting).

3. Adhere a sheet of vinyl contact paper, available at any store or market that sells household goods, to the back of the print; this will prevent the back from dissolving as the emulsion is removed.

4. Fill the two darkroom trays with tap water—one with very hot water (about 160°F) and the other with water colder than room temperature (about 50°F or so).

5. Place the Mylar or acetate sheet on the bottom of the tray of cold water.

6. Wet the watercolor paper with room temperature tap water until it is saturated.

7. Place the paper down on a clean, smooth surface and gently blot on both sides to remove excess water.

1999

Carmans LeBlanc ©

Unlike Polacolor image transfer, which usually causes colors to become muted, Polacolor emulsion transfer preserves the original intensity of the subject's colors. However, because the emulsion is removed from its support, it may wrinkle or fold over on itself unless you're careful to smooth it out in the cold water bath before adhering it to the paper. Many photographers using the technique exploit this aspect of the process, deliberately distorting the image when they transfer it to its new paper support.

8. Place the Polaroid print face up in the tray of hot water for about four minutes to loosen the emulsion. Agitate so that the print stays below the surface of the water for the entire time.

9. Using tongs, lift the print out of the hot water and place it face up into the tray of cold water with the sheet of Mylar on the bottom.

10. Using your fingers, begin sliding the emulsion off the Polaroid print, starting at the edges and moving slowly and gently toward the center.

11. Grab the edges of the emulsion and lift it up off its backing, keeping the print submerged in water the entire time.

12. As you lift the emulsion off, shuffle it back over itself (as though you're turning down a bed sheet) to reverse the image. Although it appears fragile, the loose emulsion actually holds together well.

13. Slide the support out from under the image and put it aside, keeping the loose emulsion floating in the water.

14. Stretch out the emulsion, holding it by the top two corners, and press it onto the Mylar with your fingers. The Mylar will act as a "carrying" sheet to bring the emulsion from the tray to the watercolor paper.

15. Lift the detached emulsion with Mylar out of the water (still by the top two corners) and put it back in again. Repeat this several times until you've stretched the emulsion out so it shows no wrinkles—unless you want some.

16. Take the Mylar and emulsion out of the water and place it emulsion side down on the moist sheet of watercolor paper. The Mylar should be on

top. Pat down the emulsion with pressure on the Mylar.

17. Gently lift the Mylar off the emulsion, leaving the emulsion on the paper.

18. At this point the emulsion is very malleable, so push it around or stretch it using your fingers. You can either distort the image or eliminate distortions, depending on the effect you want. Placing the emulsion and paper in cold water may help you manipulate it more easily.

19. Once you're happy with the look of the image, press it into the watercolor paper with the roller. Begin rolling with virtually no pressure, from the middle towards the edges. Increase the pressure once you've eliminated the residual water and air bubbles.

20. Once the image is set, hang the paper up or place it face up on a screen to dry.

21. Once it is dry, you can flatten the print in a dry mount press set at a fairly low temperature (about 180°F).

As with image transfer, you may draw or paint on the dry print with soft colored pencils, pastels, watercolors, inks, spotting dyes, acrylics, or markers. You may also spray on a protective UV coating to improve its stability.

Most of the time standard tap water works well for emulsion transfer. But if your tap water is too hard, you may have trouble removing the emulsion from its paper support (steps 10 and 11). Replacing the tap water with distilled water should solve this problem.

A jellylike substance may stick to the emulsion after you lift it off. This can be easily removed by stretching the emulsion taut on the Mylar and gently pushing the substance off with a fingertip. Wash your hands thoroughly after you do this.

JILL GREENBERG
DIGITAL IMAGING

GREENBERG'S TOOLS

Power Macintosh with 1.1 giga-bytes of RAM

21-inch monitor (for photo display)

18-inch monitor (for Photoshop tools palette)

Four 9-gigabyte hard drives

8000 ppi drum scanner

Flatbed scanner

Fujifilm Pictrography 4000 digital printer

100 MB Zip drive

One GB Jaz drive

CD burner

Digital audiotape drive (for backup)

As with any art form inspired by new technology, digital imaging found its first expression in exploratory doodles—the work of photographers trying every special effect the computer could deliver. The ease with which fragments of different images could suddenly be combined (a practice that previously required hours of darkroom drudgery) gave rise to a new school of half-baked photographic surrealism. The joke among more skeptical photographers was that the emerging medium had created a fast way to give a portrait subject a third eye.

Then young photographers like Jill Greenberg brought a new intelligence to digital imaging. "I once put a third eye in the middle of someone's forehead," confesses the 1989 Rhode Island School of Design graduate. "But it was for a *Wired* magazine story on a successful trendspotter. You have to have a reason, other than just that you can do it and it looks cool." Indeed, Greenberg's photographs always have a compelling visual logic to them. Their use of digital imaging's immense capabilities ranges from straightforward color and contrast adjustments (the sorts of things printers do in the traditional darkroom) to complex combinations of a half dozen separate photographs. Yet even Greenberg's composites are seamless and credible, and the photographer creates them to solve real-world photographic problems—putting a portrait subject on location without the cost and trouble of taking him there, for instance. Which isn't to say that she doesn't also try to heighten reality. Her visual trademarks: supersaturated color, quirky perspective, and a visual wit that pokes gentle fun at the "new media" trends and personalities her commercial clients often ask her to illustrate.

Those clients are themselves often part of the new media world, and they come to Greenberg for both her unique spin on their digital wares and her smart use of the computer. They include publications such as *Wired* magazine, the Bible of all things digital, and Microsoft, the owner of most things digital. *Spin* and *Vibe* magazines, and Atlantic and Sony Music, are just a few of the clients who have asked Greenberg to photograph the artists and innovators of the wired nineties—musicians in particular. Music (after all, it comes on the audio CD, our culture's first consumer experience with digital technology) is a Greenberg specialty. "My aesthetic has been influenced mainly by album covers and posters, more graphic sorts of photography," she says. "I always wanted to work for magazines and record companies." It was fortuitous that an ideal tool for such photography—Adobe Photoshop, now the premier image editing software—appeared just as Greenberg was starting her career.

Greenberg's photos still begin with real film, enhanced by gelled lights, offbeat backgrounds, and styling that ranges from campy to whimsically futuristic. For most jobs she shoots high-saturation color negative film, which pumps up the strong colors produced by her gelled lighting. Then she has her lab make 8"x10" C-prints, which she scans with her own flatbed scanner to produce a digital file for her computer work. For images that will appear on magazine covers and in other prominent spots she often substitutes color transparency film. Either way, Greenberg says that as she's shooting she's imagining what might be done on computer—the digital equivalent of what old-fashioned photographers call previsualization. Some images may simply need their color and contrast fine-tuned; others require as much as eight or ten hours of computer postproduction. "I shoot all day and do Photoshop all night," says the photographer. "It's insane, but it gives me more control." (Fortunately, she bills well-heeled clients a separate hourly rate for computer work.) Once she has finished retouching an image, she outputs it to a Zip disk or writable CD-ROM. Some clients reproduce the photograph directly from her digital files. For those

Scitex Waitress
1996

David Bowie
"Heroes" Symphony: CD
1996

who still prefer "hard copy," Greenberg sends the disk or CD to a service bureau for an 8"x10" inkjet transparency or a high-resolution dye-sublimation print, and submits that instead.

For all her computer savvy, Greenberg is acutely aware that digital imaging is no substitute for old-fashioned photographic thinking. "People keep telling me, You could be doing this or that on computer," she says. "But there are effects that just don't look the same when you try to recreate them digitally. I still sometimes use Mylar for backgrounds because there's just no way to imitate its reflections. Or I'll project a slide onto a surface or a person for the unique way it breaks up, or the way you can selectively color highlights and shadows by gelling the projector one color

and lighting the subject with another." Then there's cross-processing, an effect that dominated Greenberg's commercial portfolio early on. "If you want to get that characteristic turquoise line between red and blue, or to make colors separate into patches, cross-processing is the only way," she says. "But if you're using cross-processing to increase saturation and contrast, you can do it just as easily in Photoshop."

All that said, Greenberg is no fan of naturalism. She has been known to move a model's eyes farther apart to make her look "prettier." And she regards natural skin tones like leprosy. "I think they look kind of ugly, all peachy and smooth," she opines. "I prefer to have skin tones blown out; it's more dramatic. If you're going to make a color picture, it shouldn't just look like reality!"

Jackie The Joke Man
Entertainment Weekly
1998

DANIEL LEE
1949—Year of the Ox, 1993

Using Photoshop software to combine human portraits with animal features, Lee creates composite digital images that are startlingly lifelike. Though image editing tools make such overt manipulation possible, they also allow subtle yet powerful adjustments that are completely invisible to the viewer. In many cases, these capabilities exceed the level of control possible with traditional techniques. This is why many photographers now use computers to do what they used to do in the darkroom. © Daniel Lee

Chapter 17

DIGITAL IMAGING

Few phenomena in the history of photography have changed the medium as dramatically as has **digital imaging:** the use of computer technology to aid and even replace traditional photographic equipment, materials, and processing. Digital technology is widely used to store, archive, transfer, and display photographs, lessening or eliminating the need to deal with physical originals such as prints, negatives, or transparencies. But beyond such conveniences, thousands of photographers use the computer to manipulate their images much the way they would have done in a traditional wet darkroom. A growing number submit work in digital form for publication in books and magazines. Some even do the prepress work—digital preparations that ready an image for reproduction—that is traditionally the job of specialized facilities. The biggest benefit of digital imaging, in fact, is that it increases a photographer's control over his or her pictures, both in visual terms and in the ways those pictures are stored and used.

Most professional photographers employing computer technology begin by shooting pictures with conventional cameras and film. They then scan those images to produce a digital image file that can be worked on with a computer and output in various forms. This **hybrid** approach combines both traditional film-based and digital methods. But more and more photographers are making pictures without any film at all. These include both computer-savvy amateurs and professionals such as hard-news photojournalists and commercial studio photographers, who use filmless cameras to record images with light-sensitive chips. The resulting image files are downloaded to a computer and stored on its hard drive, ready for image editing, outputting, storage, and other applications.

FILMLESS PHOTOGRAPHY

For over 150 years photography has mirrored reality with the magic of light-sensitive film. After all that time, conventional film remains the cheapest, most convenient, and highest-quality way to produce a photographic image. But there is a filmless way to create a photographic image: by using a **digital camera.**

The main reason to take pictures with a digital camera is that it provides a way to get pictures into a computer immediately—no need to process (or print) conventional film. Once in your computer, an image can be immediately retouched and/or incorporated into layouts or "pages" on the World Wide Web, or used for many other photographic purposes. And beyond the initial expense of the camera and computer, a photographer using a digital camera can realize considerable savings in film and processing. That saving in costs is what makes digital photography so attractive to high-volume studio photographers. For photojournalists, on the other hand, time saving is digital photography's greatest advantage—allowing them to make urgent deadlines by sending digital pictures directly from laptop computers by modem and telephone lines (or even cellular phones) to their newspapers or magazines.

A filmless camera operates essentially in the same way as a conventional camera. It has a lens containing a variable-aperture diaphragm to control the amount of light entering the camera in a given period of time, and it has a shutter to control the length of that period. Some digital camera models are, in fact, built around existing camera bodies and lens systems. And some really aren't cameras at all, but rather add-on "backs" that convert existing film cameras to digital.

Regardless of their construction, all digital cameras capture images with a light-sensitive sensor, usually a **CCD (charge-coupled device)** similar to that used in video camcorders. The sensor sits where the film ordinarily would, so that the image formed by the lens falls directly on its surface. The sensor's surface is packed tight with microscopic light-gathering cells known as **pixels** (picture elements).

Pixels are the digital equivalent of film grain in conventional photography. In fact, they're a lot like the silver-halide crystals in a film emulsion: manufacturers can make them larger so that they gather more light in a given interval, which usually increases the camera's "speed." This means that fewer pixels will fit into a given-sized chip, however,

Though digital cameras are functionally similar to cameras that use film, they have an electronic sensor in their focal plane, where the film would ordinarily be positioned. The sensor (shown here surrounded by related circuitry) contains microscopic light-gathering cells called pixels, short for picture elements. When a digital camera's lens projects an image on the sensor, the cells gather light proportionally—more light in brighter parts of the subject, less light in dimmer parts. The camera (or attached computer) saves the photograph as a digital file that is basically a record of this pattern of charges.

Digital point-and-shoot cameras offer a wide range of image quality and features to suit different purposes. The inexpensive model at left is fully automatic in operation and has a sensor with a relatively low number of pixels. The low-resolution file it produces is best suited to images that will be viewed on a computer monitor and/or e-mailed. The advanced model at right has a relatively high number of pixels and many additional features; these include a small built-in monitor for playback, screw-in wide-angle and telephoto adapters for its zoom lens, and various manual overrides of its automation. Its greater control and superior image quality make its files suitable not only for electronic uses, such as Web pages, but also for physical output as digital prints.

which in turn gives a digital image a "grainier" appearance. In general, the more pixels a digital camera has, the more expensive it is—and the more likely it will be used for professional purposes.

When you take a photograph with a digital camera, each pixel in its CCD sensor produces an electrical charge in proportion to the amount of light that strikes it. In areas where little or no light strikes the sensor—the subject's dark areas (shadows)—the cells produce little or no charge. Where more light strikes the sensor—the subject's light areas (highlights)—the charge is greater. A digital camera automatically records the resulting pattern of charges in memory, much as a computer saves a text file to its hard disk.

A digital camera's CCD sensor must also be able to capture color information (though many models can be set to create a purely black-and-white image). It does this using a grid of tiny red, green, and blue translucent filter elements that

overlays the sensor. By admitting light of the same or similar color, and blocking light of the complementary color, the filter elements cause the underlying pixels to record subject colors in much the same way as the three separate layers in color film.

Images are recorded either in the camera's built-in memory or on removable memory cards or disks, or they are downloaded directly to a computer. With cameras having built-in memory or memory cards (see page 406), photographs can be downloaded later, long after they've been taken, by hooking up the camera to the computer.

The main obstacle to filmless photography—at least at the level of quality and control needed for serious photography—is cost. Inexpensive digital cameras are essentially point-and-shoot in their operation, allowing little if any image control. But even these digital point-and-shoots vary considerably in the image quality they produce.

At one end are simple models costing no more than a good point-and-shoot camera that uses film, and providing image quality that is adequate only for display on a computer monitor. These models have a **pixel count**—the total number of pixels in their sensors—in the same range as video camcorders (around 300,000), and can be used for e-mailing photographs and other electronic applications (such as putting pictures on the World Wide Web). They're not up to the quality needed for making good digital prints or for reproduction on the printed page.

On the other end of the cost scale, selling for the price of a good 35mm SLR that uses film, are digital point-and-shoot cameras with pixel counts of up to about three million pixels (abbreviated three megapixels) or more. These megapixel models can deliver picture quality that is adequate for the making of small prints (perhaps 5" x 7" or in some cases 8" x 10") on digital printers, and some even offer a limited number of SLR-style features. Most digital point-and-shoots have small LCD monitors that allow stored images to be immediately viewed, reviewed, and erased at any time. The LCD can also provide a "live" image for composing photographs, in much the same way that some video camcorders allow you to view the subject with an external screen.

Digital cameras that offer more image control than digital point-and-shoots cost even more—often much more than the computer systems needed to download their images. These models often, though not always, have substantially better image quality than digital point-and-shoots. The first step up is to cameras that are built around or modeled after existing 35mm SLRs. These feature interchangeable lenses—usually the entire existing line of 35mm lenses

pixel count Total number of pixels in a digital camera's CCD sensor and/or in the digital image it captures; a rough measure of its resolution.

RESOLUTION AND FILE SIZE

Pixels are the building blocks of a digital image, whether created by a digital camera or a scanner. In evaluating how much **resolution** you need to achieve an acceptable level of detail in a digital image, you need to think in terms of how many pixels are required. This depends entirely on how the image is being used. The larger a given digital image is displayed, printed out, or reproduced, the more pixels you will need to avoid having the pixels be visible—and to prevent visible pixels from interfering with the perception of detail in the photograph.

For this reason, digitally minded photographers try to create files as large as their computer's available RAM will accommodate. This number, expressed in megabytes, must also include the often considerable memory needed to run image-editing software (see pages 410–413). Such programs may require as much as five times more memory than the actual file size to run efficiently. For some photographers, this may mean working with images of just a few megabytes, which generally limits printing or reproduction sizes to 5" x 7" or smaller. For others, it can mean working with images of 30 megabytes or more, which would allow high-quality digital output (printing or reproduction) of 8" x 10" or larger.

The size, in megabytes, of a black-and-white image file is pretty much the same as the number of pixels used to make it. A black-and-white image made with a two-megapixel camera produces a two-megabyte file, for example. A color file is different because each pixel must be represented with three component colors—the red, green, and blue additive primaries that combine to create the full color spectrum. So to determine the size of a color file in megabytes, you multiply the resolution at which it was scanned (that is, the total number of pixels) by three. An image captured with a digital camera having a four-million-pixel chip would produce a color digital file of about 12 megabytes, for example. A 4" x 5" film image scanned at 1,000 pixels-per-inch would produce about a 60-megabyte color file (4,000 x 5,000 x 3).

Regardless of the RAM of your computer system, the quality you can get is limited by the resolution level of the scanner or digital camera originally used to digitize the image. Image-editing software can help create the appearance of greater sharpness and detail by emphasizing edges (a technique called unsharp masking) and adding extra pixels (called interpolation), but you can't create visual information where there was none to begin with. If you're having your work scanned by a digital service bureau, be sure to ask for the specific resolution you

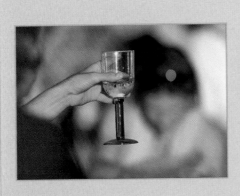

Whether you create a digital image by shooting with a filmless camera or scanning a film negative or transparency, it consists of tiny units of color and brightness called pixels. The number of pixels per inch (ppi) in the image is a rough measure of its resolution. A picture with a lot of pixels per inch is said to have high resolution, and the higher the resolution, generally the better the image quality. Here, a 35mm image (left) was scanned at two different resolutions shown in enlarged details above. The first was scanned at 300 ppi (middle), while the second was scanned at 72 ppi (right). Since the 300 ppi image has so many more pixels, it contains more information about the subject—producing more faithful color and a greater sense of detail. Note that for scanning purposes a pixel is not a fixed size; since fewer pixels must fill the same area in the 72 ppi scan, each one is much larger than the pixels in the 300 ppi scan.

resolution Overall image sharpness, largely based on the number of pixels in a digital image relative to its physical dimensions.

offered by the camera's maker. They also often incorporate extensions (resembling motor drives) on the bottom, or bulky back units, which contain the hardware needed to record and store digital images.

The resolution of these digital cameras is typically on the order of two to three million pixels or more, which yields a color file of around six to nine megabytes—a million bytes, a byte being the most basic unit of digital storage. That's perfectly adequate for the task of reproduction in newspapers or at small sizes in magazines, in which a photograph's content is much more important than its technical quality. But at larger reproduction sizes, such images may show the unwanted artifacts that can come from using a digital camera: **pixelation** (in which individual pixels are

Based on 35mm SLR design, digital SLRs offer an advanced degree of control and often accept the same system of interchangeable lenses as their film-based counterparts. Though these types of cameras don't necessarily have more pixels in their sensors than good digital point-and-shoots, they usually produce higher-quality images with greater color fidelity and a wider tonal range.

visible), stepped edges (in which contours and tonal boundaries are jagged rather than smooth), and a lack of sharpness and/or color fidelity. For still better quality—the quality often needed by both fine-art and commercial studio photographers—you may need an even more advanced and expensive digital camera.

Though some top-quality digital models are self-contained cameras, many are accessory **digital backs** for medium- and large-format cameras. With medium-format models they replace the film magazine; with large-format models they replace the film holder, usually sliding under a view camera's spring back. Most of these models must be linked by cable directly to a computer for operation, and each time a photograph is taken it is immediately downloaded for viewing on the monitor. The host computer must have generous random access memory (RAM), the maximum amount of information it can hold in active memory. This is because some of these cameras are capable of resolutions of up to 80 million pixels, for a color file of nearly 250 megabytes. To put such numbers in perspective, consider that a 35mm frame of ISO 100 color negative film is said to have resolution equivalent to at least 18 million pixels.

Three very different imaging systems are used by cameras providing this high level of quality. The first is the same as with less costly digital models, and is known as a **one-shot** approach. In such models the CCD sensor fills all or most of the image area that a frame of film would normally occupy and is exposed all at once. Such sensors have built-in color filtration—tiny red, green, and blue translucent "elements" that overlay their light-sensing cells, just as in less expensive digital cameras. These microscopic

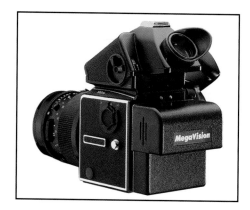

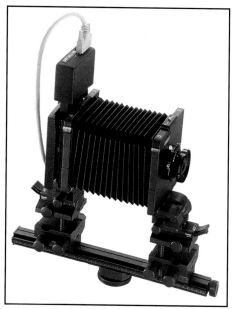

Digital studio cameras offer very good image quality, with sensors that have an extremely high level of pixels. Unlike other types of digital cameras, though, they must usually be directly linked to and controlled by a computer; image files are saved on the computer rather than internally in the camera. These models take two basic forms: add-on backs that replace the film magazine for medium-format cameras (top), and inserts that substitute for a film holder in a 4" x 5" camera (bottom). In addition to its high image quality, this design allows the full range of a camera's capabilities to be used in digital capture.

pixelation Effect (usually unwanted) in which a digital image's component pixels are visible.

digital backs Add-on backs or inserts, usually for existing medium-format and 4" x 5" cameras, that incorporate a CCD sensor for digital image capture.

one-shot Describes digital camera system in which the image is exposed all at once, with color reproduced by tiny filter elements overlaying the CCD sensor's pixels.

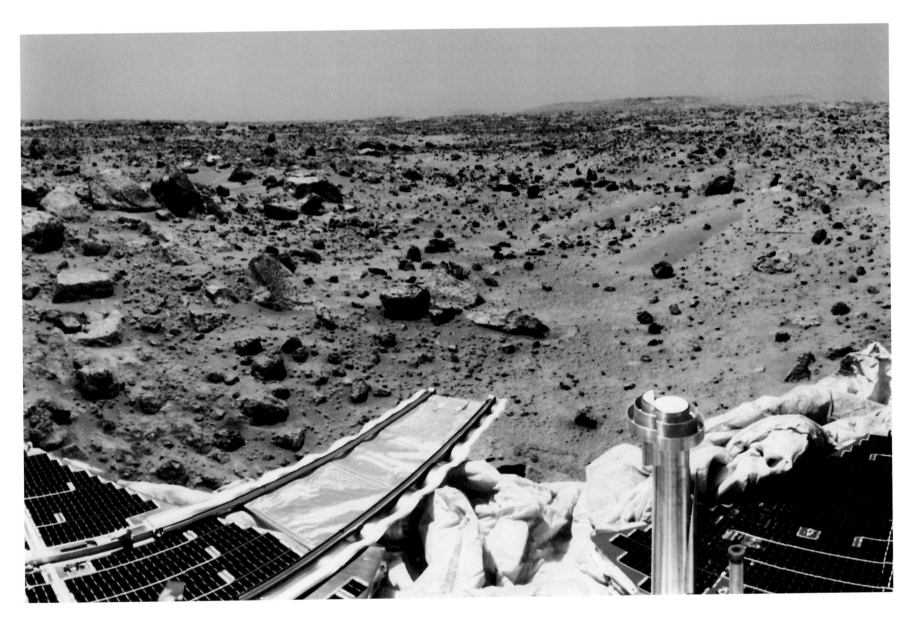

NASA Mars Pathfinder Mission, 1997

Digital imaging got its start in the military and aerospace industry, allowing remote photography of both earth and outer space from unmanned aircraft, satellites, and space probes. Here, multiple views of the Martian landscape were captured by a digital camera on board the Mars Pathfinder space-craft's lander. The resulting digital files were transmitted across millions of miles back to Earth, where they were pieced together to create a seamless composite. On this planet, amateur and professional photographers alike can now take advantage of telephone lines and wireless communications technology to transmit digital images to distant locations in a similar way. NASA/Media Services

DIGITAL CAMERA STORAGE

Most digital cameras intended for general-purpose shooting (as opposed to those designed exclusively for the studio) store their photographs on removable **memory cards**—matchbook-sized storage devices that slip in and out of a slot on the camera. A memory card is essentially "film" for a digital camera. If you have enough cards, you can shoot as many pictures as you like before linking the camera to a computer to download them. This eliminates the nuisance of having to download or erase unwanted pictures to clear storage space before continuing to shoot, which you have to do with models having built-in, nonremovable memory.

There are several competing types of memory cards, and different camera brands and models use different types. Some are even designed to slip into a floppy-disk-sized adapter that slides into the computer's floppy disk drive, allowing retrieval of image files without the need to hook up cables. Some cameras can transmit files wirelessly, by infrared signals, either to the computer or to a dedicated desktop printer. And some printers even accept cards directly, eliminating the need to download images to the computer for printing.

The number of images a memory card can store depends on the card's capacity, which can range from two to 160 megabytes or more, and on the level of resolution or **compression** at which the camera's images are stored. Compression refers to a software scheme that saves only the

Digital cameras that don't have to be linked to a computer—both point-and-shoots and SLRs—usually store their image files on matchbook-sized removable memory cards that fit into slots on the camera body. Some models use CompactFlash cards (left); others use SmartMedia cards (right). There are other, proprietary memory card formats, as well as miniature hard drives that serve the same purpose. Capacities for memory cards range from two megabytes to 160 megabytes or more.

most important information needed to create the image, and thereby reduces the image file's size. Image quality can usually be adjusted to one of three or more different levels; lower-resolution or higher-compression settings allow more pictures to be stored in a given amount of memory, but at the price of reduced quality.

filters recreate the subject's colors pixel by pixel.

With other high-quality digital models, you must make three individual exposures through red, green, and blue filters in front of or behind the lens; this is known as a **three-shot** approach. These exposures are, in effect, color separations—black and white renditions of the presence of each of those three colors in the subject. (The effect is very similar to

that created by color films' red-, green-, and blue-sensitive layers.) The three images are recombined in the computer to form a very faithful, full-color image. One problem with three-shot cameras is that subjects photographed in color must not move, since three separate exposures are needed. Both one-shot and three-shot models tend to have resolution in the 4- to 6-million pixel range, for color file sizes in the 12- to 18-megabyte range.

To achieve even higher resolution, digital cameras use a scanning approach to record the subject, in much the same way a film scanner digitizes an existing negative or transparency image (see pages 407–410). (Some scanning cameras can actually double as film scanners.) Instead of recording the subject all at once, they move a narrow line of CCD cells (sometimes called a linear array) across the image formed by the lens, thus recording

memory cards Small, removable storage devices used to store photographs in some digital camera models; they fit into a slot on the camera body.

compression Software scheme that saves only the most important information needed for a digital image file, thus reducing the amount of storage space required.

three-shot Describes digital camera system in which a color image is recorded in three separate exposures, one each through red, green, and blue filters.

one side of the scene before the other. Some scanning cameras incorporate red, green, and blue filter elements into this linear sensor (similar to the approach of one-shot models), which allow them to obtain a color image in one pass. Others capture the image with three consecutive passes (similar to the approach of three-shot models), recording red, green, and blue "separations" that are then recombined in the computer.

Because it takes time for a linear sensor to move physically across the image plane—often minutes—subjects must be completely static if they're to be rendered sharply. That makes portraiture difficult, if not impossible. What's more, subjects must be illuminated with continuous sources (daylight or tungsten light, for example) rather than the electronic flash that is standard for much studio work. These limitations, along with the requirement that the camera stay physically connected to the computer, make scanning digital cameras best suited to still life and product photography in studio settings. (A well-powered laptop computer does make it possible, if not convenient, to shoot on location.) Finally, the high price of these models—often into the tens of thousands of dollars, though as with all such technology the cost is dropping steadily—makes them more likely to be rented by photographers, when needed, than bought outright.

The reasons for using expensive digital cameras for photography being done in a controlled environment are similar to those for more mobile digital cameras. For studio operations that shoot large quantities of photographs—"product shots" for merchandise catalogues, for instance—the cumulative savings in film and processing eventually offsets the cost of renting or buying the camera.

Just as important is that the images from a high-resolution digital camera can be viewed on screen for immediate fine-tuning by the photographer (or instant client approval in commercial work), retouched on the spot, transferred to a graphic design program for placement into a layout, and separated for reproduction—saving much production time and costs as well. Such advantages put powerful pressure on professional photographers to adopt at least some level of digital technology.

SCANNING

The majority of photographers using digital technology start by shooting with conventional equipment and materials—that is, with standard cameras and ordinary film. They may even make prints in the darkroom. To make digital files that can be retouched and output with a computer—or simply to be able to incorporate those images into computer layouts or documents—they use a **scanner** to digitize images from their processed transparencies, negatives, or prints. A scanner is a device that attaches to your computer to convert existing film or print images to digital files.

There are several reasons for this approach. One is that a photographer may not have, or have access to, digital cameras. Also, it's possible to get better digital image quality by scanning original film or prints on a high-resolution scanner than shooting with most digital cameras. Additionally, a photographer may have many existing film images that he or she wants to digitize—whether to store

frame grabber Device that singles out selected still images from videotape or other video source (such as a TV signal), allowing downloading to a computer.

scanner Device that digitizes negatives, transparencies, or prints by passing a linear CCD array across the image, recording the subject from one side to another, allowing downloading to a computer.

STILLS AND VIDEO

The CCD sensor that makes filmless photography possible is borrowed from video—and still photography has merged with video technology in what are often termed hybrid cameras. These models take one of several forms. Many are essentially camcorders that record their picture digitally on magnetic tape and can be set to shoot individual still images that are then downloaded to a computer. (A few models even incorporate separate memory cards for still photos.) Some digital still cameras also can record short motion sequences.

It's also possible to retrieve selected still images from any videotape (or other video source such as a TV signal) using a **frame grabber.** These devices are either special accessory video capture boards installed inside a computer or small, inexpensive computer peripherals. They digitize video's analog signal, allowing selected images to be directly downloaded to a computer. Once they're downloaded, these images can be retouched or otherwise manipulated, then output in the same way as still images.

While still images from video sources are of sufficient quality for monitor viewing and low-level or small-scale reproduction, their quality is still too poor for high-quality hard-copy results. But the difference between still photography and videography will probably blur further as CCD sensors get better and cheaper.

Jody Dole
Alka-Seltzer in Glass
Dole uses digital imaging software and high-end printers for virtually all of his work, both commercial and personal. But rather than take a highly manipulative approach, he usually uses the technology to balance and intensify color and to make subtle adjustments to highlight and shadow tones. This image was not only captured and printed digitally, but the file was sent directly to the printer for high-quality magazine reproduction— eliminating several costly and time-consuming steps needed to make photographs by traditional means with film. © 1999, Jody Dole

Scanners are designed to turn traditional photographic images—whether on film or paper—into digital files. But as with many new technologies, photographic artists have found unorthodox ways to use them. To create this image, Eva Sutton placed a bone directly on a scanner's flatbed—essentially using it as a camera. But since the scanner only illuminates objects very close to its surface, the falloff in light gives the bone a strong three-dimensional quality.

the width of the film. The tones and colors that create the image are converted to digital form and downloaded to the computer. As with digital cameras, some scanners have red, green, and blue color filter elements in place over their CCD's light-sensing cells so that they can record the image's component colors in one pass. Others use three passes, registering red, green, and blue separately, then recombine them to create a full-color image.

Software supplied with the unit controls the scanning process, and usually allows the image to be previewed and color-corrected before the final scan is made. Usually a small display image is shown, and on-screen controls allow overall adjustments of its color. Film scanners for medium- and large-format films can cost many thousands of dollars,

Film scanners convert negatives or transparencies into digital files by projecting them onto a linear sensor that moves across the image area. They are available in a wide range of prices and sizes, from relatively inexpensive 35mm units to costly multi-format models. Their maximum resolutions vary as well. Scanners are supplied with specialized software that allows them to be controlled from your computer.

service bureau Business specializing in a variety of digital-imaging services such as high-quality scanning and printing.

storage media Means of saving and storing digital image (and text) files, for instance a Zip disk or CD.

film scanner Scanner used to digitize negatives and transparencies.

in a digital archive or to put online, or to retouch or edit in ways that were previously impossible. An added benefit is that once images are scanned at high levels of quality by photographers or a **service bureau,** the photographer needn't send original film images to a publication or printer, so those images aren't at risk of damage or loss.

Given the relatively high cost of a good quality scanner, some photographers have their work scanned by a service bureau and "written" to (recorded on) one of several different types of digital **storage media,** such as a Zip disk or a CD, for downloading to their own computers (see page 412).

There are essentially three different kinds of scanner: film, flatbed, and drum. Designed for transparencies or negatives of various formats, the **film scanner** is generally the best compromise between affordability and quality. Most models only take 35mm film, though some take smaller-format APS film and medium and large format; the larger the format they can handle, the more expensive they are. Higher resolution and better color "depth" (see the following page) also add to their cost.

In a film scanner, the transparency or negative image is focused with a lens on a surface across which is passed a linear CCD—a single line of light-sensing cells

Flatbed scanners are capable of producing image files with very high resolution. But you ordinarily have to start with a conventional print, because these units are designed to digitize reflective originals (such as prints) rather than translucent originals (such as film). Some flatbed scanners offer accessory transparency adapters, so you can scan directly from the original film, but most don't have sufficient resolution to produce high-quality image files from small originals such as 35mm negatives or transparencies.

partly due to their bigger sensors. But good 35mm desktop scanners with resolution around the 10-million pixel level (for close to a 30-megabyte color file) often cost more or less the same as good quality 35mm SLRs.

Flatbed scanners are designed primarily for digitizing reflective art (any non-transparent original), such as photographic prints. They range from inexpensive models used by graphic designers to scan artwork for layout purposes to high-end models that deliver excellent photographic quality. Many flatbed models have special attachments for scanning film (transparency or negative), but these ordinarily aren't useful for serious 35mm work because their per-inch resolution and/or density range are too low.

Flatbed scanners (which, like film scanners, may use a one-pass or three-pass approach) generally accept print sizes up to about 11" x 14".

Finally, **drum scanners** offer the best digital image quality of all. You attach a negative transparency, or print to a cylinder that rotates at high speed so that a CCD moves across its surface. Drum scanners scan very quickly for the extremely high resolution they deliver.

Scanning speed becomes an issue when large numbers of images must be digitized, for example, when storing photographs digitally. Both hardware and software affect scanning speed. Desktop 35mm film scanners generally take under a minute to scan a transparency or negative at their highest resolution; to scan larger number of images, many such models speed up the process with auto-

Drum scanners accept both reflective and translucent originals—prints, negatives and transparencies. They can accept fairly large-sized originals and produce the highest resolution available from any type of scanner. Drum scanners are the most expensive scanners in wide use and are too costly for most individual photographers to own. Therefore, you'll find them mostly at digital service bureaus, some school labs, and large commercial studios.

matic feeders for slides and special holders for strips of negatives.

Again, the level of resolution at which an image is scanned is the main constraint on the quality of the final image. The more pixels per inch a scanner provides, the sharper and more detailed the digital image. Just as important in terms of photographic quality is **bit depth,** the accuracy with which a scanner (or a digital camera) interprets color and tone. Even an inexpensive scanner captures at least 256 shades of gray per pixel. If an image is scanned at that level in red, green, and blue—256 x 256 x 256—its file may be capable of representing over 16 million colors. Keep in mind, however, that your computer monitor might not be capable of showing them all.

IMAGE EDITING

Perhaps the best thing about the digital revolution in photography is that it has actually given more creative control to individual photographers. Many photographers who don't have the time, the means, or the inclination to do their own processing and printing can work in the "digital darkroom" with computer software designed specifically for processing and manipulating photographs. Photographers who shoot for reproduction had little or no control over the reproduction of their work before the digital darkroom; now they can maintain hands-on control by preparing their images for reproduction in magazines and books. Using computer software for such purposes is known as **image editing.**

The pictures we see in magazines and books are reproduced from digital image files created by scanning an original transparency, negative, or print—and, in fact, often have been digitally altered for

flatbed scanners
Scanners used to digitize reflective art, such as photographic prints or other printed materials (such as magazines or books).

drum scanners High-quality (and costly) scanners used to digitize negatives, transparencies, and prints.

bit depth Accuracy with which a digital camera or scanner renders color and tone.

image editing Using the computer and special software to retouch, combine, or otherwise manipulate digital images.

Eva Sutton

Construction #14

Image editing software is a perfect tool for Sutton's work, in which "found" graphic materials, including old photographs and technical illustrations, are collaged seamlessly together. Sutton first scans the elements of an image to create digital files, then assembles them in the computer with Photoshop and other software. The result has a strange, ethereal quality that evokes both memories and dreams. Courtesy Eva Sutton

DIGITAL STORAGE MEDIA

Storage is an important issue for photographers working with digital imaging. High-resolution color photographs may require as much as 100 megabytes apiece of digital storage space, quickly filling up your computer's hard drive. For this reason, most computer-using photographers rely on one or more forms of **removable storage media**—individual disks or cartridges that hold digital files that are compatible with special accessory drives that "write" the files onto the media. Removable storage media also allow you to transport or ship image files for reproduction or for printing at digital service bureaus. These products vary greatly in cost, capacity, and technology. Here are some of the most popular types.

Floppy disks These familiar 3.5-inch-square disks are very inexpensive, and most computers have a built-in (or accessory) floppy disk drive. Their limited storage capacity—about 1.4 megabytes—restricts their use to small image files. But the quality of such files is fine for display on a computer monitor. And with compression, you can fit a fair number of photographs from a digital camera on a single floppy. Some manufacturers make special 120-megabyte floppy disks that require their own special drive, which also can read and record on standard floppy disks.

Zip disks Slightly larger and thicker than floppy disks, Zip disks come in both 100- and 250-megabyte versions, each with its own dedicated drive.

(The 250-megabyte drive also accepts 100-megabyte disks.) Once attached to your computer, a Zip drive operates essentially like a floppy drive. Zip disks' small size, high capacity, and low cost—not to mention the ability to erase and rerecord—have made them one of the most widely used digital storage media. A single 100-megabyte Zip disk can hold one or two very large image files, several moderately-large image files, or dozens of photographs from a high-quality digital camera.

Compact Disks (CDs) Moderately priced **CD writers** (also called CD burners) allow you to record onto a compact disk. There are two types of "writeable" CD: those that can be recorded one time (CD-R) and those that can be "rewritten" with new files (CD-RW). Compact disks hold about 650 megabytes of data, enough to

store large numbers of digital image files. Their low cost (as little as a dollar or two), together with the fact that nearly everyone with a computer has the CD-ROM drive needed to read them, has made the medium very popular among working photographers as a way of providing images to clients.

Photo CD You don't have to own a CD writer, nor patronize a digital service bureau, to put your images on compact disks: Kodak's **Photo CD** service is an inexpensive alternative. Most photofinishers can scan a roll of film to a Photo CD when they process it; many commercial labs can also scan existing individual negatives or transparencies to a Photo CD. About 100 35mm images fit on a standard Photo CD disk. Each image is recorded at five different quality levels for different purposes, from a low-resolution **thumbnail** for quick on-screen review to an 18-megabyte file that can be used for image editing, high-quality digital printing, or reproduction. (A professional version of the Photo CD adds a sixth, higher resolution file of about 72 megabytes, especially useful for scans from medium- and large-format film.)

publication. Sometimes this alteration is obvious and dramatic, but more often, it is too subtle for most viewers to discern, involving (for example) slight adjustments to color or sharpness. Once the exclusive domain of million-dollar scanning and retouching systems, this level of image control is now accessible to the average photographer.

Before an image can be digitally manipulated, it must be digitized. Digital cameras offer the most direct route, but scanning of previously processed film shot with a photographer's existing cameras and lenses is more commonplace. If you don't have access to a scanner, you can have the original film scanned at a service bureau.

To run image-editing software you need a lot of computing power: generous random access memory (RAM), high processing speed (the rate at which a computer performs operations), and available space on your computer's hard drive. This varies with the particular software. For example, Adobe **Photoshop,** the dominant image-editing program, requires at least 32 megabytes of RAM (but 64 or more is preferred) and 80 megabytes of available hard disk space. And the "faster" the processor in your computer, the more quickly it will be able to perform.

Image-editing software covers a broad spectrum of costs and capabilities. Inexpensive programs may give you basic control over contrast, color balance, and sharpness, but not much more. Advanced programs such as Photoshop, on the other hand, give you not just complex control over an image's contrast, color, and sharpness, but also provide entirely localized control, including "burning" and "dodging" similar in effect to what those tech-

niques do in the conventional wet darkroom. These familiar procedures can be done with greater precision digitally. Using on-screen tools, a mouse or graphics pen and tablet, and/or the software's edge- and contrast-sensing capabilities, you can define specific areas so that they may be lightened or darkened, or changed in color or contrast. You can change the relative color and contrast of shadows, midtones, and highlights by clicking on a graph. You can add different kinds of blur to specific image areas or sharpen an entire image. And you can work in multiple "layers" to create composite images that are not only less time-consuming to produce, but that can be at least as seamless and credible (if not more so) as anything that is possible under the enlarger or in the camera.

Some people are concerned that digital imaging makes manipulating a photograph too easy—and thus can lead to work that is stronger on technology than aesthetic merit. Yet there are great benefits to digital's easy experimentation. Image-editing software lets you experiment with all sorts of special effects, previewing them quickly if not immediately, and without wasting sheet after sheet of expensive photo paper.

Once you've retouched your image, you'll need to store it. Keeping it on a hard drive quickly consumes the drive's available capacity, so most photographers store digital images on various other media, including accessory hard drives, removable disks such as Zip and CDs, or even digital audiotape. Also, if you want to send the image out, for example, to a service bureau for digital printing, you'll have to record it on a removable disk.

There are still things you can do in the conventional darkroom, at least for now,

that can't be exactly duplicated by digital means. No digital effect can precisely simulate the richness of split-toning, for example, or the surface qualities of a special photographic paper. For such reasons, conventional photographic printmaking will continue to coexist with digital imaging techniques for those interested in the particular "look" each offers.

OUTPUT

No matter how much digital imaging changes the way you work, you will probably still want to reproduce the image in a form that can be displayed, whether as an electronic file stored on digital media or as a physical print-out for review or exhibition. **Output** is the digital equivalent of photographic printing. There are many choices available to you. If pictures are meant for viewing on a monitor only—say, for an on-screen portfolio presentation—you can simply output them to a floppy disk, just the way you would a text file. The pictures may then be viewed by anyone with a compatible computer and software designed for viewing photographs. But computer floppy disks have minimal digital storage capacity, which limits the number and/or quality of the images that can be stored on them.

Zip drives and CDs are more useful storage and viewing mediums for such purposes. They can hold a large number of high-resolution images. CDs are especially useful since most computers already have built-in compatible drives for playback of these disks (see box, page 412).

Monitor viewing is fine for many purposes, but most photographers still want prints, transparencies, or negatives of

Photoshop Popular and powerful image-editing software made by Adobe.

output Usable version of a digital image, such as a print, transparency, negative, or digital file.

IMAGE EDITING WITH PHOTOSHOP

In many respects, photographic image editing programs operate like any other type of computer software. Along the top of your screen you will see the familiar "menu" bar, a standard part of your computer's "desktop." It features pull-down directories of commands and features, which are selected with a mouse click. In Adobe Photoshop, the most widely used image editing program, you use these directories to access many of the tools needed to manipulate the image. In addition, specific tools are accessed and adjusted by clicking icons in a "tool box" that floats to the side of the image on which you are working. The image itself is presented in a standard desktop "window."

Photoshop sessions often begin by using one of the selection "marquees" to isolate a specific area of the image. In the first example here, the area around the dog's right-hand eye was selected using the "lasso" tool. You use the computer's mouse, or a pen and pressure-sensitive graphics tablet, to outline the area; the selected area is indicated by a dotted line, sometimes called the "marching ants" because of the way it moves on the screen. You can then alter the color, contrast, brightness, or other properties of the selected area.

Note the small window to the right of the largest image below, showing the selection, below. This "floating palette" allows you to fine-tune different aspects of the particular tool in use. In the example, the palette for the lasso tool makes it possible to give the selected area a soft rather than hard edge; this is done by setting the "feather" parameter to a number greater than zero. The "anti-aliasing" check-box also blends the pixels at the boundary of the selected area. Together, the feathering and anti-aliasing controls can make alterations to the selected area more subtle—the digital equivalent of moving a dodging or burning tool during an exposure under the enlarger to soften the edges of the adjusted area. When you make such adjustments, a "dialog box," such as the "Levels" box below, appears; you use it to input your decisions.

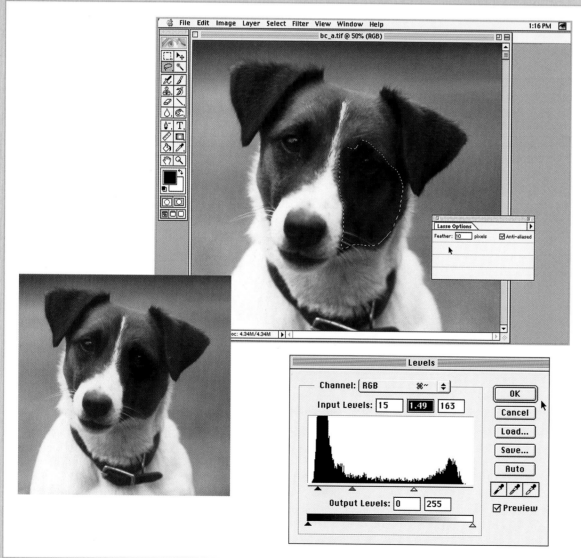

Brightness/Contrast Adjustment *In the "Levels" dialog box below, a two-dimensional graph called a histogram indicates the distribution of tones (brightnesses) in the image, from shadows to midtones to highlights. Two sets of "sliders" allow you to modify this distribution, thereby altering both the brightness and the contrast of the image. One slider lets you independently adjust the highlight, midtone and shadow points (under the graph in the dialog box). The lower slide, under "Output Levels," lets you change the overall scale from each end.*

If you've selected a specific area of the image, only that area will be affected by your adjustments; the overall image will remain the same. In the example here, the dark area around the dog's eye (left) was lightened— "opened up," to use the traditional darkroom term—by selecting it and making the needed adjustment in the "Levels" box. This increased its detail (right), just as dodging would have with a traditional enlargement.

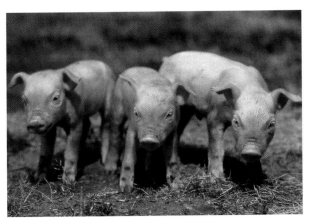

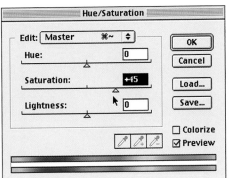

Hue/Saturation

Edit: Master ⌘~

Hue: 0

Saturation: +45

Lightness: 0

OK
Cancel
Load…
Save…

☐ Colorize
☑ Preview

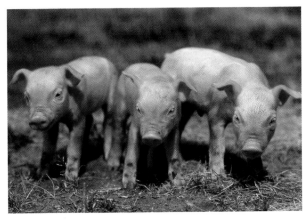

Saturation Adjustment *The "Hue/Saturation" dialog box allows you to adjust a photograph's hue, saturation, or lightness. Hue refers to a particular color cast; saturation indicates a color's intensity; and lightness describes how bright or dark the color is. You change these qualities by moving sliders along a horizontal scale.*

You can affect all hues in the image simultaneously by using the "Master" setting in the Edit pulldown menu, as in this example, at the top of the dialog box. Or, you can alter a specific family of hues, such as reds, greens, or yellows by selecting a specific channel from

that menu. Moving the saturation or lightness slider to the right increases these colors' presence in the image; moving the slider to the left decreases it. Moving the hue slider to either right or left will shift the hue of the image into different parts of the color spectrum.

Note that with many Photoshop tools, you can see the change take place in the image onscreen as you make the adjustment. (If such visual inspection is to be reliable, you must be sure your monitor is properly calibrated.) If you don't like a particular alteration, you can click the "Cancel" button to return the image to its original appearance.

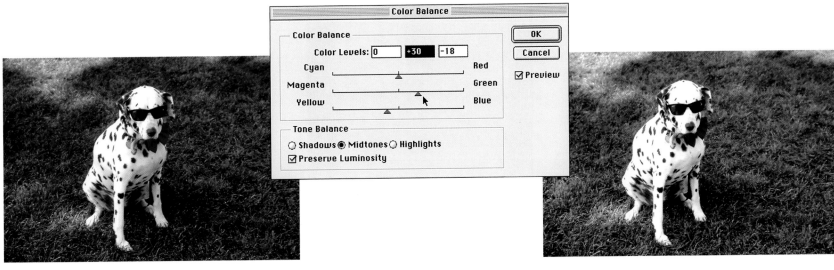

Color Balance

Color Balance

Color Levels: 0 +30 -18

Cyan ——————▲—————— Red
Magenta ——————▲—— Green
Yellow ——————▲—— Blue

OK
Cancel
☑ Preview

Tone Balance
○ Shadows ● Midtones ○ Highlights
☑ Preserve Luminosity

Color Balancing *Like the hue slider in the "Hue/Saturation" dialog box, moving the sliders in the "Color Balance" dialog box adjusts the overall hue of the image. In this example (left), the overall hue was adjusted to make the grass a warmer (more yellowish) green (right), compensating for the blue cast caused by shooting in open shade.*

Balancing color with Photoshop is analogous to color balancing with traditional color prints. But in doing so digitally, such adjustments are even more precise because you can change the color balance within shadows, midtones, and highlights independently, if you wish. A typical use is to remove the bluish/cyan cast that sometimes appears in the shadow areas of color photographs such as in this example.

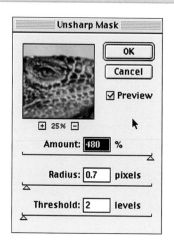

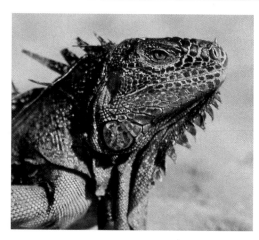

Sharpening There are several Photoshop functions that allow you to sharpen an image that is soft due to incorrect focus or blur. The most useful of these is the "unsharp mask," a "filter" that alters a complex set of parameters to create sharper edges and improve the sense of detail in an image.

As with all functions in Photoshop, this tool can compensate for imperfections only up to a point. A completely blurry image can never be made to look perfectly sharp. But a slightly out-of-focus image such as this photo of a lizard (left) can be sharpened with surprising success (right).

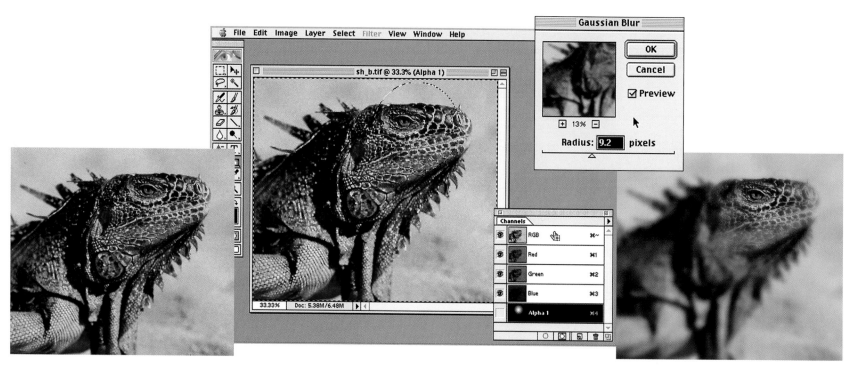

Blurring In Photoshop, a "channel" is a set of information about the image. For instance, Photoshop treats an image as being made up of a set of layered color channels that combine to make a full-color photograph. But channels can also be added to hold information regarding modifications to all or part of the image. Here, an extra channel named "Alpha1" was created. Unlike the other channels in this example, the extra channel does not contain color information about the image. Instead,

it is used to define a selection area with a soft edge. Creating this channel first limits the effect of the "Gaussian Blur" filter to only certain parts of the image—causing the eye portion of the lizard's face to remain sharp, while the rest of the image is increasingly blurred from the center outwards. Since the information regarding this change is contained within its own channel, you can delete the entire channel at any time to restore the image to its original appearance.

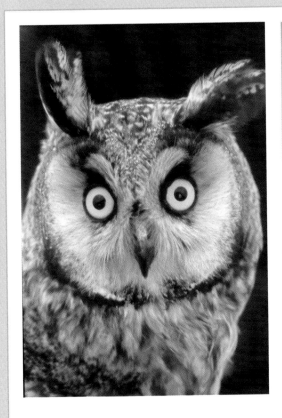
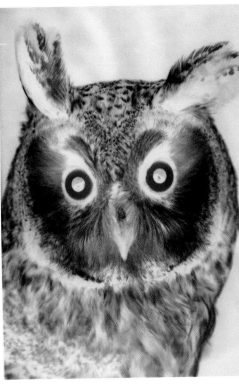

Inversion from Positive to Negative *To convert an image from positive (left) to negative (right), you use a simple inversion function from the main menu. Black-and-white photographs always invert cleanly, but color photos often don't invert into a perfect, film-like negative of themselves. This is due both to the absence of the usual orange-tinted base built into all color negatives and to the added complexity of color information in the image file.*

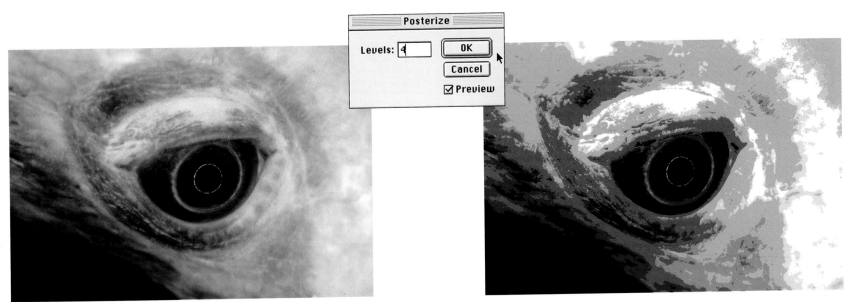

Posterization *The Posterize command essentially lets you reduce the subtle gradations of tone in an image, giving it a bolder, more graphic appearance. In the "Posterize" dialog box, you set the "Levels" parameter to specify the number of tones or brightness levels Photoshop must use to define the image. When you execute the command,* *Photoshop re-assigns each pixel to the closest matching level. Fewer levels result in a more "abstract" image with less photographic detail and more explicit color banding. More levels result in an image that more closely resembles the original. In this example, a level of four causes colors and shapes to block up extensively.*

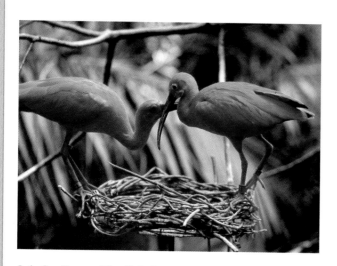

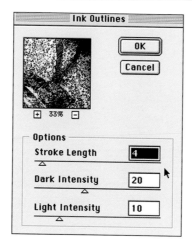

Ink Outlines The "Ink Outlines" filter is just one of the Photoshop tools that emulates a "fine art" technique. (Others include Crosshatching and Smudge Stick.) With tools that mimic hand work, you set parameters such as stroke length and intensity to adjust how the effect is rendered. The apparent surface texture and style of the resulting image are altered to imitate the look and feel of the technique in the real world.

Bas Relief The "Bas Relief" filter changes a photographic image to look like a stone-carved or fossilized relief. Since this filter functions by detecting differences in tone among adjacent pixels, you should choose an image with readily discernible surface texture to create a more pronounced dramatic embossed effect. The dialog box permits you to adjust the smoothness and level of detail in the relief, as well as the direction from which the light appears to strike the image.

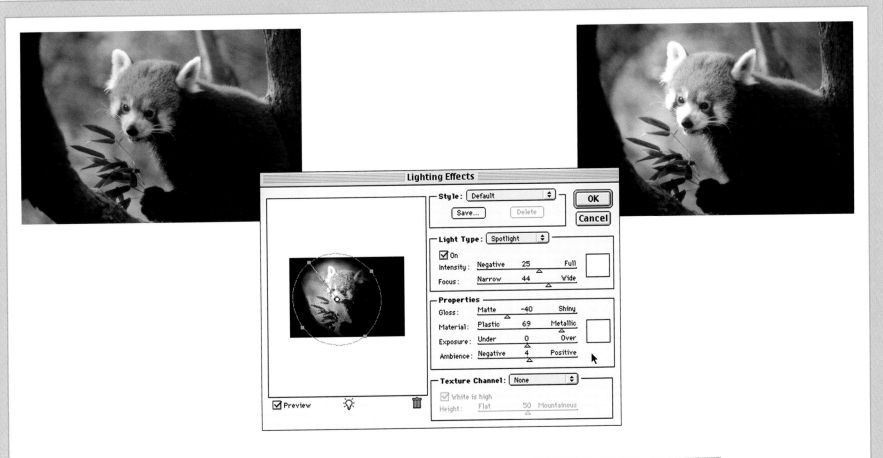

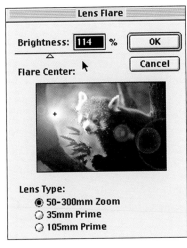

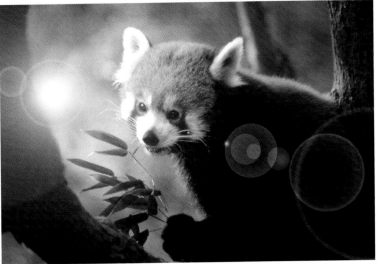

Lighting Effects/Lens Flare *Photoshop even has tools that let you dramatically alter the lighting of an image from the way it appeared when you took the photograph. You can control different effects including the lighting type, intensity, and direction. In this example (top left), the "Lighting Effects" dialog box (top center) was used to enhance the lighting significantly, as if a bright spotlight emanated from the scene's left background (top right). As a final touch, a simulated lens flare was introduced (bottom left), which emphasized the flow of light towards the front of the image (bottom right).*

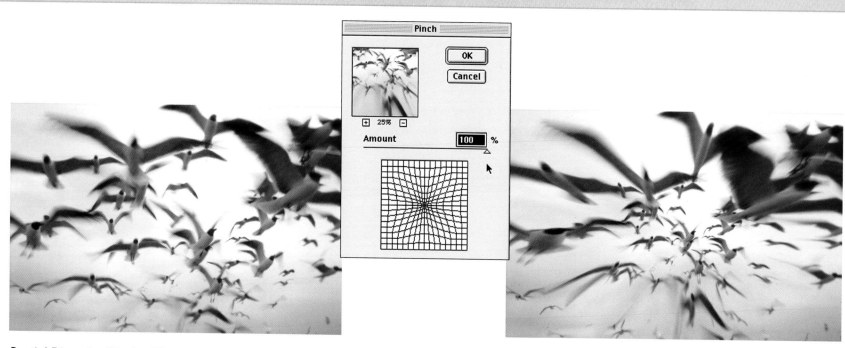

Spatial Distortion/Pinch The "Pinch" filter distorts an image as if it were being squeezed, producing an effect like the distortions in a funhouse mirror. Like all Photoshop filters, Pinch will affect the entire image unless a selection area is drawn. Moving the slider to the right makes the picture plane recede in the center, as if it were being pinched and pulled from behind. Moving it to the left makes the picture plane appear to bulge outward. In this image (left), the distortion reinforces the effect of the gulls flying out from the center of the scene (right).

Cloning Two tools were used to copy, or clone, the bunny. One tool, the rubber stamp, which is accessed directly from the toolbox, works by copying from a source point in the image to a destination point at another spot. The other technique for cloning is simply to select an area with one of the marquee tools—in this case, the lasso was used to draw an irregular outline around the original bunny—and then repeatedly copy and paste it elsewhere in the image. To aid in the believability of the cloned image, the selected areas are often transformed in size, position and orientation.

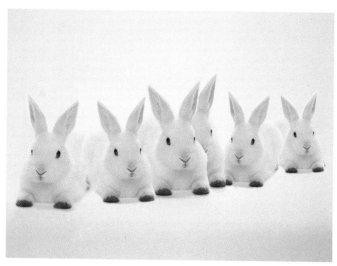

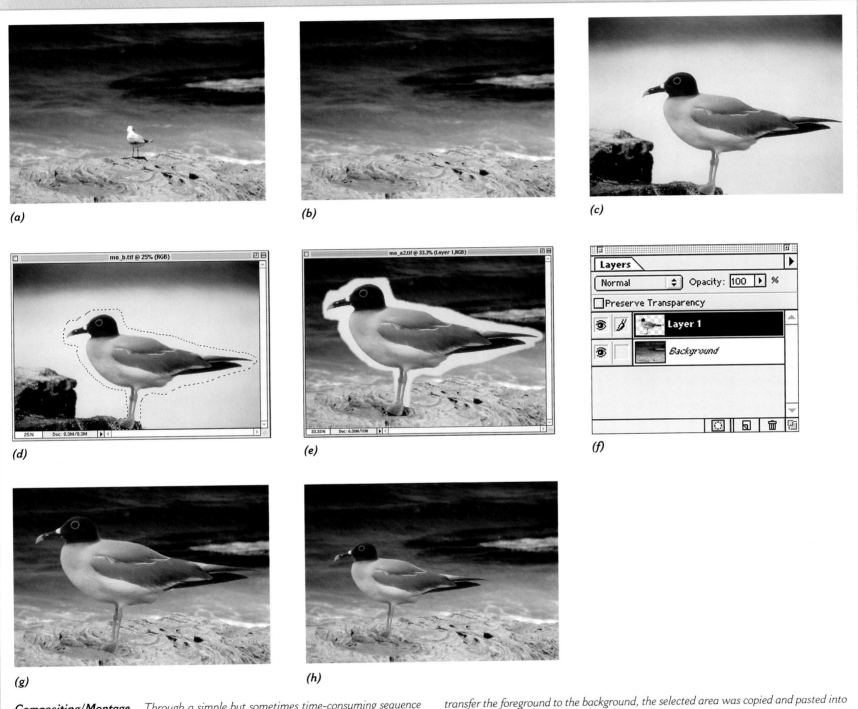

(a)

(b)

(c)

(d)

(e)

(f)

(g)

(h)

Compositing/Montage *Through a simple but sometimes time-consuming sequence of steps, two or more source images can be combined into what appears to be a seamlessly "realistic" photomontage. In this example, the steps were as follows. First, a background image was chosen (a). Then the extraneous parts of the background image were eliminated through "cloning" or other means (b). Then, a second image was chosen to supply the foreground (c). The seagull portion of that second image was selected (d). To transfer the foreground to the background, the selected area was copied and pasted into the background image (e). Photoshop automatically creates another "layer" which allows the selected part of the picture to "float" above the background (f). After this "pasting" step, the new layer was cleaned up. In this example, the eraser was used to remove the halo of extra detail that surrounded the gull in the foreground (g). Resizing the composited gull created an apparent scale change of the shoreline cliff (h).*

By spraying tiny droplets of colored dye on paper, inkjet printers offer extremely high image quality in digital output. Special photographic-quality models and paper offer prints with much of the look and feel of conventional photographic paper. But many photographers make inkjet prints on artists' watercolor and print-making papers for a more painterly effect.

Inkjet Most popular desktop printers fall into the **inkjet printer** category. In these models, microscopic drops of ink are sprayed onto paper to create the image. Quality is measured in **dots-per-inch (dpi)** of ink or dye, though other factors play a big part in the final result. You can get reasonably good quality printing on regular bond paper, or near-photographic quality with special inkjet paper. There are numerous brands of inkjet paper available; experiment to see which provides the best results for you. Transparent film materials can also be printed on with inkjet printers (see box, below). With some models you can even use sheets of artists' watercolor paper and other materials to produce a more painterly or otherwise unusual effect.

Many photographers also output their digital images on an **Iris printer,** a pro-prietary form of inkjet printer. The Iris is so costly to buy and maintain that only photolabs, digital service bureaus, and some schools can afford them, though, and the per-print prices can be high. The Iris creates photographic images by spraying cyan, magenta, yellow, and black dye onto paper rotating at high speed on a cylindrical drum. The fineness of the spray smooths the printer's 300 dots-per-inch output to produce the sense of continuous tone and seamless full-spectrum color.

The combination of that quality with the ability to print on a variety of artists' watercolor and printmaking papers, coupled with the capability to create prints up to four or more feet in width, has made inkjet printers a favorite of commercial and fine-art photographers. Early versions of the inks, which are actually dyes, were

digital images. And though some types of printers are too costly for individuals to own—you will have to go to a school lab or service bureau to print your work on them—a new generation of desktop printers has made it possible to obtain near photographic quality inexpensively. In fact, these printers have helped set the quality standard for digital imaging, and they range in the size of the prints they can make from 4" x 6" to 11" x 17" and even larger.

Keep in mind that to realize the image quality of these printers, you have to start with good-quality digital files of considerable resolution and color depth. Pictures shot with inexpensive digital cameras, or those scanned in at relatively low resolution, just won't provide a high-quality result.

DIGITAL INTERNEGATIVES

Inkjet printing also offers a digital means to a conventional photographic end, accomplished by outputting the image to a clear-based film rather than to paper. This is ordinarily done to create positive transparencies for display purposes (in store windows, for example) but also allows you to create a negative from a digital file. That negative can then be printed by traditional means, or serve as an intermediate step for various types of darkroom manipulations and nonsilver printing techniques. Many such processes require contact printing, so the negative must be the same size as the final image. Inkjet output provides an alternative method to create the needed enlarged internegative.

In the traditional darkroom, enlarging original negatives to contact-print size involves a two-step process in which the image is reversed to a positive and back to negative again (see Chapter 16). But with digital inkjet output, original film can be scanned in and output directly on film at the needed size, eliminating the darkroom work. Positive originals can even be used and digitally reversed to negatives. Precise contrast and density (critical to such techniques) can be achieved with image editing software, and the image can be retouched to yield a negative that requires no further manipulation or spotting in the final printing.

inkjet printer Digital output device that forms an image by spraying tiny drops of ink onto paper.

dots-per-inch (dpi) Term used to describe the resolution of a digital printer; generally the more dots per inch, the sharper and more tonally smooth the image appears.

Iris printer Proprietary inkjet printer that creates very high-quality digital prints on a variety of media, including artists' papers.

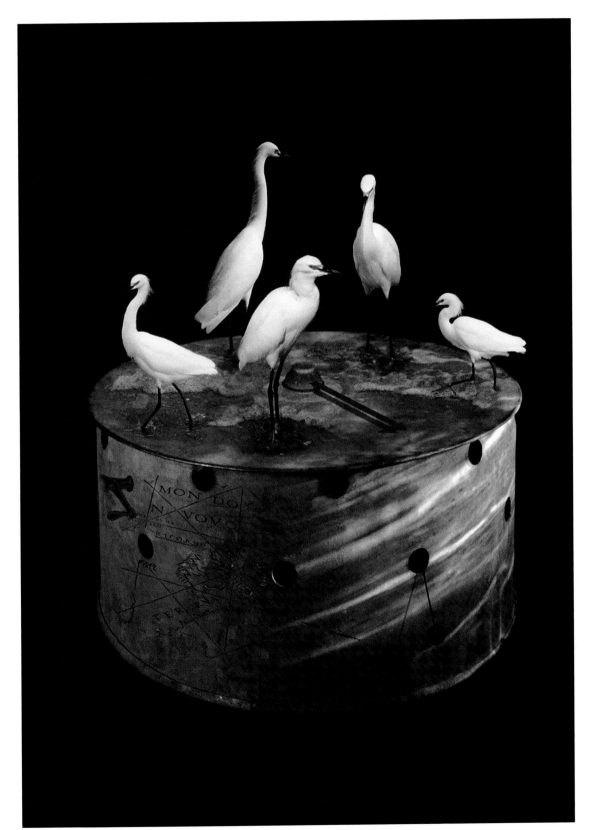

Olivia Parker

Action Toy, 1994

For many years Parker has meticulously constructed her images in the studio, combining found objects and other materials and photographing them with careful lighting to create evocative still lifes. Digital imaging affords a natural extension of the way she works, making it possible for her to combine elements without the need to physically assemble them. It has also allowed her to incorporate "live" subject matter such as the birds in this image, from a recent series on fantastic toys and games. Olivia Parker © 1994, Courtesy Robert Klein Gallery, Boston

A film recorder allows digital image files to be "written" back to film, which is then processed in standard chemicals to create a conventional transparency or negative. Some commercial photographers do this simply so they can provide a transparency to clients who prefer not to work directly with a digital file. Others use it to digitally manipulate or retouch an image but then go on to make a conventional print. Film recorders have extremely high resolution and are generally too costly for individual photographers to own, so they are most often found in school labs and at digital service bureaus.

prone to fast fading and color shifts, but the newer generations of dyes are far more stable and spray coatings can be applied to prints for added protection and permanence.

Silver Halide You can output a digital file straight back to traditional silver-halide materials—both film and paper. A device for outputting to film is called a **film recorder,** while printers that use conventional photographic paper go by different proprietary names. Having the option to "write" a digital image back to film or paper can be useful for professional photographers whose clients don't have the means (or prefer not) to deal with large digital files.

Film recorders work by passing a cathode ray tube (CRT), light-emitting diodes (LEDs), or a fiber-optic array (basically, tiny colored lights) across the surface of transparency or negative film—in effect, painting the image with light. The film is then processed normally. You can use standard films, but special transparency and negative films have color and contrast characteristics specifically designed for digital output.

Film recorders range from 35mm desktop designs to sophisticated multi-format models; both are relatively expensive, though 35mm models are within the reach of many individual photographers and are often available in school photo labs. Because large-format film recorders are so much more expensive, service bureaus charge a premium for their output. (Some models will output film as large as 8" x 10", though outputting to 4" x 5" film is the most common practice.)

Differences in price (both of film recorders and their output) also reflect differences in the resolution they provide, which in turn determines how large a conventional print or reproduction may be made from the output film before digital artifacts begin to show up. The best film recorders can produce resolutions of as high as 16,000 or 32,000 dots-per-inch, providing quality good enough (when these models are outfitted with "cine" modules) for digitally created special effects in film work.

Some photographers use digitally output film to make conventional photographic prints. This way, they can use image-editing software to do all the manipulation that would ordinarily have to be done in the darkroom and thus produce a negative or transparency that prints easily and consistently, with little or no darkroom manipulation.

Silver-halide digital printers take roughly the same approach as film recorders, though they don't require as high resolution. They expose conventional printing paper (or transparent display film) with CRTs, LEDs, or fiber optics. The paper is then processed normally, either within the machine itself or in a separate print processor. The resolution afforded by these printers, typically 300 or 400 dots-per-inch, is adequate for the large-scale applications for which they're often used. But it may not stand up to the scrutiny to which smaller-scale photographic prints are subjected, though some manufacturers have devised variations of the technology that deliver photographic quality.

Pigment Pigment prints are produced by a complex conventional process very much akin to the now-defunct dye-transfer method, one of the earliest methods of making high-quality color prints. But there are a couple of important differences. One is that durable pigments—essentially, paints—are used for the process, rather than dyes. This makes pigment printing perhaps the most permanent of all photographic printmaking techniques, whether black-and-white or color.

The other difference is that, more often than not, the pigment print process begins with a digital image. The original negative, transparency, or print is scanned to make a digital file, retouched if needed, then "separated" into its component red, green, and blue primary colors. Those three separations are then output on an inkjet printer as three enlarged black-and-white negatives that are the same size as the intended final print.

The remainder of the process is traditional. The negatives are individually

film recorder Output device that converts a digital file into a film negative or transparency, which is then used for conventional printing or reproduction.

Dye-sublimation printers are quite costly compared to inkjet models, but they create prints that have color and surface characteristics similar to those of conventional prints. Their high image quality is due to a system in which dyes are diffused into the paper surface from a "donor" sheet. This produces a very smooth appearance in the image. In addition to cost, one dye-sublimation drawback is that print sizes are somewhat limited.

dye-sublimation printers Digital output devices that form an image with special heat-diffusion process, using media with color, tone, and surface characteristics similar to those of traditional photographic papers.

electrostatic printers Digital output devices that form an image using electrically charged rotating drums and special charged inks.

color management Refers to software schemes and digital devices designed to ensure color consistency and accuracy through successive stages of the digital imaging process.

contact-printed onto special matrix films, which are immersed in pigments of their respective primary colors. After the matrix films absorb the pigment, they're placed in sequence, carefully registered, in contact with the final support material. The process requires extreme care for good results, and can only be done by specialized labs. Because it's so labor intensive, it's one of the most expensive photographic printing processes in use.

Dye-sublimation Also known as "dye-sub," **dye-sublimation printers** produce prints with color and surface characteristics similar to those of traditional photo papers, depending on the quality of the original image file. In dye-sublimation printers, dyes are diffused into the paper's polyester coating from a separate carrier ("donor") sheet by heat. That process gives their 300 dots-per-inch resolution a smoother, more continuous appearance. Dye-sub printers are pricey, though, and provide limited print size, generally within the 8" x 10" to 11" x 17" range.

Electrostatic This is the technology used by color ("laser") photocopiers, many of which can be linked with computer-controlled "driver" hardware that enables them to create prints directly from digital image files stored on various removable disks. Such **electrostatic printers** don't provide true photographic quality, but their low cost makes them useful for proofing, presentation, and other purposes. (Some photographers also have exploited the amplified quality of their color for its own sake to create a particular "look" for their photographs.) One disadvantage to this option is that print dimensions are limited to stock copier paper sizes.

There are also self-contained electrostatic models that use similar technology to output to continuous rolls of paper, allowing print sizes over four feet wide by as long as the roll permits. These expensive units were designed for billboards and technical applications, and they produce an image with a visible dot pattern that may be unsuited to small print sizes, depending on the desired effect. The dots blend together at greater viewing distances, however.

COLOR MANAGEMENT

One of the thorniest issues in digital imaging is color fidelity. Given the number of steps and devices involved—cameras, scanners, computers, monitors, storage drives, printers, and their attendant software—there are many points at which a photograph's colors can be misinterpreted. You may have begun the process with a particular idea of how you wanted the color to look, but what comes out at the end might bear little resemblance to your original ideas.

That problem has led to the emergence of software specifically for **color management.** These programs, often built into image-editing software, help you compensate for the differing color characteristics of the various parts of your digital imaging system. They also increase the chance that when your file goes out to a service bureau you'll get results close to what you intended.

What's more, if you're doing serious on-screen retouching it's important not only that your computer have full-color video capability to support your software, but that your monitor be carefully color calibrated. Calibration devices that attach to your computer monitor are available for this purpose.

DIGITAL IMAGING AND THE WORLD WIDE WEB

With the ability to view photographs built into most computer browser software, the World Wide Web has become an increasingly popular milieu for photography—and many photographers have set up Websites to display their own photographs. The reasons are varied. A Website can be valuable as a promotional vehicle, allowing art directors, picture editors, and curators to view a photographer's work without the need to receive a physical portfolio. (You just provide the Website's URL—its electronic address.) A Website can also serve as a portfolio for potential users to review, then contact a photographer directly to request specific images. The Web is being used this way by photographers both to market work for use in magazines and books and to sell actual prints.

Websites also offer photographers a good way to see the work of other photographers that they may not be able to find any other way. In fact, many art galleries and auction houses now operate their own Websites as a sales and promotional tool. Many other Websites created by companies or individuals with photographic interests or businesses also incorporate photo "galleries." Finally, Websites can also serve as sources of photographic information from manufacturers and individuals.

You can hire designers to build a Website for you, but this is an expensive way to go about it. Many Internet Service Providers (ISPs) offer Web "hosting" services for a relatively low charge, offering both the Web space (for a monthly charge) and downloadable software with which you create the site. Some online companies even offer free Websites, providing all you need to put the site together, and maintaining it for you, in exchange for the right to place advertising on it. Web design software is also available commercially.

When preparing images for use in Web pages, always compress them to expedite download time. Compressed files, since they require less digital information, take less time to send and receive over the Internet. Compression can be achieved in several ways, each of which affects image quality when the image is later converted back to its original size. One way that retains a high degree of photographic detail compresses adjoining pixels in the image grid to reduce the total number of pixels—and thus the size of the image file—when the image is written to disk. This kind of compression is referred to as JPEG for Joint Photographic Experts Group (the consortium that designed this compression method). After a JPEG file is opened or transferred, it typically produces an excellent decompressed image that looks much like the original, uncompressed file.

Web-based images can also be compressed by reducing the number of colors the image contains. By limiting the "color space" of an image, typically restricting it to 256 or even fewer colors, images are reduced in size. The visual effect may be similar to that of banding or posterization, however, due to the image's reduced color palette. (See page 417.) Unlike JPEG compression, the actual number of pixels remains the same.

The World Wide Web permits photographic exhibitions of a sort that might be physically or logistically impossible to put together. For example, Collected Visions (www.cvisions.cat.nyu.edu) is a Website from photography-based artist Lorie Novak that explores the relationship between family photographs and memory. Visitors to the site can upload scans of family snapshots that are then curated into thematic exhibitions. They can also contribute stories, poems and other fragments of text to accompany their photographs, or comment on other images in the site's archive. This makes Collected Visions an evolving interaction rather than a static presentation.

Whether you're an accomplished professional or just starting out, setting up your own Website is an effective and inexpensive way to present your photography to both the public and potential clients. John Goodman's site (www.goodmanphoto.com) is part commercial portfolio and part gallery of personal work, intended to convey his photographic range and to appeal to a variety of clients and other viewers. Online visitors anywhere in the world can get a sense of Goodman's style without the need to request a physical portfolio. The site also contains a resume detailing exhibitions, publications, and major art collections that have purchased Goodman's prints, as well as contact information for his agent and studio.

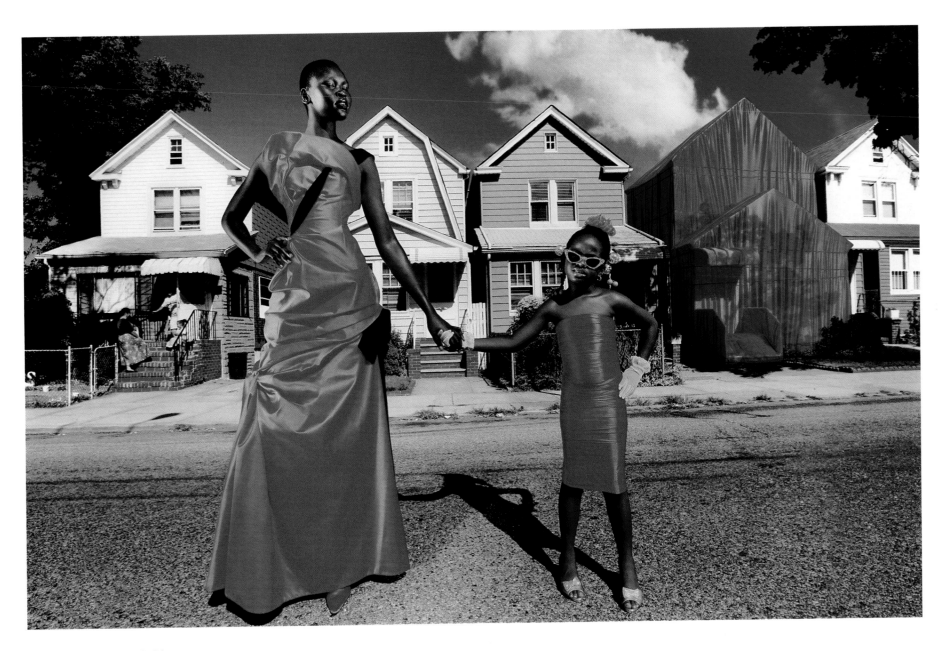

David LaChapelle My House

One of the most successful editorial and advertising photographers in the world, LaChapelle creates complex, vivid, and often bizarre scenes in which fashion models, rock stars, and other celebrities are the actors—their role to poke fun at middle-class culture. He photographs his subjects with traditional materials and then relies on digital imaging not to put these provocative dramas together, but rather to heighten the unreality that is in them to begin with. The result is richer and more seamless than any purely computer-based manipulation. © David LaChapelle Studio

CREDITS

Chapter 2 p. 35, Mark Edward Harris; pp. 38–41, Mary Ellen Mark.

Chapter 3 p. 44, courtesy Canon USA, Inc.; p. 46, courtesy Rollei Fototechnik; p. 47, courtesy Leica Camera, Inc.; p. 48, Thomas Gearty; p. 50, courtesy Mamiya America Corp (Toyo); p. 51, courtesy Calumet Photographic, Inc. (Wista); p. 53, courtesy Canon USA, Inc., Fuji Photo Film USA, Inc., and Kyocera Electronics, Inc. (Yashica); p. 54 top, Thomas Gearty; p. 54 bottom, Stacy Grieg.

Chapter 4 p. 59, Russell Hart; p. 62, Russell Hart; p. 68, Rebecca Norris; pp. 68–71, Alex Webb.

Chapter 5 p. 74, Henry Horenstein; p. 75, courtesy Canon USA, Inc.; p. 76, courtesy Canon USA, Inc.; p. 77, courtesy Canon USA, Inc.; p. 79, courtesy Canon USA, Inc.; p. 80, Bob Hower/Quadrant; p. 82, courtesy Canon USA, Inc.; p. 83, courtesy Canon USA, Inc.; p. 84, Henry Horenstein; p. 85 courtesy Canon USA, Inc.; p. 87, Russell Hart; p. 89, courtesy Canon USA, Inc.; p. 91 left, Henry Horenstein; p. 91 right, Stacy Grieg; p. 94, courtesy Eric Renner.

Chapter 6 p. 102, Bob Hower/Quadrant; p. 103, Bob Hower/Quadrant; p. 104, Bob Hower/Quadrant; p. 106, Russell Hart; p. 108, Betsy Kissam; pp. 108–111, © Chester Higgins Jr. All rights reserved.

Chapter 7 p. 117, Henry Horenstein; p. 119, Henry Horenstein.

Chapter 8 p. 126, Russell Hart; p. 129, Henry Horenstein; p. 133, Bob Hower/Quadrant; p. 134, Thomas Gearty; p. 135, Henry Horenstein; p. 142 center right, Thomas Gearty; p. 142 other, Henry Horenstein; p. 153, Russell Hart; pp. 158–161, Grant Peterson.

Chapter 9 p. 177, Russell Hart; p. 178, Russell Hart.

Chapter 10 p. 185, Stacy Grieg; p. 188, Russell Hart/Visual Departures Ltd.; p. 190, Bob Hower/Quadrant; p. 191, Bob Hower/Quadrant; p. 192, Bob Hower/Quadrant; p. 194, Bob Hower/Quadrant; p. 195, Bob Hower/Quadrant; p. 196, Bob Hower/Quadrant; p. 198, Bob Hower/Quadrant; pp. 200–203, Mark Seliger.

Chapter 11 p. 205, Bob Hower/Quadrant; p. 207, Jim Dow; p. 208, Bob Hower/Quadrant; p. 209, Thomas Gearty; p. 211 left and center, courtesy Canon USA, Inc.; p. 211 right, courtesy Mamiya America, Inc. (Profoto); p. 214, Thomas Gearty; p. 215 left, courtesy Lumiquest; p. 215 center, courtesy Westcott; p. 215 right, courtesy Stofen; p. 218, Thomas Gearty; p. 220, Shellburne Thurber; p. 221, Russell Hart.; p. 224 Bob Hower/Quadrant; p. 226 courtesy Calmut Photographic, Inc.; p. 227 top far left, Thomas Gearty; p. 227 left and far right, courtesy Calmut Photographic, Inc.; p. 227 right, courtesy Mamiya America, Inc. (Profoto); p. 229, Bob Hower/Quadrant; p. 231 left, Thomas Gearty; p. 231 right, Bob Hower.

Chapter 12 p. 240 Stacy Grieg; p. 241, Stacy Grieg; p. 255, Henry Horenstein; p. 256, Henry Horenstein; p. 258, Thomas Gearty; p. 259, Henry Horenstein; p. 260 top left, Thomas Gearty; p. 260 bottom left, Henry Horenstein; p. 260 right, Henry Horenstein; p. 261 left, Thomas Gearty; p. 261 right, Henry Horenstein; p. 262, Thomas Gearty; p. 264, Henry Horenstein; p. 266, Thomas Gearty; p. 269, Thomas Gearty; p. 269, Henry Horenstein; p. 270, Henry Horenstein; p. 271, Henry Horenstein; p. 272, Henry Horenstein; pp. 274–277, Albert Watson.

Chapter 13 p. 283, Russell Hart; p. 286, Stacy Grieg; p. 287, Stacy Grieg; p. 292, Henry Horenstein; p. 293, Henry Horenstein; p. 298, Henry Horenstein; p. 299, Henry Horenstein; p. 302, Henry Horenstein; p. 304, Thomas Gearty; p. 305, Thomas Gearty; p. 306, Henry Horenstein; p. 310, Henry Horenstein; p. 311, Henry Horenstein; p. 315, Thomas Gearty; p. 321 top left, Henry Horenstein; p. 321 bottom left, Thomas Gearty; p. 321 top right, Thomas Gearty; p. 321 bottom right, Henry Horenstein; p. 322, Henry Horenstein.

Chapter 14 p. 327, Andrea Raynor; p. 331, Stacy Grieg; p. 332, Thomas Gearty; p. 333, Andrea Raynor; p. 334, Andrea Raynor; p. 335, Andrea Raynor; p. 336, Andrea Raynor; p. 337, Henry Horenstein; p. 346, Henry Horenstein; p. 349, Henry Horenstein; pp. 352–355, Bill Gallery.

Chapter 15 p. 358, Stacy Grieg; p. 359, Henry Horenstein; p. 362, Stacy Grieg; p. 368 top left, courtesy Light Impressions, Inc.; p. 368 other, Stacy Grieg; p. 371, Henry Horenstein; p. 372, Stacy Grieg.

Chapter 16 p. 376, Henry Horenstein; p. 380, Maturi K. Prenda; p. 382, Russell Hart; p. 394, Rosemary LeBeau; pp. 396, Michele Pedone; pp. 396–399, Jill Greenberg.

Chapter 17 p. 401, courtesy Nikon Inc.; p. 402 left, courtesy Agfa; p. 402 right, courtesy Nikon Inc.; p. 403, Habced; p. 404 left, courtesy Nikon Inc.; p. 404 top right, courtesy Calmut Photographic (Megavision); p. 404 bottom right, courtesy Calmut Photography (Better Light); p. 406 left, courtesy Lexar Media Inc.; p. 406 right, Fuji Photo Films USA, Inc.; p. 409 left, Eva Sutton; p. 409 right, courtesy Polaroid Corporation; p. 410 left, courtesy UMax; p. 410 right, courtesy HiResolve Grand; p. 412 top center, courtesy Iomega; p. 412 bottom center, courtesy Ricoh; pp. 414–421 (digital manipulation), Eva Sutton; p. 414; p. 415 top, Henry Horenstein/Photonica; p. 415 bottom, Russell Hart; p. 416, Photonica; p. 417 top, Photonica; p. 417 bottom, Russell Hart; p. 418, Photonica; p. 419, Photonica; p. 420, Photonica; p. 421, Photonica; p. 422, courtesy Epson America, Inc.; p. 424, courtesy Polaroid Corporation; p. 425, courtesy Lorie Novak and the Collected Visions Project; p. 426 left, courtesy Lorie Novak and the Collected Visions Project; p. 426 right, courtesy John Goodman; designer: Jeanne Goodman.